william
sidney
mount

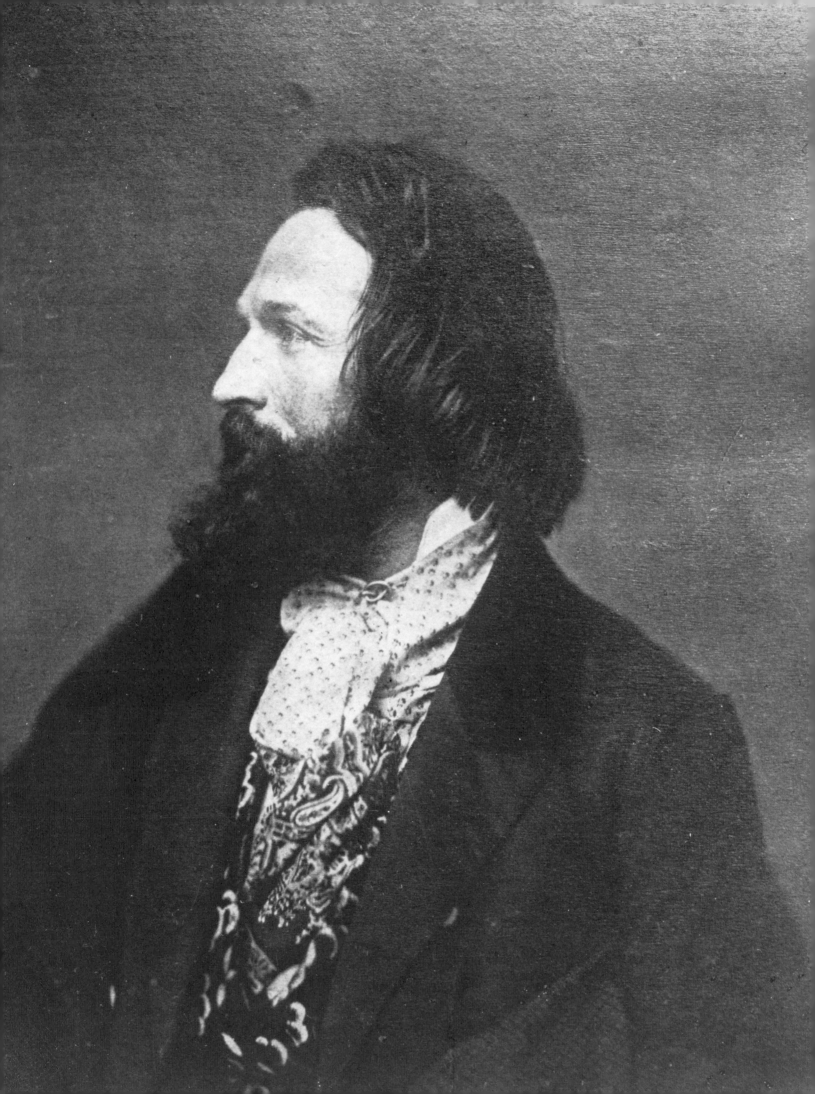

Alfred Frankenstein

william sidney mount

HARRY N. ABRAMS, INC. PUBLISHERS, NEW YORK

1. *William Sidney Mount*. Date and photographer unknown.
The Museums at Stony Brook, Stony Brook, Long Island

Library of Congress Cataloging in Publication Data

Frankenstein, Alfred Victor, 1906–
 William Sidney Mount.

 1. Mount, William Sidney, 1807–1868. I. Mount,
William Sidney, 1807–1868.
ND237.M855F72 759.13 74–4007
ISBN 0–8109–0315–6

Library of Congress Catalogue Card Number: 74-4007
Copyright © 1975 by Harry N. Abrams, Incorporated,
New York, except colorplate sections. All rights reserved.
No part of the contents of this book may be reproduced
without the written permission of the publishers. Printed
and bound in the United States of America. Colorplates
printed in Japan

Nai Y. Chang, *Vice-President, Design and Production*
John L. Hochmann, *Executive Editor*
Margaret L. Kaplan, *Managing Editor*
Barbara Lyons, *Director, Photo Department, Rights and
 Reproductions*
Eliza L. Woodward, *Editor*
Wladislaw Finne, *Designer*
Lisa Pontell, *Picture Editor*

contents

William Sidney Mount: An Appreciation 7
Foreword 12
Autobiographical Sketches and Fragments 15
Robert Nelson Mount 50
Luman Reed 68
Robert Gilmor and E. L. Carey 74
Violin 79
Jonathan Sturges 95
Correspondence, 1838–1845 101
Charles Lanman 106
Diaries, 1843–1845 127
Mr. Dignity 131
Diaries, 1846 141
Correspondence, 1846–1847 148
Goupil, Vibert & Company 152
Diaries, 1847 170
Diaries, 1848–1849 183
Campaign of 1848 201
The Queens Borough Sketchbook 205
Correspondence, 1848–1849 232
Diaries, 1850–1852 238
Theodorus Bailey 251
Correspondence, 1850–1852 258
Portable Studio 262
Diaries, 1853–1854 266
A Group of Mount Landscapes 274
Spiritualism 285
Correspondence, 1853–1855 298
Diaries, 1855–1858 306
John M. Falconer 317
A Mount Miscellany: Paintings 322
Correspondence, 1856–1858 334
Diaries, 1859 339
Correspondence, 1859 348
Diaries, 1860–1861 351
Correspondence, 1860–1861 356
Diaries, 1862–1863 360
Correspondence, 1862–1863 368
Diaries, 1864–1865 378
Correspondence, 1864–1865 393
A Mount Miscellany: Drawings 398
Diaries, 1866–1867 421
Correspondence, 1866–1867 436
Diaries, 1868 443
Correspondence, 1868 451
Funeral Eulogies 457
Estate Papers 460
Mount Paintings: Four Catalogues 466
National Academy of Design Exhibition
 Record, 1828–1869 482
Bibliography 485
List of Illustrations 488
Photo Credits **490**
Index 491

To Mr. and Mrs. Ward Melville,
without whose dedication to the memory of
William Sidney Mount
no study of that artist could
ever be attempted.

william sidney mount: an appreciation

There have been many international styles in the long history of art, but the international style to which William Sidney Mount contributed was different from all the others in one paradoxical respect: everybody thought it was a national, provincial, or parochial style peculiar to his own neighborhood.

In Europe and America, following the breakup of eighteenth-century Neoclassicism—with its grandiose subjects, its "noble simplicity and calm grandeur," and its imperial acreages of paint—came a pronounced interest in the intimate, the anecdotal, and the gently scaled. "History painting says 'This happened once,'" observes Max Friedländer; "genre painting says 'This happens every day.'" William Sidney Mount was one of those who convincingly recorded what happened every day in rural American villages before the Civil War. Every country of Europe swarmed with painters who had similar interests, and so did at least one country of the Orient—Japan. William Sidney Mount might well be called the Hokusai of Stony Brook, and Hokusai's most famous remark about himself applies with equal force to his Long Island counterpart.

Hokusai called himself "an old man crazy about painting," and it was the act of painting, above everything, which fascinated Mount. This is well shown in the scribblings with which he filled journal after journal throughout his entire career.

We turn, more or less at random, to Mount's journal for December, 1846:

The City is the place to stimulate an artist—more art to be seen. In the Country the painter must call up a feeling for art by reading the lives of Painters and other eminent men. I must paint larger pictures—takes no more time and more effective in an exhibition.

Shadows in a portrait should not be too sharpe but soft and melting away in the receding shadows. Have roundness with breadth. Lines should be sharp in particular places—only—

This sharpness and softness is important and should always be in the mind of the artist—parts of the figure should be broken with the background to produce fullness and magic of effect. It is well to turn your portraits upside down to see the gradations. . . .

A head in the dead colouring should be left rather indefinate, bold in the tinting, with green, yellow, and red—the hair touched in and the effect of the head given as regards breadth and general resemblance. The cool tints should set off the warm, and light and shadow melt, one in to the other.

Upon a light yellow tint touch on a light red and on the focus of that a cool tint made of white Naples and blue. The latter tint will make the delicate greys in the flesh etc. and the high lights etc. . . .

Flesh palette—Naples and madder lake. D[itt]o and Stone Ocher. Do and vermilion. Vermilion and Lake—adding white as you paint. Blue and white tint, purple tint. Naples and blue ["light green" interlined above

this phrase], Indian red and Lake, Ocher and blue (green), Indian red and black. You can combine any of the yellows with the reds—then add blues and greys at pleasure.

White and a very little red can be scumbled over your work in the finishing with a good effect. Colours should be rubbed in with your fingers. Titian prefered his fingers to brushes in finishing. Suffer but little white to enter your picture, and only in the demi-tints.

This is the typical entry in Mount's diary, concerned almost exclusively with technique and not at all with the observation of people and their ways with which his paintings are filled.

The entry opens, however, with one of Mount's perennial obsessions—city versus country. He repeatedly goes to New York, but no sooner has he unpacked his bag than he complains of the crowding, the dirt, and the discourtesy to be found in the urban setting. He goes back to Stony Brook, and then he complains of the psychological isolation, the country people's indifference to art, and the physical difficulties of life in rural surroundings. He made Stony Brook the center of his activities because he had inherited property there and because he had a world reputation as a painter of Stony Brook types and incidents, but he always held somewhat aloof from the village and its people. This aloofness is reflected in many of his genre paintings by a figure who might be called the "Mount Mysterious Stranger"—a man or woman (most often a man) who stands apart from the activities of the depicted group, looks on, but does not participate. The man with his back to the stove and his cap pulled over his eyes in *The Long Story* is an excellent example.

Mount's journals are filled for endless pages with notes on pigments, mediums, varnishes, brushes, studio lighting, and so on, and he will copy entire borrowed books on technique into these same journals. None of this should be really surprising, but there has been—and there still is—far too much emphasis on Mount as recorder of country life and far too little emphasis on the endlessly complex and endlessly challenging business of stroking colored oils onto canvas, which is what really interested him.

He never stopped experimenting with technique and recording his experiments in detail. But, except for long lists of possible subjects, each set down in a single short phrase or word, Mount's journals convey no hint of the fact that the man who filled them was a painter renowned for his observation of people and what they do. Indeed, one might conclude from Mount's jottings that landscape attracted him a great deal more than the human scene:

In painting a landscape from memory, many universal colors or tints are to be thought of. 1st the local color. 2d the air tints resting upon the foliage, grass, trees, figures, animals, houses, water etc, besides reflections. The bodies of some trees are grey, also of fences, and some buildings. . . .

The atmosphere must pervade every where—so that you can tell the distance from one object to another. The pink or the flesh colored mountain in the extreme distance, also, the blue, gray, and purple, which makes up the gradations of distances so delightful to be seen in the mornings and afternoons, in contrast to the grayish, brownish, greenish, redish, yellowish and umberish foreground. Every object must be made out and to have great power in foregrounds, dead weeds as well as green. . . .

Cultivate the memory. Look attentively at an object, or a scene, and go to your room and see if you can paint it from memory. *Try*, Try, we do not know ourselves, until we Try. The four seasons are presented to us one after the other, to give us painters a chance to select material. Night and day should be our daily study. Begin now, no time to be lost.

This last paragraph is particularly noteworthy because it was written in 1859, when Mount had been painting for thirty years and was in fact moving into the final phase of his career. But his journals never lose that tone of anxiety and self-exhortation. Equally obsessive and, in all probability, deeply linked psychologically, are journal entries like the following:

The stool, the Urine, and the Pores— These must be kept in a healthy condition, or disease is certain.

The *liver* must be kept in order. The stomach must be invigorated and made healthy—the strength and tone of the system must be kept up by proper nourishment, excercise and health.

Keep up the practice of washing as long as you live and use Graefenberg Vegetable Pills—if needed. [Interlined above the last few words: "Rhubarb is better."]

Eat Indian gruel, or oat meal gruel.

I cured myself of a bilious fever and cough, by taking Ayers Pectoral and a dose of Castor oil and Graefenberg Pills.

When you begin to feel unwell stop eating, in place of taking so much medicine.

For a cough, eat spermaceti—in cake form. . . .

For sore throat, chew Indian posey—or Pepper grass —also, for the teeth chew rye or wheat. Chew parsley.

A pillow case filled with hops will cause sleep—to come upon the sleeper.

Observe now what follows immediately:

A greater variety of character, and different kinds of occupation to be found in New York City.

Mr. Leutze—said that I should stand up while painting—better for health.

Perhaps I should have a room in the City. Plenty of subjects for pictures. In painting backgrounds, scumble in a variety of colors—after painting the flesh.

For all his feeling that there would be "plenty of subjects for pictures" in New York City, Mount never painted a single canvas with a specifically urban setting. He

painted a few pictures, like *Dregs in the Cup* and *The Painter's Triumph,* in which the setting could be either town or country, but although many specifically urban incidents appealed to him sufficiently to be mentioned in the almost endless lists of possible subjects with which his journals abound, these incidents were never realized in paint. His lists of possible subjects are Mount's only verbal expression of interest in people and their doings, and they define that interest in its broadest aspect. We reproduce them all in the pages that follow.

Much—far too much, indeed—has been made of Mount's aesthetic populism. It is true that he wrote things like "I must paint such pictures as speak at once to the spectator, scenes that are most popular, that will be understood on the instant." But he also frequently contradicted such sentiments: "I must endeavor to follow the bent of my inclinations. To paint portraits or pictures, large or small, grave or gay, as I please, and not be dictated to by others. Every artist should know his own powers best and act accordingly." In other words, William Sidney Mount was a man of many moods, and to emphasize one of them and ignore its opposite is to falsify him completely. Mount the populist is largely the invention of critics who are out of sympathy with modern art and who like to use the presumed general appeal of historic art as a club with which to beat contemporary expression and its presumed elitist attitudes.

To be sure, Mount was by no means totally independent of the social and political currents of his time. His first success came in 1830 with his first rural genre scene, *Rustic Dance After a Sleigh Ride* (pl. 2, c.pl. 1), which was so well received when it was shown at the annual exhibi-

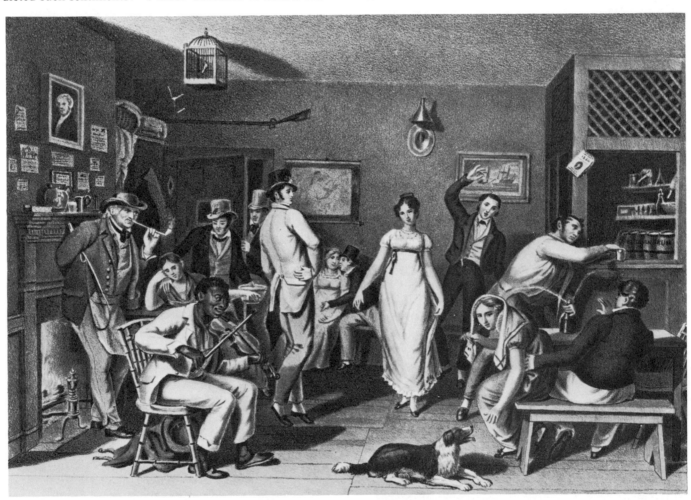

2. George Lehman. *Dance in a Country Tavern.* 1835–36. Lithograph after a drawing by John Lewis Krimmel,
7 7/8 × 10 7/8″. Historical Society of Pennsylvania, Philadelphia

Internal evidence suggests that *Rustic Dance After a Sleigh Ride* (c. pl. 1), Mount's first success and the picture that determined the course of his life as a genre painter, was adapted from the *Dance in a Country Tavern* by John Lewis Krimmel (1789–1821), the German emigrant to Philadelphia who was an important forerunner, if not the actual founder, of the American school of genre painting. Krimmel's picture is lost but survives in the form of a lithograph. Mount could not have used this litho as the springboard for his own work because it was not published until 1835, five years after the *Rustic Dance* was painted; he must have seen Krimmel's original, probably in New York. In the fourth of his autobiographical sketches, Mount speaks of seeing pictures by Krimmel in Philadelphia in 1836 but says nothing further about the artist.

The entire question of the source for *Rustic Dance After a Sleigh Ride* is discussed by Donald Keyes in his article "The Sources for William Sidney Mount's Earliest Genre Paintings" (*Art Quarterly,* Autumn, 1969). This note is indebted to that article.

tion of the National Academy of Design in the spring of that year that a eulogy of it in verse was printed and circulated in pamphlet form. (See Mount's letter of May 29 to his brother Nelson.) Even more significant, however, is the fact that this painting—the work of an artist whose career had begun only two years earlier and who, up to that time, had produced a grand total of twenty-three pictures, nearly all of them portraits—won first prize in October at the third annual exhibition of the American Institute of the City of New York.

The American Institute of the City of New York was a protectionist organization whose annual trade fairs laid very heavy emphasis on the patronage of native manufactures. Works of art were also displayed at these fairs, and it is obvious that the subject matter of Mount's painting appealed very strongly to those in charge. Cultural nationalism harmonizes well with economic protectionism, and in this instance these two forces (which are actually the same force manifesting itself on different fronts) had found the right man to encourage and protect. After winning such dramatic approval twice in one year, it is scarcely surprising that Mount decided to follow the path of genre painting thereafter.

Sheldon Reich and others tell us that Mount's consistent good humor as a genre painter reflects the limitations of a rising American bourgeois class unwilling to face the realities of industrialism, poverty, and slavery that were to lead, within the painter's lifetime, to the Civil War. R. W. B. Lewis treats the same strain in American life more leniently in his idea of the American Adam: a new man (at least in ideal) created by the new environment of a fresh young land. One may add to Lewis the observation that Adam does not work in Paradise; neither does he labor in the genre paintings of William Sidney Mount, George Caleb Bingham, Francis W. Edmonds, James G. Clonney, or any of the other American genre specialists of the first half of the nineteenth century, with the single exception of David Gilmour Blythe; much of the time this new man is doing nothing at all. From a different point of the compass, Josephine Miles reminds us that praise for the beauty and bounty of the land was the dominant theme in American poetry until a very recent time. In the light of this insight, Mount and the genre painters appear as brothers under the skin to the painters of the Hudson River School.

William Schaus, New York City agent for the European firm of Goupil, Vibert & Company, after 1850 known as Goupil & Company, caused ten of Mount's pictures to be reproduced by lithography in Paris and published by his firm for international distribution. Of these, five are bust or seated portraits of young men, of whom four are Negroes and four are playing musical instruments. *The Lucky Throw* is a study of a young Negro holding a plucked goose in his hands; it survives only in the form of the lithograph.

Goupil, Vibert & Company sold its lithographs all over Europe, and Mount seems to have been the only American artist represented in its catalogue. For years,

therefore, he was the best-known American painter so far as the European audience was concerned, and he is often the only American mentioned in mid-nineteenth-century surveys of what was then modern art. His emphasis on Negroes and music may have helped to create some stereotypes about American life in the European mind, and yet his black fiddler, banjo player, and bones player are far from the minstrel-show cliché of the happy-go-lucky Negro. Mount was, in fact, the first American painter to recognize the individuality of black men and give them a place of dignity in art. This is all the more remarkable in view of the fact that he was an active member of the Democratic party for many years, opposed abolition, and delighted in calling the Republicans of 1860 "Lincoln-poops." But he came over to the Lincolnian side when the Civil War broke out.

We turn back to Mount's journals for another aspect of his personality:

At the circle held at Mr. Woolf's, on Sunday evening the 26th [November], 1854, the manifestations were very extraordinary. I will mention that one of the letters received by the presiding Spirit Ben Jonson, was a noble lecture to the circle, which was read by the (impressed) medium, Thos. Hadaway Esq.

A colored drawing (of Oliver Blodge, a spirit) by Rollandson was sketched in fine style in one of the letters—the letter was written by six different spirits, and in as many different colored inks and styles of writing. Mr. Partridge was requested by the spirit to place his hand upon the letter for three minutes—it was then opened and the colors had faded out. In the course of the evening, I expressed a desire to restore the color by placing my hands upon the letter, and Mr. Stewart (medium) requested me to do so if I wished. I placed my hands upon the letter, a short time, and when I opened it the colors were all restored as fresh as ever.

The center or middle table kept moving for some time—pencils and letters were handed to different persons by invisible hands. I had my foot taken hold of by a spirit hand. A gentleman was requested to place his hand under the table; it was grasped by a cold spirit hand.

Raps were frequent, and we felt touches. An autograph letter was received with nearly all the names of those present and they declaired the signatures perfect—but not one had any knowledge of having seen or signed it.

Question by Wm. S. Mount—How should we best worship God?

Answer, by Ben Jonson—By following the stringent dictates of your own conscience.

Question—What creed comes nearest to the worship of God?

Answer—The worship of God.

To me, it was an interesting evening.

Mount's interest in spiritualism is usually brushed aside

as an amiable aberration if it is not brought forward as evidence of failing mental powers. I should like to suggest that it be taken very seriously in our effort to understand the artist and his period alike.

The famous "Rochester rappings" of the Fox sisters, with which the spiritualist movement began, had taken place only in 1848. By 1854 the movement had gathered much momentum; it was new and exciting, and the effort to assimilate it to Christianity, which is reflected in Mount's notes on the séance at Woolf's, was being undertaken by men of sensitivity and good will. Furthermore, spiritualism had special interest for Mount as a painter.

Painting portraits of the dead, especially of dead children, was a common practice in nineteenth-century America. Mount constantly protests against this Victorian necrophilia in his diaries and swears he will never again paint a portrait of a dead person; but when the next commission of the sort comes along, he accepts it, however unwillingly. Mount's journals are full of ironic comments about death as the foremost patron of the arts; once he makes the odd and interesting observation that the painter has one advantage over the camera in that he can remember what a dead person looked like. But the medium could bring back the dead even more convincingly than the painter. So it seemed at the time. With the passage of the decades, the painter's work has prevailed; all the people Mount painted are long since gone, but they are also quite wonderfully alive.

Mount's portraits have been neglected because of our interest in his genre painting and the wealth of incident it suggests. The portraits are uneven, but his good ones are as fine as anything his century produced on either side of the Atlantic. We know practically nothing about Mrs. Timothy Starr, for example, but thanks to William Sidney Mount we know everything worth knowing about this grand and severe old lady (c.pl. 2). Here, as in every great portrait, the human triumphs over the mortal. This is one of the most familiar paradoxes of art, and one of the most important.

References

Sheldon Reich: "A Stylistic Analysis of the Works of William Sidney Mount." New York University master's thesis, 1957.

R. W. B. Lewis: *The American Adam.* Chicago, University of Chicago Press, 1955.

Josephine Miles: *Eras and Modes in English Poetry,* 2d ed., Berkeley, University of California Press, 1964, Chap. 14.

foreword

William Sidney Mount is one of the most richly documented American artists of the nineteenth century, but very few of the documents of his life have so far appeared in print. While engaged in research among these documents for a biography of Mount, I reached the conclusion that the papers themselves tell the story most effectively and that it would best serve the cause to edit them for publication rather than draw upon them for retelling at second hand.

The Mount documents number between four and five thousand sheets. Nearly all of them are to be found at the New-York Historical Society or at The Museums at Stony Brook, Long Island (until recently known as the Suffolk Museum), which also possesses approximately three-fourths of Mount's known paintings. There are also a few documents at the Smithtown Library in Smithtown, Long Island, at the Historical Society of Pennsylvania, and in private hands. Edward P. Buffet published some Mount letters not available elsewhere in his biography of the artist, which appeared serially in the *Port Jefferson Times* in 1923 and 1924. All these collections have been drawn upon for this book. I am indebted to their owners for permission to print them, as well as to the Archives of American Art, which has the New-York Historical Society and Stony Brook papers on microfilm.

The Mount papers may be divided into several categories. Mount retained most of the letters he received and drafts or copies of many he sent. He kept diaries, maintained a detailed record of his paintings, and devoted special notebooks to particular subjects—perspective, spiritualism, music. He also left a handful of fragmentary autobiographical sketches, most of them apparently begun in response to requests from journalists and art historians but, so far as one can tell, never completed.

This book contains about two-thirds of the known Mount papers. In going over this material for publication, I have eliminated much routine matter, and have cut out of the diaries most, but not quite all, of Mount's endless quotations from his daily reading. He thought nothing of copying entire chapters from books on the technique and history of art into these diaries. Some of the shorter quotations have been left in for seasoning, and it is possible that some things which appear here as the artist's own diary entries were actually taken from other sources; he was maddeningly imprecise in his use of quotation marks.

The most remarkable of Mount's borrowings is his perspective notebook, preserved at Stony Brook. This is an apparently homemade affair wherein four pages of white paper are surrounded by twenty pages of a pinkish-lavender hue; each page is ten inches high and eight inches wide, and all are sewn into a cardboard binding signed and dated by Mount on February 29, 1836. The book contains twenty-six drawings, some of them purely diagrammatic, others pictorial as well as diagrammatic. Three of the drawings are credited to J. P. Thénot, author of the *Cours de perspective pratique* (1829); the rest, with one exception, are all copied from the *Practical Treatise of*

Perspective on the Principles of Dr. Brook Taylor, by Edward Edwards (London, 1803); and Mount's entire text is a simplified paraphrase of the letterpress in that volume. On the third white page, Mount mentions Edwards and his book, but the writing both above and below this entry is heavily scored through to obliterate it, and so Mount's indebtedness to Edwards, which was probably acknowledged in the material now illegible, is not made clear. But Edwards was a friend of Horace Walpole, and in Wilmarth Lewis's huge Walpole library at Farmington, Connecticut, there is a copy of the rare *Practical Treatise;* I am greatly indebted to Mr. Lewis for the privilege of spending an hour with it.

This point is worth stressing because Barbara Novak, in her widely circulated *American Painting of the Nineteenth Century* (1969), reproduces five of Mount's copies of Edwards as if they were Mount's own work and quotes Mount's text as if it were the result of his own observation. She does, to be sure, cite Mount's reference to the English artist in a footnote, but she obviously did not appreciate the implications of that reference. One applauds vigorously when Miss Novak remarks that it is time to take the hayseed out of Mount's hair, but her entire chapter on Mount replaces hayseed with a most inappropriate quantity of laurel. So far as technique was concerned, Mount was perennially fascinated by the cookery of paints and solvents; his perspective drawing was neither better nor worse after he had studied Edwards than it had been before, and he never mentioned the subject again.

The biographical documents collected in this book deal with every phase of Mount from 1821, when as a fourteen-year-old schoolboy he wrote the first letter of his life (it is so designated in the letter itself), to his death in 1868 and even beyond. I have included the accounting filed by the administrators of his estate in the Surrogate's Court of Suffolk County, New York, in 1874 because this is a document of first importance in identifying and authenticating many of Mount's paintings. As one would expect, however, the documentation for Mount's early years is sparse. There are relatively few letters for the decade of the 1830s, and the first surviving entry in the diaries is dated November 26, 1843.

Like most human beings, Mount met others halfway, changing his style, his emphases, and his way of playing the game of human relationships in response to his correspondents and what he believed they expected of him. For this reason, separate chapters are set aside for the letters to and from those with whom Mount corresponded frequently—Luman Reed, the collector and benefactor of artists; Robert Nelson Mount, the painter's fiddle-playing brother; William Schaus, the agent of Goupil, Vibert & Company who was responsible, through the lithographs he published, for the great reputation Mount attained in his middle years; Charles Lanman, the painter and writer; and so on. Letters to and from still others are provided under the general heading "Correspondence" and grouped by year or period.

Just as this book was going to press, Mrs. Robert J. Walker of Wellesley Hills, Massachusetts, came across a treasure trove of Mount material left by her aunt, Miss Louise Ockers, of Oakdale, Long Island. Miss Ockers was related to the Smith family after which the village of Smithtown, hard by Stony Brook, was named, but Mrs. Walker does not know how or when her aunt acquired the collection. It contains seventy-seven letters from or to Mount, ranging in date from 1835 to 1868; eighteen drawings (one of which is a sheet containing a dozen drawings all ruled off with pencil, such as Mount seems to have turned out only in his last years; see pls. 153–63); and twenty-six items that can only be described as miscellaneous—engraved invitations to the openings of art exhibitions and to social events of other kinds, newspaper clippings, bills, and patterns or templates for the fronts and backs of violins made of heavy paper or of thin wood.

A few of the documents in the Ockers collection are exact copies or slightly varying drafts of letters that have already been obtained from other sources. Some are not of major interest. Only the highlights of the collection are included here—two drawings and ten or twelve letters, mostly to Luman Reed and to Robert Nelson Mount. The entire collection will be given to the Archives of American Art.

All of the major and a great many of the minor incidents and personal relationships of Mount's life are accounted for in the papers of which this book is composed, with one possible exception. Literary historians, notably F. O. Matthiessen (*American Renaissance,* 1941) and Van Wyck Brooks (*The Times of Melville and Whitman,* 1947), assert that William Sidney Mount and Herman Melville were good friends and frequent drinking companions. This seems to go back to an entry in the unpublished diary of Evert Duyckinck, the New York editor and author, wherein he says that Mount and Melville had a good time at a liquorish dinner given in October of 1847 to celebrate the opening of new headquarters for the Art-Union. There is no evidence for any further contact between the two men, nor, indeed, is there any evidence that they were even together at the Art-Union dinner; they are simply spoken of together by one who saw them both at the same public function. There is no mention of Melville in any of the Mount papers or any mention of Mount in any of the printed collections of Melville papers nor in any biography of that novelist; it would be difficult to imagine any two artists produced by the same country in the same era who were more completely different in temperament, and any friendship between them, such as one would infer from the statements of Matthiessen and Brooks, seems exceedingly improbable.

Rather more baffling is the fact that there is no mention of Duyckinck in the Mount papers. Duyckinck admired Mount, recorded friendly observations about him even before he met him, published laudatory reviews of his work in the various magazines he edited, and is said to have owned several of his canvases—yet his name is absent from all the Mount documents. Duyckinck has been most rewardingly studied in a New York University the-

sis of 1955 by George E. Mize; its title is the subject's name.

The one literary man of his era whom one might have expected Mount to know was Walt Whitman. As Brooks observes, Whitman's descriptions of his childhood on Long Island in *Specimen Days* and elsewhere provide an incredibly precise verbal parallel to Mount's paintings. Whitman was ten years younger than Mount and was therefore growing up not far from Stony Brook at just the moment when Mount was painting that scene. In later years—to be precise, on February 1, 1851—Whitman published his only known comment on Mount in the *New York Evening Post*. It is a perfect example of the fact that American art criticism of the nineteenth century is meaningless to the twentieth. Reams of criticism were written about Mount in his own time, and at one stage in the development of this book it was planned to include a selection of it; but such a section would have served no valuable purpose. The Whitman article is reprinted in *The Uncollected Poetry and Prose of Walt Whitman,* edited by Emory Holloway (1921). Other contemporary discussions of Mount can be be found in the artist's voluminous but rather unrewarding scrapbook, preserved at Stony Brook. Rather oddly, there is no clipping of the Whitman review in this compendium. But I digress.

Throughout this book the casual spelling and hazy punctuation of Mount and his correspondents have been preserved except in instances wherein strictness in this matter would be puzzling or misleading. I have not added an accusatory *sic* after every misspelled word, however; if I did, there might be twenty to a page.

The book begins with the autobiographical sketches and ends with the "Catalogue of Portraits and Pictures Painted by William Sidney Mount," which runs from 1825 to 1866, two years before the artist's death. To this are added supplementary lists of the works Mount forgot to enter in the catalogue. Incidentally, the distinction between *portraits* and *pictures* is extremely important to bear in mind when reading Mount's prose. A *picture,* in Mount's language, is a genre scene; he uses the term *portrait* in its usual sense.

The source of each document is indicated except for the diaries; since all of the latter are at Stony Brook, one acknowledgment here will serve for them all. In the source citations the name of the New-York Historical Society is abbreviated to NYHS and that of The Museums at Stony Brook to SB.

The documents have been annotated when such annotation seemed desirable. Those who will read this book do not need to be told who Cole and Durand were, but some references to other individuals and things call for clarification. In providing it, I have avoided the idiotic footnote system which disfigures scholarly books with nasty little superior numbers scattered about each page and repeatedly sends the reader burrowing into the back leaves for an *ibid.,* an *op. cit.,* or some similar intellectual pearl. Obscurities can be illuminated and sources credited with grace and common sense; I have had the temerity to cling to this rule in the pages that follow.

Every book involving much research is a cooperative venture, and none more than this one. But before research can be undertaken, the material to be studied must be collected, and in the collecting of Mount the names of Mr. and Mrs. Ward Melville lead all the rest. Thanks to their long interest in this artist, approximately three-fourths of his known paintings may now be studied under one roof, that of the Fine Arts Building of The Museums at Stony Brook, Long Island. The Stony Brook collection is not only the largest in the world so far as the paintings of Mount are concerned, but it is equaled in the matter of Mount documents only by the vast manuscript collection at the New-York Historical Society. Mr. and Mrs. Melville put the capstone to their advocacy of Mount with the construction of the above-mentioned Fine Arts Building at Stony Brook and its William Sidney Mount Gallery, opened in the fall of 1974.

I should like also to acknowledge here the assistance of Mrs. Jane des Grange, former director of the Suffolk Museum and Carriage House, forerunner of the present Museums at Stony Brook; she was an unfailingly cheerful and resourceful collaborator for many years. So were members of her staff, notably June Stocks and Melville A. Kitchin.

Mrs. John A. Pope, director of the International Exhibitions Foundation of Washington, D.C., assisted in the organization of the William Sidney Mount exhibition that went the rounds of the museums in 1968 and 1969 and made possible the catalogue of that exhibition, which was a pilot version of the present book. The Archives of American Art, Smithsonian Institution, and New-York Historical Society were unfailingly helpful in providing documentary material. June Delappa was indefatigable in her secretarial assistance. Last of all, I am indebted to Harry N. Abrams and his staff for their generous reception of this book, and to Eliza Little Woodward, whose services, nominally as copy editor, were much more those of a creative collaborator. Without her this book could not have come into existence.

autobiographical sketches and fragments

As is pointed out in the Foreword, Mount received numerous requests from critics and journalists for information about himself. Early in his career he usually declined to provide it, but in later years—when his creative activity had passed its peak and his self-confidence began to diminish—he sometimes responded with long letters listing his works, quoting favorable reviews of them, and interlarding various autobiographical incidents. The sixth of the seven autobiographical sketches provided here, written in 1854 and addressed to an unnamed inquirer, is the best of these. It does, to be sure, repeat some of the information found in Mount's catalogue of his own paintings, but because the anecdotes are inextricably mingled with the list, it seems worthwhile to print this document in its entirety. The seventh sketch, however, is given here only in part because it does little but repeat previously recorded information.

The first five sketches and fragments are quite different in style from the last two and may represent Mount's efforts to prepare autobiographical statements suitable for publication without rewriting. They are all quite short and several of them break off in mid-sentence. The last two sketches are considerably less "literary" than the first five and would seem to be informal letters to authors, giving them material to be handled in their own way. Except for the sixth, the dates of the autobiographical sketches and fragments are unknown; nor do we know the names of any of the intended recipients. All seven sketches are preserved at Stony Brook.

Despite the profusion of names throughout these autobiographical sketches, no extensive annotation seems called for. No reader of a book on American art is unfamiliar with Henry Inman, William Dunlap, Francis Edmonds, Washington Allston, George W. Flagg, Thomas Sully, or John Lewis Krimmel. But one should take special note here of Charles Loring Elliott, for several reasons.

Elliott (1812–1868) exercised more influence on Mount than any other artist, especially in the field of portraiture. Mount adored him—he followed him about, recorded his sayings, and copied his methods. Elliott painted several extremely elegant portraits of Mount (see c.pl. 3); unaccountably, a reciprocal portrait that Mount painted of Elliott, now in the National Gallery in Washington, is one of his driest and dullest productions (pl. 3).

A persistent myth has it that Elizabeth Elliott Mount, the wife of William Sidney's brother Shepard, was a sister of C. L. Elliott, but research undertaken at the Suffolk County Historical Society in Riverhead, Long Island, indicates that she was not. She was a Long Island girl, daughter of a watchmaker in Sag Harbor. Charles Loring Elliott came from Scipio, in upstate New York, where his father, unnamed in the sources, combined the professions of farmer and architect.

A.F.

15

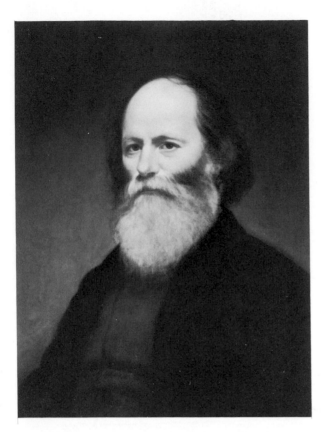

3. *Charles Loring Elliott*. 1848. Oil on panel, 27 × 22″. National Gallery of Art, Washington, D.C. Andrew Mellon Collection

I

I was born in the village of Setauket, Long Island, on the 26th of Nov 1807. The first and most remarkable event of my life occured when I was about 6 or 7 months old. I was taken from my Mother (she being very sick) to be brought up by hand—I soon declined for want of proper or abundant nourishment and after several days [was] considered dead by my kind nurse and tenderly laid away as so. My Father's sister being sent for to make further arrangements concerning me observed signs of life and immediately commenced nourishing me, she having a son about my own age—which act of charity soon restored me so far to life and strength that I might have been seen not many days after reaching for my great toe with all the enthusiasm of the infant in Raphael's *Holy Family*. From this period I remained I suppose much after the manner of other children, sometimes good natured and easily managed, sometimes the contrary. I was not always under the government or training of my mother, but alternately under the care of my Grandmother and herself until I was eight years old, when I went to N- York to the care of my Uncle to be sent to school (although I might have mentioned I attended school previous to this time in Stony Brook, the residence of my Grand Father). My first teacher there was the Celebrated Joseph Hoxie a man of good ability. My introduction into school was attended with not a little coaxing and threatening and walking around blocks in the street for the purpose I imagine of deceiving me. However I soon became more

reconciled to study and confinement and as a reward received in succession a hundred Tickets for my application. Yet, notwithstanding the many encouragements my friends were willing to advance to induce me to become a perfect scholar, my love for roaming and flying kites would not be extinguished, and consequently I indulged myself in such amusements whenever I could steal an opportunity—I remember particularly flying kites on a hill east of the Rutgers St. church, and distinctly fresh to my memory is the benevolent and venerable appearance of the late Col. Rutgers, when he heard our catechism class in the conference room at the foot of the hill.

The death of my Father in Setauket occassioned my mother to change her residence to Stony Brook, and at this time I was sent home from N- York to be farmer boy for her, where I continued untill the age of 17. It was then thought advisible that I should drop the hoe and spade for some occupation which might be more profitable in after years. Accordingly I was placed with my oldest brother, Henry S. Mount, Sign and Ornamental Painter N. York. I took pleasure in my new vocation and discussed on the merits of a sign with as much zeal as a picture dealer would on the merits of an old master. At this period I visited the gallery of the American Academy in the park, the first collection I ever had the pleasure of seeing. As I ascended the stairs, the sight of so many pictures in rich frames, the figures the size of life looking upon me from all parts of the room, created a strange bewilderment of feeling such as I have never since known. I was alone, none to disturb the senery of delight with which I gazed upon them—my mind was awakened to a new life and big resolves for the future were then made.

I continued with my brother between two and three years, in which time I spent my leisure hours in making pencil drawings or with chalk (made outlines of figures) upon darkly painted grounds. I remember at this period a young man of my acquaintance (a sort of an uper crust) offended me by reflecting upon my profession—but I had my revenge by drawing him selling oysters at a stand. The likeness was so inveterate and ludicrous that he ever after eyed me at a distance. My Brother H. S. Mount and his partner William Inslee having a great variety of ornamental work such as Hat signs, banners, transparences and engine backs, requiring a vast deal of artistical skill, I was greatly benefited by seeing their off hand manner of execution. Mr. Inslee had a good eye for colour and he was an able draftsman. He had a fine collection of pencil drawings executed by himself—also a set of large engravings by Hogarth which he took pleasure in showing me.

Inslee was very fond of turtles and when his wife was absent from home or gone to church he would indulge in his favorite dish. Brother Henry told me the following— he called to see Inslee one sunday unexpectedly. The visit was longer than both expected and at the same time a mysterious commotion in the dinner pot hanging over a blazing fire attracted his attention. Inslee looked settled. The talk continued. Again the noise was unaccountable and the pot lid was greatly agitated, and before Inslee

could reach the tongs to keep the cover in its place out jumps three turtles one after the other all sprawling to the hearth. Henry said he laughed until he had a paine in his side, and the way those turtles scambled over the floor was a caution to all creeping things.

At this time I was residing with my aunt. (Widow of the late Micah Hawkins.) A friend of hers, Martin E. Thompson, a frequent visitor, proved to me a servicable friend. He saw my drawings at the residence of my aunt, widow of the late Micah Hawkins, and recommended I should become a student of the N. Academy of Design. Accordingly I submitted them to the examination of the Council and was admitted.

I must not forget to mention that my Father was passionately fond of Music and my mother delighted in cultivating flowers. My sister Mrs. Ruth H. Seabury, although the youngest, displayed the first taste in painting when at the early age of eleven she took lessons of Mrs. Spinola. Then you could have seen me looking over my sister's shoulder, with my straw hat in hand, to see how she put on the colours. A picture was then and always has been to me an object of great attraction. I had no idea at that time of ever becoming a painter, but my mind from my earliest recollection was always awakened to the sublime and beautiful in nature.

I have often stood upon one of the hills over looking the sound when a boy—gazing and swinging my hat at the coming up of a thunder storm, watching the sudden shifting and gathering of the clouds into a squall and the shelling of the rain in the distance with a touch or two of lightning and a loud clap over head. Then my curiosity would be dampened by a wet thirst and a tall run for the kitchen fire. In 1827 I relinquished sign painting for a higher department of the art, but for a while it was neccessary for the improvement of my health to return to my early habits—the culture of the soil—though painting could not be forgotten. My first attempt in oil was a portrait of myself, after which I painted my first composition in oil, "The daughter of Jairus" a small picture—it was exhibited in the National Academy by the earnest request of my Brother Henry [pl. 4, c.pl. 4]. The President expressed himself pleased with it, and said as respects design, he had not seen its equal amongst any of the Modern masters. I hope the day is not far distant when I shall have an order to paint the above composition on canvass three by four feet—or the figures the size of life.

The time was now come that I should go with Mr. Inman as agreed upon—I was pleased in one respect and in the other I was sad. However I went. Mr. Inman gave me in writing the round of duties I was to perform—after dusting the room and pictures, I striped of my coat and went to grinding paint. I cannot tell at this time wither I left them coarsely ground or not, for while I was grinding I was thinking only of the grand style of painting. At the end of a week I presented the door key to Mr. Inman, he was on the back piazza reading. He remarked, "Keep the key, and if you do not go to church in the forenoon come and see my books and engravings." I thanked him and

4. Sketch for *Christ Raising the Daughter of Jairus*.
1828. Pen and ink, 8 × 13″.
The Museums at Stony Brook, Stony Brook, Long Island

said, "I do not intend to stop any longer," and gave him my reasons. Mr. Inman made me very good offers to remain—but I could not be prevailed upon. I preferred Mr. Inman's colouring, and he was the only artist I would have staid with any length of time—but the fear of debt and the desire to be entirely original drove me from his studio.

I cannot say that Mr. Inman was anxious to have me remain with him. I only know that he called the next day to see my Brother, fancying that he had influenced me to leave. But upon being assured that he had not, he remarked, "If he will return now I shall be glad, but if he does not I shall never again receive him as a pupil." I then commenced my second composition ("Saul and the witch of Endor")—my studio the attic of my Brother's dwelling, Nassau St, Fronting the Park [c.pl. 5]. Three or four weeks after I was established there, leaning out of the window one day I observed Mr. Inman passing along who at the same moment looked up. He gave me a friendly nod of recognition and looked pleased, probably to see me so elevated. When I considered the picture finished I invited Mr. Dunlap (who was then in New York painting his picture Christ bearing the cross) to see it. He was pleased with it and encouraged me to go on, allowing I displayed much talent. Dr. Wainwright also saw my picture and

thought the composition equal to Benjm West of the same subject. But continuing in historical painting, I found, would not even furnish me with bread—of course I was obliged to relinquish it for portrait painting. It was not wholly a sacrifice of my talents, for I found that portraits improved my colouring, and for pleasurable practice in that department I retired into the country to paint the mugs of Long Island Yeomanry.

In the fall of 1829 being in New York on business, I called on Mr. Inman, found him weary and disgusted, as he observed, with eternal Portrait painting and longing to go into the country where he could halloo and be answered only by the echo of his own voice. I invited him to return home with me. He accepted seemingly with pleasure and we made arrangements to leave the next morning by Packet. The morning being not very favorable for sailing, he concluded to take land conveyance while I prefered the water. But he arrived one hour earlier than myself, of course he was left to introduce himself into my mother's dwelling, and to herself, which he did in a manner peculiar and so very characteristic. On entering the house and approaching my mother, says "This is Mrs. Mount—I know you by your son's looks," and adds, "Has he arrived yet? He left New York at the same time I did," and immediately turned to examine a picture hanging upon the wall (a half length—Cornelia, Daught. of Hon. Selah B. Strong) asking "Who painted this?" My mother replied, "William, my son." "What, the one who was with me? How much he has improved." Soon I joined him and during his stay rambled together through woods and dales, and over hills far and near we took our guns and amused ourselves with shooting quail except when Mr. Inman left his aim to admire a beautiful bit of landscape or rhapsodize on the brilliant and luminous appearance of the distant New England shore which lies exactly opposite Stony Brook. A splendid pencil sketch of quail he presented my brother Nelson, and offered to paint for me a portrait of my mother. But the circumstance of my materials not being at home, which I have ever exceedingly regretted, prevented his doing so—at another time, I think the next autumn, he painted for Brother Shepard a fine little landscape. I shall always remember Mr. Inman gratefully and admiringly—the beauty of his colouring and the valuable hints he has given me in painting. I have stood behind his chair at his request while he was painting in a background to a portrait. The rapid and truthful manner with which he handled the drapery and books with gold bindings appeared to me like enchantment. His manner at his easel was the most elegant of any artist I am acquainted with.

II

. . . I now turned my attention to portrait painting and the first in that line from the living model was one of a shoe maker, a young man of my own age. In return he gave me a pair of shoes. He had taste and a love for art, he is now an ornamental painter some where in the state of Conn.

His generosity did not stop here. In a few days he brought two sitters, a young couple engaged to be married. He desired me to paint their portraits for twenty dollars. The ladies portrait the gentleman wished to take with him to the City, his own of course to remain with his lady love. I agreed to the offer at once and painted the gentleman first. The young lady was next in turn after her beau had left for the city. You can readily bring to your mind a young female of seventeen, sitting for her portrait to one who had had no practice in that most difficult part of the art, female portraiture, and will conceive that I had no small task. However, I dashed away with a stout heart and the first sitting was over. The lady moved from her seat and glanced at the different sketches about the room, and what seemed to stimulate me to greater exertions was a simple touch of affection I had the pleasure of witnessing as my fair sitter was about to leave. The portrait of her lover met her view. She stood long and attentively musing over the countenance of him she loved. I was busy at my easel, she turned to me with one of her sweetest looks, her cheeks blushing roses, and inquired if it would injure the painting if she should kiss it. "Certainly not," I replied, upon which she gave the portrait a hearty smack evidently to her satisfaction and departed.

In the spring of 1829 it was proposed that my Brother Shepard and myself should take a room in Cherry St. near franklin square and set up our easels for chance customers. Our notification to the public was "W. S. and S. A. Mount, portrait painters," upon a small gilt sign which I painted myself. We sat from day to day in idleness discoursing on the various styles of art, and wondering why so many should pass by without some one droping in to encourage native talent. At length being disgusted at the tramping of hoofs upon the pavements, we concluded to go to work. Shepard painted some pieces of still life, while I endeavoured to call up a dead man for a friend. I recollect of painting the portrait of a gentleman for the price of the materials. Yet still this extent alone of patronage would not make the pot boil. So after a little time we had. . . .

III

One cool day in 1830 as I was engaged in painting the "Country Dance" in an upper south room, the sun was geniel and I thought it warm enough—not so, thought my Grand Mother, for in she came with a large iron kettle (such as the yankees use to bake pumpkin bread with) glowing with hot coals and said, "Wm, I have thought since you would paint by this light that some coals would warm the room, for it is quite a cold day." I thanked her kindly and worked away. My thoughts were busy with the figures in my picture, when presently I began to yawn to feel sleepy, but I roused up in my chair and worked on. All at once I felt still more heavy and stuped. My hand and brush, palette and maulstick caught the infection. My chin settled upon my bosom like one going to sleep. There before me on the easel stood a groupe moving, in

the dance full of mirth and hilarity, while death stood over my chair ready to graspe the painter. But my good spirit whispered in my ear and my eyes moved slowly around the room and I awoke with [illegible]. The cause of my strange feelings struck me like a ray of light. I saw the kettle of char-coal. And crawling, I gathered all my strength . . . the door and opened it with difficulty—and I was safe.

Elliott the painter was caught in the same trap.

IV

As yet I have not been much of a traveler. In 1834 I visited my aunt at Athens Pa. Saw the falls at Ithica and had a look at the grand scenes from the Catskill mountains on my way home. I went to Philadelphia in Sept. 1836. Mr. Earle was anxious I should stop and paint him a picture. I was introduced by Mr. Charles Graff (a lover of art) to Thomas Birch, Esq., Mr. Lawson [illegible] and to Thomas Tuly Esq. He showed me Leslie's early drawing. They all invited me to set up my easel in their City. Mr. [illegible] showed me several of Krimmel's pictures, which I was delighted with.

[Several partially erased, illegible lines]

I was introduced by Mr. Henry Brevoort to Washington Irving, Esq. Irving kindly invited me to call[?] and see him [illegible] spend some time at his house.

V

In June 1839 I went to Boston, expressly to see Mr. Washington Allston's Gallery of original paintings. I found a great many beauties in his works. I had the pleasure to meet on the same pilgrimage, and paying homage to genius, F. W. Edmonds, Esq., the Author of *Sparking*. I also met Mr. Allston's Nephew George W. Flag the Artist—he said I must not leave without calling to see Mr. Allston. Accordingly we had a delightful walk to Cambridge. Alone by itself stood Mr. Allston's Studio. It had the appearance of a Methodist house of worship with a large wi[n]dow faceing north. After a gentle tap we heard a quiet movement within and the door swung invitingly open—and there stood the great artist with a look of benevolence. He received us very cordially, he asked me which of his pictures I preferred in his Gallery in Boston. I particularized several—he appeared to be pleased with my selection, and then he showed us a number of his designs for large pictures. Several of them were scriptural compositions, they were rich in color and expression. One drawing in particular I thought very fine, it represented a ship at sea in a storm—the waves rolling, and you could almost hear the wind whistling through the cordage, it was so truthful. And it was done simply by a piece of white chalk upon a dark ground. If my admiration of his genius could have pleased him, he must have fattened upon my visit for several days.

After showing me the above, he turns to Mr. Flagg and says, "I have a study on hand, and before you go I would

like for you to cricise it. And if Mr. Mount will turn his back to us for a few minutes we will examin it." I did so, and speculated upon what I saw before me. There stood a table loaded with the scrapings of his palette, with one end sufficiently bare for his palett and brushes. In the fire place was a goodly number of cigar ends and an old vol. on painting upon the mantle, and in all parts of the room but one where he stood and painted, the dust appeared to have had undisturbed possession for a great length of time. I have often thought since that I should like to paint a picture representing Mr. Allston in his studio—contemplating one of his pictures. After the examination, among other things he thought it strange that Mr. Dunlap in his sketch of him should make him out an idleer [who] threw away his time in smoking cigars. On the contrary, he was saveing of time and very industrious. I remarked that his table to appearance spoke in his favor. He smiled and our visit being ended he invited me to call and see him as often as I could and we departed. Time has since thrown his hazy mantle over one of the sunniest spots on my memory. I had the gratification in company with Mr. Flagg To see some of Mr. Stuart's best portraits, also pictures by Stuart Newton. Boston is rich in works of art. I remember the attentions of Mr. Alexander the Artist and Isaac P. Davis Esq, a Lover of art and a friend to artists.

I have often been asked why I have not been to Italy. It has always been my desire to see the old masters—but I still feel there is something yet to be learnt at home. The late Mr. Luman Reed, a short time previous to his death, told me It was his wish I should visit Europe to study, and at his expense. His likeness in the New York Gallery by A. B. Durand Esq. almost speaks to me and takes me back to scenes pleasant to think of. He still lives, and will be remembered, while thousands who do not encourage arts and literature will be forgotten. In his son-in-law Jona Sturges I have always found an unchanging friend.

VI

Stony Brook, Jan. 1854

My dear Sir,

Your letter of the fifth inst- is at hand. I have been asked for material, artistical and personal, of my humble self, by three or four different authors, but did not furnish any of consequence, not feeling in the humour like Lot's wife to look back.

In the year 1819. A Lady accomplished in water color painting, as taught at that time, gave my sister lessons in painting, and also taught her embroidery—to execute figures in colored silks and water colors combined. You could have seen me at that time a farmer boy dressed in a coarse working frock with a straw hat in my hand, watching with deep interest the manner in which the beautiful teacher was mixing her colors and directing her young pupil. Like most boys—sliding down hill, skating, and catching rabbits for amusement occupied most of my

attention winters after school hours—I was particularly fond of loitering around the edge of a pond, skimming stones upon its surface and watching the ripples as they melted away. Those scenes and impressions led me on to look at nature for a higher purpose. It seems we are a progressive animal—we go on step by step, indeavouring to perfect ourselves, which makes this world so pleasing to the true lover of nature.

Year 1825. I commenced drawing with lead pencil, and sometimes with white chalk on a black board. When I had a leisure moment while I was an apprentice, learning the art of sign and Ornamental painting of my late brother, Henry S. Mount. I continued with my brother between two and three years. He was an early student of the National Academy of Design and was elected an associate in 1827—

1827. I drew from the Antique models at the academy evenings and during the day time when not engaged in lettering signs. About this period I made two designs, in umber and white, from Shakspeare: *Hamlet*, Act lst, scene 5th. Ham.—"Whither wilt thou lead me? Speak I'll go no further." *Pericles*, Act 4th, scene lst. Leon.—"If you require a little space for prayer, I grant it."

A girl standing at a spring reading a love letter—painted with colors.

Reading ancient history took much of my time.

In the spring of 1828, at Stony Brook, I painted my first portrait in oil colors, a likeness of myself, head and bust life size [pl. 5]. Directly after, I painted my first composition, Christ raising the daughter of Jairus. It had caused me a great deal of study. It was exhibited in the National Academy, by the earnest request of my brother Henry. I will mention that when it was handed in, some of the counsil doubted the originality of the picture. The President, S. F. B. Morse, remarked he had never seen any design like it, and expressed himself pleased with it, and further said, as regards design, he had not seen its equal amongst any of the modern masters, and that succeeding pictures would test originality, both execution and design.

After which I hit off several likenesses—mother and child, size of life [pl. 6], one of my brother Robert N. Mount, also of Wm. R. Williamson Esqr. Now an architectural, Decorative Painter in Hartford Conn.

Portraits of a Lady and Gentleman—price $20.00.

Year 1828. I painted a scene from the *Iliad* of Homer on canvass, 3 by 4 feet. Andromache, Hecuba, and Helen, mourning over the dead body of Hector—"First to the corse the weeping consort flew—around his neck her milk white arms she threw."

Portrait of my brother Henry—painted in N.Y. [pl. 7].

Saul and the Witch of Endor—on canvass 3 feet by 4 feet. Dr. Wainwright (now Bishop) told the painter that it was equal in design to Benjm West's picture of the same

subject. A year or two after, I lost the sale of the same painting in this way. The Wife of the ex alderman, who had bargained for it, said she could not have it in her house, for the witch haunted her so. It is now owned by T. Bailey U.S.N.

Year 1829. "Crazy Kate"—from Cowper. My prices for portraits in the country in 1829 ran from 10 to 15 dollars. I painted about ten portraits at that price.

About this time, my Brother S. A. Mount commenced drawing from the antique models at the Academy evenings and at home during leisure hours. He had served his time at Coach Making, with James Brewster, New Haven, but having an ardent love for the art of painting (which every one must have to excel), he relinquished his former business—and by application he is now a successful portrait painter, and at the same time exhibits a decided taste for landscape. He was elected associate in 1833. Academician in 1842.

A picture, "Celadon and Amelia"—from Thomson's *Seasons* [c.pl. 6]. At that time I thought of the Galleries of pictures in Europe and I was desirous to become an historical painter. My mind was brimfull of the grand style, but I was too proud to ask my friends to send me to Italy. Yet at the same time I fancied we had materials enough at home to make original painters, so I reconciled myself to my own country with cheerfulness, knowing that nature is as fine here as in any part of the world, and painted portraits—as every young painter should do, even if he should make it his profession to be a painter of history, landscapes, animals, or marine pieces—and occasionally I painted a picture.

Girl with a pitcher, standing at a well.
Portrait of Wm Wickham Mills Esqr.
Portrait of Hon. Charles Floyd.
Portrait of Revd. Zachariah Green, of Setauket L. I.

Year 1830. Rustic Dance—in possession of E. Windust.

Portraits of Revd. Charles Seabury and Lady of Setauket. Mrs. Seabury gave me a letter of introduction to her daughter Mrs. Onderdonk in New York, and I was immediately invited to paint the portraits of Revd. Benjn. T. Onderdonk and his wife at double the price I had received in the country. My price for a portrait in the country previous to this was ten dollars—I painted about ten portraits at that price. Every year I charged five dollars more. When my prices were 30 dollars a portrait Henry Inman Esqr (the great portrait painter) said I did not charge half enough. "You suppose," continued he, "that you are going to ruin a man by charging him for honest labor."

Portrait of Martin E. Thompson Esq, an early friend—$20.00.

D[itt]o—of John Delafield Esqr—$20.00.
Do—of Lieutenant Tallmadge U.S.N.
Do—Edmund Smith.

I only mention a few portraits.

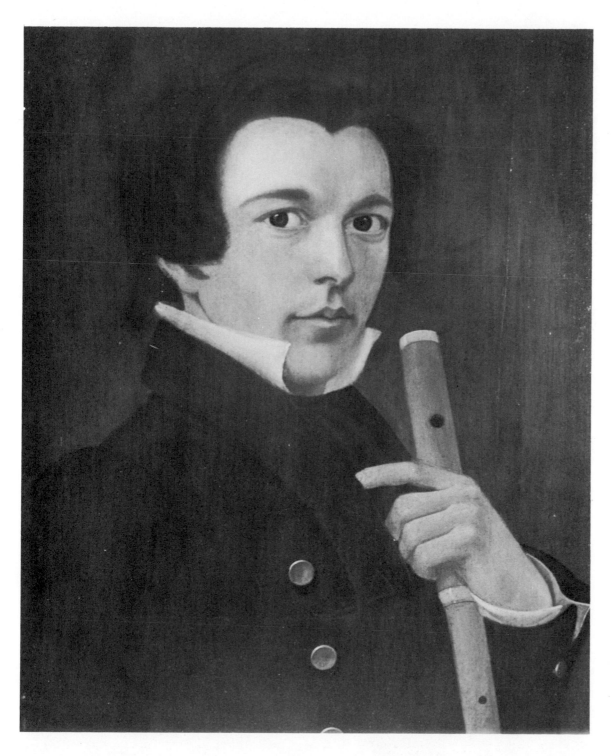

5. *Self-Portrait*. 1828. Oil on panel, 20 × 16″. The Museums at Stony Brook, Stony Brook, Long Island

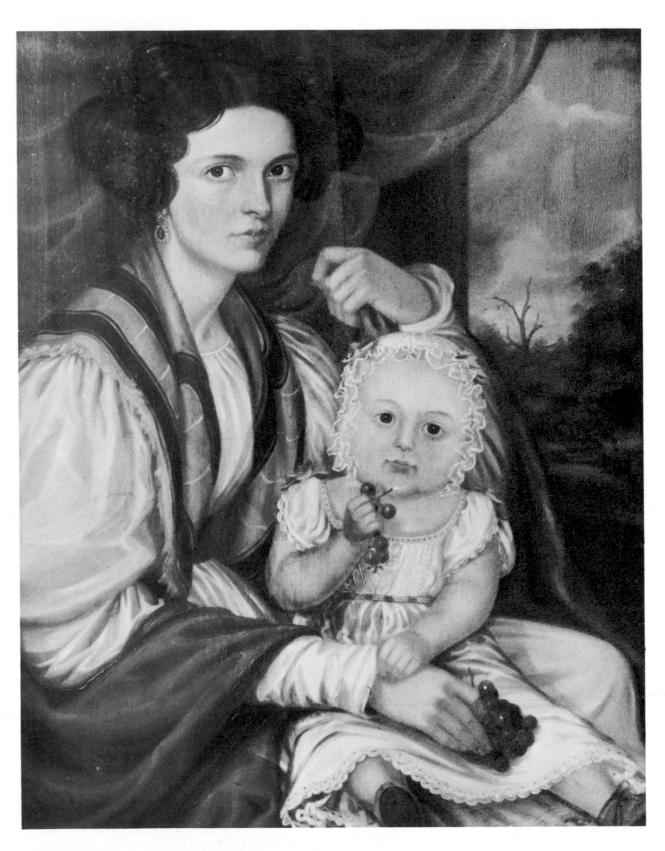

6. *Mrs. Charles S. Seabury and Son Charles Edward.* 1828. Oil on panel, 30 × 23 5/8″.
The Museums at Stony Brook, Stony Brook, Long Island

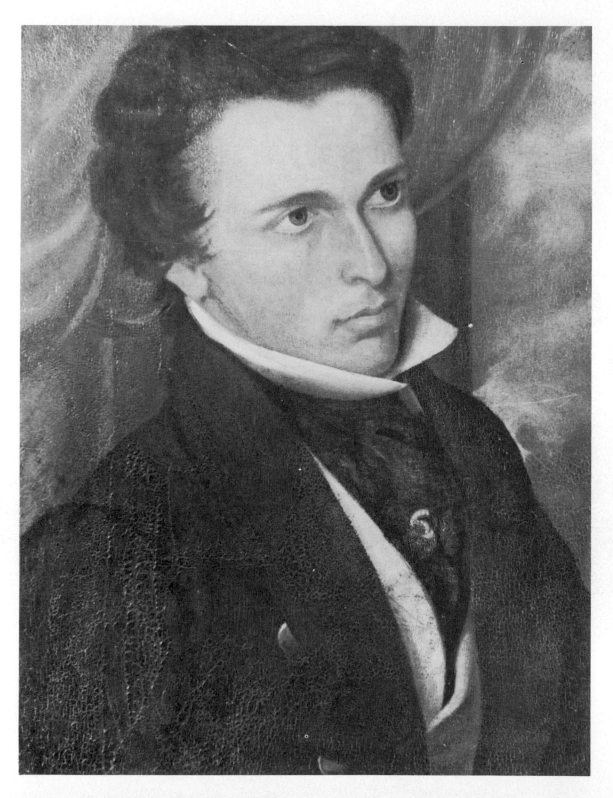

7. *Henry Smith Mount*. 1828. Oil on panel, 15 × 12″. The Museums at Stony Brook,
Stony Brook, Long Island. Melville Collection

8. *Henry Smith Mount*. 1831. Oil on canvas, 34 1/2 × 27 1/4″. The Museums at Stony Brook,
Stony Brook, Long Island. Melville Collection

Portrait of my mother, the late Mrs. Thos. S. Mount—painted at Stony Brook [c.pl. 7].

School Boys quarreling—sold to P. Flanden Esqr., New York. He gave me fifty dollars for it. George W. Flagg Esqr mentioned to the artist that on seeing the above picture he was induced to become a painter.

Children at play—landscape back ground. In possession of Mrs. Charles S. Seabury.

Half length portrait of Mrs. John Delafield—$40.00.

Year 1831. I was elected associate of the N. Academy of Design.

Portrait of Charles Russell Esqr—

Of Mr. Inman—I remember him greatfully for the valuable hints he gave me on painting. As a colorest I admired him exceedingly—I shall never forget his friendship. He sold a couple of my early pictures, refusing any compensation.

A notice of the National Academy of Design, 1830, says "Mr. Mount's picture of the dance taken from the popular story of the 'Sleigh Ride' exhibits powers of no ordinary kind, which with his Girl and Pitcher, a picture true to nature, gives earnest of future excellence."

My introduction and success in portrait painting in New York was through the kindness of Mrs. Seabury of Setauket, L.I. She now resides in N. York. Having painted the portraits of herself and husband, The Rev. Charles Seabury, she was desirous I should practice in the City rather than spend my time in the country. Accordingly she gave me a letter of introduction to her daughter, Wife of Rev. Benjn. T. Onderdonk. I can almost see the kind face of the Bishop as he desired me to paint the portraits of himself and wife—at prices double the amount I had been receiving.

An early friend—He saw my drawings at the residence of my Aunt, Widow of the late Micah Hawkins, and recommended I should become a student of the N. Academy of Design. Accordingly I submited them to the examination of the Counsil and was admitted. ~~My brother Henry paying the admission fee five dollars~~ [see pl. 8].

Portrait of Charles S. Seabury Esqr of Stony Brook L.I.

A small landscape with figures.

Portrait of Dr. Delafield.

Do—of Revd George Upfold of St. Thomas Church.

I leave out a list of portraits.

Boy resting on a fence (an old hedge) painted for Robert Gilmore Esq of Baltimore, looking over his left shoulder at the spectator, view of long Island sound in the distance. It was engraved for the *New York Mirror* by J. A. Adams Esqr.

Interior of a Barn with figures dancing [c.pl. 8] the foreground I never finished (part of the foreground unfinished)—

Portrait of the Judge Thomas B. Strong of Oak-Wood L.I.

Year 1832. I was elected Academician.

Portrait of Revd. B. T. Haight.

Portrait of Miss Julia Graham, N.Y.

A small picture—A man in easy circumstances.

The above picture was painted for the temperance society. The Gentleman who engaged it said after viewing it, "Mount, that will never do. You have represented the drunkard so happy that it will not answer for the cause." It was sold to Mr. Clover for $30.00. He afterwards sold it to Mr. Carey, I believe, for one hundred dollars.

Portrait of Edward Windust Esqr.

A Flower piece.

Portraits of the two Miss Flandens.

Do—of Judge Marvin of Wilton Conn.

Year 1833. Full length portrait of Right Revd. Benjamin T. Onderdonk. It hangs in Columbia College, N.Y.—not sold. I found him a perfect Gentleman, true to his appointments, and he kindly offered me the use of his library.

Portrait of Miss Sarah Lott of Bedford L.I.

I leave out a number of portraits.

Farmer Husking corn—in the possession of Governeur Kemble Esqr. It was engraved for an Anual.

Boy resting on the fence (with a basket in his hand) looking at the spectator. I made a copy of this picture with some alterations and left out the basket and represented a storm rising in the distance.

In the summer of 1833, I painted from the antique statues in the American Academy of fine Arts, in Barclay St., with the consent of the President, Col. John Trumble. He seemed interested in my studies and droped in earler and earler each succeeding morning (on his way to his studio in the same building) and one morning in particular he was very early and stept in with the activity of a boy and brought his cane down with a loud noise and said "Why Mount! You don't stay here all night?" At the same time and place, I had the pleasure of painting by the side of James Whitehorne Esqr. Looking at the white plaster figures and not taken sufficient exercise so effected my eye sight that I was prevented from reading for nearly three years. Had my time been spent in painting from the living model, I should have obtained drawing and color, and saved my eye sight. Col. Trumble was uniformly kind, at one time he invited me to his room and presented me with three of his battle pieces. I prize them very highly not only as his gifts but for the many associations connected with them.

A notice of the Exhibition of 1833 remarks that "Mr. Mount is capable of executing subjects of a higher class, we need only to refer to the calm and dignified full length portrait of Bishop Onderdonk, exhibited last year—a production that will rank with the first in portraiture."

Year 1834. A group of three figures (I believe I called it "After dinner")—A man playing the violin while the others are listening [pl. 9].

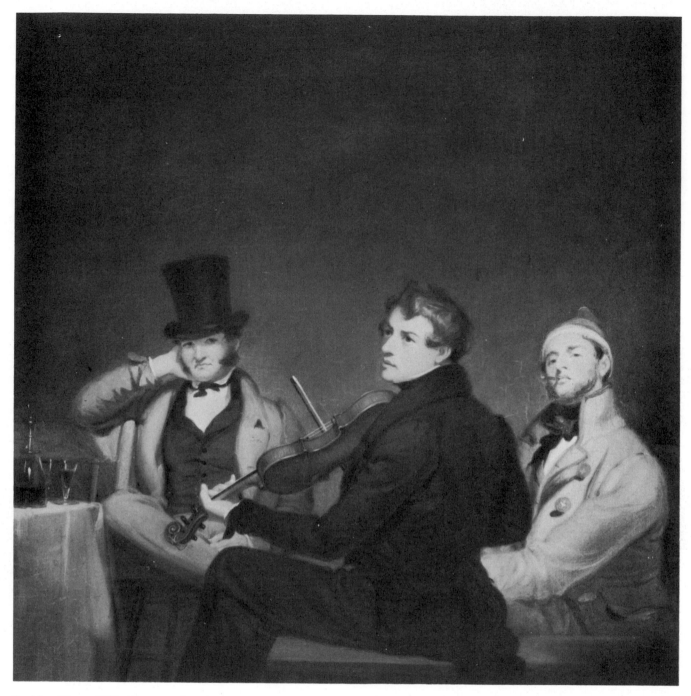

9. *After Dinner*. 1834. Oil on panel, 10 7/8 × 10 15/16″. Yale University Art Gallery, New Haven, Conn.

A small picture—Mother and Child—landscape background.

Portrait of Robert Schenck of Ohio, Late minister to Brazil.

Studious Boy—Sold it to George P. Morris Esqr. It was engraved on wood by Mr. J. A. Adams, Esqr.

A notice of the Academy in 1835 says, "The Studious Boy—Mount. This is a pearl of high price. We perceive it is for sale. Nothing could be more true, more admirable. Here we see the power of genius and drawing as in Guido, without the aid of paint. Yet we would not alter a single tint. It is, though of a pale hue, purely Italian in the warmth, the grace, the richness of its expression."

Portrait of Alderman Tucker.

Portrait of Revd. Wm. M. Carmichael of Hempstead L. Island. It was after its completion exposed to the air to dry—it soon attracted the attention of that gentleman's dog, who eagerly approached it wagging his tail with delight and at length crouched with all due respect by the side of it.

Portrait of Benj. F. Thompson Esqr., Historian of Long Island.

I leave out a number of portraits.

Portrait of Capt. Mathew C. Perry U.S.N.

Year 1835. Bar-room scene (walking the crack). In possession of Governeur Kemble. Price $150.00.

Sportsman's last visit [pl. 10, c.pl. 9] and studious Boy I sold to George P. Morris Esqr for $100.00.

Farmers Bargaining—painted for the late Luman Reed Esqr. Price two hundred dollars.

Undutiful Boys—painted for the same gentleman. Price two hundred and twenty dollars. For an improvement which I afterwards made, Mr. Reed generously sent me 50 dollars. I mentioned to him that I did not expect extra pay as I had done no more than my duty. "Well," he says, "I am desirous of doing the same." After Mr. Reed's death the above paintings were sold to the New York Gallery for one thousand dollars.

Year 1836. Courtship (or winding up)— It represents a young Lady winding while her lover is holding a skein of yarn [c.pl. 10]. Painted for John Glover Esqr. Price two hundred dollars.

Farmers Nooning. Published by the Apollo association exclusively for the members of the year 1843. Painted for Jonathan Sturges—price two hundred and seventy dollars. He has been heard to say that he values it at one thousand dollars.

Portrait of Capt. Jonas Smith; Stony Brook L.I. In 1836 Capt. Smith asked me what I charged for painting a portrait. I mentioned twenty dollars. Next year he asked the same question. I mentioned twenty five—he asked the question every year until my price reached thirty five dollars. "Now," he said, "you can paint the portraits of myself and wife." Another Gentleman asked me the same question every year, and he finally died without having his portrait painted—his family at this time would readely give five hundred dollars for his likeness.

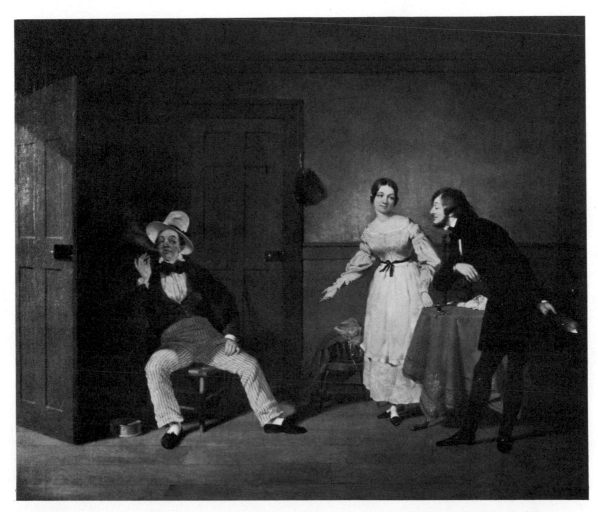

10. Francis W. Edmonds. *The City and the Country Beaux*. Date unknown. Oil on canvas, 20 1/8 × 24 1/4″.
Sterling and Francine Clark Art Institute, Williamstown, Mass.

The parallelism between Mount and other American genre painters of his time is strikingly indicated by the comparison of *The City and the Country Beaux*, by Francis W. Edmonds (1806–1863), and Mount's *The Sportsman's Last Visit* (c. pl. 9). The idea is the same in both pictures—the suave city man competing with the bumpkin for the girl. Priority is not important and the Edmonds is undated; it might have preceded the Mount (which was done in 1835) and it might have followed it. The important thing is that there was a school of American genre painters in the early nineteenth century whose members could come as close as this to sharing ideas without at the same time creating friction. The Mount is the more striking composition, although Mount's characterization is not necessarily stronger.

11. Study for *Raffling for the Goose*
 (*Tavern Scene*). 1837(?).
 Oil on panel, 8 1/4 × 12″.
 The Museums at Stony Brook,
 Stony Brook, Long Island

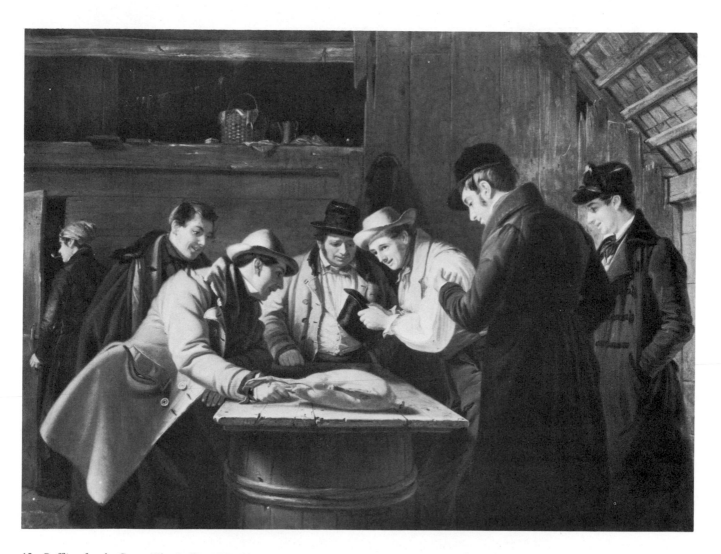

12. *Raffling for the Goose* (*The Raffle*). 1837. Oil on panel, 17 × 23 1/8″. The Metropolitan Museum of Art.
 Gift of John D. Crimmins, 1897

Year 1837. The Raffle—painted for the late Henry Brevoort Esqr [pls. 11, 12]. Price two hundred and fifty but he generously gave me three hundred dollars and said I did not charge enough. Washington Irving was so much pleased with the raffle that I was introduced to him by Mr. Brevoort at Mr. Irving's request and he kindly invited me to spend some time at his house, but I regret to say that I could not at that time accept his very kind invitation. "The Raffle" is now in the possession of Marshall O. Roberts Esqr. He paid four hundred dollars. It was engraved for *The Gift*.

Tough Story—painted for the late Robert Gilmore Esqr. of Baltimore. It was engraved for *The Gift*.

Year 1838. Dregs in the cup, or Fortune telling—figures half length and size of life. I presented it to the New York Gallery in 1847.

Artist showing his own work—painted for E. L. Cary Esqr of Philadelphia. It was engraved for Cary and Hart's *The Gift*.

[Portrait] of Samuel L. Thompson, Setauket L.I.

Do—Hon. Selah B. Strong Esqr, St. George's Manor L.I.

Year 1839. Portrait of Jeremiah Johnson, Mayor. Painted for the Common Counsil of Brooklyn—price two hundred and fifty dollars.

Catching Rabbits. Painted for Chas. A. Davis Esqr. Engraved in Paris for the American branch of the house of Goupil & Co. It is now on exhibition in the Crystal Palace, N.Y.

Year 1840. Disappointed Bachelor [pl. 13]. Procrastination his house is falling, decaying. Sold to Governeur Kemble Esqr.

Blackberry Girls—sold to the Art-Union in 1843.
Boy hoeing Corn—sold to Hon. Aaron Ward.
Portrait of Miss Phebe Warren of Troy.

Year 1841. Cider Making—painted for Chas A. Davis Esqr. Now in the Crystal Palace.

Year 1842. Scene in a Long Island Farmyard—Ringing a Hog. Painted for Jona A. Sturges Esqr. He liberally paid me thirty dollars more than I asked him for the picture.

Stony Brook August 15th 1842. ~~I have no commissions for pictures~~. This is the first day I have used my paint brush since the middle of April. I am painting the portrait of a young lady, from a sketch taken after death. The Country for repose and health, but the City to stimulate an artist at work. My motto is, "Begin now, no time to be lost."

Portrait of Benjm T. Underhill, Esqr, Oyster Bay L.I.

Mrs. Miriam Weeks of Oyster bay being desirous of presenting to each one of her children a likeness of herself, she accordingly sat to me for five different portraits.

Year 1843. Girl asleep. In possession of Miss Maria Seabury.

The Hustle Cop, or disagreeable surprise—painted for the late E. L. Cary Esqr. It is now in the possession of A. M. Cozzens Esqr. It was engraved for *The Gift*.

In July 1843, I visited Hartford Conn. and made a

13. Sketch for *Disappointed Bachelor* (*Procrastination*). 1840(?). Pencil, 9 × 13″.
The Museums at Stony Brook, Stony Brook, Long Island

drawing of the Charter Oak. Frome thence to Albany by the way of N. York. I was so delighted with the appearance of the Catskill mountains and the prospect of seeing Mr. Thomas Cole that I stoped one night in the vilage of Catskill and visited the mountain house and the falls. I spent several evenings with Mr. Cole at his house, we talked of painting and music and I found him (like the scenery that surounded him) truly interesting. As we were looking at the mountains one day we saw a column of smoke ascending rapedly to a great height. "There," says he, "goes the powder house and I hope no lives lost." We sketched and painted together in the open air and rambled about the mountains after the picturesque. Mr. Cole made me a present of a small land scape. I prize it highly.

Year 1844. Portrait of Revd. Samuel Seabury D.D. Up to this time the only copy I ever made was from a portrait of a Lady by G. Stuart.

One picture, "Trap Sprung," painted for E. L. Cary Esqr. It was engraved for *The Gift* I believe [c.pl. 11].

A cabinet portrait of Benjamin Strong Esqr.

Portrait of George W. Strong Esqr—painted at his own residence. Price sixty dollars, but he gave me seventy dollars. He was true to his appointments, which is so gratifying to a painter of Portraits.

In the summer and fall I made a few sketches from nature. In Nov. I finished a picture for E. L. Carey Esqr.—"Birds egging." Now in possession of A. M. Cozzens Esqr.

I made pencil drawings of three children for D. H. Wickham Esqr. [In his catalogue, Mount gives the number of children as four.]

Year 1845. Music is contageous—painted for Charles M. Leupp Esqr. He generously paid me twenty five dollars more than my charge. It has been engraved in Paris, by Leon Noel, for Goupil & Co.

Fishing along shore—recollections of early days. With a view of the Hon. Selah B. Strong's residence in the distance.

Year 1846. I pass over several portraits, a few taken after death. I had rather paint the living but death is a patron to some painters. Acts of munificent liberality are rare and worthy of remembering as bright examples.

Portraits of Edward H. Nicoll and his Wife—painted at his residence. Price seventy five dollars, for head and bust only, but Mr. Nicoll generously gave me two hundred dollars for the two portraits. Good actions should be recorded.

James Frothingham, the distinguished Portrait painter of Brooklyn, said that the portrait of Edward H. Nicoll Esqr. was the finest of an old Gentleman in the exhibition in all the qualities that make a great work—drawing, color, and expression.

Portrait of Soloman T. Nicoll Esqr. He paid me one hundred dollars and kindly invited me to set up my easel in New York and as an inducement he would procure as many portraits as I could paint in a year at one hundred dollars a head—and also, to furnish me funds to commence with if I needed. My love for the Country (a quiet life) and engagements to paint pictures, although not half so profitable, would not suffer me to accept his very considerate offer.

Portrait of Mrs. A. S. Brower, Brooklyn.

Year 1847. The power of Music—painted for Mrs. Gideon Lee. It has been engraved in Paris by the celebrated Leon Noel for Goupil & Co. When Mr. Charles M. Leupp, her son-in-law, received the painting, He stood a long time looking at it until I began to think I had made a failure and observed to him, "If you think this picture will not suit Mrs. Lee, I will paint her another with pleasure." "Why man," he said, "I only wish the picture belonged to me." When I mentioned to him the price, he said it was not enough and generously gave me twenty five dollars more than my charge. The painting is now in the Crystal Palace.

The Ramblers—sold to Thomas McElrath Esqr.

The Novice—painted expressly for the N. York Art-Union, the only order I ever received from that institution. Price three hundred dollars, to be finished in three months time. To have encouraged art, the price should have been named (but no time mentioned) with an understanding that if the picture was worth more than the sum offered, to have handed it over with their best wishes to the painter.

Portrait of Mrs. Eliza Smith—painted for J. Brooks Fenno of Boston.

Year 1848. Caught Napping—recollection of Mr. Strong's early days. Painted for Geo. W. Strong Esqr. Price two hundred and seventy-five dollars. The landscape in this picture was very much admired in the exhibition. Mr. Gignoux, the landscape painter, spoke in very high terms of the group of chesnut trees in the fore ground. In a figure piece, the landscape (if introduced) must be more or less subordinate and so continued as to set off the figures to the best advantage.

Cabinet portrait of Charles Elliott N.A. The last of Oct. 1848, Mr. Elliott made a visit at Stony Brook. He had promised—sometime previous—that if I would sport a pair of moustaches, he would make me a present of my portrait. The hair and canvass was ready, and Elliott painted one of his best portraits. A man with a beard is nature in her glory.

"Loss and Gain" [c.pl. 12] depicts a jolly old toper, in a rather questionable state, vainly trying to climb a fence to regain a whiskey bottle which he has suffered to fall upon the other side. This is his "loss," and the gurgling out of the liquid is, morally and physically, his "gain." We recollect the artist's once telling us the anecdote which suggested this humorous picture. In his boyhood days he saw a similar scene, and while the liquor, in its struggle to escape from the bottle, produced a jerking sound resembling the word "good, good, good," the poor toper

exclaimed with ludicrous impatience, "Well, I know you are good, but I can't reach you!" Loss and Gain—painted for R. F. Fraser Esqr. Sold to the Art-Union.

Although Mount consistently asserts in his diaries and other documents that this painting was done in the year 1848, it is clearly dated 1847 on its face.

Farmer whetting his sythe. I gave it to the National Academy. It was bought with others for the Art-Union.

I have often spent days and weeks and months without painting. There is a time to think and a time to labour. My health would never allow me to bone down to labour a great while at one time.

Turning the Leaf—sold to James Lenox Esqr. Size 13 by 17 inches, price $200.

Year 1849. A cabinet portrait of Edward W. Tiess Esqr.

I believe that if Sir Joshua Reynolds is permitted to know what is going on in this world, he quite regrets not having supported a flowing beard while President of the Royal Academy, knowing as he did that the early painters and sculptors wore beards—but the fashion of his time cheated him of that luxury. Place two portraits of two different Gentlemen side by side, one bare faced and the other with a full beard, and nature speaks with a trumpet tongue in favor of the latter as being the most natural. A man with a beard no matter what color is nature in her glory.

Just in Tune—sold to George J. Price Esqr. It has been engraved in Paris, by Emile Lasalle, for Goupil & Co.

Year 1850. California News, or Reading the Tribune—painted on canvass for Thomas McElrath Esqr. Price three hundred dollars [pl. 14, c.pl. 13].

Portrait of Mrs. Ludlow—painted for Hon. Wm. H. Ludlow. 25 × 30, price one hundred dollars.

"Right and Left"—painted for the house of Goupil & Co. It has been engraved. Price for the painting one hundred and fifty dollars.

"Lucky Throw"—painted for Goupil & Co. Price one hundred and fifty dollars. It has been engraved in Paris by the celebrated Lafosse.

Year 1851. "Who'll turn grindstone." "From the Essays of Poor Robert the scribe." Painted for Jonathan Sturges Esqr., price three hundred dollars.

Portrait of Mrs. Sarah Nicoll, of Islip L.I.—painted for her son-in-law, Hon. Wm. H. Ludlow.

Portrait of J. T. Vanderhoof—price one hundred dollars.

During July and August I painted a portrait of myself,

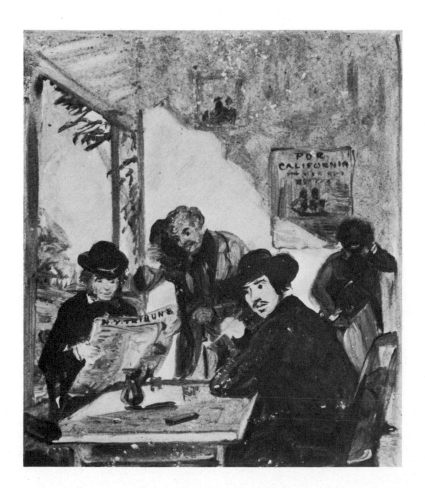

14. Study for *California News*. 1850(?).
Oil on paper, 4 7/8 × 4 1/4″. The Museums
at Stony Brook, Stony Brook, Long Island

15. *Rev. Zachariah Greene*. 1852. Oil on canvas,
24 × 20″. Collection Mr. and Mrs. Harry D. Yates,
Menands, N.Y.

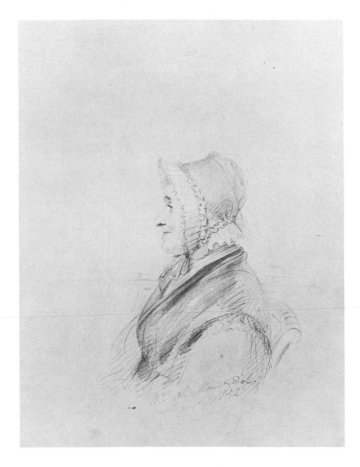

16. *Mrs. Zachariah Greene*. 1842. Pencil, 10 × 8 3/4″.
Private collection, courtesy Kennedy Galleries, New York City

with a california hat and cloak, for my Brother S. A.
Mount N.A. Also a portrait of his wife Mrs. S. A. Mount.
The [K]*Nickerbocker* mentioned them as being among the
finest portraits in this country.

I painted eight small landscapes, from nature, good
practice. In Nov. I painted a landscape by particular re-
quest, for Mr. Elisha Brooks. My first order for a land-
scape. Price one hundred and fifty dollars.

Year 1852. Portrait of Miss Mary Pickering—painted for
Wm. L. Pickering Esqr. Price one hundred and five
dollars.

Portrait of Mrs. J. T. Vanderhoof—price one hundred
dollars.

Family Group—Revd. Zachariah Green and three
of his great grand children. Oval, 20 in × 24 in, price
three hundred dollars [pl. 15; see pl. 16]. Painted for J.
T. Vanderhoof Esqr. "Mr. Green is now in the 94th year
of his age—he has five fingers and a thum on each hand,
and six toes on each foot. This venerable man is remark-
able in several respects. He was a soldier in the Revo-
lution, an intimate friend of Gen. Washington, and one
of the party who took down the equestrian statue of Geo.
III in the Bowling Green. He was twice wounded at the
battle of White Marsh, near Philadelphia, and at the
battle of White Plains. He afterwards entered the mines-
try, and became 'a soldier of the cross,' and has preached
in Setauket—town of Brookhaven Long Island—fifty-
two years. His intellect is still active, and his memory
unimpaired."

Death is at times a poor painter, and takes away beauti-
ful form and color—yet I have painted with success sever-
al portraits from drawings which I had taken after death.
My brushes are cleaned from that kind of painting.

Portrait of T. Bailey., Commander U.S.N.

Year 1853. Two portraits painted from Daguerreotypes.
I shall not paint any more in that way unless I have
double price. It pains me to see so many beautiful young
Ladies and Gentlemen of wealth put off having their por-
traits painted by the best artists, at the very time
when they have the finest color.

Politics of 1852, or who let down the bars [c.pl. 14]. Sold
to Goupil & Co. To be engraved in Paris. "The Sturdy
old farmer looks as if he was asking—'Come tell us what
the news is, Who wins now, and who loses?'"

In May painted a Group of three children. Cabinet
size, for John Brooks Esqr.

Portrait of Mrs. Eliza Spinola, of Brooklyn. Painted
for Francis B. Spinola Esqr.

Coming to the point—just finished. Painted for A. R.
Smith Esqr. of Troy N.Y. by particular request—it is a
variation of the Farmers Bargaining.

The late Luman Reed (his name is pleasant to remem-
ber) offered to build me a studio in his house and was also
anxious to send me to Europe at his own expense. Jona.
Sturges Esqr. has kindly offered to assist me if I desire "to
visit the warm skies and classic ruins of Italy."

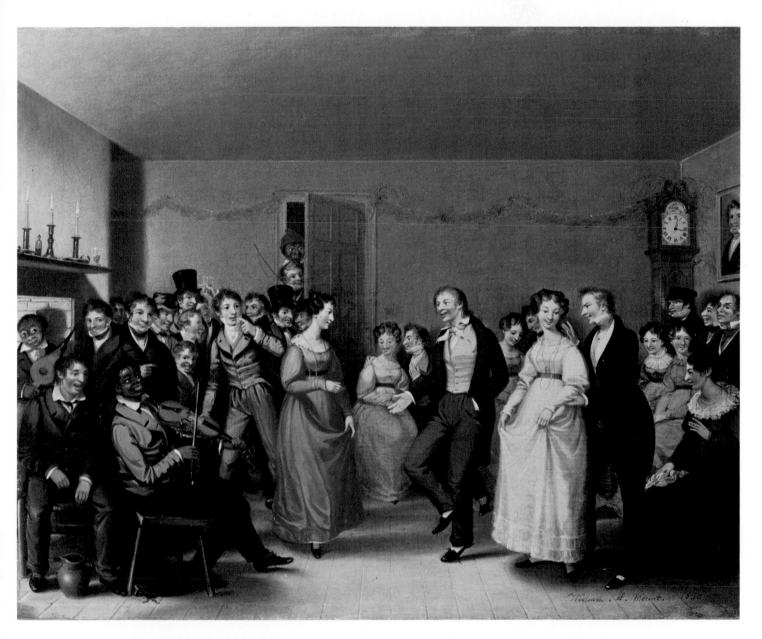

1. *Rustic Dance After a Sleigh Ride*. 1830. Oil on canvas, 22 × 27 1/4″. Museum of Fine Arts, Boston.
M. and M. Karolik Collection

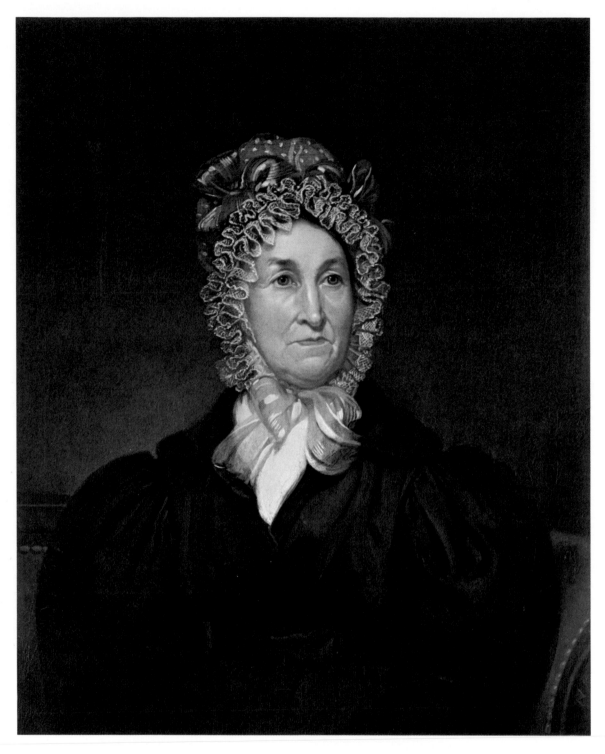

2. *Mrs. Timothy Starr*. 1833. Oil on canvas, 30 × 25″. The Museums at Stony Brook,
Stony Brook, Long Island

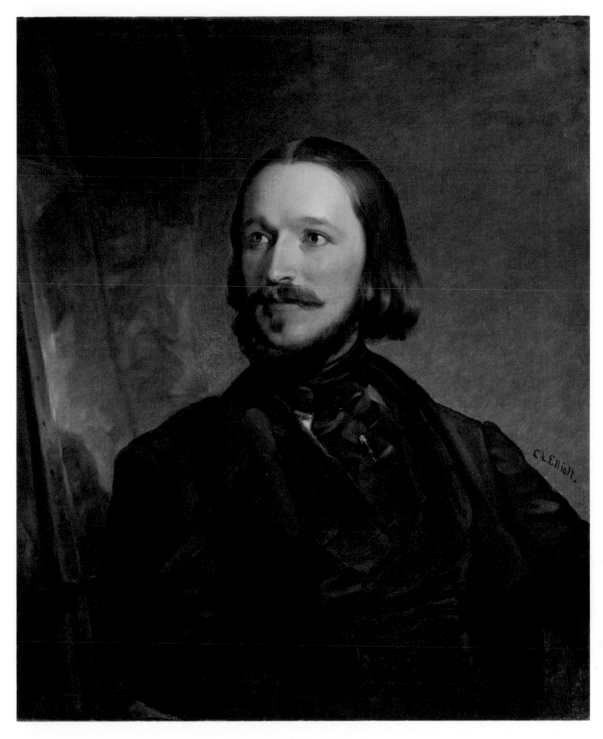

3. Charles Loring Elliott. *William Sidney Mount*. 1849. Oil on canvas, 30 3/8 × 25″.
National Gallery of Art, Washington, D.C. Andrew Mellon Collection

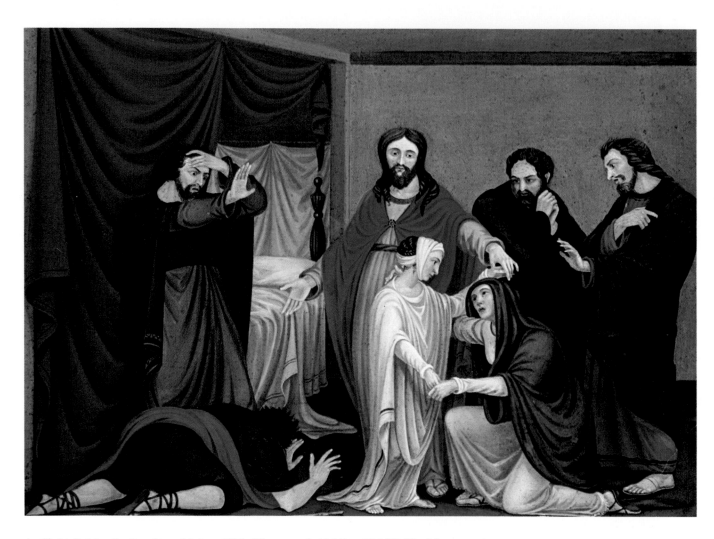

4. *Christ Raising the Daughter of Jairus*. 1828. Oil on panel, 18 1/4 × 24 3/8″. The Museums at
Stony Brook, Stony Brook, Long Island

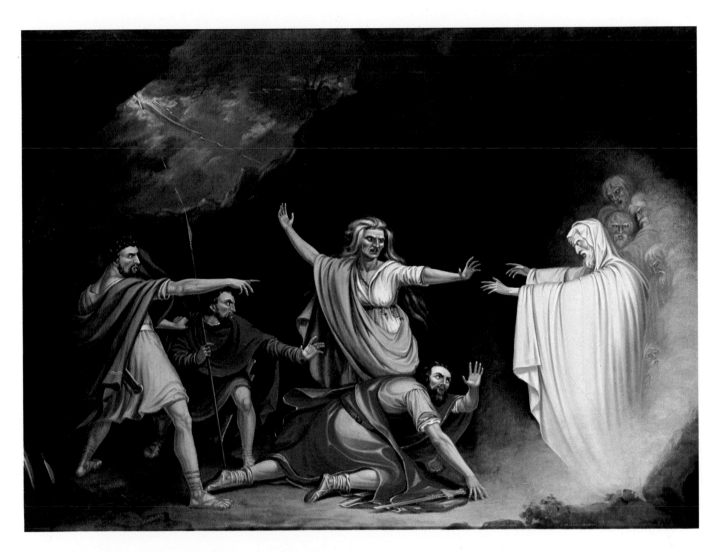

5. *Saul and the Witch of Endor*. 1828. Oil on canvas, 36 × 48″. National Collection of Fine Arts,
Smithsonian Institution, Washington, D.C. Gift of International Business Machines

6. *Celadon and Amelia*. 1829. Oil on canvas, 24 × 20″. The Museums at Stony Brook,
Stony Brook, Long Island. Melville Collection

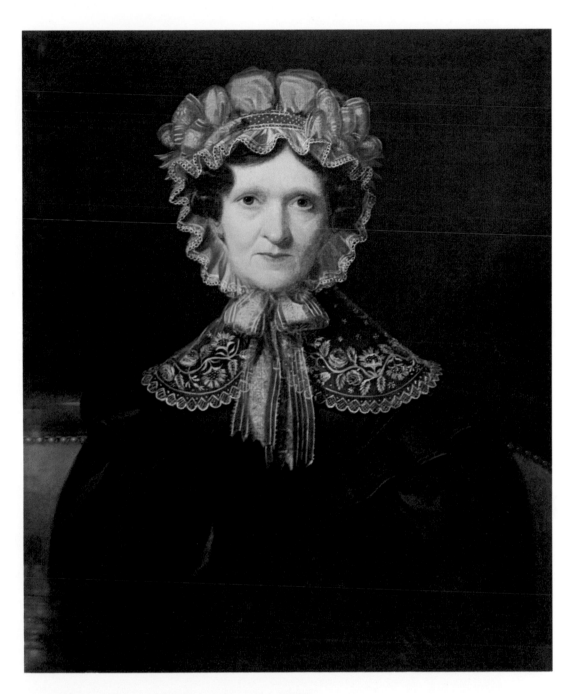

7. *Julia Hawkins Mount*. 1830. Oil on canvas, 30 × 24 3/4″.
The Museums at Stony Brook, Stony Brook, Long Island

8. *Dancing on the Barn Floor
(Interior of a Barn with Figures)*. 1831.
Oil on canvas, 25 × 30″. The Museums
at Stony Brook, Stony Brook, Long Island

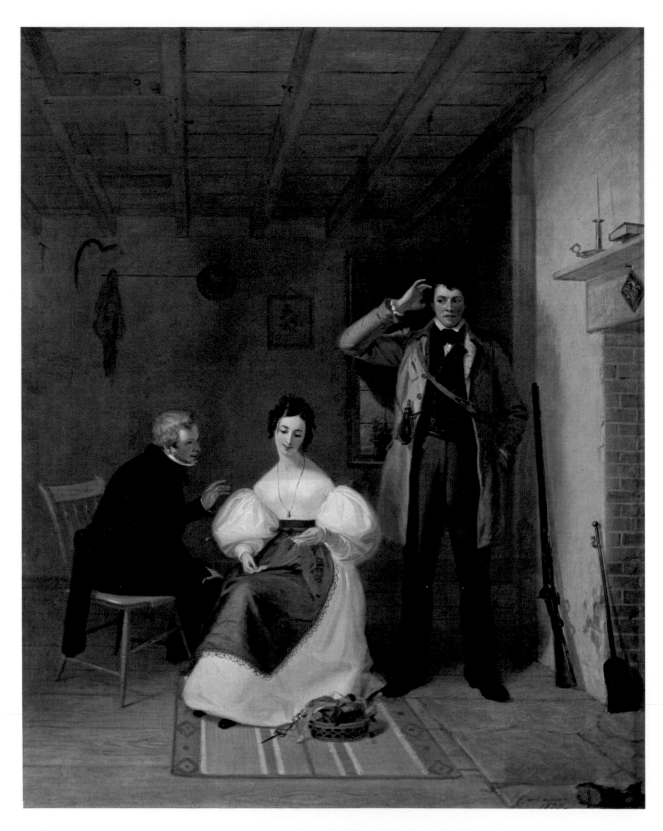

9. *The Sportsman's Last Visit*. 1835. Oil on canvas, 21 × 17″. The Museums at Stony Brook, Stony Brook, Long Island

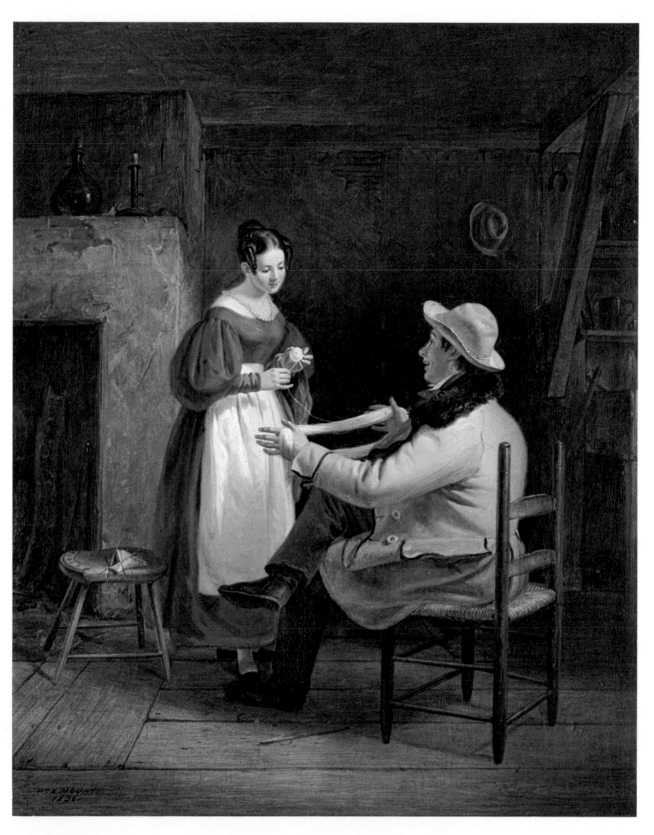

10. *Winding Up (Courtship)*. 1836. Oil on panel, 18 1/2 × 15″. Collection Helen Le Roy Smith,
New York City

11. *Trap Sprung (The Dead Fall)*. 1844.
Oil on panel, 13 × 17″.
The Museums at Stony Brook,
Stony Brook, Long Island

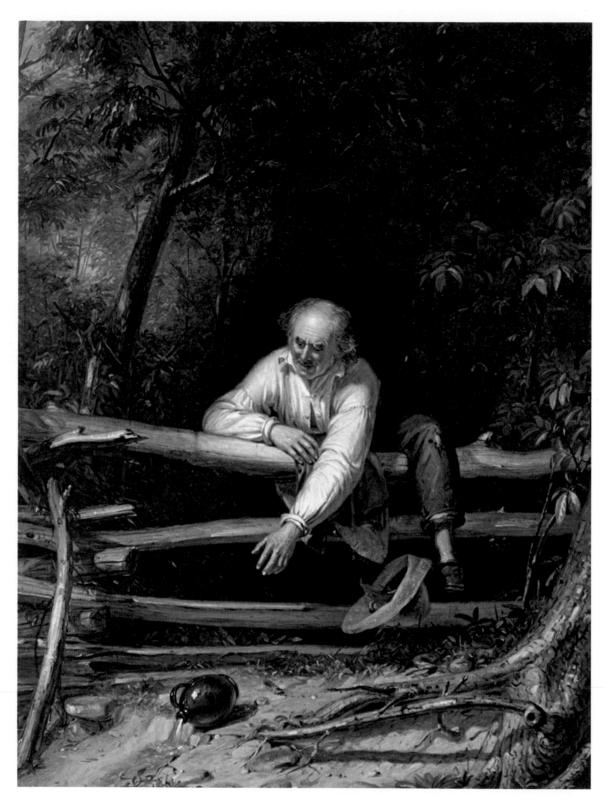

12. *Loss and Gain*. 1848. Oil on canvas, 24 × 20″. The Museums at Stony Brook,
Stony Brook, Long Island. Melville Collection

13. *California News (News from the Gold Diggings; Reading the* Tribune*)*. 1850.
 Oil on canvas, 21 1/8 × 20 1/4''. The Museums at Stony Brook, Stony Brook, Long Island

14. *The* Herald *in the Country (Politics of 1852, or Who Let Down the Bars?).* 1853. Oil on panel, 17 × 13″.
The Museums at Stony Brook, Stony Brook, Long Island

Messrs. Goupil Vibert & Co in 1827 offered to furnish the funds, if I would spend one year in Paris and paint them four pictures, but my commissions would not admit of my accepting their very kind offer.

In my opinion a short visit to Europe will not hurt any one. I have often been asked, "Have you been abroad?" A visit to Europe would be gratifying to me, but I have always had a desire to do something in art worthy of being remembered before leaving, for fear I might be induced by the splendor of Europeian art to tarry too long, and thus lose my nationality. We have nature, it speaks to every one, and what efforts I have made in art have been appreciated by my countrymen. Originality, thank God, is not confined to any one place or country and this makes it very comfortable for those who are obliged to stay at home.

Dear Sir, you ask me about color—there is no standard of color. The highest point a painter can attain is to be natural. What signifies blue, red, and yellow if there is no mind with it?

When the "Power of Music," made its appearance, "Ah! how he has improved in color," said a critic. Then again they say, "His pictures are crude and time will improve them." Well, I am pleased I have one friend as regards color, *Time*. Think a moment. Give a painting the appearance of age when it is new—how will it look when it becoms really old? No where. To be more or less ornamental is proper, when consistant with nature.

The date 1827, which Mount gives for Goupil, Vibert's offer to send him to Europe, is obviously a slip of the pen, since Goupil, Vibert & Company established its New York office in 1847. The firm's offer to send Mount to Europe came in 1849. He declined.

VII

I made a visit to Philadelphia in Sept 1836 expressly to see West's picture "Christ healing the sick," designed as a present to the hospital of the metropolis of Pennsylvania, his native state. I stood almost breathless before it. The group around the blind girl I was highly pleased with, I thought it very touching. It is gratifying that we have such a picture to "remain among us a monument of his patriotism and of his genius." The artists and lovers of art I fortunately met with I remember with pleasure—Mr. Earle, Mr. Charles Graff, who kindly introduced me to Thos. Sully, Esqr., Mr. Lawson, Engraver, and Mr. Birch. Mr. Sully's colouring I was pleased with, he exhibited to me some of Leslie's early drawings. Mr. Birch showed me a very fine landscape upon his easel, his marine pieces I have always admired. Mr. Lawson showed me several fine pictures by the late John Lewis Krimmel, one in particular, "a Philadelphia election scene." It is worth going the whole distance to see.

The cry is, why I dont paint more pictures. I must not paint Portraits etc. I find I must work at portraits—some of my customers prefer to see themselves, and it is wisely ordered. I prefer to paint pictures, for they will be remembered and hauled out when portraits except of distinguished characters (or of extraordinary color) will be forgotten. If possible, I must endeavour to follow the bent of my inclinations. To paint portraits or pictures large or small, grave or gay, as I please, and not to be dictated to by others. Every artist should know his own powers and not be dictated to by others.

The remainder of this autobiographical sketch merely repeats material already given in other sketches, and so it is omitted here.

robert nelson mount

Robert Nelson Mount was the gray sheep of his family. Because, unlike all three of his brothers, he did not paint, writers on the Mounts have all but totally ignored him. But William Sidney wrote him numerous letters full of revealing family and local gossip and equally full of talk about dances and dancing, fiddlers and fiddle music. Robert Nelson Mount was a dancing teacher throughout most of his life, although, like his brother Shepard, he was trained as a harness maker and at one time practiced that trade in Stony Brook.

Nelson, as William called him, spent much time on the road, organizing dancing schools and fiddling for parties. That is why William Sidney wrote him so often, sending him tunes and dance figures, inquiring after his health, and offering him money. Robert Nelson Mount was a year older than William, but William addresses him as if he (Nelson) were the younger. And he certainly seems to have been in need of William's solicitude.

A.F.

From 1821 to 1825, Robert Nelson Mount kept a "commonplace book" wherein he jotted down comments on events of the day and copied poems, newspaper stories, and letters he sent and received. Among these letters is the first one ever written by William Sidney Mount, who was fourteen years old at the time. It was sent in response to one from "Brother Nelson," a copy of which is also in the commonplace book. The texts of both letters are as follows:

New York, 7th August [1821]

Dear Brother,

I am now going to inform you that Unkle and Aunt Hawkins has returned from their visit in the Country, they left all friends well in Orange County. We have had very warm weather here and I expect you have had a share. Dear Brother, it is not that I forget you that I do not write, but I have never been in the [word omitted] of writing and it seems almost impossible for me to compose a letter that is worth any boddy's notice. But we are young, and I hope we shall get over these difficulties as we get older. But as the old saying is practice makes perfect, and I should be very glad to receive a line from you now and then when you can get time to write and in a little time I hope writing letters will come easy to us both. Give my love to Grand Mother, Mother and Ruth. Henry and I expect to make you a visit some time this month if nothing happens.

I am your affectionate Brother
Robert N. Mount

William's letter is headed in the commonplace book, "Copy of an Answer to the foregoing." Observe that it was written five months later.

Stony Brook, January the 9, 1822

Dear Brother Nelson,

I have long thought of writing to you and Brother

Henry, but feel myself quite incapable, at any rate I shall venture it for its being the first attempt I have ever made I hope you will excuse all imperfections.

Mother received Brother Henrys letter the 8th he commenced with wishing us a happy New Year we thank him for the compliments of the season and in return I wish you all the same. happy indeed will these years appear to us, if we should live to see twenty years hense, altho we have been unfortunate yet we may Consider ourselves fortunate children that our opportunitys are far better than hundreds of orphans like ourselves and may we improve in knowleddge as we do in years. we are happy to hear from Brother Shepard and to hear that Unkle Hawkinses family are well.

My imployment at present is to cut off wood, attend to our stock altho small, and go to school. I hope I shall make some improvement. [Illegible] Sister Ruth, where abouts are you in your studies, I don't expect I shall be able to show my head in the spring but I intend to get along by the edges, for I don't like to be sold the fag-end. so good night. Grand Mother is well, sends her love to all.

<div align="right">

from your affectionate Brother,
William S. Mount

</div>

[SB]

<div align="right">

N. York, May 29, 1830

</div>

Brother Nelson,

I have a plenty of business, I am Painting the Portraits of the Rev Mr. Onderdonk and Mr. Thompson, the Architect, etc. I shall be up home as soon as I paint 3 or 4 more, to Paint some landskapes from nature. My Contra Dance atracts great attention. I will give you a coppy of a Critic on the Pictures—he blows them up like fun, we can't find him out. Published in Pamplet form.

I have sold my Cottage.

Mount's little girl from Cottage comes;
In nature's tints she lovely blooms,
Whilst o'er her head the willow tree,
Waves as it should so droopingly.

He leads us up a Rustic Dance,
Such things are better done in France,
But this shall keep no under station,
It shows some scenes within the nation.

Take nature for a guide, and she
Will show what wants variety.
Study good composition well
One day in this thou may'st excel.

In harmony more thy collors blend,
I speak as't were to any friend,
Who leaves them, now in hopes to se[e]
Still better things next year from the[e].

Wrote in a hurry—burn up my letter.
Shepard [h]as gone up Country.

<div align="right">

Yours etc.,
W. S. Mount

</div>

Aunt Hawkins is in town. Grand mother will be up next trip.

[ARCHIVES OF AMERICAN ART] *For the crucial significance of the above letter, see the comment on the* Rustic Dance *in the prefatory Appreciation of Mount.*

<div align="right">

Stony Brook, Dec 7th, 1836

</div>

Brother Nelson,

Mother has had the pleasure to receive your letter, and it is gratifying to us all to hear that you had arived safe at Macon and was soon to commence your school. Sister Mary has received your letter. She was very glad to hear from you. Sarah talks a great deal about poppa. All well at Mr. Brewster's. I have received two letters directed to you and I have taken the liberty to read them. I answered Mr. Abm. Van Nest's letter. I mentioned you was down South and believed when you returned that you would call and make perfect satisfaction. Mr. Isaac Bullard's Clerk I saw in N. York—he was not pleased you did not call on him before you left. He said he should be glad to hear from you. If you can make money you must now see the importance of saveing it. Look to your interest. Let nothing take your attention but your business. Practice makes perfect. It give me pleasure that Mr. Carlton Smith was well received he is a clever fellow. Cousin Letty Shepherd is paying us a visit, she was pleased you met Mr. Saltmarsh. Mr. Robinson is teaching dancing school up the North river. I hear that Mr. Mathason is trying to get up a dancing school in Setauket. I see by the papers that "Mr. Hill, the distinguished violinist, has returned to N. York—after taken lessons of the first persons in Germany and England. He has resumed his charge of the Sacred Music Society."

Several serious accidents have happened since you left. Jedediah Williamson the son of Col Wm. Williamson is dead [c.pl. 15]. It is supposed he was killed instantly, he was run over by a loaded cordwood waggon; he was alone at the time. A son of Square [Squire?] Hammon of Middle Island has had his leg broke. Also, Mr. Daniel Mills has had his leg broke by the wheel of a waggon. Mrs. Mills pays every attention to him. Mr. Sturges was highly pleased with his picture—he gave me my price two hundred and seventy dollars and said the price was little enough. I received of Mrs. Haight fifty dollars for the portrait of her grand daughter. I can now receive from fifty to one hundred dollars for painting portraits in N. York. I should like for you to write to me when you can spare time and let me know the state of the arts in that county and what kind of characters you meet with. Also the state of the whether. The Boys was skating on the Mill pond here the first of December. Grand Mother sits by me in the old kitchen reading Marryatt's Novel of Midshipman easy. Brother Henry gets along with the farming very well. Egbert Smith told me to day that Mr. Mills' harness was finished and that Mr. Strong's harness was most done. Your things are all boxed up except the leather under the bench—all safe. Your letter was received the third of Dec.

Mother and Grand Mother sends their love to you. I remain yours sincerely

Wm. S. Mount

P.S. I shall spend the winter in Stony Brook.

[Note on envelope:] Shepherd is at Sag harbor. Be careful and have your hair cut short.

[SB]

Stony Brook, Jan. 26, 1837

Brother Nelson,

The last of Nov I made up my mind to spend the winter at River Head but learning that Uncle Tim's old house was to be vacant in a couple of weeks, the thought struck me that the west room would make me a good studio. I now have the whole house in my possession. I have your stove to warm my paint room and my fire wood I keep in the east room. I have thought some of keeping bachelors hall, but fearing the chimney might fall on me while cooking I have abandoned the notion. I now take board with Gen Putnam. I mentioned to you that Mr. Mathewson was trying to raise a school in Setauket. He has succeeded. He has one at Smithtown and one in this place of about thirty scholars, held at Henry's. We have also a singing school taught by mr Wheeler, besides night meetings. I am pleased you meet with encouragement, it shows that talents with industry is sufficient recommendation. I heard several scholars say the other evening at school that you was a better teacher than Mathewson.

I heard that your wife had received a letter and I whent over to Setauket to hear from you. I found your father-in-law feeding the poultry and looking after the cattle. I expect you can imagine seeing him hauling away of an evening on his fiddle his knees keeping time with his music. Your wife and daughter is well. Mr Carlton Jayne was married the other evening to Miss Rosamond. The company had a great time on the occasion.

I am sorry to mention that our next neighbour Mr Williamson the old Gentleman is no more—he died of a short illness. John M. Williamson spends the winter at Albany. Cousin Letty Sheperd is spending the winter with Sister Ruth. She wishes to know if you are willing for her to use your piano music. She plays beautyfully. Cold weather here the harbor is froze up and we have good sleighing. There is nothing to call your attention home, stay as long as the season and your business will admit.

Grand Mother is well. Mother is getting better of a cold. Brother Henry is at N.Y. Sheperd is still at Sag Harbor.

I send you Mathewson's printed "Rules and regulations of this dancing School." 1. No person or persons will be admitted into this school unless subscribers without permission of the Teacher. 2. The Scholars will observe their honors in entering and leaving the hall during School hours. 3. No lady will be permitted to leave the hall in School hours without being accompanied by another lady. 4. No Gentleman will be permitted to sit with the ladies in School. 5. No Gentleman will be permitted to sit with his legs crossed, or leaning against any other Gentleman. 6. No pushing, pulling or loud talking by either sex will be permitted. 7. No lady must refuse to dance with one Gentleman and dance with the next that shall offer in the same sett. 8. No Gentleman will be permitted to insist on any lady's dancing, who wishes to be excused, by pulling, or any other means. 9. No gentleman will be allowed to spit on the floor where the ladies' dresses will be liable to be soiled. 10. No gentleman will be permitted to dance in boots, or an overcoat, or any fantastical dress whatever, on penalty of being expelled from the School. 11. The hours of Tuition will be from 2 o'clock until 5 A.M. [sic] for ladies, and from 6 until 9, in the evening for gentlemen.

Please to drop me a line.

Yours truly, Wm. S. Mount

Macon Georgia, February 19, 1837

Brother William,

I have received two letters from you, and was sorry to learn by them that Mr. Williamson and his grandson are numbered among those that were. Such intelligence, however, is not surprizing to me; I never break the seal of a letter that comes from home without expecting to be informed by it that a friend, if not a relative, has departed to return no more. With this exception, and a few accidents that have taken place of a serious nature, your letters were very pleasing.

I think Unkle Tim's house will make you a good studio. The windows I believe are high, and there is better views from them than any I have seen since I left Stony Brook. I think also that it has quite the appearance of being the habitation of a genius. Let me know when you write again what picture you are painting, the subject etc. I have seen a very favourable notice of your Winding [illegible] picture in the *New York Mirror*. There are no painters in this part of Georgia at present but house and sign Painters, and although not superior in their line are fast making their fortunes. I found when I first arrived here a portrait painter by the name of Sherwood who had studied under Vanderline in New York and Charleston. He for a while had considerable employment which did not, however, last long, it being assertained that he did not fairly represent the "Human face divine"; having put all his customers out of countenance, they of course would not countenance him, so he packed up his affects, which he left with a friend here, and started for Florida to fight the Indians. I hope he will succeed better in taking scalps than he has in taking Portraits.

I should like much to be in Stony Brook this winter as Mr. Mathewson is there. I hope he will remain another season. I should like to get instruction from him on the violin, which I have no doubt he would very willingly give

me. If you think it would not be asking too much, I wish you would get him to write off for me his Marshal Figure and the appropriate music, also the figure of the Basket Cotilion and Coquet with the music; his way of dancing them I believe differs from the common mode. In less than three weeks I expect to open a school in Milledgeville, which is the capital of the state and thirty-two miles distant from this place. As I shall then be obliged to do my own playing, any little simple airs that you can send me will be very acceptable but do not give yourself too much trouble about them. I have made considerable progress in learning to play and call the figure at the same time. Remember me to Cousin Letty Shepard. I have found another of her acquaintance here—Mr. Overton, who is a partner of Mr. Saltmarsh, she will probably remember him, he is a very agreeable man. Tell her she is welcome to any of my music. I hope she will stay in Stony Brook until June. I might then have an opportunity to see her and hear the sound of her Pianoforte.

This has been the coldest winter they have had in Georgia for many years, the ground is frozen quite hard at this time, and yesterday morning we had a flury of snow. It is the custom here to build up large fires and open the doors. I am very comfortable, however, in my own room, as I have the privilege of keeping my door shut.

The people in this place are geting to be quite civilized, there have not been more than four murders committed since I have been here, but a great many unscientifick cuts are made, which is not surprising when you consider that almost every man carrys with him a large dirk or Buoy knife, but men who attend only to their own business need not be in fear of those weapons. I am pleased that you answered those letters that were sent to me from New York. I shall be able to call and see those gentlemen when I return. Give my best respects to Gen Satterly, Doct Dearing, and Capt Rodgers. I hope I shall find them all married when I get back. I wrote a few lines to Brother Henry by a Mr. Wallace of New York. I suppose he must have received them before this time. My love to Mother and Grandmother who I am glad to hear enjoys good health for one of her age. Write me soon if it is only a few lines, let me know if Brother Charles is spending the winter in New York or at Stony Brook and whether the fammily is all well. I shall in future write often to some one of the fammily.

I have assertained that the name of Mount is quite often met with at the South. There is a young man [tear in the paper] by the name of Joseph Mount from Washington City who[?] informs me that there are many fammilys of that name in Virginia and Maryland.

R. N. Mount

P.S. My birthday 19.
[SB]

Stony Brook, Feb. 11th, 1838

Brother Nelson,

I should have answered your letter sooner but have waited until I thought you were settled at Macon. The most important news I have to tell you is that all our family is well. Shephard and Henry are at home, the former has succeeded well with his portraits. My health is restored and I am now painting a large picture 4 feet 4 in by 3 feet 6 in, the subject fortune telling, three figures half length and the size of life. After you get through with your engagement at Macon, say one quarter, would it not be more for your interest to teach in the Female Institute at La Gran[g]e.

Carlton Smith called to see me, he seemed to regret that he had spent his time and money in building. His wife I understand has given him a fine boy. I expect he feels as if he will have to dance more than ever. His sister Ann Marian Smith was married last week to a gentleman from N. York, a young lawyer. Mathewson has five schools, one at Oyster Bay numbers society[?] scholars at 5 dollars a head. We had cold weather here all the fall and part of Dec. From Christmas to Feb. first, remarkable warm weather, so much so that Farmers ploughed and sowed. It is now snowing, the wind west. Bartlett Woods Mother is dead. I have not had time to make a sketch for you, nor find you any music. I shall be glad to hear from you.

Wm. S. Mount

Miss Renelahe Hallock is married to John Elderkin.
[SB]

Stony Brook, Oct. 14th, 1838

Brother Nelson,

Having learnt that you intend to leave Georgia in about a month for Alabama I thought I would let you know the movements of the Dancing Masters from this part of L. Island.

Mr. Carlton Smith, Mr. Nelson Mathewson [pl. 17], and Mr. Raynor from the south side of the Island will sail from New York to morrow for Agusta. Mr. Smith employs Mathewson as an assistant teacher. Mr. Raynor goes on his own hook. He told me some time since that he should figure in Alabama but I have been told since that he will visit Athens in Georgia. There is room enough for all of you. You can meet them at Agusta if you think proper, they would be glad to see you I have no doubt.

Mathewson plays on the violin better than ever and I am sorry he will steam it—he drinks too much, but I hope he will leave off. He has spent all his money and he says it will be for his interests to visit the South, success to him I say. Never speak of his failing to the Southeners.

I have engaged to paint eight portraits at fifty dollars a head. I am now drawing Mr. Selah B. Strong's portrait on the Neck (or at his residence). I have only two more to finish the engagement.

As I saw your letter in the post office yesterday I went down to Mr. Brewster's with it. Your Lady was much pleased to hear from you. Your daughter is well. She said she would go to Stony Brook with me, she is a smart girl. I had the pleasure to see Mrs. Brewster, all the family

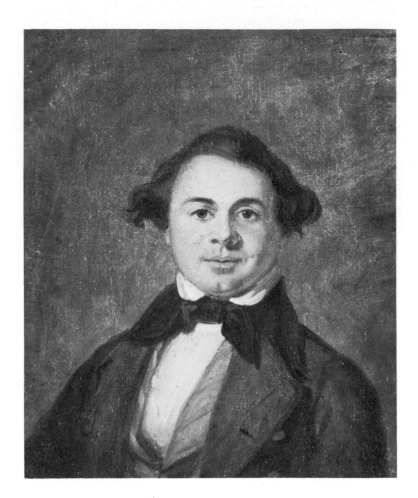

17. *Nelson Mathewson*. 1840. Oil on canvas,
7 × 6 1/2″. The Museums at Stony Brook,
Stony Brook, Long Island

is well. Brother Shephard is in the City, his wife is with Mother. Sister Ruth sends her love to you, all our family wishes to be remembered to you.

If it will be for your interest I think you had better spend the winter at the South. Make all the money you can, put it in the Bank or where you can draw it when you want it. I shall go to Europe next year if I am able and I want you to furnish some of the means. Perhaps you will like to go with me.

I sent a picture to Mr. Carey of Philadelphia about five weeks since. He is delighted with it.

Drop me a line and let me know how you are getting on.

Yours Src.
Wm. S. Mount

Shephard sent you a number of the *Mirror* directed at L. Grange I believe. Did you receive it? I don't much think that I shall spend the winter on the Island.

[SB]

Stony Brook, Jan 30th, 1839

Brother Nelson,

I was at one of Mr. Parker's Assemblys at Tammany Hall last week about two hours, and danced a few times. I saw no new figures except a Reel called the Rustic Reel, and as it is a fashionable dance in N.Y. I will endeavour to describe it [pl. 18]. The Gentlemen has two partners and they stand on the floor the same as in the Scotch Reel. When the music commences the two Gentlemen takes the corner Lady's opposite to their right hand partners and promenade out into the room at right angles from the sett and back again to places. The two Gentlemen then promenade with the Ladies opposite to their left hand partners, to the left and back again to places. The six then forward and back and pass on by one another as in the Scotch Reel, and commence promenadeing and so on. It is quite simple. The whole school can dance in this Reel at the same time, as in the Scotch Reel. Two Ladies and two Gentlemen promenade at the same time. Two Ladies of course keep their places until their turns come. Try it if you have a wide room.

[Music]

Mr. Raynor it appears did not stay at the South long. He has a school at Setauket once a fortnight, also schools at Port Jefferson and Middle island. Mr. Smith is in Augusta—he bought out the master he found there. Mr. Mathewson has set up for himself, has a promising school, fifty to 60 scholars at 10 dollars a head. So he writes to Richard Udall. I have not heard the name of the place where Mathewson has set up. It is not in Agusta. Mr. Raynor says if you had gone to Agusta you would

18. Square-dance notation and music. Letter WSM to Robert Nelson Mount, January 30, 1839. The Museums at Stony Brook, Stony Brook, Long Island

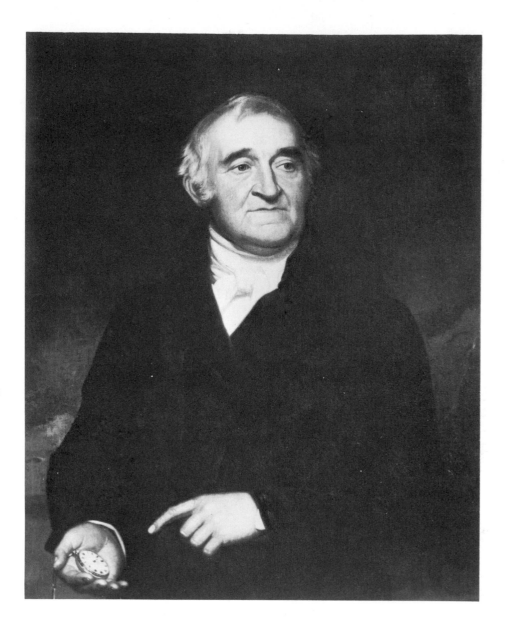

19. *Jeremiah Johnson.* 1839.
 Oil on canvas, 36 × 29″.
 Borough Hall, Brooklyn, N.Y.
 Courtesy Art Commission, City of New York

have made money. I hope you have done well notwithstanding. You must write and let me how all you Dancing Masters get on at the South. Mother says she wants to hear from you. Your wife feels quite anxious about you, she has not heard from you in some time. The subscription for the *Mirror* was paid up to 1838. I only paid for one year up to July 1839, consequently I have five dollars in my pocket for you whenever you feel disposed to call for it.

Quite a number of Marriages have taken place on this part of the Island.

I have painted a good portrait of the Mayor, Gen. Johnson, for the Common Council of Brooklyn [pl. 19]. Price $250, with frame. I painted two other portraits at the same time at his house. I shall spend two or three months at his place. This letter I have written by candle light and in haste. A scrawl complete.

Yours Affectionately,
Wm. S. Mount

P.S. Brother Charles Seabury is going to build a piano forte factory near where his house stands. To commence building it in a few days, he will put out his farm on shares.

[SB] *Mount's portrait of Jeremiah Johnson, mayor of Brooklyn in 1839, now hangs in the office of the president of that borough of New York City. Johnson is pointing somewhat testily to his watch, which stands at 2:25. Meetings of the City Council were called for two o'clock sharp, but the councilmen habitually drifted in late, to the mayor's great annoyance.*

Stony Brook, July 6th, 1839

Brother Nelson,

I answered your interesting letter on the fourth of July, but, not having time to say all I had to say then, I thought I would sit down and write you another letter.

I suppose you recollect that you told your last apprentice Mr. Isaac Smith that he could have your tools to make up some harnesses at his home. He took the tools I think a year ago last fall and worked at his Father's house, and not feeling that he understood his business sufficiently he went to Sag harbour the next Spring and worked with a harness maker until fall, then returned home. Mr. Smith then felt able to commence business for himself, as he had improved very much. Last fall he hired the Shop that you formerly occupied, of Capt. Jonas Smith, and I believe made use of your tools. He confined himself very closely all winter (too close for his health), made good harnesses, and trunks, for he loved his profession. I stoped in his shop early last Spring. I observed his paleness and told him he confined himself too much. He has not done any work in two Months. The Doctors says that he has the consumption. I asked his Father how Isaac was this morning he said that he was failing fast.

I will give you a sketch of Nelson Mathewson, he boards with Dodd at Babylon, entertaining Dodd Company with his violin for his board. Mr. Mathewson went with Mr. Smith to Agusta, as soon as they arrived there, Carlton got him a suit of clothes from top to toe, for Mat was greasy to look at. Mat pleased the Southerners with his violin and he staid with Smith two months. (Smith gave him instructions in dancing, and Mat wrote music for Smith and showed him how to fiddle.) Then Mr. Smith got another School near there. Smith had not time to collect the money, after Mat's school was up, and he gave Mathewson power to collect and to meet him at Agusta. Mat collected the corn, and lived like a fighting cock. In the mean while Mr. Smith not hearing from Mat went to the town (I forget the name) but Mathewson was not there, he had left two or three days before. The bar keeper of the Hotel told Carlton that Mat was steady at the school, but as soon as he had collected the money he spent five dollars a day and drank all the time, notwithstanding the people wanted Mat to keep another school there. Smith returned to N. York without seeing him. On Mr. Smith's second trip to N. York, after he got home he learnt that Mathewson was at Babylon. Smith pays him a visit. Mat had no money for him, all spent, but he gave Smith his note. Smith thinks of trying Mat another season and will collect the money himself. Mathewson was owing Dodd and I suppose paid him when he ought to have paid Mr. Smith. Mr. Carlton Smith tells me that he has engaged to teach Schools in Charlston and says that he would like for you to teach in Agusta next winter. Mr Smith has moved to Sing Sing, Westchester County N.Y. and would like to hear from you as he has some music to send you.

The music I sent you on the fourth you can introduce in any sett that you please. I will send you an exquisite tune as played by Mathewson, "The Braes of Athol" [pl. 20]. You have heard him play it often. It requires to be played with a scotch[?] bow, bow every note. The last strain, or part, is good practice.

I am pleased to hear that you have plenty of business engaged. I shall be pleased to see you whenever you can leave your engagements to come and see me.

Yours affectionately,
[SB] Wm. S. Mount

Stony Brook, March 8th, 1840
R. N. Mount, Esq.
[Music]

Henry's sett of cotillions—of course you will arrange the numbers and strains to please yourself.

Brother says you must compose figures to his Sett. I think the 4 number [second of the four tunes in the set] would make a good song. A good air for a song. You must like the 3 and 4 numbers, ~~practice~~ play them, ~~but dont part with them~~, if the cotillion players can catch them by ear, let them go. What do you think of them? The Gallopade you will like. La Bayadere is an old acquaintance of yours but I thought you would like it as

20. "The Braes of Athol."
Letter WSM to Robert
Nelson Mount,
July 6, 1839. The
Museums at Stony Brook,
Stony Brook, Long Island

arranged by Mathewson, so different from the way it is printed or commonly played. Only practice it particularly the last strain.

My violin is very pleasant to play on now, particularly the handel, it is narrower, the strings are nearer, the under part of the handle I did not have touched, the finger board I had reduced. Done in first rate style by C. S. Seabury. I had the alteration made some time since. I haul a tune now and then in the old fashioned way after I get through painting.

Your Wife has lately received a letter from you. All well. Mother has been quite sick, but is now very well. My knees are getting strong. I don't like waiting. I had rather paint or catch flat fish. It is sunday and I am in a great hurry, therefore you will excuse this scratch.

<div style="text-align:right">

Yours affectionately
Wm. S. Mount

</div>

[Sketch of Mount playing the violin in the "old fashioned way" for a child]

P.S. drop me a line.

[LOUISE OCKERS COLLECTION]

Undated and unsigned. From Macon, Ga., April, 1840

Brother William,

I saw this morning by Bennet's *Herald* of Tuesday last that the Mounts have five paintings in the National Academy of Design for exibition. I know not whether they are Portraits, Landscapes, or domestic scenes; but let them be either, I shall look for a favorable account of them from the Judicious and candid critic: expecting, however, that they will give them, in their remarks, a sprinkling of the assid with the sweet. Hitherto your productions have elicited a goodly share of well merited praise. But those encomiums have had a tendency to arrouse the envious feelings of the illiberal and narrow minded, who may be compared to the Buzard—a Bird that flies o'er the landscape not to admire its beauties but to search among the foul places of the earth for a carcase. In like manner these Criticks view the work of art; and are most diverted when they have discovered defects, which is food for them as the Carrion is for the Raven. This class of connoisseurs have long had their eyes on you. But your figures have been so well drawn that it gave them an annimated appearance—looking as if they could not only speak for themselves but fight for themselves also. Consequently these faultfinders kept at a distance, not having a wish to applaud nor courage to molest. If they do not obtain a full meal from any one of the five paintings of the Mount fammily, they will probably among some of them find a few bones to pick. You will come off well if that is all. Bennet, I think, intends to demollish some of your Canvasbacks entirely—leaving nothing but the frame. Just criticism is always beneficial to the Artist, and they who receive no censure are rarely deserving of much praise. All this you knew before, but it helps fill out my letter notwithstanding.

This morning at daybreak, I was arroused from my slumbers by the alarm of fire. On proceding to it, I found it to be a Cotton Warehouse, which was soon consummed without doing any other damage. Two Warehouses had been set on fire; but the other they succeeded in saving. This is the third or fourth attempt that has been made within a few months past to destroy the City in this way. The incendiaries made choice of a favorable time to accomplish their object. Our population is considerably scatered at this time. Nearly one hundred men including the Macon Volunteers have gone to Savannah, where they are to meet the volunteer companies from Augusta, Milledgeville, and other parts of the State; comprising, when together, ten or twelve independant companies. The City Council of Savannah have appropriated five thousand dollars to defray thier expences while there. A merry time they will have. When the Macon company returns home I shall get up a Ball, which is something we have not been able to do recently; the Simon Pures have put their veto on all amusements of that nature. A great revival has been going on here in religion and also in politicks. The voice of their votaries sounds aloud in the Whisky Shop and Church. The cry of "Hell and Satan" and "Hard Cider and Harrison" has become familiar to our ears. The fear of Hell has induced many to join the church; and the love of Cider has led many to join the standard of the old General. Both parties have important objects in view—the one to save their souls and the other to save the country. In Consequence of these revivals, Public Performances have received but little or no Patronage here of late. The Hungarian Singers were here in the early part of last month and were well supported. The Methodist Society lent them their aid, and so did the Clergy, who led the way to the concert Room, taking with them nearly one hundred young Ladies from the Female College, and in their train as a matter of course followed nearly all the young men in town. It was to them a lovely scene. They had gazed[?] at them before at the Church, but there they wore a serious Aspect. Now they were in a Concert Room, having on not only their gayest attire but also their prettiest smiles. They seemed, however, not to forget that their tutors were present, and when they caught a glimpse of a favorite Laddie, I fancied I could hear them say to him—

"O steal me a blink o' your bonnie black e'e,
Yet look as ye were na looking at me."

At the appointed hour for the Concert to open, the Hungarians came forward. They was but three in number, the fourth being detained unexpectedly on the road by a cold. For this misfortune they apollegized, and would have refunded the money to those present; but the good natured audience said "go on." And accordingly the trio dressed in their national Costume, commenced with their tum tum; twa twa; totolo totolo—Bass[?]. It was rather a bad opening, and many thought that they, like their companion, had a cold; but it was not so. They were in good tune and towards the close sent forth some

delightful strains. The audience generally I believe was disappointed. There expectations had been raised too high, and besides it was not a kind of music calculated to please them. Notwithstanding all this, however, they remained quietly through the performance and retired peaceably at the close, leaving the vocalist, as some supposed, to hee, hee, hee and haw-haw-haw at having added to the list of the gulled of other places the citizens of Macon.

The next public performance that came this way was Adrian the Magician. But he was too late in the day. The business of deluding the people was already monopolized by the magicians of the Moses school. In vain, therefore, did Adrian flourish his magic Wand or display his infernal spirits through the apparitions of the Phantasmagoria. Nor could his incantations have any effect on those that were already held spellbound. After performing here more than a week without obtaining enough to pay his expences, he made his Presto Chango from this place to Collumbus, leaving his adversaries to perform to full houses and in their own way.

[SB]

The document from which the following letter is taken is a curiosity. It is a large, four-page letter sheet on which Robert Nelson Mount wrote four different versions of one and the same letter to William plus two additional drafts of its opening paragraph. The version given here is the first and liveliest of the four. The others contain nothing about politics but go on at great and tedious length about two waterfalls in Northern Georgia which Robert had seen.

Milledge[ville] Georgia, June 9th, 1840
Brother William,

Contrary to my expectations when I wrote you last, I am now in Milledgeville and here I shall probably remain until August next. On Saturday last I opened my school; about 25 Ladies and Gentlemen attended. No doubt I shall add ten or twelve to the number which will form a very good class considering the times and season— Last Tuesday the State Rights Party of Georgia met here for the purpose of nominating a candidate for President and Vice President and members of Congress. Harrison and Tyler were nominated for President and Vice President and the present members of Congress were nominated for the office which they now hold, except Colquit, Cooper and Black. These gentlemen having turned Van Buren men, there names were cut from the ticket. After they had got through with their business the Citizens of Milledgeville invited them to partake of a dinner which they had provided for them under an arbour in the Court House Yard. Seven hundred persons were seated under this arbour together, eating, drinking, and making merry. After they were all filled the spirit began to work within them and they raised their voices in songs of praise to the immortal Harrison. Some were eloquent in speech-making. From what I could learn from the orators, the Administration party have ruined the Country, but Harrison

will bring about a change that shall work wonders.

Hero in despair for the loss of Leander, threw herself from her bower and perished in the sea. —Laodice.

[Unsigned]

[SB]

Stony Brook, July 12th, 40
Brother Nelson,

I believe you are aware that we have a Steamboat running from Stony Brook to New York three times a week, leaving N.Y. Tuesday's, Thursday's, and Saturdays. Capt. Lefevre of the Flushing is a fine fellow. On his return yesterday, he gave the Ladies and Gents of this place an excursion up to the head of the harbour. The first Steam Boat that ever explored the head of the Bay. We had dancing on board. Ringing the Bell, Kissing the Girls etc—all passed off fine. I spent May and June in N.Y. painting portraits. I was in Philadelphia the 2 of July. There was a very good collection of pictures in the Artist fund Society. If you should come by the way of Philadelphia call on Mr. E. L. Carey and see my picture of artist showing his work. When you reach N.Y. put up at Tammany Hall, you pay fifty cents a night for a room and eat where you please, and at what hour you please. I put up there when I am in town.

I have received your very interesting letter of April 27 with a cotillon for Brother Henry. He likes it very much, he says it is correctly written. Your letter of June 22 is at hand: a fine descriptive letter, very noisey. I think letters from the south by a [illegible] gentleman would publish well. I like your plan of getting up cotillion parties in towns, on your way home. When you arrive at a place invite the young men to hear you play, and then have the party made up, you to haul for so much, and they to invite as many girls as they please. So on from place to place. You can get up two parties a week. Easy diggings. Thats the way Shep told me that a young man got up cotillion Parties at Athens in Pennsylvania. Travelled the Union in that way. I am writing this letter in Mr. Davises Piano forte factory and with a steal pen. I am not used to writing with them, hense the bad scratch.

Mr. Orin Rodgers said he saw a letter in the post office for your wife yesterday. Dr. Deering has plenty of business. A Company of Cadets are going to encamp in Setauket. John Elderkin is going to feed them during their stay. They will come up in the Flushing.

Brother Sheperd is in N.Y. painting away. Henry has moved to Stony Brook, has opend a store in west end of the house. He dont injoy good health. Mother dont injoy very good health, altho she grows fleshey. She had a poor turn about four weeks since, a fit. I have proposed her going to see Aunt Deborah, I to go with her, but she declines travelling—I thought a change of scene would do her good. You know [illegible] Smith of Middle Island, well, he hung himself in his barn the other day. Jimmy Hawkins of Setauket put an end to himself by Poison a few days since. Two or three on the South side of the Is-

land have, I understand, cut up the same caper. New York will go for Van Buren 20 thousand notwithstanding Log Cabin and hard Cider. We are full of life hear at the North.

<div style="text-align: right">Yours very truly,
Wm. S. Mount</div>

[SB]

<div style="text-align: right">Milledgeville Georgia,
Monday September 14, 1840</div>

Brother William,

Two weeks ago this morning I set out for the Indian Springs in Company with Governor McDonald and Col Haynes, the State Treasurer. The day was clear and very warm, consequently we drove slow and stopped at every good spring we came to for the purpose of refreshing ourselves and horses. About 1 O'clock, having drove 18 Miles, we came to a halt before the door of a cross-rode-Tavern. We had scarcely stopped our Nags when we saw the Landlord, who was afflicted with the gout, hobbling towards our carriage, presenting as good a sign for a Public House as any a Painter could have devised. By the familiar shake of the hand which the old gentleman gave the Governor and Col Haynes, I readily saw they were not strangers to him. Having conducted them to comfortable quarters, he retired for a few moments to consult with his "kitchen cabinet" about matters that was of vital importance to us. When he returned he brought with him tobacco and pipes (for they have not wholly dispensed with that old Indian custom yet). And then ordered to be brought—Apples, Peaches, Grapes etc, not forgeting the old Peach Brandy and Honey which is a favorite beverage with the most of the southern people. After we had regaled ourselves with the good things that had been set before us, we took a view of the premaces. The Buildings and fences were in good condition. The trees and bushes were well trim'd. The yard had been swept clean, and so neat did everything appear, even to the poultry that we saw running about, that we were led to believe that the Ducks and Chickens was every morning washed and iron'd. When dinner was announced as being ready, we walked in to see what business we had before us, and I can assure you we acted upon, and passed, nearly every article that had been laid upon the table without much debating—and the Governor, believing that we had not violated the constitution by any of our acts, was not disposed at that time to use the veto power but gave a ready mark of approbation to all our proceedings. Before we rose from our seats, I cast an eye up at an old brass Clock that was secured to a smooth two-inch plank about which a drawing knife had made a few curves by way of ornament. The clock told us it was nearly four, at which time we concluded to ajourn. Shortly after, we took leave of our Host and was on our way to Monticello. I did not observe on the road many fine buildings, but I saw Log Cabbins in abundance, ornamented with Gourds, Coon Skins, red pepper, puter spoons, broken forks, and such like Harrison badges. If all the inmates of those Cabbins

give a vote for the Old Hero, he is shure to be elected. About half-past 9 o'clock we arrived at a Public House kept by a Mr Holland situated about half way between Hillsboro and Monticello. As the road was bad and the night dark, we concluded to stop there until morning. The Landlord and all the fammily had retired to rest, but the noise we made, assisted by the watch dogs, soon aroused them up again. As our appetites was not very sharp, we did not put them to the trouble of geting supper for us, but retired immediately to rest. When I went to my lodging apartments I found three of my old acquaintances from Macon, two of whom were teachers of music. In the morning we arose early and proceeded on our journey, not, however, until we had partake of a very good breakfast. At 8 o'clock we were in Monticello and there remained an hour or two waiting for the arrival of Mr Forsyth. But he never made his appearance and we drove off at a rate that carried us to the Spring by 1 o'clock. At this time more than a thousand people had gathered there, and they continued to arrive in crowds until dark. During the day but two or three speeches had been made; but at night there was heard the sound of many voices, and the scene was truly an interesting one. Thousands had gathered together upon the hills and in the valleys, and were illuminated and enlightened by the blaze of the faggot and the eloquence of orators. At 12 o'clock that interesting scene closed, and the assembled multitudes retired quietly to their tents. In the morning the people were address'd from the piazza of the hotel by Senator Lumpkin, who was formerly governor of this state. He is very popular with the Wool Hat Boys of the Country and the way he talked to them was fatherly.

[SB] [Unsigned]

<div style="text-align: right">Monticello, Jasper County Georgia,
Jan 17th, 1841</div>

Brother William,

Tomorrow I shall open a school in this place, which I should have done a week ago had the weather been suitable; but it has rained almost constantly for 10 days past—causing the roads to be so bad that it is with great difficulty the Stages are able to travel even at the rate of three or four miles an hour. My Class in this place will be small but I shall more than clear my expences by it, and as nine-tenths of the people are not doing as well as that, I have reason to be thankful. The times are extremely oppressive, and I sometimes wonder that I met with the incouragement that I do. There are many however of late who seem to have profited by the use of their heels, but it was not in dancing—it was in running away to Texas. I spent five or six weeks quite pleasantly at Hillsboro, and met with good success in my business. My Class was principally made up with back sliding Methodists, and on that account it was called the Methodist Dancing School. I shall remain in Monticello about four weeks,

21. "Possum Hunt." Letter Robert Nelson Mount to WSM, January 17, 1841. The Museums at Stony Brook, Stony Brook, Long Island

and shall then probably go to Edenton [Eatonton] in Putnam County.

About the time I left Milledgeville I secured two letters from you, I was sorry to hear that the pills I sent Brother Henry was not of any benefit to him. I hope when you write again to learn that his cough is not any worse. At this season of the year I can not expect that his health will improve, but I believe it will next summer if he takes propper care of himself.

I have in my possession some seed of the Scupernong grape, from which the best wine is made in this part of the country. They are larger than the Losabella Grape it is said, and more pleasant to eat. The vine from which the seed I have was gathered is very large, and the owner of it told me that from it he had made 80 gallons of wine in one year.

I will send you some seed if you have not heard of any of that kind of grape on the Island. The Scupernong Grape.

I regret that I am not in New York this Winter, as I have a great desire to improve myself in my profession. My business will be a fortune to me if I can secure a few months instruction from some of the best teachers in that City. I should not take private lessons, but join with the regular class. I have no mind to pay dear for that which

is of no use to me. With this object in view, I shall spend a portion of next winter in New York and then go to Augusta. In that place and Macon together, when the times shall have improved, I can no doubt do well. I have many friends in both places, and on that account I should stand in little fear of competition. If you have any thing new in the way of Cotillions, send them to me. If not send me a song or duet, any duet that is not difficult to perform. I can sing one part and play the other. There is more gained by singing a song than most people are aware of. While in Hillsboro I heard a short Reel played which I was so well pleased with that I took the notes of it. If you wish to give it the Negro-touch, you must raise the bass string one note. I will endeavor to collect something better if a favourable opportunity should occur, until then you may saw away on [music; pl. 21].

Give my love to Mother and to the nameless rest of our family. I hope to see them next Summer. Let me know how you get along with the brush. I think your last picture "Cider Making" should have been painted large and placed in one of the verdant squares at the Government House in Washington City.

Yours affectionaly,
[SB] R. N. Mount

To

Benj'r F. Thompson Esq'r.

A sketch of Henry S. Mount who died the 10th of Jan. 1841, in the 39th year of his age. Taken after death by his Brother Wm S. Mount.

See a brief notice of this amiable man, in my Hist. of Long. Island vol 2. page 527 — E Edition — B. H. Thompson

22. *Henry Smith Mount on His Deathbed.* 1841. Watercolor on paper, 7 1/2 × 7 3/4″. Kennedy Galleries, New York City

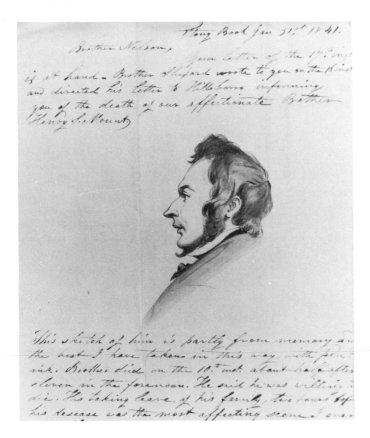

23. Henry Smith Mount. Letter WSM to Robert Nelson Mount, January 31, 1841. The Museums at Stony Brook, Stony Brook, Long Island

Stony Brook, Feb 4th, 1841

Brother Nelson,

I have not time to say much. I wrote you last sunday

and promised to send you a sett of Cotillions, I have fulfilled my promise. I think you will like the sett [pl. 24]. Take out your old box and go at it, pell mell. Some parts of the strains you must play softer than others, particularly the Minores, they are beautifull. Play some of the strains in octaves above or below, at leasure. In shifting slide your fingers up and down. You know what I mean. Let your two first fingers work up in playing the whole sett. In Mathewson style. Mr. Mathewson wrote this sett for me to learn in order for me to play it with him. I shall try it to night. He has his parties Thursday evenings. I expect when you come home you can show Mr. Mathewson some touches. Mr. Mathewson says he will be happy to learn you his style of playing. I intend to get all I can out of him in the way of Cotillions when I can get him in the humour of writing. Is the music I send you worth the postage? I have no duet to send you at present.

Yours Affectionately
Wm. S. Mount

[SB]

Stony Brook, May 2nd, 1841

"A Sett of Cotillions—Called the White Lady
—As played by N. Mathewson"

[Music]

Brother Nelson,

I received your letter yesterday afternoon. I had just arrived from N. York. We had our annual supper at the Academy Thursday evening, fine time. Academy opens tomorrow 3rd of May. Good exhibition. I have not time to say much now. I met with one of your acquaintances at Tammany Hall. Mr. Richard O. Davidson. He gave you a good name. He desired me to send his respects to you. He gave me a pamplet on the "Practical mode of Aerostation," by himself. He believes in flying.

Mathewson left here about a month since. He is at sagharbor. I understand he is quite intemperate again. He would not answer to [paper torn] with you he would require too much looking after. I sold a picture last fryday to Gen. Aaron Ward formerly member of Congress from this state. Though his influence the American Artists got the larger pictures to paint for government, Vanderline etc. I let him have a small sketch of Boy hoeing Corn. Price $125.

Mother dont enjoy good health. The 13th of April we had snow 2 feet deep on the level and in some parts of the [illegible] deeper. Sheperd is not very well, he complains very much as Henry did. The City dont agree with him. I think he should paint in the Country, go down south next winter.

Yours etc—
Wm. S. Mount

All hands round
"Camptown Hornpipe"—N. Mathewson

[Music]

24. "A Sett of Cotillions
in the Key of C." Letter WSM to
Robert Nelson Mount, February 4, 1841.
The Museums at Stony Brook,
Stony Brook, Long Island

You can make var. as you play it.

Mathewson makes use of the 2 number (in the above Sett) when teaching his scholars to Dance the first lessons. Mathewson plays Fife Hunt in 2/4 time for the last number in that Sett in the key of C, which I sent you. If I had it in two four time you should have it. I have it in the key of C however.

I hope you will find the White Lady worth the postage.

[LOUISE OCKERS COLLECTION] "... *pictures to paint for government" is probably a reference to the paintings in the rotunda of the Capitol in Washington. See Lillian Miller,* Patrons and Patriotism, *Chapter 4.*

of Long Island. He should have intimated his intention to me some time ago. I would have sent him some sketches with the pencil of Georgia scenes which would have convinced him that my talents do not lay altogether about my heels, and that if I am not an artist I might at least have been one. I would have tried my hand at the mechanic arts, and for ought I know I might have invented a perpetual motion, or done some remarkable act to have justified his handing my name down to posterity. But as it is the bare mention of my name is all that I can look for, unless he should be disposed to add—"Like a true genius he is able to command respect when his pockets are empty"—which by the bye is a noble art and one that but few understand. . . .

[BUFFET]

Fragment of letter, RNM to WSM

Edgefield—South Carolina
June 12th, 1841

You say Mr. Thompson will mention my name in connection with our family in the next edition of his *History*

Stony Brook, August 29th, 1841

Brother Nelson,

I send you: Waltz—The Cachucha. As played by Wm. S. M. [pl. 25].

25. "Waltz—The Cachucha" and "Visit Sett." Letter WSM to Robert Nelson Mount,
August 29, 1841. The Museums at Stony Brook, Stony Brook, Long Island

Mathewson was so well pleased with the style in which I played the above Waltz, that he wrote it, from hearing me play it. I had seen Fanny Essler Dance the Cachucha several times and I believe I caught the spirit of it. I am pleased to say that Mathewson always plays it as written above.

I would have sent you the Cracovienne as played by Mathewson for a Cotillion, but fearing this letter would not reach you. Let me know your whereabouts and I can send you two or three Setts of Cotillions. Have you a sett in one flat commencing—called the visit sett [pl. 40]. I believe you have. If you have not got it I will send it to you. I have procured Cotillion music expressly for you. It is of no use to me, I only play such numbers as please me for amusement.

Mathewson spent two weeks with me in July. I had to dress him up (so reduced was he in appearance) from his head to his feet, with what clothes I could spare. He wrote me some music, which I paid him for. He appeared to be quite disappointed because you did not come home. as he had hopes of going with you to the South. He told me he thought he should go out to Georgia this fall with some friend, he said he was sorry he left the South. Mathewson was in this place last week, I was not at home. He wanted to see me, was in high spirits, told Ebenezer Hallock that he was going to Liverpool with a Gentleman—had engaged his passage. Success attend him, but he must reform for his own happiness and comfort.

Shepard and his family are spending the summer and fall with aunt Debora at Athens, Bradford County Pa. I am at present boarding with Mr. Elias Smith, West Meadow Creek—taken a view of the same. I think I shall paint Old Abraham fishing. I am not certain where I shall spend the fall. I hope in some mountainous Country. I called at home last evening, Sister Mary had just received a letter from Tioga. Brother Shepard was gaining in health, had been drawing and painting a little—was painting a portrait of his Cousin Mary who I am told is very handsome. Mother's health is about the same. Dr. Dearing applied leaches to her foot the other day, which I think will benefit her. Mother says she has not realized a sound sleep in three years. She is in a constant pain—of course the want of rest must ware out her constitution. Mother desired me to send her love to you. She says she has most given up looking for you.

For my own part I am perfectly willing for you to spend as much of your time in a Southern Clime as you think proper for your interest and happiness. I believe you could get large Schools about on L. Island in the winter season, but then it would be attended with a good deal of travel and exposure to cold. Large towns are the places for your business, I should think.

Home is a pleasant place but not always the best place for one's business. I would have been better as an Artist in some particulars if I had left home four years ago. I can do more work from home. I dont have many visitors to help entertain. My time is my own. I am happy to say that Mary gets on with her affairs and the farm very well,

Julia has grown up to be a young Lady. Your Lady has received your letter with money for your daughter. I have put Uncle John's violin in order for him. She plays much more easy. Drop me a line soon.

Yours affectionately
Wm. S. M.

[SB]

Nelson Mathewson to WSM

Babylon, July 20th, 1842

Dear Sir,

I received your letter containing Music for which I am greatly obliged to you. The two peices from Frazer are verry good, I have herd him play them. I intend converting them into Cotillions with few alterations.

I have not done anything with the March yet. I have been verry much engaged since I last saw you, we have had a wedding party at our house from jamaca. Mr. Michael Holland to Miss Brush of Brushville. The Bride's Sister Miss Fanny Brush a beutiful girl accompanyed them. I shall now have to tell you the whole story since I have commenced, trusting that you will be confidential and advise your unworthy friend how to proceed in the matter that I am about to disclose to one of your seven sences. You see they got married one week ago last monday and came direct to Capt. Dodd's to spend the first night of the honey moon accompanyed by the Bride's sister only. I had been out in the bay that day on a small beach party and returned just at night when Mrs. Dodd came to me in a great fluery and usherd me into the presence of the happy party. An introduction of course followed and when I arose to make my address to the young Lady she extended her white hand towards me which made my heart jump. I was struck with the inocent manner of the introduction and the beautiful form that stood before me—on account of our being entire strangers—which gave rise to feelings that I cannot easily express. Well, after the introduction it was proposed by Mr. Holland that I should favor them with some music on the violin which I readily assented to, with a simple excuse to have permission of a few minutes to arrange my toylet, which I did with double exactness for a campaign against venus. I determined to exact my whole powers on this occasion for Mrs. Dodd had told me she was fond of music and a great Dancer. Well I opened and it seemed to me that I could play just as I was a mind to. I saw the effects of this magick instrument, as it was, steal over her senses and I redoubled my exertions until a late hour in the evening. I was satisfied after I retired that I had made an impression on her of some nature or other and was determined to advance. But this is merely waste of paper to ennumerate every particular. I got more acquainted every hour. The next morning Mr. Holland told me privately that I played splendidly, etc. and told me that his sister in law had almost fell in love with me, that I must take a ride with them in the afternoon which I agreed to—in the afternoon we walked out together arm

in arm which made the Babylonians stare. The next day they set out for home with many assurances on my part to the young Lady that I would call at her father's house as soon as I could make it convenient. Excuse me from further particulars as the mail is in and I hope to see you in this place next week, face to face, when the story shall be ended.

According to promice I write to you to inform you that there is a great Beach party to come off here next tuesday 26th inst. and I earnestly request you to attend if possible and also Mr. Hallock and your brother Nelson. We shall go to the Beach in a Sloop and have a Ball at night to which all the fair ones of this place will attend.

And now except, sir, from your unworthy friend the highest regard and esteem for William S. Mount that N. Mathewson can Bestow. Yours truly.

P.S. Dont fail to come if possible. I want to have a long talk with you on matters and things in general. If you cant come write me and put a little musick in if you please. Give my best respects to your relations and friends, excuse all mistakes,

Nelson Mathewson

[NYHS]

Oyster Bay, Nov 3d, 1842

Brother Nelson,

The young men of this place are quite sorry that Miss Parrish cant spare her large room. It is, you know, on account of the Death of her father.

I am pleased to hear that Mr. Selah B. Strong is nominated for Congress. I hope you and our friends at Stony Brook will vote for him. The Oyster Bay people think very much of him and several Whigs have told me they should give him there votes.

I have not been very well, but am quite well now. I have had a good deal of the tooth-ache. I have been taken the extract of sarsaparilla, it has helped me very much. It is prepaired and sold by Rushton of Aspinwall N.Y. I should like for Sister Ruth to make a trial of it.

I expect to get through with my portraits the first of next week.

Give my love to all.

Yours etc.
Wm. S. Mount.

[SB]

New York, Sept 1st, 1843

Brother,

I have had your violin put in order as far as the finger board and tail piece is concerned. I send you a new bridge. You must shift the sound part and bridge untill you get the proper tone.

I could not find any wild Cherry bitters. However, I have sent Mr. Brewster a bottle of bitters highly recommended. I hope he will give it a fair trial. I send you a paper of mineral for cleaning brass. Dampen your finger or a rag and apply it, it will clean a cent in no time. It is

a pounded stone found in Vermont. I send you two papers, the *Sun* and *Herald*. The Mineral, bridge, and papers are in the violin box.

Mr. Henry Brooks wishes Shepard to make a copy of his portrait, if he will do it reasonable. He can take it home if he wishes and paint it.

Yours etc.
Wm. S. Mount

P.S. You can have the finger board lower, Mr. Lake[?] says, if you wish it. I presume she is louder as she is. If the bridge is too tall you can cut it down. Try the bridge as it is.

[SB]

Catskill, Greene Co., Oct. 1st, 1843

Brother Nelson,

To begin, this is a rainy day and consequently I am seated by a good fire at the principal Hotel kept by Cooke and Vanburgen where I board.

The conversation for an hour past has been on the subject of brandy and salt as a medicine. One of our boarders, Samuel Stackweather Esqr. distinguished lawyer, says he has cured himself in forty eight hours of bilious fever, he also has cured himself and others of dysentery, has cured children of the above complaint by given them brandy and salt every two hours through the day, even after they had been given up by Doctors, has cured himself of dyspepsia, and others of the same complaint, he says it will cure the fever and ague.

He says your case of the Cancer should be published to the world. You must get Loyed to make a report. You must urge your father in Law if he is alive to use it. I hope to hear he is quite well. I stopt at different places on the North River at Newburg about a week. I find the scenery about catskill the most interesting as yet. I am painting every good day. Mr. Cole has been out with me several times. I paint on oild paper at present. I want all the practice and knowledge I can get before I touch my pannels. I shall stop here about two weeks. Then I shall go to Madison about three miles from here, or to Saugerties about 12 miles south of here. I intended to have gone to Saugerties direct, but as it cost no more, I could not [illegible] visiting Catskill. I met Mr. Cole in the street on the afternoon of my arrival, he would have me take tea with him. Urged me to stop in Catskill. I am pleased with his society. He has five pictures now exhibiting in Boston. He has two very fine Landscapes in progress, one is a view from Catskill, the other is an immaginary Landscape. This place is quite dull[?] although it contains 3000 inhabitants, there has not been a dancing school here in three or four years. I visited the Mountain House, elevated about 3000 feet above the hudson River. The day was very clear, the view was grand. I saw the same day, Sept 14th, by riding about two miles, the Cauterskill falls. The grandest sight I ever beheld. I stayed all night on the mountain and saw the sunrise. My violin has been the source of a great deal of amusement. It has enabled me to see a great deal

of character. I have played two evenings at Mr. Cole's, he is fond of Music and plays the flute. I dont let music interfere with my painting. I shall give my whole attention to painting, practice is very important to me just now. I have lost a great deal from the want of it. I shall endeavour to spend the winter in N.Y. City. Let me know what is going on in Old Suffolks, and at home. If sister has returned, she should spend the winter in N.Y. Give my love to all.

Yours etc. Wm. S. Mount

What for a visit did Shepard have at Sag harbor?
[SB]

New York, Dec. 2, 1843

Brother Nelson,

I have commenced painting at last. Took a sitting of Dr. Seabury on Thursday. D. Wickham has not enquired about the terms for singing yet, he says he will attend to it.

You had better practice your voice with your violin the eight notes, as much as you can. I heard Ole Bull last night, I was not so well pleased—full house. I had rather hear Mathewson for music. I send you the *Tribune* and *Sun*, save the *Tribune*. It contains the Hydropathy or Water cure. I want you to read it carefully. For a full rich voice I should advise you to drink cold water at your meals. I understand the young men of Stony Brook wishes to get up a singing school if they can find a Teacher. I think between singing and Dancing you might do well. Practice, Practice.

Yours etc.
Wm. S. Mount

Sister Ruth and family are well.
[SB]

Sunday evening March 31st, 1844

Brother Nelson,

I heard Mr. Chapin of Boston preach in the Elizabeth St. Church this morning. I was much pleased with him. The house was crowded. I took dinner with Mrs. Alden Spooner of Brooklyn today.

It has always run in my mind that you caught your cold returning home from N.Y. The next thing is to get rid of it. A Physician a friend of mine told me a few days ago that he had cured eight out of ten cases of Influenza simply by the freely use of flaxseed tea, and little liquorish and lemon added with it. It is very healing to the lungs. I will tell you of another remedy by which a Lady was cured after having suffered with a bad cold and pain in her breast for six months. Figs cut up and put into a bottle with a small piece of liquorish and the bottle filled up with santa croix rum. The bottle must be filled up with figs before the rum is put in. It makes a most delightful syrup. Try it. You must try the raw cotton bosom. Do you dress warm. If you wish any articles of dress let me know.

Pocket change etc. Can I send you any kind of syrup? I sent you by the Sloop Nature a letter and one from Shepard to Elizabeth. You had better try the flaxseed tea. Let me know how you get on. I send you the Sunday *Mercury*—all quite well.

Yours etc.
Wm. S. Mount

Let your bottled figs stand about two days before using.

P. S. William has quite a bad cough. If you can not get flaxseed and figs let me know and I will send them to you. Shall I send you some of Moran's candy, Indian Cough Balm or wild Cherry extract. Shepard has just returned from church, he has heard Chapin three times this day. Tell Edward that his Father wishes him (if it does not rain) to go to the Suffolk Station Saturday afternoon— if he does not hear from him to the contrary. We have had quite winter weather, snow and hail.

About Indian Cough Balm or Southern balm read the *Mercury* I send you. I have written this letter with a steel pen. I prefer a goose quill for my use.

[SB]

Tammany Hall N.Y., Dec 9th, 1845
Brother Nelson,

I wish you to send by the Packet my picture "The Fortune Teller." I shall place it in the New York Gallery until I am ready to paint another to take its place. Tack some kind of a blanket over it and secure it in a birth, or have it placed on the top of the wood in the hold. See the Capt. about it.

I shall send your clothes, the first chance after to morrow. Engage all the fiddlering you can, sing or dance if you can make money by it. I have just seen Elizabeth she is out of business. I think she had better return home and go to school this winter. I will pay her schooling. I send some papers. Shepard and myself will attend a meeting at the Academy this evening. Hence my haste.

Yours truly
W. S. Mount

Will you want a pair of boots?

[ARCHIVES OF AMERICAN ART]

Stony Brook, Nov. 21st, '53
Brother Nelson,

In the watch pocket of the pantaloons I left with you yesterday you will find a tuning fork. Please take care of it for me.

Yours truly
[LOUISE OCKERS COLLECTION] Wm. S. Mount

New York, 42 Chatham St., March 6, 1860
Brother Nelson,

I have painted five portraits in South Brooklyn—at the residence of Mrs. Becar. I painted her late husband from memory (he left no *likeness*), he has been dead over three years. I am now painting a whole length of a girl aged two years, from a sketch which I took after death— daughter of Nathaniel Marsh, on Staten Island. The parents think the likeness perfect. The sail to and from the Island is delightful—steamers and sail vessels in constant motion adding beauty to the scene.

Hon Wm. H. Ludlow told me that when a chance offered for that light house situation, he hoped you would write directly to him as he could pull the wires with Mr. Cob. Dont forget when the time comes. I send you different papers from time time.

We agree with you, we do not believe in the treating system. If you know of any habitual tippler, advise him to use New Orleans Molasses as a substitute, and it will cure him in six weeks time from a strong desire for liquor. I will pay for the first gallon.

Shepard is painting the portrait of a Lady in 27th St. N.Y.

I have some seed beans for you, they are called the "turtle soup been," they being six dollars per bushel (by rubbing them a few moments in your hand they become perfectly black). Mr. Wood, the Gentleman who gave them to me, says that beans they are the most profitable crop that a Farmer can raise— I have written this note in great haste.

Yours, very truly—
Wm. S. Mount

I shall attend Mr Liddow's lecture this evening. To morrow evening—"The statue and the picture." He talks right out—seldom refers to his notes.

I hope you will teach John how to play the violin at your leisure moments.

[SB]

Diary Entry, 1867

R. N. Mount spent several years in Georgia. Fordice Rigley kept a carriage repository in Macon, Ga. Rigley offered R. N. Mount six hundred dollars a year to take charge of one of his warerooms. Rigley commenced business in Columbia, S.C.

R. N. Mount was a great favorite down South as a teacher of Dancing. He was well acquainted with the leading politicians there.

When Mount was with James Brewster, New Haven Conn, he stitched 78 feet on the traces for coach harness in twelve hours—the fastest on record. Over six feet an hour. About 25 and 26 stiches to the inch.

luman reed

Luman Reed (1784–1836) was a farmer's son from up-state New York who made a fortune in the wholesale grocery business in New York City and assembled one of this country's most important early collections of paint-ing. He was especially interested in the American art of his own time and was particularly generous in his patron-age of Thomas Cole, Asher B. Durand, and George W. Flagg. He met Mount about two years before he died, took great interest in his work, and bought two paintings from him—*Bargaining for a Horse* and *Undutiful Boys,* known today as *The Truant Gamblers.* Reed's ten surviv-ing letters to Mount and Mount's two surviving answers were all written within ten months of Reed's sudden death. They demonstrate that Reed would have bought many more paintings from Mount if the artist had been prepared to sell them.

When Reed died, a group of his business associates headed by his son-in-law, Theodore Allen, and his former partner, Jonathan Sturges (who was also a great admirer and patron of Mount), transformed his private collection into the first public art museum in the United States. It was known as the New York Gallery of the Fine Arts. Sturges and his associates supported it for twenty-two years; then, in 1858, they gave the collection to the New-York Historical Society, in whose possession it remains to this day.

The Cole series to which Reed refers in these letters is the famous *Course of Empire,* the five canvases of which still provide a major attraction in the art gallery of the New-York Historical Society. "The Presidents," which he also mentions, was a series of portraits of presidents of the United States which he had commissioned of Durand.

The letters that follow here, especially Mount's to Reed of December 4, 1835, indicate that Mount did not par-ticipate in the famous project, mentioned by so many art historians and discussed at some length by Lillian Miller in her book, *Patrons and Patriotism* (1966), for the decorating of the doors of Luman Reed's private art gallery. However, the New-York Historical Society pos-sesses a painting of farmers piling hay onto a wagon which is supposed to have come from one of those doors and is in Mount's style (pl. 26). It was bequeathed to the society in 1963 by a descendant of Reed's who believed it to have been part of one of the doors. The picture is on panel—but not necessarily a door panel—and is in a very light, sketchy style. It may have been a study for the door pro-ject which, for reasons unknown, was never used.

A.F.

New York, July 25, 1835

My Dear Sir,

I was glad to hear of your visit to New York on my return home and wish I could have had the pleasure of seeing you. I learnt with pleasure that your eyes were better and that your general health was improved. Mr. Sturges told me that you had commenced a picture for

me which I shall long to see until I do see it. I feel as if your pictures were to be in the first rank of my Gallery of their kind as well as our friend Cole's. In Landscape your truth of expression and natural attitudes are to me perfectly delightful, and really every day Scenes where the picture tells the story are the kinds most pleasing to me and must be to every true lover of the Art. If your Brother comes to Town please give him a letter to me as I should like to be acquainted with him. Please drop me a line and let me know how you are as I shall be very happy to hear from you.

<div style="text-align: right">Very respectfully your friend Luman Reed</div>

[SB]

<div style="text-align: right">New York, Sept. 24, 1835</div>

My Dear Sir,

I have received your much esteemed favor of 22nd Instant with the beautiful picture the "Bargain" and with which I am very much pleased. I called on Durand and a few other friends immediately after the picture was taken out of the Box and we all pronounced it the best thing we had seen from your pencil, the price is perfectly satisfactory. I really feel proud of possesing this picture and I look forward with more interest than ever to the forth coming of the next one. The subject "comick" is a pleasing one and I would rather laugh than cry any time. I hope you will come and see me when you get leisure, it will give me great pleasure to see you at all times. I want you to write me when I may expect the next picture and hope you will not take any commissions for anybody until you paint a few more pictures for me. The fact is I must have the best pictures in the Country, and yourself and a few others are the only artists that paint to suit my taste. Durand has a picture in hand for me but I have not seen it nor do I know the subject. From Flagg I expect one soon. Cole is busy with the five Landscapes but they will not be finished for some time to come, and I have some others engaged by other artists of celebrity. In the picture just received you have hit off the character to a charm, it is useless for me to particularize points, the whole is good enough, the horse has no equal in any picture that I ever saw.

I was going to enclose the money for the picture in this letter but your Brother said I had better let it remain until I talk to you. If you want money write to me and you shall have it by return mail. I am very happy in becoming acquainted with your Brother and when your other Brother of whom I spoke to you about comes here give *him* a letter to me.

<div style="text-align: right">Your friend</div>

[SB]
<div style="text-align: right">Luman Reed</div>

<div style="text-align: right">New York, Oct. 29, 1835</div>

My Dear Sir,

I have seen the Collection of Pictures in White St. that we talked of when you was at my house a few days since,

26. *Haying Scene*. c. 1835. Oil on panel, 24 3/8 × 11 3/8″. The New-York Historical Society

and there are many good pictures among them. There are copies of four of Raffaelle's Frescos which are very fine indeed, one the School of Athens, they give me a better idea of Rafaelle's paintings than any thing I have seen. It gave me great pleasure to look at this collection of pictures and only seeing once does not satisfy me. When you want a resting spell you cannot do better than to take a run down here for a few days and I should be very happy to see you. The "Bargain" picture is the admiration of every one that sees it and in the *Gazette* of yesterday there is a scene described that hits it exactly and I send the paper with this. It is under the head of "a leaf from the journal of a tourist." I called on the Editor this morning and he went with me to see the picture and I assure you he was delighted with it. Durand has been home since you was here and brot with him the portrait of Madison and he has now gone to Baltimore to copy Stewart's head of Monroe which completes the series. Durand's picture of Peter Stuyvesant and his Trumpeter and Dirk Schuyler is very excellent and I know it will please you. You will have an opportunity of seeing it when you visit the City again. I feel much gratified with my prospects of getting fine pictures to fill my Gallery. Wishing you health and happiness I am you most devoted

Friend,

Luman Reed

I say nothing about the picture you have in hand for me. I do not allow myself to think of it for if I do I shall want to see it so much that I shall hardly know how to wait until it is finished. What pleasure you must take in painting.

[LOUISE OCKERS COLLECTION]

Stony Brook, Nov. 12, 1835

Dear Sir,

I received your letter accompanied with the *Gazette* and read the sketch of "Uncle Joshua," and I think the author studied the picture closely, please to give my respects to the writer and tell him I was perfectly delighted with his conception.

I am pleased to tell you I had a look at those paintings you mentioned in your letter corner of White St. a few minutes before I left town, the keeper said I was his first visitor. I love to look at the old Masters (but not at the fog[?] masters). You are right when you say that those copies from Raphael's pictures are good, particularly the "School of Athens; it acquired him all his glory; it is the master piece of design among the moderns." I like Raphael, because his figures are all easy and natural. I intend to have another look at them. It gives me pleasure to hear that Mr. Durand will soon have the portraits ready for your Gallery and also to think I shall have an opportunity of seeing Mr. Durand's picture of "Peter Stuyvesant and his Trumpeter" when I visit the City again.

I think your plan of getting original pictures a good one and I wish you success with all my heart. Your picture

takes all my attention and I take pleasure in painting it.

I often fancy myself seated in your Gallery looking over your rare books, engravings, pictures, etc.

I remain with great respect your obt. servt.
Wm. S. Mount

[LOUISE OCKERS COLLECTION]

New York, Novr. 23, 1835

My Dear Sir,

I duly received your most esteemed letter of 12th Instant and was pleased to learn the good state of your health. I have lately been to see my friend Cole, he is making a splendid picture of the third one of the Series. I do not like to say too much before hand, but if these five pictures do not open the eyes of the Sticklers for old paintings, I shall be mistaken. This is a new era in the fine arts in this Country, we have native talent and it is coming out as rapidly as is necessary. Your picture of the "Bargain" is the wonder and delight of every one that sees it. I have got home Durand's "Peter Stuyvesant." I consider it a great stride for the first attempt, it shows great feeling, but you must see it, he has commenced another for me. I find you enclosed a drawing of a door for which I want you to make a design. There are four such doors entering into my Gallery and as they make too much space I intend to have them painted and I should like to get you paint one of them, not highly finished paintings but good sketches, a single figure, a head, a cat, hen and chickens—in short anything to cover the surface and produce a pleasing effect. Cole has one door, Durand one, Flagg one and you the other, the large Doors that divide the Rooms are also under consideration. I look forward with delight to the time when I shall set eyes on the picture you are now painting. It will always give me pleasure to hear from you. Please give my respects to your Mother.

Your friend Luman Reed

[SB]

New York, Nov. 25, 1835

My Dear Sir,

In my last I forgot to mention that I prefered you would not varnish the picture you are now painting for me if equally agreeable to you. What I fear is that it may crack as there is more body in the paint than in the varnish; the former when dry will contract and by that means leave cracks in the picture. I have not had my pictures by Cole varnished and the first one looks better today than the day I recd it. The blending of the colors gives it a richness and softness that it had not at first. It will be improved and perhaps would now by varnish if thoroughly dry and probably is nearly so if not quite at this time.

I think Cole mentioned to me that mastic varnish should not be used in any case and he if I mistake not spoke of another kind, but what it was I do not recollect. You need not be afraid of the effect of your pictures if

they are never varnished. With my best regards for your health and prosperity,

I am your friend Luman Reed

[LOUISE OCKERS COLLECTION]

Stony Brook, Dec. 4, 1835

Dear Sir,

You will receive with this letter a picture: Undutiful Boys. Boys hustling coppers on the barn floor. It is not varnished as you requested and it is agreable to me that the picture should not be varnished at present.

In one of your interesting letters I find you intend having your Gallery doors painted by different Artists and I am pleased you wish me to paint one of them. In consequence of my having commissions that must be attended to, I am sorry to say, I can not further your views at present. My price of the picture Undutiful Boys two hundred and twenty dollars. I hope the picture will meet your approbaton.

Please to give my respects to Mr. Sturges and Mr. Allen.

I remain Yours
Respectfully Wm. S. Mount

[LOUISE OCKERS COLLECTION]

New York, Decr 11, 1835

My Dear Sir,

I yesterday received your much awaited letter of the 4th Instant with your beautifull Picture of the "Undutifull Boys" [pl. 27]. To say that this Picture is satisfactory is not enough and the least I can say is that it pleases me exceedingly, it is a beautful specimen of the art. The interior of the Barn is far superior to any thing of the kind I have seen, it is all good and therefore I need not particularize, the price is perfectly satisfactory and the money is ready for you any day you want it. I pride myself on having now two of your Pictures and what I consider your best productions and hope yet to have more,

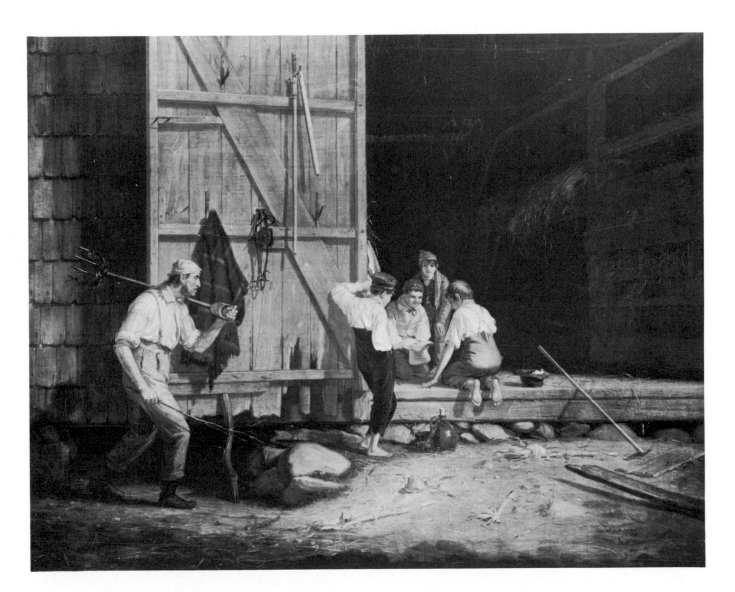

27. *The Truant Gamblers (Undutiful Boys)*. 1835. Oil on canvas, 24 × 30″. The New-York Historical Society

but it is no more than fair that others should be gratified too and I must now wait until you execute some other commissions. I should have been much pleased if you could have painted one of the Doors in my Gallery in the coming of the winter but I shall wait with pleasure until you find it convenient to do it. A few days after I wrote you last, Mr. Irving called on me and I showed him your Picture of the "Bargain" with which he was very much delighted and says he wants to become acquainted with you and I promised to let him know the first time you came in Town. He desired me to thank you for the pleasure he derived from seeing the Picture. Mr. Irving is a particular friend of Wilkie's. This Picture has been the admiration of a great number of Persons that have seen it. Mr. Durand who I called on this morning has seen the "Boys," he likes it much. I have made a great change in the front room of my gallery and much for the better. The Presidents are hung up. Durand is making great progress in the art. He has another picture in progress for me. I expect a picture from Flagg about the first of next month. I hope I shall see you here soon. Please give my respects to your Brother.

<div align="right">Your friend
Luman Reed</div>

[SB]

New York, Decr. 26th, 1835

My Dear Mount,

I am sorry that I happened not to be at home when you called for the Picture of the "Undutifull Boys," not that I had anything in particular to say more than to bid you goodbye and to wish you well. I miss the picture from the Gallery and shall be very happy when I see it placed there again. If there was anything that could have made my attachment to you any stronger it was that generous and prompt proposition of yours to make the alteration in the picture that I suggested, that willingness to gratify me in an alteration where the painting was good enough and perfectly satisfactory without it. I suppose you took fast hold of my good feelings. If the alteration when made does not please you, I hope you will restore it to its original state and send it back again. I consider this picture the very gem of my collection. I have taxed your generosity which I cannot pay, but your time I must make remuneration for. Please accept the enclosed and believe me

<div align="right">Your Sincere Friend
Luman Reed</div>

[SB]

New York, Jany. 11, 1836

My Dear Mount,

I have received your much esteemed favor of the 7th Instant and also the Picture of the "Undutifull Boys," it is improved and I am delighted with it. I have now one live Man, four live Boys, the inside and outside of a Barn

with the Barn door nearly swung back, and what is left for the imagination is really pleasing: that the hens and chickens have all run under the Barn at the approach of the old man, and you may easily imagine them there, as the depth of the Barn cannot be seen. This is your best production as far as I have seen, but still, if I do not mistake you, My dear Mount, your last picture will be the best during your whole life. That has been the case with Cole and he says he hopes it allways will be. He has often said this to me.

In a letter from my friend Cole he informed me that the third picture of the series is nearly finished, and in all this month he has promised to make me a visit and I anticipate much pleasure from seeing him. When you have executed your present commissions I hope I may be the next to be favored by the further productions of your pencil. I shall allways be on the look out for the best works on painting and perspective and you shall share with me in whatever I find that is rare and valuable. It is needless to say how much I enjoy in the company of a man of genius and who I esteem as a particular friend. A few such I have the happiness to be intimate with and I take pleasure in saying that you are one to whom my heart and home is allways open. I hope to see you here as often as you can make it convenient to visit the City and I shall be happy also to hear from you by letter in the interim. Wishing you health and happiness.

<div align="right">I am your devoted friend.
Luman Reed</div>

[SB]

New York, Feby. 29, 1836

My Dear Sir,

I was much gratified by the receipt of your letter of the 13th Instant and I am happy to hear that you find "Burnett on painting" interesting to you, such feelings for the art as you possess is sure to lead to excellence. Your two pictures in my gallery gave great pleasure a few days ago to some friends that called to see me, one of which was Mr. Fay one of the Editors of the *Mirror*. The little change in the "Undutifull Boys" made it to me seem just right and there is just enough in it. One thing more or less could not be done to make it better. I am happy in having the aid of your Brother Henry in ornamenting the Gallery Doors but we have stopped production with them any further for the present, until Mr. Cole comes to the City. The two small doors in the front Gallery have the figures painted in. One by Flagg and the other by Durand and the tiles are to be ornamented by your Brother. Durand has painted four panels on the large door. All these, by the way, are sketches. I would prefer your seeing them to giving you a description. Cole has engaged to paint one of the large Doors and when he comes Durand will go on with the other. I am pleased with the effect. On the Small doors in the back room I think some of having Statues painted, but that is not entirely concluded upon as yet.

I shall not fail of procuring any books that may be use-full in the art that fall in my way and shall be most happy in giving you and my other friends the use of them. I shall at all times be happy to hear from you and hope to have the pleasure of seeing you here before long. Wishing you health and happiness

<div style="text-align: right">I am yours most sincerely
Luman Reed</div>

[SB]

<div style="text-align: right">New York, May 4, 1836</div>

My Dear Sir,

Your Brother Henry handed me this morning your much esteemed letter of yesterday. Your letters are very acceptable, I hope you will write me often. You say that you have finished one portrait since you was here last and are about beginning another. I should like to have you take one of me some day or other when it happens convenient for us both. I hope to see you here before a great while. The Exhibition is well attended and there are no pictures that attract more attention than yours, they please everyone. They are just right and I want my turn to come for more, after you paint two more then I must have the two next. I have just got a letter from Mr. Allen dated at Naples and he desires me to tell you and Durand and Cole that he has seen nothing to make him think any less of your pictures. I like your brother Shepard's Portrait, he has a feeling for Charactar and must paint me a picture. The flesh in this portrait seems a little harsh but the man is there full of life. Your Brother Henry is paint-ing a Cattle piece on one of our Gallery doors. Durand and Cole are also at work. I shall have something more to show you on the doors when you come here. I hope to see you and your Brother Shepard here before long. Please give my respects to him.

<div style="text-align: right">Your friend
Luman Reed</div>

[SB]

Asher Brown Durand to WSM

<div style="text-align: right">New York, June 9th, 1836</div>

My Dear Sir,

It has become my lot to communicate to you the melancholly tidings of the Death of our beloved Friend Mr. Reed. He is gone!

The funeral takes place this afternoon—had my sorrow permitted me to think of it I should have apprised you of the sad event sooner, perhaps in time to have come to pay the last tribute of respect to the remains of the Man whose equal a Century to come will not witness.

<div style="text-align: right">in deepest sorrow
Yours Sincerely
A. B. Durand</div>

He died on Tuesday Morning.

[NYHS]

WSM to Asher Brown Durand

<div style="text-align: right">Stony Brook, June 13, 1836</div>

My Dear Sir,

I have received your letter of 11th inst. informing me of the Death of our best friend Mr. Luman Reed. The more I think of him the more sorrowful I feel that he is taken away from us. How pleasing he was in his address. How well he understood the feelings of the Artists. He was one we shall always love to remember.

Please give my respects to the family in affliction.

<div style="text-align: right">I am sincerely
Your friend
Wm. S. Mount</div>

[NEW YORK PUBLIC LIBRARY]

robert gilmor and e. l. carey

Mount's surviving correspondence for the 1830s—excluding that with Luman Reed and with his brother Robert—is sparse but important. Nearly all of it is with Robert Gilmor, Jr., and with Edward L. Carey. The Carey correspondence continued into the following decade, and it is provided here in its entirety.

Robert Gilmor, Jr. (1774–1848), inherited a shipping business from his father and turned the profits thereof to the service of art. His collection, which is said to have filled his three houses in Baltimore to overflowing, was one of the largest in the United States in its time and, from a modern point of view, one of the best.

The letters indicate that Gilmor became acquainted with Mount's work through a visit to Luman Reed's gallery, where he saw the two Mounts in Reed's collection, *Bargaining for a Horse* and *The Truant Gamblers* (or *The Undutiful Boys,* as Mount calls it). Gilmor then commissioned Mount to paint him a picture; *The Long Story* resulted.

Gilmor also collected books, and among these, to judge by Mount's letter to him dated December 5, 1837, was a copy of Claude Lorrain's *Liber Veritatis,* doubtless in one of the several engraved editions of that work issued by Alderman John Boydell in London. The *Liber Veritatis* is a book of two hundred drawings after paintings by Claude; the French artist is supposed to have made it not only as a record of his achievement in oil but also as a hedge against forgery (hence its title). Gilmor had obviously referred to the Claude book in a letter now lost; Mount's of December 5 is a reply.

The description of *The Long Story* in this same letter is the longest and most programmatic thing of its kind to survive from Mount's pen. It is infinitely superior to the tale woven about the picture by the professional yarn spinner, Seba Smith, and published, along with an engraving of the picture itself, in Edward L. Carey's annual, *The Gift,* for 1845.

Christmas gift books—collections of prose, poetry, and engravings after paintings, always dated in the year after publication—were a major feature of English and American publishing between 1825 and 1870. They were addressed to a genteel audience and their saccharine content was high, but Poe, Emerson, Hawthorne, Longfellow, and other major literary men contributed to them, and numerous leading artists were reproduced in their pages.

The Gift was one of the best of the Christmas books. It was published in Philadelphia by Carey and his partner, Abraham Hart, from 1836 to 1845, although there were no issues in 1838 and 1841. All told, *The Gift* published six pictures by Mount: *The Painter's Triumph* and *Bargaining for a Horse* in the issue for 1840 (these are therefore the two to which Carey refers in his letter of December 21, 1839); Gilmor's *Long Story* and *Raffling for the Goose* in 1842; *Disagreeable Surprise,* now known as *The Hustle Cop,* in 1844; and *Trap Sprung* in 1845. Ever since 1839, Carey had been requesting Davis's *Catching Rabbits* for use in *The Gift,* but he never did actually reproduce it.

Carey was a collector as well as a publisher of pictures;

he owned the first of the Mounts mentioned in the previous paragraph, the last two, and another known as *Bird Egging*, or *Children with a Bird's Nest*.

Following a well-established practice of his time, Carey engaged some literary person to write a story or poem around each of the paintings of Mount that he published. Mount even recommends his own author in his letter to Carey of December 29, 1839, although in this case the picture was never published and the story was never written.

The literature produced to go with Mount's pictures is uniformly unreadable today. It was all written by authors now totally forgotten except for the above-mentioned Seba Smith, and even his story, reprinted in his *'Way Down East* in 1854, is best left undisturbed. The best story woven around a painting by Mount is by an anonymous author and deals with the picture called *Cider Making;* it originally appeared in the *New York American* on April 14, 1841, and was reprinted by Stuart P. Feld in a remarkable article on that painting in the *Metropolitan Museum of Art Bulletin* for April, 1967.

The "E. Stephanoffe" to whom Mount refers in his second letter was Francis Philip Stephanoff (1790–1860), one of two sons of a Russian emigré artist, both of whom attained great reputation as illustrators.

The modern notion that handwriting declined in legibility with the spread of the use of the typewriter is belied by every collection of documents from the pre-typewriter era. Among all of Mount's correspondents, Carey wrote the worst hand; there are letters of his in the files of which not one word can be deciphered. Shepard Mount discusses Carey's handwriting in the last letter in this section, but although he claims he could read at least this letter from Carey without difficulty, he spells the publisher's name in three different ways—Crary, Creary, and Clary—none of them correct. And William, equally confused, spells it Cary.

A.F.

WSM to Gilmor

Stony Brook, August 20th, 1836

Dear Sir,

I have had the pleasure to receive your favor of the 9th inst., but have not received the letter you sent to me in June. It shall be inquired for. My address was omitted to be published in the catalogue of the Academy this year. If Mr. Flanden or the door keeper of the Academy had thought to direct you to my Brother's office, 59 Exchange place, you would have found my address. I was in New York in June and introduced to your friend Mr. Brevoort by Col. Trumbull. Mr. Brevoort mentioned you had been in town and wished to see me. I regret I did not meet you as I should have been pleased to have visited the gallery with you—however it is gratefying to me that your were pleased with my two pictures "The Bargain" and "The Undutifull Boys." It also gives me pleasure that you wish

me to paint you one picture of cabinet size, the subjects left entirely to my own fancy. I will paint you a picture only it will be some time before I can commence it; owing to previous engagements. I am pleased you still keep in your possession the "Boy getting over the fence" one of my favorite sketches. When you write to me please address William S. Mount Stony Brook Suffolk County Long Island.

Yours Respectfully,
Wm. S. Mount

[ARCHIVES OF AMERICAN ART]

WSM to Gilmor

Stony Brook, July 14, 1837

Dear Sir,

I have just returned from a visit to Boston which will excuse me from not answering your letter sooner. I do not know hardly what to say to you just at this time. I have not commenced a picture for you yet, but I expect to commence a picture for you in a few days, and if I should please myself it will give me pleasure to let you know the subject, etc.

I should prefer to have your picture sent you framed. Will you allow me to order you a suitable frame? Wm. S. Conely, 19 Essex St. N.Y. makes my frames and charges reasonable.

Respectfully Yours,
William S. Mount

[HISTORICAL SOCIETY OF PENNSYLVANIA]

WSM to Gilmor

Stony Brook, Dec. 5th, 1837

Dear Sir,

Your letter of the 25th ult. I have recd. containing a check for $224. I thank you for it. Such promptitude adds value to the amount.

I am obliged for the remarks respecting Claudelorraine's method for proving the originality of his compositions, and I think are very good but must necessarily take a great deal of the painter's time unless he should have a good artist with him to make outlines of his finished pictures. When I deliver a picture I note down the time when the picture is painted, to whom sold and the amount I receive.

Yours of the 29th I have also recd. fulfilling the promise of the preceding as giving your opinion of the picture, and I am happy to find with but a slight difference your impressions of my intentions are what I intended them. The man puffing out his smoke is a regular built Long Island tavern and store keeper, who amongst us is often a Gen. or Judge, or Post master, or what you please as regards standing in society, and as you say has quite the air of a Citizen.

The man standing wrapt in his cloak is a traveller as you supposed, and is in no way connected with the rest,

only waiting the arrival of the Stage—he appears to be listening to what the old man is saying. I designed the picture as a conversation piece. The principle interests to be centered in the old invalid who certainly talks with much zeal. I have placed him in a particular chair which he is always supposed to claim by right of profession, being but seldom out of it from the rising to the going down of the sun. A kind of Bar room oracle, chief umpire during all seasons of warm debate whither religious, moral, or political, and first taster of every new barrel of cider rolled in the cellar, a glass of which he now holds in his hands while he is entertaining his young landlords with the longest story [c.pl. 16] he is ever supposed to tell, having fairly tired out every other frequenter of the establishment.

I agree with you in the opinion that it is my most finished performance.

Yours Respectfully,
Wm. S. Mount

[ARCHIVES OF AMERICAN ART]

Carey to WSM

Philad., Dec. 21, 1839

Dear Sir,

I send by mail this day a paper containing a very favorable notice of *The Gift,* and more particularly of your two pictures.

We have just concluded to publish a volume next year and should like much to have an illustration from you [?]. Have you any pictures on hand which you could loan us or could we obtain one from any of your friends?

An early answer will oblige.

Your very [illegible]
E. L. Carey

I saw at the last exhibition in New York a picture by you of "Snaring Rabbits" which could answer extremely well.
[NYHS]

WSM to Carey

Stony Brook, Dec. 29, 1839

Dear Sir,

I have received your letter and the paper you were kind enough to send me. It speaks highly of *The Gift* and I am pleased to see that "With the exception of the Dying Greek, by E. Stephanoffe, the designs are all by native artists."

The Gift as a volume I think very favourably of. I must acknowledge that one of my pictures, Farmers Bargaining, is not as well engraved as I should have liked, altho the Engraver assured me that he would do it as well as the price and time at which he was limited would allow. It is my opinion that in so conspicuous a place as an Annual, the engraver if he accepts of a job should do his very best, let the price be what it may. Perhaps you can obtain the picture, Boys Trapping, that you admired so much at the

exhibition, belonging to Charles A. Davis Esqr., 365 Broadway N.Y.

The Raffle owned by Henry Brevort Esqr. N.Y. Also, the Courtship is in the possession of John Glover Esqr., Fairfield Con. The latter, engraved by Casilaer or Danforth of N.Y., with a story by Mrs. Embury or perhaps one of your favorite authors, would greatly enhance the merit of your Annual.

Yours Respectfully,
Wm. S. Mount

[SMITHTOWN LIBRARY]

W. E. Burton to WSM

Phila., Feb. 18, 1840

My Dear Sir,

Mr. Edward Carey has requested me to write a story in connection with your excellent picture, which he denominates "The Story Teller." I allude to that one wherein an old man is sitting in a bar room, near a stove, with his head bound up—an open-countenanced traveller is close by, and a man with a cloak is seen behind the stove. I feel assured that you had some definite meaning in the design, although Mr. Carey assures me that the wounded man is merely inflicting a long "yarn" upon his listeners. I fancy that the bill about the Long Island Rail Road, which is seen affixed to the wall, had some relation to the storyteller's narrative. The completeness and graphic nature of your designs in general forbids the idea of a want of purpose in the group in question. May I ask you the favor of your opinions on the subject?

Waiting the pleasure of an early answer,

I am, my dear Sir,
Yours truly
W. E. Burton

[SB]

WSM to Carey

Stony Brook, January 9, 1842

Dear Sir,

On my return home after an absence of eight or ten days to the City, I find your letter, likewise the newspaper.

I am pleased to hear *The Gift* is so well received abroad. It must be highly gratifying to you. I feel myself flattered on being again applied to, to furnish something for the coming year, but it will not be possible for me to copy the picture "undutiful Boys" at present, hence I hardly know what to say upon the subject. It is a favorite picture of mine and I should like to see an engraving of it from the original, but I can not say I like the plan of following a pencil sketch or any off hand sketch in oil colours however well done. In my opinion the engraver in all cases should draw from the original, for his own reputation, and not two or three removes from the picture. Would it be agreeable for Mr. Cheney to engrave from the picture in New York? I have an interesting picture owned

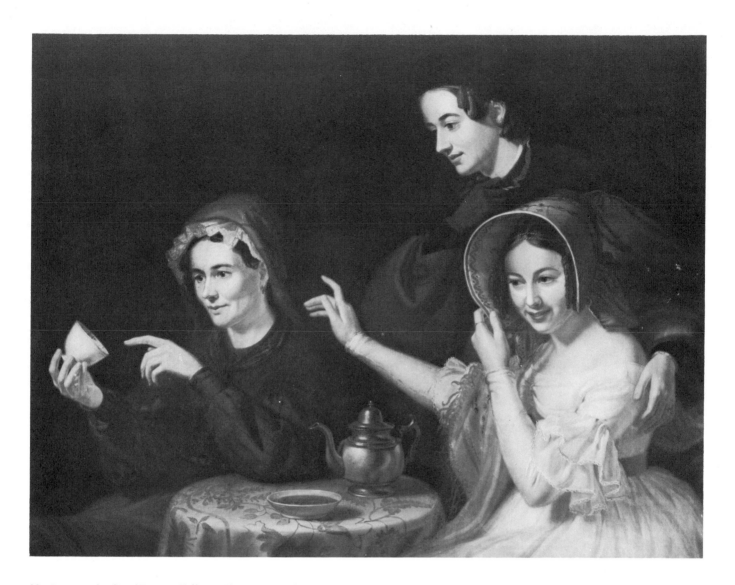

28. *Dregs in the Cup (Fortune Telling; The Fortune Teller)*. 1838. Oil on canvas, 42 × 52″.
 The New-York Historical Society

by John Glover of Fairfield Con. I presume he will loan
it to you. The subject is Courtship, always interesting. It
represents a young lady winding, while her lover is hold-
ing a skein of yarn. Size of the picture 15 in by 18 1/2 inches.
It is just the thing you want and I should like Mr. Cheney
to engrave it with his own hand.

Why not own my Fortune Teller [pl. 28], make me an
offer in Money. It would open rich[?] for *The Gift*—a good
story can be writen for it. Mr. Davis 365 Broadway N.Y.
keeps the picture for me, in his collection. Call and see it.

I am pleased you intend having *The Gift* the tallest[?]
Annual in this Country.

I thank you for the news paper.

> I remain as ever
> Your sincere friend
> Wm S. Mount

[HISTORICAL SOCIETY OF PENNSYLVANIA]

WSM to Carey

Stony Brook, March 11, 1843

Dear Sir,

I had the pleasure of seeing Mr. Cozzen in New York,
who informed me that he was in search of one or two
pictures to have engraved for *The Gift*. I told him I had a
picture somewhere in Philadelphia, The Fortune Teller. It
was exhibited at the Artist fund Society last spring. If it
would answer to be engraved for *The Gift,* you were at
liberty to keep it in your possession for that purpose.

Please write me on that subject. I am pleased to hear
you have purchased Mr. Huntington's last picture.

> Yours Respectfully
> Wm. S. Mount

[HISTORICAL SOCIETY OF PENNSYLVANIA] The Fortune Tell-
er, *also known as* Fortune Telling *and* Dregs in the Cup,

had been on Mount's hands unsold since it was painted in 1838. Its subject was probably against it. It showed a middle-aged woman telling fortunes for two young women by means of tea leaves. Except for The Painter's Triumph, it is Mount's only genre picture without a specifically rural setting, and his audience wanted pictures of country life. The size of the painting may also have caused prospective buyers to think twice; measuring 52 by 42 inches, it is Mount's largest known canvas. It is most unusual for Mount to attempt the hard sell, as he does in his letter of January 9, 1842, to Carey. But despite all his efforts on behalf of The Fortune Teller, he could never dispose of it for money, and so in 1846 he gave it to the New York Gallery of the Fine Arts. It came with that collection to the New-York Historical Society, where it hangs today.

Shepard Alonzo Mount to WSM

Stony Brook, Sept. 31 [sic], 1843

Brother Wm.,

On my return home about 10 days ago, I was told by Mr. Gould you had a letter in the office from Mr. Crary— a few days after, Elizabeth received a paper from you from Catskill to which place I should have forwarded your letter but for the uncertainty of its finding you there. On Friday last another letter from Mr. Crary to you was received at the office. Considering it to be a duplicate, I shall leave it in the office, but the first I have taken the liberty to break open, thinking it would be of some importance to you. Here follows a coppy of the Creary letter.

Phila., Sept. 6, 1843

Dear Sir: I will send in a few days to care of Messrs. Wiley & Putnam New York a set of proofs of The Gift for next year. I think you will be pleased with Mr. Pease's coppy of your picture. We have not yet concluded positively to publish another volume, but, if we do, which I consider very probable, I'd like to have something of yours in it. I was much pleased several years since with a sweet little picture of yours which was exhibited at the National Academy. It was a snow scene, a boy holding up a rabbit he had trapped [c.pl. 17]. Would you be willing to make a coppy of it for me similar to the boys in the barn and at the same price? Please let me hear from you as early as convenient. Believe me, Yours very respectifully, E. L. Clary.

This letter of Mr. Crary being written plainer than he usually writes, I have had no difficulty in making a litteral coppy of it, so you can in your answer say with the utmost propriety you have received his letter of the 6th of September. But I will suggest for your consideration the following: Would not it be better for you to write Mr. Crary saying you had received a letter from home in which mention was made of two letters being in the office at Stony Brook supposed to be from him, but as your friends did not know positively where you was, had not been forwarded. Therefore your apollogy for not answering them in your absence from home, and that you will attend to them as soon as you receive them. You must use your judgement, but I think you had better not be in haste to paint too many pictures at that price. I hope you are doing something among the mountains. Sister Ruth, Julia and Thomas returned home last night, safe and all well. Sister Ruth you hardly know she looks so fat, her cheeks are full with dimples, so much for Pennsylvania, I hope she will not be less so when you come home—it would be an excellent time for you to paint her. Joseph Shepard has gone on a whaling voyage for 15 months sailed from New Bedford.

Yours truly S. A. M.

I shall go to N. York again in a day or two.

[Notation by Mount at the bottom of the letter:] Catskill, Oct. 3rd, 1843. I may possibly spend the winter in N.Y. If so, I do not know of anything to prevent my making a copy of the above picture.

[SB]

78

violin

Like other American painters of his time, Mount tinkered with all manner of gadgets. As we shall see, he created a horse-drawn studio on wheels, made tin flutes for his friends, and, in the last years of his life, was obsessed with boats. But the invention that concerned him the most was his "hollow back" violin, which he named the "Cradle of Harmony" (pl. 29).

This was, of course, an outgrowth of his family's musical interests. His uncle Micah Hawkins, the famous music-making storekeeper of New York City, had composed a successful operetta called *The Saw-Mill, or A Yankee Trick;* he is said to have integrated art and commerce by building a piano into the counter of his store, and he frequently performed on it for the benefit of his customers. He is also reputed to have taught music to his nephews, William Sidney and his brother Robert, the future dancing master.

William Sidney was much admired throughout his life for his abilities as a country-style fiddler, and he constantly exchanged fiddle tunes with Robert. That he invented a new type of violin and had it patented was therefore only natural; and although a number of experimental models were made, the instrument never reached the stage of mass manufacture.

What Mount wanted in his violin was an increase in carrying power. The lone fiddler, playing for country dances in an atmosphere of stamping feet and shouted merrymaking, needed all the volume he could summon. Mount's solution, rather oddly, was to curve the back of the instrument inward, thereby reducing the volume of air inside its body. Furthermore, Mount's violin had no indentations at its waist, and its soundholes were straight. The patent office model bears an inscription in Mount's handwriting on its back: "Invented by Wm. S. Mount. Made by his young friend James H. Ward. Jan. 1852." This, however, was by no means the first violin for which Mount was responsible; as his correspondence shows, he had experimented with the instrument as far back as 1837, and his experimentation continued even after his patent was issued on June 1, 1852. Later he adapted the hollow-back principle to a violin of more conventional silhouette, with indentations in the sides (if without the points that usually go with them) and with the usual *f*-holes.

Like all those who play around with the construction of stringed instruments, Mount became obsessed with varnishes and fills many pages with formulas for mixing and applying them. We have eliminated most of the letters and diary entries which are taken up with this subject.

Mount apparently sought endorsement of his violin from prominent musicians of the day. Especially interesting is an undated memorandum wherein he cites the opinion offered by William Vincent Wallace and Ureli Corelli Hill. Wallace was in this country in 1844 and 1850; Mount's visit to him probably took place in the latter year, when the Irish musician was at the height of his sensational career as the composer of *Maritana* and other operas. Mount must have sought him out in New York,

29. "Cradle of Harmony. Invented by Wm. S. Mount. N.A.
Made by Thos. S. Seabury Esqr. March 1857."
The Museums at Stony Brook, Stony Brook, Long Island

and his verdict on the violin was much like that of the
proverbial parson who, when confronted with one of his
parishioners' unattractive offspring, remarked, with great
enthusiasm, "Well, that *is* a baby!"

Ureli Corelli Hill, founder and first conductor of the
New York Philharmonic, was a much more significant
figure than Wallace so far as the judgment of violins is
concerned. He had studied with Spohr in Germany, was
the best violinist then residing in the United States, and
knew his instrument. His calling Mount's "Cradle of
Harmony" a lady's violin is ironic, since Mount's inno-
vations were supposed to make the instrument more
powerful.

Mount's statement that certain violins of his were put
together by piano makers at odd moments reflects the
amateurish tinker's world from which these instruments
came. It also reflects the astonishing fact that there was a
piano factory in Stony Brook in Mount's day; he refers to
it several times in the documents. Another of Mount's
violins, as is shown by several of the letters that follow
here, was made for him by James A. Whitehorne (1803–
1888), a portrait and miniature painter who had been a
fellow student at the National Academy of Design and
was the recording secretary of that institution for some
years. Still others were put together by Mount's nephew

Thomas S. Seabury, at least one of them in a carriage
factory; and James H. Ward, who made the patent office
model, was a carpenter by trade if the New York City
Directory can be believed. In 1944 the Whitehorne violin,
one made by Ward in 1851, and one made by Seabury in
1857, were, somewhat mysteriously, photographed, with
necks and tailpieces removed, for the Rembert Wurlitzer
Company, the New York dealers in stringed instruments.
The Seabury violin was restored in 1975 by John L. Rossi,
a Long Island violin maker; and today all three instru-
ments are in the collection of The Museums at Stony Brook.
The patent office model is at the Smithsonian Institution.

Mount the inventor is inseparable from Mount the
musician. At Stony Brook there is a vast amount of
music in his hand, and a large manuscript book of
music transcribed by him is in the collection of Mr. and
Mrs. Robert Weiman in Ansonia, Connecticut. The pieces
involved are all dance tunes—waltzes, polkas, jigs,
marches, schottisches—adapted to the fiddle. Some are
folk tunes. Some are melodies taken from the popular
operas of the day. The composition of many of them is
credited to fiddle-playing dancing masters, like Nelson
Mathewson, whom Mount knew well. Some are by Micah
Hawkins; legend to the contrary notwithstanding, not all
the music of the famous piano-playing storekeeper has
been lost. A great many of the dance tunes are adorned
with variations by Mathewson, by Robert Nelson Mount,
and by William Sidney himself.

All this material may be of some musicological interest.
It was first intended that a special section of this book be
devoted to the music, but the problem of selection proved
to be insoluble. Some typical Mountian fiddle tunes ap-
pear in the letters that passed between William and Rob-
ert; here we content ourselves with reproducing the one
and only piece we have found which William Sidney
claims to have composed. It is called "In the Cars, on the
Long Island Rail Road" and is dated Stony Brook, De-
cember 4 and 5, 1850 (pl. 30). In a letter to Lanman
written on December 3, 1847, Mount states that that
morning he had composed a piece of music to be called
"Going through the tunnel on the Long Island rail road."
Despite the similarity of title to the work reproduced here,
it may well have been a separate composition; but if
Mount ever wrote it down, the manuscript is lost.
Mount's composition belongs to a special country genre
of its time, the train piece for solo fiddle, but it is also very
similar in style to the variations which Mount provided
for other people's tunes. All in all, William Sidney
Mount is not a milestone in American musical creativity.

A.F.

Brad R. Platt to WSM

Huntington, Oct. 17, 1837

W. S. Mount Esq.

Dear Sir! With this note I send a copy of the *Long Is-
lander* in which will be found a small and imperfect sketch

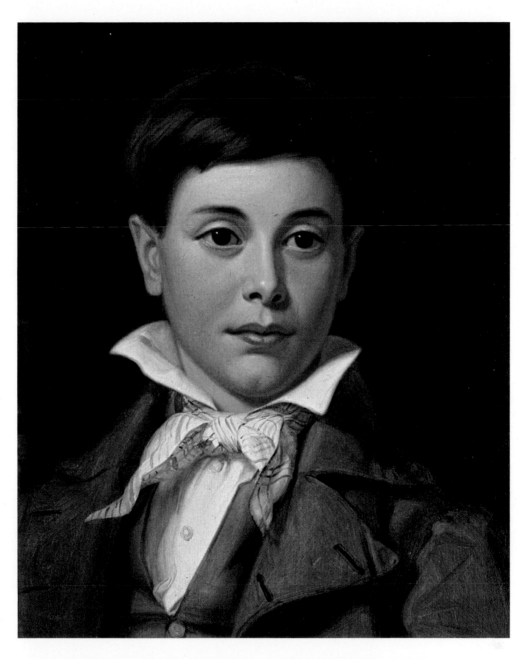

15. *Jedediah Williamson*. 1837. Oil on panel, 16 × 13″. The Museums at Stony Brook,
Stony Brook, Long Island. Melville Collection

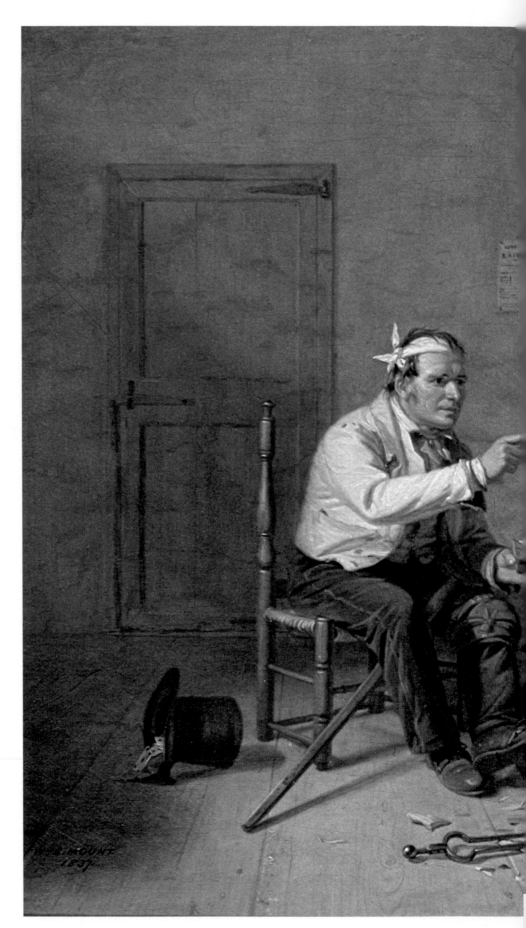

16. *The Long Story (Tough Story)*.
1837. Oil on panel, 17 × 22″.
Corcoran Gallery of Art,
Washington, D.C.

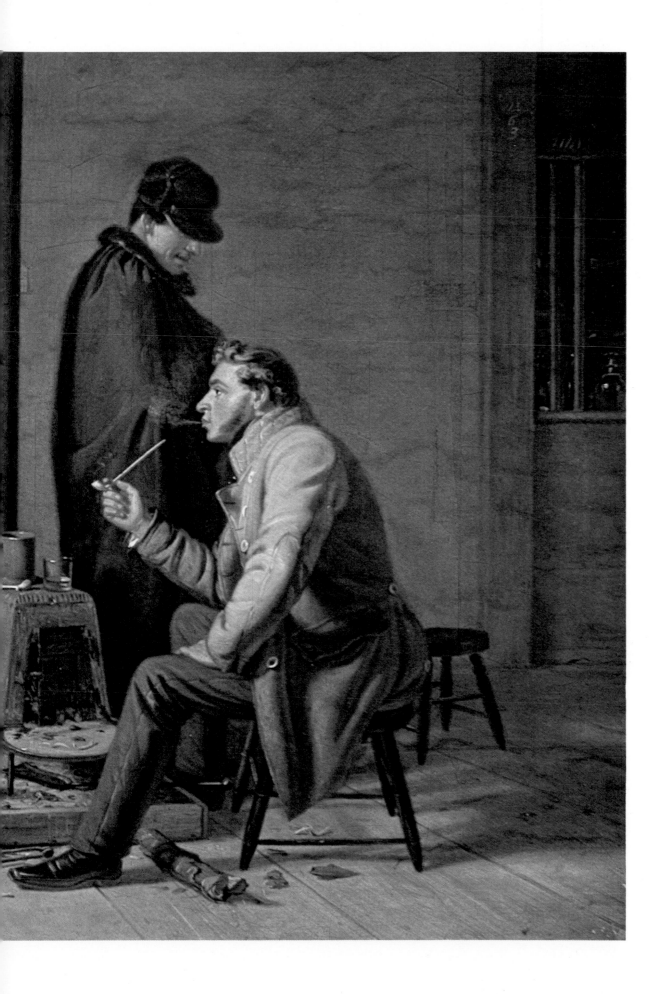

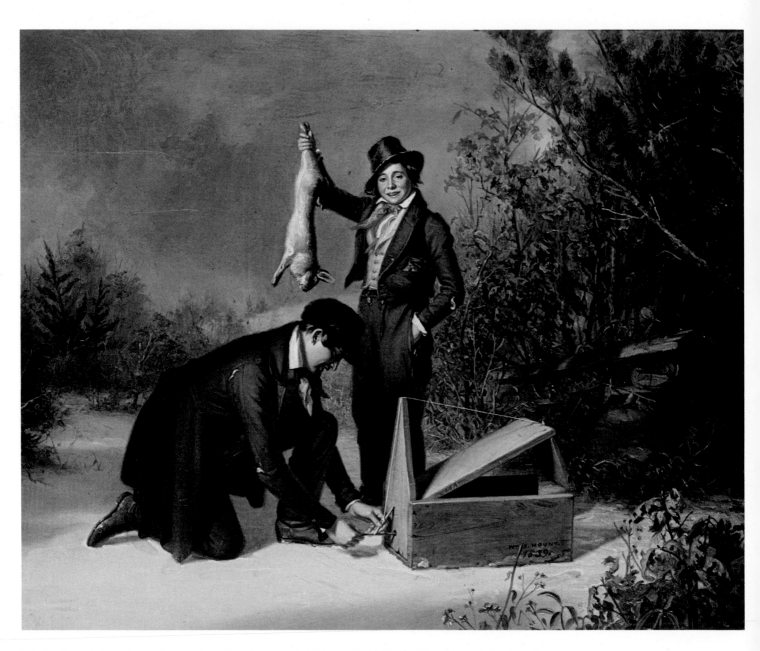

17. *Catching Rabbits (Boys Trapping)*. 1839. Oil on panel, 18 1/2 × 21 1/2″. The Museums at Stony Brook, Stony Brook, Long Island

30. "In the Cars, on the Long Island Rail Road," by William Sidney Mount. 1850. The Museums at Stony Brook, Stony Brook, Long Island

[?] by the way of a Notice of your new violin, which you had the goodness to show me at the late Fair at Smithtown. An Apology is certainly due to yourself, for thus delaying, but my excuse must lie in being necessarily absent from the office more than usual latterly, and having a crowd of items and business to attend to that would not brook delay. Could I have prepared the article whilst under the effect of or the influence of the music capable of being produced from the Instrument, I may be pardoned for flattering myself, better justice would have been done yourself and the effort to improve this Musical Instrument and the success attending your effort. There is a notice going the rounds of the N.Y. City papers of a new violin we believe now exhibiting at the Fair in Castle Garden, but we have not seen the same. Perhaps if you have not visited the Exhibition, it would be worth your attention to take a peep. Should you have another one made after the other designs, be pleased to drop me a line, should it answer your expectation better than the one now in use. With regret at not having the pleasure of becoming acquainted with your brother the Artist, and thanks for the attention shown me. Believe me ever yours in fellowship,

[SB]

Brad R. Platt

Daniel Ferris to WSM

From — D. Ferris — Phila. Pa.
To W. S. Mount

(No. 10 North Second
Street, Phila., Pa.)

To one quart of alcohol put
4 oz of gum Seedlack
2 d[itt]o——gumsandrick
2 do——Dragon's blood

Let it remain until it is disolved, then strain it through a flannel cloth and use it with a Camel's hair brush. When it is on about ten days, it can be polished with *crocus* and water, or emery and water, as may best suit the operator.

Before applying the varnish the article violin ought to be stained with acquafortis and then rub it down with very fine sand paper so as to keep the grain of the wood from starting after the varnish is put on.

[Margin notes:] 1/2 acq and 1/2 wat, 1/2 gill each. Warm the violin by the fire while applying acq, while straining and cleaning with acquafortis before varnishing. It is [illegible] to breathe the Acquafortis while staining a violin [remainder illegible].

[SB]

Daniel Ferris to WSM

Philadelphia, April 25th, 1851
Dear Sir,

I have the pleasure to acknowledge the receipt of your favour of the 20th inst. I perceive by it that you have not yet made the Violin we talked about but expect to commence it soon. You wish to know how many coats of varnish the new instrument will require before polishing. It depends something on circumstances. If the varnish is of the proper kind, that is if the spirits of wine disolves all the gums I told you to put in to it, one gill properly laid on will be sufficient. You no doubt will have perceived that the gums adhere to the bottom of the bottle and should be well shaken every once in a while and kept in a tolerably warm place until they are all disolved, and then strained through a flanel bag with a drawing string on top of course into another bottle when it will be fit for use. You will recolect before you apply the varnish you are to stain with a solution aquafortis and one third water and cause it to avaporate as soon as possible by holding it to a fire, back first, top next— 1/2 the hoop and then the other, and lastly the neck and head. It will have to stand at least two weeks before you use the crocus and water and then you must be very careful you do not rub through to the wood. I hope to have the pleasure of (please turn over, if you are not tired) seeing the picture refered by

you. In the meantime I will enclose the Mad mans gig in consideration of the Lasses of fisherow which you sent me and which I hope to be able to play to you in the real scotch straspay style next time I see you which I hope will be before a long time.

I remain

Respectfully your
Ob't Serv't
Daniel Ferris

[SB] [Music torn away]

Francis H. Upton to WSM

New York, Jany. 12th, 1852
Dear Sir,

The receipt of your application for a Patent for the Hollow Back Violin etc. has been acknowledged by a communication to us from the Commissioner of Patents. I write to say that before the application can be acted upon, it will be necessary to send a model to the Patent Office. Will you therefore provide me with one for that purpose as expeditiously as possible? The sooner the better.

Believe me
very truly yours,
Francis H. Upton
[SB] 72 Wall St.

WSM to Daniel Ferris

Stony Brook, Jan. 13th, 1852
Daniel Ferris Esqr.

I have been very backward in writing to you, yet, I have often thought of you. How comes on the bow arm? There is time for all things and music fills up a rich space. The violin we talked about I had made last summer (I made you a drawing of it on a bit of paper) at Tammany Hotel. I call it the hollow back fiddle, and sometimes the Cradle of Harmony. It is a beautiful toned instrument and admired by every one who has seen and heard it (soft and powerful). I made the varnish according to your directions, and it works to a charm.

I had not "recourse to the improved method of giving the requisites of age to woods" as the Editor mentions. I believe in having the wood seasoned by the new process. The Editors have spoken of my new violin, of their own accord—enclosed I send one article, from the N.Y. *Sunday Courier,* on the subject. I hope to visit Washington about the first of April next, when on my way, I will call upon you. I often play your tune, "The Mad Màns Gig."

I remain yours very truly,

Wm. S. Mount

[NYHS]

WSM to Francis H. Upton

Stony Brook, Jan 16th, 1852

Dear Sir,

Your letter is at hand. The model is partly finished. I am anxious to complete a portrait before I go to the City, say about the first of next month. However, if it is very important, with your instructions, I will go forthwith, to the Patent Office at Washington, with my first (and finished) Hollow Back violin.

Yours very truly,
Wm. S. Mount

[SB]

Francis H. Upton to WSM

$100

Recd from Wm. S. Mount the sum of One hundred Dollars for Fees for drawing papers for and procuring patent from U.S. Govt. for improvement in violins etc. This sum includes 50$ paid on the 2d of January last, and includes all charges and commissions in the matter of what nature Soever.

New York Feby 23d 1852

Francis H. Upton
72 Wall St
N. York

[Copy to] Thos. Eubank

[SB]

WSM to Thomas Shepard Seabury

Stony Brook, March 7th, 1852

My dear Nephew,

I am pleased to hear that you have succeeded in making a hollow back fiddle from my invention, and that it has created quite an excitement amongst the workmen in your carriage manufactory. When your cabinet writing desk arrived here for your Brother Thomas [Edward?], it convinced those who saw it that you would finish the violin. Do not let the instrument take your attention from your business—at present—I have a Patent for the Hollow back violin. The model, and drawings, have been sent to the Patent Office at Washington some time since— Dodge & Upton, Wall St., N.Y. are the Lawyers who have done the business for me. If there should be any disposed to make a violin after my invention, without my consent, they will be looked after— I do not feel at all alarmed that any one will take the trouble to make one without permission. If any one, or two, of your shop mates or friends desires to make one for himself, he has my consent to do so—free. If he should make one tell him to flatten the back as it approaches the neck, in that case the sides will not be so high at the widest part of the small end. . . .

That is the reason why my first hollow back violin or Cradle of Harmony plays so easy not being arched so much

as the others. My first—7/8—one in the Patent Office (a beautiful violin), the arch one inch and an eight. The one that Hugh Brady made is the same—1 1/8 or 1 1/4 in, I forget which—I repeat, one inch is enough for the housing[?]. Should there be another one made in your establishment give the workman every information, and take notes of any slight variation that might be made. I drew a black line with indian-ink (around my second violin) about 1/4 of an inch from the edge— It improved the appearance—If yours is varnished your carriage painter can draw a black line with paint— I am getting better of a bad cough— Egbert Smith is quite low—Sick— The hotels have been quite busy this winter with Parties, etc. All well—

Yours truly
(in haste)
Wm. S. Mount

[BUFFET]

WSM to Francis H. Upton

Stony Brook, March 8th, 1852

My dear Sir,

I am quite anxious to know if my violin arrived safe at the Patent Office. If my patent will date from the time of my first application—say the 2d of Jan. 1852—or from the time I delivered you the model, Feb. 23, 1852, or when my letters patent are made out at the Patent Office in Washington [pls. 31–33]. Please drop me a line on the subject, so that I shall see clear as a diamond. Give my regards to your partner Wm. Dodge Esqr.

Yours very truly
Wm. S. Mount

P.S. I expect to be in the City in about ten days.

[SB]

June 1, 1852

No. 8981

THE UNITED STATES OF AMERICA

To All to Whom These Letters Patent Shall Come:

Whereas WILLIAM S. MOUNT of Stony Brook, N.Y., has alleged that he has invented new and useful

IMPROVEMENTS IN VIOLINS

which he states have not been known or used before his application, has made oath that he is a Citizen of the United States; that he does verily believe that he is the original and first inventor or discoverer of the said Improvements, and that the same have not to the best of his knowledge and belief been previously known or used, has paid into the treasury of the United States the sum of Thirty Dollars and presented a petition to the Commissioner of Patents signifying a desire of obtaining an exclusive property in the said Improvements, and praying that a patent may be granted for that purpose,

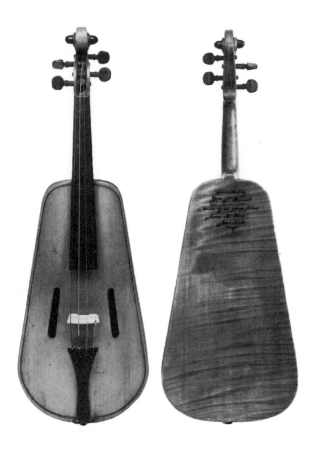

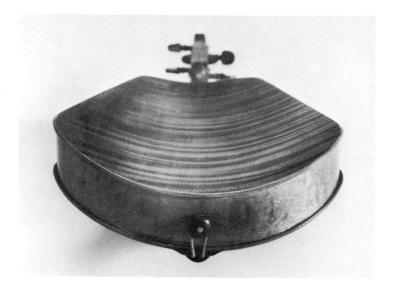

31–33. Patent office model of violin. Inscribed on back, "Invented by Wm. S. Mount. Made by his young friend James H. Ward. Jan. 1852." Front, back, and end views. Smithsonian Institution, Washington, D.C., Division of Musical Instruments

THESE ARE THEREFORE to grant according to law to the said William S. Mount, his heirs, administrators, or assigns for the term of Fourteen years from the First day of June, one thousand eight hundred and Fifty-two, the full and exclusive right and liberty of making constructing using and vending to others to be used the said Improvements, a description whereof is given in the words of the said Mount in the schedule hereunto annexed and is made a part of these presents.

IN TESTIMONY WHEREOF I have caused these Letters to be made Patent and the seal of the Patent Office has been hereunto affixed.

GIVEN under my hand at the City of Washington this First day of June in the year of our Lord one thousand eight hundred and Fifty-two, and of the Independence of the United States of America the Seventy-Sixth.

Alex H. H. Stuart, Secretary of the Interior
Thos, Eubank, Commissioner of Patents

Countersigned and
Sealed with the Seal
of the Patent Office

THE SCHEDULE REFERRED TO IN THESE LETTERS PATENT AND MAKING PART OF THE SAME

To all whom it may concern:

Be it known that I, William S. Mount, of Stoney Brook, in the County of Suffolk and State of New York, have invented a new and improved mode of constructing violins and other stringed musical instruments by which a greater strength of the parts is secured with a greater lightness of the material composing the instrument, and

at the same time a superior quality and greater quantity of tone and sound are obtained.

The nature of my improvement consists in the peculiar form in which I construct the back of the instrument, or that part which receives the strain of the strings, when they are tightened in the process of tuning the instrument. In the construction of all stringed musical instruments heretofore made, the form of the back has either been convex or flat, and hence in the process of tuning the instrument by tightening the strings the effect has been to strain or bend the back and also as an inevitable consequence, so to compress the fibers of the wood composing the sounding board in front as to alter, interfere with or impair its sonorous and vibrating qualities. To overcome this difficulty, I construct the back of the instrument, or that part which is strained by the tightening of the strings, in a concave form, so that a convex surface is presented in front toward the strings. By this form of construction when the strings are strained in the process of tuning, the effect is to lengthen instead of shorten the lower line, and thus, while the back of the instrument is relieved from the strain to which it would be otherwise subjected, the compression of the wood composing the sounding board is entirely avoided.

The drawing hereunto annexed, and which I make part of this my description, represents the violin constructed in accordance with my invention [pl. 34]. The Figures No. 1 and No. 2 representing—the former—the convex sound board front of the instrument, and the latter—the concave or hollow back.

In constructing the violin according to my method, I first plane the wood designed for the back and front to

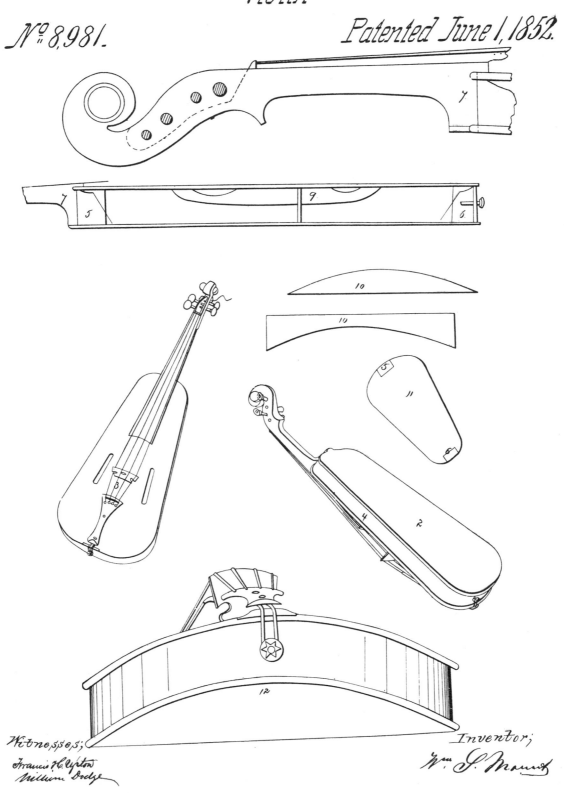

34. Diagrams of violin from patent papers. 1851. Pen and ink, 10 1/4 × 8″. United States Patent Office

the required thinness—leaving it a little thicker in the center at the bridge (No. 3). The wood I then bend either by steaming or by holding it close to a hot stovepipe or heated iron cylinder and then press it upon molds of the required shape. The bass bar (No. 9) is then glued to the sounding board obliquely under the left foot of the bridge in a line with the bass string. The holes in the sounding board (No. 8) should be cut before the wood is planed to the requisite degree of thinness. I then construct a block or mold of the form required for the violin and of the requesite depth, say three inches as in No. 11—the edges being squared from the top and mortised at each end to admit the blocks (Nos. 5 and 6). The sides (No. 4) are bent on a hot piece of iron to fit the mold, and are secured to the end blocks by means of a cramp.

The sides and ends are made to fit by the aid of a band, with two small blocks at each end, assisted by a hand screw. I then cut away the mold to fit the patterns (No. 10) and give the true curves of the back and front. The sides and end blocks I first glue to the back, and afterwards the front is glued to the back, after which I cut an ornamental groove in the sound board near the edge, and scooped away gently toward the center. The neck (No. 7) I glue on last, and cause it to pitch down a little so that the end of the finger board will be elevated about an inch above the sound board. Figure No. 12, shows the elevation of the arch at the base, which I make about an inch.

Constructed in this manner, the back and sides of the violin, by reason of the concavity, receive the strain of the strings when tightened, and the greater shortness of the sound post increases the vibration of the sound board, making the tone of the instrument more sonorous, rich and powerful. I construct the back of the instrument of curled maple—the front of spruce—the sides of birdseye maple—the end blocks of pine, and the bass bar of spruce.

That which I claim as my improvement, and desire to secure by Letters Patent is—

1. The construction of that portion of stringed musical instruments which receives the strain of the strings when tightened in tuning in such form or forms as will cause the line of that portion of the instrument to be lengthened instead of shortened, if the same be altered at all by the strain.

2. I also claim the hollow backed violin or other stringed musical instrument of similar character, constructed substantially in the manner herein set forth.

WM. S. MOUNT

Witnesses: FRANCIS H. UPTON
WILLIAM DODGE
[SB]

Francis H. Upton to WSM

New York, June 2d, 1852

My Dear Sir,

After so long a delay, I have this morning received for you, from the Patent Office a Patent for your improvement in Violins— It is all right— Exactly according to your application. Supposing that you may be in town soon, I retain it for you in my office, especially it is on heavy parchment, and it is not worth while to pay postage if you are soon to be here. But if you wish me to send it to you, say so and I will do it.

Yours very truly,
Francis H. Upton
72 Wall St.

[SB]

WSM to James A. Whitehorne

Stony Brook, Sept 23d, 1852

My dear Sir,

As you expressed a desire to make another hollow back violin, I thought I would send you a pattern of the body of my first violin. She is an inch and a quater in depth and only loses a sixteenth of an inch at the turn of the corners. The back and sound board should be parallel to each other, as possible. We must study to produce power in all the strings. You have done well, with your first. I hope the second will be better. If you should take a fancy some future day to make me one (of these American fiddles), please not to varnish it. I think these instruments should be kept back from the public until two or three perfect ones are produced. I mean in style of finish and tone.

Yours truly
Wm. S. Mount

P.S. Thin the sound board on the underside.
[NYHS]

WSM to James A. Whitehorne

Stony Brook, Sept. 25th, 1852

My dear Sir,

The 23d inst I sent you a pattern of my first violin. To day I forward to you the pattern of the neck, and a drawing of the head, against the time when it shall please you to make me a hollow back violin. My violin would have measured one inch and a quater in depth all around if the rim had not warped, it being so thin (Bird eye maple). Allow me to say, I think your violin is too deep along the middle. From one end to the other, seven eights, or an inch arch, is quite sufficient for bowing. I have too orders for these violins one is to be a violoncello, as soon as I can give attention to it. Mr. Whitehorne, how would it work to get up a concert in the course of a year, and introduce these our Yankee fiddles. At all events we might

call together musicians, violin makers, and music speculators. But first, I am anxious to obtain two or three perfect instruments [if] they can be produced. I know the *invention* is right. Do not let your mind be disturbed from the noble art of painting, making fiddles is play spell[?].

<div align="right">Yours truly,</div>

[NYHS] <div align="right">Wm. S. Mount</div>

Addressee Unknown

<div align="right">Stony Brook, Oct. 20, 1852</div>

My dear Sir,

I am delighted to learn that you have succeeded so well with your second hollow-back violin. Whenever you can spare the time—or take a fancy to make a violin for me after my model—take your own way in fashioning the top. Simply have the sides one inch and a eighth and the highest at the end as being more easy under the chin. Let the *f*-holes be in shape like your first, as being more original.

I hope to be in town shortly, when I will call and see you, and listen to the bass string of the second American Cremona. Yours truly.

<div align="right">Wm. S. Mount</div>

[NYHS]

Memorandum to Himself

[1853]

Violin invented and Patented by Wm. S. Mount. Wm. V. Wallace, composer and Violinist, after having played upon my first hollow back violin, rubbed his hand over it and made the following remark. "I have seen every kind of violin in Europe, but I have never seen any instrument like this." He remarked to Gen. Wm. Hall, who was present at the examination, that it was perfect. Mr. W. V. Wallace also observed that the tone was powerful and that time would improve it. Which it has. At this time [it has] the tone of a violin of fifty years old, owing to the freedom of the sound board. Mr. U. C. Hill expressed himself delighted with it, calls it the Ladies violin. Mr. Firth, distinguished for his judgment in violins, proposed that I should have six thousand made in the best manner in Paris. But Mr. James F. Hall advises as it is an American invention it should be manufactured in this country. It takes only 28 to 30 pieces to make this style of violin, while the ordinary violin requires 58 pieces. The tenor and basses constructed on this plan of the hollow back with concavity of sides would be less in size than those now in use, with more power.

The back and sides of the violin by reason of the concavity receive the strain of the strings when tightened, and the greater shortness of the sound post increases the vibration of the sound-board making the tone of the instrument more sonorous, rich and powerful. I will sell my patent for $20,000.00. It is worth five times that amount to the speculator.

As regards my violins at the palace, they were not made by violin makers, they were put together under my own direction by Piano makers, and at odd spells, mornings—and evenings—to test the principle.

[SB]

WSM to C. M. Cady

<div align="right">Stony Brook, Nov. 24th, 1853</div>

My dear Sir,

In wandering about the Hills the other day, I visited the burial ground, a place appropriated for the slaves (belonging to our family) [in] years gone by, on our farm, and was so much struck with the sublimity and originality of one of the monuments to a distinguished fiddler, and as my late Uncle Micah Hawkins wrote the Epitaph and placed the stone to the old negro's memory, and as you are an advocate for musical genius, I felt it my duty to send you a copy [pl. 35]. I have sat by Anthony when I was a child, to hear him play his jigs and hornpipes. He was a master in that way, and acted well his part.

<div align="right">Yours, very truly
Wm. S. Mount</div>

P.S. I take this time, to thank you for the very kind manner in which you mentioned my violins and pictures, in the Crystal Palace. The two hollow back violins in the exhibition are the first of that model. The one with strait sides, was the first experiment, the one with concave sides, is the first of that shape to test the principle. Had the back and sound board been thicker, like the strait sided one, the tone would have been firmer. They were not made by violin makers. We have tried them and know what they are. We will wait and see what kind of a hollow back a good workman a regular violin maker will turn out, in the course of a year or two. The American violin must not be given up so. In speaking to you about Micah Hawkins you can inquire about him of some of the old members of the Euterpian Society residing in the City. He was born the first of Jan., 1777, and died July 29th, 1825. He was President of the Euterpian Society, was a good comic singer, and violinist, wrote several popular national songs. Back side of Albany and Lake Champlain. Massa George Washington and Gen. La Fayette, and Author of the first opera over written in this country called *The Saw Mill, or Yankee trick*. It was performed several times in the old Chatham Theatre, with great applause, about 28 or 9 years ago. Mr. Hawkins was engaged in writing a play, and had it nearly completed when the typhus fever carried him off. I was with him in his last moments at his residence in New York. After his death his good wife, a member of the Presbyterian

35. Tombstone with violin. Letter WSM to C. M. Cady, November 24, 1853.
 The Museums at Stony Brook, Stony Brook, Long Island

Church, felt she would be serving the Lord, by giving her servant his plays and writings in manuscript to heat the tea kettle with, and I firmly believe that many a hearty laugh was destroyed in consequence.

I intend in time, to have a *tenor, violincello,* and double Bass, made after the design of the hollow back by the best violin makers. I could have sold quite a number if they had been made. Several professors of the violin have expressed a desire to see them properly brought out (something new). A lady musician told me she was tired of seeing the old fiddle and was delighted I had brought out *something new.*

Mr. U. C. Hill calls it the Ladies Violin and hopes I will make him one.

[Inscription carved on the tombstone:]

Entirely tone . . . less.
"Honor and shame from no condition rise,
act well your part, there all the honor lies."

Anthony Hannibal Clap, of African descent. Born at Horseneck Conn, 14th July 1749, came to Setauket in 1779. Here sojourning until he died 12th Oct. 1816.

Anthony, though indigent, was most content. Though of a race despised, deserv'd he much respect—in his deportment modest and polite. Forever faithfully performing in life's drama the excentrick part assigned him by his Maker. His philosophy agreed with his example to be happy himself, and to make others so, being selfish, but in the coveting from his acquaintance an undivided approbation, which he was so Fortunate as to obtain and keep. Upon the violin, few played as Toney played, His artless music was a language universal, and in its effect, most irresistible! Ay, and was he not of Setauket's dancing-steps, a Physiognomist, indeed; he was. Nor old nor young, of either sex, stood on The Floor to Jig it, but he knew the gait, Peculiar of their Hobby, and unasked, Place'd best foot foremost for them, by his Fiddle.

This Emblamatic Lachrymatory, and Cenotaph's, the grateful tribute of a few of either sex who knew his worth.

P. Hill

[SB]

Memorandum to Himself

[Undated]

Hollow back violin was Patented June first 1852. I made an improvement in 1857 by new position of *f*-holes, well adapted for the Hollow back, and will answer for all styles of violins—The patent will run out the first of June 1866. I have been thinking about obtaining a reissue, or patenting my invention of *f*-holes. Perhaps I had better visit the patent office, to see the commissioner and look over the *saw buck patents* and styles of *hooks*—

As regards the violin, if I should get it repatented I should most likely place it in the hands of some manu-facturer— I do not want the care and trouble of anything outside of my painting—only as a change, a recreation. If I should happen to be located near some work shop or piano factory, I might experiment with the violin and let the musical world have my experiments.

[SB]

Memorandum to Himself

[Undated]

When I obtained a patent for my hollow-backed violin, my object was to improve the form and tone.

The change I have made in the position of the *f*-holes is well adapted for the Hollow-backed violin, and will answer for all violins. I also use the concave sides—it gives more freedom in using the bow, and has been in use for ages.

In March 1857, I constructed a hollow-backed violin, variation of the one patented, which I have played upon more or less ever since it was made; the *f*-holes, bridge and strings, having the look of a harp; a fine toned violin, and admired by all professors, who have tried its power and brillancy. The *f*-holes should be embreced, in the patent. [Sketch of violin]

[SB]

Addressee Unknown

Stony Brook, April 14th, 1857

My dear Sir,

I desire to know If I can adopt the ordinary (The Italian) form of concave sides, and *f*-holes—which has been in use at least one hundred and fifty years—to my hollow back violin, patented June 1st 1852, or any form of sound holes to the sound board that I fancy will give more of an ornamental look to my instrument.

My portrait and picture painting prevents my experimenting much with my violin. If you grant my request—please record it with my letters Patent. I will thank you also to give me your opinion and name the expense attending it.

Yours very truly,
Wm. S. Mount

[NYHS]

Diary Entry

Sept 18th, 1859

Friday 16th I put a new bass bar, spruce, to my first Hollow back violin—also thined the bass side of the sound board and made a groove along side of the bass bar. Bass bar 11 1/8 by 1/4 & 5/8 deep—*sound improved*—

I made a groove joining the bass bar (bass side) of my first concave side Hollow back and the result is good. The treble side should be the thickest but a little thined on the outside or inside of the soundboard.

For experiment, a thick sound board could be placed

on the violin and then thined if necessary until the tone required is obtained. One of the Patent violins should be made by a violin maker—violoncello also—and then sell the Patent.

Diary Entry

[Undated]

ABOUT VIOLINS

In January 1861 adopted the improvement I had made in Hollow back violins in Sept 1859—into ordinary or Stradivaris style of violin with success. By grooving both sides of the bass bar, and thinning the bass side (and rubbing with sand paper shavings) and then varnishing with spirit varnish. And over that a coat of Copel varnish and turpentine laid on quite warm. The spirit varnish being laid on first allows the Copel to dry the quicker— I was assisted by Fred A. Pfeiffer Esq.— We improved one of his and two of mine—he cut the size of his violin down.

Diary Entry

May 31, 1868

Mr. Samuel Brewster, I have fortunately found the valuable recipe for making violin varnish. A low tone yellowish color. 4 oz. Gum Seedlac, 2 oz—do—Sandarack. Add 1/2 oz of dragon's blood, if you desire to give the instrument a redish color.

The Gums are desolved in best Alcohol in a glass jar or Jug corked tight, and kept in a warm place and shaken once or twice a day; until the gums are desolved. The varnish is put on with the aid of wool inside of a piece of linin, made up like a ball thus [sketch]. The varnish can be repeated every three minutes until you are satisfyed— then rub with a clean silk handkerchief to give more polish.

After the gums are desolved the varnish must be strained before using.

Diary Entry

East Setauket, May 31st, 1868

A drop or so of sweet oil can be used in the finishing— French polish as taught me by Mr. Brady.

My violin was patented June 1st 1852.

In March 1857, I made an improvement in the shape of the *f*-holes and sides of the violin. On May 30th 1865 I wrote to Mr D. P. Holloway to know if I could have my patent renewed or extended. To tell the whole truth I have not received any reward for my invention, not having made any violins to sell. My object has been to improve the form and tone of the violin. I have succeeded. My profession as picture and Portrait painter had drawn my attention from the patent.

May 18 1866, I wrote to the Commissioner of patents. If I remember rightly my patent was to be extended 7 years on account of my not having manufactured or sold any. The time and the opportunity has not been favorable for me to bring the violin before the public, and the first of June 1873 the time of extension will be up. It has five more years to run.

In time I may obtain a patent for an improvement in the sound board and *f*-holes of the Hollow back violin, and on all other violins.

P.S. The invention is novel useful and valuable and important to the public; the commissioner can grant an extension. I have not been remunerated for the time and expense in originating and perfecting "my Hollow back violin."

I am located where I cannot find a skilful mechanic to assist me—therefore I have to bide my time.

Copy of a note—

East Setauket, L.I.
May 31st, 1868

Jos. H. Barrett Esq.
Dear Sir: If you have an edition of rules and Directions for procedings in the Patent Office since 1865 or the very latest—please send me a pamplet.

Yours Respectfully, Wm. S. Mount

jonathan sturges

Jonathan Sturges (1802–1874) was the business partner of Luman Reed during the last eight years of Reed's life; then he became head of the firm and remained so until his retirement in 1868. According to the *National Cyclopaedia of American Biography,* he was "regarded as the leading man in the tea and coffee trade" during his active years, and he was also a figure of considerable prominence in the railroad industry.

Sturges and Theodore Allen, who was Reed's son-in-law, resolved to keep Reed's collection intact after his death. They and other wholesale grocers subscribed thirteen thousand dollars to place the collection before the public as the New York Gallery of the Fine Arts. This was the first public art gallery in the United States. Sturges and his friends maintained it for twenty-two years, but since they added very little to it, public interest waned, and in 1858 the entire collection was donated to the New-York Historical Society, where it remains to this day.

Sturges had a considerable collection of his own, including three Mounts: *Farmers Nooning* (pl. 36, c.pl. 18), *Ringing the Pig* (pl. 37, c.pl. 19), and *Who'll Turn the Grindstone?* (pl. 38). These three pictures are obviously referred to in Mount's speech of April 5, 1851. The *rifle* to which he alludes was not a gun but the scythe sharpener in the hands of the man at the extreme left in *Farmers Nooning.*

The story behind *Who'll Turn the Grindstone?* is not, as Mount and Sturges thought, by Benjamin Franklin but by one of the Philadelphian's numerous imitators, Robert Miner, whose *Essays from the Desk of Poor Robert the Scribe* came out in 1815. The incident from Miner's book is as follows:

I am sure you are one of the finest lads I have ever seen, will you just turn a few minutes for me? Tickled with the flattery, like a little fool, I went to work, and bitterly did I rue the day. It was a new axe, and I toiled and tugged, till I was almost tired to death. The school bell rung, and I could not get away; my hands were blistered and it was not half ground. At length, however, the axe was sharpened, and the man turned to me, with "Now you little rascal, you've played the truant, scud to school or you'll rue it." Alas, thought I, it was hard enough to turn grindstone this cold day, but now to be called "little rascal"—it was too much. It sunk deep into my mind and often have I thought of it since.

Who'll Turn the Grindstone? is unique among the genre pictures of Mount in requiring that the spectator be familiar with a prose anecdote in order to understand its story. In every other instance, Mount's painted anecdote is perfectly clear and self-sufficient and in most cases does not even require a title to be entirely intelligible.

The group known as "The XXI" to which Sturges refers in his letter of December 30, 1842, was identical

36. Study for *Farmers Nooning*. 1836(?). Oil on canvas, 4 1/3 × 5 3/8″.
The Museums at Stony Brook, Stony Brook, Long Island

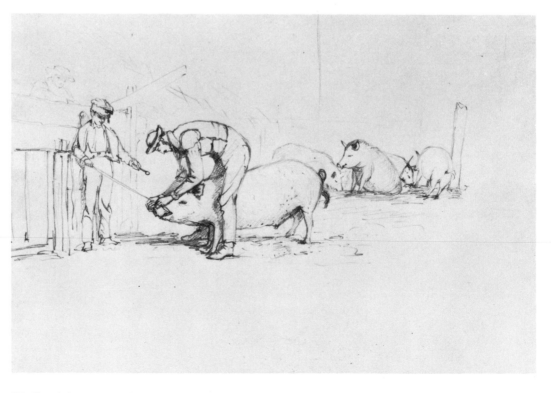

37. Sketch for *Ringing the Pig*. 1842(?). Pencil, 9 × 13″. The Museums at Stony Brook,
Stony Brook, Long Island

38. *Who'll Turn the Grindstone?* 1851. Oil on canvas, 29 × 36″. The Museums at Stony Brook, Stony Brook, Long Island

with the Sketch Club, to which he alludes on March 17, 1851. This was a very exclusive organization of artists, patrons, and literary men who met in private homes on alternate Friday nights for more than thirty years; the present Century Association is its direct descendant. At one time it was customary at meetings of the Sketch Club for the host to provide a title—the more enigmatic or ambiguous the better—on which the artists present might draw or paint a picture. At a meeting in 1841 the title given out was *The Trying Hour*. Mount responded with a magnificent pencil sketch of a pioneer woman melting fat in a large iron pot over an open fire. The title is a pun on the word *try* in the now obsolete sense of rendering fat. A watercolor of this picture, dated 1844, is well known (pl. 39), but the drawing, which came to light only recently, is the first version.

For a thorough account of the Sketch Club, see James

T. Callow's *Kindred Spirits: Knickerbocker Writers and American Artists, 1807–1855* (University of North Carolina Press, 1967).

A.F.

New York, Dec. 14th, 1837

Friend Mount

Dear Sir,

I was sitting opposite the "Farmers Nooning" *last evening* and enjoyed myself so much I suddenly felt quite anxious to get a peep at some other scene in the same line, and I determined I would write you to day and ask you if I could not be gratified soon. If I am impatient you must blame yourself for giving me so good a picture before. If you had given me an uninteresting group I should not

39. *The Trying Hour*. 1844. Watercolor on paper, 10 1/8 × 14 3/4″. Addison Gallery of American Art, Phillips Academy, Andover, Mass.

have been half as anxious for another. It's quite likely, after I get the one I suppose you are now engaged on, that I shall be just as anxious for another. What I call the perfection of art in sketching scenes is to create a desire—when one scene is placed before me—to see its successor. By the way, why would just a story painted to be continued be an interesting affair, something to be finished in another picture? I think there are some capital scenes in Jonathan Shields letter describing his going to Cousin Rubin's party—have you seen it?

I saw your brother this morning. Well, I have nothing new in the way of pictures to tell you. I should like to hear how you are getting along. When shall I order a frame and what will be the size? I intend to have the same pattern as the one you ordered for me.

Yours Truly
[NYHS] Jon Sturges

New York, Feb. 22nd, 1839

Sir,

I am desirous of having a picture from you to match the one you painted for me. I should prefer an interior. Perhaps you may have a subject in your mind that might be connected with the first picture and still be an interior scene. I should not object to a *kitchen* scene. I merely throw out the above hints to give you something of my views without intending to restrict you to any particular subject. Should you find it convenient to paint me such a

picture between now and the Spring Exhibition I should be pleased to have you do so. Please let me hear from you upon the subject on receipt of this.

Yours truly
[SB] Jona Sturges

Stony Brook, Feb. 28, 1839

Dear Sir,

I have received your letter of the 22nd inst with a request that I shall paint you a picture to match the one I painted for you. It will afford me pleasure to paint you a picture sometime during the season.

I should like to have a picture for you in time for the Spring Exhibition but I am afraid the time is too short to do justice to any group I might take in hand at this late hour, besides I am at present painting a picture (an out of doors scene etc) which will take a good deal of my time.

I might possibly paint you an interior with a single figure, in time, that perhaps might please you.

Yours Respectfully,
[SB] Wm. S. Mount

New York, March 2nd, 1839

Dear Sir,

Your esteemed favor of the 28th Feb. is rec., saying you thought the time too short to paint the picture for me

before the Spring Exhibition. My only reason for wishing it in time for the Exhibition was to see a good picture from you there. Not having seen you for some time I did not know whether you were painting any pictures that would be there or not. I wish to have you take your own time to do it. I have only to say I should like to have it by Sept. or Oct. next. I should prefer a group to a single figure. Your head is full of just such subjects as I want. Your pencil can put them on canvas. I hope to see something of you in the Spring—we must stir people up a little. I have been all winter at a certain Gentleman to send you an order. I hope to see a picture of yours in his possession yet. There's nothing new here in the way of pictures.

Yours truly

[SB] Jon. Sturges

New York, Feby 9th, 1841

Dear Sir,

Pardon me for intruding upon you in your affliction. I trust you will not suspect me of any want of sympathy for you in the loss of a favorite brother. I was taken by surprise by seeing his death in the papers—it was another warning that life is uncertain. One of the firm of Rawdon Wright Co called on me today to get your "Nooning" to engrave for the "Token," to be published in Boston, the landscape part to be done by Smith, the other part by one of them— I declined upon the ground that the copyright belonged to you and I would not consent to have it engraved unless it could be done to your satisfaction, and that *you* could receive a suitable compensation for the right. At some time I promised to write to you upon the subject— If you *wish* to have it engraved I do not know that I should object, but it would go against my feelings to have it done without compensation to you. Please write me what your feelings are upon the subject—I would not allow it to go out of the city at any rate.

It is a long time since I heard from you, what are you about? How comes on that said picture for me? Why dont you come and see us Gothamites now and then? I recd a letter from Durand yesterday, he was at Rome, was well, in good spirits and desired to be remembered to all his friends artists (etc). It has been a dull winter in the way of pictures— I hope to see a good exhibition this spring, and look to you for your share.

Yours Truly

[NYHS] Jonth. Sturges

New York, Dec 30th, 1842

Dear Sir,

The XXI met at my house last night and we should all have been pleased to have seen you there— The subject of a picture for engraving for the Appollo was brought up and I was requested to write to you and ask you where some of your pictures are which we have lost sight of. The "Winding up" (*I* think Mr. Glover has that) and some

others. Will you be good enough to inform me what pictures of yours are within our reach and if it would be agreeable to you to have one engraved for the Association if they should so decide. I am in favor of the "Undutiful Boys" and have written to Mr. Fuller to get his consent provided I got yours—I think they will select that for the purpose. Please write me as soon as you can.

Yours truly

[NYHS] Jonathan Sturges

Stony Brook, Oct 27th, 1846

Jonathan Sturges Esqr
President of the
New York Gallery of the Fine Arts
My Dear Sir,

I had hoped ere this to have painted a picture expressly for the New York Gallery of the Fine Arts—but the time to do it seems so distant that I have thought proper to present the Fortune Teller, the best picture in my possession. Should I never redeem the same by its equal or superior, it must ever retain a place in the Gallery.

If the Trustees approve of the donation, I shall be pleased.

I remain yours
very truly
[SB] Wm. S. Mount

New York, Nov. 4th, 1846

Dear Sir,

Your esteemed favor of the 27th Oct was duly recd informing me that you had presented your "fortune teller" to the New York Gallery. Personally allow me to thank you for your valuable gift.

At the first meeting of our Executive Committee I will lay your letter before them and you will then receive the usual communication from them, it being their duty to receive all donations and officially acknowledge the same.

What are you about? I wish you was some where within reach so that one could get at you now and then. You must not bury your genius in Long Island Sand. Come home amongst us now and then and see what we are at.

Yours truly, Jon Sturges

[SB]

W. D. Johnson to WSM

New York, November 13th, 1846

Dear Sir,

At a meeting of the Executive Committee of the New York Gallery of the Fine Arts, held on the 11th inst., the President Jonathan Sturges Esqr. read your communication, presenting to the Gallery the picture of "The Fortune Teller."

Then on motion[?], the Secretary was directed to acknowledge the receipt of the same, and to convey to you the thanks of the Board for your valuable gift.

In carrying out the above resolution, allow me to express my individual respect.

<div style="text-align: right">

I remain Dear Sir
Your most Obdt. Servt.
W. D. Johnson, Secy.

</div>

Stony Brook, March 14th, 1851

Jonathan Sturges Esqr.

I thank you for waiting so patiently for your picture. It is almost finished. I shall endeavour to make it creditable to both of us, so that we shall be able to go down to posterity clinging to the skirts of Dr. Franklin's coat tail. I believe he is the author of *"Who'll turn Grindstone."* It has engaged my attention from time to time, ever since you gave me the commission.

I expect to be in the City about the 20th inst. with the picture. I hope Mr. Conely will have the frame ready.

Please give my respects to Mrs. Sturges, and believe me yours sincerely

<div style="text-align: right">

Wm. S. Mount

</div>

New York, March 17th, 1851

My dear Sir,

Your esteemed favor of the 14th inst is recd announcing the fact that there is a prospect that you and I are likely to have a chance to go down to posterity, clinging to Dr. Franklin's skirts.

For that purpose and at the same time to get hold of your "coat tail" in case the other should not be sufficient, I shall be most happy to take a "Turn at your Grind stone."

The fact is I have been waiting so long, to get a "turn," that I can hardly wait for you to get here with it. I have no doubt it will be of the *real grit,* such as usually comes from your quarry.

Had Sketch Club last Friday evening, grand time, wish you had been there. We miss you from amongst us, and wish you were within traveling distance.

<div style="text-align: right">

Yours truly,
Jona. Sturges

</div>

Memorandum to Himself

New York, April 6th, 1851

Being loudly called for at the annual supper at the National Academy of Design, last evening, I made the following remarks in humorous alusion to three of his [Sturges'] paintings.

Mr. President, it is our duty to speak on all occasions: of the men that adorn their walls with pictures rather than with looking glasses. I would particularize, at this time, one gentleman known to you all.

Since the death of Luman Reed, no man in this city holds a more prominent place in the affections of artists and the public, than our esteemed President of the N.Y. Gallery, Jonathan Sturges. He has apartments richly decorated with paintings, and busts, by native artists, and I believe, has but *one mirror,* which reflects well his taste. He reminds me of some of our good, old farmers—I know him to be one, by the fact that I have *sanded* his rifle, *rung* his hogs, and *turned* his grindstone.

<div style="text-align: right">

Wm. S. Mount

</div>

correspondence 1838-45

WSM to Shepard Alonzo Mount

Regrettably, the last paragraph of the following isolated letter was torn, but it has been possible to guess around some of the holes in it. The paragraph as a whole goes far toward correcting the erroneous picture of Mount (who at the time of the letter, 1838, was at the height of his powers in the painting of country life) as the "laughter-loving genius of Stony Brook," devoted entirely to a comic view of the world. These naïvely appreciative lines of Charles Lanman's, as we have observed elsewhere, have done Mount more harm than all the unfavorable notices he ever received.

The "Mr. Huntington" whose failure to be elected to the National Academy Mount deplores was, of course, Daniel (1816–1906). He made the grade in the following year and was president of the Academy twice, 1862–69 and 1877–91; indeed, he was probably president of the Academy longer than any other man.

The identity of "Mr. Powell" is somewhat mysterious. The only Powell mentioned in the reference books who it could have been was William Henry (1823–1879), painter of The Battle of Lake Erie *and other once-famous pictures in the Capitol at Washington and elsewhere; but William Henry Powell was only fifteen years old in 1838, if the entries on him in the books are correct. The New-York Historical Society's Dictionary of Artists in America, 1564–1860 says Powell came to New York from his native Cincinnati around 1840 to study with Henry Inman, the same Henry Inman whom Mount calls Powell's master. All this suggests that the date given for the birth of William Henry Powell is much too late.*

"Mr. Page" was William (1811–1885). His Mother and Child, exhibited at the National Academy in 1835, had been a great hit and helped to establish his reputation. Mount's remarks about him here are especially interesting, since according to Joshua Taylor in William Page, the American Titian *(1957) the experiments in style which were to earn the artist that title can already be observed in this canvas, now in the Pennsylvania Academy of the Fine Arts.*

Stony Brook, May 12, 1838

Brother Shephard,

Henry arived home this morning. I am pleased to hear that you have prospects of entering into business with brushes in hand soon. Keep up your prices, you will have enough to do. I am sorry that Mr. Huntington and Mr. Powell were not Elected Associates. I think Mr. Huntington is the most original—Mr. Powell is too much in the style of his master Inman. I dont like imitation. Every Artist should look at and represent nature in his own way. Many good Artist love to be imitated, because it destroys the originality of the imitation. Inman is the only man that I want to see paint in his style and he is a good painter in his way.

I think your style is good now if you will only adhere to it. Remember the Mother and Child by Mr. Page. He has not painted so good a picture since because he altered

his style. When my picture is sold please to let me know the name of the purchaser. If it is not sold in a month's time I think I shall raise the price. If there should come out any notice of the Academy I wish you would send them to me.

I have lived in this place over four years in succession and I never knew it to be so lonesome to me as it now appears. I begin to grow tired of this part of the Country. It is too retired, quite so for an Artist. I am sometimes tempted to resume portraiture. It [s?]ings "its temptations of pleasing society, prompt pay[men]t, and ready-made looks which cost im[ita?]tion nothing." I shall get to work I hope in [illegible]. I wi[sh] you would send me 25 cts worth of letter pa[per] bluish ground. The Capt. will pay you. In haste.

<div align="right">Yours etc.
Wm. S. Mount</div>

[LOUISE OCKERS COLLECTION]

WSM to John M. Williamson

<div align="right">Stoney Brook, Jan. 30th [1840]</div>

Dear Sir,

As the late steamboat Lexington has created so much excitement, I suppose you would like to know (as the accident happened in sight of Stoney Brook) what efforts were made to save the unfortunate sufferers on board of the Lexington.

When the Lexington was first seen from Hallock's Store, she appeared to be coming directly for long beach and it was the opinion of those present that she would reach the shore in 15 minutes. Under these impressions two boats were instantly manned with eight men and preceded out of the harbour with the intention of assisting the passengers to land. They had not been gone many minutes when the steamboat turned from the shore and moved as if she had no guide, being under the control of the elements. Only one of the boats got beyond the ice and put into the Sound three miles; they saw that the steamboat drifted off very fast, and the wind rising, they returned without further efforts. All the sloops but one were loaded and aground at the time, and that one, unfortunately, was lying next to the dock and a loaded sloop out side.

A sloop should have been got out with the morning tide and gone to their relief, but I believe no attempt was made. I wish you had been home, you would have done something. I regret that I was confined to the house at the time of the disaster, having strained my knee in consequence, I expect, of cutting flurishes on the ice. I feel thankful that I am getting well of my lameness.

The conduct of Capt. Wm. Terrell of Setauket you have seen in the papers. I see by the *Sag-harbour-Watch* that there is plenty of office seekers at Albany.

You have had somewhat cold weather at Albany, 30° below zero, it must have borne hard upon the bachelors. The Sound is nearly frozen over, and we have had sleighing, ever since you left here.

We have a thaw to day, the wind south east. I would inform you that my good and excellent Grandmother is no more. She died the 22 inst. after a few days illness. She retained her faculties to the last. About an hour and a half before her death, she desired to be led to her accostumed seats, at the front room window, and the window in the kitchen. After sitting there a while she retired composedly to her bed and calmly breathed her last.

Your friends I believe are well, I hope you injoy good health.

<div align="right">Respectfully yours,
Wm. S. Mount.</div>

[SMITHTOWN LIBRARY]

WSM to Benjamin Franklin Thompson

Benjamin Franklin Thompson (1784–1849) was a lawyer and political leader on Long Island and the foremost authority on the history of that part of New York State. His History of Long Island *appeared originally in 1839 and has gone through numerous editions since, the last one in 1962. The later editions have been expanded by modern scholars, most notably Charles J. Werner, through whose hands passed a considerable number of Mount documents. Whether or not these documents came to Werner from Thompson is unknown; what is known about them is that they were brought to light in 1965 by the art historian Theodore Stebbins, who deposited them in the Archives of American Art. All the documents in this book which are identified as coming from the Archives belong to this group.*

<div align="right">Stony Brook, Dec. 5th, 1840</div>

Dear Sir,

I presume you recollect the picture you admired so much in my studio, a Boy sitting with a book in his hands and surrounded by flowers [pl. 40]. If you will accept it as a token of esteem and friendship from the Artist you are welcome to it. I value it as a sketch highly. I will send it to you the first opportunity.

I have a picture on the esel I think you would be pleased to see. The subject is Cider making in the old way. I feel in the spirit of painting and have plenty to do. In your *History of Long Island* I wish you to make the following additions respecting myself as you requested. At the age of seventeen I was put with my Brother at Sign and ornamental painting. In 1826 I entered a Student of the National Academy. In the spring of 1828 I painted my first composition picture "Christ raising the Daughter of Jairus." My second design "Saul and the Witch of Endor." Both were exhibited in the National Academy. In 1830 I painted my first Comick picture the Rustic Dance. In speaking of my first picture in your work, You have it "his first composition figure The Daughter of Jairus." Many might suppose from your using the word figure that it was a composition of one figure only, whereas it is a group of seven figures. I will leave it for your better judgment.

In describing the village of Stony Brook do not forget

40. *Leisure Hours.* 1834.
Oil on panel, 11 × 9″. Collection Mr.
and Mrs. Joseph H. Davenport, Jr.,
Chattanooga, Tenn.

to mention that it contains one Grist Mill, one Fulling Mill, one Methodist Meeting house, and one Piano Forte manufactory firm of Davies and Brothers. And also that we have a steam Boat running from here to N.Y. twice a week.

I will thank you to put my name down for one copy of the second edition of your *History of Long Island.*

I am sorry to inform you that my Brother Henry is very low with the consumption. Brother Shepard resides with his family at 33 Delancey Street N.Y.

Give my regards to Mrs. Thompson and family.

I am, Sir, yours respectifully

<div align="right">Wm. S. Mount</div>

Memorandum to Himself

The nature and purpose of the following curious document are difficult to determine. Since it is written upon a single large letter sheet, we place it with the correspondence of its period, rather than with the diaries, but it seems to have been a private memorandum rather than a letter. Apparently Mount was planning to go to England and had made out a list of the leading artists there, with their addresses. It is, of course, possible that the list was made for a friend who was going abroad, or that it had something to do with the activities of the National Academy of Design. The possibilities are endless and tantalizing. The fact that the manuscript is dated four days after the death of Mount's brother Henry may or may not have any significance.

Sir David Wilkie, R.A. Vicarage-place, Kensington. Joseph Mallord William Turner, R.A. Queen Anne-street West. Edwin Landseer, R.A. St. Johns-wood road, Regent's-park.

Charles Robert Leslie, R.A. Pineapple place, Edgeware road. Sir Martin Archer Shee, P.R.A. 32 Cavendish-square. George Jones, R.A. Keeper, Royal Academy. William Collins, R.A. 20 Avenue Road, Regent's-park. Alfred Edward Chalon, R.A. Portrait painter in Water-Colours to Her Majesty, 10 Wimpole Street. Sir Francis Chantrey, R.A. Eccleston Street. Henry Pickersgill, R.A. 18 Soho Square. Daniel Maclise, R.A. Elect 1840. Henry Howard, R.A. Secretary and Trustee. Samuel Drummond, R.A. 14 Church-street, Soho. Charles Lock Eastlake, R.A. 13 Upper Fitzroy-street, Fitzroy Square.

Wm. Frederick Witherington, R.A. Elect 1840. Solomon Alexander Hart, R.A. Elect 1840. Samuel Cousins, Engraver. John Landseer—Do. Charles Landseer, R.A. 8 Southampton-street, Fitzroy-square.

Stony Brook, L.I., Jan 14, 1841

[NYHS]

WSM to Martin Euclid Thompson

Stony Brook, Oct. 10th, 1841

Dear Sir,

I see by the papers that you are one of the Managers of the American Institute. I have, therefore, thought proper to request you to lay the following before the board of Managers of the Institute.

I received from the Fair of the American Institute in the City of New York, Oct. 1830, the first Premium for a painting representing a Country or Rustic Dance. I was told by the Secty. that if I paid two dollars I should be presented with a Silver Medal, but instead of the Medal, I was sent a Diploma. I value the latter, but I should value the Medal still more.

The vice Prest. at the time was Peter H. Schenck Esqr, Edwin Williams Recording Secy., and T. B. Wakeman Corrisponding Secy.

I remain, Dear Sir, yours with great respect,

Wm. S. Mount

[NYHS]

John P. Ridner to WSM

The following letter apparently represents Mount's first brush with the American Art-Union, and it may explain the attitudes of skepticism, reserve, and hostility which he later expressed toward that famous institution. In recent years the Art-Union has become a sacred cow among American art historians, and there can be no doubt that its activities did much to popularize painting, sculpture, and the graphic arts in this country during the ten years (1842–

52) of its existence. Mount, however, did not like the dilettantes who ran it and resented their high-handed ways, as reflected in the letter that follows here. Ultimately, however, he made his peace with the organization.

For the best modern study of the American Art-Union, see Lillian Miller, Patrons and Patriotism, *Chapter 14.*

New York, 1st Feby, 1844

Dear Sir,

The American Art-Union (formerly Apollo Association), being desirous of procuring a picture suitable for their annual Engraving for the year 1845 and finding it difficult to obtain one already finished, have concluded to apply to a few artists to make for the Association a sketch (in Oil, Water, Pen or pencil) of a subject of a National Character, for which the Committee will pay each artist Twenty Dollars.

When the sketches are finished and sent to the Association, should the committee find one of a character such as they desire, they may or they may not (as the case may be) then negociate with the artist for a finished picture of the same. The Committee however wish it understood distinctly, that in case they make a selection, that selection is by no means intended as a mark of artistical merit, as the sketch selected may be greatly inferior in point of execution to those of other artists, but may be of a character so peculiarly adapted to the object of the Assoc. as to induce the committee to select it. These remarks are made because the Committee wish to divest this project of the objectionable feature of offering a prize for competition.

The Sketch to be finished and sent to the office of the Association within two months from this date, and to be the property of the Association, for distribution among the members.

The Sketch to be a subject embracing not less than two and not more than five figures, and of a size not less than eight by ten inches.

Very respectfully
Yours etc.
John P. Ridner
Cor. Secy., A.A.U.

[NYHS]

Mary A. Spooner to WSM

The precise identity of the author of the following letter is not easily established. She was apparently a neighbor of the Mounts' on Long Island and may have been the mother of the Alden J. Spooner who contributed obituary notices of William Sidney to the New York City press and is listed by the artist among patrons who ordered pictures from him. One suspects that Mrs. Spooner was rather more interested in Mount than her protestations of maternal feeling would indicate. At all events, her high-flown Victorian style is entertaining.

Monday March 18th, 1844

My Dear Friend William,

The recent brief, but generous, visit of your brother and yourself instead of contenting me has placed me in the predicament of a beggar, whom *liberal devotions* only encourage to *larger demands*. Perhaps I should not solicit you to come over and aid me further, in my new undertaking, had you not expressed so much interest in it as to volunteer to come. I have begun my picture, but find myself an awkward practitioner, more so perhaps, from the habit of painting with water colours. Nevertheless, I think one hour's practical illustration of the art, the proportion of oil, using brushes, and manner of putting on paint, etc., would be an invaluable lesson, but in making the request, I desire not to tresspass on your valuable time, and urge you would suit your own convenience in coming. I hope you will not think me presumptuous, I do not feel so, for from the first time I ever saw you I have felt the tenderness of a parent toward you, and as you were once pleased to class the character of your regard for me with that toward your beloved and now departed Mother, I have ever deemed it *reciprocal*. I would it were my happiness in any degree, to compensate for her irreparable loss. The *tie* that binds congenial natures is as holy as it is mysterious; and delightful as the consciousness of being entirely comprehended—of abandoning ourselves, as it were, to *another self!*

Time and distance, and the artificial restraints of society in vain exerts their influence over *such*. Whether they meet or are separated, their affections are ever fresh, vivid and confiding, but I am *digressing*. I had meant to write something about *painting*—that art we both so passionately love yet alas with so wide a difference of enjoyment! And yet I would not [illegible] is not nature, the original of all that is beautiful, presented to my acceptance; shall I mourn that I cannot, as you, copy her? No; let me admire with thanksgiving though a smothered flame be on the altar of my heart. Within the last hour, what a splendid sweep of the wild, sublime, and beautiful has not the brow of nature, the ample heavens, disclosed to our view. We are surrounded by pictures, living, ever changing ones, whose influences, penetrating our own nature, reproduce successive varieties of moral beauty.

March 25th

Interrupted by company from prosecuting my intensions, dear friend, I find a week has elapsed not incensorously however, as I have been laboring under a severe cold, and now have so severe a head ache as to be almost blind. I had much I wished to say about you, and your paintings, but will have to postpone it. If you can with perfect convenience come over awhile I shall be very happy to see you.

My respects to your brother with my *thanks,* and shall always be happy to see him.

With unaffected regards, dear William I remain Your obliged friend.

Mary A. Spooner

[NYHS]

WSM to Charles M. Leupp

Charles M. Leupp was a wealthy New York merchant who had one of the largest collections of painting and sculpture in the city. The Mount that he purchased was Dance of the Haymakers—*also known as* Music Is Contagious—*one of the works of 1845 which brought the artist to the creative climax of his career (c.pl. 20).*

Stony Brook, March 11th, 1845

Dear Sir,

I am pleased to say that the order you so kindly gave me, has interested my feelings for some time. You have waited with great patience and I sincerely hope that the picture will have sufficient merit to pay you for the delay.

The size of the picture is 25 in by 30 in. I have a quarter of an inch moulding around it to preserve the edges, and at the same time when it is framed to show the whole surface of the painting. This you will mention to the frame makers. I am quite desirous to exhibit the picture if agreeable to you. I think I can get it done in time. Therefore I have written early that you may order the frame accordingly. The Academy receives pictures up to the 5th of April.

I shall be pleased to hear from you. I have the honor to be yours respectfully,

Wm. S. Mount

[SB]

Charles M. Leupp to WSM

March 12, 1845

My dear Sir,

I have your letter 11th inst and am glad to know you have not forgotten me. I have no objection that you exhibit the picture and shall immediately order the frame, agreeable to your directions.

I am quite anxious to see the picture and I hope nothing will prevent its being down by the month of April, as on the 20th of April, I am in expectation of embarking for Europe and I should like to see it before I go.

Yours truly,

Charles M. Leupp

[SB]

charles lanman

The versatility of the Renaissance man is supposed to have died out with such late-eighteenth-century characters as Benjamin Franklin, Thomas Jefferson, and Charles Willson Peale, but some men of the nineteenth century —Charles Edwards Lester, Henry Tuckerman, and, above all, Charles Lanman—rivaled, if they did not surpass, their many-sidedness. Lanman (1819–1895) engaged in a bewildering variety of occupations, reflected in the thirty-two books he published. He was an explorer, newspaper editor, landscape painter (see pl. 41), librarian to the War Department and later to the Department of the Interior, secretary to and biographer of Daniel Webster, compiler of the *Dictionary of the United States Congress,* and, finally, secretary to the Japanese legation in Washington, an experience which led him to write on Japanese literature and on Japanese life in America.

Lanman was one of Mount's most frequent and most enthusiastic correspondents, and his letters are couched in a considerably more "literary" style than any others the artist received. But Lanman's literary professionalism is surpassed by Mount's native eloquence in his extraordinary letter of November 17, 1847, describing the method to be used in spearing flatfish or eels; this parallels the painting *Eel Spearing at Setauket,* which some authorities consider his masterpiece.

Charles F. Briggs (1804–1877), to whom Mount refers somewhat ruefully in his letter to Lanman of May 2, 1847, was an editor, critic, and novelist, and a lifelong friend of the painter William Page. Mount obviously regarded him as an apologist for Page and implies that he was unable to appreciate the work of any other painter, although his ideas, as set forth by Joshua Taylor in his *William Page, the American Titian* (1957), should have made him eminently sympathetic to Mount's point of view. The precise passage wherein Briggs criticized Mount is impossible to locate today.

Lanman corresponded with Shepard Alonzo Mount as well as with William Sidney, and we include some of Shepard's letters to him here. They are uniformly more high-flown in expression than those of his brother.

A.F.

Stony Brook, Jan 23d, 1841

My Dear Sir,

I see by the *Knickerbocker* which you have so kindly sent me that you are in Norwich Conn, admiring no doubt one of God's noblest works: a lovely woman. I cannot conceive what else should have drawn you there— If so, let her weave a web around your affections, and when she walks tenderly about you and touches you with her garments, then gently place your left hand on her slender waist, and your right hand after the manner of Cupid and Psyche, and press her rich lips to yours— Believe me my friend Lanman you will never forget the impression as long as you live.

A cloud has been throwing a gloomy shadow over my sunny countenance since I saw you in N.Y. In consequence

of the sickness and death of my eldest brother, Henry S. Mount, by consumption. The circumstance of his decline depressed my spirits so much that I have not used the brush in six weeks. But nature begins to look cheerfull once more; therefore, I shall resume the maul stick in a few days. I have read "Peter Cram." I like it much— should like to know the author's name. I am obliged for the number, and other papers you have sent me. Favor me with that letter if you please.

Yours truly,
Wm. S. Mount.

Excuse the liberty I have taken in writing to you.
[NYHS]

Shepard A. Mount to Lanman

New York, January the 30th, 1841

Dear Landman,

The repeated tokens of your remembrance of me I have left unacknowledged to this late date. Your goodness will pardon the omission.

During the illness and at the recent death of my brother Henry my mind has been most grievously exercised. I intended to have written you the evening of the day that brought me the melancholy intelligence of his death—but immediately took leave of my wife and little boy and crossed to Brooklyn, was seated in the last train of cars and had 50 miles to ride that night. We moved on—slowly at first—for the moment I felt as if the weight of my own heavy heart might be the cause. It was not that, but the "laws delay" for as soon as we had passed the city bounds, away we hurried at a furious rate—the cattle scampered off at our approach—I wondered not at their timidity. There is something startling in the puffing engine, its terrific whistle and alarm bell—

I finished my journey in a stage—at eleven oclock was with my afflicted relatives, at the home of my child-hood. Before entering the house I stood alone for some minutes —the dark clouds suddenly disappeared and the bright moonlight came down and rested upon the roof of that ancient dwelling-place—my heart was full—I bowed my head upon my hands and wept like a child. This is truly a world of change. I thought of our boy-hood—by the light of the same moon how oft we had tugged our little sleds to the surrounding hill-tops, then turning with a look, perhaps a shout of consious joy, together we glided to the valley below—now the voice of him of whom I had come to take the last fond look was as silent as those snow-capped hills—

My Mother had not retired, but waited my coming. I found her calm in her grief. She had lost her first born child—as she spoke of his sufferings and death, her voice trembled, and failed. She pressed my hand, and in one

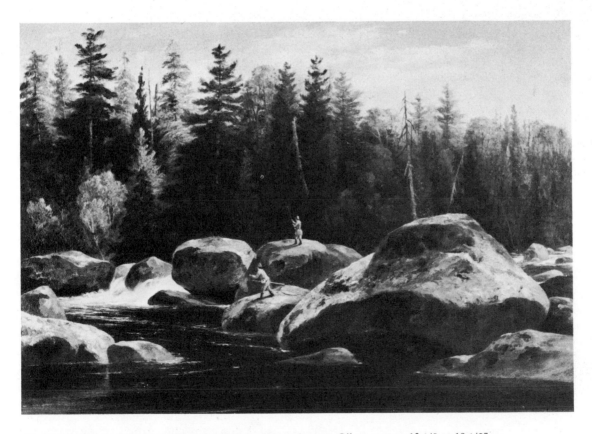

41. Charles Lanman. *Salmon Fishing in Canada.* Date unknown. Oil on canvas, 13 1/2 × 19 1/2".
Collection Mr. and Mrs. J. Stewart M^c Neilly, Chatham, N.J.

deep-long look of affection seemed to say, " 'tis to my re-maining children I look in part for support in this trying hour." My Mother has been familiar with such afflictions. My Father died at middle age—he was her first and only love—happily I bear his name, for I often fancy she delights to speak it; and to dwell upon his virtues is her chief happiness.

I went to my room, but could not sleep—a torrent of strange thoughts passed through my brain, such as in after life I may not be able to guess of. Early next morning I sat by the remains of my departed Brother, where but a week before we parted with mutual blessings. I tried to make a sketch of him but failed. I looked at his paintings that hung about the room, and then upon his firm and solemn face. 'Twas a lovely day; our venerable minister, more than 80 years of age, headed the funeral procession —we rode a distance of 3 miles to the church-yard—at the grave I stood beside his afflicted wife, and as the last rites of funeral was being ended, I felt her trembling hand and heard the sobs of her fatherless children. 'Twas past —soon after we were seated in our carriages, the horses had become impatient from long waiting and they swiftly whirled us on our way to the house of mourning. I look back upon it all as a strange dream—such is life. I have review'd this letter—'tis a curious affair, but I know to whom I send it. If I write at all, must dwell upon that which is uppermost in my mind. Friend Landman, our little association is broken. In addition to the common ties of brotherhood, we were bound together by other sympathies—with one exception, we all followed the same profession—to its many vicissitudes, we have been alike familiar. My Brother thought to the last that painting was the principal cause of his disease—that he had "nursed the pinion that impelled the steel."

The *Southern Literary Messenger* is received. I have perused it with much pleasure—especially your Sabbath Evening Thoughts are full of excellence and that unaffect-edly pious feeling that touches the heart. I think no one can read them with a just appreciation and not find himself profited. The *Courier* is at hand, the nameless Essay pleases me, if possible more than when I first heard it.

I miss your society because your companionship suits me exactly. Those of my many acquaintants whom I would choose as my friends are very few. I have not called upon any painters since you left, therefore can say nothing of the Art that will interest you. My Wife desires her respects; my little boy is sleeping near me, as you have seen him.

<div style="text-align:right">Very Truly Yours,
S. A. Mount</div>

[NYHS]

Norwich Conn., Feby 1st, 1841

My dear Mount,

What a fellow you are to close your letter to *me* with the following passage: "Excuse the liberty I have taken in writing you." After my repeated expressions of regard for your character and genius, it was not right—but no matter—I'll forgive you this time.

The *sketch* with which you commenced your letter was "masterly." The lights and shadows were well disposed— the drawing was admirable—and the "impression" it is calculated to have on those who are in love——wonder-ful. But you did not know that my lady-love was in a city south of N.Y. I came to Norwich, merely to spend two or three months "at home," among a host of friends whom I love most tenderly and who love me in return. I spend my time sleighriding, reading, writing and *loafing*, glori-ous employment which I delight in.

I wish you were here—cant you come and spend a month with me? I'll show you lots of pretty women and some beautiful, fit for *you* to paint. Only come, and I'll devote the whole of my time to your entertainment. I have lately returned from Boston, one hundred and ten miles from here, but our *"iron horses"* go there in four hours—there is a new and splendid railroad to that city. I did not have time to see any painters, but one, and that was young Burnham. I wish you knew him; he is indeed a rare fellow, and possesses the talents of a great artist. I am glad that you do not allow your affliction to depress your spirits too much. Mourn not for the dead, but rather for the living—for those who are poor, persecuted, and friendless— those who have never known the luxury of a holy feeling —a love for nature, and above all for God. Leaves have their time to wither and die, and so it is with man. But leaves do not always die only in autumn. I have seen a leaf, eaten away in early spring by a worm, in the sunshine of summer had given it a mellow tinge. What reason have I, or any other youth, to expect that it will not be so with me or him? My motto is, therefore, "be prepared to die."

Since I saw you in New York, I have visited your broth-er Shepard several times. I was not disappointed in him. I really did not think he was so good a man, so fine a paint-er. I was very much pleased with his wife; and his child I thought a beautiful and noble boy, who has his equal however in the person of my own little brother. I like the way that Shepard talks. I love and cherish any man, who resorts to his own domestic circle for happiness. *That,* after all is the place to be happy. I pity the man, who cannot be happy with the wife of his bosom and his chil-dren, preferring the gaudy pomp of the theater, or the company of the bar-room. I hope to spend yet many more pleasant evenings, with your brother and his interesting wife. They know not how much I think of them. When Shepard exhibits that "velvet hat" of his in the academy, I shall do what I can to point out its beauties. I dont think you could better it. I dont know the author of *Peter Cram.* Whenever I see any thing which I think would please, I'll send it to you. The next *Southern Literary Messenger* will contain a piece by your brother. It has been published in an *obscure* newspaper, and therefore I sent to my friend the Editor an original—its the same thing. I hope you will write me whenever you have a moment's leisure. I don't care how often. Wont you make me a confident about your plans and doings in painting?

I like to hear particulars concerning those I admire. I write as I feel. Pardon my hasty conclusions for one of my sisters has just asked me to take her to ride. The robes are in the cutter, the long-tailed bay is at the door covered with bells, and I am off—so good bye—

[SB]

Your friend
Charles Lanman

Stony Brook, Feb 20th, 1841

My Dear Sir,

I received your interesting letter at the Post office on the evening of the Eclipse of the Moon. I think it a favourable omen that you are destined to make a great noise in this world, and cause great rejoicing among the angels in the next. I am pleased to hear from you. If I could only appear in your eyes as well as you appeared in your letter I should indeed have a right to feel proud.

The *Norwich Courier* has made its appearance containing "A Nameless Essay by Ch. Lanman." Commencing, "How impressive is the eloquence of silence." Sweet piece of writing, full of original ideas, dont forget how you done it. You have genius—your writings plainly exhibit it. You think for yourself and you know how to look at nature. Stick to nature my friend Lanman and she will never forsake you.

I am pleased you think so much of my Brother and Sister. I can assure you, they esteem your acquaintance very highly. I am glad you like young Burnham and that his talents please you. Encourage him to hold on to nature. I have received a second number of the *Knickerbocker*. I dont know when you will get your pay. I presume this letter will find you painting a landscape surrounded by your friends and one or two lovely girls leaning on the back of your chair. Imagine me in the background looking on. I am not able at present to accept of your very kind invitation to spend a month with you, although a great inducement. I should be most happy to see you at Stony Brook say about the last of March or the first of April. Then I shall perhaps have a picture to show you.

As you desire, I will tell you a few particulars. I never paint on a picture unless I feel in the right spirit. When I go into a painter's studio I never turn his canvasses round, without a permit from the Artist. I always pay my debts and now and then play a tune on the violin. I am not fond like some artists of telling about difficulties. I try to be happy and wish to see others so. Lastly I think more of health than fame. I am pleased you enjoy yourself sleighriding and so on. I should like to take a ride with you, "glorious employment which I delight in."

I expect to see, one or two of your Landscapes in the next exhibition. Dash away.

Yours very truly

[NYHS]

Wm. S. Mount

Shepard A. Mount to Lanman

Stony Brook, March 21st, 1841

My Dear Friend,

This is to inform you I am once more in Stony Brook with my little family. I arrived here a week ago to day. My health is improving daily. The country is the place after all, for true enjoyment, for health, and for grattitude. 'Tis a most delightful day. My Wife has gone to attend church at the neighboring village while I remain home to take charge of my little boy. He is now amusing himself about the barn-yard chasing the hens and turkeys.

Brother William and myself will go out this afternoon to take a leisurely stroll about the fields, and along the shores; I wish you were here to accompany us: but I suppose you are spending the sabbath more like a christian. We live remote from the sound of the church-going bell, and as it is not always convenient to be there, are obliged to worship some other way. Your letter was duly received, and I assure you has afforded me real satisfaction. I have so much to say to you that I shall not attempt a reply at this time. The *Messenger* I have not received. I twice called at the post-office. The clerk showed me one of the numbers. I found Col. Frankly there sure enough. I feel honored through your influence with that popular *periodical* many thanks. Dont take the trouble to send me the *Messenger* as you mention'd. I am already too much indebted to you for similar favours. My Wife received the Hartford paper, and feels complimented by your remembrance. Her health is quite good, too.

We talk of you very often and think of you whenever we look at the blue hills of New England. Land of the Pilgrim Fathers. I must go in pursuit of my boy, he has wandered off. You bachelors have no such trouble.

I hope to have the pleasure of seing you again ere long, if not before, when we meet at the National Academy. Excuse this short letter—will do better next time.

Yours Truly, S. A. Mount

Friend Lanman, In my last letter, I invited you to make me a visit. I now repeat the invitation. If convenient I should like to see you here the last of this week or middle of next. Brother Shepard being at home is my reason for wishing to see you at this particular time. A Steam Boat leaves the foot of Market St. Wednesday and Saturday mornings at 8 o'clock. Or L.I. Rail Road Tuesdays and Fridays will bring you to Hicksville, which place you will take a stage. I should prefer the Steam Boat.

Yours Respectfully,

[NYHS]

Wm. S. Mount

Shepard A. Mount to Lanman

Athens, July 31, 1841

Friend Lanman,

I owe you an apology; but I fear it would be too lengthy, were I to give only a part of the many reasons that I could offer for my remissness: therefore, if you will forgive the

past and grant me the privilege of writing with a pencil you shall hear from me from the spot where I am sitting, upon a pile of driftwood hugely thrown around the base of a gigantic tree, one of the many hundreds that rise majesticly from the lovely little islands in the waters of the Susquehanna. I have selected this place; not so much for the comfortable seat it affords as to enable me to obtain a more interesting view of all around. Above the luxurient growth of wild weeds, I behold upon either side the pearly waters go silently along. Fit emblem of eternity this never changing stream, its course is onward, onward, and it returneth not. How unlike the ebbing and flowing of the tide upon the Atlantic shore, which is more suited to the impulse of my mind, as its daily fluctuations afford some apology for erring man in his vacillating course through this world of mystery. I am wrong in saying no change is apparent here; on all sides I behold the strongest evidence that here too it exists in its most terrible form—the rude pile on which I am sitting was forced above its natural level by the furious waters that rushed madly down from the mountain tops, mighty trees have been torn from these sunny banks and born away perchance to the ocean, whose loftiest branches an hundred years before have sported with the winds of heaven, while many others in my view, from their lacerated sides and distended roots, show that they too like Jacob of old, have wrestled with the God of storms. But I have looked on the picture only in part, was the tempest sent in wrath? Oh no, the waters have long since slept upon those inundated fields now overshadowed with the "golden grain." I have this moment been listening to the happy voices of the husbandman joined in merry song of harvest home, and as they handle the new-bound sheaf with gladdened hearts, are not unmindful of the bounteous hand of the giver.

The little birds unconscious of my presence come boldly and flutter awhile in the little creek that runs near me, and then go hopping and chirping in the branches above my head, the old wood-duck too encircled by her brood has ventured out from her hiding place in the tall brakes to sport awhile; already they have espied me, and away they go to the opposite side of the river, thrashing the water at a furious rate. Not far distant stands a group of hemlock trees. (Heavens! what a study for a painter.) With their giant arms extended, they look like the ancient Patriarchs in supplication for a ruined world. I have been walking upon the bank near the shore observing the fishes, on so sultry a day as this I almost envy them, a large one venturing near the shore. I raised my old straw hat and away he darted o'er the clear pebbles seeming but the shadow of a passing bird. Yonder comes a Muskrat steering his course for the water, he moves on as tho I had no power to harm. If I had a good club I think I could make old *stinkibus* move a little faster, how odoriferous not offensive however—[I] should have no objections tho his tail was this moment about my neck, but he is invisible, all save his ears that occasionally appear above the surface of the river. A boy is fording the river some distance above me; suppose I give you a small outline of him

42. Boy fording river. Letter Shepard A. Mount to Charles Lanman, July 31, 1841. The New-York Historical Society

[pl. 42] its hardly worth the space it occupies—never mind, you know I can do better. I left stony Brook about 5 weeks ago accompanied by my Wife and child of course. My health had become so bad a change was deemed necessary. I came by the way of Albany, a place myself nor wife had never been—we passed up the river by daylight, how truly grand is the scenery upon the Hudson. The appearance of the mountains near West Point are bold and solemn, those above Cattskill pleased me the most. Their distant and lofty brows were firmly drawn along the western sky that showered down its golden smiles, imparting to all beneath its sunny hues, like a fond Mother bending down to kiss the brow of her sleeping child. I thought of Mr. Cole every moment, he is truly a great artist, has chosen the right place to study; he should be called the *Prospero* of the highlands.

Went upon the railroad from Albany to Auburn. The scenery along the Mohawk is delightful. Spent a day at Auburn, visited the state's prison, saw all the convicts at work, likewise when marched in to their dinner, most of their faces bespoke the workings of a bad mind, poor fellows, truly the way of the transgressor *is* hard. We crossed Cayuga Lake to Ithaca in a new and well managed *steam* boat with every attention from her polite Captain, arriving the next morning at this modern Athens.

Here I am, where I shall remain 5 or 6 weeks or more. My health is much improved. As soon as I feel able shall commence sketching in earnest for I long to be thus employed I can assure you.

I suppose you saw the exhibition of the National Academy, they had a fine run of company and I expect have made some money. I will not trouble you with my opinion of the concern. I am no favorite with the wire

pullers that figure in the attic chambers. They hung my best portrait in a very bad light, and had it not been for a little loud talking, would have suffered it to remain there through the season. To use an expression of my late brother Henry's "There are some men whose bodies are too big for their bones—they will cave in some day."

My Wife desires her respects, and furthermore expresses her gratitude for the kind attentions that have afforded her the perusal of your very interesting production and other excellent matter which the papers contain.

The quadruple *Notion* was received just in time to convey as a curiosity. I have not heard from Stony Brook since I arrived here. Therefore can tell you nothing of Brother William.

Dont defer your visit there on account of my abscence. If you have come to the end of this letter without pausing, you must be out of breath. I shall be happy to hear from you. Direct Athens, Bradford County, Pa. With great Respect,

Your Friend
[NYHS] S. A. Mount

Norwich Conn., Sept. 25th, 1841

My Dear Mount,

You are not mad at me, are you, because I have neglected to write you for so long a time? I hope not. Please forgive me. Ever since I saw you I have been busily engaged in travelling about the country, sometimes hunting, trouting, sketching, sailing, riding and sometimes catching codfish at sea, which sport I have enjoyed to perfection. I could not manage to be in New York when the Academy was open and therefore could not see your "Cider Making" and your Brother's[?] painting. I have lately been to the city, but did [not?] succeed in obtaining a view of your picture, because the Davis family was out of town. I have just received *The Gift* for 1842, and am glad to see two first rate engravings from your pictures. "The Tough Story" and "The Raffle." The former is illustrated by an article from one of my most intimate friends, Seba Smith Esqr., the original Jack Downing. He is a Whig, *but* a most glorious man. *You* would be delighted with him. I want very much to introduce you, and will, soon as an opportunity presents. His wife, *I* think, is the most gifted female writer in this country.

Dont think, my dear friend, that the promise I made you, that I would visit Stony Brook was mere words. I am going to New York about the first of October, and will, if you say so come and see you then a short time. *That,* you know is a great month to be in the country. I am anxious to visit you, and see how you live at home, for I hope that my humble name, may in coming years *be linked with yours.* Is your brother Shepard at home, and is his amiable and affectionate wife well and happy, and the boy too? Sometime since, I received *a most delicious* letter from him dated in Pensylvania, but I have delayed answering it for

so long a time that I am afraid he has left the place where it was written. Tell me where he is, for I wish to write him.

By the way Mount, I am in love, engaged, yes beautifuly engaged, and, to one of the most lovely beings that ever lived. I have been with her a good deal of the summer, and in the country too. Such rides on horseback as we have had! Such moonlight walks, such glorious times, cannot be described in words—they must be felt.

She lives in New York City, but is a country girl. Just such an one as *we*, born of the beautiful and true, can appreciate. If I can only catch you in the city, I shall make you acquainted with her, for she knows you by reputation.

My Sketch Book flourishes. I have received a noble drawing from Eastlake of England, and also two from the great Cooper, the cattle painter. They are all magnificent.

Next week my name will be before the world as an author. Hilliard, Gray, & Co, one of the first houses in Boston, are about publishing a little volume of my "Essays for Summer Hours." I shall reserve a copy for you and your Brother. Write me on receipt of this; let me know if you "are alive and kicking," well, happy and prosperous. Direct to New York as I shall probably go down in about one week.

As ever, your sincere friend
[SB] Charles Lanman

Stony Brook, Sept 30, -41

My Dear Sir,

Your interesting letter of the 25 inst is at hand. I am not mad at you for not writing to me ere this. The sin is forgiven. I feel quite flattered that I am not forgotten.

I congratulate you on your state of mind, the change you have met with—an all over state of feeling, clear down to the end of one's toes. I have felt just so myself. Your heart now has a locality a resting place. I hope the Autumn of your life will be as rich in your memory as the past summer.

I should like very much the acquaintance of your friends, Mr. and Mrs. Seba Smith. Mrs. Smith was pointed out to me last spring, I was pleased with her countenance. Although I saw her but a moment, she appeared all animation and genius.

I am quite desirous to see you at Stony Brook this fall, but at present I am sorry to say My Mother is and has been very sick for three or four weeks past. Therefore your visit just now would not be quite as agreeable to yourself. I have written to Brother Shepard about the low state of Mother's health and he may possibly be home in a week or ten days, Though he intended to stay in Pennsylvania 'till the frost gave beauty to the Landscape. Shepard and Elizabeth would be disappointed not to meet you here. If it is more convenient for you to see me at this time than a few weeks hense, I shall be happy to see you. I am quite anxious to see your Essays for

"Summer hours." I shall prize the volume. Your early impressions.

Please let me hear from you often. I thank you for the *Boston Notion*.

[NYHS]

I remain Dear Sir
Yours very truly
Wm. S. Mount

November 4th, 1841

My Dear Sir,

I should have been delighted to have seen you when I was in the City. To use your own words, "As fate would have it, I did not know" where to find you. I only spent one day in town and had a few minutes to call on my friend Mr. Ridner and inquire after you. I had the pleasure of meeting about noon of the same day my brother Robert N. Mount; he had been absent at the South for four years. He was quite anxious to see his mother and friends. Hence my short stay in the great city. I am sorry to say I have very faint hopes of my Mother's recovery. She has been a kind Mother and is dear to her children, and I thank you for the kind sympathy expressed in your letter respecting her.

Brother Shepard and his better half has not arrived yet, from the West. They will likely be home in about three weeks. I shall be happy to see you at Stony Brook whenever you feel disposed to come. I am always ready to see a friend. I have not any pictures to show you. In fact, I have not done [illegible] painting since last March. I am pleased you have sold the Copyright of your essays as it is an evidence that the Publishers have a favourable opinion of it. The work being illustrated from your own drawings will make it doubly interesting to your friends and to the world.

I shall be in New York in about two weeks on some business and will give you a call. I am anxious to see you.

I remain as ever
Your friend
Wm. S. Mount

[HISTORICAL SOCIETY OF PENNSYLVANIA] *Mount's mother did not recover. She died on November 25, 1841 (pl. 43).*

Stony Brook, May 17th, 1842

Friend Lanman,

Brother Shepard and myself left the City for Stony Brook on Saturday morning at 7 o'clock—too early an hour to call upon you, which we regretted as we were anxious for you to accompany us home. This is to inform you that I shall remain here for a few days before I make another move, and to make known my desire to receive a visit from you forthwith—as early as Thursday or Friday of this week if consistent with your engagements. On

Friday the mail will land you here at 6 o'clock P.M.

I have some thoughts of seeing Norwich in the course of next week.

Yours truly,
Wm S. Mount

P.S. The Steam Boat Comet will leave Fulton Market slip Saturday Morning at 7:00.

[NYHS]

New York, May 20th, 1842

Dear Mount,

Early this morning I fixed up a couple of shirts etc. intending to go down and make you a visit of a day or two. Just then an easterly storm commenced, and is now raging furiously, which put a *damper* on my expectations.

I have made up my mind to go to Norwich in the Boat of this afternoon, and I wish this letter to inform you of the fact that I positively wish and expect you to make a visit *there*—sometime next week. The boats which you are to take lie at the Battery (Pier no. 1). They leave every day at 5 P.M.; landing you in Norwich, early in the morning, and within a stone's throw of my father's house. Steam Boats leave Norwich every day, so that you can conclude your visit just when you please. Owing to opposition, the fair is a mere song, 50¢ in one, and $1.00 in the other line. If you should want to sketch in oil, when at Norwich, I can furnish you with a well set palette, also with drawing paper and pencils. I know you will have a good time, and if you fail to come, I shall be sadly disappointed. Did I suppose that my going to Stony Brook would secure a visit from you, I would go down through thick and thin, through "thunder, lightning hail and rain."

When you get to Norwich, any body will tell you where to find me, or if you will let me know by letter when you leave, I will be at the wharf to meet you.

Remember me kindly to Mrs. Seabury, and Shepard and his wife. Tell *him* if he has an odd sketch or two which he dont want, you will forward them to me when you come. That notice of the Academy will not appear in [illegible] until next week. I am going to take this to the boat so that you may have it tomorrow P.M.

As ever,

[SB]

Your friend,
Charles Lanman

Norwich, June 24th, 1842

Dear Mount,

Your letter of the 13th inst was duly received, and I need not add, afforded me much pleasure. Many a time and oft, since you left us, has your name been spoken, by those who remember you with feelings very nearly allied to *affectionate* friendship. The fact is, you have made yourself beloved by every single member of our family,

43. "A Sketch of My Mother." November 14, 1841. Pencil, 7 3/4 × 12 3/4". Private collection, courtesy Kennedy Galleries, New York City

and more particularly by that portion of us who are capable of appreciating true genius and a noble heart. Maria sends you many thanks for that fine piece of music; Mother wishes you would come and spend the summer with us, delighting us with the melodious tones of your violin, and your free bold off-hand way of talking; and Father acknowledges that you have caused him to respect and honour a great Painter, as he would a statesman, a poet or a great historian. Most sincerely do I thank you for your kind invitation to go and make you a visit. But I cannot now accept for various reasons. The principal one is that Addy and her sister and mother are coming here next week to spend a fortnight or so, and I must be on hand to attend to them, and more particularly—to *her*. I should be delighted to go to Stony Brook again, and will go, I hope, some of these odd days.

Since you were here, I have finished two paintings, and commenced two others, but they are mere daubs of paint, and I am about half inclined to offer them up as a sacrifice to the genius of my Folly. I cant draw, I cant color, I cant compose, I cant do anything as it ought to be done, and I rather think I will not try again. But still, if I were to bone down to hard study and laborious investigation, I know that I could in time, produce something that would make people stare. But this it is impossible for *me* to do.

"I'd rather be a dog and bay the moon, than such a Roman."

Dont you think that fellow rather green who is criticising the present exhibition of the NA in the *Express*! *I* ought not to complain however, for he calls my picture —A Gem. Whew!! The fact is, Mount, we in this country are very much in need of one or two good writers, who can and would *instruct* the public on the subject of the fine arts. I confess to you that to become *such an one* is my ambition, but not my *chief* ambition, remember. If I could but make a trip to Europe, I would then try my brains and hand, to see what I could do.

Let me hear from you often. All wish to be kindly remembered to you. Present my best respects to your sister, your Brother S. and his wife and

Remember me as ever,
Your friend,
Charles Lanman

Why dont Shepard favor me with one of those good letters, which he knows so well to write?

P.S. I *intended* to have inserted *one* single good idea in this letter, but have omitted it for want of room. Dont take it out, but send it to the dead letter house.

[SB]

Stony Brook, Sept. 14th, 1842

Friend Lanman,

My Sister Ruth received a paper from you last evening. It was a gentle tap on my conscience for not having answered your letter ere this. The fact is, when a downeast chap gets his clamrakes on one's affections there is no escape. I have just been reading the poets Pilgramage. The Poet Boy upon the sea shore—you have never drawn a more perfect picture. Stick to nature. Seek out strange characters, sympathize with them, write down their strange eventful lives from their own lips—my word for it, you will reach the hearts of thousands.

A day on the Thames in a letter to Majr. Noah I recognised you as one of the *chowder* party with much pleasure.

I have just finished the portrait of a young Lady, from a sketch taken after death, perfectly satisfactory to the friends. I have represented the young Lady walking from and looking to the right of the spectator, with a bunch of flowers in her left hand. The Mother was so struck with the likeness when she saw it that she turned aside from the picture and wept.

She has so much confidence in my drawing that she wishes me to raise up her husband. I have other invitations to bring to light the departed. If artists were called upon in time, it would save many bitter reflections. I am pleased to think there is one thing that can soften the heart of a miser, and that is death—he makes poets and painters respected.

I am pleased to learn you are getting along so well in landscape painting. You have a strong feeling that way; cultivate it. I remember your picture of the *Canoe* with pleasure, a beautiful picture. I will thank you to give my respects to Mrs. Nickoll. She is a genius and will be remembered. How much more a Lady enjoys the world by cultivating the fine arts. In consequence, the world becomes a heaven to her instead of a tiresome place. I am sorry to inform you that my Sister is not well, she has been failing for some time. I have been trying to persuade her to visit the Northern part of Penn. She has lately been to Sag harbor and also to N.Y. A change of scene and air will do more to restore her health than all the doctors in christendom. Sister Ruth sends her respects to you. Also Shepard and Lady wishes to be remembered. Please give my love to all your family.

Yours truly,
Wm. S. Mount

P.S. Please give my respects to Mr. Hazen when you see him, tell him I will be much obliged if he will send me a piece of Music called Bennington Assembly as he plays it. Soon after I left Norwich, I sent a letter containing music to Mr. Hazen with a request for the above music. The sober second thought—you need not trouble Mr. Hazen for the music. I have it in my collection—somewhere I *guess.*

[NYHS]

114

Stony Brook, May 20th, 1843

Dear Sir,

I have just received your very pressing letter inviting me to the mountains. I must admit I should like to ramble about the hill tops with you, standing upon some rock over hanging some deep ravine and looking between our legs at the purple distance below. But I must tell you right up and down that I cant be with you notwithstanding your very agreeable manner. My Sister Mrs. Seabury is in poor health and is now preparing to leave for the northern part of Pennsylvania to spend the summer and fall. I have one or two portraits to finish, and then I shall pull up my stakes, and go, I have not determined where. Perhaps accompany my sister over the Mountains.

I was in town a few days since and heard you had left for the Catskill mountains with palette in hand.

By, the by, there is a great sensation in town among some of the Artists respecting a particular Sketch Book to be seen at Colman's. I fortunately heard of it just before I left and consequently happened in to Mr. Colman's, and, without my asking, he told me he had a pencil sketch of mine, and also some of my Brother Shepard's. I told him it was impossible—he described them all and his manner of getting them etc. Then if I could have put my grapplings upon you, we would have had one grand flourish. How you can reconcile yourself to your Brother Artists, I am not able to tell, unless you redeem the sketches, which I would do, if it took my last shirt.

The Sketch Book will not lose in value in the Colman's hands. He knows how to appreciate a work of the kind.

I shall look out for last week's *New World*—Letters from a Landscape painter by the author of "Summer Hours." Lanman, you are making a great noise in the world. Go ahead, only be sure your right.

Our Family sends their best regards.

Yours Respectfully,
Wm. S. Mount.

[NYHS]

Norwich Conn, January 23, 1844

My dear Mount,

Its a horrible gloomy day, and I feel that to have a short confab with *you* would do me more than a thousand-dollars-worth of good. I have been trying to paint, but could'nt succeed: my pencils were sticky, my colour dead, and my idea's few and far between. The paper you sent me was duly received and I thank you for the remembrance.

O that I had the ability and opportunity to manifest my regard for you as a man and as an artist. Yours is "one of the few, the immortal names that were not born to die." It sickens me to think of the many years I must study and toil, before I can stand in my department of the art, where you do in yours, even if that shall ever be my destiny. Yes, I sometimes think that the cup which others drink, the cup of fame, will never be quaffed by me, and then I turn away with a tear in my eye, trembling at my temerity in becoming a Painter. If I could execute my

imaginings I would be content, but how very feeble is the reality when compared to the ideal! I always commence a picture with gladness, but it soon begins to be insipid[?] and I loathe it. I know it is not right so to feel, but I cannot help it at the time; and how can I when the pictures before my mind are vivid as the sunshine and colored by a hand Divine, or at least by the divinity within me? But hold—"healm's a lee"—I must take another tack.

The article I spoke to you about on our Painters will appear in the *New World* this week, as I have read and returned the proof-sheets. It is'nt what it should be, but I'll try to do better in a long article which I have engaged to write for the *New Englander* of New Haven (one of the ablest Reviews in the Country) on the subject of "American Painters." *That* I fancy to be a *tall* subject and I hope to treat it as it deserves. You shall judge. Hazen told me he had some music for you, and if it is ready when I call on him this evening you shall receive it with this; if not, I'll send it to you soon. By the way, I want to know if you wont come and make us a little visit? We should all be rejoiced to see you as you know. "All things are now ready," do come, and we'll have some rare sport. Your presence in my studio would be of great value to me personally, and if you'll only come your expenses shall be all paid. To urge your acceptance of this invitation is the object of this letter, and my mother and sisters and Hazen too all join with me in begging you to come. Do come! Please come!! Remember me to Shepard. Write soon.

Truly your sincere Friend
Charles Lanman

Why wont you take the Boat on Friday night, spend Sunday with us, and (if you must) return on Monday?

[NYHS]

New York, Feb 11th, 1844

Dear Sir,

Yesterday The long looked for article on "Our New York painters," by a landscape painter Charles Lanman, Esqr., made its appearance causing a great sensation among the Artists and friends of the Artists, as much so as if you had thrown a great stone splashing amongst a flock of sleepy Ducks on a quiet afternoon. You have but in the [illegible] about right this time. A great many are inquiring about Lanman—who is Mr. Lanman. [Illegible] is a great thing, it will enable you to drop in and see the painters with as much freedom as a hawk amongst a lot of tame pigeons. I have received your very clever letter, also a newspaper and music. I think I shall visit Norwich sometime next spring and then I will call and see you; in the meantime I intend to look up some music for Mr. Hazen. I received a letter from Talbot a few days since, he is engaged painting a large Landscape. Cropsy is painting a large Landscape. I expect there will be number of ten acre pictures in the next exhibition. The engraving of Farmers nooning will be out this week, in some

respects I am not pleased with it. Please remember me to all your family. Shepard is on the Island.

Yours Truly
Wm. S. Mount,
182 Grand St., N.Y.

Paint away every hazy day.
[NYHS]

Norwich Conn., February 27th, 1844

My dear Mount,

I thank you most sincerely for the paper you sent me a few days ago. It cheers my heart to be thus remembered by those whom I esteem and admire as I do you. That tribute to the lamented Allston by Vanderlyn was just; such are the right kind of echoes to come from a painter's heart. How comes on that beautiful little sleeping creature of your pencil [c. pl. 21]? My first impression of that picture was not very favourable but I now think it a fine thing, and my attachment to it is that of a lover. I suppose you'll have it in the Academy? What else are you getting ready? For my part I intend to send *four*, two still water sunsets, one forest scene and one waterfall; and I confess that I shall be disappointed if they are not found to possess some qualities that will redeem them from the destiny of mere daubs. O it is indeed a very difficult thing to produce a good picture, but when done, it is a blessing that we can feel ourselves compensated for our pains by the conciousness that we have *created* something that may live a few days after we ourselves are gone. My forest picture is 30 by 40 inches, and, in my opinion, the best thing I have ever painted. Its a real Michigan forest and an entirely original subject; I am hesitating what figures to introduce, a couple of deer or a hunter and his dog. The fact is I cant expect to do much in my way until I have taken sketches for three or four summers.

According to my present plans I shall probably spend the coming summer among the Lakes of Michigan and the Mountains of Vermont. I would give a hundred dollar bill to have *you* accompany me, but I suppose you would act as heretofore—pass by me as the idle wind which you regard not. Spring'll be here in a few days and you must keep your promise to make me a visit. *Hazen* wants to see you very much, and so do my father (who has just returned) and mother and sisters. I should rejoice to have you come for many reasons, one of which is, that you might criticise my pictures before I send them to the Academy. Please answer this letter soon, and designate the time you will come. Tell me all the news in the world of Art.

Truly yours
Charles Lanman

P.S. The Whigs are carrying everything before them in this State and they undoubtedly will throughout the Union.

[NYHS]

New York, March 11th, 1844

Dear Sir,

I am pleased to learn from your very kind letter that you are engaged on four Landscapes. Something seems to wisper that they will do you great credit. I hope so sincerely. I look forward with much pleasure when I shall see them in the Academy. Mind, and work upon them up to the very last hour; if you see any thing that wants correcting dash it out and paint anew. Again, keep down every part of your picture, except that part which you wish to interest. Your eye will govern you. When your picture is finished and you wish to take off the effect of the paint and at the same time give a sunny warmth, go over the whole picture with raw sienna mixed with drying oil, use a rag in putting it on. You can use blue red and yellow, or any other compound in the same way. In glazing, if you wish to cool your warm shadows, use Blue or any cool transparent colour. I have taken the liberty to throw out the above hints about this time, hoping they may be of service to you.

I have lately painted a picture for E. L. Carey Esqr. called Trap sprung, a snow scene. Mr. Carey liked it so well that he gave me a commission to paint another to be called summer. I shall be very busy up to the opening of the Academy and after. I have nearly a years work engaged.

Mrs. Seabury wishes to be remembered to you, Give my respects to your kind parents and all the rest of the Lanmans.

Yours very Truly
Wm. S. Mount

P.S. Tell Hazen I think of him when I take up the violin.
[NYHS]

New York, Nov 7, 1846

My dear Mount,

Why dont you write a fellow? But hold on, that has nothing to do with this letter. Just as soon as my Mississippi book comes out I intend to prepare for publication a volume about "Our Painters" and their productions. My original list of names contained nearly a hundred, but with the advice of a certain friend I have cut it down to *eighteen* names, viz, Cole, Edmonds, Mount, Durand, Chapman, Weir, Doughty, Sully, Fisher, Harvey, Brown, Huntington, Elliott, Inman, Ingham, Leutze, Page and Vanderlyn. I think it would be better to write good articles about these men, than to write one hundred articles that would have to be somewhat superficial as a matter of course. All the artists to whom I have mentioned my plan declare themselves pleased with it and have promised to furnish me with all the material in their power.

Now then comes the jit of my discourse. I want you to send me at the earliest possible moment *all* the facts of your past history *as an artist*. I want you to give me particular answers to the following questions. Where and when were you born? How and where did you spend your boyhood and early manhood? What are the subjects of your principal pictures? For whom were they painted and what were the prices received? The truth is, I want all the information about you that I can possibly obtain, everything in the way of personal or pictorial anecdotes. I want to write such an article about you *as an artist*, as will be of sufficient value to be quoted throughout the world. All the information that you may communicate shall never be seen by any eye but my own. I only want the facts, which I propose to clothe in my own language. The interest of my book will depend upon the amount of information I may obtain from the several artists, and you must do your *duty* to me and to your country. —I say to me, because I am one of *your best friends.* Dont you bolt now, you strange child-giant man. Let me hear from you soon on this subject; tell me how it strikes you and what you will do.

I hav'nt anything new to tell you. Leutze's picture is the town talk, and truly magnificent. Where Sheppard and why dont he call upon me? The "Sketch Club" met last evening at Edmonds', I was present and had a pleasant time. Leupp, Sturges, Verplanck, Durand, and Huntington were there. Remember me to all your friends.

Your friend,
Charles Lanman

[SB]

Stony Brook, March 7th, 1847

My Dear Lanman,

Your very kind letter is at hand, containing an article from the *Evening Post* "about artists going to Europe." That's the way to talk, a little common sense now and then is greatly needed.

I have received art sketches from you at various times for which you have my hearty thanks. Artists should express their gratitude to the man who devotes his time to their benefit. Your notices of Flagg, Elliott, Cropsey, Vanderline, Durand, and Leutze, etc, shows that you speak from your own impressions. Elliott has a soul, there is nothing small about him. I saw the funny thing in the *Herald* describing Grey's picture of the "Greek Lovers"— it is certainly a tall picture notice. Grey has bottom and no mistake, if he would only work in the right way. I am delighted the Nicolls invited you to their party, and that you found it a brilliant and sociable affair.

How did you make out with your landscapes that you commenced so bravely? They did not indicate that you should throw up your hand so soon. I see by the mention of fishing tackle that you are not to be bound in by brick and morter, but a space to breathe in, where you can stand with line in hand, and witness the beauty and vastness of the Almighty's power in silence; and your belly made fat at night with a rich chowder. "A roving life is the life for me," as the fisherman said when he put to sea, and thanked his God when he hawled up a cod. I am pleased to hear that Matteson, Edmonds, and Huntington are doing something great for the coming exhibition. Durand, Cole, and Huntington are lucky men, it is a

warning to bachelors. However, we can afford it, no children to cry for bread. I shall not be able to reside in the City for some time, owing to some commissions I have lately received requiring close observation in the country, which I regret on some accounts, as the City is the place for an artist. Reynolds considered that the three years he spent in the country as so much time lost. I feel quite desirous at some future day of going to Norwich to call on Hazen, and your family, and hear your Father tell about diving after hard clams in ten feet water. The time he went on a sailing excursion. I have been roving about the Island the past week. Shepard is in New York. I should not have written this letter, only that you have been among the Indians, and I have a great veneration for a roving lad about your size. My Sister, Mrs. Ruth Seabury, sends her best regards to you. She is not in good health, having just returned from the City, where she has been for some time on a visit.

I should have enjoyed the oysters, with yourself, Mr. Fraser and Matteson. My regards to all. I remain Yours truly, Wm. S. Mount. Excuse this hasty letter.

[NYHS]

New York, April 10th, 1847

My dear Mount,

Enclosed, I send you some picture notices, one of which is particularly intended for your brother Shepard, to whom and to all your Stony Brook friends please present my kindest regards. There has been a tremendous excitement in town to day, on account of General Scott's capture of Vera Cruz. The old fellow has indeed proven himself to be a most splendid soldier. I am still devoting an occasional leisure hour to the pencil. It is devilish hard to paint even a poor picture, but what must be the labor of producing a great one! I have only been to the academy a single time since I saw you; and was then introduced to Ranney, whom I admire as a man and an artist. In his manners he is something like you, decidedly original, wearing a sort of I-dont-care-what-people-think sort of a look. Page has returned to the city to reside. I am very glad that the Art-Union have given you an order for a $300 picture. Pardon my brevity. Write me soon noble fellow, and ever remember me as your sincere friend,

Charles Lanman

P.S. I have obtained Peale's[?] notes on Study from McElrath. The book is interesting, but not what I thought it. He says nothing about American Painters going to Europe, but gives good opinions on pictures by the old masters.

[SB]

Stony Brook, April 13th, 1847

My Dear Lanman,

I have received your (General Taylor like) letter, containing "picture notices." Brother Shepard will be delighted with your critic of himself—it is very gratifying to me that you have given him such a lift.

Three cheers for General Scott. I am pleased to state that I have received an order from the Art-Union. I believe it was very much owing to your artistical pen. The price is $300. and to be ready by the first of Sept. I know you must have been pleased with Ranney's Sunny countenance.

I had a call yesterday from two beautiful Ladies, Miss Marcia Smith and her Sister Charlotte. They desired me to paint forthwith a portrait of their Mother, for their brother-in-law at Boston. I regret not being able to do it (on account of other engagements), as she is a splendid subject.

I thought Page would return to walk once more upon holy ground. I hope he will stay with us. Shepard and his wife and son are in the City for a few days. Paint away, nothing like it, no time to be lost. Perhaps you are not aware of it, but I think you are working yourself in a way to make a great deal of noise in the world.

Yours truly,
Wm. S. Mount

I am told there is a mistake in the Catalogue about the little cabinet portrait of my niece. It is put down a portrait of a Gentleman, when it should be of a Lady. Will you be kind enough to correct it. W.S.M.

P.S. I am desirous that you should write the History of the Campaign against Mexico with all the incidents, etc. etc.

[NYHS]

Stony Brook, April 23d, 1847

My Dear Lanman,

Your letter of the 17th containing art notices, I have read with much pleasure: Cole's Prometheus Bound I must see before long.

Your design of dedicating your forthcoming "book upon American Pictures" to the patrons of the Art-Union is a good thought, [and] throwing in some incidents of the association in the preface will add greatly to the sale of the work.

Do let me beg of you not to illustrate your work, with wood cuts in particular, Most of the pictures have been seen by the public. Do, for the love you have for the artists, leave something for the imagination. It is right to have your travels illustrated, there is no second hand about it, it comes from the mint fresh as a julip to the thirsty.

Perhaps you can obtain the loan of one or two of The Gift plates. In possession (I believe) of Messrs. Carey and Hart, Philadelphia. "The Tough Story," Bargaining for a horse, etc. However, they do not come up to the scratch.

I thank you for the honor you intend me. But, put money in your pocket by dedicating your book to the

patrons of the Art-Union. Leave out the cuts, unless you throw in an outline of each artist's head. Perhaps it will please some to have their mugs sketched off, and introduced.

<div align="right">
Yours truly,

Wm. S. Mount
</div>

P.S. I am sorry to say, my sister Ruth is in very poor health. She desires to be remembered to you.

[NYHS]

<div align="right">
Stony Brook, May 2d. 1847
</div>

My dear Lanman,

Your letter is at hand. I thank you for kindly noticing my picture of the "Power of Music." It is quite flattering. By using the brush, you have the advantage over other critics, on *art matters.*

I have come off quite as well as I expected from under Mr. Briggs' quill. It is singular that he will not admit that I can paint a portrait. It may be that the truth of one of my heads may have brought to his mind recollections of *mercantile memory.* Or, he may fancy that no man must attempt to paint a map but neighbour Page, nor a landscape, because Mr. Page was never gifted in that way. The fact is, he echoes the sentiments of his favorite. However, I thank Mr. Briggs for his good intentions.

Your article in the *Evening Post,* comparing "Cole and Durand," is very well got up. It strikes me that Durand never has painted distance and sky like Cole, he must be home again. I believe that if Huntington would give his time to Landscape, that he would lick both of them great as they are. Your mentioning my brother as one talked of to paint the portrait of the Mayor is gratifying. Last friday I felt indifferent. I wanted to bask in the sun, like a black snake. It kills me to be kept from the mountain air, or the sea breeze.

Yesterday I made a good haul of fish and received the thanks of those that were troubled with empty bellies.

<div align="right">
I remain Yours truly,

Wm. S. Mount.
</div>

P.S. The books you so kindly lent me I forwarded to you by brother Shepard. I have just read the great fight between Major Campton and the ferryman.

The examination of your *sketches* "by the light of a blazing fire." The old chief and his family grouped around would make a fine picture.

[NYHS]

<div align="right">
Stony Brook, May 26th, '47
</div>

My Dear Lanman,

Your letter containing art notices is at hand. I expected to see you here last week. All right, business first. Take your own time to come and see me, this week or next, but I shall not promise that I shall be at home week after next. I have been quite unwell the last seven or eight days.

Troubled with the ascarides, worms. They make hell upon earth.

I bought a white *Perch* the other morning taken out of Stony Brook Mill pond that weighed three pounds five ounces— the first that has been taken. I made a drawing of him. All you have to do when you reach here is to throw yourself in a fishing attitude.

I shall look for you every day, dont put off. Sister Ruth sends her regards.

<div align="right">
Yours truly,

Wm. S. Mount
</div>

In haste—

[NYHS]

<div align="right">
Stony Brook, August 5th, 1847
</div>

My Dear Lanman,

Your are welcome back again. General Taylor like you never writes unless you can put in a big lick.

New York is the field for your genius, where you can with a touch of your pen wake the painters to life. How pleasing it must be to haul a genius out of obscurity, like the rejoicings of the angels over the conversion of a hardened sinner. I am pleased with your art notices, they speak to the point. That must be a hoax, about "the proprietors of the London Art Union Journal" desiring to have my picture to engrave from? It must be your fun; however, it is quite complimentary anyway. I never wish to see a picture of mine engraved unless it is well done. I have been humbuged enough in that way. I am very busy and shall not be able to visit the City, to see you and Mr. Ridner, until the last of this month, then I shall have time to breathe a few days.

You must come and see me about that time befor I go to the city. My Sister is better, she sends her regards to you. She gave birth to a beautiful little venus, a week from last Monday. It weighed about eight pounds. I should like to visit Norwich once more, it is a tall place.

Brother Shepard is on the margin of the Susquehanna with his family. If you wish to write to him—direct to Factoryville, Tioga Co. N.Y. I will give you an extract from his letter dated July 25th 1847. "The weather has been extremely warm here. For that and *other reasons* I have not been able to paint until within a fortnight past. Yesterday I painted your bunch of fish, of its merits you must judge when you see it. I have also painted a small landscape."

I wish the Committee of the Art-Union would give him a commission to paint a bunch of fish, he would do it up rich, and it would add to the variety and interest of their exhibition.

Through an opening in the woods I have a glimpse of the sound, and old Connecticut, from my studio window.

Last evening I had the pleasure of seeing a very brilliant Aurora Borealis, it was in the form of three rings, arching from east to west. It was so light, that I could see my shadow. It is now raining and quite cool.

I am now engaged on a picture for the Art-Union. Give my regards to Messrs. Ridner, Fraser, and Benedict.

<div align="right">Yours truly,</div>

[NYHS] Wm. S. Mount

New York, September 7th, 1847

My dear Mount,

I did not accept your very kind invitation to make you a visit, for I had gone home to see a sick mother when your letter came; I should be delighted to go and see you now, but I am so busy that I cannot think of such a thing.

Enclosed I send you an article on the fine Arts, and also an adventure of mine which I think will amuse you.

I have seen your picture of the Novice [c. pl. 22]. I like it hugely, the expression and drawing are faultless. In one or two particulars, friend Mount, you have been a little careless. (Now dont frown upon me my friend, for you know I think you the greatest painter on the Continent) How do you manage to throw the same tone of color alike over that brick wall, that stick of timber, the underpining and the ground? Is it right? I think too that the shadows of your whites are not exactly the thing, they are too yellowish; and there is not quite atmosphere enough in the landscape. You have triumphed in the two grand features of a picture, but in color you can do better. Forgive me my dear Mount and write to me soon. Kindest regards to your sister.

<div align="right">Yours most truly,</div>

[NYHS] Charles Lanman

Stony Brook, Sept. 9th, 1847

My dear Lanman,

My nieces Julia and Maria were very much pleased with your graphical sketch of The Hermit of aroostook. The variety of incidents make it very interesting, particularly at the close. Your rushing out of the Cabin, after you had got snugly to bed. The appearance of the Hermit seated on the stump, and to cap all, the bathing, are tall bits of humour and not easily to be forgotten. It is well served up, and will be very much admired. That is right, let your eye run over nature before you touch your *pencil,* or *pen.*

I thank you for the art notices. I have seen the two pictures described. Mr. Hubard deserves great credit for his conception, "The vision of Columbus, discovering the New World." I am a great admirer of sea views. Mr. Bonfield is very happy in that style of painting.

I am pleased you like my picture of the Novice, and speak so free of it. I know in some particulars I could have improved it, and desired to take it home for that purpose, but Mr. Fraser, and another Gent, would not listen to it, said they were pleased with it as it was, that they were disappointed in obtaining a picture from me,

did not believe I would have a picture in time. It was good enough, and so on. For my part I wish it was better though I laboured honestly for the art-Union. In many respects I think it my best picture. However it will be well to leave that for others to say. Mr. Patterson, a friend of mine and a lover of painting, says that it is the most brilliant in colour that I have painted. So thinks George W. Austin. In the Novice I wished to preserve breadth and to tell my story. If figures are the principal, everything else should be subordinate depending on the taste of the artist. When landscape is primo, and figures are introduced, they are and must be secondo. See Cole's, and Durand's, landscapes in the art-Union, or look at Claude's landscapes. On the contrary look at Murillo's productions; all is sacrificed for the good of the figures. But what is the use of my talking in this way when you understand so well the principles of the art.

As regards the Art-Union. The plan of given orders, and having the Gallery free to the public is a good one, and highly approved of by the number of subscribers. I should have been pleased to have painted for the committee years ago, had they given me orders, but they could not expect me to paint upon uncertainty, when I had orders from private individuals to execute. Finally, the managers of the Art-Union appears to be on the right road, and we must give them three cheers for what they have done and what they mean to do. I expected to have found you in the City, and had you to return with me, but you done right in going to see a sick mother. I hope she has recovered her health. Never forget your parents and there will be nothing to darken your mind in after years. I never shall forget the warm pressure of my mother's hand when she was dying. It was the last pressure of approbation.

You must not fail to spend a week with me sometime this fall. Sister Ruth sends her best regards to you. She is improving in health. Please give my respects to Mr. Fraser, he appears to be a very clever man and thinks great deal of you.

<div align="right">Yours truly,</div>

[NYHS] Wm. S. Mount.

Sept. 11 [1847]

Dr. Mount,

I'm coming to the "Novice" soon. Do come and see the *"Slave."*

<div align="right">Your friend
Lanman</div>

Sept. 11th, I guess-

P.S. I'm writing a book upon American Fish and Fishing. If you want to do me a *smashing* favour, write me a long historical account of all the fish you know on Long Island.

In a darned Hurry

<div align="right">again</div>

[SB] Yours, etc.

Stony Brook, Sept. 15th, 1847

My dear Lanman,

I fear I shall not be able to give you that information on Fish and fishing which you desire. I am but little acquainted with the *historical* account of them, their habits etc. All I can do, is to give you an account of the different kinds of Fish taken here, and the mode of taken them.

The first fish taken with us is Flat fish, with hook and line (clam bait, in deep water and muddy bottom), commencing the first of March, and sometimes as early as Feburary, and continue until first of May, after which time from some cause unknown to us they will but seldom bite at the hook owing perhaps to more abundant food as the season grows warmer; they then make their appearance on a sandy bottom, when we walk into their affections with the spear, as you may have witnessed. Flounders are frequently taken with the line, also with spear after the first of May until in the fall. Flounders feed upon the heads of soft clams, that accounts for so many clams found dead.

Porgee's are taken with the hook in our harbours and bays about the first of June, and so on as late as October. Black fish are taken with the line (when dog wood is in bloom) and continue with us until late in the fall, where ever there is a rocky shore to be found. Mr. Thomas S. Griffen took a black fish last season off Crane's Neck point, north of Stony Brook, weighing nine pounds. Three Gents from the City took sixty weight of black fish (from one to four pounds each) at the above Point, the third of July last. The bait used was soft clams. Fiddlers are sometimes used but not always with success.

Blue fish are taken by troling, and now and then we hook a striped Bonito. Striped Bass are taken here in the seine. Mossbonkers in the same way in large quantity. Drum fish, Sturgeon, Ray Skate, and Sharke are taken here with the spear or harpoon.

Trout are taken in many of the streams and ponds of the Island. Occasionally, Pike, White and yellow perch are also here. A white perch was taken out of Stony Brook Mill Pond last spring weighing three pounds five ounces. If you will allow me to speak of eels, one was taken some years since in Stony Brook harbour by Capt. John Oaks, weighing 21 pounds, and was presented by him to one of the N.Y. Museums, and received a ticket of life membership.

Fish taken here with hook and line and with soft clam bait, are Flat fish, Flounders, Black fish, Porgee, Weak fish, the banded Gurnard, or flying fish, Swell fish, Black sea bass, Sheeps head, and King fish. The common Bergall are omnipresent. The tail part of the Swell fish are eaten by some but they should be skinned.

I believe many other kinds of fish visit us, if we understood the proper methods of taken them.

The Banded Gurnard (Sea Robbin, or Grunter, as they are sometimes called) are taken here in great abundance; they bite most voraciously at the hook, seldom stop to nibble and on that account no skill is required in bringing them in, and consequently not much sport is had in taken

them. They have never been prized very highly, but when boiled ~~out~~ and mixed with butter and vinegar, or made into a chowder, there are but few better Fish to my liking. When I prepare them for cooking in this way I usually skin them, which is done very readily by cutting the fins from the back and belly with a sharpe knife, then cut on the belly towards the head and under the fins in like manner until that part is severed from the boddy, then take out their entrails and commence skinning on the back which easily comes off with less trouble than the usual way of cleaning them.

I have been led to make the above remarks from seeing a work on Fish which stated they were "seldom eaten as food," which remarks I have no doubt has induced many a fisherman who has fished more for his dinner than amusement to throw them away, when he might have made a good meal out of them. They are far better than Porgees, and I think equal to Black fish, prepaired in the manner above stated. You will please give the Grunter a reputation.

Ruth, by Page, from your description I should like to see *her*. "The Greek Slave" I have had the pleasure of seeing. Your remarks about the background are to the point. When are you coming to see me? I may possibly be in the City about the first of October.

I thank you for the "Art news."

Yours very truly,
Wm. S. Mount

Dear Lanman, It runs in my noddle that if you should feel disposed to publish a chapter on spearing flat-fish—the breed will be used up and I shall have to mourn the pleasures of the past.

[NYHS] W.S.M.

Stony Brook, Nov 17th, 1847

My dear Lanman,

Since I received your letter I have been quite unwell. I endeavoured to write you on Sunday but it was no go. I *was* pleased to see by the *Evening Post* that your work "Summer in the Wilderness" had been favourably reviewed by the London *Athenaeum* and *Examiner*. I thank you for the art notices.

I should like to see Mr. Tuckerman's new work. He wrote to me for materials for a sketch of myself to be inserted in it, but I did not comply, having previously declined a similar request made by Mr. Lester. Though I felt highly complimented that he should consider me deserving of a notice. You disire me to write you something about Flat-fish, etc. In doing so, I fancy that I cannot add to your stock of knowledge upon that subject.

To those wishing exercise for their health the spearing of fish has the advantage over all others. I have derived great benefit from it. An old Negro by the name of Hector gave me the first lesson in spearing flat-fish, and eels [see pls. 44–46, c.pl. 23]. Early one morning we were along shore according to appointment, it was calm, and the water was as clear as a mirror, every object perfectly distinct to the depth

44, 45. Sketches for *Eel Spearing at Setauket*. 1845(?).
Pencil, about 4 1/8 × 4 1/2″, 2 3/8 × 6 3/4″.
The Museums at Stony Brook, Stony Brook, Long Island

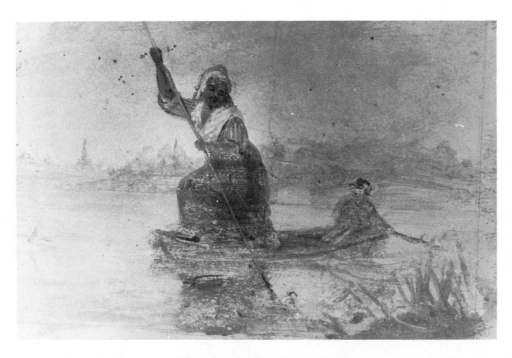

46. Study for *Eel Spearing at Setauket*. 1845. Oil on paper, 6 1/2 × 7 1/2″.
The Museums at Stony Brook, Stony Brook, Long Island. Melville Collection

from one to twelve feet, now and then could be seen an eel darting through the sea weed, or a flatfish shifting his place and throwing the sand over his body for safty. "Steady there at the stern," said Hector, as he stood on the bow (with his spear held ready) looking into the element with all the philosophy of a Crane, while I would watch his motions, and move the boat according to the direction of his spear. "Slow now, we are coming on the ground,"—on sandy and gravelly bottoms are found the best fish. "Look out for the eyes," observes Hector, as he hauls in a flat fish, out of his bed of gravel, "he will grease the pan my boy," as the fish makes the water fly about in the boat. The old negro mutters to himself with a great deal of satisfaction, "fine day, not a cloud, we will make old mistress laugh, now creep—in fishing you must learn to creep," as he kept hauling in the flat-fish, and eels, right and left, with his quick and unering hand. "Stop the boat," shouts Hector, "shove a little back, more to the left, the sun bothers me, that will do, now young *Master* step this way. I will learn you to see and catch flat-fish. There," pointing with his spear, "dont you see those eyes, how they shine like diamonds." I looked for some time and finally assented that I did— "Well, now, dont you see the form of the whole fish (a noble one) as he lies covered lightly in the sand. Very good, now" says he, "I will strike it in the head," and away went his iron and the clear bottom was nothing but a cloud of moving sand, caused by the death struggle. The old negro gave a grunt and sang out "I am a little negro but oh! Lord," as he threw his whole weight upon his spear. "I must drown him first, he is a crooked mouth, by golly." The fish proved to be a large flounder, and the way old Hector shouted was a caution to all wind instruments.

The negros here call a flounder a crooked mouth. The mouth of the flounder is placed differently from the rusty Flat-fish. Dr. Deery I believe does not mention it in his description but the engravings show the difference. When flat-fish are out of their beds it often takes an experienced eye to see them, the body being covered over with brownish or rusty spots resembling the ground or bottom. The common flat-fish are at times extremely active and wide awake, they will often turn summerset before the spear reaches them and escape, and also move along with the shadow of the boat to keep out of sight. The above are important facts, and you can arrange the materials I send you as your fancy may dictate. I commenced to day, a portrait of Mrs. Eliza Smith, the mother of Charlotte. You remember "the partridge like bosom." My sister sends her best regards.

<div style="text-align:right">Yours very truly
Wm. S. Mount</div>

[NYHS]

Stony Brook, Dec 3d, 1847

My dear Lanman,

Your pictorial letter of the 27 ult is along side, containing art intelligence. In this retired region where I have no artist to converse with, your letters are always gratefying. I often ask myself this question, am I to stay in old Suffolk Co. as long as the Children of Isreal did in the wilderness. I hope not, without visiting the City occasionally, a little oftener then I have done for the last twelve months. The loneliness and stillness here is getting to be quite painful to me. The reason is I stay at home too much. I must visit the ladies oftener, go to apple peelings, quiltings, etc. You are right, nothing like having a beautiful creature always in your eye. You say, you are in love, a good sign. Get married, and then you can concentrate your ingenious mind only on one object. Only think what a great picture you could paint having a sweet "creature" by your side to cheer you on, to wash out your brushes and smooth your pillow after the days toil—think of it. It is worthy of consideration.

I am pleased that you have taken up the brush again and are successful. You are in fine quarters. I should like to see Mr. Huntington's Art-Union picture. I believe with you that "Huntington is really a man of great talents." In landscape he is often truly delightful. How is Elliott? I admire his strength and color. I am sorry to hear of Mr. Durand's ill health. His landscapes afford me great pleasure. I wish the President health and prosperity.

I am pleased to hear that Mr. Edmonds "has nearly completed" a fine picture. His artistic talents fairly light up Wall Street.

I must endeavour to see the (great Sir Peter Paul)—the altar piece. It being a very dull morning, I took up my violin and composed a piece of music which I shall call going through the tunnel on the Long Island rail road. I think it would make the President and directors of the said road move not a little to hear it, performed on the king of instruments.

Brother Shepard is still at the west. May the Lord watch over you.

<div style="text-align:right">Yours very truly,
Wm. S. Mount</div>

[NYHS]

Library War Department
Washington, Dec 21, 1849

My dear Mount,

I know not how to begin. I am ashamed of myself. I have for a long long time neglected one of my best friends, and deserve a—kicking. Forgive me this once, Mount, and I wont do so again.

Only think of it—I am *married*, and settled for life in Georgetown with one of the sweetest and best of wives, and among the "right kind of people." I have a place under the Government which is "tip top" in every particular. I love nature more than ever, paint whenever I can, write books and if I could only have your society and that of one or two others, I should be perfectly happy. I am also connected *subrosa* with the great paper called the *National Intelligencer*, and this reminds me of what I now wish particularly to say. I intend to print a long and partic-

ular article about you and your paintings, and you must help me a little. The two or three last pictures from your pencil I have not seen, and while I wish you to send me *descriptions* of them, I also desire to receive an *authentic* list of all the pictures you have painted together with any other information which you may be pleased to communicate to one who is *sincerly* your friend. I am determined to write the article and I only want you to help me make it first rate.

I wish I could see you to talk about the art quarrels which have almost set New York on fire during the past year. Some of the folks in Gotham will find their level before 1900.

Capt Eastman came in to see me this morning. He is going to prepare a great work on the Indians etc, by order of the Government. He's a capital fellow, and he will spend the winter in Washington.

I wish *you* my good fellow to make me a visit this winter, right off, if you will. I am living with my father in law, but I can fix you off in great style, and will promise you a much "better time" than Horace Greely ever dreamed of. Now I *mean* what I say, and you must come.

Write me a long letter, and just as soon as you can let me shake you by the hand. If Shepard is with you, give him my *love* and tell him I have not (and cannot) forgotten all the beautiful things I have heard him utter about the married life. If he will visit Washington, I'll promise and send him at least thirty customers. To all those of your family who remember me, present my kindest regards. Hows your fiddle?

<div align="right">Most truly yours,
Charles Lanman</div>

[NYHS]

<div align="right">Stony Brook, Jan 7th, 1850</div>

My dear Lanman,

As you have acknowledged yourself a considerable of a *sinner*, and *repented* as a *Gentleman* ought, you are forgiven without the kicking. I am pleased to hear that you have "one of the sweetest and best wives," and among the "right kind of people." I hope your wife will sweeten your road through life. As husbands are not to be troubled with their dear better halves in *heaven* it becomes them to treat their dear *Ladies* well on *terra firma*. I sincerely wish you and Mrs. Chas. Lanman, every happiness that this good world can give. I am also delighted that you are situated to your liking under Government. It is impossible at this time for me to accept of your kind invitation to visit Washington. No—No—I am doomed awhile longer to my native isle. I know that under your guidance I should have a tall time.

As regards materials about myself, I have been asked by three or four different authors lately for information respecting myself. ~~I have declined for the present~~. I have not time to think on the subject at present, I am too busy. As you request I will mention with pleasure, two or three of my last pieces. "Turning the Leaf," "Farmer whetting

his scythe," "The Well by the wayside," and "Just in Tune." The last represents a *character tuning his violin*. The size of life, on Canvass 25 × 30. It is owned by George J. Price, N.Y. It is to be published by Goupil Vibert & Co and has gone to Paris to be engraved the size of the original by the celebrated *Emile Laselle*. Boys Trapping—painted for Chas. A. Davis of N.Y. in 1839—is now in Paris under the magic hand of Leon Noel, and then both of the above pictures, after serving the purposes of the engraver, are to be exhibited in the ensuing collection of paintings at the Tuilleries.

I have painted at intervals about fifty pictures besides portraits. I have frequently been paid more for my pictures than the price asked. I have often spent days and weeks and months without painting. There is a time to think, and a time to labour.

I have never been abroad— The late Luman Reed of N.Y. desired me to visit Europe at his own expense. Jona. Sturges Esqr. N.Y. has made offers of friendship if I desired to visit Europe. Messrs. Goubil Virbert & Co. have very kindly offered to furnish the funds if I would spend one year in Paris, and paint them four pictures. I have a plenty to do, and I am contented to remain awhile longer in our own great country— ~~at the same time besides~~ I have always had a desire to do something before I went abroad. Originality is not confined to one *place*, or country, which makes it very comforting to us Yankees—thank God.

Have you seen the engraving from my picture by Leon Noel, companion to the "Power of Music," called "Music is contagious," it is a very lively print.

If you will let Wm. Schaus know your address perhaps he will send you one, or both of the above engravings. ~~from my pictures~~. Schaus was enquiring about you when I was in the City. Brother Shepard is in town. I shall write to him or see him in about 10 days time, and talk about Chas. Lanman.

Sister Ruth is blessed with a fine boy, about five weeks old. You must come and see me next spring.

<div align="right">Yours very truly,
Wm. S. Mount</div>

Mrs. Seabury sends her best regards.

[NYHS]

<div align="right">Stony Brook, April 20th, 1850</div>

My dear Sir,

Last week I had the pleasure to see Mr. Vanderline, he is a painter of eminence and deserves encouragement from his native state, and the world. I am pleased that he is engaged painting a whole length portrait of Gen-Taylor for the Common Council of New York. They should do themselves honor by giving him one thousand dollars for the painting, but instead of that sum they only grant the *author* of "Caius Marius" five hundred dollars, so I hear. I hope you will pay Mr. Vanderline every attention and raise your pen in his favor.

Lanman, if you could write Vanderline's biography, it would immortalize you—he is a man of close observation, and is rich in materials. He is just the man for you, if you have the genius to gain his affections. I will take one copy.

The new rooms of the National Academy show off well. The large room, no. 1, contains about 84 pictures; 2 room, 77; 3d room, 88; and the 4th room 124 pictures—in all 373. One room is devoted to busts and statues, mostly of H. K. Brown. Bracket has one bust only, of Washington Allston, but it is very like. J. Mosier, one piece. The Star Gem'd Aurora Bust of Phillip Karney, by A. Piatti. Bust of Gen. Scott, by J. J. Ives, good. Brown has 13 works. *In all* 17.

We turned off in consequence of the marble room, nearly one hundred engravings, drawings and paintings, etc, and fine works too.

In portraits, Elliott is as fine as ever. G. A. Baker has improved greatly in portrait, so has Brother Shepard, and Thom Hicks. J. F. Kensett, F. E. Church, and D. W. C. Boutelle have done well. T. A. Richards is marching onward, Durand hits off Bryant's "Thanatapis," Regis Gignoux presents us with a fine snow scene, etc. Your picture of the Mountain Lake is in the Gem room, close by my picture Reading the Tribune, or News from the Gold Diggins.

<div align="right">Yours truly
Wm. S. Mount</div>

The National Academy of Design, no 663
Broadway, opposite Bond Street.

[NYHS]

<div align="right">Washington, April 25, 1850</div>

My dear Mount,

I received with great pleasure your letter from Stony Brook. All that you say about Mr. Vanderlyn is true. He is indeed a man of superior ability, and as has been the case for several years past, I shall continue to help him, with my pen, whenever I can.

I thank you for those items about the Academy Exhibition. I shall not have an opportunity to feast upon it until about the middle of June, at which time I hope to be in New York with my wife, on my way to Lake George. And now in view of this plan, I want you to make me a promise, say that you will join me at the time specified, and help me to kill a few trout in Lake George and along the Upper Hudson.

I have heard a good deal about your picture in the Academy, and long to see it. That thing of mine was painted nearly a year ago, and I am doing better things now-a-days. I paint about two hours every day, from 5 to 7 A.M. and from 3 o'clock until night, I generally take a ride or go fishing. Three miles and a half from my residence on the Little Falls of the Potomac, and there I have splendid times catching white perch and rock fish or basse. I am going out this afternoon, and would give a "ten spot" if you could be along.

By the way, I have some good news to tell you about my "Scrap Book," which Colman got away from me, and which I could never get back. I tried hard to buy it, at any price, of his brother some weeks ago, but could not as a whole. A portion of the sketches and some of the very best I did secure, and am now hoping to get the whole. My collection, as it now stands, is very rich, and it will be a long time before they slip from me again.

I am glad to learn that Shepard is doing well. He is a noble fellow, both in heart and mind, and I trust I shall yet have a good opportunity to do him justice with my pen. He has'nt a better friend in the world than I am to him, and I should be very much pleased to have him write me a long letter. Give him my fondest regards and tell him so.

I have a new book on the carpet, which will be published in England.

Glad to hear that the Academy has taken a new start. I am on good terms with the Art-Union (including for a wonder, the new President, whom I have occasionally made a little mad) but I think it a poor concern as now managed. A very clever fellow, residing in Georgetown, by the name of Boggs sent on some months ago two very good pictures to the Art-Union, and the other day was informed that the pictures *were not wanted,* the Committee not condescending to give a reason. His means are ample, but this shabby treatment has disgusted him, and he will prevent hundreds from subscribing to the miserable concern again.

But enough—Business calls. Write me soon and know that I am as ever,

<div align="right">Your sincere friend
Charles Lanman</div>

[SB]

<div align="right">Stony Brook Suffolk Co
Long Island
Feb. 29th, 1852</div>

My friend Lanman,

I have just been looking at Wilkie's Blind Fiddler, line engraving after Burnet. A present from somebody. After you have rested from your tour to the noisy City of New York, in company with the noble hearted Webster, I wish you would step over to the patent office and see if my violin has arrived. Mr. Francis H. Upton, 72 Wall St. N.Y., informed me that it should be forwarded to (Washington) the patent office the 23 inst. I will thank you to use your influence with Mr. Thos. Eubank and Dr. Gale to facilitate my procuring the patent.

All your friends here are delighted to hear from you. Shepard wishes he could have met you in the City. Please drop me a few lines.

[Sketches of violin and bridge; pl. 47]

Quite a number of the Editors both on the Island and New York City have spoken very favourably (of their own accord) of my new violin. Mr. Chilton has not an-

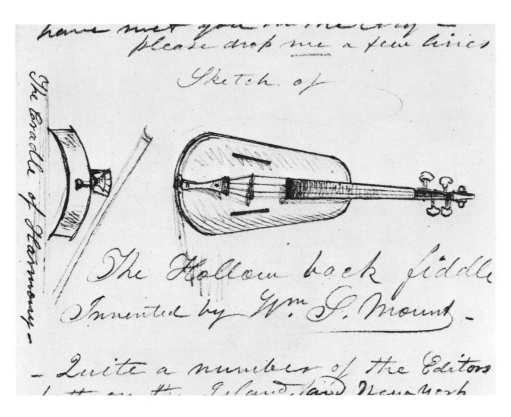

Sketch of

The Hollow back fiddle

Invented by Wm. S. Mount.

The Cradle of Harmony.

47. "The Hollow back fiddle." Letter WSM to Charles Lanman, February 29, 1852.
The New-York Historical Society

swered my letter, please give my regards to him. Give my regards to your Lady and believe me yours truly,

Wm. S. Mount

[NYHS]

Stony Brook, May 3d, 1853

My dear Sir,

Please concentrate your mind, and bring before you in his most happy moments the form and face of your late and noble friend the Hon- Daniel Webster. Tell me if he exposed his upper or lower teeth, or both while talking, or speaking; also, if they were large or small. You know that when a man speaks he moves his under jaw, the upper remains quite firm, the same when he laughs. Let me know his height, the color of his skin, eyes, hair, dress, style of shoes, or boots, his manner of standing while making a speech, if he used his arms and hands much and on which side he dressed his pantaloons. As you are a close observer and a painter, you can describe his manner to the life. A friend of ours wishes me to paint a whole length portrait of Mr. Webster, in the attitude of speaking. If I should be successful you will know more about it. Had I accepted your kind invitation, and stopped with you last July at Mr. Webster's residence, my recollections of him would have been strong. However, I had the pleasure of seeing him at the Cooper festival, and also at the City Hall N.Y. a few years ago. He appeared uneasy and walked back and forth the court room like a mad bull.

Your landscape in the wilderness, Brother Shepard

thinks with me that it is an improvement. Study in the open fields as much as you can with your brushes and pigments.

How comes on the Washington Monument. I do not fancy the design. It looks like a hundred legged bug, running away with the pillar, or a bunch of candles hanging down, or a white wash brush, standing ready for some giant to take by the handle and clean the streets of Washington [pl. 48].

Please give my regards to Mrs. Lanman. I expect to be in New York in about a week or ten days.

Shepard desires to be remembered to you.

Yours truly
Wm. S. Mount

P.S. I have lately made a *hollowback* violin, having concavity of the sides as well as *the back*. The tone is powerful, and soft, it has the mellowness of the ordinary violin of fifty years old. It is an American violin, for Brother Jonathan to play upon.

[NYHS]

Washington, May 5, 1853

My dear Mount,

I was very glad to receive your letter, and the first thing I have to say to you is this: I have three or four daguerreotypes of Mr. Webster (one the last ever taken of him) and if they can be of any service to you, I will cheerfully lend them to you. His height was nearly five feet 11 inches.

How comes on the Washin
I do not fancy the desig
hundred legged bug run
pillar. —— or a bunch
down, or a white wa
ready for some Gi
the handle and clea
Washington —

Please gi
Mrs. Lanman — I expe

48. Washington Monument. Letter WSM to Charles Lanman, May 3, 1853.
The New-York Historical Society

His eyes were a very dark brown, deeply sunken and large with heavy brows. He had small hands and feet, and was slow and methodical in all his movements. His hair, formerly very black, was latterly a dark iron gray. He had fine teeth, and when he laughed, sometimes looked fearfully. I cant describe the action of his mouth when speaking. For full dress, his affections were divided between a blue and brown dress coat, with velvet collar and gilt buttons; pantaloons black, and white silk vest; shoes, patent leather, low, and socks silk and cotton, generally figured. Always carried a white pocket handkerchief, and wore white kid gloves. His undress clothes were of every color and description.

Give my love to Shepard, and when you see Richards, ask him why in thunder he dont send me a catalog of the Academy. *What is my picture worth?*

Yours as ever, most truly,
Charles Lanman

[Notation made by Mount on the envelope:] Active Webster, social pleasant man—not the sleepy Webster as many will have him.

[NYHS]

126

diaries 1843-45

Mount's surviving diaries run from 1843 to 1868, the last year of his life; he had probably kept similar records before 1843 as well, but these are lost.

The letters, obviously, reflect Mount in his relations with the outside world—as artist, as amateur musician, as inventor, as citizen and Democrat, as professional Long Islander and a member of the old Setauket families of Mount and Hawkins. The diaries, on the other hand, take us into Mount's private world with its endless, at times almost monstrous, interlocking anxieties.

At the risk of repeating some assertions in the Appreciation and Foreword, I should like here to suggest what those anxieties were.

To begin with, the diaries are full of self-exhortations to labor longer and more effectively. No matter how much in command of his metier Mount may have felt himself to be, he never overcame his sense of inadequacy before the challenges of his profession. He was also perennially worried about his personal environment—city versus country—and its effects on his work and his reputation. His health bothered him, and his journals provide us with a gruesome, encyclopedic guide to nineteenth-century folk medicine. Amateur psychoanalysis is a dangerous game, but it is difficult to resist the conclusion that all these things add up to a significant syndrome. They are different aspects of a central insecurity.

The diaries also served Mount as a forum for dialogue with himself. They embody his feelings about events of the day, both personal and public, and they keep tabs on the progress of his hobbies, such as boat-building, fussing with his portable studio, and recording the weather. (This last hobby became an obsession with Mount toward the end of his life.) Among the events of the day that particularly concerned him were the annual exhibitions held at the National Academy of Design (of which he and his brothers, Henry and Shepard, were proud and active members) and elsewhere in New York City. Mount's diaries—and, to a lesser extent, his letters—are in fact a hitherto unworked mine of firsthand information about innumerable painters of the nineteenth century. Many of these—Cole, Durand, Elliott, Vanderlyn, Ranney, Bonheur, Leutze, Allston, Eastman Johnson—are well known today and need no identification. Others are obscure, but their identity as artists is clear enough from the context in which their names appear, and in almost every case details about them can be obtained from such readily accessible sources as *The New-York Historical Society's Dictionary of Artists in America, 1564–1860* or *Artists of the Nineteenth Century,* by Clara Erskine Clement and Lawrence Hutton. Here we restrict ourselves to identifying notes for those individuals who played some role in the life of William Sidney Mount.

Above everything else, Mount's diaries are concerned with the physical technique of painting: the properties and uses of pigments; the special qualities of varnishes, solvents, brushes, canvases, and wood panels; the lighting of studios; and so on. But from this concern arise both a difficulty and an embarrassment.

Every biographer of a man of great learning or exceptional competence in a complex technique must come to grips with the fact that what interested his hero most is likely to be an incomprehensible bore to the casual reader; this problem becomes all the more acute when the biography is presented, as is this one, through documents. The technical material in this book is less than one-fifth of that which Mount set down, and, as indicated in the Foreword, it was selected because of its possible usefulness to contemporary art historians and restorers. The technical material included here is admittedly somewhat redundant; but redundancy is of the essence of the Mount documents, and not only with regard to technique. To pare them down too much would destroy their character. Besides, some of Mount's most original and remarkable observations are surrounded by variations on familiar themes, and they should be discovered in their proper settings. Occasionally—far less often than one might think—information from the letters will be repeated in the diaries, and in a few instances we have found it desirable to preserve that repetition.

One extremely interesting aspect of the diaries is their lists of possible subjects for paintings; this is as close as Mount ever comes to writing about people in general and their daily activities. One might expect a great genre painter to be a great people-watcher and, if he were given to scribbling, as Mount was, to jot down some of his observations of the human scene. But Mount never does this; his diaries indicate that technique interested him—or bothered him—far more than subject matter. Only a few of the possible subjects in the numerous lists thereof were ever realized on canvas. When he had painted a picture embodying a subject from one of these lists, Mount would go back into the diary and scratch its title through. These scratchings have been preserved here.

A final comment on the diaries:

Mount's endless self-castigation—*Do more! Do better!*—can easily be seen as an expression of what is now popularly called the Protestant Ethic, which dictates that man justify existence by virtuous labor. But Mount, like Krimmel, Edmonds, Woodville, Bingham, Clonney, and all the other American genre painters of his time, depicts a world, contemporary with his own in dress, manners, and setting, where practically no one ever does anything worthwhile. His work consisted of painting other people defying work, and it is scarcely a wonder that he got a little of the message himself. When he died, George Templeton Strong, for whose father Mount had painted his now-famous *Eel Spearing at Setauket,* recorded that for twenty years he had been living in Eastern Long Island, "that paradise of loafers, and amusing himself and his friends with his fiddle and his pencil sketches." But Templeton Strong didn't get the point of *Eel Spearing,* either.

A post-final comment on the diaries:

Only two of them survive intact. One, known as the Whitney Journal because it once belonged to the Whitney Museum of American Art, is at Stony Brook. The other is at the Smithtown Library. The rest were "preserved" by persons unknown in a manner which, through the exercise of charity, may be described as wildly eccentric.

Not long after Mount's death, these diaries—anywhere from twelve to twenty small books—were laid open on a table, one inside another, and sewed together at their spines; then they were closed, and this grotesque, unwieldy onion was tied shut. Over the years the paper disintegrated under the pressure of the amateurish binding and tying; pages, whose precise location in chronological sequence would have been very difficult to determine under the best of conditions, came loose, and when the package was opened, we were presented with nearly a thousand higgledy-piggledy sheets to decipher. Fortunately many of the entries were dated at their start, and their continuance on subsequent pages could often be determined by context; when the context was obscure, handwriting, colors of ink and paper, and breadth or thinness of pen line helped out, but to this day the precise order of events in these diaries has not been completely determined. The difficulties involved in establishing chronology were compounded by the fact that Mount followed no rigorous system in making his entries; observations made years apart are often found on a single sheet.

The diaries are full of small drawings. We reproduce those which offer some pictorial interest. Many are unilluminating diagrams of floor plans for studios or for the winter covering of boats; others are hazy sketches of clouds or rainbows made in connection with the meteorological records which became a genuine obsession with Mount toward the end of his life. These we do not reproduce, but their existence is indicated by the word *sketch* in brackets.

A.F.

New York, Nov 26, 1843

Rent for a room and bedroom of house, No. 44 Vesey St., from Oct 26th 1843 up to first of May 1844:

Paid	$60.00
For altering a window	13.00
For cleaning room	1.00
For one air tight stove	10.81
One table	1.50
Three chairs and a stool	3.75
One cot	3.00
Straw mattress	2.00
	95.06
Board	60.00
	$155.06

"Entire application: Little can be done well to which the whole mind is not applied." ——Johnson.

Some good hints to the student on the subject of painting: In the Laboratory or School of Arts, by G. Smith, Vol. 2, London.

"Truth will triumph— Unite skill and industry."

Perseverance is my motto.

"Knowledge and ignorance: The man of knowledge lives eternally after his death, while his members are reduced to dust beneath the tomb. But the ignorant man is dead, even while he walks upon the earth: he is numbered with living men and yet existeth not." ——Arabian Author.

Done some painting in N.Y. 30th Nov, 1843.

N.Y., May 23d, 1844

I must paint pictures in the country. Practice daily or every other day—move from place to place and mind my own business. Paint, Paint. The cry is—Why dont Mount paint more pictures. No Portraits. Pictures will be remembered and hauled out; when portraits will be forgotten, except of great men. The City is not so good a place for study as the country, more time and quiet for reflection in the latter place.

Verdigris green is durable with respect to air and light, but moist and impure air changes its colour, and causes it to efflorese or rise to the surface through the oil. In varnish it stands better. Some artists make use of it in painting landscapes. Also Indigo, or Indian blue. It is of great body, and glazes and works well both in water and oil. It is injured by impure air. Not good with white lead.

To paint Sky—time about sun down. Colours to be used—Naples Yellow, Platena Yellow, vermillion, Permanent Blue and Blue black. To begin, mix Naples and Platena yellow or lemmon yellow together. Mix vermillion with the above yellows to make an orange, then a tint of red and white, Blue and white and Blue black and white. Go over the whole sky from the Horizon up with Naples yellow. Then with a delicate mixture of blue black and white with the orange tint, paint nearly the whole sky up, and top off with blue mixed with the blue black tint. For the clouds near the horizon mix the red tint with the orange; for the clouds, more elevated, put on Naples Yellow and rub the canvass base if it should be red, to make shadow at the time you paint the uper clouds. Touch in now and then red and white with the sky tint, according to your taste and feeling.

The colour of the canvass—red or salmon colour. The sky to be done at once painting. The clouds are some times dark above and light below or dark next the horizon and light above.

I must not have any relations as models, they do not work well.

[October 13, 1844?]

"A young man may bring himself to revolt in feeling at a lost hour, as if it were an unpardonable crime; but he must watch himself hour after hour, and every night before going to rest, balance the accounts of his day's employment.

"Study the great works of the great men for ever, but never as a substitute, always as an assistant, to nature.

"If you have genius, industry alone will make you ready for its inspirations; if you have not, industry at least will give you knowledge." ——Haydon.

"The Ecce Homo of Correggio in the Colonna palace: The Shadows are entirely lost in the ground, perhaps more by time than they were at first." All the shadows in the works of the Carracci, Guerchino, and the Venetian school, are made with little colour but much oil—drying oil, composed of red lead and oil.

Oct. 13th, 1844

In painting use clear colours when you can—not much white lead. Naples yellow instead. Sky at sun set—Light madder Lake red; sunrise—Indian red and or vermillion; distant mountains—use orange mars with sky tint, or burnt sienna and raw sienna mixed together in place of Orange mars.

The most distant mountains—use the most delicate blue and white and red tints and yellow as may be. For glazing—Mummy, Madder Lake and cobalt blue, burnt sienna or Asphaltum for [illegible]. Asphaltum can be used with black Umber, burnt sienna etc. etc. for body colour.

Oct. 1844

A Landscape to be rich should have as pure colours as possible, and of a low tone. The foliage should have its peculiar lights and reflections, reflection from the ground or sky. Particularly in shadows. Foliage must have local colour light and reflection from the sky or clouds or surrounding objects. If the leaves are red or brown the lights should be of a light purple colour, etc. The play of light should be in keeping with the colour of the leaves or whatever the colour may be. "That this is painted in sized colour, and coated with hard varnish."

Sun Lit—first, Naples yellow; second, red, yellow, and white, blue and white with the yellow or orange tint. The sky softened with the end of a large brush. The clouds and distant mountains painted at the same time, markes of the brush left. In painting landscapes the colours to be used pure, whenever it is possible.

Begin a portrait by painting in the hair and shadows of a face first. You can mix wheat paste with your colours.

Sun nearly down—Three trees in the fore ground in shadow. Oak leaves red, sedar dark brown, Pine green—good effect of colour.

Nov. 25th, 1844

I think on some accounts I had better spend the winter in New York City or vicinity. I should be more stimulated by seeing pictures and artists. The difficulty of getting models is one reason; a change of scene is also requisite to an Artist.

Stony Brook, Nov 1844

Flesh palette—first Krem white, then stone Oker. For Yellow—stone oker and burnt sienna. Raw sienna, vermillion, Lake, burnt sienna, burnt umber, and blue black and sometimes blue. Asphaltum, Mummy or Vandyke brown, for finishing.

To begin, mix the two yellows together, one softens the other—the same with reds. Vermillion and burnt sienna mixed together makes, with white, a beautiful flesh tint. Then ocher and vermillion, do [ditto]. First the yellows in gradation; 2nd the reds in gradation. One tint of Lake and vermillion. Then blue black or Ultramarine in gradation. Burnt and raw sienna together, black and vermillion, do—in gradation. Naples Yellow can be used in place of Ocher. Asphaltum can be mixed with all the transparent colours to advantage. Asphaltum and umber —do—and black works well together.

The only copy I ever made from a portrait was of a Lady by G. Stuart. I found no other blue but blue black for the gradations. I made use of a piece of drift coal which I picked up on the beach for my blue black. For Grey in flesh, Ultramarine ashes is spoken highly of. The above portrait I painted last winter. To paint light on hair, blue and white, black and Lake.

In painting shadows—shuch as under old Cow sheds where there is boards and board fences in shadow—use burnt umber ground very fine, Naples yellow, blue, burnt sienna and Lake. No white used except where the sky is seen through the fences.

Naples yellow or pure white glazed over flesh in shadow has a good effect. Also white subdued, over linen or a muslim shirt.

Colours should be ground every day before setting the palette.

I improved a sky and distant mountain by passing over it when dry, a thin glaze of Naples yellow and a very little Ultramarine blue and Madder Lake; it had a retiring and natural effect. A half shade tint for flesh, Burnt and raw sienna, black and white, or lead tint mixed with the above.

Dec. 1844

SUBJECTS

Two lovers walking out.

Walking out after marriage, one after the other, after the manner of Jude and Sam.

The husband two months after marriage, with a bag of grain on his shoulder going to mill.

A Whig after the Election.

A Clergyman looking for a sermon at the bottom of his barrel.

A Negro fiddleing on the crossroads on Sunday.

Kite broke loose.

Claming and fishing.

A Farmer feeding hogs.

Officeholder.

Croton Water.

Land Mark, or strengthen the Memmory.

Creeping for a wood chuck.

Please to give me a penny.

Cold victuals.

Blowing rocks.

A Group listening to the Grand Spy.

~~Have you an ax to gring (Who'll turn grindstone).~~
~~The Tribune in the Country.~~

Curtain lecture.

A poor widow about to part with relics of better days in order to supply bread for her starving Children.

Entertaining a Clergyman.

Boys listening to an old Veteran fifer.

A short history of Mr. Dignity.

Camp Meeting.

Last of the Montauks.

A poor Artist sketching his foot, while his wife is busy washing *his* shirt.

Stony Brook was Wopowog.

An effort to reach anenemy.

"An opinion about marriage: A wicked bachelor said once, that no matter whom you married, you would find afterwards you had married a different person."

"Many artists, by copying others, have so far lost the originality of there own style, that their works are with difficulty ascribed to the right owners. The great masters occasionally changed their styles, sometimes from an indifferent one to another much better, and at other times from a good style to one much inferior."

mr. dignity

This curious document, at the New-York Historical Society, is unique among the writings of Mount. It appears to be the scenario for a narrative sequence of no less than thirty-three paintings. The title, *A Short History of Mr. Dignity,* had appeared, without elaboration or explanation, in a list of possible subjects entered in Mount's diary in December, 1844; obviously, he had been thinking about it for some time, and now, two months after the diary entry, he works out the theme on paper. That, however, seems to be all he did. There is no evidence that any of the thirty-three pictures were ever painted.

A.F.

Stony Brook, Feb. 9th, 1845

A Short History of the villiage School Master Mr. Dignity. First, he is taken a view of the residence of a private family where he is to take board. 2d His first dinner with Mrs. Foster who has two daughters. They interest him so much as to take his appetite away. 3d He takes a view of his lodging room and library. 4th Mr. Dignity, feels a curious sensation creeping within him as Miss Foster plays upon the piano. 5th He grows jealous of Mr. Kingfisher, Miss Foster's teacher as he directs her fingers. 6th Mrs. Foster discovers a strong atachment between her eldest daughter Julia, and Mr. Dignity. 7th A scene when Mr. Kingfisher has to stand back, rather jealous. 8th he is not suffered to tune the Piano any longer. Mr. Dignity has something to say about it. 9th A rural landscape where Mr. Dignity and his love are observed accidently by and old negro and a boy. 10th A day or two after, Mr. Dignity blows up the old servant for watching him, whereupon the old negro with great indignity at the thought tells him he needs watching.

11th Mr. Kingfisher calls on Miss Foster and is informed that she is not at home. 12th Mr. Dignity is about to throw the piano out of doors, aided by his love. 13th Mr. Kingfisher calls upon Mr. Godone, Miss Foster's Uncle and relates the treatment he and his piano-forte has received at the Mrs. Foster's. 14th Mr. Godone, finds Mr. Dignity so officious and insolent that he threatens to knock him him into a kocked hat, much to the satisfaction of Mr. Kingfisher. 15th Mr. Dignity, showing himself off on horse back in front of Mrs. Foster's. 16th The Miss Fosters cling to him stronger than ever, he has both of his arms around their necks while seated on the sofa. 17th The whole family regard him with wonder and admiration. "That one small head could carry all he knew." 18th Mr. Dignity is on his way to take a school some distance off. 19 In the meantime a tall cousin returns from a whaling voyage and delighted to find his cousin Miss J. Foster not married declares himself and tells her he left home on her account and she is perfectly delighted and captivated and declares she loves no one else, dont no [know] any body else. 20th the whale man etc. he departs with full assurance of her love towards

him, to seek his friends in the west. 21 In the interum Mr. Dignity has been made acquainted about a rival in the field, he run walks at the rate of ten miles an hour, exhibits some tall walking and pays his accustomed visit. 22 Miss J. Foster would not go in to receive him. 23 Her Mother desires to know her reasons and Miss Foster explaining herself, then a great time takes place in the camp. 24 Mrs. Foster and her daughter Jane cries and pleads for Julia to go in and receive him, Julia declares she cannot after seeing the whaleman. 25 Then her Uncle stretches forth his hands (after the manner of St. Paul) and tells Julia to go in and see Mr. Dignity and to tell him that you love another, and you will never regret it, which she did. 26 Miss Julia Foster tells Mr. Dignity that she loves another.

27 Then Mr. Dignity sets to crying with Mrs. Foster and her Daughter Jane about the coldness of Julia. 28 Then Mrs. Foster sets her wits to work and at the lone hour of midnight seeks the bed of her daughter and weeps for her to receive and call him back, Julia to save her mother's life consents to discard the whaleman (for whom she decared she loved better than any other) and take back Mr. Dignity. 29 At the news of his success Mr. Dignity gives his scholars a holyday. He stands in the school house door with letter in [hand?] smiling at his good luck as the children are cutting capers. 30 The wedding. 31 The grand dance in the kitchen on account of the long nails in Mr. Dignity's boots. 32 He offers up a prayer in the bridal chamber. 33 Six months after marriage. The end.

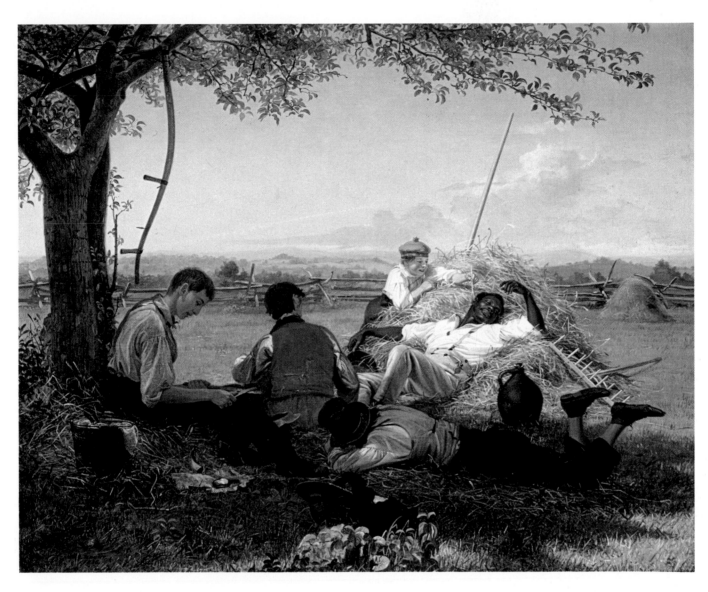

18. *Farmers Nooning*. 1836. Oil on canvas, 20 × 24″. The Museums at Stony Brook,
Stony Brook, Long Island

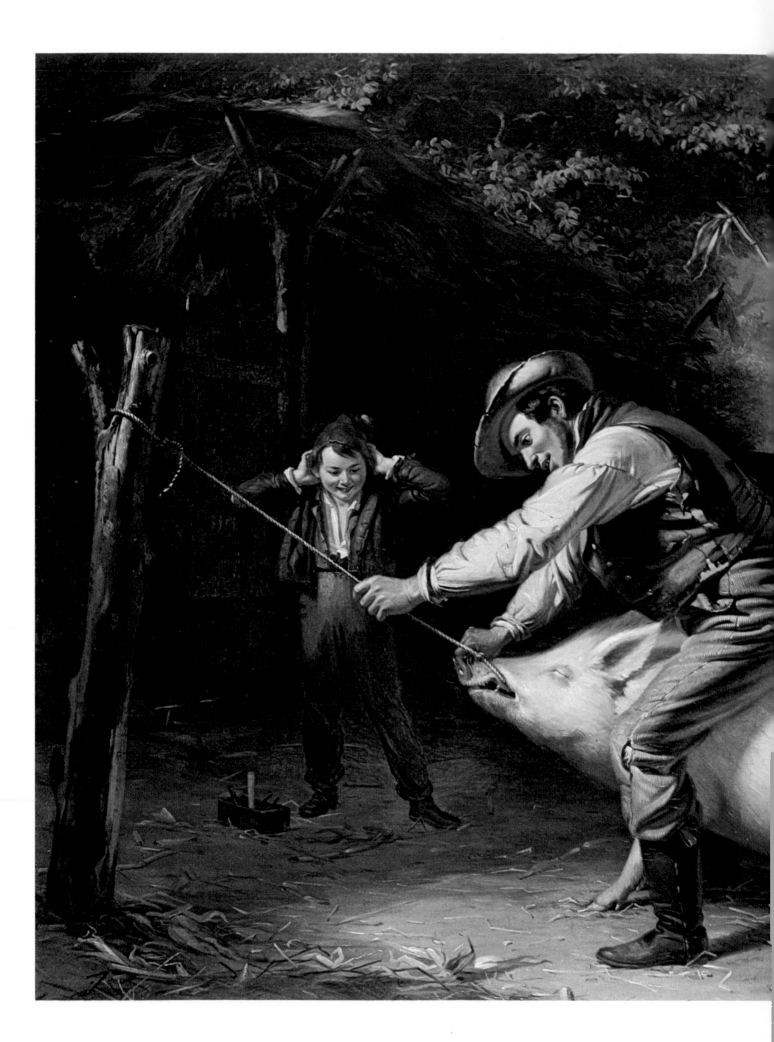

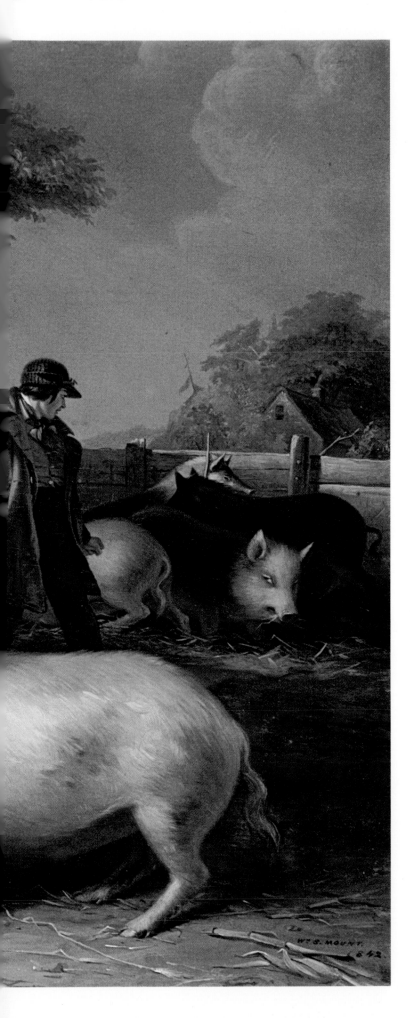

19. *Ringing the Pig (Scene in a Long Island Farm Yard).*
1842. Oil on canvas, 25 × 30″.
New York State Historical Association, Cooperstown

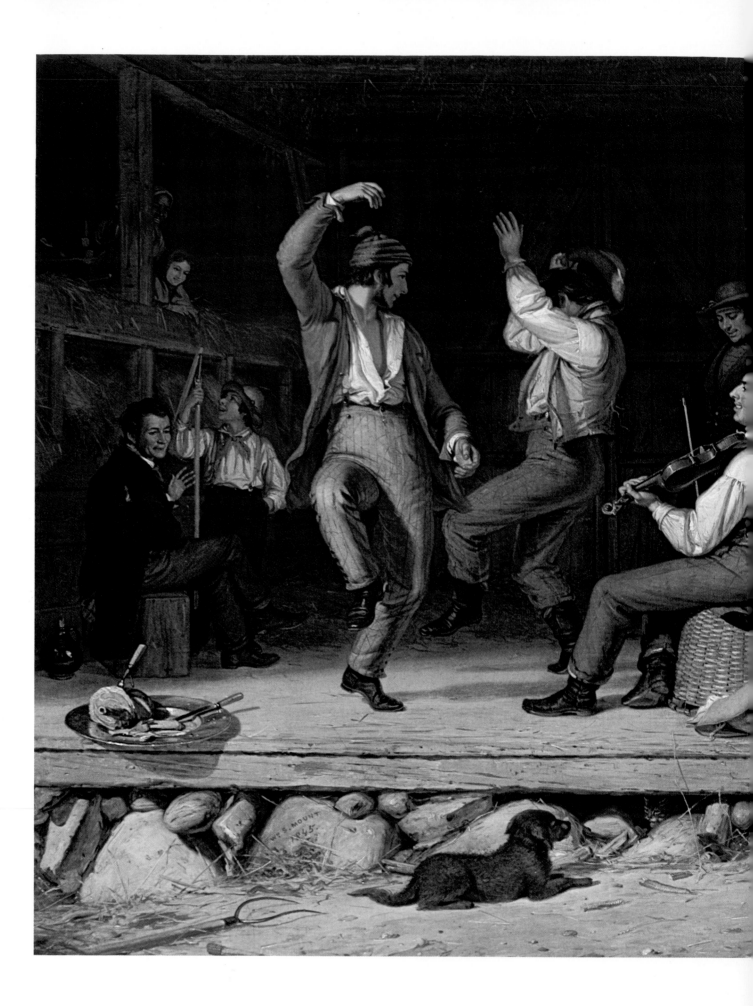

20. *Dance of the Haymakers (Music Is Contagious)*.
1845. Oil on canvas, 25 × 30″. The Museums at Stony Brook,
Stony Brook, Long Island

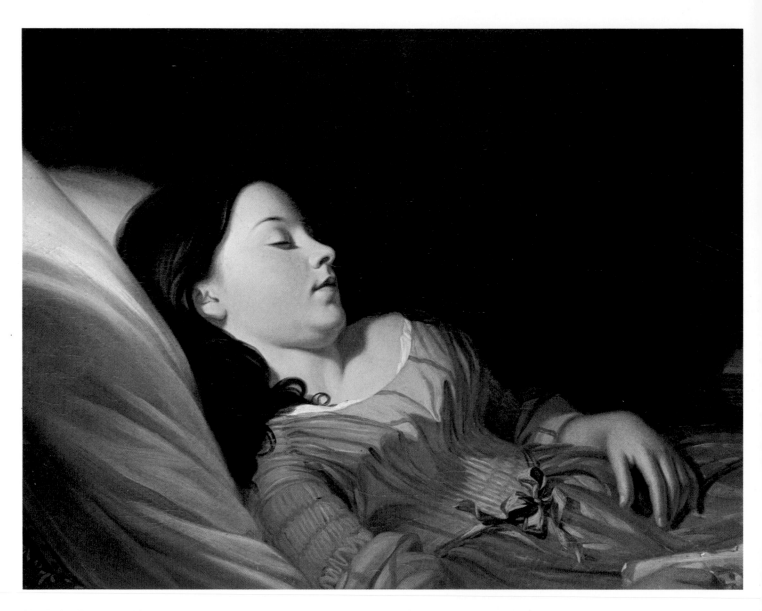

21. *Girl Asleep*. 1843. Oil on canvas, 22 × 27″. The Museums at Stony Brook, Stony Brook, Long Island

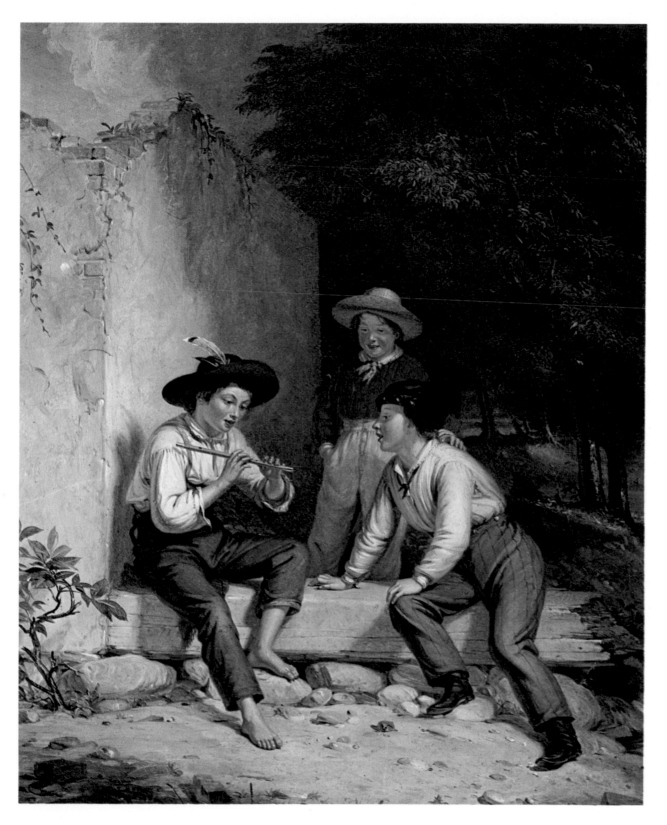

22. *The Novice*. 1847. Oil on canvas, 30 × 25″. The Museums at Stony Brook, Stony Brook, Long Island

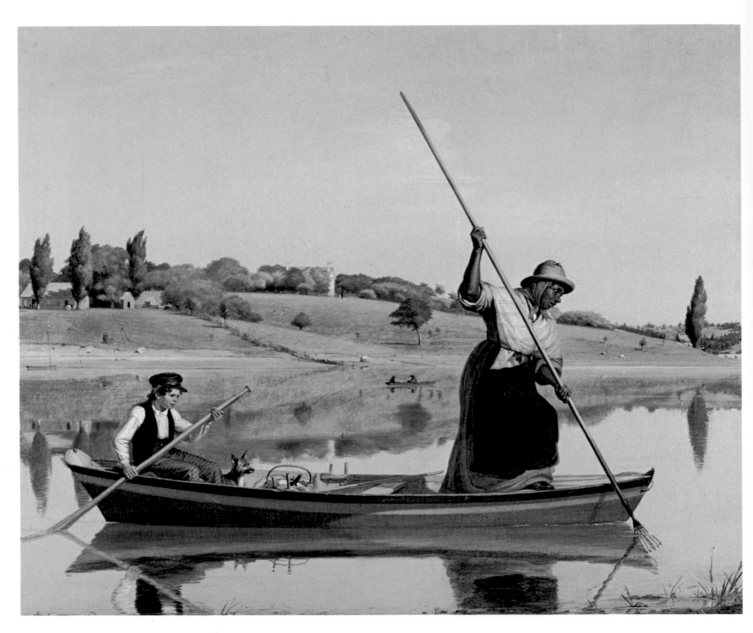

23. *Eel Spearing at Setauket (Fishing Along Shore)*. 1845. Oil on canvas, 29 × 36″.
New York State Historical Association, Cooperstown

diaries
1846

Stony Brook, Jan 1846

One of the best portraits I ever painted at one sitting, in 1835, was done as nearly as I can recollect in this way: I made a careful drawing in Indian Ink, and then made out the effect of the head with light red, raw umber, black and Indian red, black and Lake in the darkest shades of the face painted on light canvass. The gray tints in the shadow side seems to be black and white broken with the flesh tints. Raw Umber appears to have been used in the gradations in the light side of the face, and the beard and whiskers, shadows, and light of the coat. Burnt umber in the shades. The reds in the cheeks—light red, vermilion and lake. They were touched in last. The highest light in the finish—light red and white, or vermillion and white. No yellow seems to have been used—there might have been a little raw sienna, or light ocher with the raw umber and white. The portrait is front face looking directly at you. I wish now I had painted more at that time in the same way. I believe after the first sitting in a broad style, no detail and perfectly dry. A head could be painted at once with great effect.

I must keep my outline a trifle more flowing. Use stiff brushes and drive the colour. The cool tints or blue last. Use more purple tints in the gradations next [to] the hair. I must paint on a light ground and approach as near the complection as I can the first sitting—paint daring. I must go over my work like a dare devil when it needs it. I have written enough—I must paint, Paint, *Practice* and *exercise*.

To save time, it is best to make small studies in oil, of your intended picture. A painter should not be prejudiced in favor of any particular colour, but use every colour in its place, of those that stand well.

To paint a figure upon a dark ground, it should be dead coloured, rather light without much regard to light and shadow, to enable the figure to base out in the finishing.

I must not write any more on painting, but use the brushes—think with my brush in hand—*practice*.

Jan 1846

After this time, I shall be careful when an artist praises my performance to work the harder. I must fiddle less and paint more.

Practice— Practice.

Scumbling is going over the lights, where they are to be changed with the least colour, with short stiff brushes, or with your fingers, or the fat part of your hand, or with your great toe—using such colours as will clear and improve the complexion, on such parts as require it; otherwise the beauty of the first painting will be destroyed. Practice does it—it can do anything that can be done.

Stony Brook, Feb. 15th, 1846

About the year 1833, I painted a portrait of myself in half shadow [c.pl. 24], using no white lead in the shadows

but Naples yellow instead. Vermillion and Light red or Venetian red in the cheeks, nose etc. A little lake seems to have been used in the lips, with N- Yellow. In the mass of lights, stone ocher appears to have been used with the reds. A warm effect of the head was made out in light and shade and the cool tints touched in last. The picture as seen now has the look of an old Master. The shadows perhaps a trifle too much of the brownish yellow. There should have been more blue with the yellow and red in the shade. Asphaltum and Lake was used about the dark parts of the mouth, nose and eyes and vandyck Brown for the hair. Burnt umber broken in the back ground in the shade. The above was painted upon a white ground. In painting the flesh, have few colours—hold tinting—stiff brushes, very little oil, or none at all, and paint, paint.

[1846?]

I must read Vasari, on art.

In painting dark complexion, glaze with Asphaltum and touch in the different tints while wet.

March 19th, 1846

Flesh palette—Krem White, Naples yellow, stone Ocher, vermillion, Madder and carmine together, Indian red, Ultramarine blue, prussian blue, Umber, Vandyck brown, and black. Asphaltum and Lake, perhaps in the finishing.

Mix Naples and vermillion together, also Ocher and vermillion. From those mix your light tint. For lower tones of red—mix Indian red and ocher, Indian red and Lake, Indian red and black. Two tints of blue to be used with the above reds more or less, one green tint, Naples or ocher or raw sienna and ultramarine. Or raw sienna and Prussian blue. One or two purple tints. Generally the shadows and hair painted first. Touch in the background after the first sitting. The effect etc—Blue and white, black and Lake. For light on *hair—silk* etc.

March 25th, '46

I must leave these diggins for a season at least and paint portraits. They sometimes pay best. I shall not take any more likenesses after death, while there is a living subject to draw from. Pictures will not pay unless at a large price; they take so much time.

Old man's harbor was the Indian Nonowantuc, Strongs Neck Minassezoke.

March 31st, 1846

I must not undertake any more than I can do easily. System: I must limit myself to four hours a day at painting. The rest of the time to exercise (in the open air), reading and playing the violin, sufficient to keep me in good spirits. If I will observe the above, I shall be able to paint more pictures, and enjoy better health than the variable course I have been pursuing. Those artists that

have a system of labour do the most—for instance Cole and Durand etc.

I must read over again the works of Irvin, Shakespeare and Smollet's translation of Don Quixot, and other humourous works. Also the immortal *Holy Bible*. Furthermore I must not give my time to those that take no interest in my success as an Artist.

Stony Brook, April 22 [1846?]

Edmunds generally introduces a door or window in his pictures to let in the sky or reflected light, as often seen in the dutch masters.

In portraits the size of life the tints should be varied every quarter of an inch. Cool tints near the flesh in the dress or back-ground. I must paint larger pictures particularly for exhibition—small pictures if they have merit will be seen. Large pictures when well done are more impressive. I should paint large portraits occasionally for the handling. I must not spend my time in taking likenesses of my friends after death—or from Miniatures, or Daguerreotype's—to please my best friend. When in health is the time to sit for portraits. It takes death to wake up some people to the importance of portrait painting, and then it is too late for the artist do justice—to himself and friends. —Time lost—

June 1846

I must not paint any more children at the age of four years.

Visited West Point August 5 1846, to see my nephew, Thos. S. Seabury [pl. 49].

49. West Point. Diary, August 5, 1846. The Museums at Stony Brook, Stony Brook, Long Island

Stony Brook, August 17th, 1846

I must endeavour to do whatever my conscience dictates, to follow the bent of my inclinations as far as my health and circumstances will admit. Be guided by conscience in all things. Never to put my hand to any thing unless my heart goes with it.

"The ideal in art," says Cicognara, "is nothing more than the imitation of an object as it ought to be in perfect nature, divested of the errors or distortions which secondary causes produce.

Inman used to place a thin blue paper at his window to keep out the sun light.

"I cannot help saying, that the method of study in the academies tends to cramp the efforts of genius. By copying from the plaster casts, instead of drawing from the living model, or 'in the study of anatomy,' which is a remedy for tameness and mediocrity.

"He who makes imitation of the antique the beginning and end of his studies, instead of adopting it as a corrective of his taste, will be apt to fall into a tame and lifeless style; and in pursuing ideal beauty, will be in danger of renouncing truth of expression and of character." ——Sir Charles Bell, K.H.

"Anatomy is the true basis of the arts of design; and it will infallibly lead those to perfection who, favoured with genius, can combine truth and simplicity with the higher graces and charms of the art. It bestows on the painter a minuteness and readiness of observation, which he cannot otherwise attain; and enables him to give vigor to the whole form. It teaches him to represent niceties of expression, which would otherwise pass unnoticed." ——C. Bell.

I must paint every day and use more clear colours. Several pictures are expected from me. I must be up and stirring. Mr. Adams the wood engraver very kindly told me the other day that I was falling off; that my pictures were not as good as formerly. Every man has a right to his own opinion—but, I must try and do away his impressions.

An artist who desires for improvement should have all his time to himself and the less he is known to the public the better.

August 19th, 1846

Volumes have been written and works criticised to prove that it is important to study nature closely so as to give truth of expression and character to every object. Consequently I shall endeavour to copy nature as I have tried to do with truth and soberness. There has been enough written on ideality—and the grand style of Art etc—to divert the artist from the true study of natural objects. For ever after, let me read the volume of nature—a lecture always ready and bound by the Almighty.

50. Girl ironing. Diary, August 29, 1846. The Museums at Stony Brook, Stony Brook, Long Island

Stony Brook, August 29th, '46

It is my firm belief that all colours should be cooled down in the lights—flesh, draperys, everything in nature. Shadows of course warm and rich in colour—they often require cooling. I believe it is by this theory that the best colourist[s] in all ages have succeeded—Reynolds, Rubens, Titian etc.

In an exhibition of pictures you often see red drapery too bright in the light; it should be cooled down to harmonize with the rest of the picture. It is the light we must look to—proper arrangement of colours etc—as well as to shadows.

Correggiesque—beautiful [pl. 50]. The Holy Family by Correggio. Sold to the English government for 3,800 £. Only 13 inches in height.

I must make the most of what knowledge I have, go to work on what materials I have already; my stock will increase by practice. A small lot of ground well cultivated is better than a large tract under poor cultivation. It will not do to have too many irons in the fire. Keep the principle in view.

I sometimes feel as if I should give all my time to pictures, make character, expression and colour my only study. Paint scenes that come home to everybody. That every one can under stand. What I have endeavoured to do, I believe I can do again, though some of my friends think I am falling off. I Must put into practice my knowledge, and see if I have not one or two ideas left. Too much preparation will not answer—I must go to work.

Horace Walpole has said: "I prefer portraits really interesting, not only to landscape painting, but to history." A landscape is, we will say, an exquisite distribu-

tion of light and shade, wood, water and buildings. It is excellent—we pass on, and it leaves not one trace on the memory. In historical painting there may be sublime deception, but it not only always falls short of the idea, but it is always false. Thus it has the greatest blemish incidental to history. It is commonly false in the costume, always in the grouping and attitudes, which the painter, if not present, cannot possibly delineate as they were. Call it fabulous painting, I have no objection. But a real portrait, we know, is truth itself; and it calls up so many collateral ideas, as to fill an intelligent mind more than any other species.

Oil colours should be used with the same freedom as water colours—clear and limpid. Pure colours—very little white lead.

"Stuart said: Reynolds was a good painter, but he has done incalculable mischief to the rising generation by many of his remarks, however excellent he was in other respects as a writer on art. You may elevate your mind as much as you can; but, while you have nature before you as a model, paint what you see; and look with your own eyes. 'Good flesh colouring,' he said, 'partook of all colours, not mixed, so as to be combined in one tint, but shining through each other, like the blood through the natural skin.' He thought Rubens had studied well the works of the great Venetian (Titian) and that he must have discovered more tinting, or separate tints, or distinctness, than others did and that, as time mellowed and incorporated the tints, he (Rubens) resolved not only to keep his colours still more distinct against the ravages of time, but to follow his own impetuous disposition, with spirited touches.

"Stuart spoke very respectfully of Sir Joshua but thought there was more poetry than truth in his works.

"Stuart commenced his pictures faint, like the reflections in a dull glass, and strengthened as the work progressed, making the parts all more determined, with colour, light and shade. His hands shook at times so violently that I wondered how he could place his brush where his mind directed.

"He was a man of genius and a gentleman. He saw the great merit of an Artist without envy.

"Stuart thought Titian's works were not by any means so well blended, when they left the esel, as the moderns infer from their present effect.

" 'For my own part,' said he, 'I will not follow any master. I wish to find out what nature is for myself, and see her with my own eyes. This appears to me the true road to excellence.'

"Nature is to be imitated, and not the artist, who has become such by imitating her. Study the original and not the copy."

In some cases it would be better to have a room on the ground floor. It would be handy to bring in animals for studies— For a variety of models, the City is the place for an artist. Take the year round—I think a light from the west would have some advantages; most days the forenoon would be lost. The window should be large and the sill nine or ten feet from the floor. There should be other windows around the room to open at pleasure. I dont see why an artist should not be as particular about his studio as a Blacksmith is about his shop.

An artist should make a small study of his picture in oil—as regards telling the story, colour etc to suit his fancy—and then call in models and make another small picture of the same subject and arangment, with all the truth that nature can give as regards general effect etc. Then with the above preparation, proceed with the large picture, with an eye always to nature. Pictures wrough up with so much care cannot fail to interest the spectator.

Reflect your models in a looking glass and paint from the reflection. It would be necessary perhaps to have two glasses—they should be perfect. Nature looks well when seen in a glass, and I have no doubt a reflected picture of an old man or young lady would look interesting.

Prussian blue—its use is in painting deep blues, in which its body secures its permanence, and its transparency gives force to its depth. It makes deep purples with lake—and makes black blacker. It should be used sparingly with white lead. Scheele's Green is permanent in itself and with white—but not with Naples yellow. Ultramarine Ashes is a fine grey and better suited to the pearly tints of flesh, foliage, the grays of skies, the shadows of draperies, etc, in which the old masters were wont to employ them. Ultramarine broken with black and white, etc, produces the same effects.

"True Terre-Verte is an ochre of a bluish green colour not very bright. It is very durable, and combines with other colours without injury." —Used by the old Masters. I should think it might be used to advantage in painting flesh.

With white it makes a beautiful pearl tint. Terre-Verte makes an ~~brown~~ olive tint by burning.

"Cappagh Brown may be regarded as a superior vandyke brown and Asphaltum"—good in flesh.

[August, 1846?]

I have struck out a path for myself and I must follow it and try to improve it, although portraits will occupy some part of my time, as they pay best. I wish I had a commission for a large picture, figures the size of life.

I must not make myself a slave to natural objects, as not to quit when fancy leads the way. I shall obtain no credit for labourous finishing. More freedom with my style of hand will be just the thing— Practice will bring it about.

Oct. 5th, 1846

Landscapes should be painted from nature during cloudy as well as clear weather; also, such effects as will serve for back-grounds. No time should be lost on ac-

count of the weather, stormy or sun shine. During hot weather paint in the mountains in some lonely spot.

Oct. 14th [1846?]

OF LANDSCAPE

"White is the destruction of all glazing colours—the fore ground and its objects require all the strength and force of glazing which the colours are capable of producing."

To paint yellow leaves when the sun shines through them, lemmon yellow with a little blue and white. Sometimes the clear yellows. Blue black with the yellows and siennas in the cool of shade will answer for a subdued green.

Landscape looks rich in the morning or evening. A view taken when the sun is just up, would look sparkling. Sittings could be taken every fair morning at the same hour, some remarkable scene or effect should be selected— The sun striking upon figures, or animals with their long shadows, etc.

Nov 9, 1846

I have seen a warm fore ground and a cold back ground at the same time, particularly after a thunder storm had passed over, by the sun breaking and shining on the fore ground, grass, fences, trees, etc and the dark blue and purple clouds in fine contrast in the distance.

New York, Nov 20, 1846

One picture for Mrs. Lee—good. I must get my characters about me and go to work. Now's the time. I must practice light and shadow. Draw draw. Titian and Palo Veronese practiced drawing after they were forty years of age. Very incouraging.

I must paint from some of my pencil sketches. Small pieces—pot boilers. Some of my friends think that I would paint more if I were married—no doubt I should be compelled to grind more paint.

A sky light is apt to contract the eye.

[December 7, 1846]

THOUGHTS OF THE MOMENT

The City is the place to stimulate an artist—more art to be seen. In the Country the painter must call up a feeling for art by reading the lives of Painters and other eminent men. I must paint larger pictures—takes no more time and more effective in an exhibition.

Shadows in a portrait should not be too sharpe but soft and melting away in the receding shadows. Have roundness with breadth. Lines should be sharp in particular places—only—

New York, Dec. 7th, 1846

This sharpness and softness is important and should always be in the mind of the artist—parts of the figure should be broken with the back ground to produce fullness and magic of effect. It is well to turn your portraits upside down to see the gradations. Elliott says when he commences he often touches in the prominent gradations of light and darks and keeps the rest in subordination. In the same way the prominent reds might be expressed and the rest subdued etc. The best portraits are those where the warm and cool tints comes into juxtaposition—climaxes of colour as well as light and dark. Elliott says he sometimes glazes or paints his shadows with black and yellow. Also in rounding up the parts, paint with thin blue and touch in while wet with red and greens at pleasure.

I must never show a portrait after the first drawing. An Artist should never be troubled by the remarks of sitters or visitors. An Artist's mind should be wholly centered on his work.

[1846?]

An artist should never hold up a barrier or doubt himself, but go ahead. Paint, paint, good pictures will always command a price. I must give my whole mind to painting and not let a day pass without exercising with brush or pencil—never put off but go to work. There is always something to be done in every place—ideas to be treasured up for present or future use. Backgrounds to be thought over, groups of figures to be looked after, *light shadow* etc.

"We have half a dozen colourists who surpass any here. Mount has not an equal and Cole and Durand are far ahead of the french in landscape." The above is tall talking and should serve to stimulate one to industry.

A head in the dead colouring should be left rather indefinate, bold in the tinting, with green, yellow, and red —the hair touched in and the effect of the head given as regards breadth and general resemblance. The cool tints should set off the warm, and light and shadow melt, one in to the other.

Cool tint upon warm—yes, yellow upon red ~~but not warm upon warm.~~ Upon a light yellow tint touch on a light red and on the focus of that a cool tint made of white Naples and blue. The latter tint will make the delicate greys in the flesh etc. and the high lights etc.

Elliott does not combine his tints with the pallette knife, but fires at the heap for his tints. He says, glaze the shadows with clear blue, or if too red, with a little white added. Also with clear ivory black and sometimes with a little asphaltum with it—for backgrounds etc.

Flesh palette—Naples and Madder Lake. D[itt]o and Stone Ocher. Do and vermilion. Vermilion and Lake— adding white as you paint. Blue and white tint, purple tint. Naples and blue (light green), Indian red and Lake, Ocher and blue (green), Indian red and black. You can combine any of the yellows with the reds—then add blues and greys at pleasure.

White and a very little red can be scumbled over your work in the finishing with a good effect. Colours should be rubbed in with your fingers. Titian prefered his fingers

to brushes in finishing. Suffer but little white to enter your picture, and only in the demi-tints.

Homage to beauty—Mars, Venus, Cupid and Flora. The Tamborine player (Flower bearer) in the background is in half shadow. Venus on the left has auborn hair, light skin, White spencer and low on the bosum, blue gound [gowned] from the waist down and one end of a red sash over her shoulder and comes down on her lap, a black band around her right arm and a red petticoat seen above her knee. Mars in the back ground with his left hand touching Venus has on a coat of mail, red sleve from his wrist above his elbow, black hair, long beard and *his* figure in shadow. Flora on the right, light hair with light skin, her right hand resting upon her breast and looking at Venus—dress low in her neck and of a light yellow. A light purple sash falling over her left shoulder. Cupid holding his quiver and looking at Venus—he has blue wings in contrast to the flesh—his hair is dark brown. A wall with a subdued sky and clouds make up the back ground. The colouring of Cupid, Flora, and Venus, is like a peach—the grey tints in the cool of the flesh is delightful.

Titian was dictated by fancy and feeling. In painting the above picture—simply blue, red, and yellow seems only to have been used in the flesh, and also in the draperies in the lights. The above Copied by Vanderline.

"The Mystic Marriage of Saint Catharine after Corregio. The Virgin Mary is represented with the infant Christ on her knees, who is in the act of putting the ring on the finger of St. Catharine. St. Sebastian is looking on as witnessing the Ceremony. In the back-ground is represented the martyrdom of St. Sebastian as also that of St. Catharine in the remote distance.

The Virgin has on a red frock with a white chemise just appearing on the right shoulder and at the wrist a blue shawl thrown over her left shoulder and comes around by her left elbow. Infant Christ naked, St. Catharine is dressed in a greyish white with a dull ~~purple~~ yellow shawl thrown over her left shoulder. St. Sebastian has a dull purple blanket or mantle thrown over his right shoulder. The horison is high up in the picture—landscape background. Great breadth of shadow and many of them made by flowing drapery. The gradation in the flesh appeared to have been raw umber and white. The outline of the figures soft. Colours subdued and harmonious.

The above coppied from the original in the Louvre, by John Vanderline.

Copying from two or three pictures celebrated for their colouring and expression would be advantagious to an Artist.

New York, Dec 10th, 1846

Soloman T. Nicoll, kindly invited me to set up my easel in New York and that he would procure as many portraits as I could paint in a year at one hundred dollars a head and also furnish me funds if I needed—good. "A friend in need is a friend indeed."

51. Old woman reading. Diary, 1846(?).
The Museums at Stony Brook,
Stony Brook, Long Island

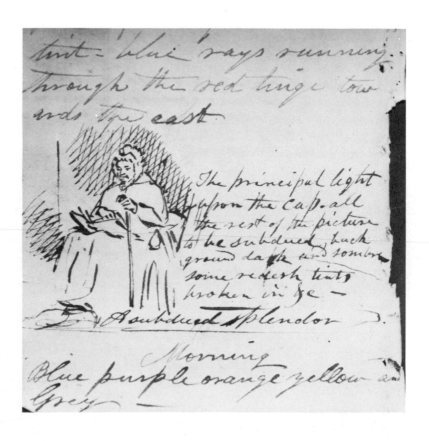

146

An artist should never be timed [timid] but dash over his work with perfect freedom. Whatever he sees in nature, fire at it—the result will surprise him. Practice will bring him off Triumphant.

Asphaltum will do to glaze with if used with care in the gradations. In shadows, Ivory black and raw sienna. It is best to paint shadows, they can be toned after if required. Madder Lake, a little burnt Sienna, vermillion and white will make a good flesh tint. Pure colours are used in miniature leaving the ivory for the high light—why not do the same in oil on a white ground.

Blue red and yellow will imitate any tone of flesh. "Let every subject have its peculiar hue and colour."

"Claude has more repose; Rubens more gaiety and extravagance."

[Sketch of three figures]

N.Y. [December] 20, 1846

In finishing silk use simply blue red and N- Yellow.

If I ever establish myself in N.Y. City to paint portraits, I must have a quiet place to board and regular hours. Study French, Music etc. and not associate with those inclined to disipation. Have a room and study to improve—

Dec 29, 1846

New York is the place for an Artist if he can put up with the noise. Croton water and regular hours will help to preserve his health. To see a variety of character, and colours, the City is the place. Or, to attend to any study during his winter evenings— On some accounts I shall have to live in the City—notwithout ending my love for the Country. It would be well to have a room for pictures —private—and go out to paint portraits; then pictures and portraits would be separate.

Paint a head with very little yellow or none at all, simply red and blue, with a little white. Let the reds tell in their places. Then tone with raw sienna. Perhaps Hopper was right when he said there was no yellow in flesh.

[1846?]

Sky lemon, sun set almost to orange near the horizon. Orange cloud below, red cloud above, fading into purple. The pearly hue above the yellow and the pearl falling into redish tint—blue rays running through the red tinge towards the east.

[Sketch of old woman reading; pl. 51]

The principal light upon the cap, all the rest of the picture to be subdued; back ground dark and somber, some redish tints broken in etc. A subdued splendor.

Morning—Blue purple orange yellow and grey.

[SUBJECTS]

. . . making a drawing of his foot, while he is having his shirt washed by his wife.

An artist viewing his own work.

A Musician catching a tune while another is whistling. Light from below.

"Woodman spare that tree" must be painted first, then the water fowl.

Boys trying to play the fife.

Tom Boy.

Tuning a violin.

Boys fighting.

correspondence 1846-47

Here Mount encounters the two most formidable biographers of artists in America and turns them both down.

Charles Edwards Lester (1815–1890) was one of those nineteenth-century Renaissance men whose versatility boggles the mind of the twentieth. He began his career as a lawyer but soon followed the footsteps of his famous great-grandfather, Jonathan Edwards, into the ministry. Deep involvement with the antislavery movement and with social reform in general took him out of the pulpit and into the arena of international polemics on behalf of the poor and the dispossessed. In 1842 he entered the American diplomatic service; according to the *Dictionary of American Biography*, he served as American consul in Genoa for five years, although his correspondence with Mount places him in New York in 1846. During his years in Italy, Lester made many translations from Italian literature and began researches on the life of Amerigo Vespucci which resulted in a book that was regarded for half a century as the last word on the subject. He also wrote biographies of Sam Houston, Charles Sumner, Peter Cooper, and others, a history of the Napoleonic dynasty, and many other volumes of historical interest. His *Artists of America*, in which Mount did not appear through his own choice, was published in 1846.

Lester is forgotten as an art historian; not so Henry Tuckerman, whose *Book of the Artists* is one of the classics of the literature on American painting and sculpture. Tuckerman (1813–1871) was a Bostonian who published novels and books on travel as well as poetry, criticism, biographies, familiar essays, philosophy, and history; the drama is the only form of literature practiced in his time to which he did not contribute. Tuckerman wanted material from Mount for his *Artist-Life: or, Sketches of American Painters*, but it appeared in 1847 without a sketch of the subject of this volume. Twenty years later, when Tuckerman expanded *Artist-Life* into the *Book of the Artists*, Mount was famous and information about him was easy to come by; consequently there is a chapter on him in that production.

Mount's reference, in his letter to Tuckerman, to the "unhappy circumstance" between Lester and the sculptor Hiram Powers is extremely interesting. In 1845 Lester published a book entitled *The Artist, the Merchant, and the Statesman of the Age of the Medici, and of Our Own Times*, a considerable part of which is devoted to Powers. He claimed to have visited the sculptor repeatedly at his studio in Florence and to have submitted his manuscript to him for approval before publication. Anticipating Gertrude Stein and Alice B. Toklas by a hundred years, Lester wrote Powers's autobiography for him, and he prefaced it with what may be the most incredible panegyric on an artist in the English language. Phidias, Michelangelo, Donatello, Bernini—all were mere groping primitives compared to Hiram Powers. Powers was outraged, and he denounced Lester as a fraud and a scoundrel, asserting that the writer had made many false statements in his "autobiography" and that he, the sculptor, had never laid eyes on the manuscript before its publication. There is a clipping about this famous affair, without indication of source or date, on

148

page 109 of Mount's scrapbook at Stony Brook. Richard P. Wunder, the leading contemporary authority on Powers, shares his opinion of Lester.

Mount's refusal to supply biographical information either to writers, like Tuckerman and Lester, or to friends, like Theodorus Bailey (see page 257), is curiously inconsistent with the series of autobiographical sketches with which this book opens. It is possible that, after being asked for biographical material and refusing to provide it, Mount then sketched out for his own private edification what he declined to provide for public enlightenment. Early in his career these autobiographical pieces may have served psychologically as a device for self-measurement; later, when quotations from laudatory press notices were interlarded with biographical fact, they served as a device for bolstering self-confidence. In either case, the sketches are related to Mount's constant self-exhortation. Almost to the day of his death he continued to castigate himself for his failure to realize his opportunities.

A.F.

Charles Edwards Lester to WSM

New York, Clinton Hotel
Saturday 22 March, 1846

Dear Sir,

I had hoped to have seen you in New York before now, for I am desirous of having a biographical sketch of your artistic life, and getting a portrait of you for my *Artists of America*. I would like to put you and my friend Elliott in the same No. and in an early one. Elliott's is ready. If you have no objection I should be greatly obliged to you, if you would furnish me a sketch of your life as an artist, with a list of your pictures, and descriptions of them—also to have your portrait, for the Engraver, done by yourself in Crayon, if you like. Has not your "driving a bargain" been engraved? I think I have seen it; it would add to the beauty of the number if the plate could be obtained to use for the Edition. Perhaps you could assist my publisher in this matter and enable them to get the loan of it. If you can furnish me the sketch all prepared, it would be just the thing, I doubt not.

May I hope you will excuse the liberty I take (Elliott says you will) and have the pleasure of an early reply.

Truly your friend and [illegible]
C. Edwards Lester

P.S. I should be greatly obliged by a very early reply.
[SB]

WSM to Charles Edwards Lester

Stony Brook, March 29th, 1846

Dear Sir,

Your friendly letter inviting me to furnish a sketch of my life etc is at hand. In the first place I am half sick with a cold, besides I am busily engaged finishing some portraits which leaves me very little time to collect matter concerning myself. I had rather remain in the shade awhile longer as I can look around and see the bright spots with much more pleasure; therefore, I had rather you would not think of me as a subject for your work at present.

Your choise of company for me (Elliott) I am pleased with—I consider him rising rapidly in his profession.

Yours very truly,
Wm. S. Mount.
[SB]

Henry T. Tuckerman to WSM

663 Broadway, N. York
July 24th, 1846

Dear Sir,

I have been promised an introduction to you by more than one mutual friend among the artists and hoped ere this to have sought you out in person, but circumstances have prevented and I must have recourse to writing. I am preparing a series of concise but I hope efficient sketches of our leading artists for a periodical with a view of collecting them in a volume at a subsequent period. The design has been kindly regarded by several members of the Academy. I am desirous of obtaining such fact in regard to your education and career. The influences which have shaped your course—the views you entertain of your profession and the peculiar bent of your tastes—will enable me to define your characteristics. I hope to do this in a manner that shall not disapprove itself to your taste and if you are disposed to aid me with the requisite [illegible] I should esteem it a great favor.

Please address me as above at your early convenience.

Oblige wishes
Henry T. Tuckerman
[NYHS]

WSM to Henry T. Tuckerman

Stony Brook, August 22, 1846

Dear Sir,

My being absent from this place for some weeks past, and the post master not knowing where to direct your letter to find my whereabouts—are my reasons for not answering it sooner.

I think your design of giving sketches of our leading artists to keep them before the people a good one. It will give me delight to read them from your graphic pen.

I feel flattered that you regard me among the leading artists, and that you are desirous of publishing a sketch of me in a periodical. I thank you for the honor you intend me.

To tell you my mind truly, I do not feel worthy to appear in any work, by any gifted author at present. I refused Mr. Lester before the unhappy circumstance with him and Mr. Powers was known to the public.

No, no, I think there is time enough yet.

<div style="text-align: right">

Yours, very truly,

Wm. S. Mount
</div>

[NYHS]

WSM to Solomon Townsend Nicoll

<div style="text-align: right">

Stony Brook, Feb. 8th, 1847
</div>

Dear Sir,

Your very kind letter of the 4th inst. is at hand. It is natural that you should desire to see your portrait to the best advantage. I sincerely feel the interest you take in it the appearance of the picture ("for my sake"). But what can I do, when the majority of the old masters, with the sanction of the moderns, say, never varnish under a year. Many a fine picture has been injured by being varnished too soon. I am just now very busy with a picture and it would be almost ruinous to leave it, now my mind is upon it. I feel that your lump of benevolence will give me towards the last of next month before I varnish your portrait. I will attend to it as soon as possible. I have an idea, that your fair visitors will not look very sharpe at the picture while the original is present. Please give my best regards to Mr. and Mrs. Nicoll,

<div style="text-align: right">

Yours truly

Wm. S. Mount.
</div>

[NYHS]

WSM to Shepard Alonzo Mount

<div style="text-align: right">

Stony Brook, 22d of Nov, '47
</div>

Brother Shepard,

Your letter of the 14 inst is at hand. It does you and Elizabeth great credit. It has come in good time as we had began to be very anxious about you all, thought perhaps you had got stuck in the mountains coming through.

I had only one sitting on Mrs. Eliza Smith's portrait last week owing to my not being very well, and the weather not good the last of the week. I some expect her this afternoon, my palette is all ready, and the dinner hour has just sounded—here's off—back again—dinner firstrate. No sitter yet, owing to the dull appearance of the weather, cloudy all over. The sound and harbour are quite calm; as the foliage is all off, I can look down upon the village, it looks grey enough, with the exception of a red roof now and then.

The people of this quiet place are just now quite anxous after money—they have just began to learn the worth of it. Yesterday lots of Woman and Men, and children, could be seen in the lower parts of the street looking along the road, and by the side of the fences, some scratching with sticks, and some with rakes, for the precious stuff. It appears that Jonas Smith Esqr. has lost a roll of Bills out his pocket, containing about seven or eight hundred dollars, he offers fifty dollars to the finder, hence the stir. It now lights up, the sun is coming out—no sitter yet. I found the windows too low at Mrs. Smith's house for a good picture. I concluded to paint it at my own studio or not at all. I have not finished Strong's picture yet, I dont look at it but once a week.

Well, I looked in upon your rooms this morning, mildew was at home in the lower rooms, a great deal of soot and plaster has fallen down chimney in the small east room. In the bedroom window up stairs a pane of glass is wanting. In the front room up stairs, all the things looked at me very pleasant, just as fresh as when you left, with the exception of the air tight stoves; the small one is considerably rusted, it had better be used, than to spoil. You or myself or Sister Ruth, had better use it, this winter.

There is about a days work for you, to make fires, and patch up, and sweeten the old domicel for the coming winter. It is clouding up again. New England looms up in the distance, a sloop is passing along, on her voyage to N.Y. City.

What do you think! The lost is found, come at last. J. D. Holmes Esqr., the old Indian, has returned. Mr. Seabury brought the astounding intelligence, he is to be found in Broadway, 304, a likeness taker, by jingoes, who whould have thought it. He takes first rate daguerreotypes, so he tells Charles. You must go and see him when you go to the City. He talks of coming up here to see us. I wish he would, bless his old soul. It is a pity he could not have Cousin Letty to take care of him this winter. It is altogether a curious day—in the morning it rained, then broke away, then drizzled again—a beautiful rainbow made its appearance in the north. It has been clouding up and breaking away all day. It is quite warm for the season.

Brother Nelson has a large school in the Factory, he numbers about 41[?] scholars, 23 young men and 17 young Ladies. I shall let him have my room evenings, when they dance together; the partition can be fixed so as to be taken down, and replaced in the morning before I go to work. I send seven young Ladies at my own expense. Stony Brook will be ver . . . in consequence . . . will show off . . . of room (to . . . to place . . . kiss [page torn away].

. . . with his lives of the N.Y. artists—they say it is beautifully gotten up for a hollyday present. You know I declined being introduced in the work. I felt complimented that he should have written to me, but I shall not resent being left out. Lanman says he will give me a copy of the work when I go to the City. I shall not go to the city in some time yet.

The feeding of the animals has past at the N- Academy. I did not attend. Lanman says in a letter that he stopt in about ten minutes, saw two or three doleful faces, and not seeing us there, he bolted. ——Copy of the note sent to you:

<div style="text-align: right">

National Academy of design

New York, Nov 1st, 1847
</div>

Shepard A. Mount Esqr.

. . . al meeting of the . . . Members of the . . . day next . . . [page torn away].

P.S. I forgot to mention that Sister Mary is boarding a young man, Platt by name, the son of a Clergyman, here

at the Pond. We never had but one teacher, that was *Holmes.*

[SB] *There is no mention here of William's portrait of Shepard (c.pl. 25), nor is it referred to anywhere in his diary for 1847.*

WSM to Delia Hawkins

Stony Brook, Nov 30th, 1847

Cousin Delia,

You must be fond of of pictures. The last time I met you I believe you was contemplating some paintings at the Art-Union, In company with Miss Hardcastle. A Lady never looks more interesting than when she is dwelling upon a work of art, of any description, or upon a lovely scene in nature. The young Ladies eye at such a time looks large and brilliant, the mind being carried away into the regions of fancy, away from fashion and vain things.

Therefore, to the devotional lover of nature and Art, I pay great homage.

Now Cousin Delia, If it would not be asking too much, I should be pleased if you could visit the Art-Union sometime when you have leisure and let me know what new pictures have been added. The names of them, and by whom painted, ~~please~~ and be particular to inquire at what time in Dec. the drawing for the pictures by lottery takes place. If by granting this request your mind should be taken a moment from your studies I shall feel quite hurt.

I received a letter from Cousin Catharine Niven, about a fortnight ~~two days~~ since. She mentioned having seen you, and spoke very highly of you, etc. ~~said she would like to correspond with you, etc. I will tell you the rest what Cousin said when I see you.~~ I will quote from her letter: "Delia Hawkins was here a short time since; I think she is pretty and very interesting and intelligent. I wish she would write to me. I would answer her letter with the greatest pleasure." It pleases me very much that I have so many pretty *Cousins* and *Nieces.* How is your next door neighbour Miss Van Norden? I wish I could live in New York where I could see somebody. It is too bad that I should spend the winter in this retired region. However, every place has its amusements. It will be quite lively here this winter, as the young folks are taking lessons in dancing.

I am pleased to hear that you are very studious. I hope you will carry away all the honors of the Institute. Give my love to Cousin Ruth. Mrs. Seabury sends a great deal of love to Mrs. Wickham, and hopes she will excuse her for not writing to her.

Yours very truly,
Wm. S. Mount.

[ARCHIVES OF AMERICAN ART]

WSM to Delia Hawkins

Stony Brook, Dec. 19th, 1847

To. Miss Delia Hawkins
 164 Grand Street, New York

My dear Cousin,

Your long looked for and very interesting letter of the 14th inst. reached me last evening. It afforded me a world of pleasure to read it. Your style of writing I like. The composition is excellent. It is so judicous throughout. I feel proud of My Cousin Delia.

I thank you for the information respecting the Art-Union, and the catalogue you will send me. I will endeavor to be in the City on the 24th if possible, but I expect business will prevent me; as I have a portrait of a *lady* to finish and take to the City when completed. The bad weather has prevented the lady from taking her sittings regular which puts me out of my reckoning.

I reccollect the water color pieces you speak of. If I should be so lucky as to draw one of them, you shall have it as a New Year present. I hope you take lessons in dancing this winter. The sealing-wax of your letter did not stick fast. I received it from the Post Office open. Good waxers are better. I wish you could be gratifyed with "a ride in the country on horse back." How much more we think of the country life when we are bound up in the City.

Please give my best regards to Mrs. Ruth Wickham.

Mrs. Seabury, and Julia, desires to be remembered to you.

I remain Yours, very truly,
Wm. S. Mount

[ARCHIVES OF AMERICAN ART]

goupil, vibert and company

Goupil, Vibert & Company, the print publishers and art dealers eventually to be immortalized (after a change of name to Goupil & Company) by its association with the brothers Van Gogh, was a very large firm, headquartered in Paris, with branches in several cities of Europe. In 1847 it sent William Schaus to New York to open the American market to its wares. Schaus and Mount became good friends, and the correspondence between them is long, warm, and revealing.

Part of Schaus's assignment was to establish a New York branch of Goupil's International Art-Union in competition with the American Art-Union, with which, as we have seen, Mount was not on good terms. This was one reason for Mount's friendship with Schaus; another was the fact that the International Art-Union proposed to send American artists abroad to study, and Mount, although he was well past the published age limits for these fellowships, hoped to be awarded one. (Later, when Schaus offered to send him to Europe *hors concours*, Mount declined.)

All this is of secondary importance, however. The main thing is that Schaus was responsible for the issuance of ten of Mount's paintings as large color lithographs made in Paris; seven of these were published by Goupil and the remaining three by Schaus himself after he had left Goupil's employ. Schaus exaggerates when, in the document which immediately follows here, he states that the earliest of the Mount lithographs put out by Goupil constituted "the first recognition of American Art by Europe"; but the lithographs did bring Mount to the attention of a much larger audience, on both sides of the Atlantic, than he would otherwise have had, and it is by no means insignificant that he plays a considerably larger role than any other American painter in the histories of the art of their own time written by nineteenth-century authorities, such as Richard Muther (*History of Modern Painting*, 1896).

The first Mount to be lithographed was *The Power of Music*, the subject of which is a black man standing outside the Mount family barn, listening to a white man playing the fiddle for two others just inside the open door. Schaus did not commission this picture, but later, when he was in a position to dictate the subjects of the paintings to be lithographed, he showed a very marked predilection for studies of black people vigorously making music themselves. This was the heyday of the minstrel show, of Dan Emmett, of Daddy Rice and his "Ethiopian operas," and of Stephen Foster; Schaus was not in business for his health, as the saying goes, and apparently there was as much interest in these reflections of blackface entertainment abroad as there was at home.

The document which follows immediately must have been written in 1855, the year in which Schaus's lithograph of *Coming to the Point* was published. It appears first, out of chronological order, because it serves well as a general introduction to the Schaus-Mount story. Although it is written in the third person and praises Schaus inordinately, it is in that gentleman's own handwriting and was obviously intended by him for publication anonymously; it was probably a press release, although there is

no evidence to show that it was ever used by the papers.

Among the five Mounts mentioned by Schaus in his press release, three bear titles different from those of the original paintings, by which they are best known today. Schaus seems to have been responsible for the devilish practice of changing the titles of Mount's pictures—or some of them—when they were lithographed, in order, apparently, to make a clear distinction between the original on canvas and the copy on paper. In the long run, however, the result of this practice has not been clarity or distinction but endless confusion and difficulty. Schaus's *Music Is Contagious* is our *Dance of the Haymakers*, and his *Boys Catching Rabbits* is Mount's *Boys Trapping*, which is not to be confused with a later Mount called *Trap Sprung*, which (in order to confuse matters completely) is also known as *The Dead Fall*. The titles of *Just in Tune* and *Right and Left* were not changed when they were lithographed. *The Lucky Throw*, a picture of a black boy with a plucked goose in his hands, is known today only through the Schaus lithograph; the original has disappeared. Schaus called the picture *Raffling for a Goose*. That title, however, was the most unfortunate of all his inventions because it is almost identical with that of a much earlier Mount showing a group of white men attending a goose raffle in the tavern that once adjoined the Mount family house. Today, therefore, the lithograph is known by its original title, *The Lucky Throw*.

As later letters show, the lithograph of *Coming to the Point* cost Schaus considerable anxiety. The picture is a second version of *Bargaining for a Horse*, which Mount had painted years before; if anyone but Mount had done it, one would be forced to call the work a plagiarism. Schaus's old employer, Goupil, got wind of his intention to bring out a lithograph of *Coming to the Point*. He entered into negotiations with the Art-Union, which had published an engraving of *Bargaining for a Horse* only three years earlier, to reissue this engraving in a large, competitive format. But Mount was able to stop this shenanigan.

Schaus's admiration for Mount is touchingly expressed in the prospectus for his American Portrait Gallery, which came out in 1850. Schaus proposed to publish twelve portraits of eminent Americans each year. The first three, announced in the prospectus, were of Daniel Webster, William Cullen Bryant, and William Sidney Mount. The Mount portrait is an incredibly awkward adaptation of a magnificent painting by Charles Loring Elliott preserved at Stony Brook (pl. 52). The adapter, one C. G. Crehen, took over Elliott's head, collar, and coat and added arms, a chair, hideously deformed legs, and a sketch of *The Power of Music*—the first Mount to be published by Goupil—on an easel at the spectator's left (pl. 53).

A.F.

Autobiographical Press Release by William Schaus

[1855?]

Early in the spring of 1847, William Schaus Esqr. visit-ed this country as the Agent of Messrs. Goupil, Vibert & Co. of Paris, print publishers, and while in New York he visited the National Academy of Design then located in the old Society Library buildings corner of Leonard St. No picture made a better impression on his mind than Mr. Mount's picture of "Power of Music." We are informed on good authority that Mr. Schaus wrote a very flattering[?] account of this Picture to his Paris house, praising it in the highest terms and pronouncing it equal to any *genre picture* he ever saw in *Paris* or *elsewhere*. Subsequently Mr. Schaus fixed his residence in New York and, in the month of November, 1847, he was introduced to W. S. Mount Esqr. by a mutual friend, Charles Lanman Esqr. the *author* and *artist*. It was soon agreed that Mr. Mount's picture should be sent to Europe to be engraved and we cannot forget to mention the readiness with which Mrs. Gideon Lee consented to part with the picture for that purpose.

This was the first recognition of American Art by Europe, for Mr. Mount's picture was the first one ever sent to Paris to be engraved. The Engraving was successfull beyond precedent and through the agency of Wm. Schaus Messrs. Goupil Vibert & Co. issued the following prints after Mr. Mount's pictures:

> Music is contagious
> Boys catching rabbits
> Just in Tune
> Right and Left
> Raffling for a Goose

The two last named pictures were ordered by Wm. Schaus for Messrs. Goupil Vibert & Co., Mr. Mount receiving one hundred and fifty dollars for each.

In 1853 Mr. Goupil Jr. purchased Mr. Mount's picture of "Letting down the bars," a political allusion to the late presidential election. Since then Mr. Mount has been busy on a portrait of our great Statesman Daniel Webster. However much the pictures of Mr. Mount have been admired, the Artist, who is untiring in his efforts to produce work worthy of the best time of the Flemish school, combined with the best qualities of a Wilkie, has never yet reaped a sufficient reward for his labours, and we have learned with extreme pleasure that Mr. Schaus, who was first instrumental in bringing Mr. Mount's pictures before the Public, was also the first to offer Mr. Mount two hundred dollars for the copyright of his new picture of "Coming to the Point" painted for Adam R. Smith Esqr. Troy, a picture which is pronounced by all who have seen it the *chef d'oeuvre* of the Artist.

[NYHS]

Diary Entry

Stony Brook Dec. 7th, 1848

I approve of Goupil, Vibert & Co. Plan of the International Art-Union to have a perpetual Free Gallery in the City of New York—where we can at all times see the works of the great masters of the continent—

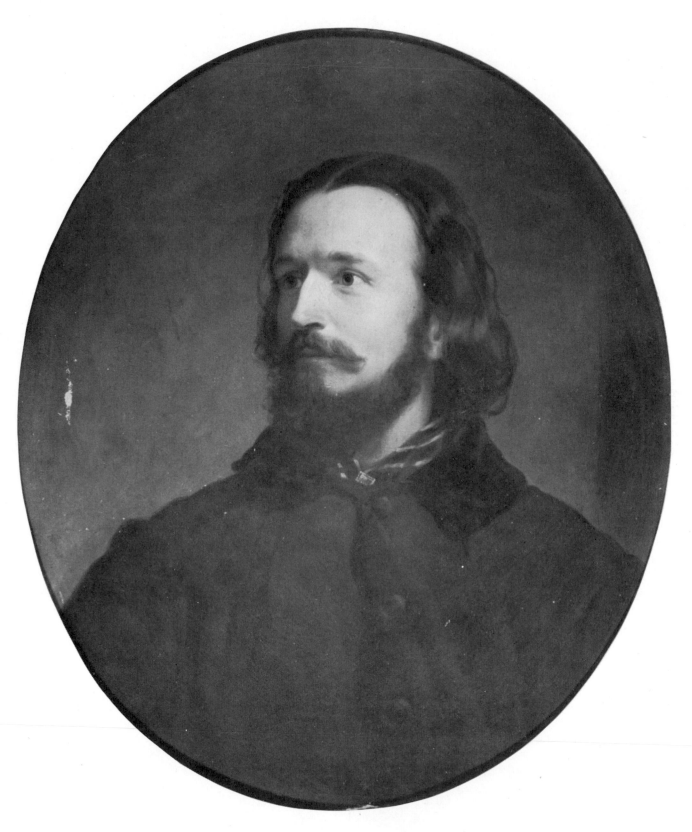

52. Charles Loring Elliott. *William Sidney Mount*. 1848. Oil on canvas, 30 × 25″.
The Museums at Stony Brook, Stony Brook, Long Island

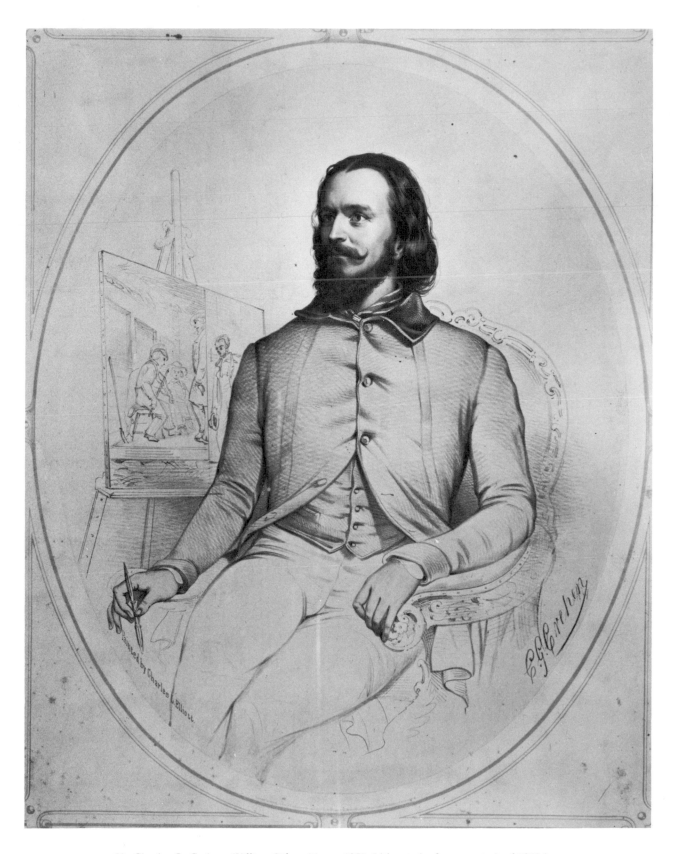

53. Charles G. Crehen. *William Sidney Mount*. 1850. Lithograph after a portrait of 1848 by
Charles Loring Elliott, 17 × 13″. The Museums at Stony Brook, Stony Brook, Long Island

The annual subscription of membership is five dollars. Each member will receive a magnificent engraving—equal to five dollars—also Paintings, Drawings, Pastels, Statuary, National publications, etc., will be distributed by lot to the subscribers—

The great feature in the plan is, "a sum will annually be set apart for sending one American Student to Europe for a term of two years, at the expense of the international Art-Union—the Student to be selected by a committee of the National Academy of Design or as a majority of the subscribers may agree upon." The Gallery at the corner of Broadway and Reade st. will be open from the 15th of December 1848—

I hope I will be selected as one of the students to be sent to Europe—to study nature in the old world. A love of art alone should induce me to see Europe—International Art-Union—School of the *Fine Arts*—open every monday from 9 A.M. until 5 P.M. Professional Artists only will be admitted. Opened, *New York*, Dec. 11th 1848.

Stony Brook, Dec 13th, 1848
Messieurs, Goupil, Vibert & Co.

I am delighted that you intend to have in New York City a perpetual free Gallery to improve the public taste. One of the great enjoyments of life is in looking at paintings and engravings—they kill time so profitably. I hope all the friends of the Fine arts in this Country will become members of your "International Art-Union." Your plan is an interesting one of having from France "a school of art and artists"—also, of sending an American Student abroad to study modern and ancient art.

I encourage the hope I may be selected as one of the Students, to be sent to Europe to study art and nature. I intend to be a subscriber to your magnificent project, when I go to the City.

Yours very truly,
Wm. S. Mount

[NYHS]

280 Broadway
N.Y. Dec 19th, 1848
My dear Sir,

We have received some days ago your very polite letter and we are indeed very thankfull to you for your kind opinion. We will endeavor to be as useful to American Artists, as we have been to those of the Continent. We regret only to say that the power of music, has not yet arrived owing to the very long delay of Steamer Husmann. Every visitor to our gallery is pleased with the print and when you come to our city we should like to see some of your other works.

Do come soon and spend some evening with your friends.

Yours truly,
W. Schaus

[SB]

Stony Brook, April 16th, 1849
W. Schaus Esqr.
My dear Sir,

I have not been able to find but one or two short notices of the Dance of the Haymakers, which you have thought worthy of being engraved in Paris. The first is short, and quite too flattering. No 195 " 'Dance of The Haymakers,' by Wm. S. Mount, perfect in character— Like all of Mr. M's familiar scenes, the expression and details leave nothing to be wished for." No 195 "Represents a barnfloor scene, opening upon a fiddler, two Long Islanders, dancing with great energy, and an old man listening with his fancy evidently touched by the performance at the right, and on the out side of the barn, a negro boy is adding to the excitement and noise by drumming on the door, evidently delighted with the 'concord of sweet music' which he thinks he produces. The noise of the clog hoppers, the music, and the loud laughter of the lookers on, is enough to arouse the village Parson. The last and not least, a cat watching a dog from a hollow beneath the door sill, is marvellous for its life and finish, quite equal to the celebrated master pieces of the kind in the Dutch school."

Yours most truly,
Wm. S. Mount

[NYHS]

New York, April 28th, 1849
My dear Sir,

During my voyage to Boston, Your kind letter of April 16th 1849 was received. Please accept my best thanks for this good information given to me in regard to the beautiful Dance of the Haymakers now in progress in Paris. I hope you are very busy at this moment in painting some charming scenes and will be much gratified to see anything you have done.

Our May number will contain a very elaborate notice on the works at the N. A. of D. and I intend sending you a copy as soon as out. Mr. Vibert & Goupil are all very well, so is also Yours very truly,

W. Schaus

[SB]

New York, July 24, 1849
My dear Sir,

We may now daily expect a proof copy of your admirable picture of "Music is Contagious" and have no doubt it will prove satisfactory to You in every respect. We had hoped to see you in this our hot city and are anxious to see you about some other compositions of the American Teniers. Are you not engaged with your new pictures? We would like to see you soon. How is it with "Raffling for a Goose"? We cannot forget your promise to paint it for us and also another picture, so as to make the set of four complete.

There is not much other news in the Fine Arts. Cholera

is the motto and it seems it has entered the bowels of a great many. If you do not fear it, come soon to New York.

Yours very truly

[SB] W. Schaus

Stony Brook, August 5th, 1849

W. Schaus Esqr.

My dear Sir,

I have just returned from an excursion and am happy to find a letter from you, announcing the arrival shortly of a proof copy of "Music is Contagious" [pls. 54, 55] which I shall be delighted to see, and if it is as well done as the "force of music" [pl. 56], I will be satisfied. In the coloured plates, excuse me if I request that the negro is not coloured blue black, ~~but~~ Figures should be colored true to the picture, liberties taken in other parts of the painting is not of so much consequence.

I have set aside pictures for the present, I am engaged with portraits ~~just now~~— I have nearly finished a whole length of a Boy. I would ask you to come and spend a few days with me, but our house is quite well filled with friends from the City, about these days. I hope to see you next fall at this place.

54. Sketches for *Dance of the Haymakers* and
The Power of Music. 1845(?).
Pencil, 9 × 5 1/2″. The Museums at
Stony Brook, Stony Brook, Long Island

This is one of the most interesting of the sketches by William Sidney Mount, for it shows that two of his most celebrated works—*Dance of the Haymakers*, also known as *Music Is Contagious*, and *The Power of Music*—were developed from one and the same idea.

157

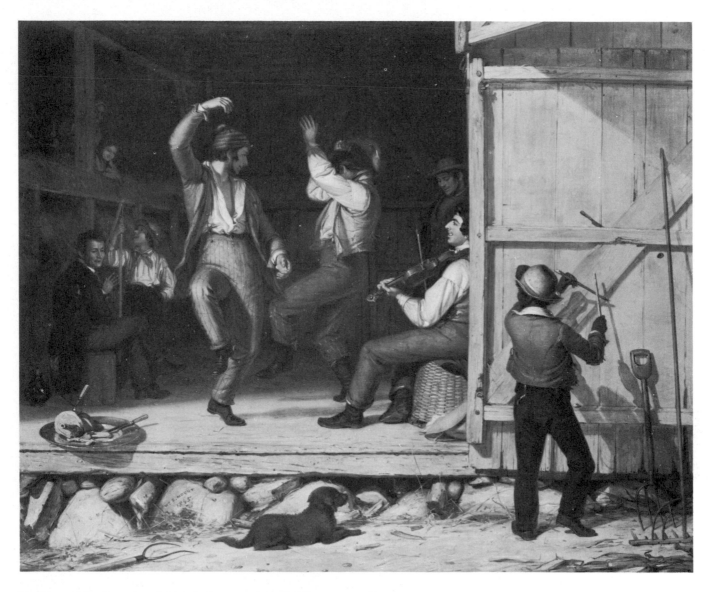

55. *Dance of the Haymakers* (*Music Is Contagious*). 1845. Oil on canvas, 25 × 30″.
The Museums at Stony Brook, Stony Brook, Long Island

Please let me know when you receive a proof. I hope the Lord will preserve you from the Cholera and sudden death.

Yours truly, Wm. S. Mount

There is a story in the *New York Weekly Universe* August 4th 1849 about my painting and selling my first picture. Which is false—got up by some *wag*.

[NYHS] *The story "got up by some wag" will be found on page 200.*

New York, Nov 9, 1849

My Dear Sir,

I have just received your kind notes and thank you a thousand times for your friendly remembrance. I take the liberty to send you through Mr. Seabury a copy of "Music is Contagious"! This latter with the power of music are in our new gallery and its distinguished author is in the mid—like a father among his children.

You say that you are pleased to know that I would like your "Just in Tune" [c.pl. 26] for the new gallery, but can I obtain it? *To have it,* that is the question. It would afford me the *utmost* pleasure to have this picture, because it is a real gem in every respect. Why! You can paint some other picture for your friend. I am sure he would be pleased to let it occupy a suitable place amongst our pictures. If you decide to let me have it, I will remit *Your price* to Mr. S. and besides acknowledge myself yours ever obliged friend. Of course this would be *in addition* to the large picture you promised me for next year. *Pray, do let me be the happy possessor!* Mr. Vibert thanks you very much

for your kind remembrance. Please give my best regards to Mrs and Miss Seabury, your brother and all your friends.

Yours very truly

[SB] W. Schaus

Stony Brook, Nov 14th, 1849

W. Schaus Esqr.
My dear Sir,

I have received ~~from~~ by Mr. Seabury your donation of the engraving of "Music is contagious," it has added greatly to my happiness. I am delighted with it, so full of life. It will I have no doubt be a favorite with the public as much so as the ~~force~~ power of music, of which it is a clever companion. The Boys Trapping, though of a different kind, will not be the less popular. "Just in tune" is engaged—therefore, I cannot at present say any thing about it. I am proud that it is a favorite with you. However, if my price should happen to be too large for my friend you shall have it, but I dont much expect it will be, he has set his heart upon it. The Courtship, now at the Academy, you might obtain by addressing the owner *John Glover Esqr* Fairfield Conn. I have read your art Journal with pleasure. I understand your new Gallery is very attractive. I hope Mr. Vibert is well, remember me to the handsome Mr. Goupil.

Please give my best regards to Leon Noel, when you write to him.

I remain, yours as ever,

[NYHS] Wm. S. Mount

Diary Entry
Dec. 1849

Messrs. Goupil, Vibert & Co. have very kindly offered to furnish the funds if I would spend one year in *Paris* and paint them four pictures. My commissions at present will

56. *The Power of Music (Music Hath Charms)*. 1847. Oil on canvas, 17 × 21″.
The Century Association, New York City

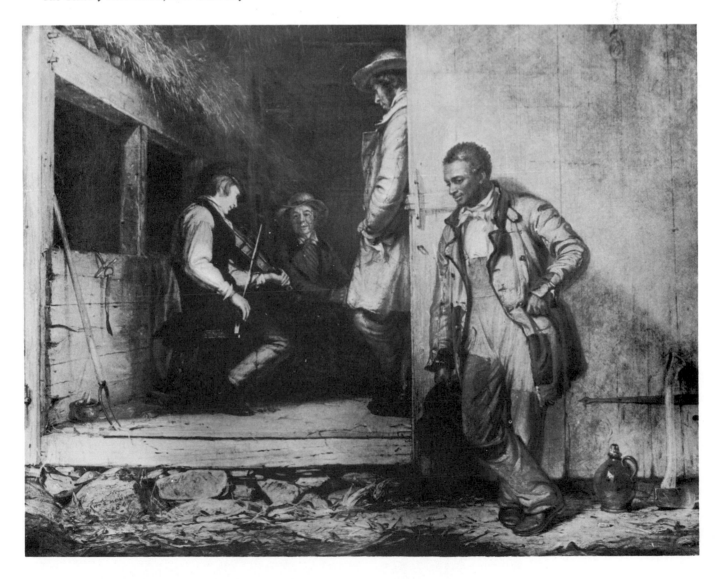

not admit of my accepting the above offer. I have some offers that I can execute better at home than abroad. I had rather be free on Long Island than a slave in Paris. When I visit Europe I had rather be (simply) a looker on.

Stony Brook, Feb 14th, 1850

Messieurs—Goupil Vibert and Co.

Your circular, about the new school of art, "of sending one American student—or more"—to Europe to study the fine arts, at the expense of the International Art-Union, is a compliment that will not be lost upon my countrymen.

I hope, Gentlemen, that you will continue the management of the International Art-Union. I have long had a desire to see France, her great painters are dear to me. The works of Le Sueur, Le Brun, Poussin, Claude, Guerin, Regnault, Perrin, Jouvenet, Lairesse, David, and latterly, the Vernets, Delaroche, Scheffer, Debuffe, etc., all have given me instruction and pleasure (principally through engravings of their works). France has been illuminated by the works of her gifted painters, and Sculptors. All nations are magnified more or less, as they encourage art.

I would go to Paris tomorrow, if my engagements would permit. I am sorry I cannot accept at present your very kind and liberal offer to spend a year in Paris. I feel very greatful for the compliment.

I am anxious to see the engravings from my pictures of "Just in Tune" and Boys Trapping. Say to Mr. Wm. Schaus, that I expect to visit the City the last of next month, and will be happy to call and see him. The coloured engraving of "Music is Contagious" which Mr. Leon Vibert presented to me is very much admired.

I remain dear Sirs, yours most truly,

[NYHS] Wm. S. Mount

New York, February 21, 1850

My dear Sir,

Some days previous I was highly gratified to receive your kind letter. The noble sentiments expressed by you are such as must honor a true American and your liberal feelings toward your brother artists will always be cherished. It gives me great pleasure to be remembered among your friends and I trust that our friendship will be everlasting.

I know that all the members of my Paris house have often expressed the kindest feelings for yourself and also an admiration for the masterly productions of your genius. How glad would they be to have you in Paris! One day or the other, you may feel inclined to visit Paris, the world of gaiety and fascination, and you may rest assured to meet with true friends.

I am glad to hear, that you are pleased with "Music is Contagious." I have had no news of the "boys catching rabbits" and that gem of "Just in tune." As soon as the

proofs have arrived I will inform you. By the way, do not forget the companion picture of "Just in tune" and also "the raffle." Is the picture of "Mexican news" ready? I hope all your family are well. Please remember me to all and believe me as ever

Yours very truly

[SB] Wm. Schaus

Stony Brook, March 3d., 1850

Wm. Schaus Esqr.

My dear Sir,

Your flattering letter of Feb. 21st I have received.

I am pleased to state, that the picture you have inquired about, "News from California," is quite finished. A few friends that have seen it, say it is a better picture than "The Power of Music."

Do you wish a negro man, or a white man as a companion to the picture "Just in Tune"? Will the same size canvass answer? 25 × 30 inches?

My Sister and Julia, sends their regards to you.

Yours truly

[NYHS] Wm. S. Mount

289 Broadway
(New York March 7, 1850)

My dear Sir,

I am very happy to learn that "News from California" are so good. Of course you will soon bring it in town when you come. I am certain that is one gem more added to so many others.

I think a Negro would be a good companion to "Just in Tune," the size I think is good also. You have probably already an Idea what you intend make the Companion and I hope you will finish it soon. Mr. Vibert has arrived in Paris. He remembers himself to you. His health is very low and I am afraid he will not recover again.

By the way, I am publishing a series of portraits "Illustrious Americans," and your portrait of course is at the head. I hope it will be fine. I let it copy from Mr. Elliott's picture and will send you a copy as soon as finished.

Will you be so good and present my sincere compliments to the ladies at Stony Brook and believe me as ever

Yours very truly,

[SB] W. Schaus

Stony Brook, March 14th, 1850

Wm. Schaus Esqr.

My dear Sir,

I am sorry to say I cannot leave the scrub oaks of Long Island until next week when I shall be happy to shake you by the hand.

I feel complimented for the interest you take in desiring to have a perfect likeness of my humble self, but I shall leave the whole matter to your better taste and judgment.

Yours very truly
Wm. S. Mount

New York, July 16, 1850

My dear Sir,

I hope this letter will find you in excellent health and entirely restored from that sad accident. Your portrait has just been returned by the Academy, also a sketch by Boutelles. I have both in my office and am not in a hurry to give them away. If in my last note, I did not mention anything about the *great* picture you intend painting for my house, it was simply because I wanted you to take care of yourself. However much I admire your paintings, I rather prefer your health, and you ought by no means think about anything else, than to recover the most precious gift we possess in this world. Presuming you are rusticating and strolling over dales and hills while I poor fellow sit like a second Jeremias on the ruins of my stock of prints! Of course I have not time to weep, and evenings only, I wander in the Elysian Fields among all kinds of loafers. So you see that even your humble and obedient servant walks through the sacred grounds of posterity—at Hoboken. The weather is delightfully hot and if it continues at the same rate, you may probably find myself on your next visit to the Imperial City, roasted in the most delicious style and ready to be eaten. Please give my *complements respectueuses* to all my friends *in, near* and *round* Stony Brook. Will you not drop me a line?

Yours very sincerely,
W. Schaus

Stony Brook, July 25th, '50

Wm. Schaus Esqr.

Your letter of the 16th inst. goes deeply to my heart. Your friendly feeling, is as refreshing as a cool breeze after a hot and sultry day. Last Monday I assisted my Brother Shepard, in painting a figure upon the stern of a new and beautiful Schooner. Called Shepd. A. Mount. We have both been complimented by the same builders. I yet suffer from my fall and the Doctor consoles me that I will not recover from it in seven months and that I must keep quiet, not do any labour. You know that is painful to one so *industrious* as I am. I hope to run next time against a wheel of fortune as you expressed in a former letter.

The Girles down here say that your moustache is handsomer than mine. I hope you will believe it. Go on spreading engravings and paintings throughout the world.

We all unite in sending our best regards to Wm. Schaus Esqr.

Yours truly,
Wm. S. Mount

We have a Pic-nic this afternoon, we wish you on hand.

289 Broadway, Aug 15, 1850

My dear Sir,

By the annexed circular you will be apprised of the name of the new firm occasioned by the death of that noble and good man Mr. Vibert. His memory will always be cherished by all who knew him. Seldom I ever was so much griefed as when the ill fated news of Mr. Vibert reached me. But what can I say more to one who was well acquainted with him?

Now I come to scold you. Why don't you honor me with a little note? Say only *three words,* "I am better," and I shall never scold you again.

Three cheers for W. S. Mount!!!

the great American Wilkie!!!

I have just received a *proof copy* of *"Just in Tune"!* Admirable! Splendid! great! It is truly. How can I send it to you? I should however prefer if you will wait until good copies come here, so that you can show it to all your friends. We do not like to show proof copies but to the artist. Lasalle has done justice to your picture and I *know* you will like it.

Give my best compliments to our friends at Stony Brook. Take good care of yourself and drop me a line soon.

Yours truly friend
Wm. Schaus

Monsieur W. S. Mount,
peintre celèbre
Stony Brook
Etats-Unis

Stony Brook, Aug 19th, 1850

Wm. Schaus Esqr.
My dear Sir,

I was about to answer your delightful letter of July 30th when I received your note of Aug 15th—announcing the name of your new firm, and that you will continue to act for the firm as heretofore. It strikes me that if Goupil & Co. should rake the world over they could not find a better representative to their N.Y. house than yourself. My best wishes attend the new firm. I am delighted to hear that the engraving of "Just in Tune" is so fine. I am anxious to see it.

The fates have been against my painting the companion to "Just in tune," but time and a little patience will bring it about. First, I had no studio; second, two hot. Third, I had a fall, and then I contrived a studio to paint your picture, and a week ago today I was poisoned so severely by a vine called the running ivy, a mercurial plant, that I have spent a week of torment, suitable only to a fallen angel of the olden time. But the sky brightens, I am better.

The ladies sends their compliments to you. Yours very truly,

Wm. S. Mount

New York, Sept 9, 1850

My dear Sir,

Your kind letter has been received and I assure you that its contents have given me great pleasure. I should like to go on Tuesday (to-morrow) but I regret that business matters will keep me in town until Saturday next, when I will take the steamboat, and have a good time—for I shall have "Just in Tune" with me.

I shall be delighted to see my friend at Stony Brook and am particularly gratified to know that your brother has not forgotten me.

Wishing to *one* and *all*, in meantime, good health and prosperity, believe me my dear friend,

[SB]

Yours very Sincerely
W. Schaus

Diary Entry

Stony Brook, Sept. 15th, 1850

Pictures for Wm. Schaus Esqr:

One picture (life size head) 25 × 30—an old man of the Revolutionary times reading an account of the battle of Bunker Hill—paper and costumes of the times.

~~One picture Negro—African—head life size—laughing, showing his white teeth and holding something funny in his hand~~—*Goose, a Duck, or a squirrel* etc.—~~Size 25 × 30~~——it is painted [see c.pl. 27].

One picture cabinet size—Negro asleep in a barn—while a little boy is tickling his foot.

~~Another—a group of figures Reading the Herald~~——painted.

A group of figures Talking—seated around in a circle.

Courtship—A Negro popping the question only think of that.

~~Bone player, Banjo player~~——painted [c.pls. 28, 29].

[Added later:] For Goupil & Co. Sept. 1853: one picture as a companion to the Lucky throw.

Three of these entries were later crossed out and the word "painted" added at the end. Oddly enough, Mount here neglects to mention Right and Left *(c.pl. 30), which was part of the series commissioned by Schaus.*

Stony Brook, Oct 20th, '50

To Wm. Schaus Esqr.

On my return home, I found the model I so much desired for your picture—had sailed. I am happy to state that I feel quite in the humour for painting, and only wish I could paint up at once your orders, but on looking over my list of engagements I find you must have patience with me as other good souls have done.

I am now painting a picture which you shall see in due time.

Brother Shepard will be down to the City with his beautiful picture this week.

The Ladies desire to be remembered to you.

[NYHS]

Yours, as ever
Wm. S. Mount

289 Broadway, Oct 22, 1850

My dear Sir,

I had double pleasure this morning, for I received your kind letter and also the visit of your brother. His picture has taken the place of "Right and left"—the latter is to be within a few days on the broad ocean. I am pleased with the Rose of Sharon and no doubt the public will be the same. I hear with delight of your good humour to paint pictures. Bravo! Bravissimo! as the Italians would say. Come soon and bring your picture with yourself. Mrs. Vanderhoff is very desirous to see you. I believe she wishes a portrait of her father. Mr. Price expects you shortly at his residence at Glencove and I have been written to meet you there. I shall write you as soon as I can go to Mr. Price, so that we meet together. I should have written you ere this, but business has been so good that we business men think too much about dollars and cents. Still my thoughts have been often at Stony Brook, and its hospitable inhabitants.

Please give my best respects to the Ladies and believe me my dear Sir,

[SB]

Yours very truly friend
W. Schaus

New York, Dec. 16th, 1850

My dear friend,

I have to communicate to you quite upsetting news. Since today I have ceased to be connected with the house Goupil & Co. Our separation arose from pecuniary matters. After my long stay in that house (nearly fifteen years) and wishing to secure me a future free from troubles, I had asked, besides a salary, to become interested[?] in all such publications as I might issue from American pictures. They have refused to accept my terms and I am now about to establish myself on my own account. We live in a great and glorious country and I have every hope that I will succeed. Among the many *true friends* I have made, I am happy to count you and I trust that your friendship for me will ever be the same. As a matter of course I intend to publish some of your future works, if you see fit to give me a chance. I am by no means willing that you should give me a preference—a preference which by the way I should consider very flattering—with any of your pictures, while I hope that we can do something together. I feel somewhat grieved to leave an establishment with which I was connected for so many years, while on the other side I feel it my most imperative duty as a man to try my own fortune if I want to become independent and perhaps free from troubles of dollars and cents.

Please remember me to your family and tell them that I shall ever feel gratified for the kind feelings entertained for me. I am as yet uncertain what I will do, but as soon as I know it you shall be immediately advised.

When you come to town you will find me at No 81 McDougal St and if you can drop me a line, please direct it to the same place. Meantime[?], I remain dear sir and friend,

[SB]

Yours most sincerely
W. Schaus

Stony Brook, Dec. 20th, 1850

Wm. Schaus Esqr.
Dear Sir,

The commission you gave me, a negro holding something funny in his hand, I have almost completed. I wish you to see the work either here or in the City. Mrs. Seabury desires you to dine with her on Wednesday next. Procure a ticket to Lake road station. You will arrive here one hour sooner. I shall expect to see you here Christmas. If consistant with your engagements.

The above I had written to you when Julia handed me your letter sealed with black— You have my best wishes. I hope the house of Wm. Schaus, and also, the house of Goupil & Co, will prosper; there is nothing to prevent it, the glorious union is large. As you desire it you shall have a share of my labours. I have not time to say more. In haste, I remain as ever,

Yours truly,
Wm. S. Mount

[NYHS]

Merry Christmas!!
Happy new year!!!

New York, Dec. 23, 1850

My dear Sir,

I received this morning your friendly letter and things have changed since my last communication. I remain with Goupil & Co. It is probably the best for both parties. This arrangement prevents my going to Stony Brook. Please express my hearty thanks to Mrs. Seabury for her kind invitation, which I am exceedingly sorry not to be able to accept. As for the picture, I have made no mention to Mr. Strong[?], and when you come to town, you may bring it with you. Should he decline taking it, I will do so. You need therefore not mention that I gave you an order, but say it is your own.

When will you come to our City? Give my best respects to all our friends in Stony Brook and believe me dear Sir,

Yours ever truly
W. Schaus

P.S. I forgot to mention in my last letter, that my beloved mother is no more. This accounts for the black seal.
[SB]

Stony Brook, Dec 25th, 1850

Wm. Schaus Esqr.

Your merry Christmas note I have just received. I thought it very strange that Goupil & Co. should let you run away from their establishment. To tell you the truth, they might rake Germany, France, England, and the United States, with a fine tooth comb before they could find a man that understands so well as you do their interest with the Americans—even at double *your sallery,* the house would be the looser in parting with you.

I am pleased you remain, it is honorable to both.

I expect to be in town next Monday or Tuesday. You will have a fine time at Mr. Benedict's, on Friday evening. I wish it were in my power to drop in.

In the death of your Mother, you have lost your best friend. You must not forget her wise admonitions. I wish you, and Mr. Mainguet, a Happy New Year.

Yours truly
Wm. S. Mount

[NYHS]

Stony Brook, March 18, 1851

Wm. Schaus, Esqr.
My dear Sir,

I had just been thinking about you and the charm that the beautiful Miss Conover held over your affections and that *poor me* was completely forgotten when your kind letter announced the happy change that was to take you from bachelorhood to union and *happiness.* I regret that I am not able to see my friend Schaus tied at the altar, but as you are left in good hands I sincerely hope that *you* and *Mrs. William Schaus* will lead a *prosperous* and happy life in *this* world and have a share of heavenly *enjoyment in the next.* All your friends here congratulate you. You are a lucky man to marry one of our York girls. Please give my best regards to your lady.

and believe me
Yours most sincerely
Wm. S. Mount

[NYHS]

[August 10, 1852]

My dear Friend Mount,

It will be not surprising for you to hear, that I have resigned the agency of Mr. Goupil & Co and intend to sail for Europe early next month. Why will you not come with me? I trust that my future career will bring me in frequent communication with you and I hope that you will never forget the first publisher of your works. Present my compliments to all the members of your family and believe me as ever

Yours truly
W. Schaus

[SB]

Stony Brook, August 21st, '52

Wm. Schaus Esqr.
My dear Sir,

I have just returned from the South side of the Island where I have been painting portraits, consequently I have just had the pleasure to read your friendly letter.

I wish it were in my power to go to Europe with you. I hope soon to see the old country, the old Masters. "I shall not forget the first publisher of my works." We all wish you to come and see us. My Sister, Mrs. Charles

Seabury, says that you must bring your wife, and let her see this quiet part of the country. Shepard and lady is at home and would be glad to see you, and none would be more happy to see you than my humble self.

<div align="right">

Yours truly
Wm. S. Mount

</div>

[NYHS]

<div align="right">

New York, August 23, 1852

</div>

Friend Mount,

Your very kind letter reached me this morning and I beg to insure to you my sincerest thanks for your kind wishes. I trust that I will have success in my undertaking as I hear from every side sympathy and promises. Gladly would I avail myself of your friendly invitation to visit you and your family, but I am afraid that business will take too much of my time previous to my departure. I will however remember that I must visit Stony Brook with my darling wife ere long. By the way, have you any new masterpiece on the easel? If not I will send you canvas, easel, colours, brushes and [illegible] etc. as I am anxious to issue soon some of your works if agreeable. Mrs. Schaus and myself beg to be kindly remembered to yourself and family and trust to see you previous to my departure to Europe.

<div align="right">

In haste, but as usual
Yours ever truly
Wm. Schaus

</div>

[SB]

<div align="right">

New York, Sept 1852

</div>

Friend Mount,

I have just returned from Washington where I had the pleasure of greeting our excellent friend Charles Lanman Esqr. who wishes to be remembered to you. Our friend is very busy with the fishery question now pending between the Anglo-Saxons; however we live in a happy age in which the pen has taken the place of the sword, and future generations may even look on the gunpowder as an odd-itie of the middle ages. I must not philosophyse too much, wishing to talk with you in regard to some business matters. You know how anxious I am to publish some of your work as soon as possible and I should be pleased to know if I could obtain the following pictures:

"Raffling for a goose" (now in Troy I believe)

"Negro asleep"—"Hay Making"

"Bargaining for a horse"

I do not wish to obtain the copyrights *gratis, but I intend allowing you an interest on the sale of each copy.* As long as I was Agent for Mr. Goupil & Co, I was obliged to act in accordance to their instruction, but now I can be liberal on my own account and nobody can find fault with it. I would also give you an order for some large heads, same size about of "Just in Tune," "Right and

left" and "Raffling"; the subjects to be something like the above and representing:

"Negro playing the Banjo and singing"

"Negro playing with bones"

How soon can I have one or both of these pictures? As it is my wish, that you shall derive an interest from the sale of all Engravings I may publish after your works, I should be pleased to see you previous to my departure. Please consider this letter strictly confidential.

Remember me to the members of your kind family and believe me my dear sir,

<div align="right">

Your true friend,
W. Schaus

</div>

Mrs. S. sends her kind regards to you.

[SB]

<div align="right">

Stony Brook, Sept 9th, 1852

</div>

Wm. Schaus Esqr.

My dear sir,

Your letter of Sept. 1st I have received. I like the tone of it. The good feeling manifested. I am ready to negociate with you, if you will state the time when and where I can meet you. I will undertake those large heads for you, although I have been urged not to paint any more such subjects. I had as leave paint the characters of some negroes as to paint the characters of some whites, as far as the morality is concerned. "A Negro, is as good as a White man—as long as he behaves himself."

<div align="right">

Yours truly,
Wm. S. Mount

</div>

[NYHS]

<div align="right">

New York, January 5, 1853

</div>

My dear Sir,

Since my return from Europe my time has been so much engaged in fitting up my new place, that I could not do justice to my friends and I hope you will excuse me if I have not written to you sooner. Allow me before all things to wish to yourself and to your friends at Stony Brook a happy new year and may you find time to paint many more pictures. This reminds me to ask you how soon you will let me have the paintings ordered so that *we* might make a beginning which I have no doubt will prove advantageous to us both. You will be pleased to learn that my darling wife presented me on the 19th of December with a pretty little daughter and that both mother and child are doing well.

I hope to see you soon in our City, at all events please drop me a line as soon as convenient.

Remember me to all the good friends at Stony Brook and believe me dear sir,

<div align="right">

Yours ever truly
W. Schaus

</div>

[SB]

Stony Brook Jan 4th, 1853

My dear Sir,

Your letter dated Jan 5th ult I found on my return at the Post Office. Yesterday was dull and rainy, today warm and sunny.

Roberson's colors, I purchased of you, are firstrate. I am delighted with them, and one thing in their favor, they are not mixed with *sugar of Lead,* which is pernicious. Colors should be pure, finely ground, and free from dust. The colourman can not be too particular.

Winsor and Newton's colors I have been using. G. Rowney & Co. I believe mix Sugar of Lead with their vandyke brown and black to make them dry. Take one of their tubes of vandyke brown and smell of the color, you will be convinced. Megillp mixed with sugar of Lead is sold by some venders. It is wrong.

Please give my respects to Mrs. Schaus, and also to Miss Schaus.

Yours as ever,
Wm. S. Mount

[NYHS] *This letter is misdated, since it is a reply to Schaus's letter of January 5, 1853.*

Diary Entry

Feb. 1854

One picture for Mr. Church, landscape painter—exchange for an old Master.

Two pictures for Wm. Schaus Esq. One a Banjo Player, and the other a Bone Player. [Added later: Painted and published.] Mr. Schaus has offered to give me two hundred dollars apiece for the above pictures, size 25 × 30, and says if I should dispose of them to any one else at two hundred dollars each or more, with a priviledge to have them engraved, he will also give me fifty dollars extra—which will make the two pictures amount to five hundred dollars. [Added later: See another article on the Bone and Banjo Players—1856, cf. proposition from Mr. Wm. Schaus.]

All the interest brought into the smallest space—the abstract of life.

Paint pictures that will take with the public, in other words, never paint for the few, but for the many. Some artists remain in the corner by not observing the above.

Stony Brook, March 2d, 1854

Wm. Schaus Esqr.

Dear Sir,

A note has just reached me from the corresponding secretary of the N. Academy, and says, "In consequence of the sale of the property of the Academy, and the necessity of delivering it to the purchaser as early as the 1st of May, the Exhibition will be opened for one month only,

beginning on the 22d of March, and closing on the 25th of April."

Having been so unwell since I saw you, I have delayed writing to Mr. Smith. Shall we exhibit the Picture "Coming to the Point" before it is sent to Paris, as the time is short?

Let me know your views, before I answer Mr. Smith's very admirable letter.

Yours, very truly,
Wm. S. Mount N.A.

P.S. My Niece, Mrs. Julia Wells, was delighted with her present. Mrs. Seabury says that you and your wife must spend a week with us when the country has put on its best garment.

[NYHS]

303 Broadway, New-York
(up stairs)
March 4, 1854

My dear Sir,

I have just received your kind favor of yesterday and I say, *by all means,* have your picture exhibited in the National Academy. I feel the more so: first on account of yourself, as some persons think you have abandoned the glorious Art, and secondly, this will in all probability be the only Exhibition for some time to come. Besides, the Exhibition will be a short one, and I can send the picture after it closes. Please write to Mr. Smith on the subject at once, and have the kindness to mention to him, that I should like the picture after the Exhibition here is closed. Mr. Smith might send the picture to me and I will take it myself to the Academy. Friend Mount, *you will be the Lion of* the artists and it will be another star added to your glorious flag!

I am happy to hear, that I am not forgotten by your friends in Stony Brook and I shall be most happy to bring my wife to Long Island next summer. Write me again and let me hear how your new pictures are coming on. Mrs. S. sends her kind regards to you.

Yours ever truly
W. Schaus

[SB]

WSM to Adam R. Smith

Stony Brook, March 4th, 1854

Dear Sir,

Your admirable letter has done my heart good. The picture has a resting place, and I am satisfied at last.

By your kindness in loaning the picture to be engraved, I have received from Mr. Wm. Schaus, two hundred dollars for the right of Copy. This is the first interest I have ever received in any of the publications of my works. Mr. Schaus has promised me an additional sum if the engraving proves successful—which is my hope.

Mr. Leon Goupil, and Knoedler, of the Publishing house of Goupil & Co, expressed themselves as being highly pleased with the "Coming to the Point." Mr. Goupil said he would like to engrave it with your permission. I then mentioned that Mr. Schaus had spoken to me some time previous and that I had just written to you for your consent, he then remarked "I am too late." I hope the above statement will afford you some gratification.

I have been quite sick with the influenza since I wrote you (the brush has had a resting spell). My head pains me and I feel somewhat stuped in consequence, but brighter days are coming, so let us rejoice in the goodness of the Almighty.

<div style="text-align: right">Yours truly,
Wm. S. Mount</div>

[NYHS]

<div style="text-align: right">Stony Brook, March 8th, 1854</div>

Wm. Schaus Esqr.
Dear Sir,

In my letter to Mr. Smith this day, I said, "It is gratifying to me that you have given your consent to Mr. Schaus, to have the picture engraved in the finest style of Lithography. And also, that you would like to have the picture forwarded to Paris after the exhibition is closed."

I advised Mr. Smith, to send the painting at once to the Academy, as the expense is borne by the Institution although I mentioned your offer to take charge of it.

The pictures you desire me to paint are not commenced. I have not been well enough. To paint understandingly the mind must be clear. Health is important. Time will bring out the Negros, and make them to shine like a full moon.

<div style="text-align: right">Yours truly,
Wm. S. Mount</div>

[NYHS]

<div style="text-align: right">303 Broadway, New-York
(up stairs)
March 11, 1854</div>

My dear Sir,

I have just received your esteemed favor of the 8th and I am much pleased with the good news it conveys. Today I have to tell you a rather strange proceeding which will perhaps not surprise you. I was informed yesterday that Goupil & Co. have applied to the American Art-Union with a view of purchasing the plates, "Bargaining for a horse," and with the intention of making a large print from it evidently with a view to injure my publication of "Coming to the Point." Of course I know you will never give your consent in such a matter, but Goupil no doubt supposes that if they buy the little plates, they can copy it in any shape. I know that you never granted such a right to the Art-Union to dispose of the copyright without your consent, besides in the present circumstances you will

surely regard my interests, as a similar subject would materially change my prospects in the coming publication. ~~If Goupil wants so much one of your pictures, why does he not go straight to you?~~ However, I think it well for you to adress a few lines to Mr. Warner of the Art-Union on the subject, saying that you have been apprised that application had been made to the Art-Union for the plates "Bargaining for a Horse" and that no doubt it is the intention to enlarge the same, and that having painted a variation of the same subject quite recently, of which I had purchased the copyright, it would be extremely painful to you under these circumstances to have anyone else publishing the "Bargaining for a Horse." You can say also that in granting the permission to the Art-Union of issuing an engraving, you did not by any means intend to convey the exclusif copyright of the picture. Say also that you hope that the Art-Union will take into consideration your interest of such a work. Of course you can arrange this letter so much better and I will thank you to send to me the likes for Mr. Warner without delay. Do tell me, has Goupil written to you about it? I am sorry to see the way my old house tries everything to do me injury and I am sure you will do what is right in the matter. You know my intentions towards you and I only regret my inability to do much more.

I am sorry to hear of your indisposition and hope you are well again now. Will you not come soon to New York? If so you must come to see me and Mrs. S. After I have told all my friends of the *Great picture* and feel confident of a *tremendous success!*

<div style="text-align: right">Yours very truly
W. Schaus</div>

Mr. Warner's address:
 Andrew Warner Esqr
 Corresponding Secretary
 Of the American Art-Union

Send the letter to me.
[SB]

WSM to Jonathan Sturges

<div style="text-align: right">Stony Brook, March 14, 1854</div>

Dear Sir,

A friend dropped me a line yesterday stating that a distinguished publishing house in N. York, has applied to the American Art-Union, with a view of purchasing the plate "Bargaining for a horse" for the purpose of making a large print from it, evidently the intention of injuring Mr. Schaus' publication of "Coming to the point," a variation of the "Bargaining" and painted by particular request for A. R. Smith Esqr. of Troy, N.Y., who has kindly given his permission to have it engraved in the highest style of Lithography in Paris, and Mr. Schaus has paid me two hundred dollars for the Copyright.

At the time I gave my consent to the Art-Union to engrave from my picture, I had no idea that they ever in-

tended to sell the copy right. The engraving was made for the subscribers only. But, I know with sorrow that they did dispose of the old plate of the "Farmers Nooning," and what miserable impressions Mr. Appleton has thrown out to the world, a lie in comparison to the original and a disgrace to his taste. How a man can pick up dollars from a worn out plate, it is like a crow picking up a few pieces from an old dead carcass. I hope you will not suffer the small plate "Bargaining for a horse" to be sold for the purpose of being magnified, and thereby lose the spirit of the painting.

Please see Mr. Warner about it at once, if convenient. If another engraving is ever taken of the Bargaining, it should be from the original painting, and the artist paid for the copyright.

This has been a beautiful day, the birds are just now singing and all nature seems smiling, thereby convincing man that Heaven is some what an improved reflection of this Earth.

I look with pleasure to the time when I shall meet you at the opening of the Academy.

[NYHS]

Yours truly,
Wm. S. Mount

Stony Brook, March 15th, 1854

Wm. Schaus Esqr.
Dear Sir,

A friend of ours in art matters has informed me that a distinguished publishing house has made application to the American Art-Union, to purchase the plate of "Bargaining for a horse," with the intention of making a large plate from it, perhaps with the intention of running your publication of "Coming to the Point" off the course. I do not believe they would move in the business without consulting me, which they have not done as yet.

Please call on Mr. A. Warner, and see about the matter, say to him that when I gave my consent to the Art-Union to engrave from the "Bargaining" I never expected the committee to sell the Copyright (the plate) when they had done with it, with a view to its being magnified, and thereby lose the spirit of the painting. The engraving was intended for the subscribers only.

I have addressed a letter to Mr. Sturges on the subject, so you perceive I am anxious to see you protected, as you have paid me for the copyright of "Coming to the point."

It is my hope that the dollar is not always to influence man from his *duty to his fellow being.*

[NYHS]

Yours truly,
Wm. S. Mount

N.Y., March 21st, 1854

Dr. Sir,

The painting "laying down the bars" is coming back and the lithograph completed. Our house in Paris requests us to send them a good title for the print. Last time we saw you, you spoke of another than the above said one. If you think one would be better, please inform us at your convenience and oblige.

[NYHS]

Yours respectfully,
Goupil & Co.

303 Broadway, New-York
(up stairs)
April 24, 1854

My dear Sir,

I have duly received your esteemed favor of April 20th and I have given the necessary orders that some pictures might be sent to me after the Exhibition. I will send it off at once.

The papers have contained but very little in regard to the Academy and I have been very much surprised to find that even artists have been unkind to your work. Of course it amounts to nothing and it is not worth while to take any notice of such petty feelings.

I hope you are well and that I may soon hear of the progress of the new paintings.

We are all well here and hope to see you soon in New York.

[SB]

Believe me dear Sir,
Yours very truly
W. Schaus

Stony Brook, April 26th, 1854

Wm. Schaus Esqr.
Dear Sir,

Your favor of 24 inst. informs me that the picture will be sent off at once. Good. I have received a few art notices, some are expressed in a kind manner, and some are abusive.

The two hundred dollar copy right, which you gave me, could not be forgiven; that raised the steel pen against me, as you had predicted. But I have not forgotten that a number of artists, while standing before the "Coming to the point," remarked that it would make a fine engraving, and that is what you desire—that is what you bargained for.

The late Thomas Cole remarked, "Fulsome praise, stupid presumption, and interested detraction make up the amount of news paper criticism on the fine arts."

You are right "not to take any notice of such petty feelings." I can truly say that I never raised a pen to injure a brother artist that I can remember.

There is given every opportunity for painters to love one another. Five thousand artists could not paint up all the character and scenery to be found in this state alone.

The very thought of such a boundless nature should make them lift up their hands with thankfulness.

I am looking forward to the time when I hope to see an exquisite engraving from the Bargaining. Give my best

regards to Mrs. Schaus and to La Petit Miss Schaus.

Yours truly,
Wm. S. Mount.

P.S. I am working for you.

[NYHS]

303 Broadway, New-York
(up stairs)
New York, Nov 11, 1854

Friend Mount,

I have duly received your kind letter and have to apologize for my long silence. Business here has been so very poor, that every trade is at a stand still. The fine Arts particularly have suffered unusually and you have done well not to bring your Webster picture to the City. Still we all must hope for better times and that very soon, and I shall be happy to see you soon. My family are all well, our little Annie is growing up a pretty young lady and may yet one day captivate your heart.

Please remember me to all your friends at Stony Brook and believe me dear sir,

Yours very truly,
W. Schaus

[SB]

Adam R. Smith to WSM

Troy, 2 July, 1855

Dear Sir,

Your letter with its welcome intelligence of the speedy return of the much regretted picture came this morning, and I am pleased that you *seem* gratified with the print, although you do not *say* so. We have missed it very much at home, and as one gets older the causes for pleasure diminish so rapidly that one becomes jealously careful of that which adds at all to them. I am quite ready to welcome the picture's return. As to the dedication, it has always seemed to me that mere ownership does not entitle or warrant one's name being at all connected with a picture, so that I leave it to yourself to decide, only begging that if anything is done, it may be the simplest possible statement that I am honored in its possession.

Those warm days! How I am able to sympathize with you.

Mr. Palmer is busy with his modeling tools and his "sketchbook" is rich in what will add to the stock of the world's beauty. You artists are of the twice blessed among men, in giving beautiful embodied thoughts to the weary workers of the world and winning warm regard, deserved.

Shall I hope to see you at my home this summer.

Yrs truly
A. R. Smith

[NYHS]

Fragment of a Letter, Addressee and Date Unknown

Dear Sir,

Wm. Schaus Esqr, whose business compels him to know something about pictures, says that Farmers Nooning, Raffling for a Goose, and Farmers Bargaining are the most finished American pictures in all the qualities that make up a perfect work of art, that he has yet seen, since he has been in this Country. When Mr. Schaus was in the employ of Goupil, Vibert & Co., foreign print publishing house N.Y., "his accurate judgement and refined taste introduced Mr. Mount's pictures to their notice" and selected to commence with the Power of Music, and Music is Contagious also followed. Catching Rabbits and Just in Tune. Lucky Throw, and Right and Left, were orders. Politics of 1852 was purchased for publication by Leon Goupil Esqr of the above house.

[NYHS]

Stony Brook
March 26th, 1856

Wm. Schaus Esqr.

It affords me great pleasure to state that I am engaged painting the *Bone Player* for you, for publication. The size is 29 1/2 in by 36 1/2 inches. I will not say any thing about the painting, as your own eye will tell you better than a description from me. I expect to have the picture finished next week. You may prepair a *head* (round molding) frame, to exhibit it in, if you think proper, in your own store.

Yours, very truly
Wm. S. Mount

[NYHS]

629 Broadway, New York
June 11, 1856

My dear Sir,

Do not find too much fault for my long silence. Your kind letter informing me of the completion of the Banjo player was received by me in due time, but I was so ill with a cold, cough, and pain in my chest prevented me to attend to anything whatever, and if I had I should have been just now prevented from seeing you in the country. You know how I am situated. If I am gone, my business suffers too much and unfortunately I can not do what I should like to do. I have seen your brother who gives me great hopes that the picture is a genuine diamond. Do you not think best to come at once and see Mr. Jones; he may want the pair and I think you can talk him into that. At any rate there are so many other folks who would like a picture like it that you have every chance to command your price. Believe me, dear sir,

Yours very truly
W. Schaus

[SB]

Diary Entry

March 5th, 1857

I heard to day of the arrival (of a proof plate) of the Banjo Player, from Paris.

Copy of note from Mr. Schaus, 1856—

My dear Sir, My Commission to paint me a picture similar to "Raffling for a goose" is to be in the following terms: Each picture to be $200—including the copy right. With a view to afford to you additional advantages, you are at liberty to sell the picture to any party and reserve me the Copyright, and in that case I will give you $100.00 —for the copy right of each picture.

Truly yours—W. Schaus, Esq.

I have painted and sold two pictures (The Bone and Banjo performers) according to the terms mentioned above—and receiving $100 copyright of each painting to be engraved.

Diary Entry

April 1857

One picture for Wm. Schaus, cabinet size—Negro asleep in a barn—a boy tickling the darkies ear while another urchin is tickling his foot.

diaries 1847

Stony Brook, Jan. 9th, '47

There is nothing to prevent me from painting pictures. I must select my figures (or model) and go to work, and keep at it from day to day and let no amusement drive me from my esel. It is time I began to make some money.

I desire now and then to shake a few eagles at some rich people, who think no man respectable without he has money.

I hope that in prosperity that I never shall forget to be charitable.

[1847 or 1848]

A figure clothed in dark and light colours is often effective.

"I think, therefore, the true test of all the arts is not solely whether the production is a true copy of nature but whether it answers the end of art, which is to produce a pleasing effect upon the mind." ——Reynolds.

Stony Brook, Jan 10th, '47

It matters not where an artist is located, City or Country, if he will only work—subjects, colour, form, and expression should ever be present in his mind.

Jan 19th, 1847

I had almost destroyed my love for painting, by having a narrow low light to paint by. A breadth of light on your model and esel for your life. There is a pleasure in sitting out in the center of your room when at work; you can breathe more free. Also a space to walk back and view your painting at a distance—which is important—

In a room 20 by 21 feet and the sill of the window 10 feet from the floor, the size of the window should be about five feet square.

A room should have several windows to open at pleasure. I prefer an upright window to a sky light. An orange yellow curtain made of muslin or flannel would produce a rich effect of colour in a room, similar to sunset, or lamp light.

After painting portraits, it takes so long to get my feelings in a train for painting pictures. They require deliberation and more study than portraits.

I feel difident to get models—I must overcome it. I must engage models, and then I shall be compeled to go to work. If one will not serve another will.

If painting on a low key will produce brilliancy of colour, will enable the artist to give the full strength of the palette—which has been the practice of the best colourists to lower the tone of the pigments by keeping out white as much as possible—then the light of the window must be subdued by some rich coloured curtain, to give the tone required.

Perhaps a curtain, made of blue, red, and yellow, equal parts, would give the tone required.

Jan 25, 1847

I painted two years ago several figures for experement. My picture was lit up by a north light, my models by a counter light, 13 feet from a south west window which was subdued by an orange yellow curtain. The figures were shaded from the light which I painted by. My object was to represent a reflected light.

The sun shining through the red yellow curtain had a rich effect.

I once lighted up my model by lamp and painted in daylight myself. I was pleased to find that Haydon had tried the same effect. The picture was rich and it required but few colours.

By subduing the light the splendor of the colours can be given, also zinc white with the yellows and reds etc, instead of white lead; and with an "egg vehicle the umber whites might be employed in an oil medium, such as barytic and true Pearl white."

In painting out of doors it would be well enough to have a skreen of red or yellow to give richness of colour to the model. When the sun shines.

In painting without a regular set palette, have a few grey tints to cool down the reds etc., when too strong.

For a change, place the light colours on the left of the palette near the elbow.

First, Terre-Verte, Flake white, lemon, or Naples yellow, Yellow Ochre, vermilion, Madder lake, Terra-rosa. bank umber, Ivory black and lake, or Vandyke brown, Prussian blue, and Ultramarine.

Umber broken with lake and vermilion will make Indian red. Umber will soften the flesh tints into shadow delightfully, so will Terre-verte. The two latter pigments, with white, will make beautiful grey tints in the flesh.

Above all, never engage a lifeless model, or one without expression, if an artist desires to colour well, or be-stimulated in his work.

Stony Brook, Jan 1847

Size of my Studio—Nineteen feet three inches width by nineteen feet nine inches in length. Height to the bottom of the window from the floor ten feet three inches. The amount of light, four feet, by four feet. Nearly a west light—fine in the afternoon of a clear day, and a good light all day when there is a white cloudy day. Cloudy weather when not too dark affords a fine light. Take the year round, I think the west light the best. A south or a North light can be had at the same time. There should be two or three small windows below the large one around the room, to let in reflected light at pleasure—13 feet from the side window frame to the north side of the room. Part of the garret floor taken up.

Jan. 1847

Perhaps some characters would be pleased to sit as models, for a sketch of themselves in oil or with pencil as remuneration. In that way an artist would have great practice—to experiment in colour.

Stony Brook Umber is good to use with colours that do not dry well, lakes, Vandyke Brown, and black. It is transparent for glazing, and with white makes a beautiful warm pearly tint in the flesh.

Should be ground in nut oil or poppy—by burning its tint is cooler. It combines well with Asphaltum.

My Brother Henry used common lampblack with white in painting the lights on his black silk hats. He had great freedom of hand in painting different kinds of furs. Lamp-Black dries badly in oil—durable.

"Sir Joshua Reynolds gives it as a maxim, that the less pigments are mixed, the brighter they appear." When pure they can be toned, with blue or grey.

Fuzeli "sunk too much the painter in the critic."

"A great characteristic of all the young men who were afterwards distinguished, was that in their youth they were listeners and not talkers when in the presence of old-er men of genius."

Wilkie received 30 guineas for the Politician; 50 guineas for the Cat[?] finger; Card players, 50 to a 100 guineas. It was subsequently sold for 500 guineas. Rent Day, 150 guineas; 150 guineas for the Alfred. The first important price he had was Angerstein's (Now in the National Gallery), viz 800 guineas; and the highest price he ever got was £1200 for the Chelsea Pensioners, from the Duke of Wellington.

"The best artists of late, in drawing their landscapes, get upon a rising ground, make the nearest objects in the piece the highest, and those that are farther off to shoot away lower, till they come almost level with the horizon, lessening everything proportionably to its distance, and observing also to make the objects fainter and less distinct the father they are removed from the eye. Those objects that are very distant—weak, faint and confused; those that are near and on the foremost ground—clear, strong, and accurately finished."

"The figure is the basis. Begin with hands and feet and heads—first the bones, then the muscles, then the antique, and after drawing these well in proper positions, draw them in difficult positions. Above all, after your day's labour, draw what you have done from recollection." ——Haydon.

"An unobtrusive crimson and green colour is best adapted to the walls of an exhibition room. A cool gray, or neutral, is in general best suited to the passages and approaches of the gallery as a preparation of the eye."

"The eye of the artist is necessarily influenced in paint-

171

ing by light and surrounding colours. Hense, the colour of the walls of the study and gallery of the artist is important to good colouring.''

"Sliding rods crossed the room diagonally, upon which a number of variously coloured and figured curtains moved beyond his subject or sitter, with which he might suit colours, or form combinations, draperies, etc. as back-grounds, or tune his eye upon feeling and principle to the colouring of his design.'' Would be useful.

Make a picture of your subject in effect before commencing painting; make nature interesting.

"The art of seeing nature, or in other words, the arts of using models,'' says Sir Joshua, "is in reality the great object—the point to which all our studies are directed.''

Some people call all labour idleness that dont tend directly to making money. They do not know the study it requires to paint a good picture. But practice makes the hand ready and gives vigor to our compositions.

[January, 1847]

In effect, I must go to the extremes of white and black—as when I painted the Raffle. Figures should never be cramped in a small place, they should have room to breathe.

Jan. 13th 1843—brother Shepard and myself found some good pigments on Long Island. I painted a picture almost wholly of those we found.

I believe with Reynolds that an artist should go about his work with "an immediate impulse,'' with life and spirit, or else put down his palette. The brush requires the whole mind.

Feb 1st, 1847

If I mind my own business, keep at work, I shall never be troubled with idle or interested thoughts about others' wellfare, nor looked upon with jealousy, for good intentions.

I have observed that when advice has been [given] with the best of motives, not only about pictures but other matters, that the advice was not always satisfactory, however good.

The best way, then, will be to ask advise if you need it; but never give any.

Keep your own plans to yourself.

Let every man think himself a great one if he chooses. But time and industry discovers truth, and true merit in the end rises uppermost.

Read good works, listen rather than talk, and when an artist flatters you, work the harder.

Never be dictated to by others, but work from impulse, and carry out your plans if possible. An Artist should know himself and not be trifled with.

Bathing, Blacking and shaving had better be done evenings in winter.

I think it is wisdom to speak well of your antagonist. Never try to build yourself up, by underrating your rival. Let every one have all the fame they can get—if they get it honestly. But time always settles that. But remember, never let yourself be lulled to sleep by flattery; but be up and doing. "Be ye wise as serpents but harmless as doves.''

Never let the happy moments pass by without doing something—if it is only a rough sketch with pen or pencil. When an artist tells you that part of the picture is well enough, never rest if you can go one touch beyond his admiration.

It would save much time, simply, to aim at locality and breadth and touch in but few of the prominent folds, and be careful where the sharpe and dark touches are made. Look at the works of Teniers: leave out dark lines in the mass of light.

It is the management of light and shadow that gives force and beauty to a figure, and with colour and correct drawing perfection will be the result. The light in front of the spectator, often has a fine effect. The proper arrangement of lines and angles—adds to the beauty of colour.

Stony Brook, Feb 16th, 1847

I am now keeping bachelors hall, in the absence of my sister. I never was happier. It comes nearest to the perfection of living. It will do in the winter.

An artist should paint without reference to an exhibition. Academies and Exhibitions are often clogs upon the mind, and take up too much time.

Some artists when they have touched in the effect, arrangements etc, must call in their brother artists to show what a fine commencement—to receive a little tickling and suggestions. And if they make a happy touch, to sit, and smoke a sigar over it half a day.

As regards expression, an artist should not be confined to one model. It is good to give instructions and money to those that are needy, and it is well to save a little of both to battle our enemies.

"Give not that which is holy unto the dogs, neither cast ye your pearls before swine, lest they trample them under their feet, and turn again and rend you.''

"First, cast out the beam out of thine own eye; and then shalt thou see clearly to cast out the mote out of thy brother's eye.''

"But let your communications be, Yea, yea; Nay, nay —for whatsoever is more than these cometh of evil.''

"This is the rule I would have you constantly observe in your commerce and dealing with men, and your whole conversation. When you have occasion to affirm a thing, affirm it steadily without an oath; when you have occasion to promise that you will do a thing, or will not do

it, promise, but do not swear, and when you have promised, be sure you be as good as your word."

"Do good to them that hate you, and persecute you"—treat them politely at least.

"Behold, I send you forth as sheep in the midst of wolves; be ye therefore wise as serpents and harmless as doves." ——Christ.

"A silent and loving woman is a gift of the Lord; and there is nothing so much worth as a mind well instructed."—"The grace of a wife delighteth her husband and her discretion will fatten his bones."

"Much experience is the crown of old men, and the fear of God is their glory."

"I will not be ashamed to defend a friend; neither will I hide myself from him."

"Learning is unto a wise man as an ornament of gold, and like a bracelet upon his right arm." ——Ecclesiasticus.

Sympathy adds to greatness, and makes the possessor of it to shine like pure gold. ——W.S.M.

Picturesque style, Salvator Rosa. Familiar or Trivial style—history treated rather familiar—Pieta, dead Christ.

March 4th, 1847

Beware of much purple in flesh; grey is better.

In painting a picture in the City, if the artist should desire to introduce a bit of a landscape, a cottage, haystack, or barn, cattle etc, he can soon place himself on the spot for his materials, as the conveyances from the City to the Country are so numerous.

It is almost needless to go after backgrounds until they are wanted. There is time enough after you have determined on the design of your picture. I believe an artist would be more industrious in the City—be stimulated by seeing more works of art, and characters, from all parts of the country. There is one serious drawback—more idlers to take one's time.

I am convinced that an artist should not be too much interupted when painting.

I do not get ahead in money matters, here in the country. Too much repose to wake a fellow up to the right spirit. Too far from my friends. "Out of sight out of mind." I might do better by having a studio in New York. I am requested to do so. The City is the place for a single man. Mr. Sturges says, that I must leave Long Island sand. Long Island is atractive, or else I should not have staid so long upon its soil. A delightful spot to dream one's life away, free from strife and care. I was born to do my part, and as the Almighty in his wisdom shapes our minds by degrees to see differently, we must move at his bidding. He will look after those that praise him.

March 5th, '47

In the spring before the grass serves for pasture is the time to paint barnyard scenes, cattle standing about, or reposing, or licking one another without being anoyed with flies. A great pest to both Artists and cattle.

A resident of the city always finds the country a delightful change.

I have more commissions for pictures at this present time than I ever had before—owing to my being in the City for a month or two last fall. I do not do much painting here, I could not do much less in the City. I might paint portraits in the City and set aside two days in the week for painting pictures.

Sir Joshua Reynolds considered the three years that he spent in the country as so much time lost.

Sometimes use a rag, a piece of silk, or a brush in glazing. Rub over clear Terre Verte or Vandyke brown and blue or clear blue. Shadows of a white shirt or linen indoors when the sun shines upon a part of a white object will be cool, almost blue—the same effect under a tree or a shady grove. When the shadows are cool the lights are warm on light or white objects.

A Coal fire is not healthy to sit by; a wood fire for your life—it should be used more in the City by artists.

For small figures, to give vivacity to expression, a broad low light might be better. And for large portraits a sky light.

Backgrounds should have the depth of moon light for contrast to set off the light and warm colours. Deep blue, red, and yellow—no sickly colour—and glaze with the same—the above three.

The focus or near the center of a picture must be light or dark. An artist should ask himself what effect he desires his picture to have before he paints it.

I have just finished a picture, The ramblers. The principal light is on the shore on the left, light and dark figures for contrast. Clouds on the right reflect in the water. The opposite shore is a green meadow, skirted with woodland, which reflects partly in the river. Foreground in shadow. The effect is pleasing.

The picture I have been at work upon to day (Listning to music), I found the figure in the center not light enough. I touched upon it and found it improved. Too sombre before.

Where the expressions are lively and cheerful the dresses must be gay and rich in colour. In representations of mourning the countenances should be more or less pale and sad and the dresses a subdued splendor of a sombre cast.

If the glazing appears too strong, scumble over some naples and vermillion in shadow or light, it will be the better for it. Drapery can be improved the same way; in fact, it should be painted with the same care as flesh to be great.

Place a variety of pure colors on the canvass—when dry smear some transparent colour over it. —Rembrandt must have done so.

A picture to produce a great effect in an exhibition, as regards colour, would not be tolerated in a private collection.

"If we refer to the heads of Raphael, Titian, Correggio, and Vandyke, we find that though broad and grand in general effect, they are far from being defective in detail, and that each separate part would form a perfect study." Hence, it would appear that the maxim of Sir J. Reynolds, to avoid details and individual character, is erroneous.

[March 7?]

~~One picture for Geo. W. Strong The Surprise or Farmer Strong looking after his boys.~~
~~One picture for Mac. Elrath Esqr price 50 dollars.~~
~~One picture for F. P. Schoals Esqr price to be $100.~~
One picture A. J. Spooner Esqr—price $150.
One picture from the poetry of G. P. Morris Esqr—"Woodman spare that tree."
One picture for N. Ludlum 302 Fourth St, an interior.
One picture for Henry Brooks Esqr—Pick nick.
One picture for Mr. Clark.
One picture for Samuel Dodge Esqr.
~~One picture for Mrs. Gideon Lee.~~
One picture for Mr. George Austin.
~~One or two One picture(s) for the art-Union, order March 7th '47. To be done by the first of September.~~

[SUBJECTS]

Figures by firelight.
Babes in the woods, or the lost ones.
The lost boy, or the run-away.
A man carrying a bag of grain on his shoulder, looking at you with a contented face.
Dress for a negro girl—flesh coloured gown, rather pinky, blue shawl, green and red ribbons, gold breast pin etc.—or, a dull grey gown with an orange shawl falling off her shoulders and gathered in her arms, or hanging over the backe of her chair. Blue bonnet trimmed with red ribbons, or a red curtain in contrast to the blue hat. Green contrasts well with brown, or blue with brown.
A white nurse tending child—yellow cap, blue gown turned up over the knees, displaying a red petticoat. Child dressed in white. Background warm, much vivacity of expression.

Stony Brook, April 12th, 1847

An artist to meditate should be alone—they who do not meditate cannot paint. Pictures painted directly from nature will always captivate, will draw the spectator near. Truth will speak—no second hand nature for me.

I must use greater diligence in future and never distrust my own abilities. But paint every thing from nature, indoors and out morning noon and night.

Man comprehends but one thing at a time. God all things, and is every where.

Paint flesh with as pure colors as possible. When dry, scumble such parts as require it, with red and white—sometimes clear blue, red and yellow.

April 18th, 1847

We must dare to do what we see, which requires some moral courage.

Fire light [pl. 57]— Two figures will answer the mother and child— I must have the man (or a boy) standing carelessly against the wall.

SUBJECTS

~~A Farmer wetting his sythe.~~
A figure sitting at the root of a tree reading or meditating.
Playing cards.
An old man cutting wood, and a little girl standing by looking on with some wood in her arms.
A sporting scene representing a man loading his gun. Boy and dogs grouped around.
I must try to paint a picture for the church at Setauket. Perhaps a head of Christ.
Lovers Economical eating ice cream out of one glass, aint you glad you have come. Only one shilling—the waiter grinning behind.
A Country woman looking at some portraits for the first time.
Boys fighting.
A nurse amusing a baby with a looking glass. The child deverted with its own image.
A little girl pointing at you with her finger.
A camp meeting scene. Interior of a tent or in a ring—etc—would do for a large picture.
A Group of three figures, one holding a light, the 2d a music book, the 3d playing upon the violin from the book before him.
A market scene—a man weighing and selling fish.
Druming up a recruit. Just listed or passing them at sixty yards.
"Woodman spare that tree." The water fowl. [After] Morris and Bryant.
Babes in the woods, or the lost ones.
The lost Boy, or the runaway.
A man carrying a bag of grain on his shoulder, looking at you with a contented face.
A Dandy walkin out with knowledge in his rear; carried by a little black boy—books etc.
~~A man tuning a violin.~~

SUBJECTS

A Boy sitting in a chair with his feet partly drawn up into it and his hands clasped around his legs above his ancles and laughing at you—comic.
A Boy, or a Girl, reading at a window. To be painted standing outside—to give a dark background.
A young artist leaving the Art-Union with a rejected picture. In N.Y. City. Some background could be taken

We must dare to do what we see, which requires some moral courage.

April 18th 1847.

Fire light — Two figures will answer the mother and child —

Sir John Soane's Museum.

57. "Fire light."
Diary, April 18, 1847.
The Museums at Stony Brook,
Stony Brook, Long Island

by Dagarriotype—to save time. Color from reccolection.

An old maid warming her back, by the fire.

A negro girl picking a goose—companion to the Lucky throw.

Three or four figures talking together about spiritualism.

The Grave of an old Negro.

The modern school Boy, loaded with books.

Playing Cards.

Two Boys drawing after them a lot of bones—a skeleton—for speculation.

The enraged Cook.

Charity.

Yankee Courtship.

The wood chopper returning.

Return from Fishing.

Portrait of a Boy, or a Girl, in the morning, or evening —sunlight effect.

A young Lady reading by a window.

A Boy studing his lesson.

A bachelor mending his briches.

The return—an old man looking at the ruins of the old mansion, the home of his early days.

A Boy sitting on the chimney hearth.

Settling up.

Farmers on business.

Braiding hair.

A woman handing a letter in at the window to her husband, a shoe maker—fine effect.

. . . illuminates the background—what a rich golden brown, how clear, and yet how deep. Oh, Rembrandt, how we moderns love to speak of the[e], thy devotedness to nature.

How much beauty in a single sun beam—it gives an importance to the simplest object, it penetrates the deepest gloom and scatters darkness, and renders it visible. Observe the shadow of the leaves as they rest upon the body of a large chestnut, or oak, etc—how prettily they break up a large surface, round or flat. Shadows without the objects are often necessary.

In painting a light blue pants, or vest, make it more raw than you intend it, then paint over it quickly with madder Lake. The same treatment might do for all draperies, varying the colors. The same mode perhaps in flesh, yellow passed rapidly over red, or red over yellow, or blue over red, etc—building up and toning down.

In summer paint out of doors. A sitter, I think, would rather be out in the open air, than in a *hot room*. Or if you

175

paint in your studio, let in a plenty of air. Dont go much into company and only to study character.

Backgrounds I consider The most difficult part of a picture to execute to keep in harmony with the figures. Landscape is also difficult to many. It wants attention—I *must* make more sketches of landscape than I have done. I must fully understand the basis of it.

May 28th, 1847

Figure in shadow, the mass of light pure yellow ochre. Middle tint, red and yellow; pure vermilion (light red) in the cheeks and lips. The shadows light red and umber. Fairer complexion, perhaps Naples yellow with gradations.

June 1st, 1847

I believe the old colourists painted their flesh with pure solid colours without white, particularly the face in shadow. The mass of light, yellow ochre. Middle tint, ochre and light red, or ochre and vermilion. The above repeated—first red and then yellow, then red over the yellow, and yellow over the red, until a rich thick body is obtained. The lips and cheeks touched with pure vermilion or light red. The prominent shadows with light red and Stony Brook umber or Cappah Brown with light red. Then with a brush filled with pure cobalt, strengthen or clear the prominent shadows and make the colours of the face less negative as they recede, melting the flesh with the background etc.

In the face of a fair Lady standing in the bright light, vermilion and naples yellow, repeated until satisfied. Then give vigor to the lights by adding white lead to the red and yellow tints. Red and white, then yellow and white, until you have gained a thick impasto and the effect desired. The dark shadows, made of vermilion or light red, or both and made negative with cobalt blue—the more delicate shadows, neck etc, etc—cooled to the tone desired with Naples and blue.

No white should be suffered to glige[?] into your shadows—they should be painted with red and yellow repeated, over and over, then cooled down to the tone you wish with blue or cool grey. The blue or grey tints are touched in the face last, but sparingly.

When dry, scumble the lights with vermillion and white, and the shadows with madder lake, ochre, or light red and Cobalt, used together or separately. Lastly, the lips, cheeks, and warm parts should be glazed with pure madder lake, and the lights on the face and bosum tipt with yellow and white.

I think the above is the way to obtain "breadth, brightness, and depth."

"Let the warm colours predominate, and you can hardly help being agreeable."

Splendid colouring is produced by laying on every tint pure on a white ground. Glaze at pleasure, "but paint as nearly as you can without it." "Rubens often painted up his flesh at once with a full body of color, afterwards mearly scumbling and glazing. Correggio did the same."

I do not believe in a regular sett palette. Three or four mixed tints for expidition. Fire at the heap for your tints, combine your tints with the brush. The lights of the flesh tipt with yellow will make the delicate reds in the flesh look more purple.

Let your colours be from the horison up, yellow, red, and blue. Break one into the other, according to nature. From the extreme distance to the foreground. First, make a beautiful azure tint the colour of a distant mountain seen in a clear day. Then paint as much of the mountain as you desire upon the sky above the horison, and then continue almost to the foreground with the same tint. Touch in you[r] middle distance with madder lake alone, broken so as to represent distant objects. As you advance towards the foreground, use Mount's umber, and finish as far as you are able with it alone. If you wish to have water in the foreground, agitated with the wind, leave the sky tint. Make the base of your mountain light, hazy, indistinct.

In the foreground use as pure colours as possible the full strength of the palette.

Simplicity and generality must never be lost sight of in our imitations of *nature*. The whole surface where the sky is to be *can* be scumble over with lake—before the sky tints are touched in, if proper. Skill will follow practice. Pure colours and a clear mind for your life.

Have a skreen in your room to keep the sun from reflecting on your picture and moddle.

When naples yellow is the highest light in flesh, tone down some of the gradations with pure ochre. Low toned subjects will require only Naples Yellow, Stone Ochre, vermilion, light red and Madder lake. Blue and Mount's umber for the shadows to give strength. Do all you can without cold colours in the flesh.

Sometimes glaze with clear blue. Scumble with vermilion and white in the finishing, or pure orange vermillion and white—perhaps a trifle of Naples with it. White is the "nourishment of light, and the poison of shadow." Naples or white laid on thinly over shadows and lights has sometimes a good effect.

Durand says that he uses no lake. Large sables to give a fine *touch*. Tall canvas for tall figures. There should be a space above for the figures to breathe.

Shadows out of doors—ultramarine ashes, blue and a very little umber. There should be but little cool color in flesh, and that in the finishing touches.

We know that hot pictures never improve by time, but cool pictures will. The silvery warmth like David, Teniers, Correggio, Titian, Reynolds, Stuart, and Malbone should be borne in mind.

Many things can be learnt by accident, therefore we should always be on the *watch*.

To paint well we should paint understandingly. The mind should be clear.

After a good day's work we feel better, and are better reconciled to the place we may happen to be in.

Genius and application should work more kindly together. Remember, the summer is soon ended—every day should tell.

A few good pictures from me would disturb some of my friends very much—"Are you sencured [censured] by your friends? Keep at work."

For a high light on shining objects, etc, touch the spot with the end of the paint tube.

Never be afraid of doing too much in the right way.

In painting a shirtsleeve, make it round before touching in the folds, etc. Care should be taken in masking in the darkest parts. Sometimes, commence at the outer edge and draw towards the center, particularly the reflections. Let colours break upon one another at *random*.

Lay figures both large and small would be useful in painting figures, and portraits in imitating draperys.

Canvass or panel should have a finishing coat of white lead and well dryed, of a brilliant whiteness, to bare out the colours to perfection. The shadows clear and transparent, to have the appearance of daylight. The colours and oils of the right consistency. Copal and Linseed (or nut or Poppy half and half) sometimes with a trifle turpentine mixed with it to make it work free. The shine of the paint can be removed the third day by passing turpentine quickly over it with a rag, without injury, if you wish to retouch the work.

For duribility I expect yellow ochre in flesh is the most lasting. Naples yellow should not combine with ochre, but used alone.

June 15, 1847

I should think that Zinc white, True Pearl white, or Barytic White, would be good to combine with Naples yellow in flesh, or to improve the ochres in shadows, instead of white lead. If the above whites should dry well with blue, red, and yellow, they would be durible—fine for low toned flesh.

It is thought that colours would be preserved by using "the entire egg, well beat and strained, would afford a practicable vehicle." Used by the old masters in oil and with water colours, or dry colours— I must try it.

In painting the sky of the Bargain picture I used Mastic varnish and turpentine mixed together. (Copal and Turpentine would be better, I think.) Also, in painting the two farmers. The roof of the shed and horse, I used nut oil; board fence, crib, foreground and interior of the shed I finished with magilp.

A crispy touch I think is given by thining your oils varnishes pigments, with a little turpentine, for the last touches in a picture.

"Does God ever let his people do things till they try."

Never say you can't.

KEEP AT WORK ——From The Chrenotype

Does a mountain on you frown?
 Keep at work:
You may undermine it yet:
 If you stand and thump its base,
Sorry bruises you may get.
 Keep at work.

Does Miss Fortune's face look sour?
 Keep at work:
She may smile again some day;
 If you pull your hair and fret,
Rest assured she'll have her way.
 Keep at work.

Are you censured by your friends?
 Keep at work:
Whether they are wrong or right,
 May be you must 'bide your time,
If for victory you fight.
 Keep at work.

If the Devil growls at you,
 Keep at work:
That's the best way to resist;
 If you hold an argument,
You may feel his iron fist.
 Keep at work.

Are your talents vilified?
 Keep at work:
Greater men than you are hated;
 If you're right, then go ahead—
Grit will be appreciated.
 Keep at work.

Everything is done by Labor:
 Keep at work,
If you would improve your station:
 They have help from Providence
Who work out their own salvation.
 Keep at work.

 Franklin

Dont be lulled to sleep by flattery. When you are praised work the harder.

June 19th, 1847

Farmers Bargaining—commenced the last of June 1835, and finished the 16th September, 1835. I was very lame at the time in one of my knees, so that I had to hobble about with the aid of a crutch.

The Undutiful Boy's—commenced the last of August 1835 and finished the last of Nov. 1835, but not varnished —sent to Mr. Luman Reed 4th of Dec. 1835.

The Bargain was varnished the 21 of Sep. and sent to Mr. Luman Reed 22d—of the same month.

"Linseed oil that has been long boiled upon litharge in a water-bath, and diluted with oil of turpentine, [is?] less disposed to run than pure linseed oil, and affords one of the most eligible vehicles of the oil painter."

June 20th, 1847

The light within, or never losing the effect of the ground, the first painting, particularly in the shadows. "The great secret of the best colourists," not combining flesh in one tint only (to have the appearance of leather) but different tints touched over one another, so that the colour underneath will shine "through each other like the blood through the natural skin."

A head can be painted up at once, or at different sittings. It does seem that opaque colour cannot wholy be left out of shadow. However, shadows might be painted in with transparent colours thinly on a white ground—of course vermilion, naples, ochres, white lead, etc, would be left out.

Some make use of raw umber and white in the first preparation for shadows, or ultramarine and white, over a warm tint, and then go over the shadow with transparent colour, and then a glaze of asphaltum over the whole.

Breadth of colour and effect might be obtained by painting over the surface with a colour having a close resemblance to the color to be imitated, and then working into it, touching in the principal shades etc. For instance, in painting a white sleeve, paint the place for it white, then touch in the folds, reflects, etc. Or for an interior, etc, scumble thinly over with mount's umber, and touch into it, according to nature—or let the shade tint dry, and then paint in the proper lines.

For permanence use Linseed oil, only, and turpentine. Oil becomes varnish by time. In my first painting when Linseed oil was used, no cracks are observed, and the colours look as fresh as the day they were laid on—nineteen years, standing—

"A rapid drying of the uper surface before the underpainting is fixed, notwithstanding the firmness of the ground, will generally produce cracking. Also thick coats of varnish, applied too rapidly, will crack."

June 21st, 1847

"It would be good discipline, after acquiring the use of black and white in the chiaroscuro, to paint designs in contrasts, with two contrasting colours, only, with blue and orange, previously to attempting the whole together. Black may even be dispenced with in these cases, because it may be compounded, since the neutral grey and third colours always arise from the compounding of contrasting colours, so that even flesh may be painted in this way: for example, with red and green alone as Gainsborough is said to have done at one period of his practice."

"A just practice of light and shade might carry with it the reputation of good colouring, as it did in Rembrandt."

An artist might derive hints (in delicate flesh tinting) from painting choise flowers, peaches, shells, etc.

Those who are not accustomed to painting landscapes should plant their easel out of doors, and paint from the scene itself—at the same time endeavour to express nature in a broad and liberal manner.

On account of the heavy dews in the morning and in rainy weather, the country is not as good a place for exercise as the City. Walk in the *road*.

Stony Brook, June 22d, 1847

I commenced a figure the face nearly all in shadow, caused by a large brimmed hat. I painted thinly over the face with light red, and touched in some of the shadows with the same. The reflections, or light on the forehead, was ochre, blue and white, the neck a green tint—ochre and blue. The lighter part of the face, ochre, very little lemon yellow, vermilion, and white. Just enough of Lemon yellow, to give the above an imitation of Naples yellow. The whole figure faintly expressed for the first preperation. I observed the same treatment in the second sitting. The third sitting I scumbled the lights with vermilion and white and some of the reflections with yellow, blue and white—some red and white, some red and yellow, etc. It only took but a few minutes to balance the head in light and shadow, and colour. No Naples was used.

If Rubens used no white lead in his shadows, he used opaque colours, ochre, light red, vermilion, and perhaps naples yellow. Or, he painted his shadows first with transparent colors and his lights with opaque colours last. Or he modeled up his heads with white lead or naples.

"It requires attention, that an excess of dryer renders oil saponaceous, is inimical to drying, and injurious to the permanent texture of the work. Sulphate of zinc, called also white copperas and white vitriol, is less powerful than acetate of lead, but is preferable in use with some colours."

In almost all cases where thick and fat varnishes, oils and paints are used, Turpentine should be used quite freely.

A critone[?] colour can be made by combining raw sienna with burnt umber, or mount's umber, or with a little vandyke, or cappah brown.

Light ochre can be softened by mixing raw sienna with it—will give it a golden appearence. All yellows, or colors that required the least white lead, I should think were best.

Pigments more or less transparent, and generally fit to be employed as glazing and finishing colours if not disqualified, according to Field's work:

Lemon Yellow
Sienna Earth
Gamboge
Indian Yellow
Gallstone
Luercitron Lake
Italian ⎫
English ⎬ Pink
Dutch ⎭
Yellow Lake

Madder Carmine
Madder Lakes
Lac Lake
Carmine
Kermes ⎫
Cormuron ⎪
Florence ⎬ Lakes
Scarlet ⎪
Hambro ⎭
Dragon's Blood
Rose Pink

Ultramarines
Cobalt Blue
Smalt
Royal Blue
Prussian Blue

Antwerp Blue
Intense Blue
Indigo Blue
Blue Ochre

Chrome Green
Sap Green
Prussian Green
Terre Verte
Verdigris

Madder Purple
Burnt Carmine
Purple Lake,
Lac Lake

Brown Pink ⎫
Citrine Lake ⎬ Citrine
Cassia Fistula ⎭

Madder brown or Fields Russet
Russiate of Copper

Olive
Olive Lake

Ochre and blue—a green tint—with a little white, will do to touch over a warm red shadow if the reflection is to be made cooler. Pure Ochre, vermilion and Light red will answer to touch in the reflections if the shadows are deep enough to bare it; if not add a little white to the above colours.

Be careful how you use blue or greys in flesh—do all you can without them. Lakes should be broken with all colors, more or less, particular[ly] with reds and yellows, also with umber.

Umber and white makes a beautiful tint—simple—also, yellow and blue with white and terre verte and white. For a very delicate grey, Ultramarine ashes and white.

We should aim at simplicity in colouring. An artist should throw his colour around as if he was pitching dung.

Stony Brook, June 27, 1847

Think of a flower garding, or the pure colours on your palette, while painting. Pass transparent colors rapidly over opaque, while the latter is fresh. Practice slight of hand movement to do it. Also, opaque colors over transparent—it produces richness.

Paint fast in painting drapery; get the prominent folds, those only that will show the figure (or parts) to the best advantage. Generalize. We have an abundance to work from, therefore we must seek for the honey with diligence as the old masters did. I believe in a ray of light (of the sun). Walk in the woods, see it touch a single leaf, or the trunk of a tree.

July '47

A painter of pictures must lead almost a monastic life. For my part I am getting tired of it. This quiet country life, this loneliness hangs heavy upon me. Too heavy to stand a great while longer. In hours of relaxation we should associate with those who have a kindred spirit, or visit a gallery of choice pictures that will stimulate the mind. There does not appear anything noble and generous in the country but the scenery and the pure atmosphere. The City should be the home of the artist. He can sally out in search of the picturesque when he pleases.

N.Y., July 5th, 1847

In Durand's landscapes, you find Grey stones, or pieces of rocks in the foreground, covered occaisionally with bits of yellow and brown moss—moss also on the trees. Asphaltum used. Weeds, roots, grass, water mullens, rocks, scrags, etc, with the foreground in shadow.

Sometimes with figures, cattle and sheep, fallen trees, and flowers, etc. catching the light grape vines in shadow, a clump of tall trees in light, rich browns glaze over the foreground. Rocks, trees etc. reflecting the sky. Paint loaded in the lights.

July 31st, 1847

THOUGHTS OF THE MOMENT

There "are two distinct classes of what are called thoughts; those that we produce in ourselves by reflection and the act of thinking, and those that [illegible] into the mind of their own accord. I have always made it a rule to treat those voluntary visitors with civility, taking care to examine, as well as I was able, if they were worth entaining; and it is from them I have acquired almost all the knowledge that I have."

"Every person of learning is finally his own teacher."
——T. Paine.

August 2d. 1847

I sometimes wish I was in the hill country among mountains and rocks, but I dont know weather it makes much difference if we can only keep our minds upon our studies. A painter of pictures must lead more or less a monkish life.

I must always paint on mondays—then I shall be apt to keep it up all the week. I have often observed, as goes monday so goes the week.

Never be afraid of doing too much. Never put off what you can do today.

Never suffer faults to stare you too long in the face, but make the corrections at once.

Criticise your own work severely—look out for bad lines and profiles, particularly in landscape.

A south and west light in winter, and not a very high light for expression, to exhibit character etc. For portraits,

perhaps a sky light. It would be well to have a retired studio in the City. By using a west light you loose too much time, particularly mornings. Have two lights south and west and darken at pleasure.

August 30th, 1847

An uper room or garret with a roof from 10 to 15 feet high, with a sky light about 4 feet square to open at pleasure, would make a fine light for an artist. The rent would be moderate. Such a room can easily be found and fitted up with very little expense. Rough coated with plaster etc. A room with perpendicular sides and roof, with sky light, and side windows would be best, perhaps—

It would be well to paint a portrait now and then out of doors, to represent day light perfectly.

Sept. 6, 1847

"The Sun-Flower. The seeds are more oleaginous than those of the flax plant, and combine the qualities for use, of the best olive oil, for burning of the best sperm, without its smoke, and for painting, it is said by Painters who have used it to be superior to linseed and is more rapid in drying. It will yield from eighty to one hundred bushels to the acre. From five to seven quarts of oil are calculated on, per bushel. The seed of the sun-flower is a most desirable food for poultry," etc.

The water in the Sound is much more blue and clear than the waters about the bay and harbours of New York City. A critic should weigh these matters on looking at a picture, not judge too hastily.

Never let your mind be drawn from your studies by foolish and trivial nonsense, but place your point of sight high; buckle on your armour with a determination to make one of the greatest painters of the age—you must make yourself.

Sept. 20th, 1847

"Glue made waterproof— Immerse common glue in cold water until it becomes perfectly soft, but yet retaining its original form; after which, it is to be dissolved in common raw linseed oil, assisted by a gentle heat—and stir it until it unites." I should say one third oil to two thirds glue. Mixed with drying oil or hard varnish, it might answer in painting.

Oct. 4, 1847

If I lived in the city, I could make drawings of celebrated characters as they visited it, for the Engravers— also paint officers of the army.

Portraits brings in the most money. The City in the winter for study to hear lectures upon various subjects, etc. Not so many wasps and flys in the fall and spring.

Ignorence remains sullen and looks around with a jealous eye, while intelligence walks abroad with a smiling countenance.

Oct.

The foliage on Long Island remains greener much later than up the North river counties. Hence Long Island will be the last place in the autumn for artists to study landscape in the vicinity of New York City.

Oct 17th, 1847

I Made my niece Elizabeth Mount a present of five dollars—also three dollars some time previous—also a gold ring.

Oct. 19th, 1847

Long Island is rich in character. It would be worth the trouble to stay a short time in each village.

A painter's studio should be every where, whereever he finds a scene for a picture in doors or out—

In the black smith's shop, the shoe maker's, the tailor's, the church, the tavern, or Hotel, the market, and into the dens of poverty and disipation, high life and low life. In the full blaze of the sun, in moon light and shadow. Then on the wave, the sea shore, in the cottage by fire light and at the Theatre. See the sun rise and set. Go and search for materials, not wait for them to come to you. Attend Fairs, shows, Campmeetings and horse racings. Treasur up something in your mind, or on paper, or Canvass, whereever you may hapen to be thrown. An artist should have the industry of a reporter. Not be ashamed or afraid to plant his easel in the market place for figures or background, or both. For painting is an honorable calling, and the artist will be respected let him sketch where he will. Time has now come that the artist should throw aside his cane and glove and like the painters of old, go forth for subjects with the industry of bees in a flower garden—sip the beauties of passing objects, and return loaded with praises from his friends and the whole world—well done, good and faithfull servant. Much shall be given to those that seek and fear not. Many interesting scenes were brought to light by the daring of Hogarth and Morland. Gainsborough gave us a beautiful group of Cottage children by rambling about the country, which would never have been painted with that simplicity and nature had he staid in his paint room. It is by frequenting the haunts of men that we learn to think for ourselves, and become originals by drinking in sweet draughts of wisdom at the fountain head. No true artist will be scared from the rich harvest before him—that is every day open to him, by timid[?] and stuck up artists. If they will remain in one spot, leave them, shake them off, for they will be to thy feelings as a night mare. Associate only with those that uses the word onward.

A very minute and close imitation of nature without regard to the effect of the whole is apt to produce what is

called the dry manner. The proper distribution of grey tints in a picture to lead the eye pleasantly over the work is important, and must not be lost sight of—hot and cool colours artfully arrainged, captivates the eye. Objects should be introduced in a large manner, with large brushes—small brushes is apt to produce the small or dry manner. A few decided touches to sharpen up the work in the foreground should be remembered in finishing.

Some artists finding a deficiency in the upper story, that they lack *Genius* at home, must be sent abroad—to steal—forgetting that beautiful nature can be *studied* here as well as there at home.

Oct 23

I urged upon My Nephew Henry J. Mount the importance of learning to draw, that it would aid him to learn the art of engraving on wood or copper if he thought he could fancy that business. Or he might, if the love of drawing grew upon him, learn to be a portrait painter. At all events a ready hand at drawing would be an advantage in any business.

Hogarth, Wilson, Gainsborough, Albert durer, Rembrandt, Murrillo etc. never studied abroad. For my own part I should never wish to see Italy nor any other country until I had given evidences of originality at home. I never desired to part with my birth right.

Nov 5th, 1847—painted out of doors—

Nov 6th

Repaired a violin—replaced the neck—it had been broken off some years. The violin belonged to my late brother H. S. Mount, a superior instrument. It is now in possession of his widow Mrs. *Mary F. Mount.*

Nov 19th, '47

THOUGHTS OF THE MOMENT

Nov 12th painted in the open air but found it too cold to remain long.

Too much time is lost by only painting by a west light. The forenoon is lost and the last rays of the sun falls upon you at a time when you wish to finish up what you have commenced. By a south light in winter and a north light in summer you can paint in the morning and have time to see what you are about and what you mean to do.

I sometimes think it is of no advantage to have a room filled with sketches and engravings—when upon the walls the interest is lost.

When an artist has no pictures around him he will be more anxious to compose and paint them. He should

travel only with his paint materials and music. Imitate the deciples in simplicity.

If I should travel it must be for improvement. Move quietly about and observe—have a room for study when I desire to be alone.

I have lived a number of years in the country and have never had any calls from artists—but one—and that was from Henry Inman. But when I had a room in the City for a few months I had plenty of visits from brothers of the brush.

"Out of sight, out of mind" unless you send in a fine picture, now and then.

All nature is filled with colour. Every thing, living or dead, but it takes one a long time to see it truly.

Dunlap is right, "an artist should not confine his observation too much to his paint room." He should go abroad daily with his sketch book or paint box, paint on the spot —let him be where he will. He should not matter about the light if he has enough to paint by.

The City is the place for an Artist, for portraits particularly. I believe I could paint portraits half of my time and paint more pictures than I do at present. If I were in the City.

Heads of truly great characters should be painted—they salt an artist down.

When you visit some Portrait painters, you will see a dozen or twenty heads staring at you—I do not think it exhibits good taste. It may serve to make the ignorant stare but it is apt to get the (exhibitor) the painter into a confirmed mannerism, by having his own work constantly before his eyes.

It would be better to have a few choise heads by different artists about the room for the sake of variety, and only exhibit one head, by himself, to his friends at a time.

The late Mr. Inman was so convinced of the truth of the above that he would after a sitting turn the head to the wall, saying that he could see the defects (if there were any) the better next day.

Nov 25th

In my practice I invariably turn my picture round to the wall after I have done painting, and also set a picture aside for some time if I do not feel in the humour for painting. I find it is of no use to work unless my heart goes with it, although Reynolds says that "you must go to work willing or unwilling." It may do where there is much labour to be done without much taste and feeling —mere drudgery.

In every fine work of art a genuine feeling is manifested throughout the whole performance. It must be so.

If I had a room for portrait painting in the City I could always set aside a day or two for painting pictures. Not at home etc.

To day is my birthday, Nov. 26th, 1847, a very fine day for the season. I feel thankful for health and that I was born in a fine country. I hope the future will be to me as pleasant as the past. I ever expect to be young, by striving to improve my mind.

"Those who are ever learning are ever young."

Shadows are deceiving. They should not be made so dark as they appear to be. They should be clear, by reflection—or by a counter light of some agreeable hue—before the painter takes up his palette. Before painting nature should be made interesting.

To day 26th I painted on Mrs. Eliza Smith's portrait, also on Mr. Strong's picture.

Nov 29, '47

I must not forget that when I am unwell that worms are the principle cause. They have been my worst enemy for years.

Winners vermifuge is good to remove them, but hateful medicine to take. Lime water injected is said to be good; to expel them, also, spearmint tea—let it be the constant drink for a week or ten days. Also Indian hemp.

It would appear that Reynolds and Stuart made their raw Umber tints of black and yellow, or perhaps they dead colored with black and white, and finished with blue and white in the gradations.

Dec 7th, 1847

The above masters often made their shadows cool first and then scumbled warm transparent colors of[on] the cool. Shadows may be cool when the mass of light is warm.

Pictures to be hung in dimly lighted apartments should be more powerful in colour, as a faint light subdues the strength of color.

In my picture of a Girl asleep, the shadows of the face should have been cooler, the mass of light being warm.

Dec 23d, '47

If I could hit the public taste by a large picture (figures the size of life) I could make money by the operation. I believe I could paint a large picture as soon as I generally paint a small one: It would give me fine practice.

Dec 30—Edward, my Nephew, says that I must not read so many news papers.

diaries 1848-49

January 1st, 1848

A new year is always welcome. I feel thankful for past favors. I spent part of today in the village of Huntington, and Stony Brook. A friend—Mr. Curtis—advised me not to bury my talents in so retired a place as Stony Brook, but to travel. I had done well but could do better etc. Mr. Patterson said that I lacked ambition, should travel to foreign parts etc. I can find nature every where.

White scumbled over flesh after it has been strongly painted has a good effect.

New York, Jan 15, '48

A sitter's chair or throne should turn round upon an axis—to turn with ease—so as to see the first views of a figure. To save labour.

Jan 17th

Banvard's room will seat one thousand persons at fifty cts admission. He clears $1,000 on a week.

The Mam[m]oth Cave would be a good subject—for a Panorama—as a figure piece, telling a story.

Canvas can be obtained 12 feet wide. It is to be prepaired to receive water colours mixed with glue. It requires two cylinders to keep the canvass in order for painting—and two men to keep it moving during exhibition. Water colors is better for rolling than oil, safer to carry about.

It strikes me that oil colors would answer if made perfectly dry—more natural. Copal varnish to be used and turpentine. Japan with the above in deep shades and black dresses.

Titian's Venus—*Colors*: Auburn hair. Red roses in her right hand. Dark green curtain behind her head. White pillow and sheet. Red and yellow dog. Crimson couch in the fore ground on the left. Grey mosaic pavement in the room agoining. Figures in the distance—one dressed white and red. Sky, foliage and the grey distance of the apartment mingling together very harmonious.

[Sketch of girl in theater box] Hair black. Red ribbon around the neck, dark cloak and muff—fine effect.

Whenever there is any money to be made by any invention there is always some one ready to lend a hand.

Stony Brook L.I., Sunday Jan 30th, '48

To live well, and have the mind clear, late suppers should be avoided. In City or Country. "Friction of the skin with a coarse towel or brush"—exercise in the open air sufficient as will favor quiet rest. "Let the bed be hard"—a little music on the violin is better than medicine. Avoid stimulating too often. Keep the mind free, never be a slave to any thing. "Retire to rest, not till inclined to fall asleep, and arise as soon as awake." Regular hours at rest I believe should be observed.

An artist in the City finding his room too warm in the

summer, can retire into the nooks and corners in the open air, in the shade, and make sketches for pictures—etc—quite as well.

King Archelaus pressed Socrates to give up preaching in the dirty streets of Athens and come and live with him in his splendid courts. "Meal, please your majesty, is a half penny a peck at Athens, and water I can get for nothing."

The air in the country, how delightful and refreshing it is. If I must have a room in the City (or near it) the sooner I get about it the better. I have lived very happily with my sister and Brother-in-law since my mother's death. Perhaps I had better to make my home among strangers. I must make a change soonor or later.

No time to be lost—begin now. Everything must be kept secondary to one's business.

A silk handkerchief is better for my neck than a thick comforter—the neck should be kept rather cool than hot.

Relations are often a nightmare upon one's time. Idlers are certainly.

Feb 7th, 1848

A painter will not be judged by his music or his fine talk, but by his pictures.

I always feel better when at work—no time to think about bad feelings—the mind is deverted from the body.

What a fine execution of hand practice will give—Color, drawing, composition—everything.

I must give my whole attention to drawing and painting and only play a few hornpipes etc on the violin for my own amusement.

We are often struck with wonder at a great work of art—with our arms folded, without trying to do likewise.

When men want me to paint for them, they always call or write on the subject. Those people that want the most waiting upon are generally tricky subjects and not to be depended upon.

To accept every invitation takes too much valuable time. Mind your own business. A private room is better for a painter than a public one, particularly for composition pieces.

Have little to do with public men, be independant, and they will come to you if you are a great artist—strive to be one.

There is a class of friends that will last as long as money lasts, then again there are some men who try to elevate themselves by hanging on the coat tails of distinguished characters.

I must design a large picture.

Feb. 23d, 1848

I must build me a paint room in Stony Brook, or in some other place—or some about the Country. I can build a room for about an hundred dollars. Size about 25 feet square with a passage on one end.

Feb 1848

I must have me a large room, or studio. Say 20 by 21 feet, height 12 to 13 feet, window 4 feet by 6 feet and a smaller window towards the south west corner. The passage or entrance to the room must be 7 or eight feet wide to place wood or have a small office, etc. If the room is to be in the Country I must place it so that the shadow of some large trees will pass over the south side of it to keep the room cool. The insides and top to be cased with boards, instead of plaster, or if I have lath, to be left in the rough. The sooner I have it the better.

In clear days there should be a thin gauze to keep out the blue sky. The light should be high—that the subject could be placed in the center of the room, to produce softness, etc.

An artist to go to his work fresh, should not fatigue his eyes by reading or too much talking. There is a time to read and a time to talk. Every artist must have his way in going to work and producing, or finishing, his productions. It is this variety of manner that pleases, and an artist that will copy another is a fool, for nature is always ready to receive him and the more he leans upon her, the greater will be his speed to excellence.

I must endeavor to follow the bent of my inclinations. To paint large or small, grave or gay, as I please. Not to be dictated to by others. Every Artist should know his own powers best and act accordingly.

I must place my picture off frequently to see the effect. Also my outline more flowing, except in the nearest parts. This softness and sharpness is highly important and will be found in nature and the best pictures. I must repeat my colours and use all the cunning I am capable of to imitate nature.

I believe in the broad style of painting. I must not have so many tints on my pallette, color more from feeling, fire at the heap for my tints.

My Brother Shepard says, in painting his still life pieces—fish etc—he mixes his tints mostly with his brush, feels out what he wants from the heap. He observes the same in painting drapery etc. He has a good eye for color.

April 7th, 1848

Ten years ago the critiques said my pictures were too cool. I could not color etc. Now they say—they are too warm. Mr. Sturges says that I must keep my mind upon my former pictures—Farmers nooning and bargaining—

as regards the most perfect coloring, etc. Cool pictures the best.

Cole's pictures—The ground of the sky salemond or light flesh color—he painted solid[?] with pure colors. Sky and clouds painted at once—with perhaps a portion of distance. He then when dry scumbled and toned, scumbled with ultramarine ashes and white—his best pictures are of a cooll tone, a warmth given by glazing with warm color all over the painting, and sometimes left to time and varnish. The handling beautifully free he painted with linseed oil, did not varnish under a year, and then with a slight coat of copal varnish with a few drops of boild oil and thined with turpentine—he lost some part of his work in the ground. Some of his cool pictures are considered the best.

Grey says that he used very little vermillion in flesh, principally venetian red and madder lake—sometimes Terra Rosa—and no other grey than blue black or Ivory black.

After you have designed or made your study (in oil) in effect as you design, then let a ray of sunlight fall on your group and a focus of light will be obtained—very beautiful—a good hint for a second study in effect and color. In such effects the light will be warm and the shadows cool.

[Sketch of man's profile]

J. and L. K. Bridge best linseed oil—N. York. Old linseed oil is best for varnish.

Be careful and not be foxy in color. Let grey have fair play.

"He who walks humbly with Nature will seldom be in danger of losing sight of art."

"Into a tin pan, pour three or 4 gallons of linseed oil, add 4 ounces of litharge for each gallon of oil. Stir it two or three times a day for a fortnight, it will be a strong drying oil." "To make it white, expose it in shallow pans to the sun and air for two or three days and it will become as limped as water."

I must build me a Paint room in Stony Brook or in some other place—or rove about the country.

Whenever there is any prospect of making a fortune by any undertaking, there is always some one ready to have a share in the enterprise.

April 11th, 1848

Cole paints distance and retains color, but other artists in painting distance looses color in comparison. Why is it so, because he paints distance with pure (or strong) colors and scumbles over with blue and white, or blue lake and white in the finishing.

His skys are said to be painted with ultramarine ashes.

A head should be painted with pure colors and then glazed and scumbled—the same a[s] Landscape.

Stony Brook, April 12th, 1848

Cole used but five colors, and passed them under the muller every morning before painting—he made a hasty sketch with pencil of every interesting sunset or sun rise, with remarks as regards color and effect.

I have sketched and painted with him in the open air and rambled about the mountains after the picturesque.

He was delighted with an original artist but despised a copyist[?]. In skys and sun sets, Durand in comparison seems to lack color.

"The instrument does not make the artist, but practice."

Stony Brook, May 4th, 1848

Painting from nature in the open air will learn the artist at once the beauty of the air tints from the horison to the foreground. See how the dew sparkles on the foliage and the grass in the sun beams early in the morning.

How glorious it is to paint in the open fields, to hear the birds singing around you, to draw in the fresh air—how thankful it makes one.

Painting out of doors will make at once an old painter out of a young beginer. Will learn him how to manage the grey tints which are so valuable in a picture—then why should we strive to work against nature when she beckons us one and all at once to be great. It requires courage to go right to nature. Five years from nature is better than twenty five spent in fancy.

I believe I can paint as good a picture in one place as another. Therefore it as quite unnessary to remain always in one place. It is well to make a change occasionally.

Some of Baker's portraits are too uniformaly warm, not grey enough broken in the flesh tints—remember "the pearl or peach."

Live well, be temperate with moderation—also take exercise. Avoid long talkers and button holders for your life.

Some of Cole's figures and [illegible] Goals have the finish of the dutch masters. The light parts of his foregrounds are very rich in color, the handling free and the light conveyed along by yellow and white, and blue flowers. Rocks partly covered with green and yellow moss in shadow—old trees in the same way. He had a flowing mind and painted from feeling. His greys appeared to be black and white—naples and white—Ocher, blue and white—vandike brown and white, umber and white—blue and white, etc. He used pure color, and plenty of it, when there was a place for it—he often used a flat brush in the foliage.

In finishing a sky, Cole would drag his brush over the fresh paint, in a strait line from the Sun, and when dry touch on the clouds.

If the Sun was on the left side, the opposite and uper part would be very blue or purple. His skys were beautifully graduated from almost pure white *naples* and *white* —naples and red inclining to the delicate purple up to a rich blue. In some of his skys he destroyed the marks of the brush, by touching gently all over the sky with the end of a large brush—one way of blending.

May 6th, 1848

In painting out of doors in a windy day, a skreen well braced should be placed to the windard. It would be of good service on the sea shore or in any bleak place. A hole, or drop window could be cut to look at the land or sea. A carriage might be made for the same purpose.

The maker and number of my Gold watch—R. & G. Beesley, 16482, Liverpool. Price—watch and chain one hundred dollars.

Read less and think more, if you wish your mind to store.

Stony Brook, June 19, 1848

Attelier, French—the workshop of an artist
Alias, Lat.—otherwise
Beau ideal, Fre.—a species of beauty, existing only in the imagination
Beau monde, Fre.—fashionable society
Bijou, Fre.—jewel
Billet doux, Fre.—a love letter
Blushing is virtue's color.
Bona fide, Lat.—in good faith, in reality
Bon enfant, Fre.—a good fellow
Bonhomie, do.—good nature
Bonjour, Fre.—good day
Bon soir, do.—good evening
Bonne fortune, Fre.—good luck
Bonus, Lat.—good
Boulevard, Fre.—Bulwark
Building is a sweet impoverishing.
Bourgeois, Fre.—a citizen, a burger
Cadeau, Fre.—a present
Chef d'oeuvre, Fre.—a master piece
Cher ami, Fre.—dear friend
Chez soi, do—a home
Cicerone, Ital.—a guide
Conducteur, Fre.—a driver
Conte bleu, Fre.—an idle tale
Coup de maitre, Fre.—a master stroke
Coup d'essai, Fre.—a first essay, an attempt
Discreet women have neither eyes nor ears.
Distrait, Fre.—absent of mind
Extenso, Lat.—at full length
Naif, Fre.—artless, natural

Sept. 9th, 1848

I have a bad cold—hoarse, cannot speak loud. Caused by waiting upon the sick all night, and going to parties—sleeping with the wind blowing upon me after drinking hot toddy just before turning in. All wrong—I must continue my old practice, to drink cold water before going to bed—no more late suppers and hot drinks.

Sept. 12th, 1848

Rain is very much wanted all over the country. The grass is dried up, and the forest trees are drooping for the want of rain. —Sept. 14th we are blessed with a shower this afternoon. —Sept. 17th fine shower in the evening.

For cholic, brandy and brown sugar, to be taken in hot water. I heard of a case of consumption cured by the use of Lamp oil: a wine glass full taken on going to bed. It is very searching. Linseed oil is good for a cold or cough—a teaspoonful at a time. A silk handkerchief is better for the neck than a woollen comforter—the latter will do well to wear on the outside, *loosly,* when travelling in the cold.

Stony Brook, Sept. 20th, 1848

Yesterday morning I painted—in the afternoon I attended a Pic-Nic on the Island. We had quite a lively time. Danced in the evening at Mr. Wm. Wells's.

This morning I Bruised my middle finger of my right hand quite bad. However, it was in a good cause. A figure painter should make it his home in the City. A landscape painter, in the Country.

Sept. 26th

This day I painted all day in the open air. Wind North. It afforded me great pleasure. Also on the 27th and 28th. Paint anywhere, no matter where—in any light.

Stony Brook, Oct. 28th

Charles Elliott Esq. finished the head of my portrait this day. The picture is to be completed in N.Y. He took three sittings, from three to four hours each time. It is considered his best picture. The first sitting he made a careful drawing with charcoal—then commenced with his colors (as they were laid on the palette, White, Naples yellow, yellow ochre, vermillion, madder lake, Ultramarine blue, Prussian blue, Stony Brook Umber, and Ivory Black; in finishing, he added Vandyke Brown and asphaltum) giving a general effect of the head in a broad manner. The second sitting he strengthened the effect and corrected the drawing where it was out. The third sitting was merely toning—by glazing, scumbling, and touching in with pure colours the reflections etc with the brush or rubbing in the colors with his thumb or fingers.

In glazing the background, he scumbled or broke down the colors with the end of a large brush. The same way as Cole as been known to, even his skys. Finishing a picture with pure colors gives great sweetness and richness, when well managed. Elliott glazes with magilp—a gummy texture is better for glazing. The colors will stay put. Bend the palette knife (to take off the rough paint).

I had the pleasure of seeing at the Art-Union, Nov. 2nd 1848, a very fine picture—Storm of Cyclops Rocks in the Straits of Gibralter, Coast of Africa. By Achenback, of Dusseldorf Germany. It is enough to emortalize any painter (though Doughty thinks it not silvery enough in tone, rather too heavy). The shadow where the light falls is painted of a thin brown warm color, and the cool or sky tints are touched in—the shadows cutting the lights very sharpe. The picture is Rembrantish in effect— the light falls on the rocks, and on the waves breaking on shore, all the foreground in shadow but clear in effect made up of brown and purple—rocks, grass etc broken in. The air tints play about delightfully. The clouds appear to move like nature, and also the rays of light darting through the clouds looking like the natural light. One can almost hear it thunder. It is altogether a stirring picture.

Napoleon Crossing the Alps, by Delaroche, is also a grand picture now Exhibiting at the National Accademy room.

Art-Unions encourage artists to paint poor pictures, by their buying so many poor ones. The artist is also beat down in his price, in almost every case.

Nov. 6th, 1848

I must turn my attention to the painting of portraits— and occasionally paint a picture. I had the pleasure of seeing on friday the third of November the engraving from my picture of the Power of Music—drawn on stone by Leon Noel, in Paris. I was delighted with it. It was better than I expected.

The Election comes off tomorrow. I hope Gen. Cass will be elected—

Nov. 10th

Gen. Taylor will be our next President.

"Dr. Culverwell M.D. says that he attends business and patients from sun rise till three P.M. and then rides from 16 to 20 miles daily and then in the same room till nine"— He says exercise in the open air must be had daily.

"Wine has been called the milk of old age, and few can totter down the hill without its assistance." Port wine perhaps is better of the two. "Mental worry is a sad plague at all times."

Stony Brook, Nov. 11th, 1848

Elliott says that he injoys himself better in his paint room than in any other place—he says when he begins to use his brushes the feeling for painting comes on. Elliott remarked to me, "When I hear a painter tell how much better he has painted after reading on art (about colors etc) then I want to hit him."

Stony Brook, Nov. 15th, 1848

Mr. Woodbeck, a house painter, says that turpentine freely used with oil will not crack—and that copal varnish will not crack over paint thoroughly dry. Much oil alone with paint *will crack*.

If I should live in the City I must not let trifles disturb the tranquility of my mind—I must also be careful and not find fault with the works of others, but look after my own defects. Praise others rather than condemn, and endeavor to improve myself in painting as much as possible. I have lost in some respects by staying so long in the country. Portrait painting is a noble art—I should like to paint a dozen or twenty heads to show some of my friends that I can paint a portrait—and I must not alow myself to be driven from portraits into the picture line. I have tried the latter long enough in the country; it will not pay. If I had a room in the City I might devote leisure days at pictures when I was not engaged on portraits. Reynolds said that pictures cost him too much outlay of thought and time. A good portrait can be painted in three sittings. The last sitting, use pure colors—toneing and rounding up the head—giving brilliancy and force—by glazing alone. I must carry out my principles in head painting— and fear not the result.

Nov. 16th, 1848

In glazing a portrait with blue, red, and yellow, white can be added (sparingly) to advantage. Glazing and scumbling will give richness. Ocher and white, with a little Lemon yellow, will answer in the place of Naples yellow— and more safe as regards change.

My flesh palette is now Cremnitz White, Lemon yellow, yellow Ochre, Vermillion, Madder Lake and Ultramarine blue—Ivory Black and Vandyke brown for the eyes and hair. Also Mount's Umber and Aspaltum for backgrounds etc in finishing. In glazing, Prussian blue and Ultramarine can be added together. Let the color of the background run into the shadows of objects that you are painting—into the shadow of the face etc. Terre Verte can be used in the flesh in place of blue.

Stony Brook, Nov. 23d, 1848

If the Committee of the Art-Union should ever desire to have one of my pictures they must come to me, or give me an order. I shall never take a picture to them again. I painted a picture expressly for the Art-Union and one of

the Committee saw it and requested me to take it up to the office of the Art-Union, that there would be a meeting on Thursday the 2nd of Nov. I did so. The next morning I called at the office and was told that the committee did not think proper to vote for so high a priced picture until they had a fuller meeting in about 20 days. I considered it a gentle hint that they did not want my picture, and I removed it from the wall forthwith.

They rejected on the same evening a beautiful picture by S. A. Mount—a piece of still life. They left word that it was too shelly. What impudence, when my brother had been requested by one of the committee to paint a picture of the kind for them—

I am sorry that so many artists allow themselves to be controlled by such a one sided affair as the Art-Union—I hope for the sake of art that it will be managed better. However, I hope the artists will not suffer themselves to be debased by a gang of speculators. I never sold but two pictures to the Art-Union.

Thomas S. Seabury commenced painting in black and white (light and shadow) white, yellow, red, and black—on the 20th of November. If he perseveres he will make a painter. Practice works wonders.

Art is jealous, and wants the whole soul. T. S. Seabury took two or three lessons a week in drawing for six months of Robert Weir Esq., Professor of Painting at West Point, in 1847 and 8. Thomas does not like to bone down to study—he has not sowed his wild oats yet. He should study alone to be original.

Elliott prefers to paint on a ground of pure white—to give brilliancy of color. He touches on the highest lights first as the key note, and then the principle shadows—giving a broad effect of the head in the first sitting with an eye to the finishing tints. In the second sitting he corrects the drawing, and gives more force to the head in light and shadow and touches on the prominent lights in a spirited manner. These last touches are seen through the finishing tints on light glazings—even the first sitting is seen more or less through.

His first and second sittings are faint in color in comparison to the last (or third) sitting. The third sitting he uses but little color, little if any white—only Madder Carmine, a little Vermillion, Yellow, and Ultramarine blue for glazing, using his brushes, or thum and fingers, to rub in the color—giving richness of color by the above method.

Lastly he strengthens the hair with Vandike brown, Asphaltum, blue etc, as the case may be—as regards color —the strength required.

I never like to see a touch in a picture without meaning.

Stony Brook Nov. 26th, 1848

In some cases in the light parts of the flesh, paint a light tint of yellow first, then near the focus of light, touch on in a broken manner red and white—*lastly pure white*.

Today is my birthday. I feel thankfull for health—and the little knowledge I have gained. The past year has been full of events. Freedom is walking at noonday and scattering Kings and Tyrants into obscurity. I hope the Election in France, coming off on the 10th of Dec. 1848 for a President, will pass off with good feeling—and a lasting republic established. And Italy the land of the Arts—I hope will obtain her freedom. Ireland is in almost a hopeless condition. She is still in slavery. England is said to be tottering—active minds are at work. The time I think is nearly at an end when one family (the blood royal) shall reign over a nation. I hope the future will be to me as pleasant as the past.

If I should have a studio in New York I must rise early—before sunrise—and take a walk before breakfast. I must not fail in doing so—*for health*. I understand that some of the artists have reported that I am intemperate. I cannot believe it—if they have reported such a lie, they are no gentlemen. Also, that I am *idle*—

My Brother Shepard, told me that he lately saw a large picture by Mr. Rosseter, which he liked very much and expressed himself so. The artist seemed pleased, and said that he had been visited by a number of artists and not one of them expressed themselves gratified. How ungenerous—Artists should be kind and speak of the beauties. There is hardly any picture without some defects. In visiting an artist in his studio it is about as well not to point out defects or give advise—even when requested to do so. Always speak encourageingly if you must speak. Never show a portrait until it is finished—flatter with the brush if possible—if you say very little with the tongue.

Go over the mass of light in the foreground with yellow (or red) as the case may be, and then glaze the rest of the picture with blue to set off the warm colors—

I painted Charles Elliott's portrait with yellow, red, and *Terre Verte,* in the flesh. Of course white was added with the above colors.

I must not allow myself to be talked out of my qualities (my style) of painting, without I am sure of a better. Be a leader rather than a follower.

I do not believe in much copying pictures. *Nature forever—Say I*—but it requires some thought to make use of nature to advantage.

Dec. 6th 1848

I understand that there is 45 students in the antique school, 35 in the life school, and five Ladies in the day school—at the rooms of the National academy of Design.

[Small sketch of two figures]

I think one could learn about as well by having a model in his own room to paint by day light, or Lamp Light, as he would at the academy.

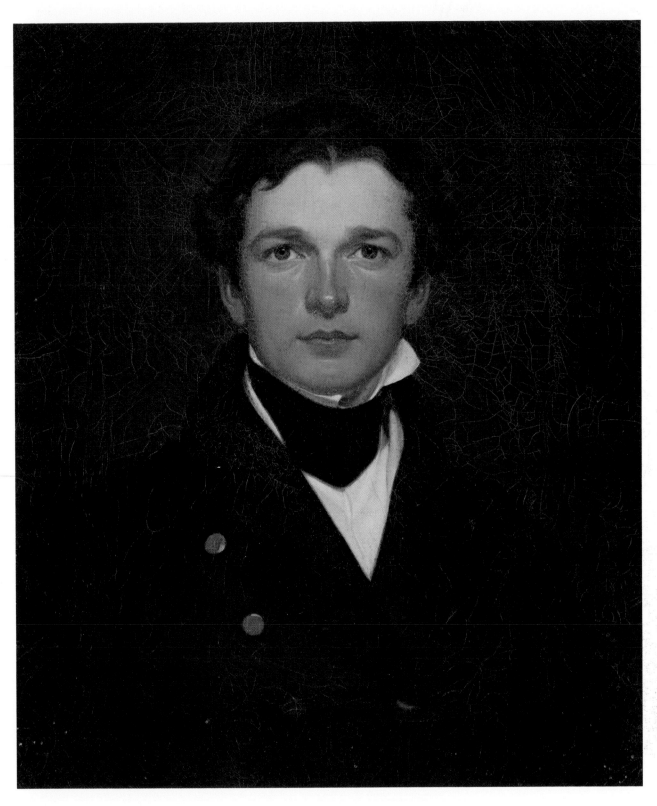

24. *Self-Portrait*. 1832. Oil on canvas, 24 1/2 × 20 1/4″. The Museums at Stony Brook,
 Stony Brook, Long Island

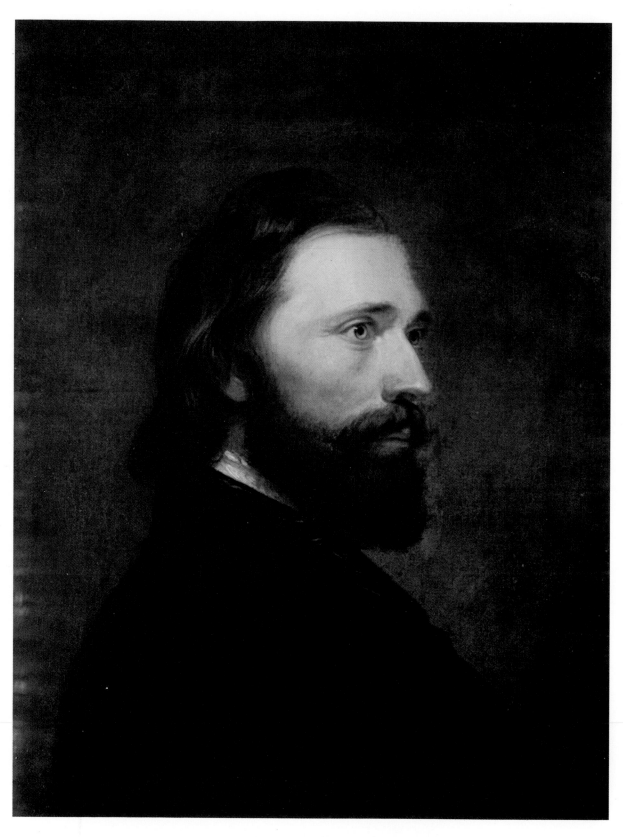

25. *Shepard Alonzo Mount*. 1847. Oil on canvas, 24 × 18″. The Museums at Stony Brook,
Stony Brook, Long Island

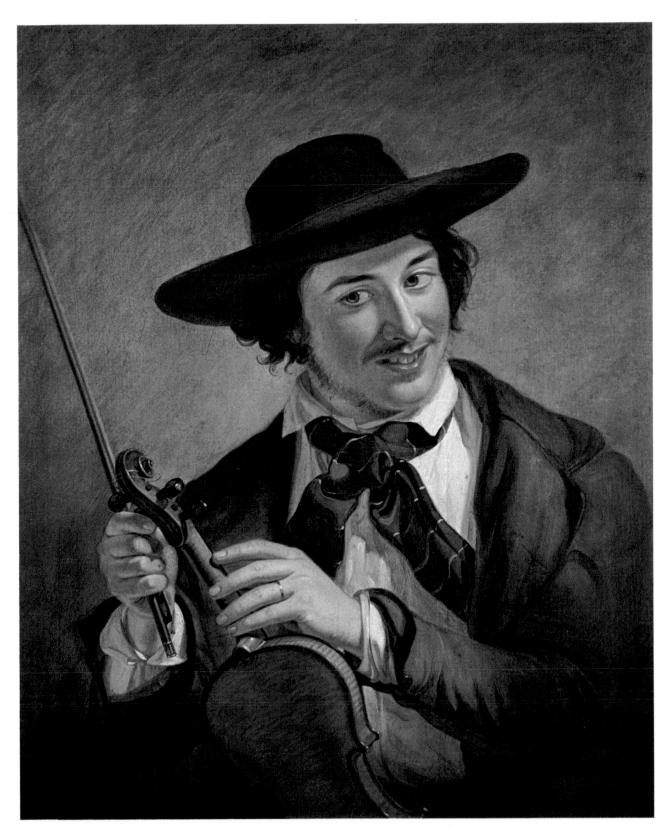

26. *Just in Tune*. 1849. Oil on canvas, 30 × 25″. The Museums at Stony Brook, Stony Brook, Long Island

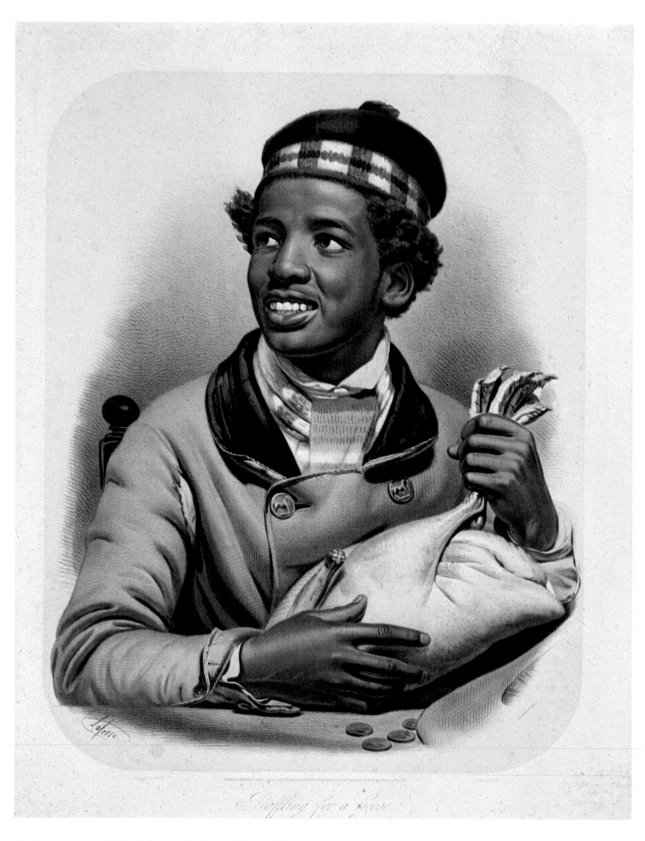

27. Jean-Baptiste-Adolfe Lafosse. *The Lucky Throw*. 1851. Lithograph, originally
published as *Raffling for a Goose*, 25 × 19 5/8″.
The Museums at Stony Brook, Stony Brook, Long Island

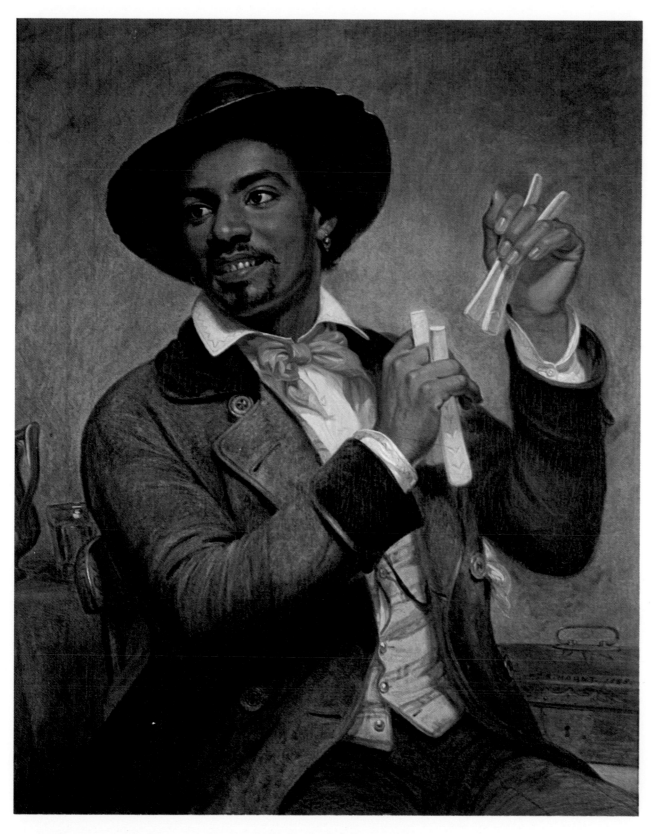

28. *The Bone Player*. 1856. Oil on canvas, 36 × 29″. Museum of Fine Arts, Boston.
M. and M. Karolik Collection

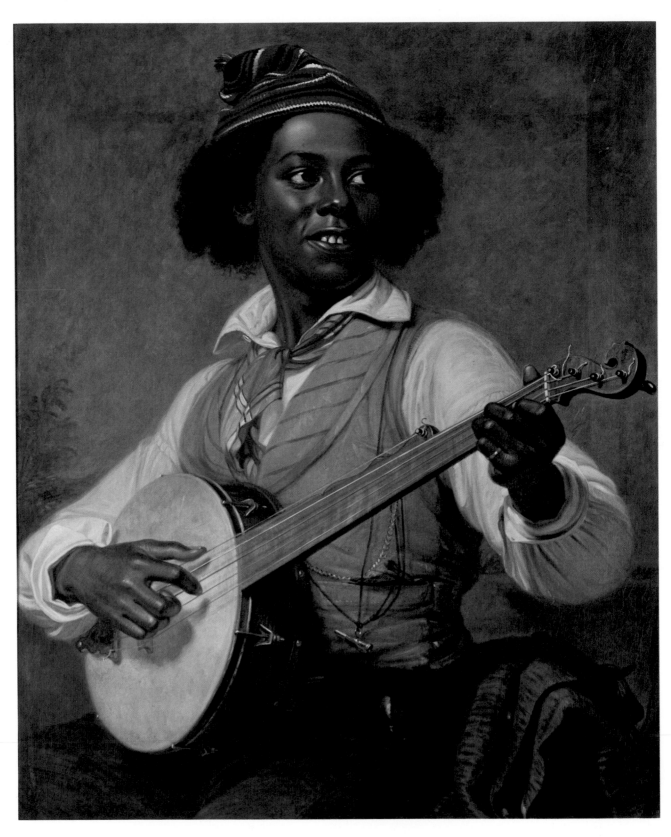

29. *The Banjo Player*. 1856. Oil on canvas, 36 × 29″. The Museums at Stony Brook,
Stony Brook, Long Island

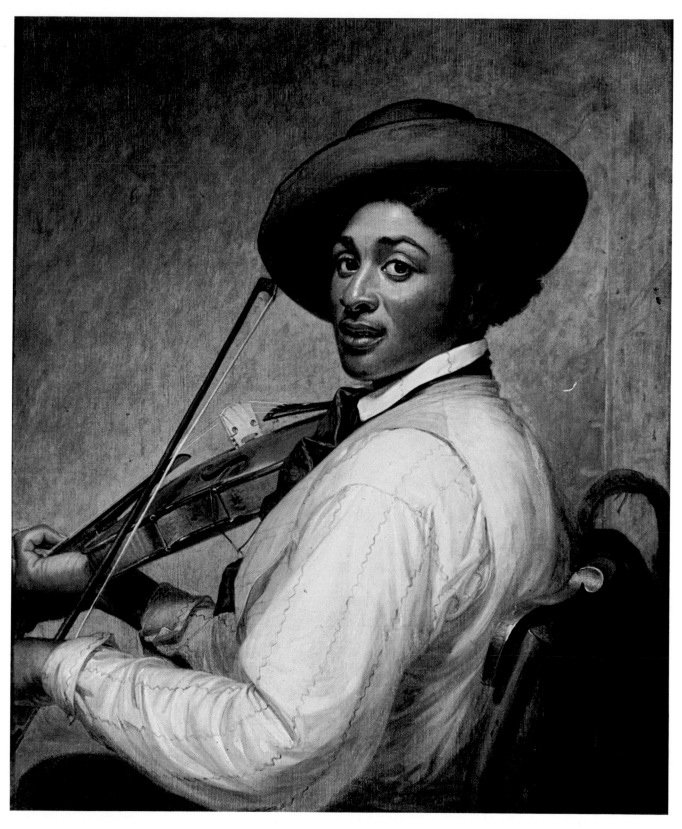

30. *Right and Left*. 1850. Oil on canvas, 30 × 25″. The Museums at Stony Brook,
Stony Brook, Long Island

31. *Farmer Whetting His Scythe (Hay Making)*. 1848. Oil on canvas, 24 × 20″. The Museums at Stony Brook, Stony Brook, Long Island

To Practice on something that will sell, will learn one quite as well.

New York City is the place for (*models*) for a *figure painter*—

Dec. 7th, 1848

Long Island appears to be very atractive. Some of the farmers have not been to the City of New York in thirty years—I know a farmer he is now about forty years old, he never was in the City. Notwithstanding all the modern improvements in traveling. A vessel will sail from here with a fair wind to the City in about six hours—from that to two days depending upon the wind.

The Cars are the most certain, but not so pleasant as a vessel with a fair wind—distance by water sixty miles. By land, fifty one and a half miles. So much for inhabitness in old Suffolk County.

This feeling, bound to one place for life, I do not believe in. It is all habit. It may do for farmers—but it will not do for artists.

I have done some painting for a few individuals in this place—in the way of portraits out of my own family. The last twenty years—the amount is 127 dollars. In some villages on the Island I have received fifty dollars for a portrait.

Dec. 8th

I finished this day my picture of Supprise with admiration [pl. 58]. By toning over the mass of light with yellow and a little Madder Lake, and rubbing it off with a piece of silk—then subduing the rest of the work with Ultramarine blue, to give value to the flesh and warm draperies. Lastly touching in yellow and Lake on the distant sky and clouds—and blending the whole into keeping with a large dry brush.

Dec. 9th

I finished this day a picture, Long Island Farmer whetting his scythe [c.pl. 31]. By toning over the Sky and distance, with blue, red, and yellow, in this instance I let

58. *Turning the Leaf* (*Surprise with Admiration*). 1848. Oil on panel, 12 3/4 × 17″.
The Museums at Stony Brook, Stony Brook, Long Island

the Lake predominate—giving a beautiful aerial warmth.

A Paint room should be of a dark cool color to sett of the flesh. You can bring in the warm draperies delightfully—on a cool ground. If the walls are dark, the floor cloth or carpet should be light. Walls blue, incl[in]ing to purple—or burnt Umber scumbled over blue—or a cool grey broken up with yellow and lake. A south light in winter, and a north light in Summer. There should be *several windows in a paint room.*

Names to pictures should be more or less poetical. There is conciderable in a name. Pictures to have a good name should be well executed.

Turning the leaf—will answer in place of surprise with admiration, or The Discovery—etc.

I must paint that picture the first opportunity, of *"Woodman spare that Tree"—*

Stony Brook Dec. 10th, 1848

The Election for President comes off today and tomorrow in France. I hope it will pass off peacefully.

Dec. 12th, 1848

I had a visit to day from Benj. Franklin Thompson. He had a great deal to say about the Monument to Gen. Nathaniel Woodhull—he is one of the committee to carry it into execution. It is a noble undertaking and when finished will do honor to Long Island—and those concerned in it.

Stony Brook, Dec. 22nd, 1848

For about two months past there has been great excitement about the *Gold Placers,* in *North California.* Thousands are rushing there to have a hand in sifting and picking. I hope it may turn out a blessing to the country—than a curse. We should be thankful for the gold that we get directly from the hands of the Almighty —and make good use of it.

[December, 1848?]

I say paint from the living, rather than from the plaster model.

An artist must not idle away his time and expect models to come to him—he must go in search of models.

If I should work with the same industry in painting pictures as I do in painting portraits I think there would be no grumbling on the part of friends why more pictures are not painted.

Glaze over a white ground with warm colour, and let it dry, then touch in the pearly tints, and reds.

In a warm light on the face, paint tender cool shadows for contrast.

Lanman says, in painting sky late in the afternoon, he uses Naples and white, near the horison. And Madder Lake to unite the yellow and blue tints—Munich Lake if you please instead of *Madder Lake.* Munich lake I am told is a preparation of Indian red—if so I think it invaluable.

I have often seen cool shadows on a Ladies face, by lamp or gas light.
Portraits, or light and shadow, could be studied by a Camphine light. The light subdued by a ground glass—to advantage.

Stony Brook, Dec 29th, 1848

It would be well enough for an Artist to have two studios in different parts of the City—one for portraits, and the other for pictures. So that he could be alone while painting his compositions.

My best pictures are those which I painted out of doors. I must follow my gift—to paint figures out of doors, as well as in doors, with out regard to paint room. The longer an artist leaves nature the more feeble he gets, he therefore should constantly imitate God.

One true picture from nature is worth a dozen from the imagination. Remember the air tints. If I should move about and paint on the seashore, and on the vessel's deck at sea, or among the mountains, or on the margin of rivers, or whereever, an interesting scene is to be found. I should paint more than to remain in one place.

The skys, as seen from (Stony Brook) Long Island away from the City, are remarkable for clearness—also the water in the harbour and *Sound* are clear and transparent.

The sky around large Citys is made up partly of coal smoke. The East river and North river about the City is not clear but murky. Rapid rivers generally have thick water.

An artist moving about from place to place will see things that will be suggestive, will stimulate him to paint. All he needs, then, is his paint box and a thin box of wood to carry his canvass into the fields. Fiddle and books, he can find most every where. The bible certainly.

. . . at your feet in the foreground you will see strong color, it then grows fainter untill it is lost in the distance. The same of the sky—it is a strong blue at the zenith and deminishes until it loses in the distance. The tones of the land and water of the Landscape, must be influenced by the sky in the distance or near by.

A painter should lose sight of himself when painting from nature; if he loves her, if a painter loves nature, he will not think of himself—she will give him variety and raise him from insipidity to grandeur.

An artist who has given himself up to nature should pay but very little attention to critiques. The canopy of heaven is the most perfect paint room for an *artist.* The

next best is a room with a broad sky light. But the painter should paint every where and under all circumstances, with out any regard to paint rooms. I must paint some striking characters—out of doors as well as in my paint room. Characters are to be found every where. Paint, paint, draw, draw.

THOUGHTS OF THE MOMENT

Cole's pictures are seldom hungry for want of color—he used plenty of it, and laid it on with great freedom with a feeling in every touch, and harmony of color rarely surpassed, even by the great Claude himself. His morning and evening effects are truly delightful. It seems to me that he used almost pure colors in his extremes. Distances over hill and dale beautifully varied, his distance very much obtained by the diminishing of objects, and then scumbled over with air tints. In foreground he often gave the strength of his palette and then glazed with transparent colors.

Some of his small sketches and pictures are painted up at once with a little after touchings, etc.

In his large pictures he finished in sections, after the effect was determined. He was the high priest of the Cattskill mountains. His residence was romantically situated. His best pictures are local, but the grandeur of the scenery and his happy choise in selecting, make *his* pictures appear highly poetical. Cole not only gives air, but color also.

The Past and Present, among his best—skys fine—owned by Mrs. P. G. Stuvyesant. Mount Holyoke—fine—*clouds* etc. The Mountain Ford—great—owned by C. M. Leuppe Esqr. Ancient Agregentum—very rich on the left distance etc—owned by Anson Baker. Conway Peak—do. The Improvisator—rich in color. F. J. Betts—The Catskill mountain and Creek. I saw Cole paint it. Landscape—early picture, bridge—D. C. Colden. Mount Etna from Taormina Sicily—very fine—H. Chauncey. Pic-nic Party—James Brown.

I have orders from Sturges and Leuppe to ~~paint or~~ copy from the Old Masters in case I visit Europe. My friend Jon. Sturges has given me an order to paint an original picture here or in Europe—I am strongly urged to go abroad. I must hire my models and go to work. The old oak must be painted, also the water fowl.

Spring of the year is the time to paint cattle.

Ruins of Aqueducts in the Campagna di Roma, owned by Miss Hicks, a favorite. The departure and return, his [Cole's] most finished pictures, owned by W. P. Van Rensselaer.

Jan 31st, '49

This is a very quiet place, here one can retire from the busy world if he pleases. It is quite too lonely for an artist—no one to talk to about the fine arts.

I take more exercise in the City than I do in the country—one had better wear out than rust out.

April 12, 1849

"In making the drawings for the Hudson River Panorama, a schooner was purchased and fitted up with rooms on deck for the exclusive use of those engaged in making the sketches. These rooms were so arranged as to enable the painters to make their drawings from nature in all kinds of weather." They have been nearly two years in preparation and have already cost about $25,000.

The Mammoth Cave of Kentucky would make an effective Panorama.

It seems my destiny to paint pictures—and to live in the Country.

"Genius will never be neglected by the public unless it neglects itself; it must not disdain the humble alliance of industry. How can it expect encouragement, unless its existence can be manifested by performances? The surest evidence of superior talent is, that it forces itself into notice in spite of adverse circumstances, but it makes a road where it finds none." True, most true—

A solitary life—"makes a man bury his talent; it lays him open to the temptation of idleness."

"Hide not your light under a bushel"—but sketch in the high ways and by ways—without fear of observation. Some artists are so timid that they will not sketch in public. A low (light or window) produces a cheerful expression on the countenance. A high sky light on the contrary, produces a heaviness or more serious expression.

New York, May 10th, 1849

Dreadful riot and bloodshed at the Astor place Theatre—about "thirty dead bodies remain as monuments of the 'vigor and effeciency' of the magistrates of New York; and two thirds of the windows of the Opera House broken," are the evidences of the violence of the mob—"It is only when it is evident that the use of fire arms will abridge the sacrifice of life that it is justifiable." The military should not have been called out—it looked like a challenge to combat—

Stony Brook, May 17th

I painted this day some canvasses and panels with clay and white lead. I used *boiled* oil—*Japan*—and turpentine, one quater clay to three quaters *lead*.

May 18th

It has dried finely without gloss—dead—and hard.

Grind clay, and dry white lead, in water, then mix with oil, japan and turpentine—and coat your canvass with the above after you have given the canvass a coat of starch and laid the flue while wet with a rubber stone. Or, first starch the canvass—then prime with clay and white lead—give several coats. It will dry hard and be lasting. The clay can be ground in water alone first—then mixed with

oil and turpentine. Clay will dry in the sun without White but will dry quicker in doors and out mixed with white lead.

Free use of turpentine with colors in doors will prevent cracking. Turpentine with a little copal and oil—will do to mix with colors while painting.

From the *New York Weekly Universe,* August 4th, 1849

A FIRST PICTURE

Some years ago, a young portrait-painter of New York, disgusted with his want of success and skill, left the city in despair, and went home to live with his mother, who occupied a small house on Long Island.

On his way home he noticed some men engaged in a horse-trade. The group struck him as one fitted for pictorial illustration. He went to work upon it, but it was his first attempt. After repeated efforts he produced a picture which approached his ideal conception, and being very much in want of money, took it up to the City with the forlorn hope of disposing of it for a trifle, sufficient to meet his present necessities.

He showed the picture to a gentleman, a connoisseur, with whom he had a slight acquaintance. "Do you wish to sell this picture?" asked the gentleman, after looking at it carefully. "I must sell it." "Very well, I should like to buy it, but I cannot afford to give you its value." Stepping to his desk, he wrote a check on the bank for one-thousand dollars, and handed it to the painter, saying: "Will that do? It is all I can afford."

The artist took the check without saying a word and left the store. All that day he wandered about the city in a maze, perfectly unconscious of all that was passing about him, and clutching tightly the vest pocket in which the check was deposited. He went to a hotel, and in the morning, his first movement was to see if the check was in existance, to satisfy himself that he had not been dreaming. Finding the precious paper, he repaired to the bank and obtained his money, went home to rejoice the heart of his mother, and to paint pictures, which have won his fortune and fame, both of which he deserves richly as an artist of genius, and a good, kind hearted man. Reader, this was Mount, the painter of the Power of Music, Albany Dutchman.

The above article about my painting and selling my first picture—is false, and made up by some *wag*.

Wm. S. Mount.

[NYHS]

Dec. 23rd, 1849

I have been busy doing nothing for five weeks past. All work and no play makes *Jack* a dull *boy*. I have enough to do—and I begin to feel that I had better do a little painting every day—to give the hand fair play. *Paint* and *Paint*.

Stony Brook, Dec. 26th, 1849

When I painted the Raffle in the winter of 1837 I used to walk over to my paint room and make fire before breakfast. I must do the same at this date 1849 and 50. To prevent my plate of paints from freezing I must take it every night to my place of boarding. I live with my Sister, Mrs. Ruth H. Seabury. Wisdom appears to be slow in reaching me. If I should put in practice what I already know, perhaps I would do better—in money— certainly. But then I have enough to pay my way—what more do I want. Then I must court labour for the pleasure of it.

I have a great deal to learn—

I often wish that I could stick more closly to my easel— "all things flourish by labor." Then I must not put off from day to day—but paint away, for time will not stay— *Amen.*

Whatever there is to be done—go right about it. To be *idle* is *wicked* and should be so considered. *This writing is idleing.* Business should be the first object of attention— fancy matters after.

SUBJECTS

A Gold digger.

A clam digger waiting for the tide.

Shadow of a rabbit on the wall, a group.

Before marriage and after marriage.

Courtship.

Reading about the gold diggings.

A negro blowing into the head of his violin—to stay the pegs.

Boy playing marbles.

Girl or Boy dipping water.

A Girl doing up her hair.

A character whistling.

A Black fiddling with great expression.

A Mother with two babies playing upon the harp of a thousand strings, a mothers bosom.

A Lady and her beau sucking at a brandy smash.

campaign of 1848

The westward expansion of the United States and the problems arising from it dominated the presidential campaign of 1848. At the conclusion of the Mexican War in February of that year, the United States had annexed some 918,000 square miles, including all of the present states of California, Nevada, and Utah, most of Arizona, and parts of New Mexico, Colorado, and Wyoming. The extension of slavery into these new lands became the major issue in the campaign. Congressman David Wilmot's famous Proviso, prohibiting slavery in all the recently acquired territory, became the rallying cry around which the issue was joined, even though the Proviso had been defeated in the Senate and never enacted into law.

That summer the Democrats nominated Lewis Cass, a conservative sympathetic to the South, for president. The Whigs nominated General Zachary Taylor, one of the popular heroes of the Mexican War. A third party, the Free-Soil, was formed in the North to oppose both; it was composed of various antislavery factions, including some former adherents of the Democratic party, had as its first objective the passage of the Wilmot Proviso, and chose as its candidate the former president, Martin Van Buren. Van Buren carried no state, but his popularity, especially in his (and Mount's) native state of New York, was great; he split the Cass votes and Taylor was elected.

The letters to and from Mount which we have assembled here reflect the excitement of the 1848 campaign at the grass roots level. Mount's adherence to the Cass wing of the Democrats, with their proslavery sentiment, is strangely at variance with his sympathetic portrayals of black people, to whom he was the first to give a place of dignity in American art. But he remained a staunch, old-line Democrat until the outbreak of the Civil War; then, despite his previous characterization of the Republicans as "Lincolnpoops," he was swept into the passions of the conflict on the Northern side. But when Lincoln ran for reelection, Mount reiterated the Democratic party's criticism of him (diary entries, November, 1864), and he carried on in the orthodox Democratic vein once the war was over.

In view of Mount's strong political interests and his occasional spurts of political activity, it is remarkable that his work so seldom reveals a political slant; in fact, he is known to have produced only one painting with an overtly political theme. That is a very crude affair to which he sometimes refers as *The Break of Day* and sometimes as *Politically Dead* (the painting is now known as *The Dawn of Day*). Painted about 1867, it shows a cock crowing on the chest of a sleeping black man, and it symbolized the idea that, from the point of view of a conservative Democrat like Mount, the black man in America was no longer a live political issue. (See correspondence for November 11 and December 9, 1867.)

It is by no means inconceivable, however, that Mount occasionally painted political pictures the clues to which have been forgotten. A former student of mine, Joseph Hudson, has written a brilliant essay, unpublished at the time this book went to press, about the political signifi-

cance he believes to be implicit in Mount's *Cider Making* (c.pl. 33); he thinks it refers to the "Log Cabin and Hard Cider" campaign of 1840, which put William Henry Harrison into the White House. He marshals two bits of evidence behind this view: One is that the painting was commissioned by Charles Augustus Davis, who was one of Harrison's principal backers. The other is that the date 1840 appears prominently on the head of the re-cumbent barrel in the foreground of the picture, although it was painted the following year and is so dated in the lower left corner of the canvas. But if Mount did paint *Cider Making* as a triumphant memorial of the Harrison campaign, it is strange that he says nothing about the matter in his letters and diaries.

Mr. Hudson also provides an explanation for the mysterious title *Politics of 1852, or Who Let Down the Bars?* that Mount gave to the painting now known as *The Herald in the Country* (c.pl. 14). This shows us a dandi-fied character, probably Mount himself, leaning against a fence with a gun at his side and a dead game bird at his feet, busily reading a newspaper to a burly countryman who stands just beyond the fence with a pitchfork in his hand. The interpretation commonly offered is that the dandy has been caught poaching on the countryman's land and has pulled out the paper and started reading from it in order to draw the rural gentleman's attention away from what he has done. This explanation is scarcely re-lated, however, to the title Mount conferred on the pic-ture.

Mr. Hudson points out that in the campaign of 1852 the right-wing Democrats (Mount's faction) united with the right-wing Whigs to elect Franklin Pierce president. The politics of that year let down the bars between the parties, and Mount depicts himself reading a leading Whig newspaper. It is by no means unlikely that other meanings and values of this kind remain to be discovered in other works of Mount.

A.F.

Fragment of Letter, Shepard Alonzo Mount to WSM

June 10, 1848

I shook by the hand the other day in the hall Cass, Ben-ton, and Houston. They are all noble-looking fellows. The Clay Whigs kick at Taylor's nomination. I believe with Gen Cass we can beat the Whigs again. I wish you could have heard the shouts at Old Tammany last night. Benton, Stevenson of Virginia and Gen Houston all spoke. The Barnburners with John Vanburen at their head is a humbug. Their leaders will go over to the Whigs on abolition and the honest Democrats will return to the Regular Nominations. Don't be caught in that trap. . . .

[SB] *Much of this letter is given over to complaint about Shepard's inability to secure commissions, his consequent need for economy, and his somewhat distraught plans for leaving New York City, where the letter was written, and*

going to Sag Harbor, where his wife's family lived. It is the only letter by one of the painting Mounts in which there is even a hint of serious economic difficulties.

B. T. Hutchinson to WSM

Middle Island, 27 Sept 1848

Dear Sir,

I have the pleasure to inform you that the Democratic Party of this Assembly District is again organized and we hope to be able to show the Committee who call meetings to correspond with Abolitionist instead of Democratic Conventions, that the people are not their puppets but that they will have a chance to learn their own insignifi-cance. We have waited for the spirit to move and it *has* moved, and now we wish to keep it rolling. A mass meet-ing was held at Huntington tuesday 19th inst—a Mass Convention agreed on, which was held at Suffolk Station 25th, at which our old friend Joshua B. Smith was nomi-nated for Assembly and the Towns organized by choosing Committees, and for this Town the following—Wm. S. Mount, Philip Hallock, B. T. Hutchinson, John Randall, Richard Robinson, E. T. Smith and Brewster Woodhull, and then those of the above who were present agreed to call a meeting at Patchogue on Saturday 30th inst. and hope it will meet your approbation and attendance.

I enclose a Notice which I hope you will approve, sign and put up at some good Democrat's say Genl Mount's, or where you think proper. Our prospects away from Suffolk and Queens was cheering, and Old Suffolk is coming, for the Barnburners are crouching and fearing to take the responsibility. I trust from information that we agree in our decision of what is Democratic, and therefore trust you will receive this kindly for yours respectfully,

B. T. Hutchinson

[NYHS]

WSM to B. T. Hutchinson

Stony Brook, Sept 30th, 1848

Dear Sir,

Your interesting letter and accompanying notice is at hand. The latter is put up in a conspicuous place. You have been rightfully informed. I go heart and soul for Cass and Butler.

The *Globe,* and *Evening Post,* are the only papers read in Suffolk and Queens. Therefore [?] should be some Cass papers distributed about, in dark and *Cloudy places.*

The Hon. Ely Moore will give us a talk in this place this afternoon. I hope he will scatter the disorganizers, wher-ever they hear him.

Yours truly,

[NYHS]

Wm. S. Mount.

B. T. Hutchinson to WSM

2 Oct 1848

Dear Sir,

I have the pleasure to inform you that you was chosen a Delegate to a County Convention to be held at Riverhead on Tuesday 30 inst 7 P.M. to represent the democracy of this Town who still remain true to their principles and their nominees Cass and Butler, and hope you will be so good as to attend. The others are Brewster Woodhull, James Ketcham, E. T. Smith, John Randall, B. T. Hutchinson and Amos Hallock.

Yours respectfully
B. T. Hutchinson
Middle Island

[NYHS]

WSM to the Editor of the *True Sun*

Stony Brook L.I., Oct 2d., 1848

Dear Sir,

The Hon. Ely Moore, I am happy to say, is now with his family in this vicinity, on a visit. His object is to rusticate, and have a real deer hunt with some of our sharp shooters, but his repose was broken in upon last saturday by a call from the democrats (the *Cass men*) to address them in this village at the house of Egbert Smith, which he did (standing in the veranda), with such good effect and expression in his manner, that the Disorganizers —the Barnburners, present—many of them shook the dust from off their coats and acknowledged to me their errors, and that they should go home *Cass men*. Mr. Moore spoke highly of General Taylor as a warrior, but as no statesman (by Taylor's own acknowledgement)— accordingly, any Aunt Peggy might make as good a President if she could only select a good Cabinet—if so, why not elect a cabinet without a President.

The Hon. speaker enlarged on the importance of having a Statesman as a President—the genius of Gen. Cass, and his knowledge of our political affairs both at home and abroad fitted him exactly for the Presidency.

I have no time to say more. If the Hon. Ely Moore could spare the time to scour through old Suffolk, the *Van Buren, Free Soil—kink*—would be taken out. Every vote given to Van Buren is a Whig vote, which makes the Whigs chuckle prodigiously.

I do not know the terms of your paper, but should be happy to receive it till after the Election. I will be in the City in a few weeks, and will pay you. I regret to say, that a very few Cass papers are taken in Suffolk County.

Yours Respectfully
Wm. S. Mount

[NYHS]

WSM to Charles Brown [?]

Stony Brook, Oct. 4th, 1848

Dear Sir,

Your letter confering upon me the Honor of a delegate, is at hand, but too late to attend the meeting. Had both your letters reached me in time, I must have declined the acceptance as my business prevents my taking part in any affair of the kind. The list of names you have mentioned I approve of.

I placed my name on the notice to let the Barn Burners know that I was a *Cass Man*.

Mr. Orin Rogers of Setauket, and my Brother Shepard A. Mount, are the only true men I know of to [illegible] definite assistance from this quarter too.

Every vote given to Van Buren is a Whig vote, which makes the Whigs chuckle prodigiously. The Cass and Butler men must stir themselves night and day, to save old Suffolk.

Yours truly,
Wm. S. Mount

[NYHS]

B. T. Hutchinson to WSM

Oct. 9, 1848

Dear Sir,

We met in Convention without contesting or concerning with the Barnburners and nominated the following ticket which I hope will meet your approbation, and that of our friends generally.

I feel that our cause is right and that the people will finally return although they are deceived by the cant phrases and professions of those who appear to have only one steady principle which is to "rule or ruin." "Be sure you are right then go ahead" is a pretty good maxim and "do what is right and trust in god or providence" is another, and I feel sure we are right and I will try to make the cause go ahead and trust to the future.

DEMOCRATIC TICKET	BARNBURNER, ABOLITION, ANTI-RENT ETC. ETC. ETC.
Lewis Cass, Pres.	M. Van Buren, Pres.
W. O. Butler, V. Pres.	C. F. Adams, V. Pres.
_____ Congress*	_____ Congress*
Joshua B. Smith, Assembly	Richard B. Post, Assembly
Brewster Woodhull, Cy. Treasurer	Wm Sidney Smith, C. Treasurer
Gilbert Carl ⎫ Cy. Super- B. T. Hutchinson ⎬ intendants David Pierson ⎭ of Poor	Jos. H. Ray ⎫ Cy. Sup. B. F. Wells ⎬ Poor Austin Rose ⎭

*probably Horace Brown of Queens Co. will be nominated on Thursday next.

*probably Henry Floyd Jones will be nominated on the 10th inst.

R. H. Walworth, Gov.	John A. Dix, Gov.
Chas O'Connor, Lt. Gov.	Seth M. Gates, Lt. Gov.

WHIG CALENDER
Z. Taylor, Pres.
M. Fillmore, Vice Pres.
_____ Congress*
H. Fish, Gov.
Patterson, Lt. Gov.

Harvey W. Vail, C. Treasurer
Richard M. Conklin ⎫
George Miller ⎬ Cy. Sup. Poor
Jonathan Frithian ⎭

*probably John A. King will be nominated for Congress, although Wessel S. Smith, Alexander Haddon and Abraham T. Rondell spoken of.
**Probably J. Bowers will be nominated, although W. Nicoll and R. M. Conkling are spoken of.

There is to be a mass meeting of Cass Democrats at Brooklyn on Friday 13 inst. at 10 clock P.M. at E. Jarvis'. Morris and other speakers are expected.

<div style="text-align:right">

Yours respectfully
B. T. Hutchinson
Middle Island
</div>

[NYHS]

WSM to Charles Brown

<div style="text-align:right">Stony Brook, Oct 15th, 1848</div>

Dear Sir,

In the first place I hope you are in good health. I wish to tell you that all hope for *Cass* and Butler in this County is not *lost yet*. Notwithstanding, the Barnburners have been with the Whigs, trying to frighten the Democrats to stay at home on *election day*. I am a Countryman, and I know the right way to arouse them. Send all your smart democratic talkers, those that have the spirit of humor and ridicule combined with good sense into all the counties of this state—tell them to visit families throughout the day, and in the evening address the farmers in the *school houses*—assure them that without *their* efforts, the country is in *danger*. Old Suffolk can be made to give one hundred and fifty majority. I have with my violin, and ridicule together, broke into Barnburnerism (Barn *Bunker,* or sore heads) as you please to call them, so that they are ashamed to name themselves.

Do for the sake of Democracy, arouse old Suffolk Co. For the honor of this state, the Democrats should not stay at home—send forth your singers, and social talkers, men that will mix in with the farmers, husk corn, drink cider, and talk, and invite them to attend the meetings in the evenings.

The speech delivered here by The Hon. Ely Moore, a few days since has had a great effect. I wish he could visit every village on Long Island. Evening Meetings, or inquiring meetings, on the subject of Politics may be a good means of awakening many. I do not know why Political inquiry meetings may not be as profitable to the salvation of the Empire State, as religious inquiry meetings for the salvation of the soul.

Please read this, voice from old Suffolk, to the Democratic Committee, as soon as they meet at old Tammany, or to some of the *Cass Editors*. I expect to be at Tammany in about ten days.

<div style="text-align:right">

Yours most truly,
Wm. S. Mount
</div>

P.S. I have offered fifty Cts a piece for all the Barn*bunker* skins that can be brought in after the Election.

Bunker is a fish that we manure land with but they *smell* very bad.

Since writing the above, I have had a talk with a Staunch Democrat. He said if the people could know the truth about the "free soil question" Van Buren would not get one vote in this town. He also remarked that Suffolk could be made to give five hundred majority for Cass and Butler.

Village meetings at this time is better than Mass meetings. Please talk with all the Cass men from this County that visit old Tammany. In fact all the Cass men stopping at the Hotels from the different Counties should be looked after. In haste.

[NYHS]

WSM to the Proprietors of the *True Sun*

<div style="text-align:right">Stony Brook L.I., Oct 18th, 1848</div>

Messrs. Gallagher & Morrill
Dear Sirs,

Enclosed, is one dollar. I desire to take your paper for one year. "No matter how great or how worthy a man is viewed, simply as an individual, the masses will not sustain him, unless he represents their cause." Hence, if Mr. Van Buren intends to force the democrats (the true sons of God) off the beaten track, he will in the end be hurled to eternal infamy.

Do for the sake of democracy, stir up Old Suffolk. The whole state, the Union should be aroused. The war cry must be Cass and Butler, and down with the Traitors. Send forth your singers and orators—and assure the democratic farmers, that without their efforts (at the Polls) the country is in danger. Village meetings please the farmers better than mass meetings—they can attend the former with less trouble, and evening meetings better than any.

I do not know why Political inquiry meetings may not be as profitable to the salvation of the Empire State, as religious inquiry meetings for the salvation of the Soul.

I wish the Hon. Ely Moore, could visit every village in old Suffolk to prevail upon the democrats to turn out. Hundreds will be kept back by the Barnburners. If the people could know the truth about the free Soil question Van Buren would not get one vote in this town. They begin to see that it is a mere cobweb, notwithstanding, it must be brushed away immediately.

A staunch democrat remarked to me the other day that Suffolk Co. could be made to give five hundred majority for Cass and Butler.

Huntington and Smithtown are the strong holds of barnburnerism. I understand that John Van Buren is to deliver a speech, in the latter Place about the first of november.

<div style="text-align:right">

Respectfully yours
Wm. S. Mount
</div>

[NYHS]

the queens borough sketchbook

In the Long Island Room of the Queens Borough Public Library at Jamaica, New York, is an extraordinary, little-known, and hitherto unpublished book of sketches and drawings by William Sidney Mount. It was purchased in 1947 from Barnard Press, a collector of historic materials relating to Long Island.

The sketchbook consists of twenty-seven pages very loosely bound and devoid of cover. Each page is ten inches long and six and a half inches high, except for no. 20, which is slightly smaller than the others. It was not part of the original binding and is clearly an interpolation, although it has been numbered in sequence with the others. The penciled page numbers are by an unknown hand. Page 16 is blank.

No firm date for this sketchbook can be suggested, but the style or styles of drawing in the main suggests that it is an early production. None of the drawings can be identified with known paintings by Mount, and the subjects of many, especially the portraits of animals, are somewhat unusual for him. To be sure, animals appear repeatedly in Mount's oils, but as accessories, not main themes, as they do here. Sketch no. 3, with its English-style cottage and its ruined castle in the distance, may well be a copy of some English original, like the drawings in Mount's perspective notebook after Edward Edwards mentioned in the Foreword. Numbers 10 and 11 are very naïve, even amateurish, in style and might have been taken from one of those illustrated treatises on human physiognomy and emotional expression that were so prominent a feature of the literature on art education in the early years of the nineteenth century.

The rest—studies of houses, flowers, boats, and barns—is good Mount. With the exception of the flowers, everything in the sketchbook is in pencil. The flowers are in color and in mixed mediums—oil, watercolor, and crayon—and may have been intended as experiments in such mixtures. Mount's independent flower still lifes were all produced very late, and so it is by no means inconceivable that the Queens Borough sketchbook contains pictorial jottings dating from the very earliest, preprofessional stage of the artist's career to its final phase.

Five of the drawings and one of the flower paintings bear the initials W.S.M. in Mount's handwriting. One drawing, the landscape on the interpolated sheet no. 20, contains an extremely faint penciled inscription that seems to read "Lancaster, N.Y." Lancaster is in the extreme western part of the state, near Buffalo, and there is nothing else to show that Mount was ever in that part of the world.

In the same envelope with the notebook, and apparently derived from the same source, the Queens Borough Public Library preserves a very small drawing (4 3/4 × 3 1/16″) on cardboard of a man in a tall hat looking through the opened half-door of a small house with a tree and shrubbery in front. It is also signed with Mount's initials, and on the reverse is a bust-sketch of a woman with long hair. Neither side is reproduced here.

60

61

63

67

68

69

71

72

73

74

75

76

77

79

80

81

83

84

correspondence 1848-49

William E. McMaster, author of the silly letter that comes first in this section, was a portrait painter, once well known, now completely forgotten. Publication of his letter here could help in identifying such old portraits as may still be puzzling the antique dealers and other cognoscenti around Cazenovia.

T. Addison Richards is a much more serious figure. He was one of the abler painters of the Hudson River School, was professor of art at New York University from 1867 to 1887, and was an active member of the National Academy of Design and its corresponding secretary for forty years, from 1852 to 1892. In addition, Richards, who was born in 1820 and died in 1900, traveled a great deal in both Europe and America and published much on travel and on nature. At the time Mount wrote him, he was twenty-eight years old and had only just been elected to the Academy.

B. F. Thompson, historian of Long Island, has previously been identified. Mount's letter to him describing the native pigments which he and his brother had found round and about Stony Brook is one of the most remarkable of all the Mount documents.

George Pope Morris, to whom Mount addressed his bitter tirade against the Art-Union on December 3, 1848, was at that time the editor of the extremely popular *Home Journal.* He was one of the leading literary figures in New York, had been associated with the formidable Nathaniel Parker Willis in a variety of journalistic ventures, and was widely esteemed as a poet. Even Poe praised his *Woodman, Spare That Tree!,* and Mount repeatedly expressed his intention to paint a picture based on it. He apparently never did so, although he went so far as to make an oil study, which is preserved in a private collection in Stony Brook (see pl. 85).

The "Tom" to whom the Navy officer Oscar Bullus refers in his letter to Mount was the artist's nephew, Thomas Seabury.

A.F.

William E. McMaster to WSM

Cazenovia, June 2nd, 1848

Dear Sir,

Now that I have finaly left N. York and after some four weeks of country life in Auburn, fairly settled down in this charming village of Cazenovia for a few summer weeks, or months, my thoughts naturaly turn to old scenes of city life, and familiar friends. I have been trying to remember *how* we became acquainted, but not having been formaly presented, or introduced under the severe rules of fashionable Ettiquette, I only remember that we met in a picture Gallery, where you so completely "Whistled" yourself into my admiration, that I took the earliest opportunity to seek introduction which has resulted in the acquaintance we have, which, together with the esteem in which I view your tallents, and your respect shown me in our few last meetings this spring in N. York, is my only appology for

addressing this, friend Mount. You know I am one Nature's men and since my return to the country have buried myself in frolicing amid her varied scenes. You will not be surprised to hear, that after viewing Our Lamented Cole's Collection that I should have [illegible] enthusiasm for Landscape. I have painted two since I saw you. One A Moonlight Effect—of some merit.

You see from the date of my letter that I have written from Cazenovia. I have forgot if I told you much about my last summer spent in this place, but sir, I tell you its beautifull, good scenery—and society. I painted some 22 portraits here last year, and shall probably paint nearly the same number again this summer. I rec'd a commission this morning from Mr. C. of N.Y. for Nine pts. of his friends who reside here in C. You see then that I'm "ellected" for the Season. Some of them are "pretty Misses." What despach do you think I will make? Ha! ha! There's no telling what an Artist's success will be, when "there is a Lady in the Case." (Let's see, I believe you spoiled a picture once for some charm of the kind?) My romance of mind has somewhat subsided and since I left those "Eloquent Eyes," at the NA of D, my tenderer part of nature, has pleaded strongly in their behalf (or rather in *my own*). You know a charming face full of inteligence and beauty has an irresistable influence upon me, and though they vanish from my presence like the sight of a last year's rainbow, there is still left, upon my remembrance a hue of their former brilliance and beauty, and if the single beam of some future unborn Sun shall chance to shine upon the pathway of where gleams my *ray of hope,* the charmer will spring into new Existence and one heart at least be not left Desolate. Well, there sir, I dont know whether you will dub me a fool, an Ass, or some Moonstruck sentimentalist. But whatever be the thought only believe that I am a little charmed with Miss P. and Miss S.

Now friend Mount, I have a word for you confidence. After we last met in N.Y. I met Miss Price at the Art Museum. We passed word together remarking upon the pictures, and when she left, she left a very favorable impression upon me of her tallents and true Ladylike politeness. You remember you introduced us at the Academy [illegible]. I saw her several times after, and called at her residence (178 East B Way) the night before leaving. I think she has tallent and many accomplishments and (though she may have guessed it from my manner) she also has my *best friendly esteem* which, even should it not be requited[?], I feel to say with a great man, "has been given to a worthy one." When will you see Miss Harriette P.? At such time as you may, you will confer a favour of no trifling value, by any kind remembrance of me to her.

I have written at some length upon this point—still I would not burden you with such frendship matter—you know that my social nature is at least *something*—and if the delivering of these respects to Miss P. is a labour, I feel confident that their reception will but be unattended with respect at least; if only for your sake. But away with

this theme, I shall tire you, and I am not one, that wishes to use my friends.

We have a pleasant village and the time of flowers will now come. We shall have pic Nics and parties—but the *news* is not much—you will therefore see that I must close this long letter without much to interest.

While at Auburn, I spent several evenings with your Cousin W. W. Shepherd, who by the way, is one of the choice spirits—he made many inquiries after you etc, which were all answered; as best I could. I "went off" last week in full blast upon a Lecture of Art. The Critics say I done well, but I dont pretend know. I assure you however, if my pen was capable, that A certain *particular friend of yours* who resides on *L.I.* received Eulogy which justly belongs to "America's best Dramatic painter." Can you guess it? ha! ha! Don't go too far from "Stony Brook."

Now my dear Mount, oblige me by an answer to this at an early convenient opportunity. My Compts to your brother Shep, Elliott, [illegible] etc. when you see them. Tell [illegible] I have not yet made that "ten strike." You know my weakness, (if such it be) will be particularly gratified by any mention of 178 East B Way.

I close then, and remain with sincere respects,

Yours truly,
Wm. E. McMaster

P.S. Did you tell me that Miss P. was "Engaged"? How is it? Address—Cazenovia, Madison Co NY.
[SB]

WSM to Thomas Addison Richards

Stony Brook, Oct 20th, 1848
My dear Sir,

Your very kind letter containing art notices, I received some months since. I know your bump of benevolence will excuse me from not answering it sooner.

The month I believe has arrived, that you predicted you should return to the City from the country, where you have been roaming about the gardens[?] like *Pan* of the olden time, viewing the *mossy trees, stones* and *gurgling brooks.* One day's painting from nature in the quiet of a cool retreat, the canopy of heaven for a paint room, adds more to the repose of the soul than all the care of the Astor estate could give in a month. What precious comfort we painters have. Worship God all day and fiddle and dance at night.

Your *art notices* are ably written, they possess a good quality, they lean upon the favorable side. It is the sign of a good heart when we can see merit in others, and spontainiously acknowledge it. I hope you have been greatly benefited by your rambles in the country, in health as well as in *art*. I shall endeavor to call upon you the few hours that I shall spend in the City in the course of a week or ten days from this time.

God will preserve all worshipers of nature, I truly believe, so you must put yourself down as one of the *elect*.

<div align="right">Yours truly
Wm. S. Mount</div>

P.S. Please give my regards to Durand—and to Lanman, when you write to him. I understand there is a fine picture exhibiting in New York. Napolion *freezing* across the alps. I must see it.

P.S. #2. Charles Elliott, is here.

[NYHS]

WSM to George Pope Morris

<div align="right">Stony Brook, Dec 3d, 1848</div>

My dear Sir,

The manner in which you introduced my picture "Sportsman at the Well" in your art notices, I am pleased with, also, that you intend to give a description of it should it ever "journey back from this place, and find a nook" some w[h]ere in the City. I hope it may be so fortunate, as to find so good a resting place among so many interesting works of art. Allow me to detain you a moment and relate to you why I took the above picture home with me. I painted it ~~for myself but~~ with a view to have it owned by the Art-Union, for distribution as a number of my friends wished to see several of my pictures in that institution. Accordingly I invited one of the Committee, I believe a warm friend, to see it. He saw it and advised me to send it to the office of the Art-Union, that the Committee would meet on Thursday evening the 2d of Nov. and that I should know in the morning the result. The next day I called at the office, and was told that the Committee concluded not to vote on so high a priced picture (only three hundred including frame) until a ~~fuller~~ larger meeting which would take place in about twenty days. I thought it was a delicate hint that my picture was not wanted. I took it down from the walls of the Committee room and departed. I have never sold but two pictures to the Art-Union, and was beat down in my price on one of those. Last year they gave me an order, the only one I ever received from that quarter. I completed the picture in time, and it gave satisfaction ~~to the committee.~~ The one now in the Art-Union—"Loss & Gain"—was not obtained from me. I sold it to Robert F. Fraser Esqr. The Art-Union does not give orders this year, but intend to buy pictures at low *prices* to grind the *Artist* down. I am convinced that such a system will in the end produce poor pictures, and the insulted public (that pay their annual subscription of membership, *five dollars*) will inquire why they, and the artist are not better treated.

I will add—The Committee rejected on the same evening a beautiful picture by S. A. Mount, a piece of still life (shell fish). Price Fifty dollars. They left word with a Tall, genteel looking Englishman engaged in the office, that the picture was too shelly. What impudence, when my brother had been requested by one of the Committee to paint a picture of the kind for them. I have been told that some of the Committee of the Art-Union are so noble in their views of art (in their efforts for the "promotion of the Fine Arts") that they would gladly see pictures sold by the yard measure. Artists will be compelled to exhibit and sell their own works as heretofore in their own rooms. Mr. Matteson and Mr. Stearns, told me that they had *allready* adopted that plan for their own safety and dignity, as artists.

With respect and esteem I remain yours truly,

<div align="right">W. S. Mount</div>

[SB]

Fragment of a Letter, Addressee Unknown

<div align="right">Stony Brook, Dec. 15th, 1848</div>

My dear Sir,

"Strike while the iron is hot." I am pleased to say that there are a few mortals living (and you are one of them) that go in for cleanliness and health, in spite of the demonical grin of the Master *Cholera,* as he looks upon the dirty City as so much capital to commence business upon.

In the year 1825, it was the law and the daily practice in the City of N. York for every man to sweep and scrape the dirt from his own door into the centre of the street, early every morning. At nine o'clock The *Corporation Carts* would remove the dirt— Every nuisance *thrown* into the streets was fineable. Then the laws were maintained, and the citizens and *strangers* walked erect without fear of having their feet soiled, and their noses drawn out of character by villianous smells. Then man moved as a man— but not as a hog moveth. Those pleasant days were not to last long—some designing politicians whispered to the people that it was burdensome to clean before one's own door, and if the good folks and people would give them their votes, they might set aside the hoe and shovel. The good deluded public smiled, *the deed was done*, and the great and growing City of New York has *stunk ever since*.

I remain yours truly a reader of your paper and an exile from the City until it is thoroughly cleaned. . . .

[SB]

Benjamin Franklin Thompson to WSM

<div align="right">Hempstead City, Dec 30, 1848</div>

My dear youn[g] friend,

I feel bound[?] to write you if for no other purpose than to thank you, as I do most sincerely, for the exquisite pleasure I felt, during the visit you allowed me, to your studio, and the surprising fact you disclosed of having succeeded in finding most of the native colours, required in your art, upon old Long-Island. In all that has been written upon the geology of the island, it has been reserved for you to make this extraordinary discovery, and I shall take it kind of you to furnish me with a list of the colours so

found, with the names by which you designate them, or by which they should be known to Artists. I had as you may well conceive a very pleasant and cosey ride with Mrs Floyd, as far as the Pond, and spent as agreeable a night with Mr. and Mrs. Mills. He would not confess to the gout, so I left him alone in all the glory derivable from believing himself tormented with Rheumatism and beginning another turn of the screw to convert it into that affliction of good-feeders, the gout.

I was sorry that my good friend Mr. Seabury was not at home, but the kind good humour of his wife and the agreeable politeness of Miss Julia and her sister were ample amends.

If I knew any young man a little better than all others, I would recommend him to reach the white house on the hill, for a bird worth caging, not one of your Magpies, Mocking birds and Whipoorwills, but a genuine Canary, or rather Lark, lively, bright and beautiful. Tell her from me to look out sharp, and not allow herself to be taken with chaff, or caught in an ordinary snare, or imprisoned by one of your cunning and designing trappers.

I have been employing myself since my return, with copying out and arranging a great number of epitaphs previously collected in my journies over the country, and writing historical notices to be attached to each of them as appear deserving. I hope a monument will be erected to the grave of the Rev. Charles Seabury soon, that I may avail myself of the inscription, to which I would append an account of his family. His grandfather Samuel, and great grandfather John Seabury, are buried here, also David a brother of Samuel, celebrated in his day for great personal strength. I have epitaphs of all these, as well as of the Bishop of Connecticut. I have made quite a genealogy of the Seabury's and should be glad to make it more perfect, if you could give me, through your brother in law, the dates of the birth of himself and his brother, and of each one of the children. John S. Seabury has lately received a letter from a Mr. Seabury of Portland, Maine, one of the same family, who is trying to collect a complete account of the family, from its first appearance in this country, and we are trying to assist him. When finished it is to be printed in pamphlet form for gratuitous distribution in the Seabury family alone.

We shall all be most glad to have a visit from you when most convenient, and as I know it will be a labor of love for you to paint the portrait of our dear, dear Henry, we shall leave it to yourself, where it shall best be done,

Should you visit us, you can determine this matter, for it is our desire you should consult your own pleasure on the subject. Our beloved boy, with your good brother of the same name, have finished the labor appointed them in this world, and their spirits beckon us from the grave, saying, prepare to follow. Oh, how I pity poor Henry's widow and children, to be deprived of a husband and parent, when they most needed his counsel and support. To go away in early life, to bid adieu to all the beautiful things of this great and beautiful world, and plunge into an unknown future, is terrible even in contemplation, but

it is well that in almost all cases, they who die, do not feel it so keenly, as those whom they leave behind. But I am growing serious, and in this mood, bid you adieu, with love to the household of faith.

B. F. Thompson

P.S. Please hand the enclosed to your neighbor Williamson.

[SB]

WSM to Benjamin Franklin Thompson

Stony Brook, Dec. 31st, 1848

My dear friend,

Your very agreeable and friendly letter is at hand. I have forwarded your note to Col. Williamson. It affords me great pleasure to make known to you the colors found on this part of Long Island—a proof that we have the materials for good pictures, if they have not yet been painted.

As long ago as 1838, when I was painting the "Farmers Nooning," my late brother H. S. Mount, handed me a piece of native umber and desired me to make use of it in my picture. I did so, and found it as he had represented, transparent, and a good dryer. I have used it more or less ever since and find it a valuable pigment. It looks lighter and makes a cooler tint when burnt—directly opposite to Turkey Umber. In the gradations of flesh, with white it is truly delightful. It unites harmoniously with all colors. It should be ground in nut, or raw linseed oil. In Jan. 13th 1843, my brother S. A. Mount proposed that we should explore the high banks bordering the Sound, for the sake of exercise, and to see what we could find in the way of native pigments—the weather was fine and warm. As we strolled along the bank we picked up pieces of *brown, yellow,* and *red*—we thought the rich "placer" must be some where near. Shepard struck his hoe a few feet up the bank and we were astonished to see a lot of bright *red* running down the bank and mingling with the sand. It was a rich day for us—we worked with the spirit of gold diggers, and were well paid. The red found in balls, was in tint like India red, and venetian red—some of these sandstone balls contained purple, some yellow, and some red, like orange vermillion. While digging in another part of the bank, about seventy feet above tide water, we dug out a white powder encased in a covering so slight that it would not hold its own weight, so we were obliged to take the powder out with a spoon. I have found that the action of fire will not change it. It has the power of cleansing silver at the moment of application. I have used it in painting. I think *Titian* must have used something like it, in toning the flesh of his pictures. The yellow we found in broken lumps, resembles Naples yellow, but richer in tone. I found that the steel palette knife would change its tint, accordingly I used the bone knife instead. Some of the yellows resembled raw sienna. The browns had the nature of Vandyke brown, Colonge earth, and Cappah brown. We also dis-

covered pure *black*. What interested us very much was the finding of several *brimstone balls* of a sea green color, with lines radiating from the centre, smelling strong of sulpher, evidently showing this part of the Island to be volcanic. Here *we paused* and turned around expecting to encounter old cloven foot, with Capt. Kid behind him. After the smell had passed away we resumed our investigations. We found large bodies of stone and sand, bound together with a sort of brownish paste, giving a varnished appearance and forming into solid rock, as the pieces seperated with difficulty. Along the shore we walked over large blocks of red, and yellow sand—also black sand such as is used in sanding letters. Most of the reds and yellows, and some of the browns require washing before using. I have painted several pictures with colors found in old Suffolk Co. Mr. Frothingham, our fine colourist, was delighted with the umber I presented to him—he said his old Master, Gilbert Stuart, used a native umber, and he had been a long time wishing to obtain some of it. He gave me some choice color in exchange.

These balls must have been in great estimation by the Indians, not only for the color they contained, but as *instruments* of *music* they served as whistles, very shrill and piercing. Indian arrows, and stone axes, are found all over this part of the Island, striking examples of ingenuity.

[Sketch of arm and ax]

You may expect to hear from Mr. Seabury shortly.

I intend to visit you before long (if I can find the time) then we will determine about the *portrait* of *Henry*. Speaking of colors, I found some native tints above Newburgh, on the North river—also, large quantities of brown, umber, etc. round about the village of Catskill, but not the quality of Stony Brook Colors. I questioned Mr. Thomas Cole about the colors I found there—he said he used the Umbers in his pictures.

I wish you all, a happy New Year.

Yours most truly,
Wm. S. Mount
[SB]

Oscar Bullus to WSM

New York, Sept 24th [1849]
My Dear Sir,

I think I will take a run down to Stony Brook, the last of this week or beginning of next, in the first place to see you all before winter and to thank the whole of you for your kindness to and care of my daughter, and to assure you of my sincere desire to reciprocate your hospitalities toward me and mine. Secondly I want my picture. I have been several times on the eve of sending you the money by mail, but I am afraid of that mode of sending money, but if you would like it put to you in that way in preference to any other, you can let me know. They have had a grand jollification at the Art-Union, upon the occasion of opening their new gallery of paintings. You know I do not pretend to be a first rate judge of paintings but I have seen a great many in my travels, and I ought to be something

of an amateur at least in the fine arts. In looking round the rooms, I did not see what I call a striking picture, not one that it would give me any particular pleasure to be the possessor of. They say Goupil & Co. have some very fine ones: three of which have been presented to them by the French Minister of the Interior I believe. I shall go there soon to enquire for the "Power of Music." I do wish you would allow the public to see your "California Boy"—that mischievous looking dog, tuning his violin preparatory to a break down. If you will let me have it, I will procure its exhibition in one of the parlours of the Astor and will engage that a number of southerners that are now on here shall see it. I do really think you can find a purchaser for it on your own terms. If I could afford to buy that picture I would give you $1,000 for it—"without winking."

However, you can tell me about that when I see you. Remember I live 22d Street, the first house west from the 6th Avenue. The stages run up the 6th Ave, consequently they run within a few feet of my door. Tell the Girls that they must both come down with me.

Yours very truly
O. Bullus

If you would like me to deposite the money I owe you for the Picture, anywhere in this city say so.
[SB]

WSM to George Hart

Stony Brook, Dec. 2d, 1849
My Dear Sir,

I received last evening through the politeness of Mr. Egbert Smith, a very kind note from you containing an Autograph of your noble friend, George Combe Esqr *which I value*. The bottle of whisky I thank you for. It reached me just in time—my Sister, Mrs. Charles Seabury, gave birth to a fine boy about nine o'clock last evening, and the *nectar* warmed the hearts of us all, and we remembered the *Hart*—that presented it, of course. We drank your health.

The picture "Just in tune" I exhibited to you and Wm. Coit by twilight is to be engraved, and then exhibited in the Tuileries for 1850 in *Paris*.

My Nephew Thos. S. Seabury is pleased with your remembrance of him. Please give my best regards to Mr. Coit, when you see him.

I remain yours very truly,
Wm. S. Mount
[NYHS]

Oscar Bullus to WSM

U.S. Steamer Michigan
Erie, Decr. 24th, '49
My dear Mount,

Your faver of the 17th inst. I have duly recd. Thomas arrived here some two or three days ago—I think on Wed-

nesday. Most of the Boats on the Lakes having been laid up for the winter, he came from Buffalo, to this place in the stage. He is living at Brown's Hotel and is full inducted into the manners and customs of the natives. He has already been to several parties; and seems to have known the people all his life. He has his bedroom next to mine and he shares my sitting room. I have got him to work writing for me, and is ready upon Steam: My Chief Engineer and he are getting on together and it is his own fault, if he does not learn something.

I wrote to my wife to tell him not to get many clothes, until he came here—as it was, the suit he brought from New York made him look like a yankee pedlar. He was much dissatisfied with them himself and asking my advice and upon hearing that they were not paid for I advised him to send them back forthwith, which he had done by the Express. He has been measured *here* for clothing which will be more suitable and which he will like better.

Whatever service I can be of, I shall exercise on his behalf of course. As my Clerk, I can exert a certain degree of authority over him, in common with all under my command—this will no doubt serve well, as far as it goes, as long as my officers perform their public duties well. I have no right or disposition to interfere with their private pursuits, unless they are guilty of courses which would cast a reproach upon the service itself and then I can always avert it.

Therefore you see the many ways in which a young man easily enticed, and led away by vicious example, might go astray and altho it would be apparent to me, yet I could not interfere with him: unless as I have stated, he became a public reproach. The only thing I fear in Tom's Case is that he likes to frolic too much. There are many young Ladies here, some of them at the house. They like to dance and to hear him fiddle—this you see will be a draw back towards my efforts to bringing him into business or rather studious habits. But a small portion of his time is needed by me—the rest might be usefully employed in study. If he minds what I tell him, he will be glad of it one of these days that he has entered the service—if he does not, I think he will regret having done so. I merely throw out these hints, not only for you to ponder upon, but for his father's information. He can improve himself if he will—if he does not, I cant coerce him to do it.

I wish you would come up here some time or other—there is first rate sport with the Gun in many ways. Lots of parties, at which you would be mightily amused—at some of them they "*go it strong.*" Living here is very cheap, and I do not see why you could not come up and paint here awhile, as in Stony Brook—that is to say, if you will stay there, Give my best regards to your Sister and the girls and [believe me]

<div align="right">

Vy truly yours
O. Bullus

</div>

[SB]

diaries 1850-52

Jan. 18th, 1850

The beauty of Elliott's coloring depends on his glazing, during the last sitting—allowing the previous painting to appear more or less underneath. In the first sitting he gives the effect of the head in rather a silvery style of colouring. In the second sitting he corrects the drawing and effect if it requires it—in the same style of coloring as the first. The third and last sitting only requiring the strength of the palette by glazing with (brush or thumb)—clear blue, red, and yellow etc as the case may be. Sometimes he improves the high lights after the head is dry—as the last touches. Elliott told me that in commencing a portrait, he touched on the highest light (on the fore head) with pure white first—then the next highest light on the bridge or side of the nose, as the case might be—the next on the upper lip—and last on the chin. He then worked from the lights into the receding shadows, and darks, touching in different tints in a spirited manner, observing the reflections etc. He generally makes his *shadows clear*—a *great merit*. Elliott's cool portraits are best—in my estimation. He suffers white to mix more or less with his transparent colors in his first and second sittings. As I mentioned above, he finishes with transparent colors. Elliott is very particular about getting his magilp to the right consistency—using it as thin as it will stay put.

Some of his portraits look heavy and leaden—and others again too warm to resemble the sitter in color—want tinting in the half shadows.

Tuesday the 15th I was in New York. In painting, I frequently commence the shadows first—thinly—and next the lights—on a light or white ground, using few colors and clear as possible and ground fine—

A painter should be temperate in eating and drinking and only three times a day. Coffee is not healthy—neither is *poor Brandy*—one's health is better without both. I must not board any longer at Tammany Hall N.Y. in winter, it is too noisy. Dancing, political meetings etc.—boarding in a private family would be more quiet, or a less public Hotel. To live in New York one should live quiet —and keep regular hours—have a private painting room if possible. During a short stay in the City I must in future put up at the Irving or Astor house. I shall then meet with more lovers of art.

I think painters lose a great deal of time by not painting evenings—in winter. They could paint in any warm quiet room. The coloring could be corrected by day light. We observe beautiful effects by Lamp light and Gas light —a female shows off well by such light. It is said that the old masters studied and painted at night. Why not we moderns do the same? Portraits are painted in London by lamp light.

If I loved money, and should work every day steady, I believe I could make more than some of the gold diggers in California.

I must not write any more letters if possible— "To a man full of questions make no answer."

I must paint up my commissions without delay, that alone will occupy all my daytime. I must not lose sight of my real friends, those who give me orders.

Stony Brook Jan. 21st, 1850

Monday morning—snowing fast, wind east. I hope we shall have six weeks good sleighing to give life to old bachelors—the sound of merry heels [bells?] in winter is so cheering.

These hanging on friends are of no benefit to any one. Your real friends, those who give orders, give you no trouble. Idlers are a nuisance, and a nightmare upon one's thoughts during working hours.

Make but few acquaintances.

Make it your study to be happy. Be industrious—remember, that you must have no time to yourself until your orders are completed. I mean that you shall not lose sight of your orders. I would not have you a slave to anything.

Engham says that he makes it a rule to paint every day in the week and sometimes sundays.

We are too apt to be thinking about other people's business rather than our own.

THOUGHTS OF THE MOMENT

If we cultivate a love of art we cannot help being industrious. We must not be a slave to rules—yet we must not lose sight of them.

In painting a head, first touch the prominent shades and lights, then the prominent reds. A painter should have large combativeness—to make him contrast his colors continually.

Reynolds, sometimes used only white, yellow, lake, ultramarine and black, in painting the face—sometimes he varnished over the lake with vermilion—sometimes he painted without yellow—yellow added to the mastic varnish, alone, to finish. Sometimes black was added to the varnish in the finishing to lower the tone of the colors. He frequently painted with wax varnish. Note, I should think wax might be mixed with Copal varnish to advantage —or nut oil instead. Copal, and turpentine, with a very little wax will do to paint with—first desolve the wax in turpentine over the fire.

Hold fast to what is good.

A painter, to improve as a colorist, must experiment. He must be a cunning workman. Effects are sometimes produced by accident. Reynolds, and all the great colorists experimented—more or less.

"My son, gather instruction from thy youth up: so shalt thou find wisdom till thine old age."

"If thou seest a man of understanding get the[e] betimes unto him."

"Open not thine heart to every man."

"Forsake not an old friend."

"If thou wouldest get a friend, prove him first, and be not hasty to credit him."

"If a skilful man hear a wise word, he will commend it, and add unto it."

Jan. 28th, 1850

"An honest woman will reverence her husband."

"Watch over an impudent eye—and marvel not if she trespass against the[e]."

"A woman, if she maintain her husband, is full of anger, impudence, and much reproach."

"If she go not as thou wouldest have her, cut her off from thy flesh, and give her a bill of divorce, and let her go."

"He that getteth a wife beginneth a possession, a help like unto himself, and a pillar of rest."

"The grace of a wife delighteth her husband, and *her discretion* will fatten his bones."

"A loud crying woman and a scold shall be sought out to drive away the enemies." ——Ecclesiasticus.

Feb. 4th, 1850

THOUGHTS OF THE MOMENT

Fine day—

Time flies—I lost three days last week, in consequence of attending two parties.

One who looks well after his business has but little time for regrets. No one can pass through life without some regrets. Happiness in this life should be our aim.

It is good for health to dissipate once in a great while—

A rolling stone will obtain a polish. I have thought of travelling all over my native state, perhaps the whole Union, making sketches of scenery—of character—and taking portraits in oil—and with pencil—besides looking up good violin players, and painters. Something can be learnt from every one—besides keeping a journal—of passing events.

"Men who know the same things, are not long the best company for each other."

"Every hero becomes a bore at last."

"Napoleon said, 'You must not fight too often with one enemy, or you will teach him all your art of war.'" ——Emerson.

Stony Brook, Feb. 10th, 1850

A fine day—

"Talk much with any man of vigorous mind, and we

acquire very fast the habit of looking at things in the same light, and, on each occurrence, we anticipate his thought."
——Emerson.

Look at pictures and you will learn to see nature—observe nature closely and you will be a good judge of a true picture—

Paint thinly—first, with pure transparent color near the tone you wish to imitate, and then while wet paint up to the life, or thing itself. Observe the same manner at every painting and you will have richness of color. Have but few colors and ground fine—for transparency and depth very much depends upon it. (Use varnish and a little wax) with oil and turpentine. The wax must be desolved in turpentine over a slow fire—and then the Copal or mastic added.

When we know that Teniers, skimed the canvas so delightfully—it must have been by a system like the above that he became so famous as a colorist. Glaze the shadows, and if it requires it, paint them thinly over again. Shadows should be clear and silvery. In painting, labour should not be thought of. Sometimes an object can be hit of at once painting—providing the mind is clear and every thing works well.

It is by cultivating the fine arts that our path through life is made more pleasant—the reflection is certainly cheerful.

France has been illuminated by the works of her gifted painters, and sculptors. All nations are magnified more or less, as they encourage art. If I should ever visit Paris and should be called on to give a toast at an artists dinner, I would give the following:

France has been illuminated by the works of her gifted painters and sculptors—and the reflection has reached America, and I am here like a *miller* surrounded by a glory of light.

April 18th, '50

EXHIBITION, 1850

Coast scene by Huntington, very fine picture, size about 3 feet 9 in, by 5 feet 3 inches.

Landscape by A. B. Durand, 4 feet 1/2 by 3 feet.

The Drink of Milk by J. T. Peele—large figures size 4 feet by 3 feet 2 in.

Autumn Scenery by Kensett, very fine, size 4 feet 6 in by 3 feet.

Landscape composition from Bryant's Thanatopsis, size 5 feet by 3 feet 3 inches.

Paint fancy pictures if you desire to hang on the line. Durand says objects in shadow should be more or less flat to make distance. The remark will apply to figures as well as to landscape. A picture should have repose.

Mr. Peele varnishes his picture with megilp varnish and touches upon it while wet. Mr. Durand says when a distant mountain approaches a nearer and darker mountain

it becomes lighter at the junction. Mr. Peele has been making studies in oil, the general effect only from the old masters in Mr. Nye's Gallery. Peele was painting today the same place.

Vanderline says I must mass more in light and shadow.

When I visit the City again I must bring my paint box and paint something every day for practice. "Be always busy. The more a man accomplishes, the more he may."

"Concentrate your energies if you would make a figure in the world."

Never be trameled by societies. They serve as clogs to genius.

I have lost a month by being one of the hanging committee of the National Academy of Design. There is always small minds enough that wishes to figure at such times.

"We go for activity—in body, in mind, in purse, in everything."

I must write to Lanman about the merit of Vanderline. I must think about taking a room in N. York. I must finish Sturges's picture; d[itt]o George P. Morris—also background for Lenox's picture. Paint if possible every effect—paint every day.

Leslie says that "manner is a departure from nature."

Reynolds says that "peculiar marks are generally, if not always, defects." Then Reynolds' manner, by his own logic, must be defective.

"It may safely be assumed that no painter ever became great who did not begin with scrupulous finish." Large nature gives most satisfaction to liberal minds—for instance The Plague by Poussin—and The Bull.

Stony Brook, April 21, 1850

I must not drink any more ardent spirits for fashion sake, but only as a medicine. Learn to say no! Brandy should not be used in the council room. Smoking, Chewing, and drinking Brandy—also eating between meals—is not healthy. The stomach in such cases has no repose. The mind is kept clouded and thick.

In New York, where there is so much noise and excitement to excite the nervous system, no ardent should be taken—not even strong tea or coffee. I feel thankful that I never learnt to use tobacco in any form.

Stony Brook, April 25th, 1850

One picture for Manlius Sargent Esqr, Boston.

I have engaged to paint a picture for James Lenox, similar to the Power of Music—to be finished by next autumn. Also a picture for Mr. J. Sturges. Also, Woodman Spare that Tree, for G. P. Morris [see pl.85] and one from Bryant's Water Fowl. Also, Waiting for the tide.

Portrait for Mr. Ludlow, L.I. and N.Y.

I must paint every other day if possible.

85. Study for *Woodman Spare That Tree*. c. 1850. Oil on paper, 4 1/2 × 5 1/2″.
Whereabouts unknown. Photograph courtesy Floyd T. Wood, Stony Brook, Long Island

Stony Brook, May 20th, 1850

Apple trees in full bloom the 17th and 18th of May. Edward finished planting corn the 13th. This spring is considered backward—I noticed that the Walnut, and Oak buds, did not burst forth until the 10th inst. In 1847 they burst fourth the 2nd of May. 20th of May white frost.

June 5, '50

I feel that I must dare to paint, let myself out more than I have lately. New York painters talk so much about a head painter, that I must try and see what I can do in that line of art.

Of a *head,* make a correct drawing first, with thin paint, after which touch in the effect of the flesh in transparent colors—when dry paint the head fairly out in a masterly manner with all the boldness that you would paint a piece of drapery.

To succeed in this world, and the world to come, we must dare. A faint heart will not answer. Never hang back through the fear of the merit of others, but dash away in your own way.

I now paint from four to six hours a day—in painting a portrait. Why not do the same every day in painting pictures—

SUBJECTS

Floging in the Navy.
Playing the beatle.

After glazing or toning the background, let the same tint run into the shadows of the portrait, and if too heavy, take it allmost off with a rag. A painter must be a cunning workman—Elliott observes the above while finishing. Fingers are often as good as brushes.

I receive a hundred dollars for painting a head.

July 1st, 1850

Warm weather—

My friend Wm. Schaus—returned to N. York to day. He paid me a visit last fall.

I must paint such pictures as speak at once to the spectator, scenes that are most popular—that will be understood on the instant.

To *paint flesh*—dead color with Black and white, and Vandyke and white—mostly shadows, with Vandyke brown and white—and while wet, touch in the color of the cheeks, lips, eyes, and hair. When dry glaze over the flesh with Lake, and Yellow Ochre, at the same time repeat as above. Mount's Umber can be used in place of Vandyke brown. Repeating the colors gives richness. The above manner will do for painting very delicate females—very little blue is used.

The student, must "accommodate his knowledge to the purposes of life"—every day knowledge.

The secret of great acquisitions—"is to attempt but little at a time," repeated—over and over again.

Genius should never slacken too long, or he will be beaten in some things by a persevering plodder.

[July, 1850]

To produce an effect like Rembrandt, let a ray of light strike your model from a side light, or light from overhead low down. In that case have one light on your model and the other on your easel. Rembrandt minded his own business and let others talk while he painted.

In painting it will not do to niggle, but paint if you know how to draw, in a liberal manner. Kensett is too small in his foliage and wants variety in tinting. Church has detail—sometimes too much—but too opake in color. There is a sameness in Durand's works, he seems to lack invention. He sticks too close to himself, he should throw himself upon the bosom of nature and paint her more rude and wild, extravagant and startling—not tame and sleepy but wide awake.

Some of Elliott's portraits are hard and flesh bound—often too much glazing. Baker has some good portraits, more loose and flexible—so has Hicks.

I must read about painters—and paint more.

Cut a hole in the wall to paint candle light pieces.

I must learn only those things which will be of use to my business. Scott says qualify yourself to receive fortune when she comes your way.

Stony Brook, July 4th, 1850

Last evening in stepping from a light waggon, I carelessly placed my left foot on the forward wheel—the horse started, which threw me with great violence upon the hind wheel, hurting my right side. My ribs are very sore this morning, every breath I draw effects my right side. However, rubbing, and time, will make me feel fine—

I am now having a sky light made to place in the roof of the old house to convert the east garret into a studio. Any common garret can be made into a good artist room with a little expense.

I have lost, I think nearly half of my time for the want of a suitable painting room.

[Sketch of studio plan; pl. 86]

Elevation of the front or south side, 8 feet; height of the north side for painting in the summer, 12 feet. Consequently the building will look after this manner [sketch].

A building rough plastered can be put up cheap—and

the painting room being on the ground floor, a horse can be lead in to be painted—or a cow, Elephant etc.

Gen. Zachery Taylor—President of the U.S.A.—died on the 9th of July at half past ten in the evening. His last words were, "I have endeavoured to do my duty"—

I had rather my friends would say that I did not paint enough—than to hear them remark that I painted too much.

A hole cut through the roof in the Garret, July 8th 1850—

August 11th, 1850

I have not painted in five weeks—been fixing up a garret for a paint room and making ready for work. [Sketch of paint room]

Lydia Seabury is on a visit.

Stony Brook, Sept. 26th, 1850

If we are industrious our leisure will be the happier.

Practice without reasoning will make but little headway to excellence. Reflection should be at the end of your brush in painting every thing. Contrasts of colour should be noted down in your rambles, and good conceptions carried out while your mind is fresh and if you are painting a landscape composition or a view from nature never think of an artist or a picture. It is thinking that makes a painter.

In painting water, if there is clouds flying, the water must receive the light of the clouds and the blue of the sky, and then the ground colour of the water and the foam etc. Remember water being transparent reflects all colors. In landscape—the light of the sun must be observed first upon objects, and then the sky tints touching here and there giving a sparkling effect to foliage, grass, rocks, water and every thing. Lastly reflection of the sky and other objects more faintly playing in the shadows, giving more fulness and a lifting quality to every thing. Landscape is a beautiful and a difficult art and few have excelled in it. The changes of color are so rapid that the painter must have his mind strongly imbued with it and work while his mind is fresh with nature—and as I observed before, no thought of how another painter would manage the same subject. And do not forget the silvery tones—even in the deepest shadows, darkness must be made visible by the play of the air tints. In other words surrender yourself up to the accademy of nature.

An artist should travel often in the country to enjoy landscape—a good landscape in a picture Gallery is agreeable to the eye and calls up many agreeable associations.

Figures are more lasting on the mind and attractive than Landscape on account of expression and sympathy. They often combine beautifully together.

I made a trip up the North river on the east side, in the

& I have lost, I think nearly half of my time for the want of a suitable painting room — +

No 1. entrance
No 2. reading

Studio —
[diagram with rooms 2, 4, 1, 3, 5]

No 3. for wood
No 4 painting
No 5 Sky light

in the roof.. Elevation of the front or south side. 8 feet — hight of the North side for painting in the summer 12 feet — consequently the building will look after this Manner

[sketches labeled "south side" and "north side"]

— A building rough plastered can be put up cheap — and the painting room being on the ground floor a horse can be lead in to be painted — or a cow — Elephant &c

Gen: Zachery Taylor President of the U.S.A. died on the ninth of July at half past ten in the evening. His last words were, "I have endeavoured to do my duty —"

I had rather my friends would say that I did not paint enough — than to hear them remark that I painted too much — W.S.M.

A hole cut through the roof in the Garret — July 8th 1850 —

86. Drawings and plans for studio.
Diary, July 4, 1850.
The Museums at Stony Brook,
Stony Brook, Long Island

cars as far as Fishkill, opposite Newburgh on Saturday the 21st of Sept 1850. The ride was new and delightful to me, on account of the noble scenery on the Hudson. Sunday I rambled with Tice—called on Durand—he received us kindly, he was unwell with a fever. He had been sketching in the Kattskill Mountains and got sick—he told us that he should return as soon as he was able. Durand is too close a student for health. Artists should remember that rocks and mountains are stationary—not kill themselves painting them. Tice made me a present of a sketch in oil of mountain scenery—water tumbling over rocks. The rides about Newburgh are delightful. N. York is the place for a painter—when he gets tired of bricks and mortar, he can redily take a trip into the country to refresh and strengthen his eyes with beautiful nature.

I do not approve of our best pictures being owned by misers—so that artists must take a note and his hat under his arm before he can have a sight of some favorite picture. The best works should be obtained and placed in

some public Gallery—for the benefit of amateurs and artists.

Never look if possible at a bad picture, or a bad character.

After intently looking at a landscape, or a water scene, or a group of figures, I should go right to work and paint my impressions, and not look at any paintings at the time, but think of the great master nature.

Stony Brook, Oct. 29th, 1850

Opaque colors are better in water-colors, in some particulars—and transparent colors are well adapted in oil.

Grounds—I can recommend a light grey ground. The best sketch I ever made was painted on a grey ground—more daylight—on account of the grey showing through. The sketch was made when the foliage was off. The most perfect landscape ground, I think, would be to make the center, or one third of the canvas or pannel *grey* and the top and bottom *red*—the grey and red melting into each other with a perfect gradation. The ground should be prepared with reference to the subject to be painted.

Have few colors on your palette either in water-colors or in oil—"We believe five or six would have been thought sufficient for the Caracci, and Domenichino, and Gasper Poussin." "Poussin's style is the poetry of the pastoral."

The most perfect grounds are white, redish, or yellowish. The two last for landscape grounds—grey, red and green tints are to be seen in the light sward or sunny parts of Durand's pictures.

[1850]

Backgrounds of portraits should be shadows.

How beautiful a light haired girl looks—relieved by a shadow. Shadows thrown across a dry road—the grass if any will be dark green, the ground of sand will be cool or bluish. When the sun crosses the road or street every thing in his track is lit up—the ground redish, or yellowish, or umberish, or warm grey—the grass of a light green.

In painting a landscape—the shadows should be considered first; the more shadow, more impressive your picture—more shadow more light, more light less color. Shadow will make a small object look light, the eye is rested by shadow. In painting a view, draw on the canvas or panel then take notes of the effect and paint in your room. You may paint the sky first in your room and when dry paint the view from nature—or paint the landscape first, and lastly the sky when you have leisure—a good plan—I have tried it.

Make studies of old trees, rocks, water, clouds. Water-color painting is said to be more convenient and effective in painting from nature, particularly small sketches. In

autumn—the principal colors in Landscape are green, red, grey, brown, purple, yellow, and blue.

The best pictures to be seen in the Art-Union, New York Gallery and the old Master collection are the dark pictures. Tone pleasing—subdued.

Dorson's, L.I., Nov. 2nd, 1850

In painting meadow—patches of sand must be seen—logs, water, etc. Variety in form, light and dark, and color makes a picture.

Stony Brook, Nov. 7th, '50
[Sketch]

Sun Set— The effect of colors were Green, or warm grey—Orange and purple. First, Sky—warm grey, it appeared green by contrast to the orange clouds, and purple shades. The rays from the sun were purple. Trees brown. Simple, in color. Grand—sublime.

Stony Brook, Nov. 8th, 1850

My paint room at this time is in a garret on my own property. The first and second stories is occupied by my Brother and his family. They invited me to place a sky light in the garret and now they say they have not room enough—and now my ingenious Sister-in-law, Mrs. S. A. Mount, says, she intends to place a bed for her children at the foot of the stairs leading to my Studio. Undoubtedly to cramp my goings in and goings out. Sublime—truly. Mothers with three or four children are very ravenous, greedy as wolves—old bachelors must stand around.

A man and wife generally understand each other—Two to one. An ungenerous act always hurts my feelings. But the best way is to laugh—and forgive. I think I had better hold on to my room—until I can obtain a better some where else.

Stony Brook, Nov. 13th, 1850

Brother Shepard is now painting a small landscape scene towards evening. He says he made out his forms lightly (thinly in color) in the first painting—many of the lights in different parts of the work is done with the point of the brush handle with very good effect. When you can see the sun—you need not look for shadows from trees etc.

Dec. 15th, 1850

Colors should be obtained pure—if the color man is honest he will give them to you in a pure state. In paint-

ing flesh if you please you can mix madder lake with vermilion and vermilion with Indian red, Yellows with each other, and blues also. Small fitch brushes are better for some purposes than sable brushes—a small round brush to sharpen up, light or shadow—in the finishing touches. A large round brush for rapid painting—to skim the canvass.

Stony Brook, Dec. 21st, 1850

I saw a beautiful sun rise this morning in coming from Setauket—first, a rich warm grey (almost yellow) and a large cloud lit up with an orange red, the shadows of the cloud a rich purple—dark fore ground—how simple.

In painting a Negro the principle colors are *Vandyke brown, Terre Verte, Indian red, vermilion,* Madder lake, *Yellow Ochre* and a trifle Burnt Sienna.

The dark spots or Shadow of the figure should just show on a dark ground. The ground should be broken and full of air tints. Repeating of color gives richness. In the shadows of flesh of white persons, vermilion and black—Indian red and black—the same with Vandyke Brown. Dont be *afraid* of *labor* if your work looks *easy* and *natural*.

It is evening, and the last day of 1850. My Niece, Julia A. Seabury, and my Brother Shepard A. Mount left about noon for New York to spend New Year. My Brother, Robert Nelson Mount, my Nephew Charles E. Seabury, and Shepard S. Jones have gone to Huntington L.I. to attend a Ball to be held at Scuders. It is now snowing fast.

"Every man must patiently abide his time—about what the world says of us. The talent of success is nothing more than doing what you can do well, and doing well whatever you do without a thought of fame"—

It is easier to ride than to walk and easier to talk than to work.

More light can be obtained from a sky light than from a side light—and more agreeable. A paint room should be grayish, and green broken in places for relief to the eye.
The size of the light depends upon the size of the room.
More light, less color—consequently the light must be regulated, made large or small at will.

Stony Brook, Feb. 8th, 1851

The Lucky Throw—I painted with great care. My model was a bad sitter, which caused me some anxiety and made me repeat my color—perhaps to the benifit of the picture.

I must endeavor to paint every day but first of all to have a right conception of things. Some men paint all their lives without doing any thing. Always if possible make labour tell—

There is pleasure when you have done something. The world respects you.

Feb. 12th, 1851

Every time I visit New York I should take a picture with me, if it should be ever so small—some lovers of art will buy an 8 by 10 inch picture when they would not purchase 29 × 36. Woodman spare that tree I must paint next if possible. "Perseverence will overcome difficulties." I believe I should paint more if I did not live in Stony Brook. I should be more among strangers—spend three months in a place—new scenery and strange characters would compel me to paint.

I must paint one picture from Bryant's Poetry.

April 1851

SUBJECTS

A Batchelor mending his coat, or pants. It should be painted in his room, to make it effective.
Lady and her beau sucking at a brandy smash through a glass tube.
A man standing or leaning against a horse—a Long Island horse.
A man watching for ducks over a bank.

ORDERS

Mr. Wm. Schaus desires me to paint him an old man reading about the battle of Bunker Hill (or some one reading it for him, paper and costumes of the times).
He also requests me to paint him a Negro courtship. Rather genteel.

Stony Brook, April 1st, 1851

In finishing a painting be careful and give force to the foreground—darks and lights. Strengthening the foreground tones down the distance. Therefore the painter should think well before he glazes. In painting Who'll Turn Grindstone I used Megilp thined a little with Camphene. I must take notice how it stands time—if it will crack. (If the artist desires money he must paint portraits —pictures cost too much.)

Memorandum to Himself

Stony Brook, April 18th, 1851

I will relate the following, which took place a short time since in the City of New York. A poor man, but respectable, somewhat advanced in years, thought proper to call about twilight on an old acquaintance who bore quite a personal resemblance to himself but who had by

good luck and attention to his business made his apartments to glitter with splendid mirrors. The servant opened the parlour door—the plain man entered—he saw as he supposed his friend approach him—he bowed and said "good evening." His friend also bowed ~~at the same time~~. He spoke again, his friend was silent. He confusedly took a seat, and thought to himself, if my old friend has not a mind to speak to me, he need'nt. I am as good as he. After a few moments of sullen soliloquy he looked around and ~~he~~ discovered that he had been mortifyed at his own image. The ten acre looking glass was before him.

[NYHS]

Stony Brook, April 19th, '51

In landscape—Terre Verte will lower the tone of bright yellows and greens. Most of our painters are turning their attention to landscape painting. When some painters find they cannot succeed in figure painting they turn into landscape painters as being easiest to immortality. It takes old time to weigh the qualities of men.

FEW COLORS

Nov. 1848—I painted a small cabinet portrait with vermilion, Naples yellow, and Terre Verte. White was added with the above colors—Vandyke brown for the hair.

For the greys in flesh—if you please, use willow charcoal with white. For the shadows of flesh—Terre Verte, Mount's umber, Vandyke brown, or Cologne earth, and asphaltum—desolve the gum asphaltum in turpentine. My late brother, H. S. Mount, used to make his transparent shadows with hard coal, ground fine. Before the painting is fairly dry, dry color might be laid on spairingly.

This year S. A. Mount thought proper to exhibit two landscapes. The President, A. B. Durand, remarked to me that they were infamous attempts. He was sorry that my brother should attempt to paint landscapes when he could paint portraits so well. (Rather big language for the A. B. President.)

Some of Elliott's first sittings have the effect of true color—more warmth of color than his finished portraits, more pleasing to my eye. I have one of his first sittings—a portrait of Henry J. Brent, Esq. Elliott kindly presented me. I prize it very highly.

In some of Elliott's late heads the cool tints are too prominent—the cool tints of the flesh look like wet linnen—not enough of warmth. In the Portrait of Mrs. Shumway, the neck and bust exhibit no warmth of flesh. Flesh should show a warmth—even through fine lacework.

Deep Cadmium yellow, Boutelle tells me, is fine in landscape, and he believes would be better in flesh than Naples, more safe with other colors. It is a new color.

It is said to be durable. We know that yellow ochre is lasting—Venetian red, Yellow Ochre and Charcoal would make a lasting flesh palette. Perhaps Vermilion, Cadmium and Terre Verte. Naples yellow is too sickly-feeble.

Deep colors should be used to produce strong colouring. Deep toned Yellows, Reds, Blues, browns, and blacks. I have used Naples too long. It will do in its place. I must use Ochre or Cadmium, or Raw Sienna in place of Naples yellow. Use no weak color, and you cannot help being strong. Look around our exhibitions and you will see a lack of pure color. Our palettes are crowded with too many gay pigments. Obtain the deepest, or low toned, reds, Yellows and blues. Make the most powerful combinations. Keep so—admit no feeble pigments on your palette. Miner K. Kellogg says that Chrome yellow burnt makes a deep toned color and is durable.

Shadows should be in keeping with the complexion at light parts of the flesh. Shadows clear.

"So true it is, that it is not the time that is wanting to men, but resolution to turn it to the best advantage." Not to idle, but to work—not to paint pictures when you should be painting portraits—or vice versa. Endeavor to labor to a good account.

Dry colors burnt— Venetian red burnt changes but a little to the color of Indian red, improved in tint. Antwerp blue burnt makes a dull red. Naples yellow, d[itt]o—changes to red. Terra Rosa, do—no change. Yellow ochre, do—makes light red. Chrome Yellow burnt, do—orange red. Lemon yellow, do—changes to a rich orange. Terra di Sienna burnt is of an orange russet color. Terre Verte burnt becomes olive. So does Blue ochre—also Verdigris. It dries well in oil and is more durable than the original verdigris. Scheele's green turns to olive. Peachstones burnt make blue black. Prussian blue burnt makes blue black. Vandyke brown, do—changes to black. Most of the copper greens afford olive colors, by burning, and more durable.

I painted a portrait once with Terre Verte, vermilion, Naples Yellow and white, in the flesh—for the hair I used Vandyke brown.

Hold fast to that which is good. Let others experiment if they will.

Stony Brook and New York, May 14th and 15th, 1851

In the afternoon of the 14th Mr. Osgood showed me (in his studio at the University) a fancy portrait of a Lady. It was good in color and well relieved on a dark ground. He said he only used three colors in the flesh—one color at a sitting. First day—blue; second day—red; third day —yellow. The painting reminded of Allston's color. Osgood turned around from the wall a very pleasing head of a young lady nearly in profile looking at a prism, sweet in color. He said he touched in or painted first thinly with blue and white, then red and white, and lastly yellow and

white. The hair he painted with black and white, when dry glazed with burnt umber. The cheaks and lips, he finished with a glaze of red. He also exhibited to me a portrait of a little girl very tender in color—done in the manner described above.

Red and yellow should often be mixed together in painting flesh. Naples and Vermilion, or Lemon Yellow and Vermilion, or orange vermilion—alone with white. I think after one has found out a good method of coloring —he ought to stick to it. Reynolds did, after he found out the most durable colors. So did Titian, Murillo, Paul Veronese and Rubens, etc. Be sure your right—then practice will polish the canvas with truth and beauty.

I commenced a portrait of Mrs. Nicoll May 17th 1851, at my studio at Stony Brook. Color and likeness successful. The first sitting I made a drawing with white chalk and India ink. I then touched the high lights first with pure white, then with red, yellow and blue thinly—the effect of the face, using a little Vandyke brown more or less. The day before the second sitting I glazed the flesh with Lake, blue, etc—color and likeness good—which greatly assisted in painting the second sitting. Painting or scumbling or rubbing in every sitting in such a manner that the underground or color shows throughis rimpotant to give depth and transparency.

A face might be painted at once with a thick body of pure color, as Rubens is said to have done—passing the colors rapidly over each other.

Orange vermilion (is a bisulphret of quicksilver—new color) resembles red lead in appearance—durable, excellent in scumbling of flesh. Chrome orange, one of the most durable chromates of lead—it is brighter, but not so durable as orange vermilion.

Asphaltum is first dissolved in turpentine and used (to prevent it from cracking) with Vandyke brown, umber or cappagh brown. Vandyke and raw sienna combine well together.

Sometimes place your portrait in the dark corner of your room if you wish to see the effect of light and shadow, the likeness, etc. Shepard told me it was his practice.

Stony Brook, July 6th, 1851

To copyists—when painting a portrait from the life, just fancy that you are copying a fine portrait by Titian.
George Baker—says that he commences his portraits quite gray—which gives value to his warm colors. He uses no Naples in the flesh, but yellow ochre and raw sienna. He prefers to paint up at once, if possible—the first sitting governs the rest.
Kyle says, consider the head as an egg in light and shadow, and paint boldly up to life.
Portraits in Crayon and lead pencil are becoming fashionable.

The sun shining through blue paper—the light will be cool and clear like the north light.

I consider the highest point a painter can attain is to be natural.

What signifies blue, red, and yellow if there is no mind with it.

Stony Brook, Jan. 20th, '52

Let those parts of a character which are prominent, the stamp of the foot, the head, the elevation of the hand— all the striking and expressive parts of a figure or figures —should be contrasted light on dark. Reynolds and Rembrandt understood such effects.

To make white-wash permenent—to half bushel of stone lime slackened in boiling water, add one peck of salt, one pound of glue, half a pound of Spanish whiting, and three pounds of ground rice—boiled to a thin paste, well stirred while boiling. Glue to be dissolved in hot water, all mixed together and put on boiling hot, in a clear day. For out or inside work. The above composition looks dark when first laid on.

Gradations in landscape—Green, brown, purple, blue, sometimes the distance a pearly blue or purple tinge.

Friend Thompson—if the noon of your life should be as happy as your morning, your evening would resemble one of Cole's Sun sets. That it may prove so, is the wish of your friend. Wm. S. Mount

Feb. 11th, 1852

I had better take board with strangers—or with some one of my very good neighbors. They do not look for perfection—and I shall have less sympathy, and more activity of mind for my art.

Stony Brook, Feb. 27th, 1852

I must paint small pictures 7 × 9, 10 × 12, etc, as well as to paint 25 × 30 and 29 by 36. I might even try my hand at a large picture—figures the size of life.
I expect I shall always be compelled to paint portraits, but I hope to paint no more portraits after death's doings. A dead subject never looks so well as a living one.

A single character will sell—will hit off. Such choice bits can be struck off in any village. To work with spirit, one should reside with strangers.

At J. T. Vanderhoof's, New York, 16 May, 1852

Some artists commence their portraits with warm colors first—lastly with cool color. In landscape the

87. Sketch for *The Breakdown*.
1835(?). Pencil,
about 3 1/2 × 4 3/4".
The Museums at Stony Brook,
Stony Brook, Long Island

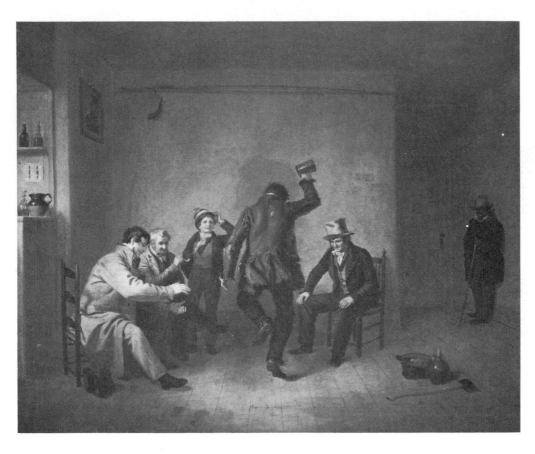

88. *The Breakdown*
(*Bar-room Scene,
Walking the Crack*). 1835.
Oil on canvas, 22 1/4 × 27 3/8".
The Art Institute of Chicago.
William Owen and Erna
Sawyer Goodman Collection

colours should be repeated, the same as in painting portrait. It is by repeating colors which produces richness. For flesh, white, ochre, vermilion, and Vandyke brown. Lastly Lake and Ivory black.

Desolve white wax in turpentine, then use it alone in colors while painting. If you must use Megilp let it be the last thing to glaze with in finishing. First place *Nut oil, Linseed* or a little *Mastic* with nut oil.

Pentaquit, L.I., August 1852

I made a drawing of an old Lady Mrs. Hannah Smith aged 73 with India ink. After I dismissed my sitter, I glazed the cap with cobalt, and the background and dress,

with black and burnt sienna mixed, and used thinly with Megilp drying oil. My object—to kill or subdue the white ground so that I could see the head (the effect) better while dead coloring. In the last sitting I scumbled with pure white and touched parts I wished to leave transparent. The portrait successful, in color and likeness. At the same time I painted a portrait of Francis Amelia Moubray, aged 10 years. I hope to paint no more portraits after death, or from Daguerreotypes. I dont believe in Vaults.

Nov. 14th, 1852

My friends in New York again urges me strongly to take up picture painting and not to paint anything else—

248

89. Farmyard with pigs.
Date unknown.
Pencil, 8 × 12 1/2″.
The Museums at Stony Brook,
Stony Brook, Long Island

90. Sketch for
Cider Making. 1841(?).
Pencil, 6 3/4 × 13 1/2″.
The Museums at Stony Brook,
Stony Brook, Long Island

or I must be excommunicated. I'll think of it.

Bar-room scene [pls. 87, 88] 22 × 27 in—painted in Setauket in 1835 at the house of Gen. Satterlee by the aid of two south windows and separated (in winter) by a curtain to divide the two lights. The artist by one window and the model by the other. Sportsmans Last Visit done at the same time—and by the same light. Courtship, or Winding Up, painted in the same way—at Stony Brook, at the residence of Capt. Henry Smith. The Raffle—and Tough Story—were painted by using two windows. Boys Trapping, Disappointed Bachelor—also.

Schoolboys Quarreling, year 1830—the shed was partly painted out of doors, figures in doors. Boy Resting on a Fence—painted in the open air, Stony Brook, year 1831. A Man in Easy Circumstances, year 1832—painted at Stony Brook—indoors. Farmer Husking Corn—painted (in 1883) in the open air—the Canopy of Heaven for my paint room. Studious Boy in the same way. Farmers bargaining painted out of doors. Undutiful Boys—also. Boy Hoeing Corn—in the open air [c.pl. 32]. Cider Making—painted on the spot [pls. 89, 90; c.pl. 33], also, The Farmers Nooning. The background of The Power of Music, 1847, painted on the spot in the open air—the figures I painted

indoors. Artist Showing His Own Work—painted in 1838 —indoors and by two windows [c.pl. 34]. I could reach to the top of the light with my hand. Most all of my portraits and pictures have been painted with a low light. It is thought—not a high or a low light which makes a picture.

Caught Napping, 1848 [pl. 91]. Landscape partly from nature, the figures painted in my Studio. Loss and Gain —the same. Farmer Whetting His Scythe—painted on the spot.

Today an early friend called to see me—Rudyard Williamson, a decorative painter. He says—To paint on pasteboard, first prime with pulverised pumise stone and Boiled oil—when dry a coat of white lead.

To paint on panel—first, varnish the wood with shellack, two or three coats, then a coat of white lead. Rub down your canvas, or panel, with sandpaper, or with a piece of pumise stone with water.

Innis first paints his landscapes in water—and lastly with oil colors.

Paste with a little Glue—to fasten sketches painted on paper on pasteboard.

91. *Boys Caught Napping in a Field* (*Caught Napping*). 1848. Oil on canvas, 29 × 36 1/8″. The Brooklyn Museum. Dick S. Ramsay Fund

Stony Brook, Dec. 12, '52

My Nephew Thos. S. Seabury has he says made up his mind to become an artist. I have a drawing done by him in 1844 and 48. I hope he will stick to his resolution—he has made several attempts but did not persevere. I have urged upon him the necessity to *draw, draw, draw*—and paint first, in light and dark, with White, Yellow ochre, and black, from casts of feet, hands, and heads, and the whole length figure—and then from the life, portraits, etc. And also, at the same time for a change of practice, to draw with paint from Julien's engraved drawings of noses, mouths, eyes and ears.

He has commenced to day, Jan. 20th, 1853, to draw out-lines of noses and eyes—how long he will stick remains to be seen. My Nephew Malcomb has also made some drawins.

Mr. Williamson says to make a transcript, exact, and with dispatch—draw your design on thin paper, with soft pencil, then give the paper a coat of turpentine and the drawing will show distinctly threw the paper. When dry, trace the lines seen with soft black crayon, then place the drawing on the canvass, or wall, and trace the lines over again with a sharpe or round pointed stick. In that simple way the drawing can be copied as often as you please for portraits, pictures, etc.

To make shellack varnish, dissolve the gum in alcohol.

Nathaniel Jocelyn, Artist, says he uses the following mixture of oils and varnishes while painting.

Drying Oil	3	parts
Oil Turpentine	2	
Copanba	1	} 3 parts
Copal	3	

An artist is not a painter every day because the spirit is wanting. It is a common observation among painters —have you been successful today. However, very much depends upon the mind being concentrated on the picture. A painter should be free from annoyance—from small minds and mosquitoes.

theodorus bailey

Theodorus Bailey (1805–1877) was one of the most illustrious of nineteenth-century American Navy officers. He spent his entire career in the Navy, played a prominent role in both the Mexican War and the Civil War, and was retired as a rear admiral in 1866. The "orders for sea" to which he refers in his first letter to Mount took him on a three-year voyage to the South Sea islands. It was common practice in those days for the commanders of such voyages to have their portraits painted before they left, because there was a considerable chance that they would never come back.

A.F.

New York, Sept 24th, 1852

Dear Mount,

My Brother wishes me to have my portrait taken [pl. 92] provided it can be done for $75— I know I have an ugly phiz to paint, and the limit is low for an artist of your merit. But if you think you can afford to paint my likeness for that price I would prefer you to any living American Artist. My Brother wishes me taken in uniform, and you will of course stay at my house if that arangement is agreeable to you.

I am expecting orders for Sea soon—and would be obliged to you for an early answer. With kind regards

I remain
Yours truly
T. Bailey
[SB] 864 Broadway

Stony Brook, Sept 30th, 1852

My dear Sir,

Your kind note is at hand, inviting me to paint your portrait. I am sorry to say that just at this time I am not able to visit the City. I am just getting up from a bilious attack, and in a few days I expect to be stronger. If it would suit your convenience to board about a week at Mrs. Smith's Hotel, in Stony Brook, I will commence your portrait forthwith. For $75—or, if you can delay three weeks, I will paint you at your own residence (at the same figure) as I had rather take your likeness than any other living American Gentleman.

Yours truly,
Wm. S. Mount

P.S. Oct 1st—I am not quite as well this morning, but I hope to be able to work in a few days.
[NYHS]

New York, Oct. 5th, 1852

Dear Mount,

If you think you will be well enough next week to commence on my picture, I will come up if nothing occurs to

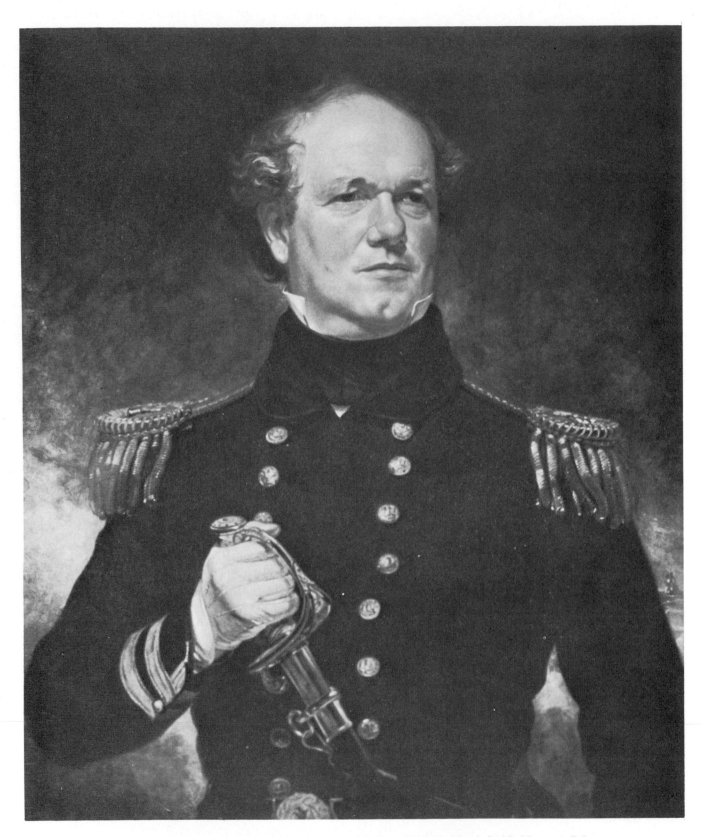

92. *Admiral Theodorus Bailey.* 1852. Oil on canvas, 29 × 25″. Collection Mrs. Elizabeth Morris Smith, Newport, R.I.

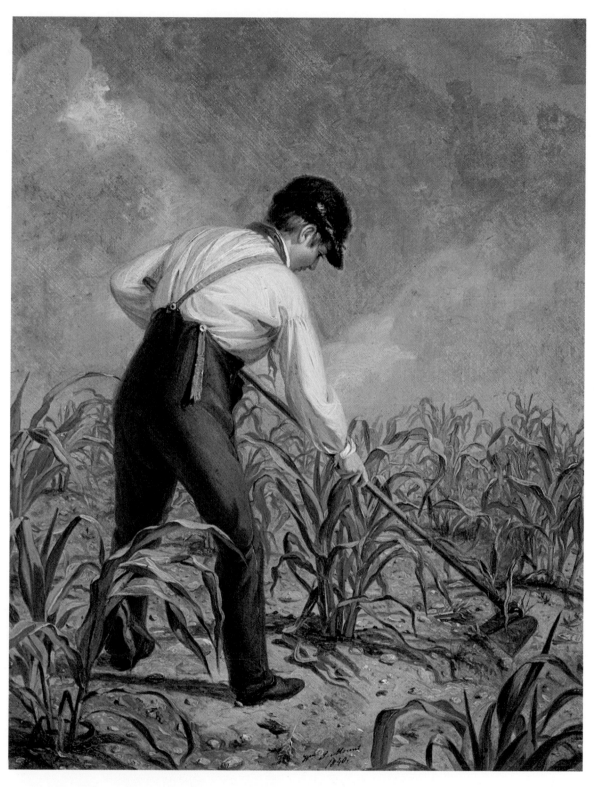

32. *Boy Hoeing Corn.* 1840. Oil on panel, 15 × 11 5/8″. The Museums at Stony Brook,
Stony Brook, Long Island

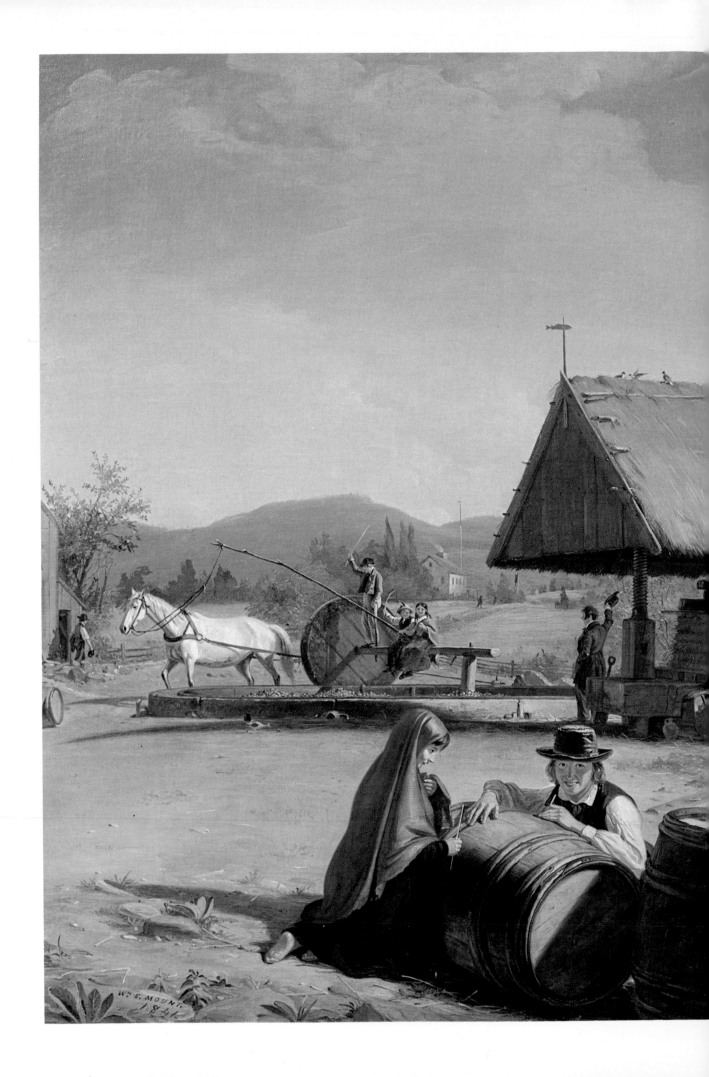

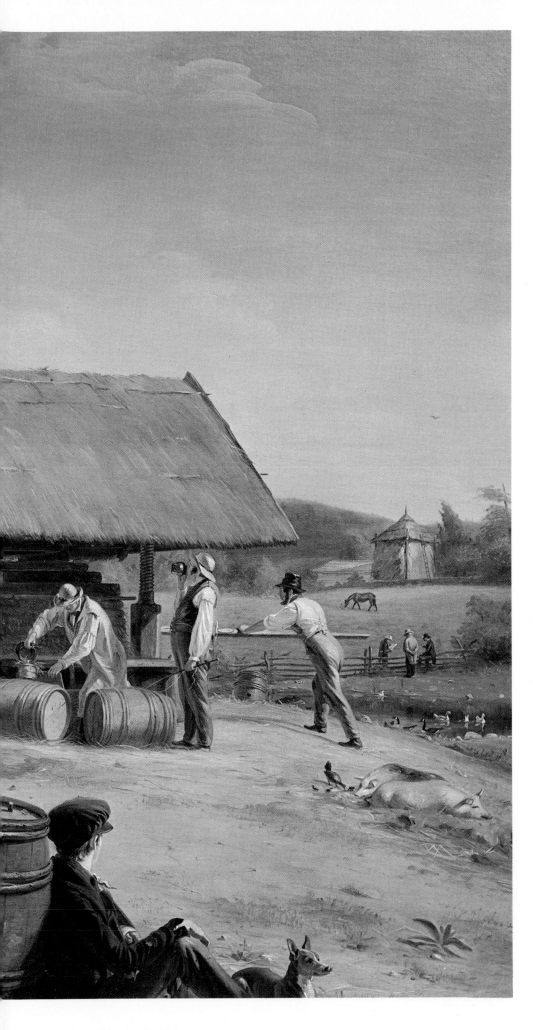

33. *Cider Making.* 1841. Oil on canvas,
27 × 34 1/8″. The Metropolitan Museum
of Art. Charles Allen Munn Bequest

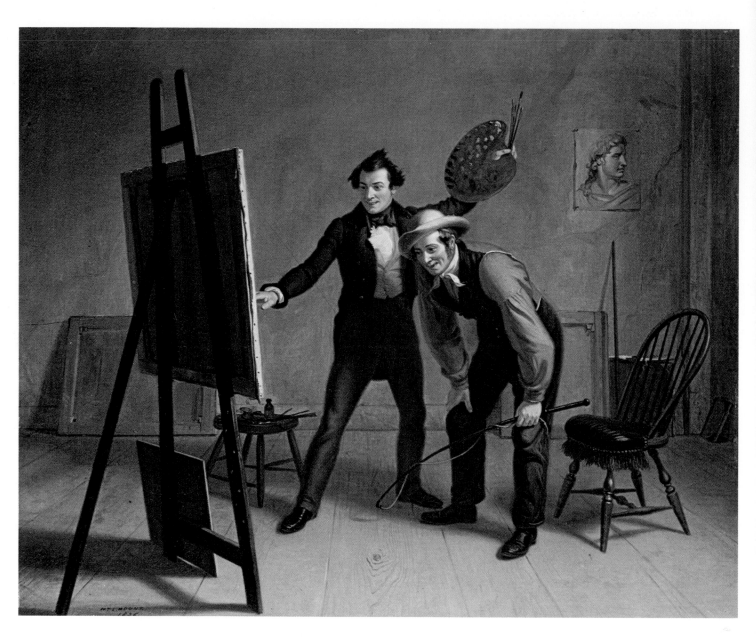

34. *The Painter's Triumph (Artist Showing His Own Work)*. 1838. Oil on panel, 19 1/2 × 23 1/2″.
Pennsylvania Academy of the Fine Arts, Philadelphia

prevent. Please speak to the Landlady of your hotel to give me a good room when I come up.

<div style="text-align: right">Yours very truly
T. Bailey</div>

P.S. Have you a Steamboat running to your place and what wharf does she start from?

[SB]

Diary Entry

At Stony Brook, Oct. 1852

I painted Commander Bailey, U.S.N.—Canvas 25 × 30, Price $75.00. The first sitting I painted thinly and carefully, and at the same time painted the background around the head and touched the effect of the hair—a silvery grey. I tried the same manner with success in painting the hand and sword. I had two sittings a day.

I imitated some of the flesh in the above portrait by driving the color with the end of the brush—the same as the brush is sometimes used in painting foliage and grass in landscape.

In painting, "the end justifies the means." It does not matter how the color is laid on as long as the effect of nature is produced—if the painter uses his great toe in the operation.

<div style="text-align: right">New York, Oct. 27th, 1852</div>

Dear Mount,

The frame for the portrait is to be sent home on Saturday, altered according to your directions. My family are very anxious to see the painting. Will it be convenient for you to bring it down next week? Say on Tuesday. Come directly to my house. Mrs. Haight wishes to see you when you come down, on the subject of taking her mother's portrait. I will call there with you.

<div style="text-align: right">With regards
Yours truly
T. Bailey</div>

[SB]

<div style="text-align: right">Stony Brook, Nov. 1st, 1852</div>

T. Bailey, Esq.

I am pleased to hear that the frame is ready and also that your family are desirous to have a look at the *Commander*. The portrait shall be taken directly to your house. I shall be happy to see Mrs. Haight, and will call with you at her residence with pleasure.

<div style="text-align: right">Yours truly
Wm. S. Mount</div>

P.S. I will try to reach New York this week. The landscape is so interesting—I am anxious to make a few more studies.

[NYHS]

<div style="text-align: right">New York, Dec. 28th, 1852</div>

Dear Mount,

The painting of the witch of Endor raising Samuel which I purchased of you some years since has to me a peculiar value as one of the early fruits of your genius. But I would like to have from you an account of your first efforts at drawing, colouring, shading and painting. What induced you to turn your attention to Historic painting.

The History of the painting in my possession, with a narrative of the circumstances, trials, troubles, advantages and disadvantages and encourgagements which you met with in painting this one of your earliest pictures, and why you abandoned the Historic style for the one in which you have become so eminent. In short, I want a brief history of your life as connected with painting. I hope always to retain your painting and want to know under what circumstances of encouragement and discouragement it was undertaken and finished, and why you abandoned that style for the one which has given you so much fame and reputation.

Your portrait of me is very much admired. Please give me a call when you come in town. Be pleased to congratulate your niece the late Miss Seabury for me and believe me

<div style="text-align: right">Truly yours
T. Bailey</div>

[SB]

<div style="text-align: right">Stony Brook, Jan 5th, 1852</div>

My dear Sir,

Your kind note requesting me to furnish you with materials of myself as "connected with painting." Now Capt. that is asking a little too much—why it would take me three months to shell it all out, to clean the cob all off, and who would feed me with pudding and milk all that while. Echo answers who.

I am pleased your portrait is so much admired. I will call and see you when I visit the City—and believe me,

<div style="text-align: right">Yours truly,
Wm. S. Mount</div>

[SB] *This letter is misdated. It is a reply to Bailey's of December 28 and should be dated January 5, 1853.*

Other letters from Bailey may be found in the correspondence for 1868.

correspondence 1850-52

WSM to C. Bishop

Stony Brook, Jan 10th 1850

My dear Sir,

Mr. Elderkin handed me your *note* inviting me to assist you at one of your publics at Roslyn. As much as I should like to hear *you perform* in the *ballroom,* I am not able to meet you at this time. My Brother, R. N. Mount, has two parties a week—Tuesdays, at Port Jefferson, and Thursdays, at Stony Brook. You will perceive that he cannot assist you this evening.

I have seen Mr. Shepard Jones. An engagement prevents him from playing with you this evening. I hope you will, under the difficulties, have a pleasant time. In conclusion allow me to say that no class of men should be more honored by the rising generation or better paid than the musician, and dancing master.

Call and see me when you travel this way.

Yours truly,

[NYHS] Wm. S. Mount

R. S. Chilton to WSM

Washington, 28 March 1850

My dear Mount,

I am making up a book of sketches and autographs which is already tolerably well advanced. Through the kindness of some of my friends, I have procured mementoes of some of the best artists in this country. Last week, Sully was kind enough to send me a pen drawing. As I should consider this collection altogether incomplete without a contribution from one whose name is so prominently and honorably connected with American Art as yours is, I take the liberty of soliciting a sketch from you. The smallest scrap, with your name attached, will gratify me.

Vanderlyn is here, painting a portrait of Taylor for the Common Council of N. York. I see him frequently.

I have been living here nearly a year, having been appointed Librarian of the U.S. Patent Office. Washington, however, is a poor exchange for N. York as a place of residence.

Sincerely hoping that you will comply with the request contained in this letter, if you can do so without putting yourself to inconvenience, I remain

Faithfully yours,
R. S. Chilton

P.S. Tom Officer, who is here at present, begs to be remembered to you.

[SB]

Eugene Lies to WSM

New York, April 2, 1850

Sir,

Mr. Dubourjal whose address I enclose is painting a miniature of my late wife from Daguerreotypes. My wife's

maiden name was Emma M. Holly and as I understand you were well acquainted with her, I take the liberty at Mr. Dubourjal's request, to ask you to call at his studio tomorrow morning or this afternoon for the purpose of advising him from your recollections as to the likeness.

This favor will be gratefully remembered by

Your obdt servt—
Eugene Lies

[SB]

William Handy Ludlow to WSM

Sa[y]ville, April 22d, 1850

Dear Sir,

I wrote to you about a fortnight ago, relation to painting a portrait for me in the City. The lady whose portrait I wish is my mother residing at 20 Amity Place. I am desirous to receive a portrait of her as soon as possible. Can you take it soon? If so, please inform me, and I will write to her. Please also state where your studio is in town, and on what day and what hour you wish her to call. I would like a portrait of the ordinary size, with full face.

Yours Respec.
Wm. H. Ludlow

[SB]

Josiah D. Canning to WSM

Gill (Franklin Co.) Mass.
Jany. 18th, 1851

My dear Sir,

I should certainly hesitate long ere addressing thus familiarly an artist to whom I am a total stranger personally, and it may be probably by repute also. But my apology is this: that bards and painters are alike brothers in the ideal world. Please, sir, to accept my apology and allow me to proceed.

I forward with this note a copy of my poem, "*Thanksgiving Eve,*" in pamphlet form, to which I would respectfully direct your "distinguished consideration." It has frequently been suggested to me by friends, literary and other, to present a copy thereof to some American artist, that from the text of the poem he might transfer to canvass a living picture of the domestic scene. Unfortunately not being honored with the acquaintance of any painter, worthy of the name, I have heretofore refrained from following out the suggestion. But the reception, the other day, of a fine engraving from the publishers of the *Knickerbocker* magazine, entitled *"Music is Contagious,"* copied from a painting by W. S. Mount, Esqr. has prompted me to action in the matter; and the extreme naturalness of that rustic scene leaves no doubt on my mind who could paint "Thanksgiving Eve." The observance of this festival, although originally confined to the New England States, has of late, as you well know, become very popular in different parts of the Union, and becoming more so as year succeeds to year. A painting of the social circle about the New England Farmer's hearth would possess uncommon attractions to the patriotic beholder; and an engraving finished and well executed, copying the picture, would be a very saleable and popular ornament for the walls of the homes of thanksgivers.

I am at this present time considering proposal of a Boston publishing firm for a re-print of my "Eve" and other poems. It ill becomes one to blow his own trumpet, and I feel a degree of delicacy in calling your attention to the subject matter of this letter, lest peradventure it may savor of a blast of egotism. I merely say regarding the poem: please honor it with a perusal, and should your brush be excited to transferring its homely features to your speaking canvass, your very humble servant would feel himself *magnificently* honored in suggesting a picture to an American Artist. Please respond, and believe me to be

Yours with deep respect,
Josiah D. Canning
the "Peasant Bard"

P.S. I am indebted to Messrs. Goupil & Co, New York, for your address.

[NYHS]

Victor G. Audubon to WSM

New York, Jany 20, 1851

My dear Sir,

I have an idea of trying a new kind of lithography in *colours entirely*. Will you loan one of your works for the purpose—I will guarantee the safe keeping of it, and safe return to you? A figure piece would be best with interior or at any rate not a great deal of landscape.

The print, if successfully done, would be sold, and an arrangement made to give you a certain sum or a share in the profits.

Should you not feel disposed as above, would you object to the experiment being tried with one of your pictures in the possession of any one here?

Your early answer will greatly oblige me.

Yours truly,
V. G. Audubon

[NYHS]

WSM to Josiah D. Canning

Stony Brook, Jan. 26th, 1851

My dear Sir,

You are right, we are brothers. *Poets, and Painters,* are one family—we see nature with kindred eyes.

I have read your magnificent poem "Thanksgiving Eve"—with great pleasure—and the scenes you have selected are handled with artistic skill. I have two years work engaged and the subjects mostly considered, but, if I should in the meantime take it into my head to paint a "Thanksgiving Eve," I will most certainly refer to your Poem. I will mention to you F. W. Edmonds, T. H. Matteson, and Darly, of New York. One of the above artists

might take a fancy to illustrate your Poem—as they are engaged in that line of art.

I feel flattered with your "distinguished consideration," and shall cherish your name as one of the gifted of the nation.

I am yours, with great respect,
[NYHS] Wm. S. Mount

WSM to Victor G. Audubon

Stony Brook, Jan. 26th, 1851
My dear Sir,

I have read your kind letter with a great deal of interest.

I have but one picture that I can call my property— an *out of door scene*—and not yet finished. If I had an interior of my own I would loan it to you for experiment with pleasure, but, I think you must agree with me that it would be proper for me to see a specimen of your new style of lithography so that I could obtain the loan of a picture with confidence.

I shall be happy to hear from you again and I shall be delighted to hear of your success in your new style of engraving. Give my best regards to your brother J. W. Audubon, and believe me yours with deep respect—

Wm. S. Mount

[NYHS]

Henry J. Brent to WSM

Rochester New York
Dec 21, 1851
Dear Mount,

I wrote you many weeks ago, saying that Mr. James Wadsworth of Geneseo, Livingston County N. Y., desired me to obtain a picture of yours. I directed my letter probably to the wrong place as I had no recognition by you of its receipt.

I afterward wrote to Elliott to tell you what Mr. Wadsworth wanted, but Elliott too is silent.

Do orders go a begging? Paint a picture priced (150$) for Wadsworth. He wants one with a horse in it and when framed (for which extra) draw on him for the amt, or write to him— He is good for ten thousand times the Amount. He is making a collection and I suggested you. I hope you will set to think about it and oblige him. I have read with pleasure the Frenchman's critique of your work.

I am very truly yours
[SB] H. J. Brent

WSM to Henry J. Brent

Stony Brook, Dec 29th, 1851
My dear Sir,

Your kind letter has found me at last. A thousand

thanks for the interest you have taken. I should like very much to paint a picture for your friend Wadsworth, of Geneseo, but what encouragement can I give. I have already two years work engaged. If Mr. Wadsworth will submit to the Barber's rule (first come etc) and pay according to the merits of the picture, I will place his name on my list. It is difficult to paint, and think of the price at the same time.

As I write this in my Studio, your portrait by Elliott looks upon me—

Yours most truly
Wm. S. Mount

~~I hope your brush moves upon the sky, the land, and the water.~~

[SB]

John M. Moubray to WSM

Penataquit, Febr. 2nd, 1852
Dear Sir,

We wish two or three portraits painted and would like to know if you could do it, and also if a portrait could be painted from a daguerreotype likeness, as I have one or two of my child that I lost about two months since. She was ten years old and the likenesses are very strong ones. I shall remove her from the vaulted grave in which she now rests to a family vault that we shall build as soon as the spring opens and will be ready about the first of May and then she can be seen if it will assist any in the painting of it as her coffin is so fixed that she can be looked at without exposing her to the air.

Please write me if you can do it, and at what time, and also the expense, and I will come and see you and make arrangements therefor.

Obsequiously yours
John M. Moubray

[SB] *Mount actually carried out this ghoulish assignment. See his diary entry from Pentaquit, dated August, 1852, on page 248.*

WSM to A. K. Smith

Stony Brook, Feb 29th, 1852
My dear Sir,

Your letter has been waiting my return from New York —how wonderful that our thoughts are made to lie quiet in ink, upon snow white paper.

I think you are right—I shall try to paint you a good picture.

I am pleased that your letter has reached me just at this time, for one reason. Oh! how a good action gladens the heart. *D. W. C. Boutelle is a Landscape painter,* and resides in New York City. He has a fine picture of a "Trout Stream—Shower passing off" in the Art-Union. *Boutelle is a native of Troy.* I am sorry to say that he has

lately been burnt out—perhaps you can give him an order, or you can influence your friends, to see that he has orders. His prices are from *twenty five to three hundred dollars,* and deserves incouragement particularly at this time.

Speaking of works of art, one good picture, or a sketch, or a marble bust, well conceived and executed, *makes the owner respected.* You mention E. D. Palmer, his head, and bust of a child in marble. Exhibited in the National Academy last spring, is ever to be remembered—it is pure as a summer cloud. Go on adding to your collection. You have made a good beginning.

> Yours truly,
> Wm. S. Mount

P.S. I understand from good authority that Robert Walter Weir—West Point—has several pictures to dispose of and a large family to support. I have thought it my duty to mention it.

[SB]

portable studio

Stony Brook, Nov 17, 1852

A Design for an Artist waggon, to sketch and paint in during windy and rainy weather [pl. 93].

No time is lost on account of the hot or cold air. This vehicle with glass windows can be drawn by hand, or behind a waggon if the painter should not wish to keep a horse.

I believe a true painter should have no home—but to wander in search of scenery and character during Spring, Summer and Autumn, some pictures to be finished on the spot, and others to be finished (in the Studio) in the winter—figures to be added. Painting constantly from nature (with good taste) would be the quickest way to make a perfect artist—both in Landscape and figures.

"Truth is mighty and will prevail." Perhaps it would be greatly to my interest to travel (with my waggon) and paint pictures and occasionally a portrait to keep up a large style of handling. I could find rooms with two windows in every village and city. There would be a novelty in the enterprise. I must think of it. Better be moving than rusting out in one place.

May 1858

I have been thinking for a long time, since Nov 17th 1852, about the importance of having a studio upon wheels; it might be called the *camera,* to paint portraits, pictures and landscapes—free from much dust, heat and cold—during windy and stormy weather. Sea views, snow scenes, swamps, meadows, and ponds, animals etc could be taken while seated in this carriage better than in any other way, as regards the time saved.

Then my paint room would not be confined to any one place or village. I should have had one years ago, however. Just in time. The size should be about 8 feet long by 5 feet, inside measure, and 6 3/4 feet in height with 4 windows (plate glass) on the sides and ends. Also a sky light at the end over the door. The wheels to be low and the whole studio made very light, with white wood covering. Size of windows 21 × 36, from the floor to the window 32 or 35 inches.

A large umbrella will answer as a shade while painting very early, morning and evening.

A light hand carriage could be covered with musslin as a shade to protect the artist from wind, dust, and the sun—while painting a landscape etc during the warm weather. Size 5 feet by 6 feet in height at the posts, 6 feet 2 inches up to the apex of the roof. Height of the wheels, about 22 (24) inches. [Sketch]

WSM to Effingham Tuthill

Stony Brook, April 25th, 1861

My dear Sir,

I think of having the height of the (three) windows from the floor three feet (36 in)—instead of 2 feet 10 inches. It will serve to make my light higher.

The exact width between windows I have not fully determined upon, therefore, you will please *notify me for their position*. It is to me the most important part of the studio. Do not forget the height from floor to roof (or rafters), seven feet eight inches in the clear. I forgot to mention the thickness of the floor. I presume you will have it about an inch thick. As regards getting in and out of the car, you might continue a step out of the tongue or on or over it.

The sky light we can let down by a cord part of the way—instead of side ways, thus [sketch] so as to let in cool air during hot weather if it is to be had.

Your genius I believe will (comprehend the whole) make it all right.

Washington City is better guarded today. *Peace and Union forever.*

I hope my health is better to day. Give my regards to Mr. Skinner.

<div align="right">Yours truly
Wm. S. Mount</div>

P.S. Please answer that you have received this note. Have the door as high as the windows.

[Memorandum by Mount at the bottom of his copy:]

Curvature—two inches.
Length of curve, seven feet two inches.
The bar of iron laps on at each end, 3/4 of an inch.

[Sketch]

2 bars of iron, 1 3/8 by 3/8 thick.

[SB]

Stony Brook, April 27th, '61

I gave an order to Mr. Effingham Tuthill, Carriage Maker at Port Jefferson L.I., to make me a portable studio—a small paint room on wheels—to be useful in windy amd stormy weather—in taking views from nature —also for figures and portraits.

Size 7 feet by 12 inside measure in the clear, and 7 feet 8 inches in height. To have three plate glass windows, a door and a sky light. To be drawn by one or two horses.

[Added later:]

I commenced boarding with Mr. Tuthill the eleventh of May. He only charges me twenty shillings a week—he would not take any more. I like the people of this place very much. The children are well *behaved*—

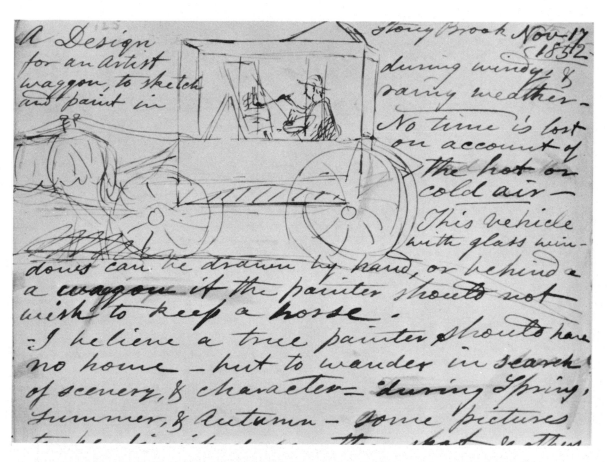

93. Portable studio. Diary, November 17, 1852. The Museums at Stony Brook,
 Stony Brook, Long Island

Stony Brook, May 4th, 1861

We had quite a snow storm this morning. May 5th—Ice and a heavy white frost. Apple blossoms had begun to show themselves.

Port Jefferson, June 10th, 1861

Wm. S. Mount
To E. Tuthill, Dr.

1 stand	1.50
Ladder with irons	2.00
Seat across end of studio	1.50
Window in door	1.00
Oil and paint	1.00
Windows in sides	4.50
Frame under sky light	.62
Sealing inside	1.25
	$13.37

Received of Wm. S. Mount Thirteen dollars and 37 cts which is in full for *portable studio*.

E. Tuthill

[Notation by Mount at the bottom of the page:]

	$13.39 [*sic*]
Two drawers to paint stand	.74
	$14.11
one side blind	1.00
Studio	$100.00
Glass	28.25
extra fixings	13.37
	$141.62

June 29th

My carriage or Portable Studio, is about finished; at a cost of one hundred and forty five dollars. I gave my time in finishing it up, after the builder had done his work. So far it is considered a success. I hope it will always prove so.

Port Jefferson, July 27th, '61

Moved my *Portable Studio* to Mrs. Hulse's store and weighed it. Nineteen hundred and ninety pounds. There was about two hundred weight in the studio at the time. Therefore, the weight of the Studio is about eighteen hundred.

Mr Jones moved it first—he made no charge. Mr Hawkins moved it the second time (short distance)—no charge, but I gave him a shilling.

	$00.12 1/2
Moved by Mr. Early	$00.25
Do——	$00.25
Do——	$00.25

[Added later: Moved the Studio to the other side of the road under the bank opposite John Davis's house in East Setauket, Nov. 22, '62.

In May 1863, moved into Mr Davis's front yard, North east of the house.]

Port Jefferson, August 28th, '61

To day I commenced painting in oil in my little portable studio (an *original picture*, Peace and [Humor]). I had not painted in two months, but amused myself by fixing the windows and door of my studio, to keep the rain out. The people of this place are very friendly and I am frequently invited to fairs and Pic-nicks. Very amusing, but they take a deal of time.

I wish my studio had been finished by the middle of *May*—to have studied foliage from spring to fall. There is enough to be done if the Lord will give me health, spirit and judgement to imitate his works. So far I like my studio and hope to paint many good pictures.

Port Jefferson, Oct 6th, '61

Yesterday was a very warm day, thermometer 84. The middle of Sept was hot, 96. I have been the last three weeks filling up the seams of the studio on the outside with melted bees wax—1/4 of turps added. Also while [with] hot demar varnish and oil. Sometimes I added white lead with the wax. Any drying oil or Japan can be mixed with the wax while hot. I gave the studio two coats of paint. The storm drove into it so that I was compelled to give it a thorough painting. I expect to wax some of the seams on the inside.

Mr. Tuthill has also strengthened one of the floor timbers—no charge.

On the evening of the 20th of June 1862, Mr. Joshua Dayton, with an assistant, fired the cannon (owned at Port Jefferson) within seven paces of my Portable studio —fortunately the glass was not broken but the easel and several things were moved and thrown upon the floor. It was lucky, but I should not like to have the firing repeated.

July 28th, 1862

I painted this day the roof of my studio with white and a little verdigris and linseed oil—it had a yellowish greenish tint. The verdigris is said to toughen the paint. The roof is tight. To prevent the sides of my Studio from leaking by driving rain storms, Mr Tillotson recomends the siding to be painted with Yellow Ochre and boiled oil, and shirt muslin (if you please) pasted or spread over the fresh paint. When dry, paint it any color you please—and it will be tight for years. *It would be good for the roof.* Some say that siding should be put on in this way—thus [sketch] and will be tight. Studio still at Port Jefferson.

WSM to Samuel Putnam Avery

Port Jefferson L.I.
August 1862

My dear Sir,

It affords me pleasure to send you (at your request) a sketch in oil of my *Portable Studio*—my own design and the first ever built for a painter, that I know of. The idea had been in my mind about seven years. The Studio was built May and June, 1861, by Mr. Effingham Tuthill, at Port Jefferson, L. Island, under my supervision.

You will please accept the sketch (in oil) as a present. As you requested I send you the measurement. Inside measure—Length from post to post, 12 feet, 1 inch. Breadth 7 feet, 1/2 inch. From floor to ceiling, 7 feet 9 inches. The Studio has six windows (French plate glass). Three of the windows are large and three small. It has one sky light, English glass. Also two ventilators, one at each end of the room. The step to enter is movable and hangs under the door after the pole is removed. The door is double and has a small glass in the upper half, with a slide made of wood.

The plate glass windows are framed with black walnut and slide into wooden packets—when not wanted. The air tight stove is placed behind the door—the siding and floor around it is protected by zinc. The interior of the studio is of a dark brownish color, black and venetian red, drove thinly with drying oil (no white) so as to leave the grain of the wood, and resembles hard finish.

The diameter of the wheels is about 20 inches. The springs or running gear, are of wood—and designed by Mr. Tuthill. One team of horses draws the Studio. The roof is canvassed and was wet with water before painting. It required three coats of oil and white lead. You will perceive in the sketch that the sky light is raised by an iron rod about three inches. From the ground to the top of the sky light, 10 feet 4 inches.

Mr. Avery, I consider it the extract of the finest studios in the world.

Yours, very truly,
Wm. S. Mount

P.S. From the floor to the bottom of the windows, about 3 feet 2 inches. Between windows, from post to post, two feet 2 and 1/2 inches.

I have just painted the roof with white lead, Linseed oil and a little verdigris to make the paint firmer and more durable. It has a yellowish greenish hue. It is about a year since the roof was painted, and will not require any more paint for several years. [Mount later crossed out this paragraph on his copy.]

The sketch is on oil paper. If you think the sketch worth framing you can slightly oval the top corners *as you please*.

I send ~~the sketch~~ it this day boxed up to your address, 48 Beekman St N.Y., by the L. Island Express. W.S.M.

In haste— I have not time to remoddle this note. Give my regards to Mr. Falconer when you meet him.

I received a paper about Coleman. Good.

[NYHS]

diaries 1853-54

Jan. 1853

All good portrait painters are Gentlemen, and cheerful in their manners—their vocation makes them so.

Stony Brook, Feb 28th, 1853

In painting David Kearney's portrait from a Daguerreotype I dead colored with black and white, lastly with flesh colors.

In painting the cabinet portrait of Mrs. Samuel Seabury I painted with flesh colors at once. Vermilion was the only red used in the first paintings: Madder lake used in finishing. It was less work and the best of the two. I have one more Daguerreotype to copy and I hope never to copy another. The artist is not half paid for his trouble. They take too much time.

SUBJECTS FOR A PICTURE

A Dog pissing against the skul of a Horse.

Another—Girl or Young Lady, in full dress, making signs with her fingers for the omnibus to stop.

Workmen looking out of a window to see the military.

A Mother with two babies (playing) or resting upon the harp of a thousand strings, a Mother's bosom.

A Young Lady *sucking* up a *brandy smash* through a *glass tube*—her lover doing the same.

A colored woman (a white girl) drawing water out of a pole well.

An old Man standing at the grave of his Mother.

A Boy riding on another one's back.

Over and under—two children looking over and under a fence.

If I should paint another Farmers Bargaining, I must have one of the figures in the act of cutting towards his body to clinch the bargain [pls. 94, 95].

[April 16, 1853?]

ORDERS

Manlius Sargent of Boston desires me to paint him a picture similar to the Power of Music.

One picture for G. W. Strong, Jr.

One picture for George Austin Esqr.

D[itt]o for James Lenox Esqr.

Do——for C. M. Leupp Esqr.

Do——for A. J. Spooner Esqr.

Do——for N. Ludlum Esqr. Interior.

Do——for S. Dodge Esqr.

Do——for S. T. and Henry Nicoll Esqr.

Do——for James Wadsworth Esqr of Geneseo, Livingston Co. N.Y. A Long Island horse must be painted in the picture.

One picture, Negro Courtship, for Wm. Schaus, April 1851.

Also one picture (life size head)—an old man of the Revolutionary times reading an account of the battle of Bunker Hill. Paper and Costumes of the times.

Also, one picture Cabinet size—Negro asleep in a barn—a boy tickling the darkie's ear, while another little urchin is tickling his foot.

April 16, 1853. Mr. Wm. Schaus wishes me to paint him a full length portrait of the Hon. Daniel Webster. Size 17 × 23.

On another page of the same diary, Mount repeats substantially the same list, with the addition of two names and information on the prices charged:

ORDERS

One cabinet picture for T. C. Evans.

One sketch for Mr. Brady Esqr, 359 Broadway.

Pictures——One for George Austin, price about $500.00
 One for James Lenox—$300
 One for A. J. Spooner—$150
 One for S. Dodge Esqr—$100
 One for M. Sargent of Boston—like
 the power of Music.

One picture for Henry and S. T. Nicoll—subject Country tin Pedler.

June 14, 1853

I will repeat again—a painter should as far as possible go where fancy calls him. A change of place is as necessary to the mind as to health. City in the winter (hire a furnished room) and the country in the summer. Paint those subjects you love—if possible. I have not painted sea views, with vessels sailing—I mean made pictures of them—nor *storms* on the water, as well as on the land. Nature for ever—and then glaze. Nature is the shortest road to excellence—therefore study nature in all her keys.

I must make study of clouds, also of the water when agitated. On the vessel's deck would be a good place to study the above effects. "Woodman spare that tree" must not be forgotten.

In touching up an old painting I used a low tone of nearly clear colors—Yellow ochre, Vermilion, Lake, and Permanent blue. I used pure colors whenever it was possible.

It is of no use to paint a landscape in the house from fancy, when a better one can be painted in the open air.

In speaking of the Old Masters, Cole says in one of his letters—"I do not believe that they theorized as we do: they loved the beauty which they saw around them, and painted."

Of Modern Italian art—"There are a few German and English artists in Rome who paint with more soul than the Italians. It would scarcely be credited that, surrounded by the richest works of the old schools, there should be a total ignorance of the means of producing brilliancy and transparency, and that among the greater part of the Italians glazing is unknown, and the few who, from seeing the English at work, have acquired some knowledge of it, use magilps and varnishes as though they were deadly poisons. Indeed, of all meagre, starved things, an Italian's palette is the perfection."

Cole was temperate—"he rejected all ardent spirits, and tobacco in every form."

He says—Genius has but one wing, and, unless sustained on the other side by the well-regulated wing of assiduity, will quickly fall to the ground. An artist should be of the world, but not of it. "He thinks our time and mind is dissipated by newspaper indulgences. The artist must be exclusive, if he would be great."

The above reflection reminds me of the time when I painted the Bargaining and Undutiful Boys in 1835, the Nooning in 1836, and the Raffle in 1837. I was lame and had to use crutches when I painted the two first. Confinement fixed my mind upon my work.

Revd. Zachariah Green, now living, aged 93—1853—born 1760, the eleventh day of Jan, Town of Stafford, Hartford County, Conn.

Married by the Revd Zachariah Green, on Wednesday 23 Dec. 1801, Thomas Shepard Mount of Setauket to Julia Ann Hawkins, of Stony Brook, L. Island.

1st—Henry Smith Mount, born Oct. 9th 1802, on Saturday at half past 6 o'clock, P.M.

2d—Shepard Alonzo Mount, born July 17th 1804, Tuesday at 2 A.M.

3d—Robert Nelson Mount, born Feb. 19th 1806, Wednesday at 3 P.M.

4th—William Sidney Mount, born Nov. 26th 1807, Thursday 11 o'clock A.M.

5th—Ruth Hawkins Mount, born Dec. 25th 1808, on Sunday 5 o'clock A.M.

6th—A 5th son, born and died Nov. 20th 1810.

7th—Jonas Hawkins Mount, born June 22d 1812, Monday 1/2 past 4 o'clock A.M.

8th—Julia Ann Shepard Mount, born May 6 1814, Friday between 12 and 1 o'clock A.M.

Henry Smith Mount died Jan. 10th 1841.

Thomas Shepard Mount, born March 9th 1779 and died Oct 21st 1814.

Julia Ann Mount, born March 8th 1782 and died the 25th of Nov. 1841 in the 60th year of her age—59 Y[ears], 8 M[onths], 17 D[ays].

Major Jonas Hawkins, died April 24th 1817. His wife Ruth Hawkins died Jan. 22 1840, aged 92.

My Uncle, John S. Mount Esqr, died the 25th of Feb. 1853.

My Aunt, Mrs. Margaret (Peggy) Davis, died 21st of March 1854 about sun down.

Aunt Penelope Mount, died the 31st of March 1854 about 2 o'clock P.M.

Stony Brook, June 15th, '53

I returned from N.Y. last week not well. I am now

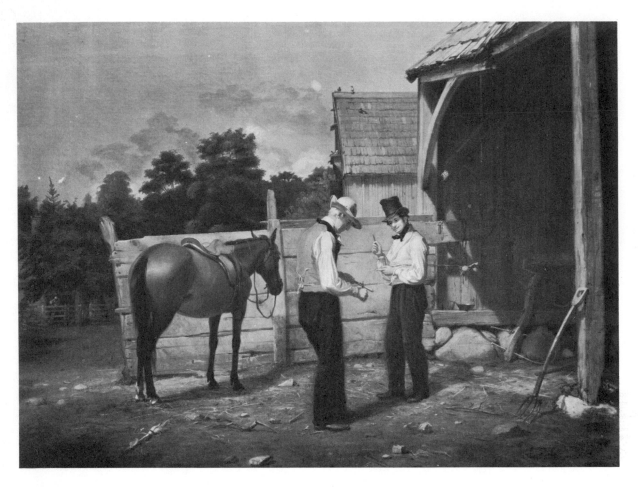

94. *Bargaining for a Horse (Farmers Bargaining)*. 1835. Oil on canvas, 24 × 30″. The New-York Historical Society

better. The life of Thomas Cole N.A. by Louis L. Noble, I am now reading with much pleasure.

Cole says (in one of his letters) that "the artist must, like a magician, draw a circle round him, and exclude all intrusive spirits."

When I would paint pictures, some spirit will hint to me at the moment to put it off—to fish, to sail, or to visit, or to paint portraits, where my heart is but seldom. It must be the spirit of opposition that torments me when I think of my duty. Exercise, music and reading, and I should say observation, are the only things that should take a painter's time. It is of no use to lay down rules, a painter will be a painter.

J. E. Snodgrass M.D. "Says that crushed ice swallowed, or ice pills if you please, will cure the cholera morbus"—will also cure sickness at the stomach.

Tea made of Timothy heads will cure the bilious cholic.

Half a tea spoonful of Salratus, sweetened, to be taken in hot water—to cure the bowel complaint or cholera morbus—feet to [be] soaked in hot water with ashes.

For cholera, common salt, one table spoonful, red pepper, one tea spoonful, in a half pint of hot water.

For Rheumatism, put half ounce of salt petre, to a pint of good gin—take a tablespoonful three times a day be-

fore eating.

For head ache, two tea spoonfuls of pulverised charcoal and water.

For worms take Pink and Lenna with a little ginger, or cloves with it—to cause less pain to the patient. Pikery and Gin is said to remove worms—good bitters for the spring of the year. If I take medicine it must be worm medicine.

[June, 1853]

For health—beware of sweets. Make use of molasses instead of butter—beware of melted butter—everything that contains butter is not good for the stomach. Fish is bilious. Raw cabbage is good. Jamaica rum on sugar is recommended for consumptive people. No brandy when one is bilious, and eat but little—oysters or clams with broth, but no butter. Eggs beat up with brown sugar to be taken in the morning. In fever, when your feet is cold, place them in hot water, and bathe your head and chest with cold water and you will soon perspire. Occassionally use rock salt to clense the stomach. If you must use brandy put salt in it—it is good to preserve the hair, and is said to cure the cancer to bathe with it, and to take a table spoonful before each meal. For worms make a tea of sage and burnt oyster shells. Cankered mouth, burnt oyster shells and

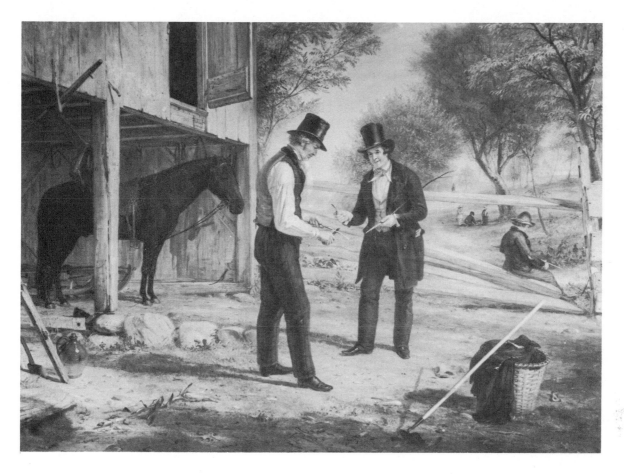

95. *Coming to the Point.* 1854. Oil on canvas, 25 × 30″. The New-York Historical Society

Mount was constantly importuned to repeat his successes, to paint another version of *The Power of Music, Farmers Nooning,* or some other popular work of his for this or that collector. He did not comply with most of these requests, although he filed them away in his diaries, often with the implication that he intended to do so. Only once, however, did he deliberately and obviously repeat himself.

Coming to the Point, painted in 1854, is a second version of the *Bargaining for a Horse* of 1835. The earlier picture had been a huge success because it exemplified—or could be read as exemplifying—a favorite American myth, the victory of the hayseed over the city slicker. Comparing the two pictures illustrates all too drastically how sadly Mount's powers had begun to fall off by 1854. The solid modeling, acute characterization, and sure sense of space and placement exhibited in the 1835 picture are not to be seen in the version produced nineteen years later. But not all of Mount's pictures of the fifties are as weak as *Coming to the Point.*

water. Gargle the mouth and bathe the lips with it.

For Croup, fold a wet towel around the neck and stomach of the child, and over the towel place dry flannel.

For dysentary, take blackberry syrup or two or three tea spoonfuls charcoal. Study yourself. For weak eyes, sometimes apply hot water or open them in cold water—every morning—rise early. If you are bilious, use Jayne's Sanitive pills. For Rheumatism, *drink Lemonade. Saltpeter* is *highly recommended.* Eat of sweet flag root to drive away wind.

A cheerful disposition is better for the health than to be cross-grained—there is too much friction in the latter. To paint in the City—I should take board down at the battery, or out of town.

There is one thing certain—when an artist is doing well and in the spirit of work, he should not suffer himself to be broken up.

July 28, 1853

Jacob B. Crane, 53 Charlton st—wishes me to paint him a picture like the nooning.

Also—James Wadsworth of Geneseo—Livingston Co. N.Y.—requests me to paint him a picture. A L.I. horse to [be] put in the painting.

One picture for Mr. Church, Landscape painter—exchange for an old master.

SUBJECTS

A clam digger waiting for the tide.

Shadow of a rabbit on the wall, a group.

Before marriage and after marriage.

A Negro blowing into the head of his violin, to stay the pegs.

Boy playing marbles.

Girl or boy dipping water out of the pond.
A Girl doing up her hair.
A character whistling.

Stony Brook, Oct. 27, 1853

In drawing or painting from nature—place a stick about the hight of a man (5 to 6 feet in hight) the distance you would like figures from you. Two sticks would give the true perspective of the figures to be introduced.

Painting flesh in shadow—first a red tint, over that a light green tint.

To paint sky— Next to the Horison, yellow tint—above, red tint—above that, a blue tint. Harmonise them together with a large brush. Sometimes it would be well to go over the place of the sky with some transparent red and then work into that. Repeat the colors while wet until you obtain a perfect sky.

To paint a clear beautiful sky with clouds flying—on a yellowish white ground, dip your brush into clear blue, graduate the sky thinly, until it looks clear and cool, then let it dry. If the clouds are flying, time in the afternoon sun on your left. First go over the place of the clouds in a flying ragged manner with a flesh tint and orange tints—then touch upon the lower range of clouds with a light azure tint for the shadows in a loose manner. The same to be observed in the upper and larger clouds—only the colors are deeper and shadows stronger.

SUN SETTING—IN A CLOUD

Sky	*Clouds*
Blue	Yellow and Orange
Greenish	Shadows red and purple
Purple	

Land
Purple distance
Middle ground brown and greenish

Reflections in the water and so on. Reflect the landscape in a looking glass or an interior of a room, and paint from the reflection. Bring the landscape in the room. Look in the glass and see it.

Stony Brook, Oct. 1853

I am happy to say that I left off drinking strong drinks three months since. I feel better in every respect. I drink no coffee—tea I shall give up also.

Stony Brook, Oct. 28th, 1853

This day I made a small study of Webster before the people. It contains six figures.

Yesterday I tryed my hand at a Sun Set, or just before setting—from fancy, or recollection.

I should be more regular in painting from nature. It is exciting to paint in the open air. Studies must be made in the Spring as well as in the Autumn. I made no sketches last Summer. My health was not good. I hope to do better in future. Three Falls past I painted landscapes in the open air—one sitting each—principally upon prepared oiled paper. It gives one great dexterity of hand. Sketches of interiors must be taken. Snow scenes also.

My brother, Shepard A. Mount, has made great progress this Fall in painting landscapes from nature. He is determined to paint from nature at all seasons when his time will admit.

Temperance and industry make one's eyes bright. Cold water alone as a drink, is enough to brighten any one's intelect.

To get along successfully with the Ladies, it is best to let them have their own way.

My Sister-in-law, Mrs. S. A. Mount has not thought proper to speak to me in one year—a long time, when she could be so agreeable. I believe she has regard and friendship for me, but her husband is opposed to her being friendly to me. I am sorry to say it. I wish them both well. Yet the extraordinary manner in which they have acted toward me the last three years leads me to believe what I have stated. My relations are all around my studio.

Now remember, confide not in your friends—they watch you—do the best you can—you will not please all. If you must speak of them speak well of them. Have few words. Attend to business. Minding your own business strictly hurts people most—do not tell who you are painting for. You are young yet, be true to yourself—nature is smiling—time is short at best.

I often tease and joke my friends to study their expressions. I play the violin for the same purpose.

If people will be Jackasses, they will find some politician or King to ride them.

"Genius is instinctively noble-minded."

Stony Brook, Dec 1st, 1853

A new method of painting has been discovered and employed by the celebrated Horace Vernet. It consists in mixing the colors with olive oil. When the picture is painted, the back of the canvass is covered with a coating of fuller's earth, which draws the oil through, and absorbs it entirely. The painting is thus reduced to the nature of a paste. The fuller's earth is then removed from the canvass, and a coat of linseed oil is applied (always at the back). The colors, in their turn, imbibe this oil, and all the mellowed tones of the old masters are obtained. Perhaps the oil applied at the back would rot the canvass.

Essential oil varnish for pictures—Solution of Resin in oil of Turpentine.

Wm. S. Mount—Elected Associate 1831—Academician 1832.

Henry S. Mount—Elected Associate 1827.

S. A. Mount—Elected Associate 1833—Academician 1842.

—Samuel Finley B. Morse then President of the N. Academy of Design.

THOUGHTS OF THE MOMENT

There is no standard of color. If a picture has no more merit than what color gives it, its foundation is very small.

A painter should use color only to tell his story.

Thought and color should travel together.

Look at a picture and you will learn to see nature. Observe nature closely and you will be a good judge of a painting.

In a figure piece, the landscape (if introduced) must be more or less subordinate and so contrived as to set off the figures to the best advantage.

Where tyranny reigns—there ignorance prevails.

"Progression is the word; let it be stamped upon your mind in characters of living flame." The above written by a Medium.

Dec 29th, 1853

Thos. S. Mount, offered me this day eight hundred dollars and a half of an acre of ground for my part of the home place.

"Wm. S. Mount, will be regarded as one of the pioneers of American art, and his paintings will always be pleasantly remembered."

Stony Brook, March 5th, 1854

I have been quite sick with the influenza for three weeks past. My head pains me and I feel somewhat stupid in consequence, but brighter days are coming—so let us rejoice in the goodness of the Almighty.

There are some pictures which I could paint in N. York, on account of character. A great variety of color, certainly.

One requires to be temperate in all things, to have a clear mind there as well as in other places.

Cold water is the most perfect drink—to stand by.

A wet towel was placed around my neck and across my chest for four nights and two days—has been of great benefit to drive away my cold. Gin and Molasses, half and half—also Dr. Houseman's cough drops—has been beneficial. If we do not note these experiments down we are apt to forget.

There is more spiritual influence in the City than in the country.

No merit in belief, but in good acts. The Spirits say, there is no crime in the long catalogue of human wickedness, so sinful and so certain to be punished, as the want of love and kindness towards our fellow beings.

LOVE AND UNITY

"None can love God who are unkind and uncharitable to those they see around them."

Stony Brook, March 19th, 1854

To enjoy health, I must eat but little—particularly at supper—and take more exercise. To dance in my paint room, or walk in the fields. My health is such, that if I spend three months about a picture, I am compeled to lay off from four to six weeks—and recruit.

From April, to July, I should reside in the City, while the Exhibition is open—*also during Winter.*

Perhaps a private studio in the City or near it—where I could leave for any part of the country, to study character and scenery for health and improvement in my profession—would be just the thing. Try it and see how it will work. Must you confine yourself to Stony Brook for ever?

I am confident that music adds to my health and happiness. Therefore it would be well for me to reside in N.Y. to take a few lessons of some great Master—on the violin.

[Sketch of studio plan; pl. 96]

I must not confine myself too much to my Studio—leave it for three or six months. It—a skylight—is a good light for portraits. Side or upright windows—better for figures. As long as you can find nature agreeable it is no matter whether you paint by a sky light or a side light. Teniers, I am positive, did not paint altogether in his room, but out in the open air. Some of his best pictures were done in that way. That is the way I painted in 1831 and 1833. I must do so again. Work as much as possible from nature, *indoors* and *out.* Figures painted in the open air, have a wonderful effect—providing the subject is good. It is singular that our landscape painters do not paint more figures.

As I have said before—If I should work with the same spirit in painting pictures as I do in portraits, my friends would not complain.

This is a new country—and a great opportunity for a native artist to distinguish himself (to salt himself down).

Good pictures will sell. The country is large—and it is not necessary to stop long in one place, but move about and be excited to paint more pictures.

There is any quantity of Portrait and Landscape painters—but few figure painters.

[Sketch of studio elevation; pl. 97]

The painter should have his carriage to paint in, to take views from, not exposed to the wind and rain—his sail boat (Mackanaw make) and his studio—and that should be in some village near the City.

...t and see how it will work—
...you confine yourself to Stony
...for ever?

...m confident that music adds
...y health and happiness...
...e it would be well for me
...side in N-Y—to take a few
...s of some great Master—
...Violin—

96. Plan for studio and exhibition room. Diary, March 19, 1854. The Museums at Stony Brook, Stony Brook, Long Island

...pictures.

There is any qua
ntity of Portraits & Landsc
ape painters—but few
figure painters.

97. Elevation for studio. Diary, March 19, 1854. The Museums at Stony Brook, Stony Brook, Long Island

...should have His carriage to paint in—
to take views from—not exposed to the wind
& rain—his sail boat (Mackanaw make)
and his studio—and that should be in
some village near the city—

Stony Brook, April 3, 1854

The time has arrived when I should *paint larger pictures*. There are three styles which will be noticed in an exhibition: a highly finished, original painting, cabinet size—a large picture, good color, and fine effect—and lastly, a very poor picture.

James J. Mapes wishes me to paint him a picture, price one hundred and fifty dollars. He observed, that "I should paint many pictures for small prices and at the same time have some large pictures on hand—for those who are able to pay." By pursuing the above course I shall have more practice and better pay. Many painters by dwelling so long upon one picture lose facility of execution. Their manner is apt to be cramped and stiff in consequence.

In future, I must fiddle more and paint more—at the same time take proper exercise.

A painter should walk humble before nature, have self-respect, but not much self-esteem—modest, polite and kind to his brothers in art. If he should criticise, he should not elevate himself by running others down—but by striving to raise others he will raise himself.

CURE FOR WORMS

Professor Mapes says, devide the contents of two papers Seidlitz powders into five different parts—and take one of those parts every day——to be continued.

Stony Brook, April 5th, 1854

To day is the first day I have painted in about two months—in consequence of a severe cold in my head, throat and chest.

When painting the artist should think of the color of the Exhibition room or the place where his pictures are to hang.

I can truly say that I never raised a pen to injure a brother artist that I can remember.

There is given every opportunity for painters to love one another. Five thousand artists could not paint up all the characters and scenery to be found in this state alone. The very thought of such a boundless nature should make them lift up their hands with thankfulness. They should be so spiritualised that envy could not enter their hearts.

July 30th, '54

This has been a hot month. I expected to have been in some cool retreat in the mountains at this time but cir-

cumstances have prevented. The time has come that I should make portraits the principal and pictures the secondary.

Pictures cost too much time. Particularly small pieces—apt to get one in the habit of niggling.

In youth, small paintings—in old or middle age, a larger style.

I must paint portraits and large studies—pictures.

In painting with migilp, when it is dry, oil the picture with linseed before working—and rub it off.

Memorandum to Himself

[1854?]

Engrave the portrait of the Hon. Dan. Webster, as perfect as you can, as I have represented him. The active thoughtful man—not put on Napoleon's nose, nor his belly, but make Webster a pure American as *he is*, and you have the thanks of the artist.

I must paint Webster the active social pleasant man not the sleepy Webster as many will have him.

[SB]

[1854 or 1855?]

WEBSTER AMONG THE PEOPLE

Painted by Wm. S. Mount.

The great Statesman is addressing the people from the platform of the railroad depot—his whole figure is expressive of thought, even his very hands give force to what he seems to be saying. He is represented as the active thoughtful social man—not sleepy as some would have him. Webster has a "majestic" presence and is contrasted by the introduction of other secondary figures. One is a reporter while another is waving the American flag and the third with his clenched fist, shows that his mind is fixed, and the whole three appear to be deeply interested in the matter of Webster's discourse. The background is simple and effective, and the whole picture purely American. It is the most original of all the whole lengths we have seen of *the great orator*.

[NYHS] *Mount was ultimately dissatisfied with this picture and cut it up; apparently he approved of some parts of it, but no trace of the work remains today.*

a group of mount landscapes

Interest in Mount as a genre painter has obscured the fact that when the mood was on him he could also be a superlatively fine painter of portraits and a landscapist of exceptional quality. Portraits by Mount are reproduced throughout this book. Herewith is a cluster of his landscapes in pencil and in oil.

Mount was not a landscapist in the ordinary sense of that word. He never produced large-scale scenery on canvas, but throughout his career he sketched in pencil and, in his later years, painted numerous small pictures of Stony Brook and its environs. Together these sketches and pictures provide an intimist view of the Mount country unparalleled elsewhere in the artist's work. Mount occasionally ventured afield from the environs of his birthplace, and we provide one landscape typical of that fact, a product of a trip into the Catskills and westward to the vicinity of Madison, New York, that he undertook in 1843 (pl. 101).

Mount's early landscape drawings are most extraordinary in their sketchy freedom and the variety of linear and tonal effects, achieved entirely with a pencil, which they display. But perhaps the most remarkable landscape Mount ever painted is an unsigned, undated study from his later period (pl. 107). Its light, almost uniform brownish tonality, its lack of visual incident, its sense of the immense, flat expanse of the marsh, and the three tiny human figures near the horizon toward the right, all suggest the work of the quasi-surrealist, neoromantic painters of the 1920s.

98. Untitled. 1834. Pencil, 9 × 11″. The Museums at Stony Brook, Stony Brook, Long Island

99. Untitled. 1834. Pencil, 10 1/4 × 8 1/2″. The Museums at Stony Brook,
Stony Brook, Long Island

100. *The Row Boat*. October 6, 1839. Pencil, 10 3/4 × 13 1/2″. The Museums at Stony Brook,
Stony Brook, Long Island

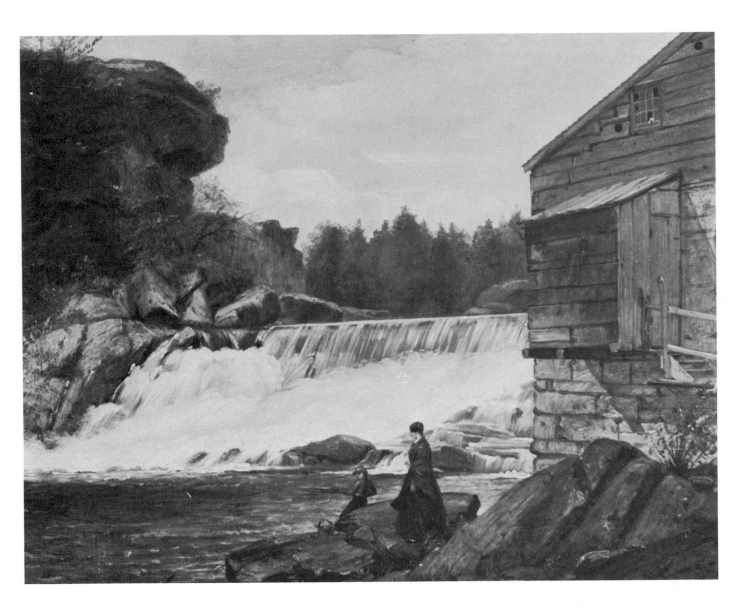

101. *The Mill Dam at Madison.* October, 1843. Oil on panel, 12 7/8 × 17″. The Museums at Stony Brook, Stony Brook, Long Island

102. *Long Island Farmhouse Piazza with Imaginary Landscape Vista (Corner of the Mount House).* c. 1846. Oil on panel, 12 3/4 × 17″.
The Museums at Stony Brook, Stony Brook, Long Island. Melville Collection

103. *View of the Sound over Long Island Shore* (*Landscape and Water*). October 17, 1851. Oil on paper, 10 × 14″.
The Museums at Stony Brook, Stony Brook, Long Island. Melville Collection

104. *Man in a Boat*. 1852. Oil on paper, 10 × 14″. The Museums at Stony Brook, Stony Brook, Long Island

105. Untitled. October 22, 1859. Pencil, 8 × 12″. Inscribed, "From green & brown, to purple & blue in the distance. Rich in color." The Museums at Stony Brook, Stony Brook, Long Island

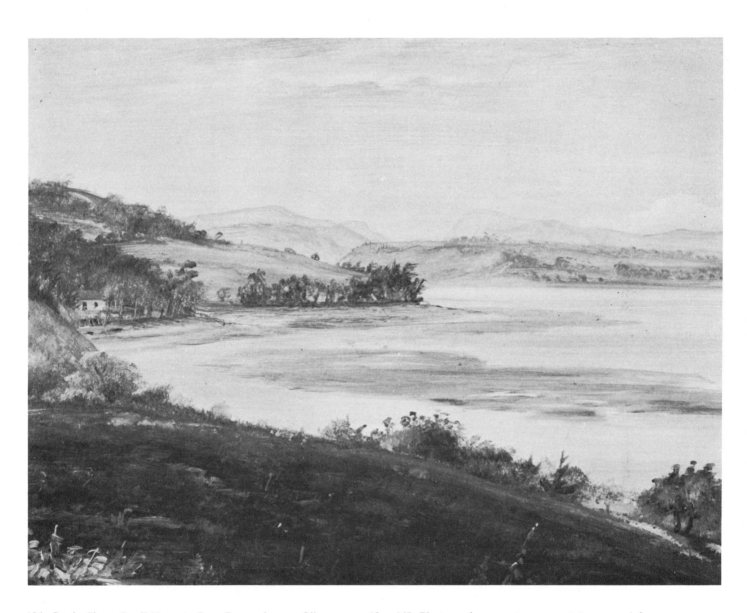

106. *By the Shore, Small House in Cove*. Date unknown. Oil on paper, 10 × 14″. Photograph cropped to conceal damage at left and right edges. The Museums at Stony Brook, Stony Brook, Long Island. Melville Collection

107. *Crane Neck Across the Marsh*. Date unknown. Oil on panel, 12 7/8 × 17″. The Museums at Stony Brook, Stony Brook, Long Island

spiritualism

As is pointed out in the Appreciation, Mount's interest in spiritualism is usually shrugged off as a mere eccentricity, but the perceptive reader will take it very seriously in relation not only to Mount as an individual but to the times in which he lived.

One religious revelation after another swept America in the nineteenth century. Some of these led to established churches like Christian Science and Mormonism, but for every church, sect, or splinter group that has survived to our own day, at least fifty founded in the last century proved to be ephemeral. Spiritualism is best seen against the background of this religious ferment.

It began with the famous "Rochester rappings" of the Fox sisters in 1848. By 1854, when Mount's interest in the subject was at its height, a strong effort was being made to assimilate spiritualism to Christianity, as his notes on the subject clearly show. In addition, Mount may have been drawn to spiritualism because of the common practice in his time of painting posthumous portraits, especially of children (see pl. 108). Mount constantly protests being called on for this bizarre kind of commission and makes macabre jokes about the subject; but he seems never to have turned one down, even when a grief-stricken father proposed that he study the face of his dead daughter through the glass of her coffin when the body was exhumed before being deposited in the family vault which he, the father, planned to build. (See John M. Moubray's letter of February 2, 1852, on page 260 and Mount's related diary entry on page 248.) There is a pronounced necrophiliac streak through all the popular arts of America in the nineteenth century; spiritualism, in its finest aspect, was an effort to spiritualize it.

Mount's documents on spiritualism are all dated in the years 1854 and 1855. The most important are his spiritualist diary and the two long letters dictated to him by the spirit of Rembrandt; these are both preceded and followed here by short, random jottings. The spiritualist diary, opening with the account of an experience of April 14, 1854, is a notebook which Mount kept exclusively for the recording of séances and similar events. The letters from the spirit of Rembrandt actually represent long-deliberated thoughts on aesthetics in general and painting in particular; it is my feeling that Mount cast them in the form of communications from the spirit world simply as a striking literary device. The diary entry headed "Presbyterianism" is not, strictly speaking, related to Mount's spiritualistic interests, but it helps mightily to explain why Mount was attracted to the new religion.

The sources for the miscellaneous documents in this section are given for each. The long spiritualist diary is at Stony Brook. The letters from Rembrandt are in the collection of the art historian John Davis Hatch, who obtained them from the late Harry McNeill Bland, the well-known dealer in American art. There are slight discrepancies between the extant copies of these letters.

A.F.

285

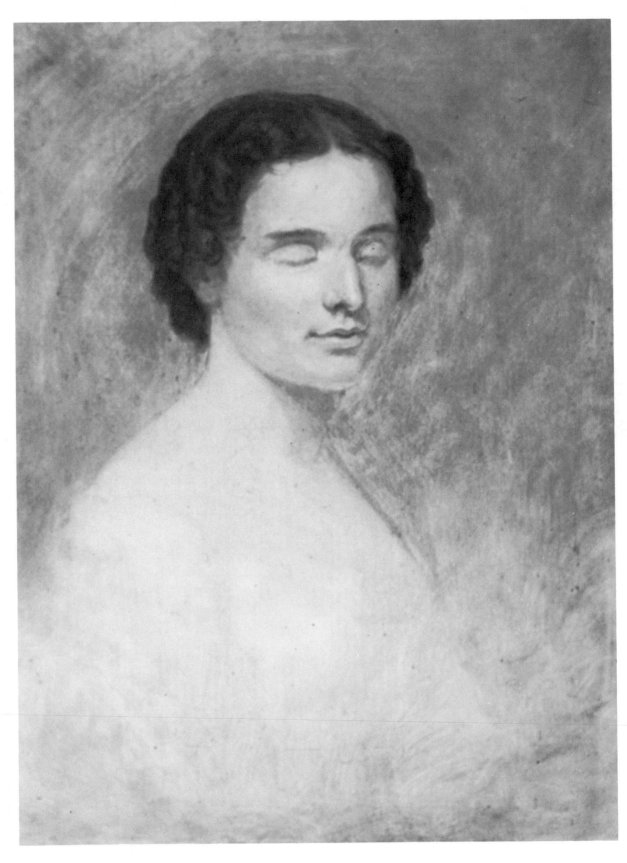

108. *A Woman After Death*. Date unknown. Oil on canvas, 8 1/2 × 6 1/2″.
The Museums at Stony Brook, Stony Brook, Long Island. Melville Collection

Stony Brook, March 6th, 1854

What does this passage of scripture mean in the Revelation of St. John the Divine, Chap. 3d, 20th verse. "Behold, I stand at the door, and knock: If any man hear my voice, and open the door, I will come in to him and will sup with him, and he with me." It appears like the table rappings—ask the spirit of Ben Johnson if it is not similar.

Also the second chapter and eleventh verse. "He that hath an ear, let him hear what the spirit saith unto the churches. He that overcometh shall not be hurt of the second death." What is meant by the second death.

What meaneth this passage in the First Epistle general of John, 4th chapter and 12th verse. "No man hath seen God at any time. If we love one another, God dwelleth in us, and his love is perfected in us." I ask, do we not see God in his works.

Was Jesus Christ sent here to be the Saviour of the world.

Also fifth chap. and eleventh verse. "And this is the record, that God hath given to us eternal life—and this life is in his Son."

Also, chap. fourth, first and second verses. "Beloved, believe not every spirit, but try the spirits whether they are of God—because many false prophets are gone out into the world."

"Hereby know ye the Spirit of God. Every spirit that confesseth that Jesus Christ is come in the flesh, is of God." What does St. John mean by the above passages.

[NYHS]

New York, Wednesday Evening, Nov. 22d, 1854
Present—Isherwood, Hadaway, Stewart (medium), Bridgman, and Wm. S. Mount.

Micah Hawkins [Spirit]

Question by Wm. S. Mount—Have you met Penelope and Peggy.

Answer—No, not yet.

Q.—Are they progressing.

A.—Yes, all progress, some slowly, some fast.

Q.—What sphere are you in.

Answer—3d.

Question—In what sphere is Jonas Hawkins.

Answer—4th.

Q.—In what sphere is Mother.

Ans.—6th.

Wm. S. Mount—She wished to do to others as she would be done by.

Answer—The true creed.

Wm. S. M.—My Brother Henry, what of him.

Answer—4th, just on the verge of the 5th. As I write he changes. Signature *Henry*.

Hadaway—Question. Is Jonas Hawkins with you.

Answer—He's in New Zealand. He wanders as a *Tourist*, whose expenses are paid, and whose curiosity about the sublime and beautiful conquers every other feeling.

During the short sitting, raps and scratching were heard, and we felt touches about our legs and feet, by spirit hands. An umbrella was taken from between my legs and conveyed to Mr. Isherwood, who sat on the opposite side of the large table.

At the circle held at Mr. Woolf's, on Sunday evening the 26th 1854, the manifestations were very extraordinary. I will mention that one of the letters received by the presiding spirit Ben Jonson, was a noble lecture to the circle, which was read by the (impressed) medium, Thos. Hadaway Esq.

A colored drawing (of Oliver Blodge, a spirit) by Rollandson was sketched in fine style in one of the letters—the letter was written by six different spirits, and in as many different colored inks and styles of writing. Mr. Partridge was requested by the spirit to place his hand upon the letter for three minutes—it was then opened and the colors had faded out. In the course of the evening, I expressed a desire to restore the color by placing my hands upon the letter, and Mr. Stewart (medium) requested me to do so if I wished. I placed my hands upon the letter, a short time, and when I opened it the colors were all restored as fresh as ever.

The center or middle table kept moving for some time—pencils and letters were handed to different persons by invisible hands. I had my foot taken hold of by a spirit hand. A gentleman was requested to place his hand under the table; it was grasped by a cold spirit hand.

Raps were frequent, and we felt touches. An autograph letter was received with nearly all the names of those present and they declaired the signatures perfect—but not one had any knowledge of having seen or signed it.

Questions by Wm. S. Mount—How should we best worship God?

Answer, by Ben Jonson—By following the stringent dictates of your own conscience.

Question—What creed comes nearest to the worship of God?

Answer—The worship of God.

To me, it was an interesting evening.

[SB]

Spiritualist Diary

About four o'clock in the morning of the fourteenth of April 1854 I instantly awoke with a loud scream. I was lying on my back at the time with my hands across me, my right hand on the top of my left hand, when by a concussion they were pressed suddenly down upon me with a power of fifty pounds, knocking my breath almost out of my body. I felt well before and after the shock. I was just entering into a dream before I was struck. My room door was locked, and the window raised about two inches—which is my practice, to have my window open both winter and summer—for fresh air.

March 11th 1854. In passing through the village of Setauket, I stopped to see one of my aunts, but, she being from home I fell into conversation with an old Lady, about the new manifestations. "The light from the spirit world." She said she had heard about the Rochester knockings, and nothing more. I then read from a spiritual work, giving a description of the spirit life after death, and the identity of (spirits) of our friends after death. She observed to me to stop. It was nothing new to her, and as the tears ran down her cheeks, she related that she had heard her son John who was dead distinctly speak to her, and she had often felt his head against her cheek. She felt the impression of his presence and she believed that the spirits of our departed friends are around us.

"Death is the sleep of the involuntary powers. Suspended animation in some human beings. Desire causing principle is the electro-nervous flued. When equalized through the system, it is cause of health. Two systems: The arterial carries the cherry red blood, which is positive, and ever flowing from the lungs and heart to the extremities, and the veins carries the dark blood, which is negative and ever flows from the extremities to the heart and lungs.

"It is computed to take four million particles of our air to make a speck as large as the smallest visible grain of sand, and yet electricity is more than seven hundred thousand times finer than air. Electricity is the power that controls matter, even from the smallest particle up to the most ponderous globes and that mind is a self moving substance that controls electricity, and that hence all power and vision substantially dwell in, and eminate from the mind.

"Electricity can neither be seen nor weighed—which moves with a velocity of twelve million miles per minute, and can travel around this globe in the eight part of a second.

"The Infinite Mind, or spirit, is above all, and absolutely disposes of and controls all. Hence mind and its agent electricity, are both imponderable, are both invisible, and coeternal."

"Mesmerism is the doctrine of sympathy.

"Electrical Psychology is the doctrine of impressions.

"In Mesmerism there is a sympathy so perfect between the magnetizer and subject that what he sees, the subject sees, etc, etc.

"The person in the electro, psychological state, is a witness of his own actions, and knows all that transpired—can hear and converse with all as usual."——John Bovee Dods Esq.

Aunt Margaret died March 21st 1854.
Aunt Penelope died 31st March, 1854.

They sneer at Mediums without thinking that every school master is a medium as well as a priest—we are all mediums more or less. It is gratifying that we shall enjoy a beautiful and progressive future to all eternity. How much more rational than to sit and sing psalms, how it agrees with Gods Divine teachings. The idea is much above what we have been taught that minds can never forget it, better than the bugbear of eternal brimstone. That kink in the head and spiritualism is bound to go ahead.

1 Corinthians, Chap. 25th [15], verse 19th— If in this life only we have hope in Christ, we are [of] all men most miserable.

20th— But now is Christ risen from the dead, and become the first fruits of them that slept.

21st— For since by man came death, by man came also the resurrection of the dead.

22— For as in Adam all die, even so in Christ shall all be made alive.

35— But some will say How are the dead raised up? And with what body do they come?

36— Thou fool, that which thou sowest is not quickened, except it die.

44— It is sown a natural body, it is raised a spiritual body.

45— The first man Adam was made a living soul, the last Adam was made a quickening spirit.

49— And as we have borne the image of the earthy, we shall also bear the image of the heavenly.

50— Now this I say, bretheren, that flesh and blood cannot inherit the kingdom of God; neither doth corruption inherit incorruption.

51— Behold, I shew you a mystery; we shall not all sleep, but we shall all be changed.

52— In a moment, in the twinklin of an eye, at the last trump. For the trumpet shall sound, and the dead shall be raised incorruptible, and we shall be changed.

53— For this corruptible must put on incorruption, and this mortal must put on immortality.

54— Death is swallowed up in victory.

57— But thanks be to God, which giveth us the victory, through our Lord Jesus Christ.

"The revelation through Moses taught the existance of one God. The revelation of Christ taught the immortality of the soul." But Spiritualism not only teaches us progression here and here after, upward and onward forever and that God is ever present and full of love.

The withering influence of Priest craft has kept minds from seeing the truth—any inovation against their belief, they cry devil. Let it die out, etc. The Bible is made up of good and evil.

If God is local he cannot hear our prayers but in one place. But as God is everywhere he can hear our prayers without our going to Church.

The immortality of the soul as taught by the spiritualists—a beautiful doctrine—an active existence after death, which is the resurrection, an improvement on the old belief of the body and soul waiting to come together at some future period.

All learning is given to benefit man—hence in all time people have been inspired ~~by~~ of God.

I am one of those that believe that God is not confined

to the Bible. The Sun shines and his light will continue to illuminate the world.

"God wants you, every one of you, to reach forward forever, and cultivate every thing, every individual seed which he has planted in your souls.

"Immortality exists now and forever; and that immortality is one of progress and of happiness, and not of misery—

"The soul has not changed with its valley life, but will always be soaring toward perfection in every thing of which it is capable of thinking."

True Spirituality teaches that Heaven is a living fact, a happy state of being; that men and women live and love in Heaven, and they there sympathize and feel affections for their associates in spirit-land, and for associates and friends on earth. Heaven is no far off place. Where love is, there is Heaven. Lord teach me to know my enemies that I may treat them kindly.

"Progress of Spiritualism will not and can not retard that of Christianity, but instead of that, while it strips it of some of the lumber which a superstitious church and ministry have burdened it with, it is left so clearly reasonable, and so easy of comprehension, that the wayfaring man, though a fool, may not err therein."

Dan Webster was born in the town of Salisbury, New Hampshire, Jan. 18th 1782. He died the 24th of Oct 1852. He was of Majestic presence.

Conference—March 14th, 1854
Mr. Davis remarked of these table movings. At first he supposed it was some hidden power of the mind, or some successful trick, perhaps, but the wonderful things he had witnessed compelled him to adopt the spiritual faith. They would stand the test of trial by their fruits. In his experience he had found them to breathe charity and human reform, in all their modes of appearance. They preach equality, brotherhood, and eternal life beyond the grave—the very quintessence of Christianity. He concluded by urging a true social reform founded on real spiritual Christianity.

"The unbelief of men cannot frown truth into falsehood. The Belief or unbelief of mortals cannot in the least effect those truths that God has established inherent in nature"——Dods.
Talent and modesty will always be respected.—— W.S.M.

Conference
Mr. Woodman said that error, bigotry and superstition should be treated as enemies, not the persons who are the subjects of them.

Conference—March 16th, 1854
Mr. McDonald stated a case in which a pressure apparently equal to one hundred fifty pounds had been made upon his foot by an invisible power and asked for an explanation of the manner in which spirits could produce such results.
Dr. Young thought that all power was resolvable, at the ultimate analysis, to the will of God. Mr. Fishbourgh explained and enforced the theory that all power was under the direct and personal action of the divine power, and that the highest power is capable of controlling all the inferior ones—that the human spirit therefore, is capable of volitionally controlling gravitation and the natural fluidity of the atmosphere, and pressing on one's foot with a column of temporally solidified air, or producing almost and [any?] other phenomena of physical movement. The conference then adjourned.

Conference—Tuesday, March 23, 1854
Mr Stuart remarked, "Every man is to himself the only revelation of God he can possibly have and even then within himself there is mystery to the clearest insight. So of heaven and so of hell; they can only be realized within the soul. And the purpose or mission of spiritualism was to develop man's spiritual nature so as to enable him to speak with his angel brothers and sisters face to face, and to be in more constant communion with the upper spheres."
Mr. Pray said, "We are in the sphere of effects, the causes of which are beyond our reach." He regards God as omnipresent, as being the author of all things and of all thought; but we can know nothing of him definitely, though we may feel his existance and presence. He spoke of the spirit manifestations and of the yet unborn science to be unfolded by them.
Mr. Farnsworth, Medium said, One of the impressi[ons] he has received is, that spirits do not come to teach creeds and dogmas of theology, but rather to free men from them, to take the subject of immortality out of the shadowy and changing realm of faith, and place it in the solid and eternal domain of fact.
Mr. Davis remarked, Spirits with whom he had communicated had generally affirmed that with them God was synonymous with love; that when they said God commanded them to do so and so, they meant simply that love impelled them to the action of duty to be performed. He did not think that prayer or worship, in the popular sense, was of much value. He related some interesting physical manifestations which occurred to-day in a circle at Mrs. Brown's in Twenty-sixth Street. A hand, invisible, but palpable to the touch, was placed upon his foot, and the raps were made as if one finger of the hand was elevated upon the others, and then brought down forcibly and distinctly upon the foot.

Rev. T. G. Young—A Preacher for upward of twenty years. He says, "I believe in the unity of truth, the fraternity of man, the immortality of the soul, and the supremacy of God. To antagonistic deities I am infidel. I do not believe that man ever fell, but that he has been ever rising. By following his footsteps from savageism to

civilism, you have the argument. All human souls are, I believe, unfolded from the exhaustless fountain—Deity. They are inherently pure, and destined to progress forever. Total depravity, original sin, endless sin, endless misery and a literal lake of fire, are the *bugbears* of superstitious minds. We begin to breathe an atmosphere in which such ideas cannot live." To escape the consequences of sin, we must cease sinning—leave it behind as Paul did Judaism, by entering on the highroad of love and wisdom.

From J. Walcott—Concord N.H., March 1854, extract.

One lady in particular, who was a bitter opponent, and attended the lectures for the purpose of gathering arguments against the subject, felt impelled to look the matter in the face for herself. The result was a long and beautiful communication from the spirit of her daughter, which affected her even to tears, and she left the medium a full believer in spiritual intercourse, saying, she would not take a hundred dollars for the consolation derived from that interview. So much for clerical opposition.

While the above incident was being related at a circle, I became impressed, and this pictorial vision was displayed: In the center of a mound, or piece of elevated ground, was a beautiful garden filled with choicest flowers of rich perfumes, a large number of children appeared gathering them into bouquets, in each of which they inserted a short communication written on paper. The parents and friends of the children, in the form, appeared coming up and receiving the flowers and mottoes, which gave them great delight as they read them and passed them down to other friends. Above the group was displayed a silver cross bearing the words, "Love one another," enveloped in a halo of light, shedding its beams down upon the children and people. Presently there appeared some tall, thin spare men, with shrunken cadaverous faces, in white cravats and long black robes, who raised their hands with a holy horror, warning the people to beware of these things, as they all came from the evil one. A little child approached and passed some of the flowers and a paper to one of the gentlemen in black. The communication was, "Dear Father, if this is of the devil, you had better have one at your elbow when you preach in your pulpit: it would do you good."

From the spirit of Revd. Samuel Dean

I was on the point of speaking to you a short time since, but yielded to the earnest desire of one who has just communicated with you. I was about to speak of the beautiful in nature and art, and its effects on the human mind. There is a presence in every thing in nature, and there is an influence from every thing in art that harmonizes the human soul, and lifts it up into the clear sunlight of nature's God. But what are there in comparison with those grand truths which are bursting upon mankind today, and to which you are all coming. What matters it to you though some may sneer and others denounce these truths? You have only to be true to your knowledge and your light—they will fall powerless at your feet. Each person must be true to himself and all the world will be right. A departure from right by one person mars the harmony of the world.

March 25th, 1854

On Sunday evening Judge Edmonds lectured at the Melodeon. The hall was crowded. He then remarked his subject would this evening be the "Divine Character of the revelations now being made to man through Spiritual Intercourse." It is in the short space of six years, since these manifestations were developed. We are but feeble children tottering, as it were, over the threshold of knowledge. This is absolutely necessary; for were the floods of light about to shine on the world communicated at once, we would be dazzled and overpowered. We receive it as rapidly as we can be educated and filled to receive it.

One consideration which induces the belief that these revelations are true is the manner. It comes to the humble and the lowly. Think what would be our fate if it came through men of fashion. Would it not be tainted with sectarianism, dogmatism, and conventionalism. The object of these manifestations is not to convert, for in times past few were converted by miracles. It is the principles revealed which works the revolution.

There is scarcely one real evidence of Christianity, said Judge Edmonds, which does not apply to Spiritualism.

If these communications are revelations, it is important to know what it teaches. The revelation through Moses taught the existance of one God. The revelation of Christ taught the imortality of the soul, but it was not given to man to know what the immortality was. We have been told that heaven was a mystery, not intended to be revealed to man. But Spiritualism unbars[?] its gate, and we gain full knowledge of all its glories. Now we learn that death but frees us from the trammels of this earth, and gives us a world where we may soar aloft to regions of eternal happines. Man is a creature of progression. The starting point, according to many, is death. But no, it is our birth. From that point we progress. From the hour of our birth to the hour of our death our lives should be spent progressing, in order that the hereafter may be spent profitably.

We should progress in knowledge, purity and love. If this (Spiritualism) is the way in which the devil presents himself, in the name of heaven, in what garb would God himself appear.

Judge E. described a scene in the Spirit world—as communicated by a spirit. A golden cross stood in the heavens, surrounded by a bright halo of glory. At one side a figure stood pointing to bright letters that glittered above the cross, "He saved mankind by living not by dying." And beneath the cross, "Do ye likewise."

May 6, 1854

Extract of papers from a gentleman who is widely known and distinguished in scientific circles. An inquirer

after truth. He says, "One tenth of the manifestations are so conclusive in their character as to establish in my mind certain cardinal points. These are: First, that *there is a future state of existence,* which is but a continuation of our present being, devoid of such portions of our organism as we now understand as material; that the great creed[?] of nature and her laws is progression; that spirit is in nature a motor, in man an essence; that the facts set forth in the scriptures are not contradicted by modern spiritual revelations; that modern spiritualism is in accordance with scientific truths, so far as those truths are established beyond a doubt.

"It is true spirits can and do communicate with mortals, and all cases evince a desire to elevate or progress the Spirits of those with whom they are in communion.

"I intend to present before your readers some communications on scientific as well as other matters, which are equal to the best efforts of any living men who have written on the subjects. As to the advantage to arise from Spiritualism, it is sufficient at present to say that all truth is valuable. 'It is a boy now, but may become a man.'

"Thus far, Spiritualism has done more to do away with Deism in five years than all our Church organizations during the previous century.

"Tables have been moved without the assistance of mediums, while their hands rested upon them—that they have been moved when no person has touched them, and in such way as to give intelligent communications by alphabet.

"Mediums have written upon subjects with which they were not acquainted, in languages which they did not understand, in a style of letter or character that they had never used before, and with a degree of rapidity which can not be imitated by any living penman not affected by spirits. That physical demonstrations, such as the movement of various pieces of furniture without hands, the movement of musical instruments, the writing of pencils on paper, without the assistance of other than spirit-hands, the drawing and painting of faces in spaces of time too short for any known process, have occurred. Bells placed on the floor have rung, individuals have been lifted from their chairs, moved in the atmosphere, and replaced in their seats by spiritual influence. Persons have been touched on different parts of their bodies by Spirits.

"Some Mediums see spirits, and describe their appearance so accurately that their identity can not be dobted. Others have heard spirits speak, and many are impressed by Spirits in an unmistakable manner.

"Thousands of erring persons have been reformed by Spiritualism, and many a chilled heart that had almost ceased to beat in unison with its fellows, has been warmed into consciousness by communications from loved ones long since passed from the form.

"Nothing has been so effective in reclaiming the vicious, and rendering the family circles of those who have given the subject fair consideration, a perfect school-house for Christian feeling; and it has been the means of educating many a wayward and inconstant heart into

prayerful feeling, which places man in communion with his God by elevating him to the plane he desires."

Washington Conference

"There are probaly upward of three hundred families in Washington who are experiencing in their midst these manifestations. They are almost as various as they are extended, hardly any two families receiving the same form of spiritual exhibition. Some have moving tables, others the raps, and others still are made media for the execution of beautiful pictures in new and novel forms unknown to art, and with exquisite effect."

SITTINGS

"In every family there is some person susceptible of being some sort of a medium. It is best in the commencement of each session to sit round a table and join hands. This produces an equilibrium of the magnetic forces or nervous fluid, and enables spirits to influence the members of the circle—they must feel interested and sit patient and silent some two hours at a time, two or more evenings in a week."

1854 [month illegible]

When indifferent about painting—make a visit—leave home a few days.

Odyle, or Od, force, independent of those before recognized as heat, electricity, etc, developed in the vital processes of the animal functions. Spiritod, or simply Spirod, meaning intelligence connected or not with ordinary matter. This agent of the mind, as well as its employment by disembodied intelligence. The Spirod force seems to be evolved more favorably in certain localities. The only possible doubt that can present itself is whether the phenomena may not be caused by an unconscious action of the mind. Startling fact.

"In the previous revelations there was a want of incentive to obedience of God's commands. The reward promised was an immortality which was not defined."

"On the earth men can go forth to battle, and send each other's souls to their other homes. A spirit cannot take that which he can not give—a human life."

"Occult force [page torn] normal perpendicular operations of the faculties[?]. Alchemy, hidden secret. Elixir vitae, or water of life. Roger Bacon, Alchemist. Cornelius Agrippa, Alchemist, astrologer and magician of hermetic philosophy.

"Paulus Jovious says that the devil, in the shape of a large black dog, attended Agrippa. Pareilus [Paracelsus] also (Alch). Dr. Dee, Talismania magical—Rosicrucians of the philosopher Stone, also, Cagliostro."

"The credulity of dupes is as inexhaustable as the invention of knaves."

April 18th, 1854

The secret of Table knocking or rappings have not been found out yet.

[Page torn] very heart thereof: this thought alone—*God is Love.*

Also, were written in words of a bright silver flame, the words—Love one another. Some of the spirits floating in the air drew out a scroll and spread it before me. On it was written, *Progression, onward, upward, forever.* Whenever I had read the words, they fell back. I saw new scenes, new countries, new stages of progress, one above another without end.

"Beseech them no longer to grovel in the earth, seeking their enjoyment in earthly objects, to look up, up—and [page torn] them free.

"Dear Father, God, teach us thy law, [teach?] us to know ourselves and thee; teach us that our nature begun here, will exist and progress through eternity; teach us that thy law, based on love, requires but the exercise of that love for its fulfillment.

"Aid us in our efforts to feel, to know what is our strength, and teach us to love one another, as we are all from one source."——Swedenborg.

Two Letters from the Spirit of Rembrandt

A copy of the original by Rembrandt's Spirit—the original of which was handed to me at the miricle circle.

Delivered to the Circle on the 29th Jany. 1855. Communicated through translation of Nozen. A few words of advice from P. Rembrandt to his friend Wm. S. Mount.

Urged by the constant appeal of your aspiring soul to my departed spirit which on former occasions has endeavored to prove its sympathy for your very laudable exertions—takes this opportunity through the kindness of another spirit to express a kindred affection for a brother artist of very considerable pretensions.

Presuming that you may be somewhat at a loss to account for the interest I take in this communicating with you, I deem it proper to state, that, inasmuch as I made it my principal object during my eventful *career* to aim at investing my pictures—whether etchings or paintings—with a truly *National Character,* that is to say, I endeavoured notwithstanding all sorts of fierce and malignant criticisms to make my pictures purely *Dutch* both in the deliniation of costume and figure out of love for *Nationality*—so my dear friend am I drawn towards you by a kindred sympathy, seeing that you are the best *National* painter of your country. But you must understand that in making this assertion, I do not mean to infer that there are not many clever national painters in America, or that you are the only representative of national art, what I would state is that your pictures are, generally speaking of a purer cast than those of your contemporaries, and better calculated to inspire the judicious portion of your country men with a commendable pride for national talent. Yet my dear friend you are not to infer from what is here writ down, that as an artist you are altogether faultless; but, on this subject I shall not at present treat. It may be sufficient however, to state, that there is somewhat too much of a sameness of design in most of your pictures. By this asserveration I would imply that you are too prone to repeat the same subject in a different point of view—a *licence that can only be executed to Historical,* Sacred, or dramatic representations. What you have done, has for the most part been done well, and in many instances with considerable originality of style.

You have frequently importuned me to favor you with certain hints for preparing your palette, and also, for advice upon painting. Now I am most willing to enlighten you upon that subject; but, before doing so, would call your attention to one important fact, that, *your style* of *painting* is *thoroughly unsuited for those Brown and sombre tints* and *broad masses* of *transparent shadow in their various grades with which I was accustomed to characterise my works.* Besides the very nationality of your subjects, and to which I have already alluded—must prevent you from employing them with effect. The best of my pictures, are, for the most part dark interiors. They being the best adapted for those magical effects which result from deep gloom, contrasting with reflected lights produced from the effect of sunlight judiciously admitted from a small aperture in the roof of my Studio. In addition to these remarks I would also add that the costume of my native land, altho' not altogether suited for historical subjects, was introduced by me into most of my pictures with an effect that disarmed criticism; and if you have seen any of my Scriptural pictures you will there observe that the *"uncouth costume"* as my defamers were pleased to designate it, invests them with a certain *Rembrandtish* character which so many admire—for, in good truth I selected my models without reserve from amongst such of my neighbours who would be pleased to favor me with a sitting, and after I had dress'd them according to my fancy in a turban, fur mantle, a gold chain and a jewell'd sabre, and placing them in a gloomy recess where the light was admitted through a small opening in the roof, I produced certain effects which have been very much admired, because they are peculiar as regards the play of reflected lights on various portions of the figure proceeding from an illuminated back ground—for I delighted to paint my historical personages entirely whith umber and subdued reds upon a light vaulted background composed for the most part, of Stone of a yellowish green tint. But of this if you have seen any of my principal works you are of course aware.

You have seen then that the National costume of my Country was no drawback to my works; now, in that respect, you labor under a disadvantage, because you cannot introduce the Costume of your Country into a scriptural subject without a gross impropriety. Consequently when you would paint a Scriptural Subject you must perforce depend upon the costumes of others that

have painted before you, and for this reason you cannot be altogether original nor "Rembrandtish," nor ought you to repine in this respect, for *Raffaelle* notwithstanding his great and sublime merit was but an imitator of *Leonardi di Vince.* He was only original in conception, not in coloring. For this reason you will perceive a greater individuality of style in my pictures than in his, because they are purely original in character and treatment.

Now my dear friend, notwithstanding that I feel pleased to witness the ardour you evince for forming a style upon my works, I would remind you once more, that the style to which *you* have hitherto devoted your mind is totally unsuited to that of mine; and *if you are wise* you will adhere to that treatment which is not only the best adapted for your genius, but also for the gratification of your admirers. My style is—if I may so express myself *"Too Brown"* to be incorporated with yours. By an examination of my works you will perceive that I *revelled* as it were in rich brown tints. In fact you may judge of my love for that rich warm tint by examining this Communication, which is as you will readily perceive written in my favorite color. I have had numerous imitators since my exit from your Earth, but none of them as far as regards painting imitated me so wond'rously as the great English painter Richard Wilson, whose firm and decisive touch was imminently calculated to produce crisp and determined style of impasting which was perculiarly my own. He was indeed a kindred genius in every sense of that term and also delighted to revel in those rich brown tints to which I have already alluded.

With regards to my love for those piculiar and mysterious effects of light and shade that predominate in most of my pictures, it may be proper to inform you that my attention was first directed toward it by the very extraordinary light and play of tints which I observed daily in the basement of my father's mill. The basement was a gloomy vault, composed of stones which had become marvellously tinted into a variety of colors through damp and age. The roof was formed of huge oaken cross beams supported here and there by wide stone pillars resting on the floor. This wall damp and murky was shrouded in a continual gloom, save when a portion of light was admitted through a trap door. Here I was accustomed to station myself and with a curious scrutiny observe the various play of light illumining the stained stone walls, and the striking relief with which certain Jew merchants, clad in their habilaments of brown cloth and fur cloaks and Caps were wont to visit the gloomy chamber in order to purchase flour of my father. It was there that I became enamoured of those effects which I labored to imitate, and which I at length brought to perfection. I traced these effects to their source, and when I became a painter never admitted either light or shade into my pictures unless they could be accounted for, as proceeding from a legitimate source. Thus then it occurs, if you will take the trouble to examine any of my pictures, you will find that I never admit such auxiliaries, unless on the principles of truth. It is owing to a respect of this essential

and a propensity for carelessness that many artists produce pictures with glaring errors as regards light and shade. When you admit light into your pictures, be sure you do so with a due and proper regard to its accessories, and that you do not scatter it in false patches. I am sorry to complain my dear friend that too many artists neglect this principle; and you will find false lights predominating over all their pictures. You should study effect through the medium of the atmosphere, and particularly observe how it is effected by perspective. It was a maxim of mine to instill this axiom upon my pupils, that *"Light begets Light"* an axiom from which painters should never suffer their minds to depart. This coupled with broad masses of transparent shadow judiciously applied should form the first consideration of an artist, for on this depends the principal of *Chiaro Scuro* in which I was thought to excell, and without a thorough knowledge of which all attempts at a judicious *relief* must ever fail.

At some future opportunity I may enlarge upon this and the art in general. In the interim believe me as one who has your interest truly at heart, and who endeavours, to the best of his abilities to convey his regards however imperfectly through this undeveloped Spirit.

With this assurance, I take pleasure in subscribing myself—

> Yours Sincerely
> Rembrandt (signature follows
> that of Rem van Rhyn)

March 25th, 1855

Rembrandt, to his friend Wm. S. Mount.

My dear friend.

On a former occasion I had the pleasure of addressing myself to you, through the medium of the Spirit *Nozen.* I now avail myself of the present opportunity to develope my thoughts through the kindness of the Spirit Bactha, and sincerely trust, that you may be enabled to derive some degree of amusement, if not instruction from the few hints here set down by the good will of Bactha, who, notwithstanding that he is still undeveloped, is nevertheless, a most valuable agent for your circle, and one whom I trust you will duly respect, for like his companion Nozen, he is both intelligent, and trustworthy, a rare quality, my friend, even amongst the vast number of spirits that generally attend circles.

My dear friend, I have come to speak of myself, of *Rembrandt,* and of what Rembrandt did in connection with that great art which he so enthusiastically followed for his calling. Therefore, deem me not egotist, if I dwell on my own individual peculiarities, and the means I pursued to attain them; and that style was, I believe, mainly owing to *self Confidence.*

And here, I would fain remark, that, without a proper degree of *confidence* in ourselves, we cannot arrive at that degree of perfection at which a true artist aims; in fact, *Confidence* is absolutely necessary in order to enable us

to acquire firmness, solidity, and that crispness of touch, which is the very charm of *Impasting,* and which *Teniers* brought to a state of perfection unequalled in the present day, and which drives many an artist who views his works into absolute despair. Now, my dear friend, *that* firmness of touch, in which I, in common with that great artist excelled, was entirely acquired by confidence in ourselves. Now, had I not possessed this confidence and I acquired it at the very outset of my career, I might have struggled in vain for that fame, which made me a *Rembrandt.* This style I acquired from my worthy master *Peter Lastman,* who, from his peculiar and firm manner of impasting, was yclept by his contemporaries "The Modeller," because, his works were impasted with so thick a body of color, as to resemble modelling; and he produced emmense effects by the solidity of touch, arising from that *confidence,* to which I have already alluded, and which, can only be acquired by determination, and a peculiar kind of genius for a striking and original style.

It may appear very strange, nay almost culpable to you, my dear friend, when I state, that, I never felt any interest whatever for the works of *Raffaelle,* or *DeVince.* To be sure, I did not have much opportunity to see *many* specimens of their works; but, those which I *did* see, appeared to my eyes, as an *attempted refinement upon nature.* I saw much that was grand and elevated in their varied conceptions, and beautiful in outline; nor, could I avoid admiring their splendor of coloring—the magnificace of their draperies, and the devine expression beaming from the faces of their madonna's and holy children; but, let me confess, that I became weary at beholding a monotanous sameness, and an apparent continual straining after a certain style of graceful outline, not only perceptable in their representations of holy families, but, also without any judicious reservation, in their apostles, peasants, and every inferior human auxiliary. I found, in those productions, the same grandeur of folds in drapery pervading that of saint, peasant and philosopher—the same unvarying graceful outline predominating everywhere, so, that my senses became cloyed, as it were, with their excess of sweetness, and I longed to depict nature in a less artificial and more popular mode. For the accomplishment of this end, I determined, to create a peculiar school for myself, in which I might depict nature in an unstudied aspect— that is to say, I resolved that the models for all my groupings, should be placed in such positions, that, whilst they amply fulfilled the design, *all straining for effect might be avoided,* for, I observed, according to my notions, that, the groupings in works of the masters already refered to, appeared artificial, and savoured too much of *theatrical display.* They were, more over, characterised by a peculiarity of lines, which stamped them with an individual *mannerism* in part with each other, that I could not applaud. I therefore, determined, to depend upon my own judgment, and this resolution, added to the instructions I had received from *Peter Lastman,* and G. Shooten— together with an admiration for the style of *Caravaggio* (whose spirit will be present at your circle this evening)—

induced me to form a style, in which I might represent Nature untrammelled by the formalities of convential rules of elegance, and, in such a form as the happy but unstuddied circumstance of the moment should offer, accompanied by the *most profound attentions to breadth of transparent shadow.*

Thus, then, by depending on my own individual resources of mind, and a *good eye for local color,* I launched forth on my sea of adventure, with a firm determination to avoid the style of any artist whatsoever, and, to create a school of my own, that should be founded on certain principles of light and shade, which, from their truth to nature, and peculiar treatment of *chiaro scurio* should gain me a footing on the pedestal of Fame. I rigidily adhered to this resolution; and thus, instead of becoming the servile imitator of other masters, I became a *Rembrandt.* But, this great step could only be accomplished by *Confidence* in my own capab[il]ities, and a most rigid determination to succeed. Now, this Confidence, is, as I have already stated, necessary for the attainment of excellence in every department connected with art and science. Your desponding artist, who has no confidence in himself, *must not expect that folks can perceive it in his works.*

Inspired then, by this *confidence,* I set to work, with a few colors, for, I was no admirer of those new invented colors that were daily comming into vogue. But, I took good heed, that those which I had selected, should be pure and well ground. My palette was made up thus— *White—Yellow ochre—light red—cinnibar* (or *Vermilion*) *—burnt ochre—Spanish brown—Bistre—Umber, Raw and burnt—lamp or Ivory black—verditter* (now superceded to advantage by *Cobalt*)—*Lapis lazuli,* or *Ultramarine— Burnt-Sienna* (I seldom used the raw article, because I found *it had a tendency to turn black*)—*Indian red— Antwerp* or *Prussian blue*—purple lake, and a very rich brown glaze composed of *finely powdered spanish liquorice.* With these few colors, then, I dashed in my effects [here the drawing of a hand appears pointing to the following] *after my design had been* carefully drawn on the canvass or panel so that I had something certain to work upon; and I made it a very *particular rule, to put as much effect* and finish as was possible in at the first stage, taking care, however, to blend nothing definately. But, all this could not be accomplished until the effect I intended to produce was so well developed in my mind by previous ideas, that, by closing my eyes, I could perceive, as it were, the picture I intended to create before me; and, by the constant observations I made on peculiar effects daily submitted to my view, *and, which I was most careful to set down on the spot as the most precious relics in a drawing-book which I kept for that purpose,* I, by degrees, accumulated a vast mass of treasure, of which, I made good use on various occasions, in some of my best pictures.

I was also most careful, to assertain the chemical qualities of my colors, so that, time should not injure their original brightness, and purity, by any injudicious mixtures from my hand.

With regard to that peculiar style of gloom, and the mysterious lights and shadows which characterize my productions, it is almost unnecessary for me to repeat, that, it was my custom to paint in a darkened room—that is to say—the design I intended to produce, was situated in a dark room, so contrived, that, from an adjoining chamber, in which I was seated, and in which a sufficient quantity of light was admitted to enable me to mix my colors without its being permitted to interfere with the effect in the darkened chamber, I could behold the general arrangement, my models were placed in such a position, in the gloomy apartment, that, the light which streamed in from an aperture from the roof, served not only to illumine the principal figures from the head to the shoulders with a pretty strong but softened light, but, also, to illumine that apartment with a certain mysterious atmosphere, that served to detach these figures from the background in *semi* relief, whilst, *each accessary received its portions of reflection* according to *its properly arranged* station in perspective. In fact, I painted *nature* as I beheld it through a certain medium of my own creation, yet, in most strict accordance with those principles *from which she never errs.* I followed her through gloom, and loved to depict the mysterious light slowly creeping along the stone floors, and up the walls of my old and delapidated apartment; but, when an accidental ray suddenly obtruded itself through some crevice, I immediately shut out the unwelcome guest, because, *it totally disarranged the chario-scuro* of my *picture,* by *introducing false lights,* which distracted the *attention of the beholder by strongly illumining trifling or inferior objects, and, so, destroying that concentration of brightness, essential for the principal effect in my picture.*

To produce an effect of strong central light in a picture it is not absolutely necessary, that, such brightness should be attempted by a mass of bright color. On the contrary! I found that, I could produce the most surprising effects, by mere half tints, Thus, I could concentrate into the center of my picture, a very brilliant play of light from white satin draperies—whose highest point of brightness was produced from the judicious employment of *white, light-red,* and *black,* mixed to a warm pearly hue—the reflexes composed of *yellow ochre, white* and burnt *umber,* the deep shadows of *white, burnt umber* and *black;* but, in order to produce this effect, it became absolutely necessary for me to economise the lights in the fore and backgrounds, in order, *that the eye of the spectator should be irristably drawn to the principal light* of the central group, so, that notwithstanding that *the principal mass of light was only composed of half-tints,* it still appeared as brilliant as if painted with the brightest colors. Thus you will percieve, my dear friend, that *brightness of effect does not depend upon brightness of color, but, on the judicious treatment of accessaries no less judiciously introduced into the picture.*

I generally dashed in my first effects, in an interior— with a full brush of flowing color, using no other vehicle than pure drying oil. I employed little or no white in this stage of the proceeding, but piled up/on my palette mounds of *raw* and *burnt sienna, yellow ochre,* and a small quantity of *prussian or antwerp blue*—these two last colors, judiciously mixed with a small quantity of *yellow ochre,* and blended into certain portions of the walls, produced that peculiar green that which so many of my admirers are pleased to laud.

And thus I worked my way along introducing, whenever opportunity offered—broad masses of pure browns and transparent shadow with a third sized hog-tool— *whose properties were flat,* and *elastic,* and by the judicious employment of which, I was enabled to produce a sort of grain, or cross hatching on the canvass, in certain places, admirably adapted to receive impastic touches; and [a pointing hand drawn here points to the following] *when any accidental beauty developed itself, I was careful to cherish it with greater jealousy then my own drawing.*

On some future occasion I will commune further with you. In the interam, receive the best wishes for your spiritual and artistic progress from

Rembrandt

March 1855

Mrs. McElrath wishes to have a letter from that friend of whom she dreamed the other night or a letter from one of the spirits that attend the *Miricle* circle, as a test.

Answer: Mrs. McElrath shall have a letter.

[SMITHTOWN LIBRARY]

[1855?]

CIRCLES

A circle can not go wrong if they sincerely desire to obtain spiritual communion and will meet often enough and be attentive. Some half a dozen men and women (who are deeply interested) to meet often; sit around a table in almost darkness (that they may be more passive), join hands, etc, sing a few songs or hymns at first, then continue the circle in silence at least an hour if necessary. This would soon produce mediums, and it would not be long before some of the party would be able to see and describe the spirits present, or be so influenced that spirits could speak through them or write through them. Some development would certainly take place.

[SB]

[1855]

Why don't the clergy of the orthodox faith give us the locality of heaven—we want proof of a hereafter and not be confined in the grave until the judgment.

If all religion is man's invention, then Spiritualism is the best of the lot.

"Grave, you are not the abode of the dead. Ministering spirits, sent by the Devine Being, our heavenly Father,

have by a known natural law of the universe discovered a way on which I can ascend to the topmost point of the Mount. A life of practicle good is essential."

The inscription here was "Knowledge is Progressive."

By teachers: "Spirits fresh from this world, called the rudimental sphere, are examined to determine their rank in the spheres."

Hypocrites sail under the garb of christianity.

Priestly rule decreases as science increases. Man makes the priest. God makes the medium. Everyone can not be a painter any more than to be a medium, but priests are manufactured whether they have the spirit or not.

[SMITHTOWN LIBRARY]

April 1st, 1855

At the circle we received an oil portrait, and a letter in the same envelope—from Ben Jonson himself. The portrait is to be framed and placed on the table during sittings. Also the oilcloth was received and taken away. We received a number of letters—and many of us were *touched with spirit hands*. I was touched several times, and a letter put in my hands.

[SMITHTOWN LIBRARY]

Sunday morning, April 15th, 1855

At Dodsworth's Hall I listened with great pleasure to a discourse by Andrew Jackson Davis. He stated that Moses was in the back of the head, and christianity was on the top of the head. Notwithstanding Christ was so much talked about, in business, men followed the law of Moses. He said incline to that which your mind admired most—and perfect yourself. He observed that all things grew out of mind and darkness, that darkness was necessary—all things germinate in darkness. ——A. J. Davis.

Spiritualism is nature itself. It teaches one to think, and thinking is the road to freedom.

[SMITHTOWN LIBRARY]

WSM to Thomas H. Hadaway

Stony Brook, April 22d, 1855

My dear Sir,

Believing you to be a sincere spiritualist searching after truth fearlessly wherever it may be found, I feel it my duty to say that last week at the Telegraph office, 300 Broadway, Dr. Warner mentioned to me in presence of Mr. Partridge, that Mr. Stewart (medium) of the Miricle circle told a friend of his, that he (Stewart) was writing a book to show spiritualism to be a humbug, as he had deceived many prominent individuals interested in spirit manifestations and intended to bring their names before the public.

Now if Mr. Stewart is acted upon by cruel spirits (to his great injury) I am sorry for him, and I hope God will have mercy on his soul.

Ever since Ben Jonson, came out against the dark circles, there has been kicks at the miricle circle—certainly a want of charity.

As Messrs. *Stewart, Partridge,* and *Dr. Warner* are friends of mine, I wish you would ask them when they are together about the above report. *An explanation may be given.*

The kind manner in which I have been entertained by yourself and the members of your circle has led me to drop you this note.

Yours, very truly,
Wm. S. Mount.

P.S. I have not mentioned this subject to anyone but Brother Shepard.

[NYHS]

[1855]

PRESBYTERIANISM

How cold and ridged. When Sunday should have been a day of happyness it was to me under blue skies decipline[?], a day of gloom. I was pleased when the sun went down and often dreaded when Sunday came, for the thoughts of eternal damnation and brimstone was to be raked over, which to my mind seemed strange when I could not discover anything in nature to bare the doctrine out.

[SMITHTOWN LIBRARY]

[Undated]

With what Colours did *Rembrandt* paint his pictures?

His principal colors were Raw and burnt Sienna, White, burnt Umber, Yellow Ochre, Brown Ochre, the principal of course with Vermillion. Browns were the more frequent.

Mount—What cool colors did he use? Black and White or Blue and White?

Seldom either. Cobalt, Lapis Lazuli. Cool shades were mostly pearly greens, glazed down with brown. Rembrandt's grounds are browns, if you paint a shadow, as they approach nearest to nature—and the light should come from the top of the room.

The Room should be of a dark paper or cloth, and an oil skin medium should cover the place through which the light comes. For instance you make a water colored sketch of your subject, put it in a box, and make a hole in the top of the box, and then look through a place fitted to receive the eye—you will find a glorious effect produced.

W. Mount—I should like to know what colors W. Wilson used in his landscape painting, and how he prepared his palette.

Wilson—For Portrait or Landscape.

Mount—Landscape.

Wilson—White, Yellow Ochre, Raw and burnt Sienna, Indigo, Brown Ochre, Sap Green, Lamp black, Verdigris, Burnt Oil and Turpentine.

Mount—Did you use Megilp.

Wilson—No.

M.—Did you paint with *gums*?

Wil.—No vehicle but Oil and turpentine. Megilp clots the colors.

M.—What Oils would you use with the colors?

Wil.—Poppy and Burnt Oil—poppy for Skies. For portrait painting, Vermillion, Burnt and raw Sienna, Umber, yellow Ochre, Black, Indigo, and White.

G. MORLAND'S PALLETTE

Blue, Chrome, Burnt Sienna, Raw Sienna, Burnt Umber, Raw Umber, Madder of sober hue, Lake, White, Black, and very thin oil.

TITIAN'S PALETTE

White, yellow Ocher, Indian Red or its substitute Light red. Black, Blue, Bright Yellow, Vermillion, Lake and Burnt Oil. The Browns were Burnt Sienna, Umber and Bister.

Prepare his grounds for Painting—Light Ground approaching pale Grey.

Ground composed of—Flour, in Water Color.

[SB]

correspondence 1853-55

Benjamin Tredwell Onderdonk (1791–1861), Episcopal Bishop of New York and professor at the General Theological Seminary, was the central figure in one of the major religious scandals of the nineteenth century. In November, 1844, he was charged before an ecclesiastical court with "immorality and impurity" and on January 3, 1845, was suspended from his office. According to the *Dictionary of American Biography,* this was "the first trial of a bishop ever held under the canons of the Episcopal Church and was the most sensational episode in the history of the church up to that time." The case was agitated for many years. Onderdonk had numerous supporters; his enemies were accused of hypocrisy in railroading him out of office on grounds of personal conduct when what they really disapproved of was his theology; and the General Theological Seminary steadfastly maintained him in his professorial chair. But Onderdonk was never exonerated, nor restored to his position in the hierarchy.

In 1833 Mount painted a full-length portrait of Onderdonk in his episcopal robes. He was inordinately proud of it and lent it to Columbia College, where it hung for many years. As late as 1865 congressman John Gardner, who wanted to obtain a commission for Mount to paint a mural in the Capitol, proposed that the artist bring the Onderdonk picture to Washington to show other members of the House of Representatives what he could do. The portrait seems to have disappeared, however, and the first letter in this section helps to explain why.

The writer of the letter, W. Alfred Jones, was librarian of Columbia College, a voluminous writer on literary subjects, and the author of one of the earliest appreciative essays on Mount himself (pl. 109). The two institutions—Trinity Church and the General Theological Seminary—which Jones mentions as possible recipients for the Onderdonkian hot potato (which Columbia was eager to get off its hands) do not possess the portrait. It remained at Columbia at least until March 4, 1857, when Jones sent Mount an all but peremptory order to remove it at once. This letter may be found on page 335. Although the Seminary does not have the Onderdonk portrait, it does own two other Mounts of Episcopal ministers, Charles and Samuel Seabury. The Seaburys and the Mounts were related. Thanks to this relationship, Mount had painted bust portraits of Bishop Onderdonk and his wife in 1830; these now belong to the New-York Historical Society, and they are reproduced herewith as examples of workaday, very early Mount (pls. 110, 111). The full-length portrait of the bishop in his robes must have been exceptional, however.

Note, by the way, the schedule for the Columbia College library which Jones gives in the letter that follows immediately here. It was open from one to three in the afternoon, on Mondays, Wednesdays, and Fridays. Six solid hours a week!

A.F.

W. Alfred Jones to WSM

College Library
Apl 15, 1853

Dear Sir,

I received a visit from Ex-President Duer a few days since, who made a suggestion with regard to your full length of Bishop B. T. Onderdonk that perhaps I ought to communicate to you. As the Trustees never paid for the picture it remains still your property, unless you have at any time made a donation of it.

He seemed to think Trinity Church might buy it, and I know of no good place for it in the Vestry Room of the Church. Would the Theological Seminary purchase it? It is well where it is; if you could dispose of it to advantage, and perhaps some years hence after the Bishop's death, when the concerned feelings of party will have died away, it may sell to much better advantage. I merely drop these hints.

Look in upon me when you come to College, the library hours are 1–3 Mondays, Wednesdays, and Fridays. Pray give my remembrance to Mr. and Mrs. Seabury, your nephews, nieces, your brother's family and all the pleasant acquaintances I made during my agreeable visit to Stoney Brook three (?) summers since.

I hope to be able to accept one of the many kind invi-

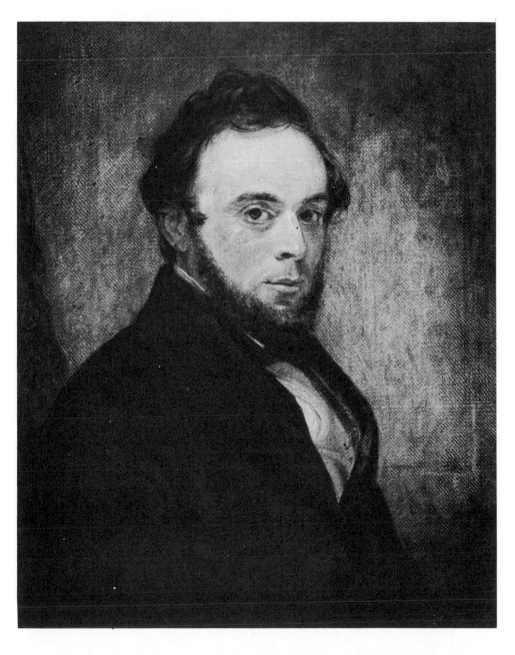

109. *W. Alfred Jones*. 1853. Oil on canvas, 9 × 7″. The Museums at Stony Brook, Stony Brook, Long Island. Melville Collection

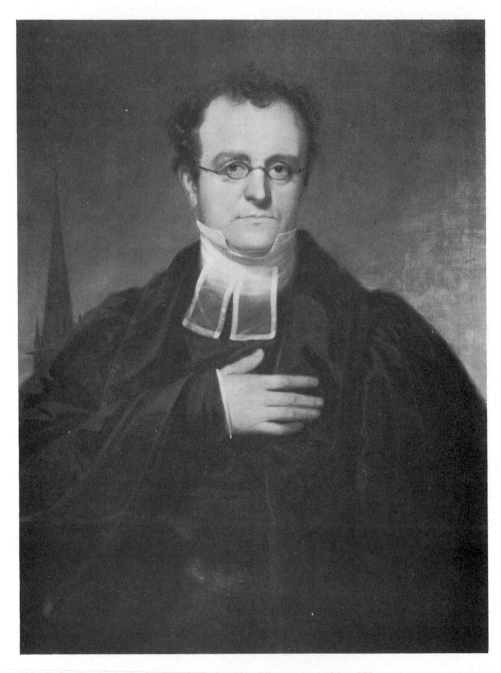

110. *Bishop Benjamin Tredwell Onderdonk*. 1830. Oil on canvas, 34 × 27″.
The New-York Historical Society

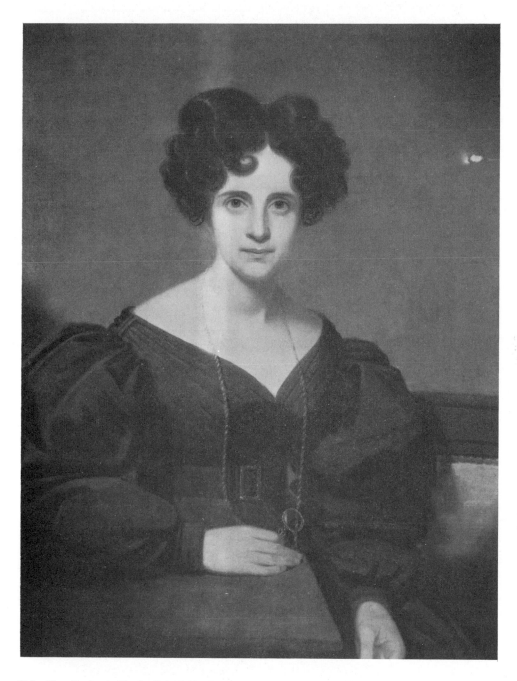

111. *Mrs. Benjamin Tredwell Onderdonk*. 1830. Oil on canvas, 34 × 27″.
The New-York Historical Society

tations I have received from your friends and spend two or three days with you this summer in company with my wife.

Meanwhile I remain, yours very truly

W. A. Jones

[SB]

WSM to Marshall O. Roberts

Tammany Hotel, N.Y.
May 27th, 1853

My dear sir,

I am desirous of obtaining a loan of the "Raffle for a Goose," now in your possession, to exhibit in the "Exhibition of the Industry of All Nations," as I consider it one of my best pictures.

By answering this immediately you will much oblige your friend,

Wm. S. Mount

[BUFFET]

Marshall O. Roberts to WSM

New York, May 27, 1853

Dear sir,

I am honored with your favour of this date requesting the loan of the Raffle for a Goose painted by yourself and now in my possession, and find myself so situated that it will be impossible for me to comply with your request.

I regret this exceedingly because it would afford me the highest pleasure to gratify your wishes, but having paid a very high price for the picture and built a gallery for the purpose of exhibiting such works of art as yours, I do not think it just to myself to loan my good pictures to the Crystal Palace for many months to my own disadvantage.

I shall have my room finished and ready for my pictures in a few weeks and they will be open to your inspection at any time.

Very truly yours,
M. O. Roberts

[BUFFET]

George W. Thurber to WSM

Patchogue, Dec 20, 1853

Dear Sir,

Speaking of boats, when I saw you last, I told you I had built one after your model. I did not at the moment recollect that I had noticed it through the columns of our country paper. I therefore send you two papers, with my comments in, and you will oblige me by drawing them, as they break my file. If you have read Davidson's model, you will find that he proposes, about the same for steamboats—the principle is right for steamboats on rivers, but for sea doubtful. My communications appear in Whig papers, is the reason perhaps you do not see them, and

your Whig friends hear of your success before you are aware of it.

I contemplate writing short Biographical sketches of our prominent men in Suffolk, and I should be thankful for the period of your birth, the number of pictures, who you first worked with in New York etc. etc. together with a daguerreotype.

Truly yours
George W. Thurber

P.S. You will discover, in the communications typographical errors, which you correct, I wrote about it, and it was in consequence of the proof reader.

[SB]

WSM to George W. Thurber

Stony Brook, Jan 3d, 1854

Dear Sir,

Your letter, and papers are at hand— They have afforded me pleasure. I will return them. I thank you for having noticed in the Suffolk weekly *Gazette* of 1851, my model yacht (oval shape) and my new style of violin. During your last visit to my studio, you appeared to be much attracted by my new model yacht Saturn, as broad as she is long, with a keel much longer than her deck, with her stern, and stern post, inclining inboard, and her rudder broadest at the water line, forming nearly an obtuse angle, having the most friction near the surface of the water. Much better than the most resistance at the bottom of the rudder, old way [sketch]. My way, new way [sketch].

I am pleased with the interest you take in such matters. You have a catholic mind, which includes the interest of others besides your own. I am satisfied by experiment that a sail boat should have great breadth of beam, or bearings, with a long keel to enable her to carry successfully in any position a large amount of canvass, to make her pitch where she looks[?]. Such a boat can be steered with ropes, the same way as some boats are steered by having the main sheet, traveller, over the rudder ropes— this or the rudder post may pass up through the boat. [Sketch] Then the steersman can [sketch] have at command the main sheet, and tiller, without moving from his place.

[Sketch of sailboat; pl. 112]

You see breadth of beam, No. 2, carries the most canvass. My boats have not been beat by a different model. It can not be done, having the same length on deck, by any ship builder taking any ordinary sloop or yacht model. And I am glad to hear you say the same thing, of the one you built after my model. Length on deck one foot nine inches, greatest width eleven inches, with a long keel.

South Bay is the place to test these models on a large scale—say 12 feet by 18 feet on deck, or 12 feet wide by 12 feet in length. Such a boat would create a laugh, but she would pay the builder to try the experiment. The

the most friction near the surface of the water.
Much better than the most resistance at the
bottom of the rudder - old way. I new way

— I am pleased with the interest you take
in such matters, you have a catholic mind —
which includes the interest of others besides your own.
I am satisfied by experiment that a sail
boat should have great breadth of beam, or
bearings - with a long keel to enable her to
carry successfully in any position a large
amount of canvass. to make her fetch when
she looks — Such a boat can be steered with
ropes - the same way as some boats are steered by hav-
ing the main sheet traveller, this
over the rudder ropes - this
or the rudder pass
up through the boat. Then the steersman can

Breadth of beam ⋯ eleven feet. Length on deck
seventeen feet — Center board can be added if necessary

have at command the main sheet, & tiller —
without moving from his place —

No. 3 No. 2 No. 1

9 feet by 20 feet 17 feet by 17 feet 14½ by 24 feet

You see breadth of beam No. 2 carries the most
Canvass — My Boats have not been beat,
by a different model - It can not be done,
having the same length on deck, by any

112. Sailboat. Letter WSM to George W. Thurber, January 3, 1854. The New-York Historical Society

south bay boats are very fine, but we want something new —wake up the boat builders along the south side.

As I am the inventor of the above models you will see that Suffolk Co. has the credit of them.

About materials of myself—as soon as I can attend to it, I will send you a few items.

[NYHS]

Yours truly,
Wm. S. Mount

WSM to Edward P. Mitchell

Stony Brook, May 25th, 1854

Dear Sir,

My price for pictures are from two to three hundred dollars. The painting I had in the exhibition this spring "Coming to the point," 25 × 30, price $300.00. It was painted by particular request. Mr. Wm. Schaus, paid me two hundred dollars, for the copy right, so the painting stood me in five hundred dollars.

I have only one painting on [hand? Page torn] 25 × 30. Hon. Dan. Webster, among the people. It contains four figures and will be finished in about a month from this time.

Let me hear from you at your leisure.

[SMITHTOWN LIBRARY]

Yours truly,
Wm. S. Mount

William W. Bennet to WSM

Port Jefferson, June 2nd, '54

Dear Sir,

I arrived at home yesterday afternoon and learned that you had called to see me in the way of assisting you in painting the portrate of the Hon. Daniel Webster. I fear you have made a poor selection in taking me, but as I have already said you are entirely welcome to any assistance I can give you and I shall be most happy to have you come here at your earliest convenience and stay with us as long as you can spare time, and *feel at home*. So I shall expect you to come soon.

[SB]

Yours respectfully and truly,
Wm. W. Bennet

WSM to William W. Bennet

Stony Brook, June 3d, 1854

Dear Sir,

Your note is at hand. I am pleased that you will give me one or two sittings to aid me in my cabinet portrait of the Hon. Daniel Webster. As your figure is said to resemble the God like—you may expect to see me about the first of next week.

[LOUISE OCKERS COLLECTION]

Yours truly,
Wm. S. Mount

WSM to William W. Bennet

Stony Brook, June 5th, '54

Dear Sir,

Please jump into the stage to morrow and ride out to my Studio. Give me a sitting. You shall have dinner with me at Mrs. Seabury's, or at the Hotel as you may fancy— then you can return by stage in the afternoon.

I would be pleased to accept your very kind invitation to finish Webster at your house, but I find on reflection that your windows are not high enough for this picture. My model (yourself) must be placed in a broad light.

I shall expect you tomorrow. Do come.

[LOUISE OCKERS COLLECTION]

Yours truly,
Wm. S. Mount

C. M. Cady to WSM

23 Park Row
New York, Nov 8, '54

Dear Sir,

I go to Sag Harbor next Tuesday to hold a Musical Convention commencing Wed. the 15th inst. at 9 A.M. and to conclude with a public concert Friday eve, the 17th. I am told that you very likely may be present and so in today's *Review* I announced that you were expected. Please bring your violin with you and don't disappoint us. You will find warm friends.

[NYHS]

Yours truly,
C. M. Cady

WSM to C. M. Cady

Stony Brook, Nov 12th, 1854

My dear friend,

If it was not for an engagement in N- York this week in the way of pictures, I should be most happy to meet you and your musical friends, at Sag. Harbor, and take with me a delightful performer on the violoncello.

Please call on (my musical friend at the Harbor) Walter Elliott Esqr.

[NYHS]

Yours very truly,
Wm. S. Mount

Hermann Giebner to WSM

Stony Brook, Decb. 28, 1854

Respected Sir,

I avail myself of this the first opportunity I have had since my return from New York of addressing you. I suppose, you would like to know how things are flourishing in Stoney Brook. For some time I have been acting in cause of humanity and now have been sued for it.

Capt. Davis charges me with stealing his girl away and his wife tells some hard stories (all base lies) about me.

But I will never mind it, there is not a respectable man in Stoney Brook but applaud my action in this matter.

The piano business is dull yet, and I am labouring around to make my living. I do enjoy still pretty ~~fair~~ good health and your money will be ready before a long time.

I do suppose you are enjoying yourself finely in New York.

No parties are going on here except a ball wich will come off next New Year at the Stoney Brook Hotel.

The violins and bass violins are our best friends on this long winter evenings the best companion through live is indeed a violin.

Now dear Sir, I have to close my letter, hoping to receive soon a kindly answer.

> I am Sir,
> with the greatest respect
> your most humble servant,
> Hermann Giebner

[NYHS]

WSM to Hermann Giebner

> Tammany Hotel, N.Y.
> Jan. 7th, 1855

My dear Sir,

Your letter of the 28th inst is at hand. I am pleased you find consolation in music. When a man acts in a good cause, in the end he triumphs—but the wicked have a hard road over Jordan. In the affair of the Girl, I think you acted right. As to hard times, keep your courage up—spring will soon be upon us, bringing business, and singing birds to enliven our labours.

> Yours etc.
> Wm. S. Mount

[NYHS]

George Searing to WSM

> Jan 27, 1855

Sir,

I herewith hand Judson & Co. on G. S. Robbins & son, sight, for fifty dollars, being an installment on "Walking out."

I regret I cannot report much improvement in Mrs. Searing's health, she is better than she was last winter, but not so well as this the summer. We intend making a trip to ocean springs (on Lake Ponchirtrain) hoping the mineral waters, change of air, etc. may prove beneficial.

We shd be pleased to hear from you with a little history of what has transpired in yr village during our absence.

Mrs. S. joins me in kind regards to you and all enquiring friends.

> Yours very truly,
> Geo. Searing

[NYHS]

diaries 1855–58

May 6, 1855

In painting portraits in the country, let the light come in at two windows—the painter at one window and the sitter at the other. Providing the lights are low.

An artist should not remain long with his relations (if he is a bachelor) as he is apt to loose ambition—to idle his time. New faces and new scenes wake up his soul —he lives in a new atmosphere, his ambition is aroused. Strangers look upon his works with interest—their faith strengthens him—all is harmonius. Beware of close miserly people, also of those who would rather pull you down than build you up. Keep company as much as possible with the youth—their influence is cheering. Let the youth keep company with aged people and listen to their experience—and likewise the middle aged to be as much as possible in youthful company.

Study to be happy under all circumstances. If the circle is not harmonius, move until you find one. Give a kind word or a look to all.

Commodore Perry said to me of his own accord that when he returned from Japan that I should paint his whole length portrait.

Treat people as you find them. If they feel disposed to be reserved, and not willing to be social, do not interfere with their humor, but favor by imposing no restraint. Bear all things in quietness.

[SMITHTOWN LIBRARY]

[1855]

FROM MR TRACY

The artists should have a perpetual exhibition, to exhibit their works in a good light, to have an intelligent man to receive visitors, to explain the artists' styles, subjects etc. A free Gallery all the year, to exhibit their pictures, portraits. More exhibitions the better for art.

[SMITHTOWN LIBRARY]

[1855]

SUBJECTS

A young female cleaning a window.

A boy stealing watermelons.

A Clergyman counting the money after preaching— Oh, lead us not into temptation.

A schoolmaster having spraint his ancle, the boys are in high glee.

A man seated or leaning against a fence—the house in the background—axe and dinner pail.

A man standing or leaning against a horse.

A man laying for ducks over a bank.

A Man or Boy fishing with a spear.

A Girl feeding chickens.

After walking from the picknick, Samuel is bid by Su-

san good afternoon at the door. Sam sees Susan, his fair one, at the window. Sam and Susan walk out. The Wedding. Three months after—Sam is carrying home a bag of flour on a wheelbarrow. Twelve months after: They walk one after the other, Sam carrying the baby. To hit the times, Sam should be made quite a dandy before marriage.

[1855]

Paint pictures in private homes—also by the wayside, in Porter saloons, Blacksmith shops, shoe shops—wherever character can be found—and not be confined to your studio. Receive callers at your boarding house evenings—but have no studio for idlers. Let your pictures be little or big as the case may be, as regards price etc.

Paint in a different style from others as regards size and subject.

Paint familiar pictures, Comic heads and Groups, or single figures—any kind of a picture that will be artistic and true to nature. Follow the bent of your own mind—do not paint to order. Please yourself as to subjects.

When I painted to please myself, I was myself. When one paints to order, one sells his birth right.

Did you not learn to paint because you loved art and nature? Yes. Then continue to paint where your love and inclination lead you. One picture painted out of pure love and inclination is better than ten orders.

Paint large or small pictures as the subject may dictate.

Do not forget the foot of the ladder. Remember your first impressions. If you work in the right spirit the spirit will be kept up.

[1855]

All good artists exhibit a neatness in all their works. Not only their palette and brushes are cleaned with care but they are Gentlemen—for instance Vandyke, Sir Joshua, etc.

Stony Brook, April 3, '56

I finished the bone player this day—over white ground. I rubbed the canvas over with Venetian red—ground in oil thinned with turpentine—it should be used with drying oil. Any color can be given in the above way. When dry commence painting.

If the flesh of the Negro should be too warm, when dry rub over thinly some blue—to cool it down. I painted the above picture without varnish. Boild oil and raw oil. The latter dries fast enough in hot weather. It is thought to be more durable—more limpid your colors, the better your work.

April 6th, 1856

I expect to take my Bone Player to the City to morrow. When I return I shall take board down in the village for the sake of exercise and change. Some people incline to get saucy if you board with them too long. Particularly a young Lady thats been brought up at a boarding school.

113. Fishnets. October 18, 1856. Pencil, about 4 1/2 × 7 1/4″. The Museums at Stony Brook, Stony Brook, Long Island

Jan 15th, 1857

Boys harnessing up a dog to draw a small waggon. A man reading by a window.

Have a studio with windows from all points of the cumpas. Side windows— [Sketch of studio]

Rise early—make fire, and sweep out your room before breakfast. Windows and door thrown open to let out the dust and let in the fresh air.
Paint, sketch and draw.

Stony Brook, March 5th, 1857

I am now looking at a small French painting of Paris lent to me by Mr. Falkner. It represents a group of Ladies, in rich costumes, sitting, reclining, and one standing under some trees. A slave on the left near the foreground prepairing to boil some water or coffee in an ornamental dish over some coals of fire. Landscape background—some water in the foreground—a shady Autumn scene, rich and obscure to wander about in. The painting is very rich in color, looking as if the palette of colors were thrown onto the canvass in a very scratchy manner—colors scumbled, glazed, and draged over each other, a constant change of tint at different times. The effect of sun light is very happily hit off. The figures and landscape, is simply, a general effect of color—having breadth of light and shade.

I see more and more the importance of a soft, scratchy and broken out line to obtain color in oil painting. Softness is the handmaid to color. And then one color over another until a fine tone is obtained.

Stony Brook, May 2, 1857

Rain—

Santerre (a French artist of the last century) voluntarily confined himself to the five colors used by the ancients—"Ultramarine, massicot (a yellow), red, brown, French white, and Polish black. This proves, that it is not the great variety of tints upon the palette which produces fine colouring, but the manner of employing them."

"A German, named Mayer, has calculated that with the three primitive colors (red, blue, and yellow) modified more or less with black and white, we might produce by their different combinations, eight hundred and nineteen tints."

N.Y. May 20th, 1857

Softness and sharpness must be observed in all pictures, of figures, portraits, animals and landscapes, as well as distinctness in the foreground and obscurity in the distance in certain effects. I am convinced that the greatest pictures and in nature, that all sharpness must be avoyded beyond the principle figures. Even, in rounding a figure, the strongest darks, and of color, must be in the front lines of the object to be painted. Perspective of color, as well as of forms. All strong lines, as well as color, must be broken down by greys—or should know their place. The relief of figures is not fully understood yet. You will see some times, strong attempts that way. We have the colors, the mind must be drilled to use them. Reason must move with the brush. The way to arrive at relief in colors, is to have the sides of figures etc grey or blue—in degrees, as the case may be—and at the same time pay strict attention to light and shade.

May 31, 1857

Why should men strive against their nature. Some have great talent for dancing—Hornpipes, Jigs, and Reels—but they think it beneath them—and those who play comedy to perfection think they are best calculated to play tragedy. So with painters—some will take portraits indifferently, when they would make good landscapes, and others again who would excel in comic pieces, will endeavor to paint contrary to their genius.

Oh man, try to know ~~yourself~~ thyself.

Yesterday, and the day before I made three or four sketches of flowers. I used copal and raw oil, half and 1/2—it dryed hard. In one of the pieces I used Demar varnish and raw oil 1/2 and 1/2—it did not dry so hard. It might, if I had mixed boild oil with it instead of raw oil—or only one quarter raw oil or added some turpentine.

It is said, that those oils and varnishes that dry quick—will crack. The Demar varnish has more body than copal. Copal and raw oil with a trifle bees wax—would give it more body and perhaps dry slower, and be more durable. The first paintings should dry ~~slower~~ faster than the last—in that case use the copal first and the Demar last.

Find out by experiment which are the best oils, or mixtures for painting and hold fast. Some of the old Masters had their colors ground in water—and then added oil or varnish, or both as they needed them. Much oil alone with paint will crack—the ground must dry to prevent cracking. It is necessary that paint should keep its place. Mr. Evers says, desolve Dutch or purified borax in warm water—then add your oils, and the color will hold its place.

Varnish first, and then paint before it is dry, with your colors thinned with oil, to good working condition—without putting your *brush into oil*.

Have confidence (says Rembrandt) in your ability, if you wish to shine as a painter.

Stony Brook, June 21st, '57

First mix your colors with oil (raw or nut) with the palette knife, to the consistency you desire. The freedom and beauty and durability of your work depends very much upon the preparation of your colors. Then, if your colors require any more thinning, use varnish and oil, equal parts, with your brush alone—Demar varnish and Raw linseed oil.

I am painting two or three pictures with the above mixture—so far I like it very much.

June 30th

I commenced a sketch of a boy life size (Henry Dearing) by painting his nose first—at the nostrils. I used no lake in painting cheeks and mouth. The order of my palette—first, on the left by my elbow, white. Ocher, vermillion, blue, mars red, Terre verte, vandyke brown, Ivory black and burnt sienna. The flesh—yellow ochre, vermillion and blue. Sometimes scumble over the light parts of the flesh (when dry) with yellow and white, or red and white, or grey and white as the case requires.

[1857]

Demar varnish, and drying oil could be mixed together in the same way for glazings.

Force of color—"Two contrasting tones must be brought together, and the power of each will then be felt."

In order to be stimulated to a variety of subjects for painting, sketch and paint one season with a marine painter, another season with a landscape painter and another season with an animal painter etc. But not to imitate them —only nature.

Oct. 1857

The Horse Fair—by Rosa Bonheur. The principal light falls on the two horses and the rider. The horses are nearly white with grey spots—the pants of the rider is a greenish grey. He is talking with a man on the left in a green shirt with a blue and black cap, on a clay bank horse with yellow mane. Between the nankeen and the brownish black horse, a man with no hat with greenish pants and white shirt, is leading a rearing white horse. The rider of the rearing black horse is dressed in a green shirt and pants, in fine contrast to a brownish yellow horse—a sorrel—on his right and approaching the foreground (without a rider or leader) with a straw colored striped blanket lashed on his back.

Still on the left, is a rhone a brownish greyish horse led by a man with a white shirt—greyish brown vest, no cap, with dull greenish velvet pants; just in the rear of the roane are two men managing a fractious white horse —other horses with their riders are approaching the principle group, all animated and interested in the prospect of having a great time at the fair. The animation of the group entering the gateway are full of life. The spectators on the rise of ground on the right are in fine contrast and keeping. The landscape is simple and the whole painting is full of air tints.

Rosa Bonheur has but few colors, and uses them for a good purpose. She is a master in foreshortening, and in relievo. The shadows are clear and solid—the whole picture is loaded with color—the handling of the brush is distinct. The lights of the clouds are put on with the palette knife. She is a remarkable painter and the vigor of her style and truth to nature goes home to every one who sees this painting of the Horse Fair.

I understand that Rosa—commenced the above painting on the bare canvas after having oild it with boild oil. The canvas is loaded with color. She keeps her outline soft or ragged as the case may be. She has the genious to keep her animals in motion as well as at rest.

FRENCH GALLERY

Plowing—by Madlle. Rosa. A very natural work. The man and his oxen are honestly at their business. The coloring is true to nature. It is one of her best. Price $3,000.00.

Dec 23, '57

A man currying a white horse's tail, in the sunlight—a fine effect—time morning. The sun a little to the left, the shadows approaching the foreground on the right of the artist.

[1857]

Simple subjects that are understood are the ones to paint.

When you have money procure models, and get to work —"willing or unwilling" to determine that the work with God's help shall be accomplished.
Will a painting to be finished, and go about it.

Strive more to paint from memory the scenes you witness. To sketch or paint them daily as they occur.

Read the lives of painters.

[January, 1858]

"Drinking water neither makes a man sick, nor in debt, nor his wife a widow."——Spanish Maxim.
Cold water is better for me than tea or coffee.

January 12th, 1858

Before leaving the City I had the pleasure of seeing Mr. Aspinwall's picture of the "Conception" by Murillo, now on exhibition at Williams & Stevens Gallery, on Broadway.

It is a noble picture, simple in color, little more than blue, black (brown) and white, red and yellow. The expression of the virgin's face is truly delightful.
The price $30,000.00.

Jan 15th, '58

Repeat your colors but not your ideas. Give expression to your thoughts.

Take your paint box and canvass, and go to your neighbour's house, or to his barn or to the meadow or river, or to the mountain top. Go any distance if it will be the means of producing a good picture.

Pictures are wanted, paint them—do not idle your time. Paint— Paint—the older you grow the more industrious you should be. Be ever active, have courage and confidence.

May 6th

My health is better for taking several rides on horse back—also for taken the syrup of the superphosphate of iron—a teaspoonful three times a day in a wine glassful of water. By Alex. Cushman.

In very hot weather the artist might paint by a flued light at night and sleep days.

Have a room in a corner house, with three or four windows. Use two windows while painting from models, by having a curtain between them.

The importance of painting from nature is, it hurries the artist up.

"Lay out your work on a broad and intelligent principle; whether you give much detail or little, it will command attention."

"Take blue, red, and yellow, and let a green be added to the group—the red will gain an ascendancy by the blue and yellow being harmonized by the compound color; or, in place of a green, let a purple be present—the yellow will increase in value from the same cause. This is the reason why cold colours have more force in a warm picture and warm colors in a cold."

Stony Brook, May 9th, 1858

The sun is out after a long spell of wet weather. We had the pleasure of seeing the first apple blossoms the 8th inst —they are nearly all in full bloom at this writing.

I have great reason to be thankful to my Creator for every happiness which I enjoy. I hope he will give me wisdom and continue to guide my heart and hand for *his Glory*.

In order to give more attention to painting than I have done for some time past, I must drop writing and reading to some extent and give my whole mind to the study of Nature, and endeavor to represent her in the most captivating and interesting way possible. To be serious, the art of painting where there are so many phases of Nature to be represented, should require my whole time. Therefore, I do hope that when the love of painting takes a hold of me, that I will be able to drive away all temptations that will lead me away from the path I have chosen. The art of painting stands high in the estimation of the world and I must try to do honor to its opinion.

Henceforth, I must go to my paint box "willing or unwilling" every day and worship God in doors and out (in his works) with the paint brush or pencil in my hand, and [illegible] should be induced [illegible] on a journey, or to visit, or go to a sewing society, to take my sketch book with me; so that I shall be in the way of being as industrious as any of the members. When all nature is so animated with beauty, why should I fold my hands.

Must my time be spent in looking and my hands at rest, when a glimpse of the western sky is visible? No, from this day let no trifle draw me away from my business,

from the book of nature which is bound by the most distant star that mortals can behold.

The Ideal: "The preference of that which is fine in nature." ——Hazlet.

Darken the windows of the interior you wish to represent so that your picture (with figures) will have a subdued look.

In small pictures paint on[?] silk.

"Coloring is the decorative part of Art." Colors should be so treated as to produce Unity; and that, as with lights and shadows, so whatever variety of tints may be introduced into a picture, they must be so blended and incorporated with each other, that they still form parts of a whole.

As well as Breadth of Chiaroscuro, there must be Breadth of Tone, the fundamental quality of Harmony.

Tone implies a degree of transparency, by a process termed glazing: viz, passing a transparent color over a previously prepared tint.

In remote objects during sunshine, the only distinction between the lights and shadows is to be found in the difference of tint, shadows being blue, or purple, and the lights a warm yellow, or fleshy color. It is usual in Oil to paint the distance stronger in color than it is intended to remain, and [ink blot] dry, to pass some very thin opaque color (technically to scumble) over the whole. Thus the most perfectly aerial tints are produced.

In Water Colors the too highly colered distance is washed out to obtain the aerial tints.

Colors are said to be supported by others which present some resemblance, but are inferior in brilliancy; as blues by purples, crimsons by reddish browns, yellows by orange. *Contrasted* by those which are the most opposite, as blues by orange or browns, reds by green, yellow by purples. *Balanced* when by opposition they are so neutralized that no one appears principal or predominant.

A small spark of bright color will balance a large mass of subdued tint. Equal brightness will require equal masses.

White and black give value to all colors and tones. With regard to the beauty of individual tints, [illegible] greenish blues, and greenish yellows; they both appear sickly; and never place such a green between blue and yellow as would result from the mixture of the particular tints of those two colors which are made use of.

Both blue and yellow become agreeable as they incline to red. Red becomes rich as it inclines to blue, brilliant as it inclines to yellow. All shades and tones of purple or orange are agreeable.

May 22d, 1858

Cool and wet—

To work mornings, and evenings, at sun rise and sun set, during the warm weather, I must paint before breakfast and supper; at such time the light is warm and the

shaddows cool. Models can be obtained at such times.

Thank God, I am active from being temperate, and cold water is the best beverage for me. Though I am getting in years it is my duty to attach myself more and more. . . .

[May, 1858]

I painted the Banjo player in eight days (16 sittings), two sittings a day. The Bone player in seven days (or 14 sittings), two sittings a day forenoon and afternoon. [These pictures were painted in 1856.]

About the first of January 1858, Mr. Charles B. Wood made me this offer—that if I would take a room in the City and paint pictures that he would pay the rent of the room and buy every other one of my paintings.

Stony Brook, May 24th, 1858

I have not painted in about two months. A resting spell is good for my health, also a time to think. Labor is a pleasure when the mind and health is in a good condition. I must not complain any more about loss of time, it is all right. We are governed by an invisible power, who shapes our time and condition, and we should take heed. I do not think it is idling when I am writing about what concerns my profession. We should know ourselves, and be ever mindful of our duty.

Stony Brook, May 27th, 1858

"Whom the Lord loveth he chastened." —I have had the piles for three days.

I use Fanny's Ointment made of blue lilly, or flower de luce, heel all and moss pink, or mouse ear. Use most of the blue lilly—boil them down and mix with hog's lard. — From Lewis Ruland. Besides, taking twice a day a small quantity of rheubarb root, and sitting in cold water— I am better for it.

Some recommend to wash the part in castteel soap and water. Worms, piles, rheumatism, colds and billious habbit I have been troubled with—I have the sick headache now at this writing. I must eat light suppers and use no drink but cold water. The Almighty will please give me wisdom and health forever.

To paint a landscape at twilight, paint the view by lamp light. Paint a moon light in the same way—also, a night scene with figures walking about with a lamp, or a bond fire, or a house on fire could be painted in the same manner.

June 4th, 1858

An idea came into my mind to day (as I had been thinking about using brushes with longer handles), to place the end of (the handle of) my brush into a port crayon—and if I wish it longer, to put a piece of a brush handle in the other end, thus [sketch of brush with extended handle].

"Onwards and upwards by slow degrees to noble art we rise."

"Yield not to difficulties."

During hot weather, I must try and paint from nature in the open air, no later than eight or nine in the forenoon and from four until sundown. The rest part of my time to be painting in doors, or reading, or sketching, or sleeping, as the case may be.

Rise early if we wish to see the freshness of nature.

June 6th, 1858

You can tone and strengthen your picture after a shower of rain if you desire it—then the roads, and roofs of buildings are of a lower tone.

Here what Cole the great Landscape painter says: "He thinks our time and mind is dissipated by newspaper indulgences. The artist must be exclusive, if he would be great."

If you love God and nature keep your mind and brush at work.

"Have confidence (says Rembrandt) in your ability, if you wish to shine as a painter."

Work, If you desire affluence, honor and esteem.

Commenced a drawing this morning, June 7th, 1858.

I feel thankful that I am permitted to commence work today after a rest of about two months and a half from painting—my mind having been more or less occupied with other matters. Besides, my health not being very good, I had not much inclination to paint.

It is singular with me I have long intervals of rest from painting. Perhaps it is wrong to put off work from day to day—after a while it becomes a habit to idle. Be that as it may, Rest and reflection seems like food to me.

June 8, 1858

Eat no fish (or clams) especially at night.

June 11th, '58

BACKGROUNDS

Back of the barn.
Mrs. Smith's horse shed.

SUBJECTS

Boys wrestling, and others looking on. In the foreground of a landscape if I think proper.

A Girl looking at some flowers. Landscape.

A man hoeing corn, on a side hill.

"Jairus' daughter" for Mr. Wood.

A boy sitting on a plank waiting for his companion. [In margin: waiting for his playmate—to teter with him.]

Boys shelling corn in a crib. [Sketch]

June 18, 1858

I noticed this morning that every kind of tree had a different shade of green.

Chew camamile flowers and take pulverized Turkey Rheubarb in molasses when you are bilious.

July 4th, '58, I made a drawing on canvass of Mr. Copcutt's horse [pl. 114]. 5th—painted the horse and dog. 6th—dead colored his dog standing up in a chair [pl. 115]. 8th—painted on the dog.

In his own catalogue of his works, Mount refers to both these paintings as having been done in the year 1859.

Vehicles— Drying oil mixed with thick copal varnish, and diluted with thin turpentine oil. A small portion of bees' wax may be added—without drying oil—it would dispose to crack.

The above to be mixed warm. The sun would make it light[?]. White Lac varnish is highly recommended in painting. Also borax. Lac mixed with an equal portion of oil of turpentine keeps its place and forms a fine empasto.

Desolve Dutch or purified borax in warm water—then add your oils and the color will hold its place. [This sentence was later crossed out.]

Wilson used linseed oil and oil of turpentine, thickened by the sun—and bees wax added hot—the parts warmed.

Stony Brook, July 16th, '58

To day I exposed to the sun Linseed oil, to bleach, also linseed oil and turpentine equal parts, also lindseed oil and Litharge—to make a drying oil. The latter is good. I have used it about the first of October.

July 22nd, '58

About sun set—sky greenish. Blue and warm purple clouds lit up with orange. Orange tints, purple clouds, sky greenish gray.
Blue cloud, orange near the horizon.

After sunset—sky yellowish gray. Blue clouds lit up with vermilion.
Yellow sky near the horizon. Trees brownish green.

To paint a sunset—reflect the sky in a mirror, then you have sufficient light on your panel—or canvass—while painting.

Still later in the evening the clouds are blue, later still, orange and gray sky, with redish purple clouds, orange sky near the horizon.

114. *Ariel.* 1859. Oil on canvas on board, 10 × 8″. The Museums at Stony Brook, Stony Brook, Long Island

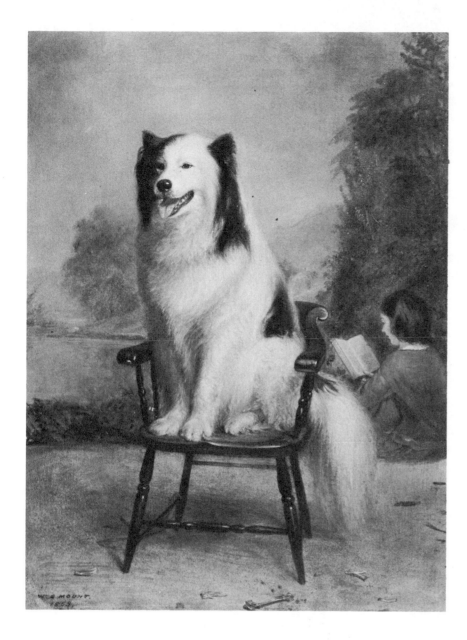

115. *Esquimaux Dog.* 1859.
Oil on panel, 17 1/2 × 12 1/2″.
Bernard & S. Dean Levy, Inc./
Sloan & Schatzberg, Inc.,
New York City

July 23d, 1858

Painted a head to day the size of life. I much prefer it to painting portraits of a cabinet size.

July 28th

First and second sitting, painted the effect of the head and bust—third sitting, glazed with blue, red and yellow and improved the likeness. By glazing and scumbling, at the same time paying attention to expression, form and reflexes, to throw the figure as it were from the canvass —good effect and flesh color can be produced.

Design your figure (or figures) and then look up your back ground. Paint your figure lightly—when dry, glaze in the effect of your background.

July 29th, '58

I give God thanks, my health is good. I take no other drink but cold water.

"Why will men put an enemy in their mouths to steal away their brains." Drinking is a habit. Industry is a habit, and so is—temperance.

"Chicago, Thursday, Aug 5th: One hundred guns are now being fixed in honor of the successful landing of the Atlantic Cable." ——Capt. Hudson—To his family.

Trinity Bay, August 5th 1858: God has been with us. The telegraph cable is laid without accident and to Him be all the glory. We are all well. Yours, affectionally, Wm. L. Hudson.

"Triumphant completion of the great work of the century"—The Message of Queen Victoria to President Buchanan.

The Presidents reply: Washington City, Aug. 16th, '58—Every body crazy with joy.

Stony Brook, August 19th, '58

Mrs. S. A. Mount died the 18th inst, aged.

August '58

I painted a portrait life size with much more pleasure and without spects than I did a cabinet portrait, with spects. First I made a careful drawing with white chalk and india ink—one sitting. First sitting in colors, painted as near the complexion as possible, and sweetned the colors with long brushes—had three sittings from the life. I improved this portrait when the Lady was not present.

Sept 2d, 1858

The Fathers of the Atlantic Telegraph. A picture—"Peter Cooper, Moses Taylor, Marshall O. Roberts, *Chandler White,* David Dudley Field, and Cyrus W. Field, met at the house of the latter, where around a table covered with maps, plans and estimates, the subject was discussed for four successive evenings—the practicability of the undertaking examined, its advantages, its *cost,* and the means of its accomplishment." The counsil of six.

Another picture—"Morse the inventor, Field the executive, Everett the mechanican." Trio.

Oct 7th

I have been sketching landscape in oil—good practice. If I should follow it up, I believe I would make a landscape painter. Nature, is the *father and mother of art.*

In painting Landscape I must make nothing of it, particularly the foliage and grasses—things must be known by their masses, a pleasing obscurity. It is not necessary to copy every thing we see before us, but to select with discrimination. It takes but a few materials to make a picture. Only a few well considered touches, in the fore ground while finishing, to make a landscape.

Oct 22d, 1858

In painting in the open air I must use an easel so that I am compeled to sit up strait to my work. By resting my picture on my knees and bending over to my work, has caused at two different times, a severe *pain in my chest.* I also strained myself in trying to shove a boat off the shore. The 5th inst. a heavy cold set in, besides a violent attack of pin worms—has troubled me for the last ten days. For the above complaint I have been taken Jayne's Tonic vermifuge—I do not like it—and Sanitine Pills—I do not like it.

Pink, senna and manna is said to be good for worms— sweeten with molasses and add milk. Also, a tea made of worm weed. I should stand while painting as much as possible. The 20th inst. I stood up and painted a background. It gives one a better opportunity to see the effect by stepping back from the easel, and more exercise. For exercise and to strengthen my arms I must use dumb bells.

To add to my bodily difficulties my left groin is much swoolen (from a cold) and quite painful.

"Cowhage is a good vermifuge, given in molasses, or arrowroot jelly. Salt and water is good to drink. Salt and water may be injected also."

Many diseases proceed from worms. "A woman was doctored for Dyspepsia; when she died, worms came out her mouth."

As regards my own case, I must take worm tonics of some kind. If I was cleared of worms my health would be good. Garlic and Gin, is said to be good for worms.

"Liver complaints a cause of worms and Dyspepsia. Large quanties of mucus generally mark a deranged state of the liver—healthy bile neutralizes it. A dose of Sanitine Pills should be given every night as long as there is a mucus or slimy discharge from the bowels, and until healthy, yellow bile appears in the emenation and a cure is effected.

"Symptoms of worms, and onlargement of the belly— The sleep is disturbed, irritation or itching at the lower end of the bowels, alternation of diarrhoea and costiveness and Rheumatic Pains of the joints, etc."

The dried bark of the root of Dog wood, pulverized and mixed with molasses, will expel worms.

I must play the violin a little more than I have of late, it is good for my mind and health.

Oct 31st, 1858

A very fine warm day— My health is a trifle better. While unwell I must eat but little meat, say once a day.

I must change my board.

It is time I began to think about painting some large Historical picture. *It can be done with the help of God.*

Nov 2d, 1858

I commenced boarding this day with my sister Mrs. Charles S. Seabury.

Nov 28th

My health is much better. I am working every day. Two bottles of Dr. Gedding's cough syrup done me some good. Roast potatoes with salt are good to be eaten, not to be ate too steady. Toasted bread moistened in warm water and salted—salt is more healthy than butter. It is snowing to day. Nov 15th we had quite a snow storm.

Stony Brook, Dec 28th, '58

Experience has taught me that if I ever copy another ambrotype (I hope I never shall, as they are bad for the eyes)—to obtain the effect, and finish as much as possible without the aid of the magnifyer. In the first place paint some distance from the Daguerreotype.

In the last sitting, glaze with red, yellow, and blue, to give strength where it needs it, and retouch the head with

different colors while wet. Paint the dark shadows first—and then the lighter receding shades. Nature, and sometimes good pictures, have but little light.

[1858]

"Nothing can be arrived at, in this world without physical and mental exercise conjoined."

To be remembered: If you paint over a panel or canvas that has been painted and thoroughly dry, with paint mixed with about two thirds turpentine when it is dry it will scale off. Particularly on an old painted ground, or very hard wood. It should be two thirds boiled oil and one of turpentine for durability. Or if the paint is too smooth and hard, your work will scale off.

Oil your panel first and before it is dry give it a coat or two of cream colored paint, or any color you desire.

Some artists paint their subject at once upon the bare wood, or canvas. [Added later:] and repeat, utill [until] finished.

To varnish over the back of your canvas with demar varnish would perhaps add to the durability of the painting. I[t] might set the canvas.

I am anxious to get more knowledge of Landscape painting so that I can combine figures with the landscape more readily.

To produce a representation of foliage—an old worn hog-hair tool having scanty hairs, and those of irregular length, is employed. Such a brush leaves a jagged, varying, busy touch. Sometimes the brush is crushed perpendicularly and flat upon the color on the palette and the points of the hair [illegible]—thus charged with color, the brush is held loosely between the thumb and finger, and the points of the hair touched upon, or rather jerked against, the work. The irregular scratchy-looking foliage thus produced, is touched and worked, while it remains wet, with small hog tools or sables. Fill a flat sable with color, and then draw it over a tooth-comb—the hair is divided into several points, from which the color is transfered lightly to the work. Color is laid in for grass by lightly touching the canvas, and jerking or flicking the brush upwards, so as to produce a free and natural representation of irregular blades of herbage. For long straggling stalks of grass, or for weed or hedges, a finely-pointed sable is used in a similar manner.

[1858]

26th— I commenced a portrait of Newton Ludlom from an Ambrotype and from a drawing after death—finished the the 27th of Dec. Finally I had to confine myself to the ambrotype, not knowing the boy.

Demar varnish and drying oil works well, with a little turpentine added. Also Japan with a little varnish and turps added, for blacks and browns.

[1858]

ORDERS

One picture, scripture piece, for David A. Wood Esq.

Two pictures for Charles B. Wood. One to be a scripture subject—price $500.00. The other two hundred and fifty.

N. Ludlum, No 7 East 17 st, desires me to paint him a picture—an Interior—with figures. This order has been given some time.

One picture for D. R. Barker Esq, No 1 Monroe Place Brooklyn—view of an Old Mill, or any thing I desire to paint. Price to be from $150 to $200.

[1858]

When about to paint a landscape, first, look at the relative strength of the colors, both of the sky and the land, from the horizon to the foreground, also, their gradations of light and shadow.

At sun set the gradations of the land are very strong in subdued colors—a solomn grandeur of greys, purples and dark browns, but no black—I mean in general effect.

Make small studies both at sun rise and at sun set and the strength of the colors will be soon understood. At such times, objects both animate and inanimate are bathed in a glory of light. Oh! the beautiful hour of twilight for lovers of art and nature.

If an artist desires to be everlastingly original, and not a manerist, he must always paint direct from nature—when it is possible.

ON VEHICLES

"Copal varnish, combined with linseed oil and oil of turpentine, affords a vehicle superior in texture, strength, and durability to mastic and its macgilp. Linseed oil is essential to prevent its cracking—strong copal and turpentine in equal portions with one sixth of drying oil mixed together, hot, afford this vehicle; and if about an eight of pure bee's-wax be melted into it, it will enable it to keep its place in the manner of macgilp." ——Field.

Demar varnish and a small portion of bees wax combined hot—would keep its place.

A small portion of turpentine might be added, if desirable. I shall Try it.

I am using Demar and raw oil equal parts.

Try Demar and Barbary tallow mixed together.

For durability use but little vehicle with your colors after they are mixed.

[1858]

Order your canvas or panel white and then you can paint it a light cream color—if you desire it, with white, yellow ochre and a little vermilion—an orange tint.

For durability, it is important to have a ground that will sustain the colors in the most brilliant manner, and perfectly dry. It is pleasant to look at pictures, but instead

of being carried away captive by the works of others into an imitation, keep at work and look at nature for ourselves. We must not lean to much upon the ideas of others, but think for ourselves.

"It is necessary that theory and practice should proceed together; otherwise, however well your taste may regulate your choice of form and color, your hand will be unable to obey the dictates of your eye."

OF SKY

Commence at the top of the canvas or panel with (the best) blue white and a little Naples Yellow—and increase the white and yellow, as you go down. Some paint the Horizon first. Mr. Church says he paints the distant objects first, he mixes up a set of sky tints of different gradations to facilitate his work.

OF SKIES

If black is required for a gray, use Frankfort Black—made of willow twigs.

In all your pictures have life, action and expression.

"The true effect of nature consists always of certain mixtures of softness and precision."

Try and represent the gradations of color and of light and shadow so natural in your painting; that it would appear as if you could step inside of the frame and walk about.

[1858]

SUBJECTS

A white man looking at the grave of Uncle Tom.
Bryant's water fowl—I must make a study.

Woodman spare that tree. For G. P. Morris.
Six oranges for a shilling—Large size.
A young and beautiful female cleaning a window. Oh! what a look she gave.
Out of funds at an apple stand.
A child playing with a sun beam.
The shoe maker—to be painted on the spot.

SUBJECTS

A Dog pissing against the skul of a Horse.
A Girl or Young Lady, in full dress, making signs with her fingers for the omnibus to stop.
Workman looking out of a window to see the the military.
A white woman, or a colored woman—drawing water out of a pole well.
An old man standing at the grave of his mother.
A boy riding on another boy's back—or a man's back.
Over and under—two children looking over and under a fence.
A man, boy, or Girl, lighting a lamp.
Effect, A Sail boat, in almost a calm, between the spectator and the sun.

"At dawn, when first Aurora's light reflects o'er hill and dale, And gilds the dew washed lily's head, that sleeps within the vale; When first the lark shall plume his wing, and soar from bondage free, To warble forth some merry notes, Then give one thought to me.

"And when the shades of evening are fast falling into night, An hour, that well seems made for thought, and quiet is in delight, etc." ——From Lewis Hess.

"Reclining soft on many a golden cloud." ——Rowe.

Morning and evening is the time for the painter to color from nature.

john m. falconer

John M. Falconer (1820–1903) was a joiner. He was active in the affairs of the Art-Union, the National Academy of Design, and other artistic societies, and there is scarcely an American artist's biography of the nineteenth century from which his name is absent. Falconer was himself a painter, etcher, and enamelist, but he derived his income from business. The Windle & Company to which he refers in these letters, and by which he was employed, is listed in New York City directories as "importers of hardware, plated ware, and cutlery."

A.F.

Stony Brook, Dec 13th, 1856
167 Hudson St.

J. M. Falconer Esqr, Your good nature will not allow you to scold me when I tell you that I have not painted you that picture. The fact is I do not always paint. After I left you my health was not very good, about the last of July I was attacked with the rheumatism, and lost for a time the use of my right arm. I have been stopping the last four months by the harbor side—two miles from my studio—health good, and thankful for past favors. You will naturally conclude that I have had some sport at fishing, and sailing—even so. I have taken the liberty to make a (variation) copy from your little french picture. ~~Also~~ my last work, a portrait of a child after death—another to be painted imediately of a young Lady, taken away in the bloom of life. At times, it did appear as if my only patron was death. Therefore, consider death not as an enemy but as a friend.

My visit at your house I remember with pleasure, the choice books and Engravings you have collected, and paintings, by artists of your own acquaintance; besides, the sketches in oil and water colors done by your own hand during leisure hours, from your wareroom[?] give evidence of a love of nature and art truly gratifying and worthy of imitation.

I hope to see more of your work when we meet again. If the picture ~~humour~~ fever ever comes over me, I will try and hold you in rememberance.

Yours truly,
W. S. M.

[NYHS]

N.Y., Dec 20, '56

Dear Sir,

Glad you are now well and have the brush in hand. I reply to your welcome tho unexpected favor of the 16th inst. I trust your pains may have been like fire to gold a purification leaving you in purer mood and health, able and ready to work smartly and successfully on some of the subjects your treatment of which has given pleasure to so many of the hardworked of Gotham. I am sure I would have been sorry had I known just when you were sick, but now you don't suffer you won't ask me to sentimen-

talize and give utterance to a pity that could do nothing for you—but do try hereafter and let rheumatism alone. I have had twinges of it that made me very savage and entailed rubbings of liniment etc that were exhausting to a doctor's bottle and fatiguing to my arms; latterly I have had none of it. I found *black silk* laid over the sore spot, a very good shield to much of the pain.

I am glad you are painting and I feel certain you are glad. This winter you can do much—maybe in spring I shall be favoured by you and have another specimen of an artist's works which I admire and I trust appreciate. Half the interest I have in my pictures, are in the knowing of their authors, with whom it has been my advantage to spend many pleasant hours. I have no ambition to form a large collection but I wish a representation of the best of my friends. I did not suppose you had got to fever hight with my picture—made up my mind to wait and must wait your time, but I trust after a time you will give me evidence you have had a good time and had me in view. You speak of Gay's picture which you copied. I should like to see it when you come to town. Gay's house will be completed in two months. He will not want it till then, and you need not go to any trouble sending it before then, unless indeed you favour us with yourself in person. Shall we not see you soon, if so [illegible].

<div style="text-align:right">Yours very truly
J. M. Falconer</div>

I regret, missed you on your calling.

If you are not engaged tomorrow come up and take a bit of a family dinner with us. I will be home all afternoon and very much like to see you.

[SB]

<div style="text-align:right">New York, Feby 28th, 1857</div>

My dear Sir,

I foisted off a very short letter on you some time ago, and now, a momentary respite from the constant hubbub of city occupation affords me opportunity of making amends and I doubt not acceptably to you, as the object is to enclose to you a sketch of celebrated "fabricants" of your favorite musical instrument, the expressive violin. I cut it out of an *Evening Post* a week ago meaning to mail it at once, and only since I sat down to this came to me the thought that it might be old matter to you. If so, still give me credit for the deed, and live in hopes that I may at some future time send you something of a fresher interest, but you and violins were so inseperably connected in my mind I could not resist excising it for you.

Some two weeks ago I had the pleasure of seeing your brother for a brief period and I had hoped to have seen him again before this but have had such a heap of engagements in the time, I have been very little at home. He told me you were at work on portraits, which was in some measure satisfactory, but not wholly so, for I had hoped to hear you were making canvasses more valuable, by putting on them some of the pleasant happy subjects you

used to treat so successfully. The Academy is to have the old building[?] opposite Bond Street and there will be lots of room. I earnestly hope to see you represented in such a way that all friends and admirers may participate in new delights and from them have the more vivid recollections of the good things of the past.

The Exhibition will doubtless be good—the enlarged rooms will be attractive, and growing numbers of art brethren growing in strength will by their more numerous and improved contributions add to the attraction. Edwin White will have some good things. Cropsey's "Warwick Castle" and "Mt. Jefferson" painted in England may be expected. The Young landscapists are doing well, and some of the older ones are well supplied with commissions. R. L. Stuart has recently given Durand, Kensett and Gignoux something to do. Stuart, you know, is in the Sugar business now, having dispensed with the Candy business at which the money that has given him a palatial residence on 5th Avenue was made. A Mr. Wright, of Hoboken, a Cotton Broker, is also patronizing art—he has bought a picture of the celebrated Rosa Bonheur's for $8,000. It is now engraving in Paris. He has also in contemplation a set of 4 pictures (embodying celebrated men of America) for his dining room. Statesmen [illegible] Artists and some of other vocations whom I can't think of now. Baker, Elliott, Huntington, and White I have heard named to execute them, but my impressions are, they are not yet to be put among "Fixed facts." White is painting "A New England Thanksgiving" and "A Hugenot Hymn at sea." You will have noticed that he is to paint for the State House at Annapolis, Maryland, "Washington resigning his Commission," to be 8 by 14 feet. He has made his studies of the room and is now about a study for the composition. He intends leaving for Paris about next June, accompanied by his wife, and a real kind sustaining spirit she is to him. We poor old batchelors don't scarcely understand what we lose in not having "better halves" —and a generous being of this clan has friend White been blessed with.

I have a long letter from Cropsey, would you like to read it? If so? say so! and I will mail it to you for perusal. It has interesting matter anent London, and art and artists. Hart promises to send me home a picture he has newly completed for me—it is a Scotch Castle with sea coast designed to hang with Cropsey's Donne Castle which you know is deeply esteemed by me. Hart is so conscientious and painstaking that I feel certain of something good. What are the chances of your getting to town soon? My friend Gay whose little picture you had to copy has got his house completed and expects to have it furnished by middel of April—so if you can conveniently send it by that time it will be in ample season.

Let me hear when you will be in town, and what you are about—when you have leisure.

I am half possessed with the idea of moving to Brooklyn with a view to getting out of the gradually enhancing cost of living here. The winter fogs and detention from ice are somewhat of a bar however and I am quite unde-

cided though in looking about I have gained some knowl-
edge of Brooklyn and of the value of brick and frame
buildings.

May you ever be well and happy is the sincere wish of

<div align="right">Yours very truly
John M. Falconer</div>

[SB]

New York, Sept. 21, 1857

My dear Sir,

Your favor of 18th inst. at hand this morning.

I am at home, and expect to be all this winter. Come
and see me when you are ready?

Your intention as to my picture, pleases me hugely.
Send it to me when convenient, or when you are coming
to the City on other business, bring it with you—but
do not deliver it to me at the store, fine art is "tabooed"
there. I am ready for the picture, whenever your conven-
ience is suited. If you come at once I will have to give your
picture the old frame. If your visit, or the picture, or
either, or both, are delayed, I can have the new frame
ready—that is, if you let me know by return mail
—two weeks ought to suffice for the getting up of the
frame. I did not get a frame ready for I thought I should
owe[?] more to the future, before you would be forthcom-
ing, but your ready fulfilment of my desire, renders me
more firmly a believer in the doctrine that artists feel
more warmly for those, who knowing art, love it for
itself.

Several times, a notion seized me to write you, but
delicacy prevented me, for I feared you would see a nigger
in the fence in the shape of myself, importuning you to
be up palette and doing my picture, but that is over and
if time serves you may hear from me hereafter.

. What besides have you been doing? Know you the
N Academy have new rooms—that we are to have an
Exhibition of English pictures, as early as next month,
among the names are Turner and some of the Pre Raph-
aelite great guns?—that Williams & Stevens failed—
that Nodler has bought out Goupil's and Co. But I must
end now to pen some quittances of my foreign friends'
claims on one which have been put aside for want of time.

Looking for a reply from you per mail or *in propria
persona,*

<div align="right">I remain
Very Truly Yours
John M. Falconer</div>

P.S. Please address me "Care Windle & Co," which en-
sures an earlier delivery to me of letters.

[SB]

New York, Sept. 26, '57

My dear Sir,

Yours of 24th at hand. I did not intend putting your
picture in an old frame save for the temporary showing of

it, to you. I wanted to have the Diaz and your picture
match in size and in frames, but as you give 10 × 13 1/4
Inches sight and the frame I have just measured gives only
in sight 9 1/8 × 12 1/8 Inches, there will have to be a frame
made to suit yours specially and some 2 weeks will elapse
before it is ready. The pattern is so quiet: if you remember
it, it will I think be what you like.

You do not say when you expect to come in town—
pray advise me on this point. Gifford is just back—is at
Hudson. I met Elliot yesterday, he looks pretty well.

Do you say that the frame if it is 10 × 13 1/4 Inches will
be enough to cover your picture so as to look neat and
leave no undesirable space.

Your early reply will oblige

<div align="right">Yours very truly,
J. M. Falconer</div>

[SB]

New York, Oct. 16, '57, Mday P.M.

Dear Sir,

That frame is not yet done, but—will be before the
banks resume specie payments—probably in 8 or 10 days
if there be gold leaf enough in the land where with to
cover it over.

The English Exhibitions open to private view on Mon-
day 19th from 9 to 5 and 5 to 7 P.M. at the New Academy
rooms in 10th St.

The French Exhibition in Old Art-Union rooms opens
to private view on same day—you better come and see
both.

I have given the "Mischievous drop" to a friend to pho-
tograph and mayhap I can get a copy for you at an early
day. My friend is very much pleased with your success
in the picture and thinks the Expression and rendering of
the heads capital. He is the only one who has ever or will
see it, till it is in frame, except my sisters whom I permit-
ted to peep at it—they declared it was beautiful.

What did you think of the Horse fair by Rosa Bon-
heur? I have not seen it yet, so can offer no opinion on it.

The suspension of specie payment brought not the relief
that the "shorts" expected—money to debtors is as scarce
as ever and the only change seems to be that people
generally look happier.

<div align="right">With best regards
I am truly yours
J. M. Falconer</div>

P.S. Dr. Magoon has had a call to the 1st Baptist Church
of Albany.

[SB]

New York, May 6, 1858

Dear Sir,

Some of the Landscapes in the Exhibition are to be
engraved on wood and published in the Illustrated Paper

issued by Leslie. W. Parsons, whom you have met, makes the drawings on the wood, and sends me a note asking me "to write to W. S. Mount for a sketch of 'Any Fish to Day?' for the illustrated article in Leslie's paper, any size he choses. I ought to have it by Tuesday next at latest." Now I obey him at once in hopes that, you may be inclined to give him an opportunity of giving publicity to one of your pictures, that you may have whatever reputation grows out of such. If you will enclose a sketch to me by mail, I will see that it is put in Mr. Parsons' hand instantly that no time may be lost.

If you are unwilling to do anything please advise me so by return mail as Mr. Parsons may wish to give somebody else a chance.

The sketch may be either in Pencil, Pen and ink or India Ink, sepia or oil and will be taken care of and returned to you. Mr. P. does not say what size the engraving will be, but he can enlarge or reduce it to proper size.

It is likely that Blauvelt's "Warming Up" will be one of the set.

How are you? How have you been? What are you about? All of these you may solve if you have liesure to drop a line to yours Very Truly

J. M. Falconer

P.S. *Harpers Weekly* gives you a notice for "Any fish to day." McMarten scores up still, hard rubs at the hanging committee.

Frodsham is here but merely to settle up matters relative to the "Horse fair" which has gone to Mr. Wright's Gallery at Weehawken. The French Exhibition entailed a loss of $4,000 dollars.

Care Windle & Co.

[NYHS]

Stony Brook, May 8th, '58

My dear Sir,

Your note is at hand, I have no desire to have "Any Fish to Day" engraved (at present), notwithstanding, give my best regards to Mr. Parsons.

Please remember me to Mr. Frodsham.

Yours, Very Truly,
Wm. S. Mount.

P.S. I seldom preserve a drawing after the picture is painted.

[NYHS]

New York, June 28, '58

My dear Sir,

I saw in Philadelphia a few days ago part of your family —one of your children, altho in the party was 6 children, partaking of or delighting in a *muss* which your flock generally have not done. What I saw and was much pleased with was your "Take one of your size," a work of yours that I had never seen before either on Canvass or engrav-

ed. I was instrumental at an auction where it was offered, in helping to bid it up which I did as far as $150, but after that longer purses were of more avail and at 165$, Edwin Forrest became its purchaser as he also did a work of Leu ze's.

Your picture was dated and signed 1830, was in good sound condition and order and colour generally in full freshness altho the thinnest paints had darkened most. The lettering on the book is as distinct and clear as if it were yesterday's work, and the little *bantam boy* of rueful countenance has his *clarets* as pure as when you first drew it off your palette. It was in the collection of a Mr. Jones who had met with bad luck and whose home and household gods had to pass under the red flag of St. Peter's.

You doubtless remember the work and it ocurred to me that a slight recall of it might be pleasant for you as there would doubtless be stored away in memory random facts of interest that were connected with it when produced and which lapse of time and new interests had almost given the go-by to.

I suppose you will be up to the Academy closing but if Wednesday be as hot as to day the suffering will be great —for those who are compelled to spent themselves.

What are you about in these dog days? How is the fishing? Do the fishes bite when thermometer and barometer stand so exalted.

Wishing you ways of pleasantness and paths of peace.

I am very truly yours,
[SB] John M. Falconer

Stony Brook, July 1st, '58

My dear Sir,

It is gratifying to hear from you, and also that you made an offer for some of my stray children and found them in good condition. Although, they are in good hands, I should have been well pleased, had you purchased them. I have been using the brush about a fortnight (after two months and a half spent in tinkering at other matters). I hope from this time to give more attention to painting. Fish enough to be had for the trouble but I have not been out this season. I shall be pleased to see you at the Stony Brook Hotel (where I am at present) when it will best suit your convenience. Give my best regards to your mother.

Yours truly,
[NYHS] Wm. S. Mount.

New York, July 6, '58

My dear Sir,

Yours of July 1st came duly in hand and I would have made reply to it sooner, but that the Anniversary of the Nation's Birthday was immediately ahead and gave me less liesure. That is now over, and I hasten to acknowledge your kindness in asking me to make a visit to Stony

Brook, a pleasure that I hope to accomplish later this season, if you remain at your present quarters. I have arranged to go up the North River this week as far as Kingston, where some subjects that I am fond of, are located and which I mean to transfer to my folio if I possibly can. My absence will not extend over a week and after that has ended some weeks will elapse before I can go off again.

Good Mrs. Crocker gave me the Mischievous Drop off the Walls of the Academy twenty minutes before the exhibition closed. I posted home with it and put it on the wall where I feel sure it looks better, and if not admired by so many it will have a more thorough appreciation from the few.

The last of my gettings has been a sketch by Ranney which possibly you have not seen, and a sketch pronounced Horace Vernet's will be new to you.

The Artists are all off and there is a dearth of art news since Gignoux sold his picture of Niagara for 5,000$—Williams & Stevens are to engrave it as a pendant for Church's. 3 pictures from Cropsey are here—are good—better than his last, larger works altho they gave satisfaction to their owners. I am glad you are again to take up palette and brush and hope pleasant weather and quiet mind may enable you to give birth to something nice.

I will send you a catalogue of the Philadelphia sale as a leaf of time's present journal.

My Mother and girls are well and desire their regards to you and hope the pleasure of seeing you here before long.

<div align="right">and I remain Truly Yours,
J. M. Falconer</div>

[SB]

<div align="right">Port Jefferson, May 9th, 1862</div>

My dear friend,

As regards the Presidency I am pleased to hear you speak so well of both candidates—but I agree with you that Mr. Huntington is the man to fill the chair. The friends of Mr. Gray should feel proud that he is Vice President and rest satisfyed, and put in their strength for Huntington. I have not seen my Brother yet. He has for years predicted that D. Hunting[ton] would be the President of the National Academy. We will try to be on hand and see how the barometer stands. "A Home in Missouri" etc. is good. You must do more. My regards to all. In haste.

<div align="right">Yours truly,
William S. Mount</div>

[LOUISE OCKERS COLLECTION]

<div align="right">Portable Studio
Setauket L.I.
Oct. 30, '64</div>

My dear Falconer,

I am not dead but living. Thanks to your dear mother that your memory has been strengthened concerning me. It is truly gratifying to hear from you—from one whose soul expands with every good thing under the sun. I am pleased you are interested in the monthly meetings of the L.I. Historical Society and hope to pay my respects to the Librarian with you before many months rolls around.

You say the Artists have not achieved much during the past season. In this part of the country it was too hot and dry. If one attempted to paint in oil the gnats would do the most daubing—they would seek death in their admiration of the colors. What annoyances we painters have.

I will try and send a painting to the Artists Fund Society. You may expect to see me for a few moments this week.

Please give my best regards to your good mother and sisters.

<div align="right">Yours truly,
Wm. S. Mount.</div>

[SB]

a mount miscellany: paintings

This is a group of paintings by Mount about which there is little or no documentation.

We begin with two studies for pictures that seem never to have gone beyond the preliminary stage; if they did, the completed works have been lost. The one known at Stony Brook as *The Letter* or (less justifiably) *The Farewell* is unique among the works of Mount for its tragic, melodramatic subject matter (pl. 116). The father sits dejectedly with the letter in his right hand. The mother makes a gesture of despair. The child looks up questioningly. Through the window, the bearer of bad tidings is seen trudging off down the road. It is easy to see why Mount, the painter of "comic" pictures, probably did not pursue this idea any further; no doubt, however, he had some details in mind which would have given the work a more specific point than is revealed by the study.

The Volunteer Fireman, a tiny watercolor at Stony Brook, is more in Mount's accustomed vein (pl. 117). One child points to the fire through the window. Another hands his father his fireman's trumpet. All four characters—father, mother, and children—seem to be taking the fire alarm with the utmost equanimity, grinning from ear to ear. Here again, the final product, if there was one, would doubtless have contained more than the sketch.

Costumes Drawn at the Bowery Theatre January 23, 1832 (c.pl. 35) is in much the same vein of watercolor as *The Volunteer Fireman,* with its similar grinning faces. They are charming pictures in their own right, and they help to date the other work.

Reuben, one of Mount's more impressive early portraits, dates from the same year, 1832 (pl. 118). Reuben is a shadowy figure. The subject is said by some around Stony Brook to have been a gardener, by others to have been a field hand. Indeed, the sitters for many of Mount's portraits, both male and female, are now unknown, their identities having been lost over the years. The portrait we reproduce next is of a known subject, although the painting itself has been in private collections ever since it was painted, has never been publicly shown, and is reproduced here for the first time (pl. 119).

The Card Players is a work of Mount's full maturity, listed in the inventory of his estate but otherwise entirely undocumented (c.pl. 36). It was "lost" for many years, but was discovered in 1965 by Theodore Stebbins of Yale in a private collection in Massachusetts. It provides a wry comment on the mores of rural America in the middle of the nineteenth century. The two card players have sloped off to hide in a ruined building and indulge in their little game. The Mark Twainian revolt implicit in the subject of the picture is made quite *explicit* in one of its details: the book with a title page reading *Sermons,* which lies among the discarded things in the trash barrel on which the man at the right is sitting.

One expects the paintings in the world's greatest museums to be completely documented, but there is not a word among all the letters and papers by or relating to William

116. *The Letter* (*The Farewell*). May 11, 1862. Oil on canvas, 3 1/2 × 5″.
The Museums at Stony Brook, Stony Brook, Long Island

117. *The Volunteer Fireman*. c. 1840. Watercolor on paper, 4 × 4 1/2″.
The Museums at Stony Brook, Stony Brook, Long Island

Sidney Mount concerning the *Long Island Farmhouses* at the Metropolitan Museum (pl. 120). It is typical Mount in its subject matter and treatment. Someone has guessed 1854 as its date, and that will do as well as any other, since the work is obviously neither early nor late in style; it bears no date from the artist's hand.

The sprig of currants, dated July 22, 1856, is typical of numerous small still lifes of fruit and flowers that Mount produced in his last years (pl. 121).

We end with two of Mount's most prophetic productions. *Banjo Player in the Barn* (c.pl. 37), listed as *The Banjo Player* in the inventory of the artist's estate, is an extraordinarily moody, Eakins-like picture; it is even Eakins-like in its somber color and the modeling of the figure in the light. Charles J. Werner, the historian of Long Island, told Bartlett Cowdrey and Hermann Warner Williams, authors of the first study of Mount by professional art historians, that the picture was unfinished and that Mount intended to add dancing figures in the space behind the banjo player. If so, one rejoices that he never did so.

The Artist Sketching is an impressionistic self-portrait (pl. 122). The contrast between the woods with which he is surrounded and the vista of snow-capped mountains on his easel is a good joke; the dense, rich, nervous brushwork throughout the painting shows that Mount was capable of experimenting in ways other than those in which he had been trained and had won his following.

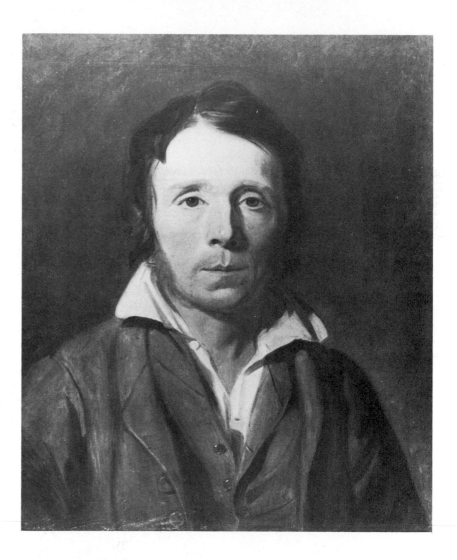

118. *Reuben*. 1832. Oil on canvas, 21 1/2 × 17″.
The Museums at Stony Brook,
Stony Brook, Long Island

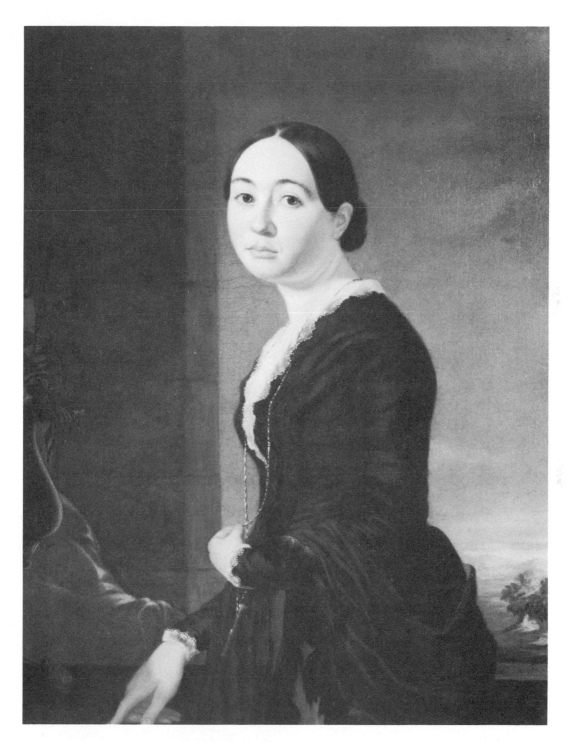

119. *Mrs. Ebenezer Beadleston*. Date unknown. Oil on canvas, 36 1/2 × 28 1/2″.
Collection Mrs. Walter Corrigan, New York City

120. *Long Island Farmhouses*. c. 1854.
Oil on canvas, 22 × 30″.
The Metropolitan Museum of Art.
Gift of Louise F. Wickham in memory of her
father, William H. Wickham, 1928

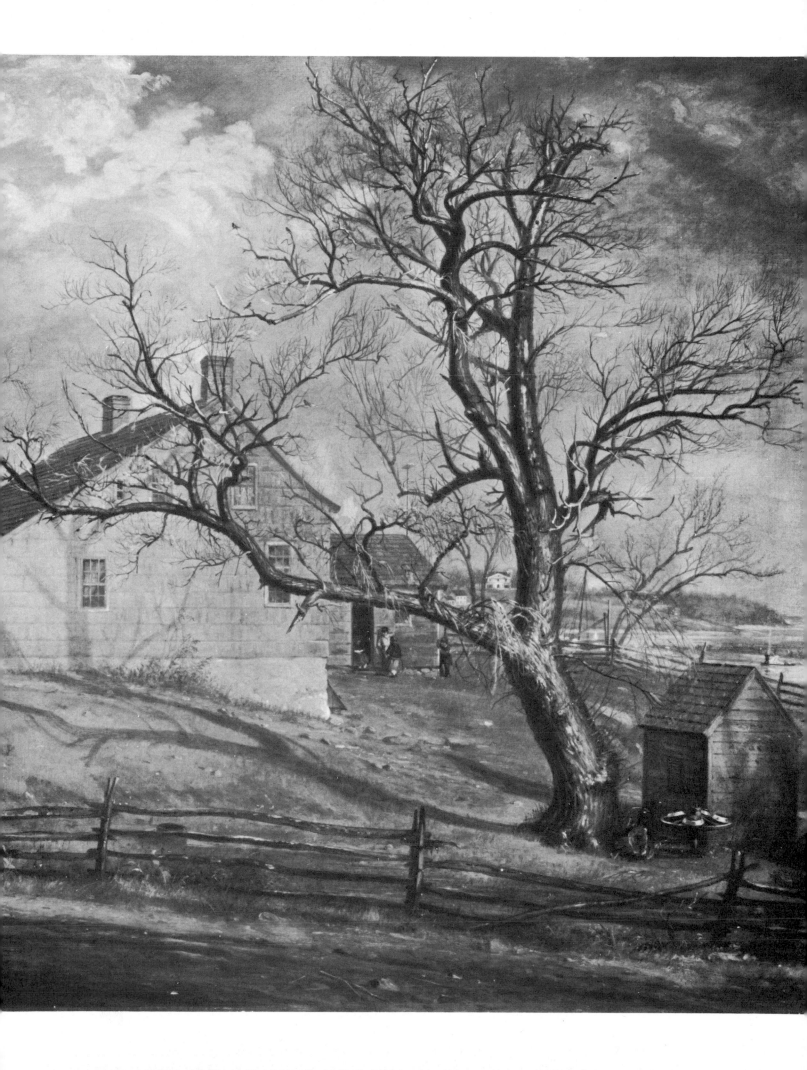

121. *Currants*. July 22, 1856. Oil on paper, 10 3/4 × 14 3/4″. The Museums at Stony Brook,
Stony Brook, Long Island. Melville Collection

35. "Costumes Drawn at the Bowery Theatre." January 23, 1832. Watercolor on paper, 4 3/4 × 3 1/4".
The Museums at Stony Brook, Stony Brook, Long Island

36. *The Card Players*. Date unknown.
Oil on canvas, 18 5/8 × 24 1/8″.
Reynolda House, Inc., Winston-Salem, N.C.

37. *Banjo Player in the Barn*. c. 1855. Oil on canvas, 25 × 30″. The Detroit Institute of Arts

122. *The Artist Sketching*. c. 1855. Oil on paper, 9 × 6 1/2″. Present location unknown

correspondence 1856-58

H. W. Parker to WSM

Brooklyn, N.Y., Jan 22nd, '56

Dear Sir,

By request of Geo. Morris, I am writing a series of notices of "Studios of American Artists," the first of which is to appear in the *Home Journal* of this week.

I shall be greatly obliged if you, or a friend of yours, will write me a letter-post page in reply to this, letting me know, in a sketchy way, something about your studio, and its situation, and outlook, what is to be seen in it, what pictures you have finished and in progress, as also what special merits your intelligent visitors find in them. After writing about those in N.Y. I would like to notice artists in the country.

[NYHS]

Yours very respectfully
H. W. Parker

WSM to H. W. Parker

Stony Brook, Jan 24th, 1856

H. W. Parker Esqr.

Your letter, and the *Home Journal,* inform me that you are walking amongst the artists to see if they have been busy, and at the same time chronicleing to the world their merits, as painters. As to myself and my brother, Shepard A. Mount, we are wintering at Stony Brook not being fashionable enough to run away from the scenes of our childhood. We are engaged chiefly in portraits both in the City and Country as calls may happen.

As to a description of our studios, I will refer you to an article (No. 80. For August 1851) in the *Whig Review,* by Wm. A. Jones Esqr.

[NYHS]

Yours, very truly,
Wm. S. Mount

Rev. Elias L. Magoon to WSM

24 Market Street
March 8, 1856

Dear Mount,

Please hear me for my cause and *yourn.* Before the birds come out to be shot, and the foolish fishes snap at your naughty hook, just set your highness down good-naturedly and make me a picture. A pig in distress, a "nigger" entranced, or any other angelic subject will do only let it be a nice small bit with brains in it.

This popping the question has been in my bones a long, long time, and now it is out because *I do* want a specimen from a man whom I esteem, and an artist whose genius I have for years admired. My dear fellow will you jot me down a bit and name your price? I will garner marriage-fees and work extra anywhere just to possess what you can do, and if I were not a parson, and you were not so smart, I'd lick you if you refuse.

[SB]

Yours amiably
E. L. Magoon

WSM to Nathaniel Smith

Stony Brook, Jan 26th, 1857

My dear Sir,

As I have completed your order (a very arduous one), it is proper for me to state at this time that it is not common for artists to make sketches of persons after death, and from those sketches paint portraits. I believe I am alone in this part of the art in painting almost from memory. Painters often take likenesses after plaster casts or from Daguerreotypes, and these charges are much more than from the life. I have found by experience that painting after death costs me double and treble the time that it does to paint from the living. Therefore, I give you a list of my prices for portraits (from life) in the country.

Size —27 in × 34 in with hands—	$100.00
Size —25 in × 30 in with one hand—	$ 85.00
do —25 in × 30, head and bust only—	75.00
Head and bust of a child, life size—	50.00

Portraits taken after death double price—even at that price, I am not paid for the anxiety of mind I have to undergo, to make my efforts satisfactory to the bereaved friends and relatives. Taking all things into consideration I shall not charge you in this instance quite so much. For the portrait of your daughter Sarah Cordelia, $125.00. For the portrait of your son, seventy five—

$125.00
 75.00
―――――
$200.00

Yours truly,
Wm. S. Mount

[SB]

W. Alfred Jones to WSM

Col. Coll
Mch 4, 1857

D Sir,

At a meeting of the Trustees, yesterday, I was directed to write to you requesting the removal of the full length of Bishop Onderdonk. In the new college there will be no place where it can hang nor do I see what is to be done, if you don't take it away, except to roll it up carefully.

The college will move toward the end of April, won't you meantime let me know your wish.

I spoke to Dr. Haight about Trinity Church and the Theol. Seminary. But he says he can't see *any* place for it. Perhaps Dr. Seabury or Berrian, might suggest some plan.

Sometime hence it will doubtless possess a peculiar value as a work of historical portraiture, for churchmen.

Pray write to me soon that I may send your answer on to its destination.

My portrait of you is printed in my new 1st vol. of a new edition of my writings. I sent a message to you more than two months ago which I suppose you never recd. It is now too late. My best regards to all your friends.

Yours very sincerely
W. A. Jones

[NYHS]

WSM to William Cullen Bryant

Stony Brook, May 6th, 1857

My Dear Sir,

The first of July 1849—I thought of a plan to propel a boat with great rapidity, she being partly sustained by the aid of large cylender (or drum) wheels—air tight.

The paddles on the outside of the rim, and fastened to the arms which lead from the shaft thus [pl. 123] to have from three, or two to six wheels on a side, and to be driven by steam. I had been thinking of this plan from time to time—until a few days since, a Gentleman (residing in this place by the name of Nathan Oakes) mentioned to me the same idea. I observed, it was a singular coincidence, I having a memoranda of it. Mr. Oakes proposed at once, that we should obtain a patent together. The wheels as well as the boat is the sustaining power. His opinion is, that with wheels forty feet in diameter, she can be driven from N. York to Albany in one hundred and eighty minutes. When the wheel boat is in motion she rises on the surface of the water, leaving keel enough to steer by. With twelve wheels, it would require the boat to be about fifty five to sixty feet in width by three hundred in length. The size and number of the wheels, would govern the length and breadth of the wheel vessel.

To the commissioner of Patents, I said—at the bottom of the note—Please remember, that we intend to obtain a Patent for the above plan.

You may let the public know of this plan, if you think proper.

Yours very truly
Wm. S. Mount.

P.S. I regret to hear of Crawford's illness.

[Memorandum by Mount at the bottom of his copy:] I forwarded one let. I sent to day (May 7th 1857) a copy of the above Invention, dated May 5th, '57, to the Commissioner of patents at Washington D.C.—also, a copy to Nathaniel P. Willis, of the *Home Journal,* dated 6th '57.

This paper was read this day May 7th, '57, in presence of Mr. A. Mills, Mrs. Mills, and Richard Davis. Mr. E. Oakes read, and saw all the three letters. It was read yesterday by Mr. Richard Wood of Brooklyn, in presence of the Miss Mounts.

I sent a copy of this letter to Mr. Nathan Oakes.

[NYHS]

Thomas S. Mount to WSM

Trinity Building, Oct 24, 1857

Dear Sir,

I am going to ask you to paint me the tins which we will give you. I want him to bring them down with him when he returns. You will see below how I want them painted. By granting me this favor you will save me a few quarters and greatly oblige

Yours etc
Thos. S. Mount

*drum) wheels - air tight.
- of the rim, and fastened
om the shaft thus___ to
ix wheels on a side
. I had been thinking
time until a few days since
this place by the name of
. to me the same idea. I*

123. Paddle wheel. Letter WSM to
William C. Bryant, May 6, 1857.
The New-York Historical Society

Directions.

1. The largest tin to be painted: white ground with black letters and narrow black margen, as follows.

Thos. S. Mount	
----------------	48
Atty & Couns at Law	

The name to be in block capitals and the "atty & Couns at Law" to be in italics and small letters except the A, C, and L, which begin the important words, which should be capitals—and 48 as represented.

2. The other two with black ground and white letters with a white stripe upon the margin, simply the name upon each.

| Thos. S. Mount |

Thomas S. Mount to WSM

New York, Nov. 18, 1857

Dear Sir,

I received your letter this afternoon. Mac told me that you could not paint upon the tins I sent home, without a good deal of trouble, and then they would probably not be likely to last very long. I therefore purchased two more, which have been Jappanned, and have sent them home on board the Cabinet.

Since I have purchased them don't you think it would be well to paint them also? Then I can take my choice between them. I am very much obliged to you for painting those I first sent, and will leave it to you whether I had better have the others painted or not—though I think myself that they would make a better appearance on account of being Jappanned.

If you should paint them, I would like to have them painted as follows,

The small tin,

| Thos. S. Mount | (In capitals)

The larger,

| Thos. S. Mount | (The name in capitals;
| Couns at Law | the rest in italics)

Mother will have some things to send down I suppose before long and she can put them in with them.

I am happy to hear that Miss Gorsuch is well, and should like to have been present at your concert.

We are doing as usual.

The Judge argued today on the Parish will, and would have finished but the Surrogate was taken sick in the midst of his argument. I think the Judge will get the best of it. Notwithstanding O'Conor spoke 4 dys.

The Judge is doing finely and so with his worthy family.

Yours etc.
Thos. S. Mount

Loveland's lectures at Dodworth's were very much liked. They gave him the greatest attendance and in the evening the Hall was crowded. I heard them talk of it in the street after the meeting.

I spoke to Loveland, and he wished me to give you his compliments.

S. O. Fuller to WSM

Bethlehem NJ, Mar 23rd, '58

Dear Sir,

I have often thought I would write you and have as often deferred it. I now have occasion to write respecting the productions of a scholar of mine (as I am at present teaching) and wish your opinion respecting the merits of these samples I inclose [pls. 124, 125]. The young man who has sketched these is 15 years old, and has had *no instruction* in sketching and has been compelled to work summers, and go to the *district School* only in winter. He is a good reader and pretty good at spelling and fair at Arithmetic and a specimen of his writing you see on the sketches. Is he worthy of encouragement in anything that would look toward an artist's profession?

He tells me he had read of Hercules and the Dragon and formed his own conception of them which is here shown you. If you will do me the favor to candidly give your opinion I shall regard it as a great personal favor. I would be pleased if convenient to have S. A. Mount also see it, and let me know if there is not talent in him which will open to him a brighter future than that of a plodding life where his aspirations can never be realized or his powers have the opportunity for development.

He is possessed of quite limited means, which may be discouraging to him. Any suggestion you may make will be looked for with interest. He possesses a powerfully retentive memory and everything he reads is treasured for use.

124. Unknown artist. "Hercules and the Dragon."
Letter S. O. Fuller to WSM,
March 23, 1858. Pen and ink, 8 1/4 × 5 3/4″.
The New-York Historical Society

125. Unknown artist. Two goddesses. Letter S. O. Fuller to WSM, March 23, 1858. Pen and ink, 3 1/4 × 8″.
The New-York Historical Society

My family are in usual health and wish to be remembered to you and to S. A. Mount and family. I would also have written to S. A. Mount had I supposed he was in Stony Brook.

Will you please direct, if you have time to comply with my request, to

Little York, Hunterdon Co., N. J.
Sincerely yours,
S. O. Fuller

Are you as much interested in Spiritualism as when I saw you?

[NYHS]

WSM to Dr. Joseph H. Ray

Stony Brook, June 9th, '58

My dear Sir,

I painted the portrait of your friend Micah Hawkins, May 1856. But feeling I could improve it, was my reason for not sending it to you before. This is copied from a portrait by Lewis Child, the distinguished sign painter.

By removing the nails, the top of the box will come out. You can hang the painting in a good light by the string which is attached to the frame of the painting, or you can hang it up and exhibit it in the box, until you feel disposed to obtain an ornamental frame—size of the canvas 11 in by 9 inches. Hatfield & Co., frame makers, No. 6 Astor Place N.Y. will make you such a frame as you desire. You will please accept this oil sketch of My Uncle from your friend, Wm. S. Mount.

P.S. You can dust off the picture with a silk handkerchief —but suffer no one to touch it with their fingers, as the work is fresh.

You only send the size of the painting to the frame maker.

[NYHS]

diaries 1859

January 1859

For worms, I have been using with good effect worm weed—it blossoms at the root (bitter)—take a pint of N.C. rum, 1/2 pound of loaf sugar, add a decoction, one pint of the bitter, to the above—drink two or three times a day—a first rate tonic.

[Added later:] April 28, 1859

Worm wood or tansy will answer in place of the above, when worm weed cannot be obtained.

Eat occasionally the fat of meat. Eggs are also good— to give strength to the brain.

Mr. Conklin says, for a hacking cough, eat spermaceti. It cured his son, Dr. Conklin, also himself.

New York, Feb 3d, '59
36 Laight St.—at Wood's

Commenced touching up an unfinished picture by W. Ranney. He appears to make a careful drawing of his design and then glazes over the figure (or whatever he is painting) with red, blue, yellow, brown, Green, purple etc., and then works into the above while wet, or otherwise as the (time) or case may be.

In some of his skys he changes the tint very often—blue and white, red and white, and yellow and white—and when the atmosphere is hazzy, he also scumbles different tints upon his figures and animals—colors broken—in patches.

N.Y., Feb 5th, 1859

I had the pleasure of seeing one of the cheap landscape parlors. Mr. Johnson, an Englishman, paint a landscape in thirty five minutes—size about 25 × 31 he talking during the time—he has but few brushes—he never touches his maul stick on the side of his picture and never uses one, except in the finishing touches with a sable, and then he rests his hand upon his short stick which is supported in his left hand by the lower end of the stick resting upon his left thigh.

He makes a hasty drawing with lead pencil first, and then dashes in his sky with large brushes. Yellow next [to] the horizon and blue above and sometimes red and purple clouds resting between. He sometimes turns his picture bottom side up while laying in the sky—he uses no blender but a large hog tool [and] flat varnish [illegible] to unite the different tints (sometimes)—next, he paints in the distance—mountains, castles, rivers, vessels, land and trees and bridges and shrubery and grass up to the foreground, a road if necessary and a figure to give effect. The whole effect of the land is laid in with blue, purple, grays, and browns colors from the horizon to the foreground. He then touches upon the above gradation tints (or ground work) with contrasting tints, freely laid on—with a scragly old brush—particularly the foliage of the trees, shrubry and grasses. The reflections of the land and trees etc in the water, are laid in at the same time, his brush

flying rapidly above and below—all the colors of the landscape made very gaudy, to catch the eye.

Mr Johnson mixes his colors (the commonest kind) out of tin boxes—upon a piece of glass, with boild oil, and then transfered to two paletts, placed on a bench near his easle, in quantity enough to paint from eight to 15 pictures in a day—at 30 cts a piece.

I have seen Johnson paint a large landscape in 27 minutes. This rapidity of painting is worthy of attention and imitation, as very many effects of nature are better represented by being painted quick particularly in the dead coloring—and even in the finishing of some parts of the picture.

At another visit I saw an additional rapid painter, he was a German and would paint sixteen landscapes in a day, ten large, 25 × 30, and six about 15 by 21 in. He would have 10 pictures of one subject—and six of another —in one day. This painter would place his canvasses on the wall thus [sketch indicating them in a row]. He stood while painting. These pictures were never retouched—it would not pay. These painters could not retouch and finish up a picture.

Mr. Johnson told me that he could not finish up a picture. He gave the effect and that was all he could do, and observed, that in early life he made sketches from nature.

Mount's description of the "cheap landscape parlor" is one of the most remarkable passages in his diaries. It brings into focus a vast, voluminous aspect of nineteenth-century art activity about which art history is completely silent but which Mount, with his ceaseless curiosity about the techniques of painting, was not one to ignore.

SUBJECTS

"Lo, the poor Indian whose untutored mind, sees God in clouds or hears him in the wind"—a large picture.

Part of the congregation sitting on a fence out side of the house of worship—or sunday's employment—Talking and whittling.

One small picture for Mrs. W. J. Hays.

N. York, March 13th, '59

I have been touching from ten to 13 pictures (by different painters) the last five weeks, by particular request. I should not fancy it as a business—it would be time lost. However, it has taught me the importance of having two or three pictures on hand at the same time, and drying them one after the other in the shade or in the open air.

Commence a picture with burnt umber, or vandyke brown, or Ivory black, if you desire to make an old Master.

I saw a battle piece by Rembrandt—the highest principal light was about the strength of Yellow Ochre, the colors well contrasted and the effect powerful. The painting appeared to say, be sparing of white (lead).

Landscape—Berghem (with figures and animals). Sun

about half an hour high—rich in color—blues browns, greens, yellows, and brownish purples.

The deepest sky was made of blue, red and yellow, graduated to the Horizon. Clouds of venetian red (or vermilion) yellow ocher and white—the light on the clouds, Naples yellow added to the above—the same light tint for the horizon. The whole picture seems imbued with sun light. The foreground is strongly shaded, the foliage of one of the trees (in sun light) is ocher and a little cadmium, a little blue and brown added to the above in places to give strength. The green next and darkest foliage in the foreground. Burnt umber and burnt sienna is much used in the foreground.

A green made of cadmium (or chrome), black and burnt sienna.

Alumn, burnt—makes a fine and durable black. Burn a small piece at a time—hold a thick piece of paper, or tin over the blaze.

N.Y., March 20th, '59

I had the pleasure of spending a few hours with Charles Baker Esqr, 43 west washington place near six Av. He is a great admirer of Cole—and imitates his style of painting very successfully. Mr. Baker says he seldom uses any drying oil, and paints his skies and distances up at once, with raw linseed oil. He has promised to make me a sketch in oil. [Added later:] He gave me a painting the 10th of April '59, size 9 3/4 in by 7 in.

Johnson says, to paint sky very fine, to mix color enough to paint over the gradation 3 different times.

Mix megilp with palette knife only with such colors that dry tardy—black, brown, and lake. It is only when too free use of megilp is used that a painting is injured by it. There is very little Lake in flesh, or landscape.

A. Richard, makes his pupels to copy his landscapes, with but few colors—Black, blue, red, yellow and white.

In a tour to Europe Gifford says take but a little luggage (a satchel) or carpet bag large enough to hold sketching materials and two shirts.

N.Y., April 5th, '59

Consentration of an idea and effect makes a picture— subject, color, and light and shadow.

The representation of sun light (all over a picture) without rarely[?] a shadow but the receding tints would not be very inviting. There should be a striking effect of some kind. Use nature for that purpose, but never loose sight of her.

Consentration of thought as well as of [illegible] light and shadow. *Get the effect of nature and memory must do it, after all our study.*

In painting flesh—first, make all the shadows one agreeable tint, and after the effect of the head is given, then individualize.

The Academy (1859) has on exhibition over six hundred paintings, drawings etc.

April '59—One landscape for David A. Wood.

April 14th, '59

Wm. Wright Esqr. at his residence Hoboken desired me to paint him a picture. W. P. Wright's first drawing perhaps would make a good picture. Subject—a girl gathering may flowers.

A picture for Samuel P. Avery, 38 Beekman St. He says —"I saw a subject the other day. A boy with a bad cold in his head, his feet in a pail of water, head tied up with white bandage, a red flannel band about his neck—and *such* a woe-begone countenance—nose as red as fire—and in his hand the inevitable tallow candle—which he had been applying to his nose liberally. I [wish] you would catch another such and fix him for me."

One picture for Mr. Waters of Baltimore. He would like to have a head of the Esquimaux dog—Neptune.

I arrived home April 16th '59, after having spent over ten weeks with Mr. Charles B. Wood, 36 Laight St, N. York. Mr. Wood said, that if I desired to study landscape this summer from nature that he would furnish all the money.

Figures combined with landscape would be interesting and at the same time instructive to the artist. The finest scenery for backgrounds should be selected.

Pictures in many respect are more interesting than portraits.

I must try and finish the picture of Webster, and then be careful how I paint another with accessary figures— before I consult the person for whom the picture is painted for.

"Experience is a good school if not bought too dear." The above painting I have partly cut up. It is my way when a composition is not satisfactory.

New York City is the place to make an artist work— he is stimulated by the works of others.

Never paint anything unless you fully comprehend it.

Stony Brook, April 20th, '59

The order of my palette is as follows. First on the left, White; Ochre, vermilion, blue, Madder Lake, Indian red, and a little vermilion added; burnt Umber, ~~Van. brown~~, Ivory Black, terra verde and burnt sienna—some times I add venetian in place of Indian red.

And for Landscape—add cadmium, Emeraude Green, Naples Yellow, Raw Umber. Raw sienna, Madder yellow, Lemon Yellow. Prussian blue for foreground, where deep greens are wanted. Ultramarine blue with the Yellows, will make all the delicate greens required.

April 27th, 1859—Cherry trees are in bloom.

May 2d

A slight frost this morning—we have had fine weather for three or four days.

May 6 and 7th

Apple trees in blossom—

In April, I obtained some stereoscopes and found in coloring three of the water colors (particularly in the flesh) only red and yellow was necessary—Gamboge and Carmine. They having been printed with black, and some with brown upon a white ground. —Practice.

In oil then, to give the effect—1st color with black and white, or umber and white, or black, yellow and white, or venetian red and white—and scumble with red and yellow, and where there is much shadow particularly in the flesh of females, the cool would set off the warm colors.

Use a color, or a mixed color that will give the hue or local color of the flesh in light and shadow.

The second sitting, strengthen the relevo of the head or flesh, and touch in the ornamental tints—red and yellow, etc.

Or on a silvery grey ground paint (drive) thinly with yellow and red, and some white where it is needed— shadows with blue, red, and yellow.

New York, May 13th, '59

About the durability of oil colors—a talk with Mr. Vollmering. Cremnitz white, zinc white, Naples Yellow. He said that vermilion should not be mixed with it. Field says, it should not be mixed with the ochres—to be used pure or with white lead.

Light Ochre or yellow ochre, Brown Ochre or dark ochre, Cadmium Yellow, Lemon Yellow—Field says, is adapted to high lights in painting, and has a peculiarly happy effect when glazed over greens in both modes of painting.

Strontian Yellow, light color, Roberts yellow Lake, Gaudes Yellow Lake, Madder Yellow—Field says, has a tendency to become orange and foxy. The same of Indian Yellow. Yellow Lake, if used, should be as simple as possible.

Vermilion: Light red, terra rosa, and Indian red—of the later, the most rosy is esteemed the best. Madder Lake and Pink Madder, Madder carmine or Field carmine, Burnt sienna, Madder brown, or Russet Rubiate.

Ultramarine (blue Ochre) Cobalt blue for glazing in the flesh (the cool tints) when the paint is dry.

Florintine brown, not to be had in this country.

Robertson's Ivory black. Use no Umber, burnt, or raw. First, painting of the flesh with madder Lake and light red, with cobalt for the grays. Use vermilion only for *glazing and scumbling and finishing*.

When the painting is dry, *Use Megilp only to rub over*

the painting. Use your colors with nut, raw or boiled oil as you please.

Prussian blue for landscape in the foreground, also burnt Terra Verte—"the best is of a bluish green color not very bright." Use no Vandyke brown but use instead, Ivory black, burnt sienna and red; make up your Umbers with black, ochre and red.

Ultramarine for the sky. Clouds white, I expect, to be glazed over with yellow or red. The shadow of the clouds white, yellow, Light red and Ultramarine. For dark cloud more blue and red—and if not dark enough use blue black, or black and blue mixed together—red etc. He mentions Capsenna[?] madder.

Field says that cobalt Green is durable, also Chrome Green, native Green and Terre verte. Also, blue ochre. "[Illegible] greens neither give nor receive injury."

"The best greens are mixed greens being a compound of blue and yellow to supply the place of green pigments by mixing, glazing, hatching or otherwise blending them in the proportions of the various hues required."

Regis Gignoux says—that Emeraude Green and Malachite green are durable [illegible] yellow, or mars yellow. With the yellows and blues mentioned above by Vollmering, durable greens can be made.

Vollmering was copying Cupid resting upon some flowers—a charming picture. He said the original (in the flesh) was dead colored blue—light of the figure blue and the shadow purple.

In painting flesh Rubens says, "Paint your highlights white; place next to it yellow, then red—using dark red as it passes into shadow; then with a brush filled with cool grey, pass gently over the whole until they are tempered and sweetened to the tone you wish."

To paint flesh, Field says, "Take flake white or the best white lead; for the second, cool lemon yellow or warm Naples yellow; for the third, cool or warm vermilion broken into shadow with madder carmine and manganeze, or Cappagh, brown; and for the last, mineral grey—Ultramarine ashes—and leave out black even when painting a Negro; it will be an artist fault if he do not paint flesh that is at once natural, beautiful and durable."

"Russet Rubiate, Madder brown, or Field's Russet, is prepared from the rubia tinctoria, or madder root. It produces with yellow the glowing hues of autumnal foliage, etc, and with blue the beautiful and endless variety of greys in skies, flesh, etc. Intense madder brown dries the best."

Shadows of flesh can be made with white, blue and burnt sienna or with blue (white) and madder brown—or blue, red and yellow or blue with strong reds and browns as the effect might be.

A. B. Durand, says he often uses Canada Balsm, and 1/2 turpentine to paint with.

A good brown, Stony Brook Umber and Asphaltum—or with Vandyke brown. Cappagh brown is "regarded as a superior vandyke brown and asphaltum"—there are two kinds, light and deep. Dark or burnt Madder and burnt sienna makes a good brown. Raw sienna and Vandyke make a good color. Use Cappagh and Ivory black—leave out Vandyke.

Hypocastanum, or Chestnut brown—dries moderately well. American brown, burnt Terra Verte—good.

Fields says, "fineness of texture is gotten by grinding and lenigating extremely, but is only perfectly obtained by solution—and this few pigments admit of; it merits attention, however, that colors ground in water in the state of a paste, and others, such as gamboge, in strong solution in water and liquid rubiate, etc., are miscible in oil, and dry therein firmly—any water-color in cake, being rubbed off thick in water, may then be diffused in oil, the gum of the cake acting as a chemical medium of union to the water and oil without injury."

Stony Brook, May 19th, '59

I engaged a Piano for my nieces to practice upon. Value of the instrument one hundred dollars. I paid eighty dollars for it. Delivered by C. S. Seabury—May 30th '59.

Notwithstanding the rage lately for small pictures, Messrs Gignoux and Church have painted large pictures with considerable applause and proffit. Made mony by exhibiting them.

"To prevent Lake from growing fat, by grinding with it a little dryer in white capperas."

First draw the portrait with white chalk—to get the proportions—and finish the drawing with charcoal. Better than India ink.

Oakdale, July 10th, 1859

Draw with charcoal and then commence with oil colors—the shadows thinly with transparent colors, or nearly so (with an eye to the resemblance), next the highest lights in their right places and the receding shadows (or out line) with a pure transparent color. In fact, all moderately dark objects should be commenced without white.

After the first sitting and the flesh is dry and hard, glaze with red, yellow and blue, to strengthen the head, or bare neck, or arms in color and relevo—and improve the drawing, with or without the sitter as you please.

At most every sitting, glaze first, and scumble and paint into it—touching from nature where it is required. I often take a sitting from memory—good practice. In the first painting I use venetian red, in place of vermilion, but finish with the latter.

I find madder brown usefull in shadows—also, burnt terre verte.

Repeating the colors gives strength. In some instances after the portrait is finished and dry, scumble over the lights of the flesh with some light agreeable color, so as to give a more finished and *youthful look, which is often desirable.*

Sept 4th, 1859

S. A. Mount, has just completed a fine portrait of R. Gorsuch life size. A good subject and a good artist will make a fine picture.

1859

From the 1st to the 4th of Sept. I had a very severe tooth ache [pl. 126].

The two small teeth on each side of the two large front teeth—have troubled me the most the last two or three years. The nerves having been killed and the teeth filled with gold. With the above exceptions my teeth with aid of the Dentist—are in good condition.

[September 6, 1859]

I left Ludlow's, the 27th of July '59. I have done some painting to day Sept 6th—did no painting through the month of August.

Had I painted some of my pictures with great care the size of life I might have been rich. Perhaps there is time yet. Just as well paint subjects large as small, all it wants is energy and a large room.

Sept 11th, 1859

Rosa Bonheur—"is the most distinguished female painter living or dead. 'Yes,' she replied, 'I have been a faithful student since I was ten years old—I have copied no master. I have studied nature, and expressed to the best of my ability the ideas and feelings with which she has inspired me. Art is an absorbent—a tyrant. It demands heart, brain, soul, body, the entireness of its votary. Nothing less will win its highest favor. I wed art. It is my husband—my world, my life dream—the air I breathe. I know nothing else—my soul finds in it the most complete satisfaction.' 'You don't love society?' we said. 'Yes, I do,' she replied, with an air of impatience; 'but I select that which pleases me most. I love the society of nature; the company of horses, bulls, cows, sheep, dogs— all animals. I often have large receptions where they are the only guests. I also like the society of books and the thoughts of great minds—I have no taste for general society—no interest in its frivolity. I only seek to be known through my works. If the world feel and understand them, I have succeeded.'

" 'Have you given the Women's Rights question any attention?' we asked. 'Women's rights! Women's nonsense!' she answered. 'Women should seek to establish their rights by good and great works, and not by conventions.

" 'If I had got up a convention to debate the question of my ability to paint 'Marché aux Chevaux' (The Horse Fair), for which England would pay me forty thousand francs, the decision would have been against me. I felt the power within me to paint—I cultivated it, and have produced works that have won the favorable verdicts of the

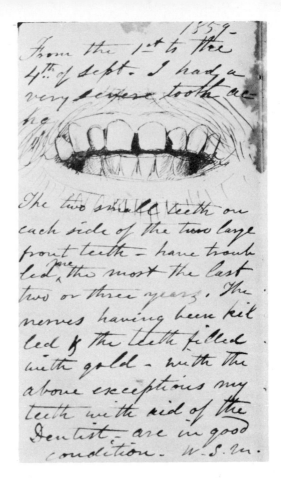

126. Teeth. Diary, September, 1859.
The Museums at Stony Brook,
Stony Brook, Long Island

great judges. I have no patience with *women who ask permission to think*.'

"Rosa Bonheur's paint room is at No 32 Rue d'Assas —a large, square, oaken-finished room on the second etage. She is about thirty five years, petite, with quick, piercing blue eyes, and brown hair, worn short and parted on the side, like a boy's. Her dress was a brown alpaca skirt sans crinoline, with a blouse jacket of black cloth. She looked very boyish. Mademoiselle also has an atelier in the country where she spends much time. By birth Rosa Bonheur belongs to France—by the rights of genius, to the world." ——Extract from the *Home Journal,* Paris, August 10th, 1859.

[1859]

On friday morning the 16th of Sept. 1859, my brother-in-law Chas. S. Seabury was taken sick (with a chill first), and grew worse and worse until the 29th inst when he died at 1/4 past 6 A.M.

(Remarks)—He was taken with a chill at one o'clock at night. Mrs. Seabury, had his feet placed in hot water and gave him hot jinger tea to drink and offered him a dose of pills (castor oil would have done), which he declined to take—had he taken the medicine it would probably have saved his life, as the Doctor did not arrive until 2 o'clock P.M., 13 hours after he was taken sick. The Doctor gave his patient mercury and done all he could for him, but he took cold upon it, and *went down, down.*

Stony Brook, Oct. 2d, '59

I have had a bad cold in my throat and chest, for a number of days, occasioned by getting into perspiration several times, and taken one cold upon another. Sleeping with my window too high up—damp weather—triming trees—and catching flat fish, of course getting into a high state of perspiration, and not cooling off gradually enough.

Not much used to bodily labor, it is dangerous for me to get too warm.

"When at much hard work, or exercise, throw off your clothes, and when finished, put on your garments directly. For under garments thick flannel. If you wish to stay in this world take care of yourself," is the advice of Dr. Dering.

"Teach me to number my days." We must watch ourselves daily—and be temperate in all things, avoid *too much excitement, keep quiet and cool.* I find that cold water is better for me than all other drinks.

For a cold, mustard plaster for the throat or chest, elm flower mixed with water—to be taken. Also, castor oil.

Oct 3d, 1859

I sometimes regret that I ever lived or boarded with my relations, although pleasant at times. Two much company and excitement. I have done scarce any thing the past nine weeks, whereas, if I had gone off sketching up the North River, Vermont, or any where from home, no doubt it would have been better for my health for practice, and for my reputation as an Artist. However, perhaps it's all right. I have experimented with my Patent violin, made a few pencil sketches, and a sketch of a child's head, in oil, of Ida Pfieffer, as a present or an exchange for work done. Color good, but few colors—Y. ocher, vermilion, F. blue, ven. red, Robertson's black, B. sienna and white.

Had quite an exciting talk with Mr. Copcutt—he used language not usual for a Gentleman—and he commenced the wordy attack. My Niece and sister, against me, think of it.

N.Y., Oct 28, 1859

Charles B. Wood, says that If I come to N.Y. I shall paint his portrait.

SUBJECTS

A dog standing up while a pretty woman is holding a piece of bread over his head—a girl seated by the table looking on.

A man hooping a barrel—scene out of doors.

A man wheeling a wheel barrow load of Cabbages.

(I have been thinking about having a sail boat made for taking views from— Landscapes, as well as marine pieces, rocky coasts, etc.)

A girl or a Lady feeding a parot.

A boy lighting a segar with a burning glass— Order from C. S. Seabury.

A rag picker trying to take a bone from a dog. The bone of contention.

Dog eating and growling, an old hen looking on—a young woman viewing the scene from the door.

FRENCH AND ENGLISH PAINTINGS

"The Hayfield"—by Rosa Bonheur—general effect of nature as seen through a dark glass—Claude mirror. Figures quite unfinished—yet they look well at a distance.

"Banks of the Seine" by Constant Troyon, 7 × 9 feet, loose scratchy style—but fine effect of light and dark. He understands the use of grey tints.

"View near Amsterdam" by Emile Lambinet—he exhibits a fine quality of green in shadow, as well as in light —his pictures are fresh and spunky, and he understands the value of cool tints.

"Towing a (Horses) boat"—fine effect of light and dark line about sun set.

"The Family dinner" by Frere—all eating out of one dish—good color, cool tints well mannaged. His pictures are full of color, and tells his story well.

Many of the foreign painters go in for effect and color —and when that is obtained they seem satisfied. Great results are produced by thought and practice—for instance, conceive or immagine a fine Landscape, or figure piece, and paint it right up, spunky.

"The stool, the Urine, and the Pores— These must be kept in a healthy condition, or disease is certain.

"The *liver* must be kept in order. The stomach must be invigorated and made healthy—the strength and tone of the system must be kept up by proper nourishment, exercise and health.

"Keep up the practice of washing as long as you live and use Graefenberg Vegetable Pills"—if needed. [Interlined: Rhubarb is better.]

Eat indian gruel, or oat meal gruel.

I cured myself of a bilious fever and cough, by taking Ayers Pectoral and a dose of Castor oil and Graefenberg Pills.

HEALTH

When you begin to feel unwell stop eating, in place of taking so much medicine.

For a cough, eat spermaceti—in cake form.

I must study to know myself, and mind my own business, particularly, when I get no credit for taking an interest in the affairs of others.

For sore throat, chew Indian posey—or Pepper grass— also, for the teeth chew rye or wheat. Chew parsley.

A pillow case filled with hops will cause sleep—to come upon the sleeper.

Dr. E. Newberry, thinks that I should continue my picture portraits, pictures of character, half lengths—size of life.

A greater variety of character, and different kinds of occupation to be found in New York City.

Mr. Leutze—said that I should stand up while painting —better for health.

Perhaps I should have a room in the City. Plenty of subjects for pictures. In painting backgrounds, scumble in a variety of colors—after painting the flesh.

In painting Landscape there should be a continual change of color, not only in the sky—clouds—trees—water *but in the field of grass.* Nature is full of color—and brilliant color.

"Impure oil is death to color, never boil your oil—take your oil and pour it into a bottle with water. In a day or two, the water will turn muddy—that is muck from the oil, pour it off and add fresh, and so on, until it looks clear. To make it still more clear put the oil into a pan with a glass over it and place it in the sun all day. It must not go too far, or the sun will turn your oil to varnish. When it is as clear as crystal, and not too drying, drain carefully, and cork it tight. Grind your prime colors, and lay them on with this oil, and they shall live. Hackert would put sand or salt in the water to clear the oil quicker, but John used to say, Water will do it best, if you but give water time."

Snow will purify oil.

Oct. 31st, '59

I received a written apology from Francis Copcutt *for "hasty and foolish words."*

Anger is bad for the health. Avoid it—keep cool.

Ice 21st of Oct, and snow the 27th three inches deep.

I painted in the open air on the 4th, 5th, and 7th of Nov—Indian summer.

Pictures every where. It would be a fine practice for me to paint Landscape and figures from spring to fall.

Have a boat made to take views from part of the time.

Keep away from your relations and Stony Brook—as much as possible.

Spend a winter in Virginia—or Tennessee.

To paint a snow scene—first, the effect of the Landscape, if in Oct, and then paint the snow with all its attendant colors.

Money spent for models is well spent—providing good use is made of them.

Paint from models, and from memory.

Church has sold his Heart of Andies—for $16,000. One day's exhibition amounted to $500.00.

Page's Venus—has made money by exhibition.

Some of the French and English pictures in N.Y. have brought large prices.

In painting a landscape from memory, many universal colors or tints are to be thought of. 1st the local color. 2d the air tints resting upon the foliage, grass, trees, figures,

animals, houses, water etc, besides reflections. The bodies of some trees are grey, also of fences, and some buildings. The bodies of some trees are a dark brownish gray.

Part of the Landscape at times is in shadow. The sun touching here and there, giving a brilliant effect—the same on the water when it is agitated. The whole picture must be daring and bright in color. The atmosphere must pervade every where—so that you can tell the distance from one object to another. The pink or the flesh colored mountain in the extreme distance, also, the blue, gray, and purple, which makes up the gradations of distances so delightful to be seen in the mornings and afternoons, in contrast to the grayish, brownish, greenish, redish, yellowish and umberish foreground. Every object must be made out and to have great power in foregrounds, dead weeds as well as green. Rocks, water, reflection, men, women, children and animals. The character and handling, or touch and forms of objects should be remembered, and hit off with freedom with an eye always to nature if possible to strengthen the memory.

The whole painting should be struck off with confidence to truth and with the richest colors. Cultivate the memory. Look attentively at an object, or a scene, and go to your room and see if you can paint it from memory. *Try, Try,* we do not know ourselves, until we Try. The four seasons are presented to us one after the other, to give us painters a chance to select material. Night and day should be our daily study. Begin now, no time to be lost.

I made a study of a kitchen some twenty years ago, useing mastic varnish with the colors as I painted. The sketch has never cracked, but looks clear and silvery as the day it was painted. Evers the scene painter used mastic in his oil pictures.

[1859]

"Bilious complaint: 1st take a gentle emetic, or, as a substitute, a portion of mandrake—after which one or two of the bilious pills occasionally, also the wine bitters, and a tea made of the *bark* or *berries* of the black alder—for diet see bill of fare for invalids."

It will be absolutely necessary to abstain from all kinds of greasy meat, sweet articles, pastry, and rancid butter; likewise *coffee* and *chocolate* both of which increase these affections.

"To prevent bile in some countries, they use pepper sauce, mustard, stewed fruits of various kinds, and sound hard cider."

"Eat little and often is a pernicious practice."

Perhaps two meals a day would be quite often enough for an Artist.

"Costiveness must invariably be prevented."

"If there is pain in the head, cold applications of vinegar and water, will be of much benefit in relieving the violence of the pain. When the fever is subdued, cooling drinks, cold cammomile tea, or bitter made of dog-wood bark, poplar bark, and Virginia snake root in quantities as the stomach will bear."

Stony Brook, Nov 13th, 1859

It looks wrong to see an inventive painter sticking to one place.

Church said when he was tired of work—he would spend two or three days in the Country to recruit. N-Y- City is a good locality for Painters, etc.

I must paint abroad and keep my rooms at Stony Brook for store room—and never spend my summers there. It is too hot. South side of the Island is cooler.

Mrs. Selah B. Strong thinks, that I should have painted more pictures—had I left Stony Brook years ago.

The value of time is felt when you are in a hurry to get ready to go to some place and cramped for time.

To strain Copal varnish, or oil, spread cotton over gause or crape and let the varnish strain through both—so says, Josiah Martin, a varnisher and polisher—and also, a fine Banjo performer.

[Late 1859?]

The gradation of lights as well as shadow must be observed. In some flesh, next to the highest light comes red and then yellow and then grey or brownish grey. I have seen a light (on the head of an old man) surouned with a greyish yellow and then red. The lights on flesh are some times of a very light greyish tint, blue and white—or red and white or yellow and white. Strong and lively colors some times require to be broken down with grey tints.

After the first sitting is dry it is good practice to strengthen the memory by glazing (correcting) and improving the painting all you can before the sitter sits down, and have but few sittings. Paint all you can from observation and memory and then finish from nature—and sometimes [illegible] as the case may be.

If you desire to make a careful drawing—commence with white chalk first and draw in the head—then go over the drawing with *char coal,* or good indian ink, and or paint in (thinly) the masses of shadow and obtain as close a resemblance as you can—over the char coal if you like—providing the ground is not absorbant.

I have frequently painted a head after a few lines was made with white chalk (red would do).

A good drawing will inable one to paint with more confidence. Remember the *nose,* it is the first member to enter the door.

It is interesting to observe heads and faces as regards color and expression, by gas, or lamp light. The beautiful play of light over the glossy hair, face, neck and shoulders—of a pretty female (or of a child). The form of the light deserves the closest attention of the painter—as well as of *shadow*. The light on flesh is cool—a greyish yellow, very light—broken upon masses of red, etc., some times, white with a very little blue.

Shadows and reflections must (often) be cooled down as well as the lights and the whole head, or figure must be modeled into perfect keeping; so that the work will charm every beholder. Let the light fall up the sitter through the window blind, even, when the sun is not upon it. It serves to lower the tone of the flesh—and makes some females look more beautiful.

N.Y., Dec 20th, 1859

I saw Rossiter's collection of pictures to day—to be sold at auction.

It is difficult to say which he is best in, figures, or Landscape. He uses a full brush in the latter. He delights to paint figures, in half shadow and with good effect—he uses blue, or some cool color in his flesh with skill. The shadow of his linen[?] reflects the sky—his best pictures in color is where he uses a variety. Lately—6 × 10 inches—female figure with landscape background, sky, clouds etc., cool and warm colors, fine tone.

Wise and Foolish Virgins, size of life. A female half shaded by a fancy colored umbrella—fine effect.

Giorgione and Companions Going to the Lido, Venice, in the Olden Time. A variety of color and fine tone.

Primitive Life in America. Moonlight canoe with figures.

These three pictures received the Gold Medal. From the French Government—at the International Exhibition, 1855.

Brook through the meadows. Effective and handled with great freedom.

Study for The Patric[i]an—showy painting.

[1859]

"Studies from nature possesses the charm of freshness, of purpose of reasonableness, of faithfulness." ——A. Penley.

I must keep at work and God will assist me. There is no time to be lost. Draw and paint, or, paint without drawing, that is, draw with the paint brush.

[1859]

SUBJECTS

[Sketch of girl] A young Lady looking at her face in a mirror.

The broken willow in setauket.

Maria on horse back.

LIGHT AND SHADE

First, have your picture in black and white as regards effect—viz, determine the effect in your mind before you commence painting. A substitute for asphatum—mix Prussian blue and burnt sienna. Long flat brush for touching the [illegible] animals.

Good introduction to my sketch—When Gen. George Washington was passing through Stony Brook on his visit through the Island with his aids, my Mother was at that time a little school girl, and stood and courtesyed to him while he raised his hat to her salutation—at the same time, her companions ran away.

SUBJECT

A boy shelling corn, in a crib.

Fishing by fire light, fine effect. It should be painted from nature.

Obtain the handsomest women and children for models.

SUBJECTS

A boat hauled upon the shore—an old mill for a back ground.

A Boy sitting on a fence under a tree his water pail on the ground.

One man looking at a drawing or reading by a window, while another is standing by him looking on—good effect.

A Boy playing horse riding a fence—"get up here."

A Girl picking up chips at a wood pile.

Two boys, carrying a jug with a stick through the handle of it.

An Old woman dragging scrags.

One lamb standing on the top of a rock, other lambs looking at him—fine effect.

A flock of sheep at the pond.

Time is wisdom's highest prize. Draw and paint.

Paint some subjects on a dark warm ground while it is fresh.

SUBJECTS

A time to laugh— A time to mourn. Two pictures.

King Solomon with his sixty wifes.

Two scripture subjects for the Messrs Woods. D. A. and Charles B. Wood.

Three children sittin in a door.

Two children, one of them waiting for a bite of corn, or apple.

To strengthen the memory by whipping— "It is stated that the boundaries between towns were formerly established by whipping a school boy on the site."

A young Lady sheding tears over a magazine.

Red
Yellow
Green
Blue
Purple
Yellow

SUBJECTS

Richard Hawkins driving his steer with the rope in his hand, the waggon to be loaded with sea weed. Would make a fine painting—for character.

Girls studying their lessons seated on one bench.

Going to the ball.

Brawling the next day—the Old woman scolding.

A negro playing the triangle.

A Boy playing on the Jews harp.

A negro or a white boy playing on a tin pan or pail.

[1859]

New York is the place for character of all kinds in every profession. It is the place for soild children. Dirt and color, mingled together.

Have a private studio in the City, so that you can go out after suitable studies for pictures and some times finish the pictures on the spot where the scene is laid.

By having a public studio, you will have two many visitors. I begin to like the City, and the idea of a private studio—the pictures which I could make in my private rambles about the city and country. I could exhibit at various places after being finished if required at my room.

Hundreds of good designs are injured by the want of a proper knowledge of light and shadow.

Paint every thing under the sun that is proper to make a picture of.

Go to work and God will help you.

SUBJECTS

A group of men in different and natural positions sitting around and outside of a country tavern, smoking, chewing, whittling and spitting, talking and whistling.

People outside, of a country church.

Batchelors button—a pretty girl sewing on a button for a batchelor.

Lost or won—for Mr. S. P. Avery.

"If you wish to excel in anything, but especially in painting, constant application and study must be given. There is no railroad to perfection in art."

"Let your palette be of sandle wood, as, being of a light color, you will see the tints better. The best colorists have used light grounds to paint upon.

Have the palette of an oblong shape, as it holds more colors, and is better to put into a case when you go into the country."

correspondence 1859

Samuel Putnam Avery (1822–1904), a portion of whose letter of January 27, 1859, so impressed Mount that he copied it into his diary on April 14 of the same year, was an engraver, collector, and dealer in works of art and one of the founders of the Metropolitan Museum. According to Lillian Miller (*Patrons and Patriotism,* 1966), Avery specialized in acting as sales agent for artists, like Mount himself, who lived outside the big cities.

Many good folk wrote Mount to suggest subjects to him, but few wrote at such length and so bootlessly as did Caroline L. Ormes Ransom (1838–1910) in her letter of June 9. Miss Ransom should have known better than to attempt to give an artist ideas, since she was herself a painter, and a very successful one. A graduate of Oberlin College, she was a pupil of Durand and Huntington in New York and of Kaulbach in Munich. She had been born in Ohio and maintained studios in various cities in that state before the Civil War, but the last part of her life was spent in Washington where, among other things, she helped to found the Daughters of the American Revolution.

Hyperion, a passage from which Miss Ransom suggested to Mount as a subject for a painting, is one of Longfellow's two published novels. The passage in question occurs in Chapter 1 of Book II, which describes the coming of spring to Heidelberg.

A.F.

WSM to Nathaniel Smith

Stony Brook, Jan 7th, 1859

My dear Sir,

It is two years since I painted the portrait of your beloved daughter Sarah Cordelia, and your infant son, from memory, to the best of my ability. My charges are double for such work, although in this instance I did not ask it. Miss Mary B. Strong of Oak wood paid me for the portrait of her Niece taken after death, only head and bust, not so large a picture as yours, one hundred and fifty dollars.

I shall be greatly obliged to you, if you will pay what is coming to me early next week.

Yours truly,
Wm. S. Mount

[Memorandum by Mount at the bottom of his copy:] Mr. Smith's last payment in full was made the fifteenth of Jan, eighteen hundred and fifty nine.

[NYHS]

Samuel Putnam Avery to WSM

48 Beekman St.
Jany 27, 1859

My Dear Friend,

I hope you do not think we have all forgotten you—although you seem to have forgotten us. I hope your

absence from the city has not been occassioned by illness, your artist friends certainly thought to have seen you at the Ranney exhibition.

Are you about something for the opening exhibition? And have you done or thought of doing anything for my little collection of small pictures. I hope you was quite in earnest when you promised to do so. I saw a subject for your graphic pencil the other day—I wish you could have seen it, I am sure you would have placed it upon canvass for the perpetual delight of thousands. A boy with a bad cold in his head, his feet in a pail of hot water, head tied up with white bandage, a red flannell band about his neck—and *such* a woe-begone countenance, nose as red as fire—and in his hand the inevitable tallow candle—which he had been applying to his nose liberally.

I wish you would catch another such—and *fix* him for me.

I have a friend in Baltimore a gentleman of wealth and liberality who is getting pictures and would like much to add your name and genius to his collection—but hears there is no chance. Now I would like to know wether you cannot hold but some hope—which I should be most happy to communicate to him. Please let me hear from you if you have a few minutes to spare.

Will you not be here at one of the next receptions?

> Your friend most truly
> in haste
> Samuel P. Avery

WSM to Samuel Putnam Avery

Stony Brook, [January] 29th, 1859

My dear friend,

I have not forgotten you, nor the order you kindly gave me. It is difficult to paint up to a given price. I have just painted a couple of pictures. I thought of you, but I could not afford to part with either one of them for the price we agreed upon. I expect they are sold. The subject you mention, is good. You are a very particular artist in the way of pictures, and I wish to do something for you and your Baltimore friend in the course of time. I expect to be in the City next week, and then we will have a talk.

> Yours, very truly
> Wm. S. Mount

Addressee Unknown

Stony Brook, Jan. 30th, '59

My dear friend,

Enclosed is one dollar, I wish you to purchase a silk handkerchief—75 cts—half Gal of New Orleans molasses 25 cts—and take a swallow every time you feel thirsty between meals. It will stimulate and strengthen you— try it.

If ever you are in trouble never drink strong drink, it will please your enemys if you do, and seriously effect your nervous system. I do not treat nor suffer myself to be treated at any place where liquors are sold; notwithstanding, I am on the best of terms with the dealers.

The treating system is a money making arrangement and makes drunkards also. "Come take a smile," one man says to his friends—they drink, in a few minutes another and another of the party treats—and they get ~~very~~ talkative—very much so. And the liquor vender is ~~very much~~ highly pleased with his company.

Sometimes to help along business the bar keeper slaps his tumblers together and says, "come Gents, it is my treat"—and they all jump to their feet and make for the bar, like pigs to the trough.

If you wish to be amused read Felix Belly's letter to Louis Napolen—published in the times of the 25th inst.

Come and see my pictures, Shepard is painting a very good landscape. I expect to go to the City on wednesday. Good men are scarce therefore take care of your health. God requires it of you.

Get Sarah to hem your handkerchiefs.

> Yours, very truly,
> Wm. S. Mount

Caroline L. Ransom to WSM

Sandusky, June 9th, '59

Friend Mount,

This morning whilst reading *Hyperion* (by Longfellow) I came across the following passage—

"The May flowers open their soft blue eyes. Children are let loose in the fields and gardens. They hold buttercups under each others chins, to see if they love butter, and the little girls adorn themselves with chains and curls of dandelions, pull out the yellow leaves to see if the schoolboy loves them, and blow the down from the leafless stalk, to find out if their mothers want them at home."

Is not this a pleasing picture of the sport of country children? I think so, and it seemed so appropo to the subject I gave you a few weeks since for a picture, that I cannot refrain from sending it to you, trusting that your kind, generous spirit will pardon this intrusion upon your notice. It is not *etiquette* I know, but I am not willing to be always governed by the conventional wiles of society that so enslaves the world and too often checks our kindest and best impulses.

When I read this passage I instantly thought of you and your picture, and felt prompted to write you at once. If I err in so doing please set it down as an error—of the head rather than of the heart.

With this text before you I trust you will be inspired to paint one of your best pictures; for the subject is not only a very pleasing one, but one that will interest all lovers of children who have any knowledge of their [illegible] sports. Perhaps you are not fond of children as I am, and cannot enter into the spirit of the subject as I think I could were I gifted with *your genius* and experience in painting. How is this? Do children interest you? If not I fear you will not take pleasure in painting this *pet*

picture of mine. I say *my pet picture* because it is one that I have long thought of, and wished to see painted, and proposed to you because I thought you had the right spirit and genius to paint it.

The little girls adorning themselves with chains and curls of dandelions; pulling out the yellow leaves to see if the schoolboy loves them, and blowing the down from the leafless stalks to find out if their mothers want them at home are all beautiful accessions to my first thought of holding buttercups under the chin, and think they might be very happily wrought into a delightful picture.

My friend I do want you to make a successful painting of this for the next Academy exhibition, for there will be nothing else like it, and Longfellow is good authority for artistic inspiration. Miles Standish had too great a run, however, at this exhibition, I think, for its merits as a Poem. No one will think of this subject between us, and you will have the buttercups, dandelions, and lovely children playing with them in the green fields all to yourself, and trust will make one of your best pictures from them. I hope so.

By date of this sheet you will perceive that I am in Sandusky where arrived two weeks since and commenced painting again, most vigorously, cheered with the hope of spending next winter in New York. You can hardly imagine how much I enjoyed my visit there, particularly with some of the artists and looking at their pictures. I visited the Academy almost daily, paying my artistic devotions to some choice specimens of some choice *authors*. I missed a very pleasant face however during my last visit there that had made some of my former ones more delightful. Can you guess whose it was?

I got more acquainted with Carpenter[?] after our talk about "the spirits" and liked him very much. He seems to possess such a pure, loving spirit that I quite loved him notwithstanding he has a wife and children, which no doubt serves to enhance the loveliness and humbleness of his spirit. You need not tell him this nor any one, nor even think of it again yourself as it is only one of my extravagant impressions about those I like.

Pardon this long letter. I only designed a short note when I commenced, but somehow it was always easy enough for me to talk with you (as I once imprudently confessed) and it is equally easy to write you. I find, besides, I am lonely here and have no one to talk to about either art or nature.

With many wishes for your happiness and sucess believe me

Your friend
C. L. Ransom

[SB]

diaries 1860-61

South Brooklyn, 1859 & '60

Portrait of Mrs. Becar—25 × 30	$100.00
do—of Mr Noel Joseph Becar, from memmory	$100.00
Mr. and Mrs. Denison—27 × 34	$200.00
Their son, whole length, Wm. Denison—41 × 32	$200.00
	$600.00

Portrait of Wm B. Townsend on Staten Island—22 × 27 —Price $75.00.

Commenced a whole length of a child about the 17 of Feb—for Mr. Nathaniel Marsh on Staten Island. When finished it was considered a good likeness—painted from a drawing after death. I also painted a portrait of Mrs. Marsh.

In future I must if possible have a room by myself while painting at the residences of the rich—not to allow Tom, Dick, and Miss Smith, etc, a child or two, hanging around the easel.

Dust and excitement is too much for me when I am anxious to do justice to the work. I have painted many a portrait and never permitted the sitter, Lady or Gent to see the work until finished.

I have never charged for touching up the work of another, particularly of portraits.

New York

On the evening of the sixth of Jan, 1860, Mr. Charles B. Wood gave me a commission to paint him a picture for five hundred dollars.

Work— Work—

For flesh painting—mix Burnt Umber with Ivory Black and Yellow Ochre, Burnt sienna and Vermilion. Mixed together—Venetian red and black for brown.

Mix but few tints—yellow ocher and white, vermilion and white, blue and white, two tints, and blue, yellow and white—a greenish gray. Red can be added to the [remainder of sentence missing].

[January]

My flesh palette at this time: On the board near my elbow—white. Yellow Ochre, Vermilion, blue, Venetian red, Ivory black, Burnt Sienna and terre verte. Sometimes Madder lake might be added.

For dark complexions duller yellow and red can be used—but, the above I think is sufficient for all complexions.

Jan. 18, '60

Commenced a portrait (27 × 34) of Abel Denison Esq, 256 Brooklyn. First made a drawing with white chalk to arrange the body and hand. Then went over the whole outline with good India Ink. From one sitting. As he

could not sit for several days I painted the head and hand from memory, rounding up the parts (thinly with pure color), then adding white, red, and yellow in the light parts. The first sitting in consequence was improved by it.

I passed over sparingly vermilion with megilp mixed with linseed oil—at every sitting from life—and strengthened the work with Ochre and blue etc, as required. After the above preparations and while fresh, painted directly from the sitter. Painted Mr. Denison's head and hand in about three or four sittings. Dress and hand two sittings. Painted a great deal without him.

Mrs Denison's portrait took a longer time. The painter should charge more for a Ladies portrait.

Coast scene—wind storm by Andrea Achenbach—near sun set, bold effect. Boutelle, who has copied him, thinks he first toned thinly with raw umber—and when dry touched in the light of the clouds with Ochre, (modeled them) with Ochre and white, no red. French Naples Yellow and white for the brightest clouds (white loaded upon the yellow to give brilliancy). The sky painted first—or at the same time with the clouds—when dry glaze powerfully with Mars Yellow. Then paint thinly over the whole with the same tints. Lastly, tone the clouds with Mars Yellow and Madder Lake.

Foregrounds, rocks, etc, in sun light (on the right) burnt sienna and white—with tints broken in.

The sky, first permanent blue and finish with Ultramarine—Asphaltum to give force to the rocks etc. in shadows—green, red and yellow tints touched in. The lights loaded, but not painty—but few colors—warm and cold beautifully contrasted.

Emeraude green for the water in the the foreground.

Mount Desert, Sunset, by R. Gignoux. In the style of Achenbach although in his own style—much tinted and loud in color. The artist told me that he painted over the above (forcible picture) thirty times.

When Ladies desires to be painted handsome and the color and drawing of their faces improved—and a flattering likeness obtained—the artist should receive from their fair hands, 25 to 50 dollars extra.

Head and bust of a Gent, one hundred dollars, of a Lady $125—so and so on, according to the work to be done.

A good portrait is the work of time as well as a good picture, and the artist should have courage to charge a good price.

It often happens, to paint one Lady portrait is equal to painting two Gentleman.

New York, March 18th, 1860

I saw to day, an invention for flying. It is not to be moved by gas—but with Bysulphate of Carbon and some other mixture. M. Nelson the inventor is quite sanguine of success.

A new metal called Alluminum.

For a headache after a party, take common salt and water. For Diorea, drink a tumbler full of cider. For bite of a snake, apply fresh chicken meat—one piece after another. The first application will turn the meat black etc.

ABOUT LIQUORS

Warehouse [illegible] Gin (and whisky), made above Hartford—called Conn. Gin—or you can procure German rye Whisky, or Bourbon Whisky, or Rio Whisky—made from cracked corn—or Scotch Whisky—or Monongahela Whisky. The above and occasionally good brandy are better for those troubled with dyspepsia. Liquors are often adulterated with poisons—stricnine etc. I must drink no more coffee—and let whisky alone.

May 21st, '60

ABOUT EYES

Having painted a portrait of Mrs. Porter for M. C. Morgan 65 Garard[?] St. Jersey City—from a description and from a number of ambrotypes—and by using a magnafyer, my eye sight became very weak—so that I had to leave off reading and painting, and started for and reached Stony Brook May 12th 1860. I bandaged my eyes for seven nights, with tea leaves and the tea, also different remedies—Brandy—and also sage tea leaves etc, and applied during the day time, hot water with a linen napkin—the last done the best.

I must not read by gas light nor drink much spiritous liquors—hot water best for the eyes.

To paint well, the eyes must be kept in good condition. Read less—particularly in the morning. Paint first, before reading. *Must not read by gas light.*

Speaking of having a carriage to paint in (a studio on wheels), Mr N. Conklin, the dentist, suggests "a tent, instead"—to keep off wind and rain. Size, six feet by five feet on the ground, and six feet in height—with two French plate glasses in sides opposite each other—20 × 24 in. The tent poles (the uprights) should be shod with iron. The tent to be rooled up and put in a box—the latter to have handles to carry it. [Sketch]

My price for painting a portrait in the City or vicinity—head only—$100.00, one hundred dollars; including a hand, one hundred and twenty five dollars.

Portraits after death double price.

May 27th, '60

It is about time to lay aside my extra flannel. The past winter I have worn two pair of flannel drawers at the same time—in sitting close by the window in private apartments. It is important to health to keep warm.

I made a drawing of Mrs. Marsh—with india ink—and then varnished the whole canvass with Megilp and a little turpentine, then touched the lips and cheeks with vermillion—as a preparation for the first sitting in colors.

Stony Brook, Sept 30, 1860

To day I put on flannel drawers. Last winter I wore two pair of flannel draws—it was important in large rooms and sitting near the windows.

Dec. of 1860

Having worn muslin drawers the whole season I put on over the muslin two pair of thin white drawers—exposed out of doors as an artist is at times, it is important for his health to dress warm. Two thick pair of bluish flannel drawers would be warm enough.

[The following paragraphs were added later:]

I approve of the above, as I have on at this moment three drawers and three shirts, Jan. 6th, '62.

April 8th, 1862—I saw this day a man who had on three flannel shirts—he goes on the water. E. Tuthill's brother, P. G.—goes to sea.

Fourth of March, 1861

I played the fife for the Stony Brook and Smithtown Fusiliers at the Branch and head of the river. Hon. E. H. Smith delivered a short but neat speech to the company. The company numbered about 50 men.

In a cold day wear a silk handkerchief over your face (as a vail) to keep the cold off. You can see through it when walking or riding.

March 5th, 6th, & 8th, 1861

Built a Porch at our front door and a leader the whole length of the house—both cost about $13.00. I do not include my time. Chas. Howe, carpenter.

Varnishing Day March 18. Private view evening 19. Open to the public March 20th, etc—will close wednesday, April 24th. The Academy is to move to the new edifice about to be erected in 23 st, cor 4th ave.

Mrs. Charlotte Cutting left Stony Brook for Hempstead, March 12th, '61.

March 14, 16 & 17th

We all hope for the Union of States—and peace for ever.

Cold in my face, tooth ache—

April 13, '61

Charleston April 12—Civil war has at last begun. Fire opened on Fort Sumpter.

Anderson returning the fire. Splendid fight of 34 hours. 13th—the fall of Sumpter.

The united Northern sentiment: Hang out the Star Spangled Banner.

Preparation for the defense of the Capitol.

20th

Monster meeting in N.Y.—19th Mass. Volunteers opposed in their passage through the City of Baltimore—two or three soldiers killed and several wounded.

Destruction of the Arsenal at Harpers Ferry by Federal troops.

Port Jefferson L.I., June 27, '61

I commenced a portrait in oil (a sketch) from description of Lucy Davis (died about two years and a half ago). Daughter of Wm. M. Davis—Painter of fruit, flowers, and landscape. I executed the painting after the drawing was made in two days. Mr. Mrs. Davis, and friends are delighted with it, as a likeness. I made them a present of the portrait.

Notwithstanding I had not painted but one hour since New Years day and that was about the first of January—yet I painted with as much freedom and ease the 27th of June as if I had been handling the brush every day—an interval of six months. The troubles of the Country had greatly taken my attention from painting—but I hope now to have a more ardent love for studying from nature.

I also hope with the blessing of God that we shall have a free and happy country.

[August]

My niece Ruth H. Mount was married to Noel Joseph Becar—on tuesday August 6th, '61—at St James Church Smithtown. [Added later:] Mrs. Becar died Sunday Dec 15th 1861, regretted by all who knew her.

My eyes are weak caused by drawing on white paper (some boats) in very hot weather, 2, 3, and 5th of August 1861. Applications of hot water, as hot as I could have it, assisted in drawing out the inflamation. Also tea leaves sewed up in a bag and the bag moistened in the tea and bandaged on the eyes all night—for several nights. Also brandy applyed in the same manner—frequent washings of brandy is good.

Never suffer any cold water to enter the eyes while in the state of inflamation. *Drink no liquors.* I have been in the habbit of opening my eyes in cold water for several years past, but I shall abandon the practice.

Yesterday, August 11th '61, I assisted my brother in touching up some of his portraits.

August 27th, '61

Three funerals to day in this place—a few evenings since I heard three raps giving warning of the above death. I have been very hoarse, my cold is better.

Port Jefferson, August 27th, 61

Demensions of a sharpy—In length 17 1/2 feet, width 6 feet, stem 21 in, Stern post 26 or 27 in—dead rise six in, mast 23 feet, rudder 31 in, boom 23 1/2, gaft 8 1/2 [pl. 127].

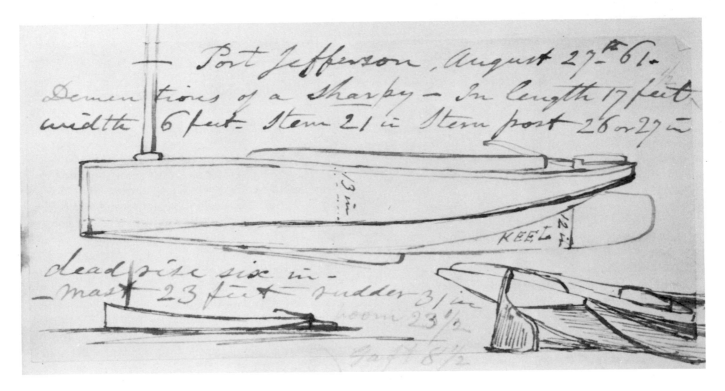

127. Sharpy. Diary, August 27, 1861. The Museums at Stony Brook,
Stony Brook, Long Island

ABOUT BOATS

There is now building in Port Jefferson a Sharpy for
fishing—she is sixty feet in length, 13 1/2 feet in height.
Center board about 18 feet, dead rise at the stearn 15 in.
Height of sides 6 to 7 feet. Flat on her bottom foward so
that when ballasted she will only draw about 2 in at the
bow so as to run up shore.

The style of this boat would answer for Government for
gun boats—to go up shallow rivers—besides they are
hard weather boats, ride the waves like a gull.

Draft of a Speech, 1861

A FEW WORDS BEFORE ELECTION

Officers and *members* of the National Academy of
Design: I move for your consideration that we have a
change of officers, so that those who have been in office
a long time, and say their duties are so arduious, can be
relieved. We have often heard our President speak of a
change of office—he evidently meant that it would give
more *satisfaction* to the *members*. As the Academy is now
managed, it is good for the few to the expense of the
many.

Why should we imitate the Royal Academy by voting
for one man every year—is that according to the spirit of
the American Constitution. We should elect a new Pres-
ident every three years. It would give our artists new life,
there interest in the Academy would be doubled, the busi-
ness of the meetings would not be delayed for the want
of a quorum. We have had for some years a Landscape

painter. Now let us have an historical, or portrait painter
to preside over us. Here are men that would grace as
painters the Presidential chair—Messrs. Huntington,
Baker, Kenset, Elliott, Church, Gray, Edmunds, Stearns,
Casilier and Hicks.

If there are any honors, or burdens, all should share in
them. If there is honor in holding an office, it should not
be held for ever by one individual. Fellow Academecians,
had we honored ourselves with a new President every
three or four years, we should most likely have had the
late Thomas Cole to have presided over us, and one
every way worthy, as a man and as an artist—and no
doubt the honour would have been to him (on his death
bed) a gratifying reflection. The above reminds us of the
honor that we might have paid to the late Henry Inman.

No one in this room has a higher opinion of the social
and artistic qualities than I have of our President, and if
we are to be blessed with one man for life, I do not know
of a better than Mr. Durand.

It is to be hoped that the President, the Counsil, and the
hanging committee, we are about to elect, will go in for
the interest of the Academy more (as much, certainly)
than for their own individual interest; thereby creating
harmony. As this institution is governed by artists alone,
we should act upon every idea that will stimulate us to
progress in the art we have chosen—at the same time to
hold in remembrance the title of our school of art (not
the academy of management, but) the Academy of De-
sign.

Painting of familiar subjects has the advantage over

writing, *by addressing itself to those who can not read or write of any nation whatever*. It is not necessary for one to be gifted in languages to understand a painting if the story is well told. It speaks all languages—is understood by the illiterate and enjoyed still more by the learned. It exhibits the progress of a nation in refinement and elevates those who encourages the arts and sciences.

The National Academy of Design, has so far reflected great honor upon the country by its Presidents, Academicians, Associates, and Honorary members, Professional Amateurs, and Honorary Amateurs—and containing some of the Greatest names, living and dead, that the country (including eminent Europeans) has produced. The first founder of this institution and the first man that has girdled the world in less than forty minutes—and our first President—Samuel F. B. Morse, Painter, Modeler, and inventor of the Telegraph; William Dunlap, Vice President, the painter and historian of New York; A. B. Durand, distinguished landscape and portrait painter (and formerly engraver of two very beautiful versions of the Declaration), and now President of the N. A. of Design; the late John J. Audubon, Painter and Naturalist of N. York; the late eminent portrait painter Henry Inman; the living Charles Elliott; and our poets Wm C. Bryant, Fitz Green Halleck, and Washington Irving. The late James Fennemore Cooper the novelist; Rev. Orville Dewey, besides Charles M. Leupp and Jonathan Sturges, our eminent merchants, and James J. Mapes Esq, chemist, agriculturalist and spiritualist. Is there not talent and genius enough to satisfy any reasonable man— if not, look over the list of great names in the catalogue. This Academy should be sustained by every liberal mind throughout the country on account of its influence upon art and artists—and it will be called by those that come after us the time honored institution. And it will stand and be an ornament to the country, if the artists will keep together.

[NYHS]

355

correspondence 1860-61

WSM to S. O. Fuller

Leggett's Hotel
42 Chatham St.
New York, April 2, '60

My dear Sir,

Your young and worthy friend (George B. Terwilliger) has an opportunity of corresponding with Mr. Gilbert Graham, 95 and 97 Duane Street, N.Y. Messrs. Hoger and Graham have seen Terwilliger's drawings and I think will take him in the lettering and ornamental shop, Duane St, providing he will be bound for the term of three or four years. Perhaps the first year he will obtain his board and cloths, the next year he will do better, etc.

If Terwilliger will have the courage to go through, he will benefit his employers and himself at the same time. He will have his evenings to himself (to practice drawing) and to see the different exhibitions of paintings now open in the City. I commenced as an ornamental painter. It is very difficult for a young man to obtain a situation in business in this City—I am very well acquainted with Mr. Graham, he is a good moral man. Mr. Graham attends to the ornamental department in Duane St. and Mr. Hoger looks after the House painting part of the work in third avenue.

Ornamental and picture signs are always wanted and painted.

My regards to Mrs. Fuller.

Yours truly,

[NYHS]

Wm. S. Mount

M. C. Morgan to WSM

Banking Office of
Winston Lanier & Co.
52 Wall Street
New York, May 26, 1860

My dear sir,

Your highly esteemed favor of the 23 inst was duly recd.

I was a little apprehensive not seeing, or hearing from you before, that "your eyes had got you down." I am very glad to hear that they are better and hope soon they will be as "good as new," equal to a *real magnifyer*. It must be delightful in the country now. I should enjoy it amazingly if I could run down and "lay off" with you a few days and luxuriate amidst the flowers, but how can I a "galley slave" think of luxuriating. It is only artists, gentlemen of taste, refinement, of leisure, that can thus "lay off" and enjoy life and the beauties of nature. Well, I wish you and all thus highly privileged, great happiness in your favored position, and then too, far more and better, at pleasure to call welcome spirits from the "vasty deep" and commune with those long departed, on themes past, present, and to come—nay more, to present us with pieces of art, unsurpassed by mortal hand! Guide our thoughts, our hands, whereby miracles almost are performed. Ah! me, I can enjoy none of these things, a slave

to business, locked up in a 7 × 9 office!!

I forget whether you saw the new frame in its place. It was duly recd the day appointed, and pronounced very beautiful indeed—price $22 and paid for.

The picture is very much liked generally—indeed it is considered excellent under the circumstances of its production, some say it could not have been better, if you had had the person before you. Yet in copying so cleverly from the photos, which were very *serious,* and without the usual vivacity of countenance, we have need, if possible, of a little touch, some how, or some where—no one knows how or where, and would not dare *say,* if they did know.

When you come in we will canvass the matter over, and if possible give a touch to throw a little more animation, into the countenance, and yet we are afraid to let the brush touch it!!!

When you get out of "pin money" drop in and see me. When hungry go to Jersey. The latch string, you know, always hangs out there.

We expect Mrs Ludlow to see us next week some time. Excuse this long yarn, and believe me

[SB]

Yours Very Truly
M. C. Morgan

WSM to Edward Henry Smith

Stony Brook, Oct 16th, 1860
My dear Sir,

I am pleased to hear you are nominated for Congress. Now is the time for action—Wm. H. Ludlow in an answer to my note says, "If you have a meeting in your place (Stony Brook) before the Election, I will endeavor to be with you." Tell the Republicans (Lincon Poops, that's the name for them) if they desire a change we intend to give them a Democratic President. Mrs. Francis Spinola mentioned to me if the people desire it, her husband would bring up a distinguished speaker by the name of Marshall to address them.

I have sent the following letter to Mr Jennings:

Stony Brook, Oct 16th, 1860
Richard Jennings Esqr
My dear Sir, I learn "the Americans have nominated you for member of Congress in this district." It is complimentary, but look at the future consequences. If you ever desire to go to Congress, and do not wish to see Mr Carter elected—roll up your sleeves and come in and support Edward Henry Smith. It will immortalize your name among the Democrats, a hint to the wise is sufficient.

The American Party is almost fizzled out, and *you are too smart a man* to be humbugged by them—but let them follow you. You know the Democratic Party has beaten the opposition, two to one, ever since the formation of the Government, and in one instance, I believe the democrats had three Presidents in succession.

[NYHS]

Yours truly,
Wm. S. Mount

WSM to William Handy Ludlow

Stony Brook, Oct. 24th, '60
My dear Sir,

I have just consulted the prominent Citizens of this place, and we desire to know if you can address them, some evening next week. (Say Wednesday, as it is steam boat day.)

Yours truly
Wm. S. Mount

P.S. Please answer immediately, as we wish to give the meeting publicity.

[NYHS]

WSM to John R. Reid

Stony Brook, Oct 27th, 1860
Dear sir,

The *N. Y. Times* gives a hint that the South will secede if Lincon is elected, and make Breckenridge President.

Another idea presents it self. The Prince of Wales has made his first and perhaps last visit to see his possessions in the Canadas, fully convinced that the North and South will separate. The North will swallow up Canada (British America) while the South will take in Mexico and Central America. Two great Republics side by side—perfectly happy—consequently Republicanism and Abolitionism used up.

The Democrats are waked up, ready to see the bullets fly on the sixth of November.

For Congress, we shall support Edward H. Smith and the Union ticket.

At a Republican meeting at the Methodist Church in this place, I heard that Rev. Daniel Jones was called upon to commence the meeting with prayer, but declined—exhibiting on the occasion good sense, as he has been accused of preaching political sermons. I am please to hear you will address the people at the head of the harbor (Smithtown) next Thursday evening. The Hon Wm. H. Ludlow will address a Democratic Union meeting at the Stony Brook Hotel—Wednesday evening. While fighting the great battle I hope you will be able to speak at Setauket (Brookhaven).

[NYHS]

Yours truly
Wm. S. Mount

HOW TO SAVE THE UNION

Have each house of Congress supplied with a band of music and whenever any speech is being delivered calculated to excite unduly the passions of either party—let the music of a national and patriotic character be substituted and the result will be harmony, and prove the truth of the Poet "for all time," that "music has charms etc." [This was apparently a draft for the following letter:]

To the Editor of the *Herald*

Stony Brook L.I., Dec 14th, 1860

Mr. Hudson,

Please suggest in the *Herald,* the importance of having in each house of Congress a *band of music,* that when a Union speech is delivered, the band shall strike up some stirring National air—to harmonize the debates.

If music, prayers, and union speeches, offered up with a firm resolve for each state (in the future) to mind its own business—If this I repeat, will not tend to keep this glorious Union together—what in the name of heaven will?

Yours, truly—

Wm. S. Mount

[NYHS]

Dr. N. Conkling to WSM

Brooklyn, Dec. 24, '60

My Dear Sir,

Yours of the 19th inst would have been responded to before this, but I have been at home but a few days during which urgent business has occupied the time.

I intended to have revisited your pleasant village long before this time, but have been prevented by business which I could not defer.

I shall go to Patchogue in two or three days to do some work already engaged. I will go from there to Stony-brook.

The misnamed Republican millenium has not made its advent yet. The "higher law," which means the invasive and aggressive will of such men as Beecher, Greely, Seward, Sumner, Wilson, Hickman, Abe and a host of other descendants of the Puritans "imbued with the thirst of their fathers," is not yet the law of the land. The descendants of the cavaliers and huguenots, resolve not to submit to it. It seems that our beloved country is not quite forsaken of Heaven and given over to the rule and ruin of unprincipled leaders and those whom, by sophistry for selfish purposes, they have induced to confederate with them. I think that what justice demands will be forced by the stringency which current events are producing from those who in prosperity would never grant it, and that harmony and prosperity will return and that political demagogues and fanatical pulpitarians will sink below par with sane and honest men. If this is distastefull to you please destroy it and excuse the author.

Please give my best respects to Mrs. Smith and accept assurance of esteem from

Yours Truely

N. Conkling

[SB]

Fragment of a Letter, Addressee Unknown

[February, 1861]

Extract of a speech by Mr. Lincon, Columbus, Ohio. "It is a good thing that there is no more than anxiety, for there is nothing going wrong. It is a consoling circumstance that when we look out, there is nothing that really hurts anybody. We entertain different views upon political questions, but nobody is suffering anything."

Dr. Conkling, the dentist, is stopping at the Hotel. We have read Mr. Lincon's speeches delivered on his way to Washington. Mr. Conkling says they remind him of the 13th verse, 10th chapter of Ecclesiastes: "The beginning of the words of his mouth is foolishness and the end of his talk is mischievous madness," to think that he is going to stand on the Chicago platform, without endangering the safty of the Union.

Give my love to all.

Yours very truly

Wm. S. Mount

[SB] *The quotation from Lincoln is correct. It is taken from an address before the General Assembly of the State of Ohio delivered on February 13, 1861. The full text may be found in* Abraham Lincoln: Complete Works, *edited by J. G. Nicolay and John Hay, 1920. At about the same time, one suspects, Mount wrote the following sentence, which is not part of a letter or diary entry but stands entirely alone on a small slip of paper preserved at the Smithtown Library:* "Those who voted the Republican ticket voted to kill white men and enslave themselves in order to give freedom to the Negro."

M. C. Morgan to WSM

N.Y., Mar 1, 1861

My dear Sir,

Your very kind favor of the 26th ult is at hand.

We are obliged by the offer to hang the portrait in the Rooms of the National Academy, but the family prefer not to allow it to go out of the house. They they think too much of it, to have it away. Some time when we can find a lady with a mouth like the original, we must try and improve the picture, tho many call it good as it is, and all are astonished that you could do so well, under all the disadvantageous circumstances. When over drop in and see us. All send kind regards to you, and expect to see in the Academy some of your superior handy work. Has Long Island seceeded yet?

Yours Very Truly

M. C. Morgan

[SB]

C. G. Thompson to WSM

694 Broadway

New York, Aug 20th, 1861

My dear Sir,

You will find enclosed a facsimile—a counterfeit presentment of what I am, not what "I use to was." And as a friend of mine in Boston says "More picturesque than beautiful."

The "ages," as Bryant might sign[?], are slowly but surely creeping upon us. And if we only stand up against them manfully; and while our externals are becoming scarred and wrinkled, we push on, heart and souls fresh and young. We shall have every reason for thankfulness to the overuling power of a just Providence; and shall justly claim our shares of happiness, warm if the world is such [illegible] and unfeeling around us.

I was much pleased from[?] incidental meeting at Brady's yesterday. And I beg you when you are in the Great Babelon of New York and have a few moments to spare you will throw them away with me at my Studio, 694 B. Way.

<div style="text-align: right">

Believe me, Dear Mount,
Yours Ever Truly
C. G. Thompson

</div>

[SB]

diaries 1862-63

[January, 1862?]

19th—Departure of the seventh regiment for Washington D.C.

21st—Navy Yard and eleven ships destroyed at Norfolk Va—by order of the Government.

For my part, I wish to see peace and harmony throughout the country, and if each State had minded its own business, the present state of affairs would not have happened.

My belief is that the Union of all the states will be preserved—and the time will come when the leaders of the rebelion will run for their lives.

Port Jefferson, Feb 1, '62

Painted a portrait of E. T. Darling Esq.—25 × 30.

First, made an india drawing (previously outlined with chalk).

2nd—painted the effect of the head and then called in Mr. Darling and painted an hour and a half.

3rd sitting—painted without *specks*.

5th d[itt]o—scumbled over the flesh with light flesh tints, over the shadows with yellow ochre. His friends think it a fine likeness.

I should have a Pension.

Paint a girl reflected in a glass. [Sketch]

Port Jefferson

Wm M. Davis has painted a picture which has attracted attention called "The Neglected Picture." It has been photographed card size and for sale, 25 cts.

Mr. Davis painted last fall his best and largest fruit and flower piece. Good—

March 8th, 1862

I like my portable studio. It stands the south side of Mr Darling's boat shop. It is warmed by an air tight stove. The wood for the past winter has cost $3.00 and some to spare. Expecting to move from time to time, I only bought a dollar's worth at a time. I have sawed my own wood and my health and consequently my eyes are better—a great blessing for a painter.

I have not taken any medicine in three months—occasionally a glass of pure cider—take no tea or coffee and *no rum;* better for it.

Never paint a picture unless you see the subject throughout clearly. Then you can work with confidence.

Port Jefferson—Evening March 31st, 1862

At present I feel that I must use no more varnish while painting—but use as I have done for the last month bleached raw oil and Boilded oil mixed. Pale japan for Black. In summer use Bleached oil alone. Boiled for black

—or megilp out of the tube. The latter may be rubbed over where you wish to paint. (At times) a little pure varnish might answer—to paint over to produce same effects—Mastic or Demar. Mr Davis says he works without varnish and drives his colors and uses but little oil, and then varnishes his work a short time after it is finished. It used to be my method.

I can work with more freedom with oil—some painters use a little turpentine with oil—it will do perhaps in the first paintings. By bleaching oil it dries quicker. I assertained the fact by experiment.

I have just finished two pictures—Returning from the orchard, size 19 3/4 × 26 1/4, on wood. Going traping, on canvass 25 × 30.

"The Confederate in Tow" I concluded not to send to the exhibition. Hearing there was want of room I did not send any portraits—this year I exhibited three pieces, "What have I forgotten," "Returning from the Orchard," "Going Trapping."

[April, 1862?]

For painting a house outside—first coat use English white lead and *mix verdigris with it—for durability*. Zinc white for finishing *inside work,* and use with it demar varnish. *Zinc* is a finishing color.

Bleached raw oil will dry quicker than raw oil but will not retain its clearness. I have tried it. Therefore good raw linseed oil is better—particular in summer on account of its drying slower. It gives the painter time to improve his work. In winter we can add *good boiled oils to the raw* and pale japan (a few drops) to black etc—those colors that do not dry well.

Demar varnish can be used to make the color stick if required in place of Magilp.

Demar and Japan will mix well together—also Demar and raw oil and I [have] reason to believe durable.

Copal, I have not experimented much with.

Price of turps—$3.00 per gal.
do—Benzene— .70 per gal
do—Kerosene— .60 per gal

Kerosene has been used to mix with paint in place of turpentine. It is good to rub a stove with—also, lately, Benzene with paint.

There is no use of painting a picture without there is mind in it. The story must be well told, *good expression* and *brilliant in color*. Mass in the effect with large brushes and touch in some of the details with small brushes.

Feel out your subject first and then look out for individual nature after, unless you see in nature all you may desire.

The painter should cultivate his memory to paint the forms and effects he has seen, and to [illegible] subjects also.

1862

National Academy of Design, 625 Broadway. In the Derby Gallery.

Varnishing, april 12th. Public exhibition, do 14th. Will close about the end of June.

I understand my Brother Shepard will have several good pieces in the Academy.

Port Jefferson, April 9th, 1862

Wm. M. Davis, will exhibit for the first time a number of his fruit and flower pieces. Mr. Davis painted last month a picture (25 × 30) Done Gone. Both the Neglected picture, Jeff Davis, and Done Gone have been exhibited in the show window of Mssrs. Ball, Black & Co, and have produced quite a sensation and photographed, Carte de Visite size, 25 cts each.

Mr. Davis, in painting his picture of Jeff Davis, procured an old frame (of Mr. Raynor) with a broken glass—then made a drawing of the head of Jeff Davis on paper and placed it in the frame behind the broken glass. The cards were placed between the glass and frame—the cobwebs on the outside. The frame being knocked out of square, the (design) or picture was placed in a good light and imitated.

DONE GONE

Mr. Davis selected a head stone and printed on it, "Hic jacet secesh" and arranged about it the various accompaniments of the rebel soldier. Every thing (the incidents of the war) that he could think of to tell his story—was placed about the grave stone on the table and imitated as close as was desirable. A very ingenius way to tell a story by still life arrangement. The different objects were well painted. The painting is on exhibition at Messrs. Ball, Black & Co's show windows, in Broadway.

Mr. Davis is now painting the portrait of Mr. Sidney Norton of the Custom House N. Y.—his residence is in Brooklyn. I have advised Mr. Davis if he desired to paint figures to paint portraits in order to get a knowledge of the flesh tints: A piece of fresh beef I presume would give some knowledge of the flesh tints.

Brother Henry painted (beef) still life—first rate.

I have hinted to Mr Davis to visit the Academy on varnishing day to see the painters touching up their works—and also, to visit the different exhibitions in the spring and paint Landscapes in summer and fall.

Success (I say) to all lovers of art and nature—

April 18th, '62, N.Y.

Wm M. Davis ordered Mrs Croker (door keeper) to alter [No.] 475 marked Fruit to read 4 apples and a pare when the painting represents *four oranges and a lemon*. It looks like courting notoriety at the expense of truth.

Port Jefferson, May 4th, '62

I have been thinking for some time of boarding at Setauket with my brother R. N. Mount, and walking over to the Port. [portable studio?] every day. It would give me good exercise—four miles a day would do.

It is about time I stopt painting so many Photographs for nothing— It takes too much time.

Setauket, May 18th, '62

I board with My brother and walk to the Port. every day (dinner in the basket). I can see more scenery.

May 24 & 25—colored two Photographs for Mr F. Hawkins, Stony Brook.

May 31st—colored four Photographs for Capt Havens Jones, Port Jefferson.

June 21st. Working on my picture of Peace and humor (The Cannon).

July, '62

SUBJECTS [pl. 128]

Boys sailing Boats. [Sketch]
Two men grinding a chisel, one holding, the other turning. [Sketch]
A Negro reading to a little white boy. [Sketch]
A man grinding an ax alone—a man or boy carrying a lot of green hay [illegible].
A man resting against an old well, his horse drinking out of the trough. A pole well—good subject.
A girl, or a boy, cracking hickory nuts, or black walnuts.
Modern style of nursing a child—a contrast to the old style—bottle and breast. The child in a basket or chair. "I want a small child teaching us humility and courage." ——Henry Glynn.
Mr. Charles B. Wood desires me to paint him a picture for five hundred dollars.
The Mother, Child and Parrot.
Horses looking over the shoulder of a painter while he is sketching in the field. [Remainder of this paragraph illegible]
The ripple, a man or boy washing his clams in a basket —his hoe in one hand and basket in the other.
A woman or girl holding an apple, pair or peach. [Sketch]
Flowers stuck in a bayonet.
A negro eating an apple— [Sketch]

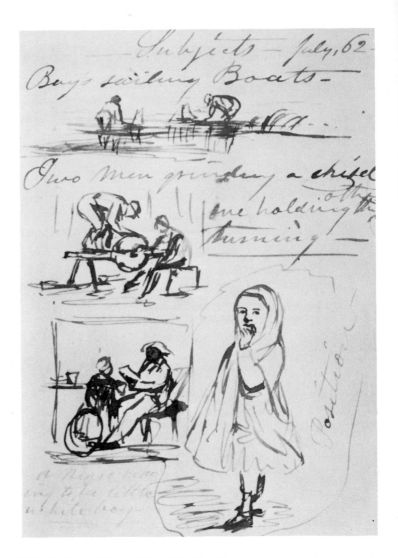

128. "Subjects." Diary, July, 1862. The Museums at Stony Brook, Stony Brook, Long Island

August 1st, '62

Made a sketch in oil of Effingham Tuthill 8 × 10 in, a present. His wife is pleased with it.

August 2, '62

Made a sketch in oil of Rev. J. S. Evans, for the benefit of the Presbyterian Church at Setauket and Port Jefferson. It proves a success. The Ladies, The Miss Strongs, have received quite a sum, $50.00, and have presented the cabinet portrait to Mrs. Evans.

I painted the two portraits in five days. I only drew the outline with white chalk and painted in the effect at once.

August 12th, '62

I eat no apples nor pairs, drink no liquor, tea or coffee —only cold water—and walk five miles a day. My health is better for it.

Take no medicine—but occassionally drink a glass of salt water and eat about two lemons in 7 days (for acid). Lemons is good to keep off the rheumatism which I have been subject to.

August 23, '62

For 5 or 6 days past I have reputtied and painted the seams out side of my studio after driving in the old putty with iron.

I intend to putty up the cracks inside of the studio—and perhaps varnish or oil out the interior. Also, give the exterior a thick coat of paint. To prevent if possible the atmosphere from acting so powerfully on the thin siding.

August 30th, '62—Brother Shepard made a visit to brother R. N. Mount.

Port Jefferson, August 31th, '62

With diligent labor, for the last two weeks I have stopped up every (crack) or seam on the outside of the studio with putty and thoroughly painted it with white lead, Linseed oil and a little pattent dryer. The color is the shadow of white, set off with *Red, White* and *blue*— and yellow at the sills of the windows and door.

The inside seams I also puttied and varnished with De-mar varnish and camphere, and also with benzene (no turpentine in consequence of the war). Benzine is now used in all the Carriage manufacturers—in place of turpentine. It is good to remove paint from cloths.

Painted at Stony Brook Sept '62, two portraits—Mrs Wm. H. Wickham and daughter—finished their sittings in seven days, and background in three or four days.

In the last of October I painted five miles from Peekskill Landing—The portrait of Andrew Hood, 25 × 30, in eight days.

Prices——Mrs Wickham $75.00
 her child 50.00
 $125.00
 Mr Hood $75.00
 $200.00

Snow Storm the 6th of Nov, '62. Snow 4 to 6 inches in depth.

I made a visit to E. Tuttle's at his particular request and painted four photographs for him.

I must drop the photograph painting—it takes too much valuable time.

Nov 14, '62

Strengthened the portrait of Lucy Davis, Daughter of Wm. M. Davis of Port Jefferson.

Setauket, Nov 22, '62

Commenced board with Mr. Tuttle May 11,' 61. May 18th, '62 board with Mr. and Mrs. Mount, Setauket, and walk to my (Portable) studio at Port Jefferson. Moved my Studio to Setauket to day, Nov. 22, '62.

My studio was moved up to Setauket to day from Port Jefferson by Mr John Davis and Mr. John Denton (it moved in fine style and no damage with two teams). Messrs Davis and Denton would not receive any pay for their labor.

Setauket, Nov 24th, '62

I worked on my picture of "Laying off"—my brother R. N. Mount sat for one of the hands.

Nov 26th, 1862

This is my birthday and thankful for all the favors showered upon me.

I commenced to paint to day (after a careful drawing) a view from my studio window of the residences of John Davis and R. N. Mount, as a background to figures in the foreground. Before I commenced the drawing I washed off the canvas with a clean sponge. When dry I rubbed over the surface with kerosene [in margin: raw oil will do as well] it being an old canvas. I then made my drawing with white chalk first—and lastly corrected the outline with India ink, using hog's gall—it works well. Perhaps it should have been in gall. Washing a painting makes it dry harder.

Setauket, 6th & 7th of Dec, '62—very cold weather closed up the harbor—16 below zero.

To day 14th of Dec—very warm and pleasant. Gulls flying low—indicating good weather.

I have resided in Setauket about six months and I am happy to state that I have not drank a glass of liquor in any of the stores. My eye sight and health is better for strict temperance.

Three meals a day and cold water is good for any man.

Dec 21st, 1862

Six degrees above zero this morning. Put on an extra pair of drawers this morning. The legs should be as well clothed as the body. Two muslin and one flannel—flannel outside. Put flannel shirt inside—and two muslin shirts outside. It growing colder.

Jan 1st, 1863

We hope Peace will make this a happy Year, long to be remembered.

TO A PAINTER

Read less and observe more—if you wish your mind to store. ——Mount and Holmes.

Stony Brook, Jan. 4th—Walked from Setauket in the evening.

Setauket, Feb. 4th

Weather at zero—the saturday following flies were out. It was warm.

Feb 14th, '63

Brother Nelson and myself played duets together in my portable studio, for the first time.

Capt Jones of U.S. Army joined us and good music was the consequence, he being a good violinist.

Feb 16th, 1863

I have done but little painting since Christmas. I hope to be able to paint more.

My nephew Thos. S. Mount cutting and selling wood off the Mount farm at Stony Brook in 1862, without my consent or knowledge, troubled my mind very much—also, the intemperance of a friend. *Right wrongs no one*.

I am invited to three parties this evening, one in Baltimore, one in Patchogue and one at Smithtown. I have concluded to stay at home.

Last week I was out most every evening. We had a visit from an army officer—Capt. Jones, Mr. Evans's friend—a good performer on the violin. His bowing was quite peculiar. He produced some striking effects. He was a tenor player in the Euterpean Society— My brother Henry, and my uncle Micah Hawkins belonged to the same society— many years ago. Hawkins was president of the same society.

I believe I must have a violin in my studio—to practice upon. To stimulate me more to painting. I remember that

129. "Good Subject." Diary, May 29, 1863.
The Museums at Stony Brook,
Stony Brook, Long Island

364

when I painted my best pictures I played upon the violin much more than I do now. The violin was the favorite instrument of Wilkie. All the great painters were fond of music.

[March, 1863?]

The painter not rich in money has one consolation; he owns all his eyes takes in—the riches of sight.

Setauket, Long Island
March 22nd, 1863

This afternoon is warm and spring like—the people are out sunning themselves and thinking perhaps of the future of their great country and Democracy; like the warmth of the sun cannot be kept down forever.

The works of genius are suggestive—they lead the mind on, on, almost to the bounds of eternity.

March 31st—The National Academy opens this year April 13, 1863.

Setauket, 8th of May, '63.

We have had a cold east storm. I have been coloring some *card visites* and large Photographs—in watercolors. My ambition is satisfied in that line of painting at present.

It is a kind of work *partly following but not leading. It is slavery.* I must use the colors for my own compositions.

Time is precious, we should have a care what we do.

Geo. H. Yewell says that E. Frere, the French painter, paints loosely, commences in an indistinct manner at first painting, and repeats the colors as the work progresses. Frere takes his paint box etc to a cottage and makes up his pictures according to the interior arrangements.

[May, 1863]

Painted the portrait of W. H. Wickham the last of April '63 at his residence, 308 Lexington Avenue. I glazed the head with venetian red first, then followed with terre verte and touched in when required with vermilion. Venetian red should be ground fine.

A dark background should have atmosphere. Mr. Bellows, painter, observed to me about a landscape back ground to a portrait—that it appeared too dark about the head and shoulders, the light above the horison should have been carried more up into the dark to render the atmosphere more visible. Nature is full of air tints—perspective in color as well as in drawing is important.

Sale of Hall's pictures, evening April 15th, '63—the collection bringing exclusive [of] frames over $7,000. A bunch of purple grapes brought over $185.00. Raspberries in a cabbage leaf $130.00. Bunch of currants $150.00. Three peaches $81.00. The mimic Bull Fight $450. [Illegible] $360. Collection of one hundred works—good times for the fine arts.

May 21, '63

"Mr. J. F. Cropsey, American painter, in London sold off his pictures and sketches for over 1,200 guineas, a sum which at present rates of exchange will give him about $8,000 in N. York."

May 21 '63 and 22nd—hot weather. Thermometer over 90. See the difference May 25th, '63—thermometer 46.

May 29th, '63

Putty sold at the stores is not fit for use—the whiting is evidently mixed with fish oil as it falls out of the cracks—will not adhere.

I make my own puty, half white lead with whiting and a little Painter's dryer. I shall try one seam with clear white lead as an experiment. It is best. A tin roof to my studio is recommended. It would be noisy in a rain storm.

Received a letter from John M. Gardner of Washington D.C. May 1863 respecting the painting of the eastern staircase of the Senate Chamber to represent Washington descent of the Alleghany as described by himself. He says—"I have just bespoken with the commissioner of Public Buildings for our friend Mount."

GOOD SUBJECT [pl. 129]

A man or fat boy standing on a chair with candle in hand—looking on the top shelf of the pantry for something to eat. At the same time he has a piece of pie in his right hand.

Hat filled with fresh apples. [Sketch]
shelling corn. [Sketch]
Union picket whistling Yankee Doodle—and at a distance a Confederate picket whistling Dixie.
J. Davis's boy and dog (effect and color).
Boys and girls making willow whistles.
One horse drawing four workman, they seated on a plank of a small waggon. It would add to the humor of the scene by introducing a negro driver or as one of the workman. A bundle of hay for the horse should be added to complete the general effect for a good foreground to some fine landscape background.

As regards spending time painting apple blossoms and lilac etc, they are always the same thing over and over—but men and animals are not always so. Man and his dress is ever changing.

SUBJECTS [pl. 130]

Paint a lady by a reflected sun light—good effect and fine color.

A workman looking at a bunch of fish. Mr. Risley would be a good modle. [Sketch]

130. "Subjects." Diary, May 29, 1863.
The Museums at Stony Brook,
Stony Brook, Long Island

SUBJECTS

A boy (driving his horse), a chair harnessed up and a chair for a seat (a buggy).

Children scuffling.

I know this much that owing to poor health an attack of *ascarades*.

Writing letters copying Washington's notes and coloring photographs, *I have not painted the early foliage yet*.

It does appear that when I am anxious to paint for improvement, something steps in to interfere.

Drinking 4 tumblers of salt water—wild cherry bark soaked in spring water for a drink—and an injection of Aloes—has helped me. Also one dose of brimstone. I should think that was enough to wake up the worms. The above were not all taken at one doce though.

My health is better.

I hope never to paint for private individuals, or for the

government unless my heart goes with the order. Therefore I had rather select the subject to be painted and thoroughly understand it before the work is commenced.

To paint simply to make money, I cannot do it; a painter should know his own ability and have regard for his reputation.

A man should [k]now himself and keep at work—if he really desires to accomplish much in painting or in any undertaking.

Have courage under all difficulties and positions in life.

August 5th, '63

I made a paste of wheat flour (and water) and added powdered dry *ultramarine blue* to give the paste a cool color (quite blue) and spread it over the skreen (both sides) with flat brush, it being muslin. The light through the sky light (Portable Studio) is improved. The above is a better coating than demar varnish or oil for durability. The wheat paste can be washed off, if too thick, at any time.

The mastic varnish sold in some of the color shops in the City is *positively bad* for a painting. I found it so in varnishing Mr Hood's portrait, and had at last to take mastic varnish and bleached linseed oil—united them together hot, and varnished the portrait in the sun—and let it dry in the sun two or three hours—it had a fine polish, but the mastic varnish said to be (I believe was not) mastic was too thin and dryed dead—sunk into the ground or distance.

I must try and paint out of doors all the time I can spare—*begin now.*

August 24th

Received three dollars for painting three photographs from a lady—she even desired me to take $5.00, she was so well pleased.

I listened to a national Thanksgiving sermon at Setauket August 6th 1863 delivered by Rev Dr. Noll.

Showers and warm weather continues—*good for the crops.*

Setauket, August 25, 1863

This morning I requested my sister in law to speak to Walter & Carlton (liquor dealers) on the subject of her husband's intemperance. She observed that she had talked to him—that she did not intend to speak to the dealers on the subject, and the sooner her husband run down the better for all she cared.

Last evening he fell out of Carlton's store door. Last winter Carlton said he sent two men to bring in R. N. M. from the road side to prevent his freezing to death—all originating from the treating system and the *morning dram.* It is sorryful to contemplate—

The Dr told him that he had the chronic diarrhoea and if he stopped drinking he would get well.

Setauket, Sept 20th, '63

To day is a cold wind North north east—storm of rain.
18th a *heavy wind* and rain storm from S. South east.
12th made a drawing on canvass of Mr Jayne's house and out building as a background.
19th commenced a cabinet portrait of Cornelia Monson from a photograph which I had colored.

Nov 10 & 11, '63—Ice—

Nov 16th

Rain, wind East.
I painted or colored 2 straw hats—and painted over panels and canvass. Last Thursday I painted the iron braces under the *stove,* filled up the crack on the roof with white lead rubbed in, so far good—also filled up the sides in the same way—and the cracks or seams inside, using putty knife and also rubbing with rags or spunges. Occupied about three days.

Setauket, Nov 26th, 1863

My *birth day* and Thanksgiving day—
News of the defeat of Gen. Brag—by *Gen Grant.*

Nov 27th—first ice in my studio—

About the first of Dec' 63 I painted two small fruit pieces—apples natural size—the first I ever painted as pictures by themselves.

Dec. 5th I painted out of doors. It is considered by the oldest inhabitant that this fall '63 has been the mildest yet.

Dec 9th—the coldest yet. The Boys were able to slide on the small ponds.

Dec 11th

Recd a letter from my nephew W. S. Mount from the Military Prison at Alton Ill. dated Dec 4th '63—he says he shall take the oath and come home.

About the 11th of Dec, '63—the first snow fall in depth one inch.

Dec 16th '63

It being a fine day I filled in some seams on the outside of my studio with *white lead* mixed with a little painter's dryer—having removed the old puty made of whiting.

Mr. Gilbert Wilson, called to see me this afternoon desiring me to give him instructions in painting.

correspondence 1862-63

The fourth letter in this section is typical of the bland, courtly, and somewhat effusive correspondence that passed between Mount and Samuel P. Avery in the sixties. Most of it is rather inconsequential and is omitted, but this particular letter, with its reference to Kensett's painting and engraving a picture after Mount, adds something to the record.

According to Lillian Miller in *Patrons and Patriotism,* Avery was acting at the time of his correspondence with Mount as an agent or dealer for artists who resided at a distance from big cities, but there is no evidence in the letters to show that he was ever involved with Mount in that way. Calvin Tomkins (*Merchants and Masterpieces: The Story of the Metropolitan Museum of Art,* 1970) identifies Avery as "an engraver who had branched out as a dealer in European paintings." "Avery was instrumental in forming the collections of William H. Vanderbilt, August Belmont, and other New York millionaires," says Tomkins, "and for more than twenty years he would function as the Metropolitan's principal adviser and expert on all art matters." He was a trustee of the Metropolitan from 1872 to 1904.

Also of special interest here is Mount's somewhat peppery correspondence with a Congressman, John M. Gardner, who wanted him to paint a mural of Washington descending the Allegheny for "the eastern stair case of the Senate Chamber" in the Capitol. Emanuel Leutze's *Westward the Course of Empire Takes Its Way* had only just been installed in a similar staircase landing on the House side and was causing considerable stir. The huge size of the space to be filled—thirty feet long and twenty feet high—was, of course, entirely foreign to Mount's small-scale way of working, and the proposal came to nothing, although he did attempt a study for the mural (pl. 131). It is one of his feeblest efforts, adapted from a painting of the same subject by Daniel Huntington, a sketch of which, in Mount's hand, is preserved at Stony Brook (pl. 132).

Gardner had originally approached Mount in 1856; his idea then was that Mount should paint the death of Major André on the stair landing in the Capitol. This letter is rather involved, and since it had no result, we omit it. Also omitted are two letters of 1865 wherein Gardner proposed that Mount bring samples of his work, especially the portrait of Bishop Onderdonk, to show to members of Congress as evidence of what he could do. Mount apparently did not comply, and the entire project seems to have evaporated thereafter. The letters which have been left out may be found in Chapter 53 of Edward P. Buffet's biography of Mount which ran serially in the *Port Jefferson Times* in 1923–24.

Mount's quarrels with his in-laws over family property and his encounter with the outrageous racketeering journalist, J. H. Layton, are other highlights of this section.

A.F.

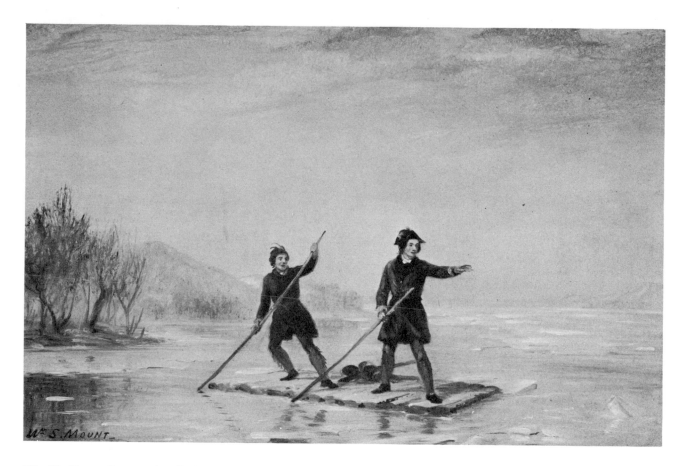

131. *Washington Crossing the Alleghany.* 1863. Oil on panel, 7 1/2 × 11 3/4″.
Private collection, Long Island

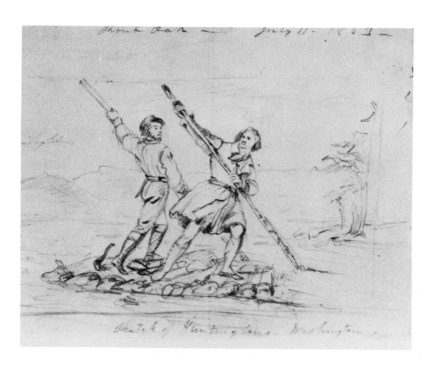

132. "Sketch of Huntington's Washington."
July 11, 1863. Pencil, 7 3/4 × 5 3/4″.
The Museums at Stony Brook,
Stony Brook, Long Island

WSM to Charles B. Wood

Setauket Suffolk Co.
Long Island, June 1st, 1862

My dear friend,

My niece Maria told me that you was pleased with my picture of "Going Trapping" and had some thoughts of owning it, which is complimentary. You have exhibited good taste in selecting and a knowledge of the price of paintings. As I spend so little time in the City, I will thank you if you will use your influence with the picture lovers, Mr. Stewart, or any one else to take the picture at my price three hundred and fifty dollars. But if you desire to purchase it, you may have it for three hundred dollars.

Rev. F. Noll, Episcopal, of Setauket told me yesterday that the above picture done him more good than if I had given him one hundred dollars as it took him back to the time when I had painted such compositions—also, that the work had *immagination and brains* in it. The frame is not included unless desired, as it is a portrait frame. (The sight measure of the painting is 25 × 30, there is a moulding around it.)

Brother Shepard's portrait of his daughter Mrs Becar was favorably noticed in the Sunday *Times* a few weeks since.

The Artists speak very highly of my pictures this year.

I board in Setauket and walk to Port Jefferson a distance of 2 miles every day (dinner in basket).

My regards to all your family.

Yours, Very Truly—
Wm S. Mount

P.S. If I should sell I desire to retain the copy right, to engrave it.

[NYHS]

WSM to Andrew Hood

Setauket—Suffolk Co.
Long Island N.Y.
June 15th, 1862

My dear Sir,

Your very kind letter inviting me to paint your portrait, I fully appreciate. It has found me in the midst of a picture and sketches which I would like to finish (or nearly so) before I commence your likeness. I have no studio in N.Y. City—but have one at Stony Brook. I have a Portable Studio, my own design, at Port Jefferson which I am using at the present. For the sake of my health I board at Setauket and walk to Port Jefferson every morning (dinner in basket) a distance of two miles over a hilly road. Your portrait I can paint at some friends house in the City. Or, at Stony Brook, or at your residence at Peekskill (if the windows are of good height, a foot higher

than you can reach with your hand will do) or, I will paint it at Port Jefferson, if you can spare the time to visit that place for recreation.

Mr. Townsend's portrait I painted at his residence on Staten Island.

Yours, truly—
W. S. Mount

[NYHS]

Charles B. Wood to WSM

39 W. Bway N.Y., June 21st, '62

My dear Sir,

I have your favor of two days since and would reply sooner but have not been well. Your offer is very tempting and had I not resolved not to speculate in Pictures of my artist friends I would buy "Trapping."

The Academy closes on Monday. Can I be of any service to you then?

Yours sincerely
Chas. B. Wood

P.S. All quite well at home and wish to be remembered to you. If you are in town, stay with us, we have plenty of room and glad to see you.

[NYHS]

Samuel Putnam Avery to WSM

Removed to 102 Nassau st.
Aug 7th, 1862

My dear Mr Mount,

Your kind and interesting note as also the sketch of your portable studio came duly to hand. For the latter I am at a loss for words to express to you my thanks for your complimentary and valued favor.

I certainly shall frame it as you have made it quite a picture, and with the artist himself added will become in time a historical work. I like the looks of the *studio* and should think that it has a *perfect* arrangement. A peep through the open window and its inside suggestiveness makes me feel anxious to get within. I cannot thank you sufficiently for your great kindness but hope the future will show me some way to repay you.

Mr. Kensett, has also made me a present which has its interest from being connected with your name. He has given me a small copy in oil done by himself from a picture of *yours* of a boy reading at a doorstep and showing the interior with a female figure. I have a wood cut of the same picture nicely cut by Adams. Mr. K. made the copy before he became a professional painter with the intention of engraving it, and did about half finish the plate while in Europe, he however abandoned the graver at

that time and *rust* finished the job.

Did you ever know of this?

I will be obliged to you if you will let me know when you painted the picture, its size and who for and where it now is (if you know) and if I can get a look at it. Mr. K. says that it is a very fine picture.

I am very sorry that he never finished the plate. The association of your joint labors in the work would have been an interesting event in American art.

Derby has the gallery open again and I was glad to see your two pictures there and in a *good light*. They look like different pictures—or as if you had worked on and greatly improved them. Particularly the "return from the orchard" shows much finer. I am sorry now that I did not think of sending *my* little fellow—but I was so indignant with the way it was treated before that I was glad to get it home, where it is a great favorite. I have promised however to lend it to Knoedler in the fall.

Falconer is up north river just now having his vacation.

Nearly all the Artists are away. Elliott is busy with his new house, a snug little box on his acre of land overlooking the valley of the Hackensack and where he will in all probability end his days. He says that he will also build a small studio on the ground and try and do more subject pictures, illustrations of Irving and Shakespeare—he has one under way of "Anthony Van Corlear returning from a mission to Peter Stuyvesant." We will go out together when you come to N.Y. and see his "shanty."

Enclosed is a photo from a drawing of freind Kensett made for me by Saintin [Sartain] just before he (S) left for Paris.

Boughton has sent me a lot of cards of the celebrated french and english artists which you will like to see.

Wont you tell me the best way to get to Port Jefferson? And without saying *when* let see if I can get away run down and see you for a day or two—only letting me know if you leave for any other place.

I hope you are well this summer and enjoying yourself with your beautiful art.

Please when you see your brother give him my kindest regards.

And believe me to be your grateful friend

Samuel P. Avery

I have better light and cheaper rent here—and better location for business in good times.

[LOUISE OCKERS COLLECTION]

Oscar Bullus to WSM

U.S. Naval Rendezvous
New York, Septr. 3d, '62

Dear Sir,

The Navy is in want of sailors: and I know of no better material in the world than the men who navigate our Long Island coasting and Sound vessels.

We all owe military service of some kind: and to those who would prefer the Naval Service and the prospect of prize money to three years service in the Army, I would gladly receive them at my office No 9, Cherry St.—near Franklyn Square. The wages of "Seamen" is $18.00 mo, "On Sea" $14, Land $12: they have the privilege of enlisting for one, two or three years and receive three months pay in advance to furnish their own outfit. Knowing you to be a good patriot: I take the liberty of asking you the favor to make known the wants of the service, in your locality Stony Brook and Port Jefferson and Setauket.

We are receiving as Landsmen a body of the finest young men that probably ever entered the service of any country and they will soon make sailors—but we want good and experienced men at once. The only reason this class of men do not come in, as fast as we require them, is that they are paying a large bounty in the merchant service, but in appeals to the Long Islanders I am certain that considerations of higher importance than dollars will prompt them to come forward now and enter the naval service, for one two and three years at their option.

I had the pleasure of recg a letter yesterday from Maria for which I return my thanks, and for her invitation. I cannot leave now—I have two offices in full blast. During the month of August I enlisted 11 hundred men.

Very truly yours
O. Bullus

My headquarters are at 9 Cherry St.
Office No. 2, 85 South St.

[SB]

Andrew Hood to WSM

N.Y., Oct 15, '62

Dear Sir,

In answer to yours I could prefer sitting for my portrait at my Residence near Peekskill, but question if you will have time, as I expect to leave the first week in Nov. for N Yk, but as I may be in *Boarding,* it would not be convenient for you and I shall not be able to wait on you at your Studio.

May I request an answer wether you can proceed with me, to my residence, say—Tuesday next; I leave N Yk by the 3 PM train—if so please come to my office No. 4 William St. before 2 PM, and if you so intend drop me a line to that effect.

Waiting your reply
I remain
Yours Truly
[SB] Andrew Hood

WSM to Shepard Alonzo Mount

Setauket L. Island
Dec 31st, Farewell to 1862

Brother Shepard,

It being a stormy day, snow and rain, rain and snow, for a variety from the east, I thought to drop you a line from that quarter. Myself and Mrs. Henry S. Mount's family took Christmas dinner with sister Ruth. Mr. and Mrs. R. N. Mount and son were invited, but did not go to the feast—therefore they lost the eating of the 10 pound turkey and the large suit pudding. We had a good time and Bob was around with the Boys. Next day I looked for some of brother Nelson's letters he wrote me from the South, as he wished to look them over concerning the methodist and abolitionist. The former in particular, as they in many instances broke up his dancing schools.

On saturday following on my return, having reached the top of the hill, I saw that some ship timber and walnut trees [illegible] had been cut on our land. Mrs Mount's little negro boy passing by at the time told me there was more ship timber cut in other places by Mr. Hawkins residence and in the three square lots. On examination I was astonished to see so much timber dressed out and some had been carried away—Locust, Oak and Chestnut. Some of the timber was [illegible] feet long and 3 and half feet at the buts. This timber did not shade the corn. It was sold to Mr. Meyer Hand of Setauket to use in building a Brig. I was greatly surprised that Mrs. Mount, nor her son Thomas did not notify or ask my consent about their intention of cutting the timber. I have seen Mr. Hand, he told me that he did not know there were any owners but Mrs. Mount—we were left out of the bargain—we are considered as tenants. Mr. Hand had it all his own way—he made them an offer, fifty three dollars, they accepted. Our nephew Thos. S. Mount did not know or did not think to have the timber measured by Judge Williamson or some competent man—the sum of money would have been much greater. If timber is sold we should at least have the worth of it, as any wood of all kinds is selling high. They have done wrong—it was a trespass to contract and sell my property without my consent, the act is finable (if maliciously), a county jail would loom up in the distance. Suppose we should cut off some wood without their consent or knowledge to fix up some part of the house or spend the money as we pleased, would they like it? I think not. I have never cut or trimed a tree on the place but to [illegible] some other near it. They dug up the box wood in front of our house that our mother set out. They threatened to dig it without my consent and did it. The last year they have cut off about fifteen hundred hoop poles, two hedge rows into cord wood. The excuse for the latter was that the trees shaded the corn—but it appears the timber and the poles did not. I have requested Mrs. H. S. Mount and her son Thomas that they must not cut any more wood off the home place where we are joint owners—without informing me and for what purpose. I informed them that

I had rather taken the money out of my own pocket than to have had them acted toward me as above stated. Brother Nelson sister Ruth and Edward Seabury condemn the act. If a thing is worth having it is worth the asking. Right does not wrong any one.

I wish you a happy N. year.

Yours Affectionately,
Wm S. Mount

[SB]

WSM to Mrs. Henry Smith Mount

Setauket L.I.
Jan 1863

My dear Mrs. Mount,

After my mother's death, myself and brother Shepard concluded to let you, so far as our position was concerned, have the use of the farm (at Stony Brook, we being joint owners), to do the best you could do with it and we to pay our part of the taxes, but, with the understanding, that you should not cut off any green wood for any purpose except, for fencing material (for the farm only; you having a piece of wood land of your own for that intention). You was pleased with the arrangement and have acted strictly and done as well as any woman could do with the farm under the circumstances, up to eighteen hundred and sixty two.

About ten or eleven years ago (how time moves along) you desired Shepard and myself (I owning one quarter of the farm) to join with you and cut off some cord wood on the farm joining Setauket road. We agreed, providing a crotch and pole fence was placed around the cleared land to protect the sprouts. We did not see the fence, neither did the cattle, which was a bad thing for the tender sprouts. The lots were sold off to the highest bidder. Your son, Henry [Thomas] S. Mount, managed the affair and after a length of time each one obtained their money and receipt.

Now different tactics appear to have been adopted. Perhaps owing to my absence from home. In walking over the Mount farm lately at Stony Brook, I was astonished to see so much wood and timber had been cut and carried away the past year, eighteen hundred and sixty two, without my consent or knowledge. "If a thing is worth having it is worth the asking." It was a trepass to contract and sell my property without my consent. Therefore, you lay me under the necessity of notifying you by letter, that I forbid you or any one of the owners cutting and carrying away, or cause to be cut (after the date of this letter) any more green wood, of any description (namely, oak, chesnut, dogwood, cedar, walnut, and hoop poles—also, fruit and shade trees) from the free hold where we are joint owners, without my consent, under the penalty of the law—except, for fencing material, chesnut, for the farm only, and timber oak and chesnut for repairing the

buildings on the place when required. "Right wrongs no one."

About *fire wood*. Any dry stuff not fit for fencing or cord wood, and only useful for fire wood. I am perfectly willing that it should be used for fuel on the place by all the family; if agreeable to the rest of the owners. With a little economy there is enough dry wood for us all.

The *Mount farm* is a *home* and admired by strangers; an evidence of its beautiful location, with its trees, vines and shrubs. Therefore, we owners should take counsil together and make the place a perfect paradise.

You will please make known to the family (interested) my sentiments, and my best regards.

> I remain as ever,
> Your affectionate
> brother in law,
> Wm. S. Mount

The following, at the bottom of Mount's copy, may have been part of a draft for the letter:

. . . under the circumstances.

Our beloved brother Robert Nelson worked the farm with great success for about eight years before your husband H. S. Mount moved upon the above. All the Mount family have [illegible] upon with more or less success.

[SB]

WSM to the Washington Allston Association

> Setauket, L.I.
> Feb. 13th, 1863

Gentlemen,

Having been personally acquainted with the late distinguished painter *Washington Allston,* from whom the association has taken its name, I feel thankful to the "Board of Management" for their kind invitation, and in as much as I cannot attend personally the "Soiree" on the evening of the 16th inst—owing to previous engagements—I take the liberty to send you my photograph—with my best wishes for the prosperity of the Association.

> Yours, very truly,
> Wm. S. Mount

[NYHS]

WSM to Edward Henry Smith

> Setauket, L. Island
> Feb 24th, 1863

Hon. and dear Sir,

Will you please present the enclosed request to the President of the U.S. and use your personal influence with his Excellency to induce him to recommend it to Congress for their favorable action.

> Yours, very Respectfully,
> Wm. S. Mount, N.A.

[NYHS]

WSM to Abraham Lincoln

> Setauket, Suffolk Co, L. Island
> Feb. 24th, 1863

To Abraham Lincoln,
President of the United States,
Sir,

The American Flag should wave in every village in the Union. As an American Citizen, I most respectfully request, that you recommend to Congress the "Good old Flag"—"The Star Spangled Banner" to be forever kept *before the people* by hanging it placed upon every Post Office in the City and Country. So that the Stars and Stripes shall forever wave "O'er the land of the free and the home of the brave"—and not be forgotten by our rising generation.

Mr. President, you can travel for days and weeks through towns and villages without seeing the Flag of the Nation, even the vessels in our harbours are often destitute of The National Flag. I feel that you will at once take deep interest in my request, and present the subject before Congress. viz, the importance that our Flag shall be seen in rural districts as well as at the Seat of the Government.

> Very respectfully your
> obedient Servant,
> Wm. S. Mount N.A.

P.S. The Flag would test the Union sentiment of the Post Masters. We must all try and save the Union and show to the world "that the land of Washington" can exist.

[NYHS]

WSM to Edward Henry Smith

> Setauket, L. Island
> Feb. 25th, 1863

Hon. and dear Sir,

In writing to you yesterday, I omitted to mention, In case the President of the U.S. should recommend to Congress the importance of placing The National Flag—The "Star Spangled Banner"—upon every Post Office in the City and Country, that it would be very gratifying to me if you will confer with the members of both houses of Congress, to effect its passage.

Although you have but a few days to work—yet, Congress, like the last fire sparks on a candle, is the most *active, sparkling,* and *brilliant at its going out.*

> Yours, very Respectfully—
> Wm. S. Mount N.A.

P.S. In some of the rural districts where the Post Office does not pay much, the *Flag* would require to be in size only about *four* by *five feet*, which the (Government Agent) the Post Master—would, I have no doubt, be proud to display.

We are sorry to hear of the death of Lieut. Maxwell Woodhull—I was personally acquainted with him about

the time I painted the portrait of your uncle, Edmond Smith.

John Nunns Esq. desired me to give you his respects and to thank you for Public Documents.

Your friend Revd. J. S. Evans, thinks the placing the National Flag on the Post Offices, is a good idea.

We wish you health and success.

[NYHS]

J. H. Layton to WSM

Thursday 14 May
295 North 2nd St
Williamsburgh

Dear Sir,

It has given me the highest pleasure to examine your paintings and those of your brother, now on exhibition at the Academy. I am not quite done yet. The "Portraits in General" will come in the last paper.

In being detailed as special critic on the Cols[?] *Home Journal*, I have made a bold strike for American *genre* painting. Two articles on the Academy have already been printed; two more are yet to come. I wish you to be sure to get the first article and see what I have to say. In the [illegible] (which is enough to kill any mortal critic—it is so full of work) I piquantly ask if anyone will loan young Benson an old flax-wheel for a model: one of those wheels upon which the linen was spun which has now been so useful in the shape of lint in staunching the wounds of our young heroes.

Now, all this is very graceful to mention in print when applied to a youngster—but I must impress a veteran of the brush to carry the day.

If you had seen what I have seen—hundreds and hundreds realized by the *genre* paintings of Carl Hübner and Meyer von Bremen and Ed Frère—simple little studies of spinning wheels and domestic life—you would be tempted to commit the brusquerie I once committed of pitching Belmont's Catalogue to the other end of his own gallery in sheer rage that not a single American *genre* painting was contained therein.

Willis is delighted with the stand I have taken and hopes some veteran of the brush will back it.

Now, I can put you in the way of doing a splendid thing. I *know* what you can do in this line. Years ago I examined your studio and found therein a fine study of your great-grandmother reading her Bible by the fireside; also a cabinet miniature of her—the very poetry of old age. This was years ago, but the impression is vivid.

But, on reflection, I do not want a very old lady at the Spinning-Wheel: *au contraire*, let it be a good, buxom middle-aged woman spinning on a flax-wheel, with distaff in hand. I say *spinning*, and I mean it. There will be several "Richmonds in the field" no doubt, for the *Home Journal* has great prestige and what it says will set the artists to hunting up the wheels—but I want a *masterpiece!* And

you *can paint* it. I want an American Meyer von Bremen by next exhibition. I want—

"Aunt Eliza at the Spinning-Wheel."

You go to the Misses Strong of [illegible] and ask for the old flax-wheel on which "Aunt Eliza" used to spin their household linen. (If they have destroyed it they are vandals!) Then tell them you want "Aunt Eliza"—of Port Jefferson: her name was Brown, but she has since changed it to Frazer, I think. She spends the winters in Williamsburgh, the summers at Port Jefferson, and though brusque, she is a *character* and one of the kindest-hearted women that ever breathed. Don't make the mistake of relying on a photograph of her and a sketch of the motionless wheel. Get her to set in propria personae and *spin* real *flax* and make the dust fly and put *motion* in the tread. Make her turn out her old-fashioned "toggery"—and see that even the fabrics are those of other days.

Then go to work and do yourself justice and I will do *you* justice if I am in this country at the next exhibition. I know this is impertinent to suggest what a *Mount* should paint—but Willis has done bravely to come out for American art and and I have always relied on you to sustain the movement.

I wish you would write a few lines expressing your thoughts on our movement and head it *Dear Willis*—that I may append it to my last paper in the *Home Journal*. Send it to my private residence.

Yours tly
J. H. Layton

[SB]

J. H. Layton to WSM

295 North 2nd, Williamsburgh

Dear Sir,

Is the publication of this going to injure your feelings? I cannot buy your painting, for I am poor, but *I can make a great noise about it*. We must have someone to make a noise over [it] or we lose[?] the ground we gain[?]. Mde. Crohen [?] says she forwarded your letter. I was in hopes you was in [illegible]. Reply quick or you will be too late. The *H. Journal* goes to press early.

Yrs. tly.
J. H. Layton

[Enclosure:]

To the rescue ho! of *American art*. On dit.— It is rumored that Wm. S. Mount, N.A. has received the commission to paint an American *genre* painting of "Aunt Eliza at the Spinning-Wheel," the subject to be the bona fide flax-wheel upon which was spun the family linen of one of the F.F.'s L.I. As much of the venerable web has figured extensively on the field of battle in the shape of lint, prepared by the fair hands of the ladies (the Misses Strong), it has been proposed that the ancient wheel should be immortalized by a *Mount*. "Aunt Eliza" yet a

buxom dame is the veritable spinner. How the dear old ladies of "lang syne" do last! Though artistically speaking this is a *genre* painting it will assume the dignity of historic art; and from what we know of Mount's skill, we boldly pit this forthcoming American *genre* painting against any Meyer von Bremen in market.

(Please return copy with what alterations you see fit.)

[SB]

WSM to J. H. Layton

Setauket
May 22, 1863

My dear Sir,

Your letter of the 14th inst. after zigzagging over land and water has reached me; also your second note without date found me at East Setauket. I feel grateful for your appreciation and suggestion respecting "Aunt Eliza at the Spinning Wheel"—a good subject, but engagements for some length of time will not suffer me to accept your very kind request. I am pleased to hear you speak so well of Mr. Willis, and he has my thanks, for what he has done for American Art—his love of nature and works of art would naturally make him a good critic and you deserve credit for your "bold strike for American genre painting."

My health has been very poor for several days.

Yours truly
Wm. S. Mount

[SB]

WSM to John M. Gardner

Setauket, L. Island
May 28th, 1863

Dear Sir,

Your kind letter respecting "the painting of the eastern stair case of the Senate Chamber"—was through the politeness of our mutual friend Martin E. Thompson Esq, handed to my niece Elizabeth F. Mount, who dispatched it to me. Allow me to say, that I feel both complimented and thankful that you should hint or bespeak "with the Commissioner of Public Buildings" (about a commission) for me to paint "Washington's descent of the Alleghany."

Even if I had an order to paint a picture from the many scenes in the life of Washington I should not be able to commence it immediately, on account of previous engagements.

In most cases I would much prefer to select my own subject, although, your choice of subject might turn out very fine in effect and point of history. Note 1—page 10—do you select? "Last night, the great men assembled at their Counsil house" or, "We set out about nine o'clock with the half king, Jeskakake," etc, about 11 figures—not including the horses and baggage—a day light scene.

There are some stirring scenes on pages 18 and 19. "A Party of French Indians in ambush fireing at Mr. Gist and Washington" just after passing a murderous town, a number of figures. Also, "Washington traveling in an Indian walking dress, and continued with them three days"—a number of figures. Page 19—the "getting over the river on a raft" etc, a stirring scene, which are important in the life of Washington—it is *English and French history* (*not American*); but, interesting nevertheless, *A starting point.*

I would be much obliged if you could consequently let me know the size of the *panel* (or panels, if any) to be illustrated in the Senate Chamber, and if the picture is to be completed on the spot, or to be painted elsewhere on canvas and conveyed to the place designated—the time given etc or any information on art matters you may feel pleased to communicate.

Yours, very truly—
Wm. S. Mount, N.A.

P.S. I would like to know the specific scene to be illustrated. I quoted from Marshal's life—printed 1804—and the pages of the notes in the later editions may be different.

[NYHS]

John M. Gardner to WSM

Washington D.C.
1st June, 1863

Dear Sir,

Yours of the 28th *ult.* was received on Saturday and Maj. French informed me that he would to-day give me the dimensions of the staircase, and to-day he says it is the size of Leutze's picture for which the government paid from 20,000 to twenty five thousand dollars he don't know which, the contract was made by Meigs and the last payments were made by himself, French.

I have also just seen Mr. Peter Force, formerly mayor of this City and compiler of the American Archives, and showed to him Washington's report. Mr. Force has a copy of the old edition. I asked him to read it and give me his opinion of it as a subject for the painter and informed him of my correspondence with you. Mr. Force has always thought Washington should have been represented in early life. Mr. Force wishes to see Washington in his hunting shirt. I reminded Mr. Force that there was a description of the dress in the report. Had you not better consult Mr. Everett and Jared Sparks: for I do not altogether understand that report. Also Dr. Phillips about the river-gods; the Abbé Barthelemy has something about them in the *Voyage d'Anacharsis*, if I recollect aright. The Member of Congress elect, Brooks, from the City of New York is, I have no doubt, a *connoisseur*; he is the brother-in-law of John Cranch, the artist.

You write of my choice of subject: I had not thought of another; nor do I know of any suitable to your style and

character or which is necessary to complete the series of paintings and sculptures illustrative of the life of Washington now in the Capitol. You are thinking of a painting for some Academy exhibition and to suit the views of a purchaser who estimates the amount of "work and labour done and performed," the price of paints and other materials. I found the subject and told you where to look and you found it on page 19 of your copy, page 10 of mine. None of your Red Sea with the Israelites crossed over and the Egyptians submerged, we want to see the Alleghany river full of ice pouring down those stairs and bearing that raft with young Washington and Mr. Gist: no other creature in sight, no skulking Indian nor bird, no rain in the brambles. The event is more recent than those illustrated by the four last pictures put up in the Rotunda. Major French, the Commissioner of Public Buildings is a literary man and admirer of your pictures which, he informed me, he had at his house. I could not speak of you to him without naming a subject, and he immediately expressed his approbation of both, the artist and subject. You will incur risk in the "choice of subject" as you call it. How can you get an appropriation through Congress? Washington's Presidency has not been illustrated, his procession through New Jersey, the Inauguration in New York, a state reception, Mr. Lear etc. None of these incidents, however well represented, would produce the effect you could manage with the subject named by me. On his farm at Mt. Vernon with Nelly Custis. The scene of his death, Dr. Craik. Better try Gen. Jackson or Davy Crockett.

Though no physiognomist I am affected by an association of character with appearance and have always considered the likeness of Washington which was painted for Claypoole to be the best. You should of course be governed by the testimony of actual observers. There is an account in Irving's life of the portraits. Simplicity, naturalness, unity. *Ars est celare artem. Ars longa vita brevis est.* I am sorry I have not a copy of Hippocrates or I would give you the Greek of the last saw.

Well here is some information you need. Leutze's painting is on the wall and the $25,000 mentioned at the beginning of this letter, or the greater part of it, must have been paid in specie or its equivalent. Panel! (The Capitol of the United States is not a coach.) It is probably as large or larger than the side wall of the room in which you will be sitting with this letter. The Capitol is no longer the government bakery. There are three more staircases to be painted, for which Congress has made no appropriation and prohibited any expenditure, after that 25,000.

You will have to visit Pittsburg in mid-winter, ascend the Alleghany and identify the place, observe the flora, such as were growing during the last century, particularly the evergreens. The fauna, etc. But take a look over head. Let it be cloudy, sun obscured or not risen. Time given: till finished.

<div style="text-align: right">

Your friend and
Obedient Servant,
John M. Gardner

</div>

[SB]

376

WSM to John M. Gardner

<div style="text-align: right">

Setauket, L. Island
June 6th, 1863

</div>

Dear Sir,

Your interesting letter of the 1st inst—is at hand. The valuable information it contains is to me important. To have the approbation of you and Major French in the face of so much artistic talent now in the Country is very complimentary.

Your choice of subject turns out to be my choice. "Washington's desperate struggle in crossing the Alleghany river"—is the grand turning point in his history. Life or death. The future of our country depended upon that crossing. Your selection of subject is excellent, and I feel that (with suitable preparation) I can paint it of any size required; if I have the assistance of my friends J. M. Gardner and Major French (at the proper time) to see that I obtain the commission and appropriation from Congress, to go on with the work: next fall and winter.

At the annual meeting of the Academy of Design I did not think to ask Mr. E. Leutze, the size of his painting. Will you be so kind as to send me the exact size of the starecase so that I can make a small study picture that is to be painted—length and breadth thus [diagram] in proportion—at my leisure.

<div style="text-align: right">

I have the honor to be your
friend and Obedient Servant
Wm. S. Mount

</div>

P.S. I expect to go up the North river about the 15th of this month, near Fishkill to paint some portraits.
[BUFFET]

John M. Gardner to WSM

<div style="text-align: right">

Washington, D.C.
10th June, 1863

</div>

Dear Sir,

Can you not spend a week with us here in Washington? My father and the family would all be glad to see you at 566 New Jersey Avenue, on the second square South of the Capitol. This is the time for you to see the building with its paintings sculptures etc. in a good light and when the rooms are not occupied by Congress, Courts Committees etc., who would exclude you.

Mr Walter, the architect informed me the dimensions of the stair cases, the part meant to be painted, was 20 by 30 feet. Mr. August found the drawings of the Western Stair-case of the Senate Chamber and upon measuring with his scale made the memorandum I enclose, nineteen feet nine inches by twenty nine feet four inches. The smaller dimension is the height. Leutze's painting—but you must see it.

The family (my) inform me that the member of Congress elect did not marry a Miss Cranch; that it was his brother Erastus. I enclose a scrap from the Republican

newspaper of Saturday last. C. P. is a brother of John Cranch. And remain, truly, your friend and,

Obedient Servant,
John M. Gardner

I did not receive yours of the 6th before today.

[BUFFET]

WSM to John M. Gardner

New York, June 16, 1863

My dear Sir,

Your very kind and prompt letter inviting me to spend a week at your residence is duly appreciated.

I shall most likely go up the North river this week, but I hope to have the pleasure of seeing you and your father's family—and the great works (this year) at Washington.

According to the size sent me—the river and landscape will be prominent unless the figures are somewhat colossal, but it depends upon the kind of effect the artist may select.

I have had the pleasure of seeing Mr. C. P. Cranch, he is an associate of the National Academy of Design—was Elected 1850. John Cranch electd. 1853. Your father (Col. Gardner) I understand was the first to nominate Gen. Andrew Jackson for President. It would have been well for the country had he nominated and elected another such man at the right time—but we shall come out right yet. Reflection, generally comes after fighting. The rebel raid on Maryland and Pennsylvania, is causing considerable excitement in this City. I have the honor to be your friend and Obedient Servant,

Wm. S. Mount N.A.

[BUFFET]

WSM to Edward Henry Smith

Setauket L. Island
July 23, 1863

Dear Sir,

Will you be so kind as to inform me if you presented my letter dated, Feb. 24th 1863, to Abraham Lincoln, President of the United States—respecting the American Flag.

Yours, very Respectfully,
Wm. S. Mount N.A.

[NYHS]

Andrew Hood to WSM

N. York, Nov. 9, 1863

Dr. Sir,

We were quite disappointed that your engagements prevented your making us a week's visit during the beautiful autumn weather we had. We had quite a gay time among our neighbours, and a goodly meeting at our House at the close of the season. The Young people were much longing for your Fiddle and Fife. We have all removed from Shrub Oak and my family quite domiciled at Yonkers, all in good health.

I was expecting you daily to call for your glass at 42 Stone St. and would have paid you at the time but as you have not made it convenient I enclose you a Check for $50.00 which I suppose you will receive in due course. Please acknowledge the same.

With kind regards from Mrs. Hood
believe me I remain
Yours sincerely
Andrew Hood

[SB]

WSM to Andrew Hood

Setauket, Suffolk Co, L.I.
Nov. 13th 1863

My dear Sir,

Your kind note containing a check for $50.00 on the Pacific Bank N.Y. payment for the portrait of Annie, I have received. The glass I will call for when I visit the City.

It would have been very gratifying to me if I could have spent a couple of days with you, to have assisted in stirring up, with you and Andrew, the "Young people" with *Tambourine Piano* and violin. Music is a softner, people cannot fight very well when lively music is about. Allow me to relate, that on one occasion I stopped a fight at an Election, by playing a lively hornpipe on my violin—from shoulder hitting they went to dancing.

The day after we parted at Stone Street, I stopped at Goupil's about 10 minutes, but, had not time to look over some drawings for Andrew, as the Steamer left at 11 A.M. and also the *riot* was increasing.

I have not been in the City since the 13th of August. I then called at your store, but you had just left for the cars. Your country residence at Shrub Oak is delightful. Please give my best regards to Mrs. Hood and all the rest of the family.

I remain yours sincerely,
Wm. S. Mount

[SB]

W. H. Phare to WSM

82 Broad Street
Dec 3d, 1863

Dear Sir,

Sometime when you are in the city I should like to see you in regard to painting the portraits of my wife, myself and two children. I am in my office as above from 8 1/2 A.M. untill 4 1/2 P.M. Except from 12 untill 2. I live in Brooklyn 349 State, shall be pleased to see you at either place. Drop a line stating time you expect to be in the city, oblige.

Yours very truly
W. H. Phare

[SB]

diaries 1864-65

Setauket, Feb 4th, '64

This year commenced bad for me—that is with a bad cold in my throat and chest, while I was in the City—the cold lasted me about 15 days. I have been painting for several days past with a great deal of spirit.

We have very mild weather for the season.

I have painted a successful cabinet portrait of Mrs. Marcena Monson, partly from memory.

Feb 12th, 1864

"Child's first Ramble" a sketch painted for Brooklyn and Long Island Fair, in aid of the U.S. Sanitary Commission—Size 6 1/4 × 8 3/4 in—price $50.

Feb. 17th '64, the coldest weather yet—3 degrees of zero.

Feb 23, very warm. Thermometer 54—flies out—humming about.

I have not got rid of my cold yet; for a cold on the chest the plaster should be placed between the shoulders.

Setauket, Feb 27, '64

I write with a small picture on the easel 10 × 12—with small figures. It appears to take as much time to finish up a small painting as a large one and consequently not so profitable—unless I can realize a large sum for a small work. Even then it is more trying to the eyes than a large cabinet picture and more confining.

Hereafter I must try and never make a sketch unless for a large work. —Paint large.

Setauket, March 3, '64

About snow. The surface of snow has a rough granulated appearance in the sun light and in the shadow—like fine ripples on a heavy sea—most distinctly seen agreeably when the sun is at the left or right of the observer. With a clear sky and a bright sun the shadows are cool, almost as blue as the sky. The light of the warm snow is inclined to a yellowish tint.

The shadow sometimes redish (reflections) or yellow—or white reflections. Foot prints, or sled and waggon tracks are more distinctly seen in light than in shadow. (Men's foot prints are much more aparte than Boys.)

You will observe a cavity around the stumps or stems of weeds and grass—sometimes circles in the snow around them caused by the wind. Snow broken up, is a good study. Sometimes you will observe (a day after a storm) snow on buildings and none on the trees. Snow on green or brown foliage contrasts very finely, autumn or spring.

About ice. If water freezes in a calm time it will be transparent and reflects objects—and will be lighter in color than water particularly when agitated by the wind.

Setauket, March 10, '64

I fowarded my first fruit piece (apples on tin cups) to the Metropolitan Fair, N. York—for the album—to the care of Wm. S. Haseltine, *artist*. Size 6 1/2 in by 9 inches. Price $50.00.

About the 18th of March '64

I sent a sketch in oil of cherry blossoms, to Mrs. Wm. H. Wickham. She having written to me that she should have a table at the Metropolitan Fair, N.Y.

March 23, '64

Noel J. Becar, of Smithtown L.I. married Julia B. Thorpe of Bridgeport Conn.

The Public Exhibition of the National Academy will open on Friday, April 15th—and will close on the 25th of June.

If I had strictly attended to my own business, instead of working up sketches for Fairs, my larger works would have been more advanced. I hope the time spent is all right and the sick and wounded soldiers will be benefited thereby. The Committee on the receipt of donations should acknowledge their safe arrival at once, but they did not treat me with that politeness. They occupied about two months of my time. Music for lectures etc.

"Central Park—
Shakspere—
April 23, 1864

Celebration of the Tercentenary Anniversary of his birth. A statue to commemorate the event." The Fair concluded. Sword contest.

Grant Received	30,291 votes
McClellan	14,509 do
Grant's Maj.	15,782
Before the envelopes were used, the vote stood—	
McClellan	11,903
Grant	9,647
McClellan Maj.	2,256

Apples on tin cups at the Fair (donated by W. S. Mount) sold for $35.00.
The "Power of Music" was exhibited at the Fair. [Added later:] May 10th '64—there is a Photograph of the above painting selling (card size) for 10 cts.

Made a sketch in oil of Sanford Denton's child after death—$10.00.

Setauket L.I., April 26th, '64

The appearance of the country has improved very much the past two days—the grass has a greener look, more of it, and the peach blossoms are almost out. Some of the apple trees have commenced leafing—and the willow is more yellow—and the Balm of the Gilead is in bloom.
How beautiful all nature looks—it is a pity that nations will fight.
The goose berry is about the first leaf out—
The Dandelions and May Pinks are the first to blossom.

May 5th painted peach blossoms, also, on the 7th. Painted *Rat tail cactus* on 7th and 9th.

May 7th went flat fishing. Thermometer over 80.
9th- 85, very warm for the season.
Last of May thermometer 88 degrees.

May 1864

Sold my picture "Boys going Trapping" to Chas. B. Wood. Size 25 × 30—for $325.00. It was worth much more.
Painted a cabinet Portrait of the Late Mrs. Monson for Mrs. Selah B. Strong, $100.00.

Received, Setauket, May 9th 1864—of Mrs. Selah B. Strong, one hundred dollars for painting a (cabinet) portrait of the late Mrs. Monson.
Received payment. ——Wm. S. Mount

Setauket, June 6th, '64

The forenoon of to day devoted to *coloring four photographs—card portraits*. This volunteer painting *I must put a stop to*. It takes too much *valuable time*, besides it is very confining in *hot weather*.
Make studies on oil or (water color) every liesure moment from nature when not engaged in the Portable Studio.

Try and work to some purpose—larger figures and more effective. Work at home or abroad. Paint atmosphere and all its effects. Paint from recollection—of what you have seen: great effects of storms—also, storms coming up—as I see now at this writing—

[Wash drawing; pl. 133]

Sudden change from heat to cold.

Setauket, June 10th

Mount's corn knee high, frost this morning—in Setauket.

Setauket L.I., June 11th, '64

I presented John R. Davis Esq a cabinet portrait in oil of himself. He gave me three sittings.

have seen: great eff-
ects of storms — also,
Storms coming up —
as I see now at this
writing —

Sudden change from
h... —

133. Wash drawing. Diary, June 6, 1864.
The Museums at Stony Brook, Stony Brook, Long Island

Setauket June 20th, '64

Received a present of 20 panels from Mr. Chas. B. Wood—14, 26 × 33—one of them contained a female head by S. L. Waldo; 4 panels over 32 × 40 in; and two long oak panels, 15 × 26 in. They are well seasoned per- haps from 20 to 40 years old. I thoroughly rubbed down the panels with pumice stone, water and marble dust to give the surface more grain. The old paint left on. Some times I used a block of wood, water and marble dust or grit—using the cloth gives too fine a surface.

Perhaps two or three of the panels will require a scraper to take off some of the plane marks. [Added later: Pumice and marble dust is the best—I have tried both.]

They formerly belonged to Samuel L. Waldo, distin- guished portrait painter, I prize them highly.

23 of June, '64 was a hot day thermometer 88.

24th 32 degrees cooler.

25th of June, wind west—at two P.M. 94 degrees; 90 at 6 P.M.

June 26th at 6 A.M. 82 degrees; at 7 A.M. 84; at 9 A.M. 88; at 10 A.M. 90. The thermometer hanging on the shady side of a large black walnut tree and a strong west wind blowing upon it—at 11 A.M. 92; at 12 noon 94; at 2 P.M. 96 degrees; at half past 2 to 3, 97 degrees; 20 minutes to 4, 91 degrees owing to a cloud and a few drops of rain— it fell and rose. At 4 P.M. to 93; 1/2 after 4, 93 degrees; half after 5 P.M. 90 degrees.

Monday 27th of June, at 2 P.M. 82.

Tuesday morning 28th, at 6 A.M. 58.

New York, 25th of June, at 2 P.M. 97.

Sunday 26, at 2 P.M. 99 1/2 degrees—the hotest, for a great number of years.

[Added later: July 11th 89.

August 1st 99 *in shade*.]

June 27th

It is very dry weather. The grass is drying up—this morning I filled in the seam of the studio with lead. Rubd the lead in with a rag—drove in the old filling or putty with a narrow corking iron—and fill in with white lead.

June 30th, '64

Rain to day (no rain in about 24 days)—it was thank- fully received.

July 6 and 7 showers.

July 9th

Painted my studio with zinc white and raw oil.

Visit from Mrs. S. Newsins she has a bad cough.

11th showers early this morning.

July 20, '64—killing larks not lawful (by Dick Rizley).

25th a glorious rain—had not rained in 14 days and then only moderately. The drought has been severe through- out the country—smoky days—corn, potatoes and every- thing green was drying up.

July 26

Painted on The Tease—had not painted for a month. The panels and Studio occupying my time.

Friday 22 had a visit from Mrs Wayne and her two daughters. Visitors most every day.

27th—Thermometer 90 degrees.

29th—do 92.

31st—do 94.

August 1st

Hot weather. J. Barry's Thermometer, London, stood 99 in the shade at one P.M., and M. A. Rennell's ther- mometer stood 97—two degrees lower.

August 2—84 degrees.

Do—3—Glorious rain and *never more needed*.

I never recollect so much east wind in the month of July.

[The following dates were squeezed in: August 7th '64

—88 degrees. Do—16—about 90. Do—25th—92 degrees. Do—30—summer heat.]

Shepard and Bob, on a visit.

July–August 7th, 1864

[Sketches] Sky looks watery and the atmosphere a little smoky—the rays in the shadow of the clouds and sky, but not across the light of the clouds. Bluish clouds (rich in color) tiped with a beautiful yellow as the sun goes down say (an hour high) the light of the clouds take more of the orange tint (rich Naples yellow). The sky a greenish tint, the cool rays running through the warm sunny sky. The ray or cool colors (bluish) for the sky. The yellowish ray for passing over the clouds.

A few studies should be taken from nature, for reference.

The sun in the bluish clouds is a deep orange red indicating dry weather.

Thermometer August 10th 96 degrees.

[August 12]

August 11th, 94 degrees. Last night 11th was the hotest, the wind having died out—spent the evening at Capt Tyler's to hear some Piano performers.

12th—this morning thermometer 70, wind east and smoky the sun looks red.

11th—Painted some corn standing.

Made a visit to Stony Brook from Saturday 13th to the 18th of August. Dr. Seabury's daughter and Miss Page from Schenectady were present at my sisters.

We were blest with heavy thunder showers on the 17 of August '64. So heavy a rain never was known in Setauket.

"A good paint for fences and barns is made with linseed oil, Plaster of Paris and *Zinc* or *white lead*."

To give flesh strength of color, scumble over venetian red and white and let dry—then work over that if necessary.

August 23

Spraint my ancle in stepping into a boat. Wheat brand, vinegar and salt, sugar of lead—was good—at times pored on cold water.

Chicago, August 31, '64

Gen. McClellan nominated for President on the First Ballot. The choice made unanimous. George H. Pendleton chosen as candidate for Vice President. The nominations to be ratified throughout the Country on the 17th.

I hope they will be elected and the whole country once more united, for ever.

Gen. McClellan's letter of acceptance gives gen. satisfaction.

Near Atlanta— "Life in the trenches. The weather is exessively cool. Our sunsets are glorious, and would do for the representation of an Italian Sky."

Report of the fall of Fort Morgan—also that Atlanta is occupied by Gen. Sherman.

September 3rd, '64

Had a visit from Rev. Samuel Seabury wife and youngest daughter. They were pleased with the sketches and portable studio.

Sept 5th was a stormy day—rain—had fire in the studio.

Sep 7th—Gen. Spinola's house burnt down.

Sept 10th

Commenced a large cabinet portrait of Miss M. Harmer. Drew in the head and figure with white chalk and painted in the likeness at once—head six inches in length—last sitting Sept 17, 4 for the face and 2 for the dress. Used Nap. blue and white, Terraverde and white, Venetian red and white.

11th, 12th, 13th—had fire in the Studio. Wind north, cold for the season.

16 & 17th, 1864

Good weather.

Naples, ultramarine blue and white for receding shadows—also Terraverde and white—red can be used to vary the tint. *Dark shadows Venetian red and blue* (grown fine) white or blue and white can be added to vary the tints. Naples and Vermillion—with white or with blue and white if required—for Ladies' portraits, or fancy faces. Also—Madder lake (rose) and vermillion. Glaze with blue, red and yellow ocher—and touch into it.

Size of Miss Maggie Harmer's portrait on white wood panel, 13 in by 17 in—paid $100.00. Mr. Harmer was delighted with it. I sold him a fruit piece, apple on Champagne glass, $25. It was worth more—

Sept 22nd, '64

Made drawings of three men—Patrick Cain, James Cain, and Patrick Shields. They were drowned in Smithtown harbor. Mr. Charles Hulse, was accidently shot about the same time.

Setauket L.I. [October]

So far we have had a pretty good Autumn—the first frost and ice, was on the mornings of 10, 11, and 12th

of October—did not do much damage near the salt water.

October '64

Eight, tenth, 11th and twelvth, painted a couple of sketches from nature.

13th—Painted Mr. Davises dog in a small picture, a domestic scene.

It is a great advantage to paint directly from nature—and to select with judgment. The summer was too hot to paint out of doors as much as I could wish, besides the gnats were troublesome. In Sept, I made study of corn—for a composition.

Oct 19th

R. N. Mount was invited by Capt Tyler to take a sail to Rondout and to Providence—he was much pleased—with the trip.

Poets are benefited by reading the works of other writers—so are Painters benefited by the works of others, and more so by the study of Nature, the mother of all art.

Nov. 4th, 1864

Price of clothes at Brooks N.Y.—
Dress coat—$28 to 35
Business coat—$18 to 25
Pants—$10 to 15
Vests—$5 to 6

Price of clothes at Baldwin's, 70 Bowery—
Dress coat—$20 to 30
Short nobby Sack—$15.00
Pants—$8, $9, $10
Miset[?]—$8.00
Vest—$5.50
com. pants—$4.50
do vest—$2.50

Three bristle brushes, Knoedler's, 45 cts. Flat brushes. [Sketch]

[November, 1864]

HOW SHALL WE VOTE

"Lincoln and half a million more soldiers on account of your approval of his acts, or, McClellan with a restoration of the Union as the sole condition of Peace.

"Lincoln with a long war and separation, or McClellan with a short war and the Union of the states.

"Keep Lincoln in office another four years, and your taxes will be doubled.

"It is evident that President Lincoln has not been anxious to have the southern states return to the Union, fearing that the Democratic Union vote of the south would prevent his re-election. That is—Lincoln thinks more of his re-election than he does of the Union of the states.

"The democratic party desires the Union restored as soon as possible.

"A lady of intelligence made the remark that if Lincoln was re-elected, it would be through ignorance and Greenbacks.

"When a republican calls you a copperhead in a fair argument, then as a compliment, call him a nigger head.

"The republican party is the sympathy party, three white men to be killed, to free one negro.

"The Democratic Party is as old as the constitution (as a principle) and will last forever, but, the Republican Party is aged about twelve years."

By whom was the war brought on and so many lives lost, not by industrious mechanics and farmers, but by educated scoundrills, Politicians, and even preachers, both north and south——W.S.M.

"The irrepressible conflict—when the tax gatherer comes around."——R. N. Mount.

By whom was the war brought on? Not by mechanics and farmers, but by abolition fanatics; led on by bigoted war preachers.

Two Preachers, in this place, *be it said to their credit,* have not addressed political meetings.

[NYHS]

[November, 1864]

"'Tis they who would rend the stars and stripes—that noble flag, the blood of our revolutionary fathers, embalmed in its red. The purity of the cause for which they died—denoted by the white; the blue—the freedom they sustained, like the azure air that wraps their historic hills and lingers on their lovely plains." ——Gen Riley.

Setauket—1864

A large vote was polled (at Elderkin's) Nov. 8th—a majority of 219 for the democratic ticket. Two of the Republicans expressed themselves in favor of a king. $14.00 was offered to a democrat to vote the republican ticket.

Nov. 9th, 1864

Abraham Lincoln is re-elected President. The democrats seem well pleased with the result. They desire the republicans to finish the negro agitation and the war—

Nov. '64

WEATHER

12th very dark clouds in the afternoon. Hail storm in several places—I made a sketch from nature.

13th snow in the morning, pits of snow on saturday Nov 5th.

14th varnished the "Tease" with demar, mastic and bleached oil warmed. I have been touching it up from

time to time since May last—the picture is improved. Though Mr. Wood told me to spend my time on some new picture. It is to me a gratifycation to succeed. Mr. Wood, says it is greatly improved, more atmosphere, force and relief.

I delivered the "Tease" to Mr. Wood, Wednesday the 16th of Nov. Visited the Artists Fund Society, while in the City. Also—Cropsey's sketches and pictures made during the season. Also, Miss Hosmer's statue—all good but the drapery of the left arm. The figure had dignity emotion and expression.

Nov. 24, '64

Thanksgiven day, having a cold I staid at home and primed some canvasses, with white mixed with linseed oil —a little patent dryer (liquid) and benzene. Also, used the above mixture of oils together, thin, while painting, to prevent cracking.

Twenty three years ago my dear mother died. I often think of her [see pl. 134].

Nov. 26th, 1864—My birthday—thankful for every blessing.

Nov. 28th

The attempt to burn the City of N.Y.—eight Hotels set on fire about the same time in the evening. The black carpet bags found contained a quantity of paper, about a pound and a half of rosin, a bottle of turpentine and one or two bottles containing phosphorus in a granular state and in water—the rosin and turpentine for the purpose of holding fuel to the flames, the phosphorus to ignite them, as it is the peculiar property of this substance to take fire immediately it is exposed to the atmosphere.

Fourteen hotels were fired, the beds were found sprinkled with turps and phosphorus. Attempts also, to fire the shipping.

It appears that phosphorus like all combustible articles, requires an abundant supply of oxygen and as the rebels left the rooms tight and locked, the Hotels were saved and perhaps the City.

Nov. 29th, '64

I must now devote most of my time to figures. The dance on the turnpike etc, etc.

[December]

From Nov 28th to this time of writing, Dec 8th, the weather has been mild.

Great interest is manifested to know if Gen. Sherman will get through Georgia, he is now reported at Millen, by the rebels.

[Added later:] Sherman's gift to the Nation, capture of the City of Savannah 21st of Dec, 1864.

Saturday morning Dec 10th, severe snow storm. Thermometer 16 degrees above zero on 15th. 11th rainy, (drizly) Friday.

About the middle of this month Dec. '64—ice in my studio—up to the 10th the mildest weather yet.

Dec 12th, 10 degrees above zero—wind West.

[1865]

There should be a law made that any clergyman agitating the slavery question should lose his parrish—

About Jan 1st (I think the 2nd) 1865—6 degrees above zero.

Jan 6th & 7th & so on

Been making sketches with lead pencil for pictures. Mostly figure pieces. If a painting is to be low in tone (except a few light parts to assist in telling the story), should be very rich in color—browns, reds, yellow, grays, greens, black, and white. Color laid on heavy on some parts with a very thin palette knife.

Wm. Wickham Mills Esq died friday evening about 9 o'clock—caught a cold—and intered wednesday 11th of Jan.

Jan (1865) 16 & 17th

I have a good deal of distress at the pit of my stomach and ribs—rubed with Tobias Lineament a tea spoonful at time—it affords relief. [Added later:] Jan 27th got over the above bad feeling—occasioned by riding down hill—laying on the sled got badly jolted.

Gray, brown, white and black—has a good effect, relieved by some bright spots of color.

I desire to paint two or three good pictures.

For rich colors, look on your palette.

"Sermans in stones and running brooks." When God had made man he pronounced him good, and hence the image of man is seen on the bark of trees and in the foliage, in the clouds and in the foot prints and snow and ice of winter.

Jan 19th, 1865, cold at Zero.
Jan 29, continued cold weather.

About the first Feb, 3 degrees above zero—at some places 3 below.

Setauket, Jan 29th, '65

I must scold myself—urge on, dash away on some new figure piece. Work 4 or 5 hours a day—have confidence and ask God to assist me. Pictures will "cover the land as the sea covers the great deep." Ideas are to be found in every thing if the Poet, sculptor and painter can pick them out.

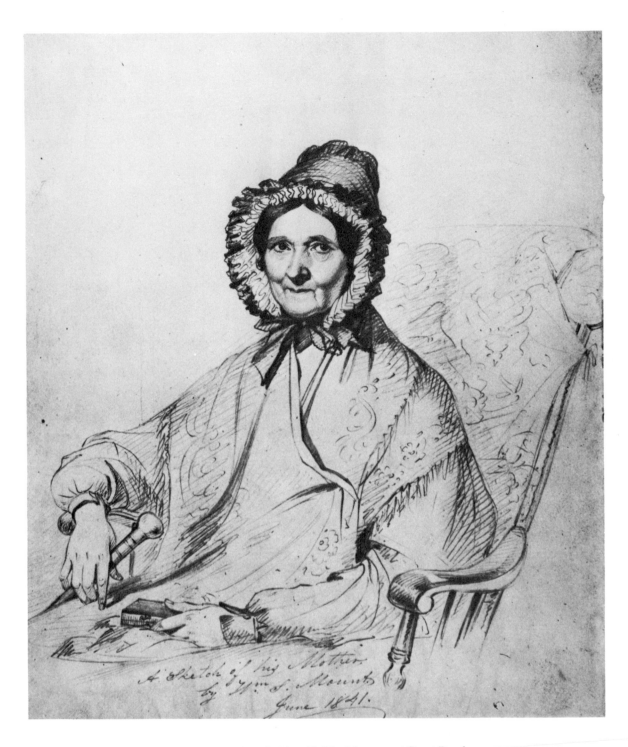

134. "A Sketch of his Mother." June, 1841. Pencil, 11 × 8″. The Museums at Stony Brook, Stony Brook, Long Island

Samuel L. Thompson died.
His wife died.
I am painting Mrs. Thompson's portrait—27 × 34.

Setauket, Feb 30th, 1865
Recd a letter from John M. Gardner Esq on the subject of my painting a picture for Congress—size 20 feet by 30. [Added later:] Also, a letter from the same March 1st '65.

Charleston occupied by *Union forces 18 of Feb '65.*

March 16, 1865—Frogs peeping—sign of mild weather.

19th
Glazed over the lower part of the "Catching crabs" with madder lake and raw sienna—[illegible] oil (bleached) and Demar together, added a little boild oil—

glazed the sky with madder lake alone—rubbed all in with the palm of my hand.

The same treatment with muzzle down and touched in some of the clouds and foliage in the glazing. Also toned "Northern sentiment" and Loitering by the way, same manner.

[April] The War cloud is passing away.

April 3rd, '65

Richmond ours. Glorious news. Weitzel Entered the Rebel capital yesterday morning.

April 9th—surrender of Lee and his whole army to Grant. Great rejoicings.

[Added later:] "We mourn the Nation's loss"—Abraham Lincoln assasinated April 15th, 1865.

[April]

I have been remodling one of my paintings—"Tease"—painted for Mr. Chas. B. Wood.

To make a more finished painting, varnish it—and when dry oil it then paint over the work in parts where it is necessary.

If you wish to work a long time upon a picture before it drys, use nut or raw linseed oil.

The painter with but a little money has one consolation, he owns all his eyes takes in. —The riches of sight.

Make a brush out of broom corn, to paint grass, foliage etc.

Eight, ninth, and tenth of April my cold was very bad, drank flax seed tea cold—and also molasses up to 13th, 14 and am better for it. Thursday 6th of April took two of Ayer's pills at night, next morning took one. They weakened me too much, felt worse after it. Castor oil would have been best. Five grains of opium mixed with oil, will prevent griping. Opium is not good for me but a little might do in taking oil.

Varnishing day the 15th '65 in the new building.

Painted my skiff boat about the 20th of March 1865.

[May]

Andrew Johnson President of the United States of America.

Jefferson Davis captured at day light on the 10th of May; by Col. Pritchard commanding Fourth Michigan Calvary.

"Jeff Davis reads The Proclamation offering a reward of one hundred thousand dollars for arrest. He trembled like an aspen leaf, dropped the paper from his hands and sank into reveries and sulliness. His wife picked up the paper, read its contents audibly, and they all burst out into tears.

"Jeff said, Valorous soldiers indeed, to make war upon women and children.

"Mrs. Davis remarked that she was not aware that an old woman and four children were of so much value, to be escorted by so many soldiers."

"Washington, May 23rd, 1865

"The first day of the great review has past. Eighty-five thousand veteran soldiers Pass in Review before the President and his Cabinet, General Grant, Sherman, Congress, the Diplomatic Corps and Hundreds of thousands of other spectators. Their pathway strewn with flowers.

"The only National debt we never can pay is the debt we owe to the victorous Union soldiers.

"Second day of the review—Sherman's veterans on Parade. In both days about one hundred and fifty, to two hundred thousand veteran soldiers marching along."

The comic element—"The Contrabands and Pack mules Form a Feature of the Occasion. Amusing was the appearance in the rear of the First Pennsylvania cavalry of a solitary negro, *black as a coal*, mounted upon a mule. He was recognized as the original cause of the rebellion, although he rode along apparently unconscious of *his importance*.

"The transportation brigade of the 'Bummers Corps' caused much amusement as it passed up the avenue. The lean and lank mules, heavily loaded with blankets and articles of subsistance and camp, were attended by their colored drivers and headed by two whitish colored mules of a diminutive size, ridden by two diminuitive contrabands, was novel and unique and caused shouts of laughter and rounds of applause from the lookers on."

"Washington, May 25, 1865

"Col. Pritchard, who captured *Jeff. Davis,* at Irvinsville, presented the identical garment worn by the rebel chief on the occasion, to the War Department to day. It consists of a cloak and shawl; the latter having been tied around his head as a hood, and the former, of a material known to the ladies as waterproof cloth, was worn as a skirt.

"Mrs. Davis had acknowledged to him, Col. Pritchard, that the articles were worn by Jeff. as a disguise at the moment of his capture, the cloak being worn as a skirt and the shawl drawn, hood fashion over the head to conceal his features. Under these garments he wore a full suit of drab and cavalry boots, with the pantaloons stuffed in the boots.

"These consisted of a water proof cloak and shawl, worn by the fugitive chieftain of the rebels at the moment of his capture."

Jeff's capture prouduced great consternation in Richmond.

Most all of the prominent Rebels have been arrested—C. C. Clay, Vice President Alexander H. Stevens, Gov. Vance of N. Carolina, etc, etc.

Setauket, May 28, 1865—Storm from the north east—

Thursday 25th painted the roof of the studio.

27th rainy—hauled out my boat to paint when the weather clears off.

May 30 & 31st painted my skiff and sent a letter to the Commissioner of Patents.

Hot weather June lst. Thermometer 85 1/2. It was very hot for the season about the 18 of May 1865. Thermometer 87.

[June]

Sunday, June 4th, '65—hot day—88. June 8—88. Saturday June 3rd, '65, painted on Mr. Floyd's portrait, a copy, morning and afternoon (painted on a light ground). After work, my eyes began to itch and I thoughtlessly rubbed them with the back of my first finger. Inflamation set in—I did not paint any more for a week, until the 10th inst. I had previously been painting the top of my studio —also the boat. White paint and sun shine was perhaps too strong for my eyes—

I applyed tea leaves wet in the strong tea—but I found hot water the best remedy and exessive in the open air. It is singular, that in 1860, when painting a portrait from a description, and using the magnifyer often—and close application—my eyes became inflamed. A day before my eyes failed me, 1860, I drank one glass of cider. Also, Friday, June 2nd, 1865, I drank only one glass of cider and my eyes were weak and inflamed the next day. *Moral* —Temperance in work, as well as in eating and drinking, is good for the eye sight.

For *eye sight*—out of doors with fresh air—particularly in warm weather.

As soon as the eyes are pained by reading, writing or painting: then stop at once.

I was brought up in luxury, that is, I always had enough to eat and wear—

June 1865

"John R. Reid, Editor of the *Suffolk Democrat*, says the new Academy is a model for all future galleries. Your famous Long Island artists—the Mounts—have several fine specimens of their most excellent handiwork on the walls; and they attract attention from all who can appreciate dainty limnings[?] of Poetic conceptions."

Setauket, June 29, 1865

I saw ripe blackberrys this day on R. N. Mount's farm. The earliest ever known. —Foward season. The farmers have been cutting hay the past week. Yesterday 28th of June, wheat was cradled. This season is ten days earlier than any season for a number of years. The old fashioned red cherry are ripe. Thought to be very forward to find them ripe on the Glorious Fourth.

Miss Anna Evans sat for the hands in Mrs. Samuel Thompson's portrait.

June 30th, '65—between 12 and 1 o'clock Thermometer 91 degrees.

July 3

Went to the city to witness the Military display on the Glorious fourth. Also, to have a look at the paintings at the N. Academy, and took some notes of the works.

July fifth 1865 sold two more paintings to Chas. B. Wood Esqr, four works that were on exhibition at the N. Academy.

They were—Peace, size 22 × 27 on canvass; Catching Crabs [c.pl. 38], canvass 18 × 24; Loitering by the way [pl. 135], on panel—size 14 × 9 3/4; Early impressions are lasting, panel, size 11 7/8 × 9 3/4.

Mr. Wood paid for the frame.

Peace	$300.00
Early impressions	$150.00
Loitering	$200.00
Catching crabs	$250.00
	$900.00

Thursday 6th of July went to Glen Cove to touch up some paintings at Mrs. Price's, and at Searing's.

Thursday July 13th, 1865

I saw a field of corn at Glen Cove tasseled out. Corn at this time of year largest ever known. We have frequent rains—which is good for Long Island.

July 21st. Thermometer 86 in the shade.
July 28—88 and 90.
Do 29—88.

I forgot to mention that Mrs Seabury had a party (24th of July). Mr. and Mrs. Draper, and Mrs Wayne, also Miss Carrie Strong, the Miss McVickers etc.

25th—a party at Judge Strong's.

Setauket, August 4th, '65—Thermometer 90.

Sunday 6th *fine shower*. It was needed, it had not rained in about 12 days—the 25 of July.

9th had many visitors in the afternoon. Miss Henrietta Thompson among the number. Mr. E. T. Darling is placing a center board in my skiff (the Pond Lily) making her a sail and row boat.

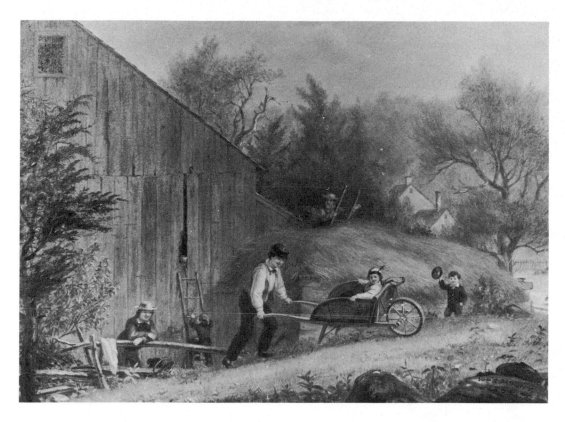

135. *Loitering by the Way*. 1865. Oil on panel, 9 3/4 × 12″. The Museums at Stony Brook, Stony Brook, Long Island

Mrs. Samuel Thompson's portrait finished—expect to take it home this afternoon.

August, 14th in the morning—good shower of rain.

Sept. lst. Thermometer 90 on the walnut tree in the shade.

Sept. 2. A glorious rain in the morning, had not rained in 19 days

Sept 5th, '65. E. T. Darling and Wm. S. Mount took a sail in the Pond Lily—she is a success.

Sept 6. W. S. Mount and Wm M. Davis took sail up Conscience Bay. Thermometer 92 de.

Sept 7th. Myself and Charles Hawkins took a sail.

Size of paintings I exhibited in the N. Academy:
Peace, sight measure 22 × 27 in frame.
Loitering by the way, 14 × 9 3/4.
Early recollections are lasting, 11 7/8 × 9 3/4.
Catching Crabs, 18 × 24 (sold to Chas. B. Wood).

Tuesday Sept. 12th '65
Sailed to Bridgeport Conn—staid two days with Mr. Frederick Wood. Very plasant.

Spent part of the day 15th in N- Haven, returned, met Maria and Mary Seabury at the wharf on their way to Mr. Wood's.

The month of Sept. up to sunday evening 17th has been very warm. The hotest known for years.

Sept 20 painted a sign for Henry Nunns. I must not suffer so much of my time to be taken up with such work.

[October, 1865]
How time flies—yet pleasantly.

John H. Hudson and my self took a sail to Wading River, Sept 30, '65 in the Pond Lily, and opposite Miller's Place about a mile and half in the sound, wind west, we saw a strange fish going west [pl. 136], the tail only was out of water at the time seen—about 5 and 6 feet. The color brownish gray.

After that exhibition the wind came off south—we arrived at two P.M., time three hours and half, took our dinner on the beach. We left Setauket half after ten A.M. We had a pleasant visit. I made several sketches of scenery with pencil—one sketch of George Hudson Esq. We made our stay with Mr. Lester Mills and G. Hudson. The wind blowing heavily for several days from the North. We did

136. Big fish. Diary, October, 1865. The Museums at Stony Brook, Stony Brook, Long Island

not return untill saturday, the 7th of Oct. at 4 P.M. We had wind s. west and s. s. west. A heavy roll on, occasioned by the late heavy blow from the north and west—time about five hours. The boat first rate.

Setauket, the first frost of the season, Oct 7th, '65.

Oct. 17–18

Made repairs at the east end of the house, took down the trumpet creeper and nailed up the grape vine (in place of the creeper). The grape vine was a present from the late Henry Inman. I was assisted by S. A. Mount. In the evening a heavy rain came on. It was very much wanted.

Oct. 19

Presented my Niece Evelina with an air tight stove and stove pipe—she is to return the compliment by painting me a flower piece next spring. Eve bids fair to make a good painter—and as she has a new studio in the attic, she will be inspired to new efforts. [Added later:] She has painted me a good flower piece, 1866.

Sunday—Wind north, clear and cold. I made fire in my stove for the first time this season. Also, put on flannel drawers—over muslin.

Oct 19, '65—solar Eclipse of the sun.

Forgot to mention that I made a visit to Hon. Wm. H. Ludlow, Sept 23d 4th and 5th— Painted his moustaches on his portrait. Also varnished 10 or 12 paintings.

I have been working so much for other folks I must try and do something for myself—

Tuesday 24th

Worked on the scare crow in the afternoon—it happened to be calm. Oct. of '65 has been *very boisterous*. The past summer has been the calmest known for years.

The past week I have been digging a ditch (to deepen) threw J. R. Davis' meadow. Sanford Denton assisted me an hour or so.

Ice—25th Oct, '65.

$185.00

Received (East Setauket), Oct. 1865, of Mrs. Mary L. Berrian $185.00. One hundred and eighty five dollars, for one portrait of her mother—Mrs. Samuel L. Thompson (taken after death). My price was two hundred dollars, but threw off fifteen dollars.

Wm. S. Mount

P.S. Portraits after death double price.

15 & 16 of Nov, '65

Painted on the scare crow or Robbing a cast off scare Crow of a hat. "Even exchange no robbery" [c.pl. 39].

To day 16th—this afternoon made a small sketch from nature. Finer weather never was known at this time of the year.

Nov. 26—my birthday. Thankfull for health, hope for the future.

Nov. 28, '65

Mr. Luther H. Tucker's marriage with Miss Cornelia Strong Vail passed off very brilliantly this evening—

Received books and panels—from F. Copcutt Esq. for a sketch of his dog Neptune. The panels must be painted and well dryed before using.

Sunday, 3rd of Dec, '65—very warm day for the season. Also—monday, tuesday and wednesday.

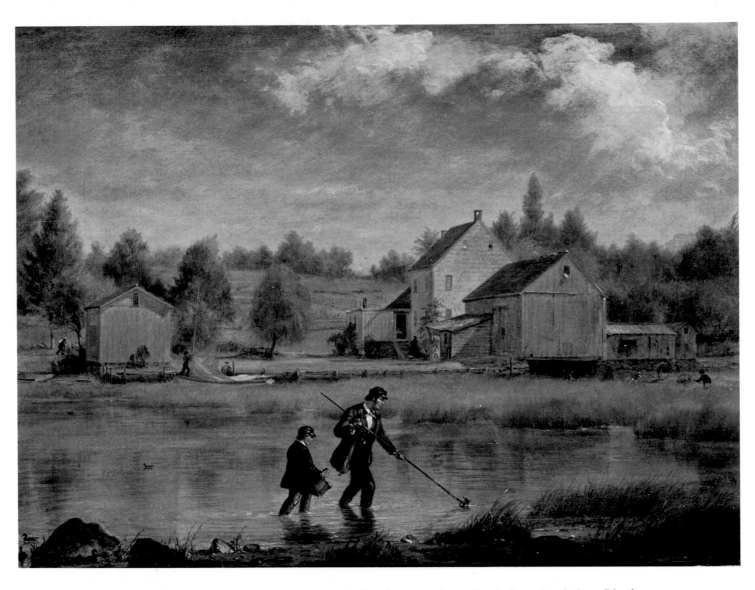

38. *Catching Crabs (Spearing Crabs)*. 1865. Oil on canvas, 18 × 24″. The Museums at Stony Brook, Stony Brook, Long Island

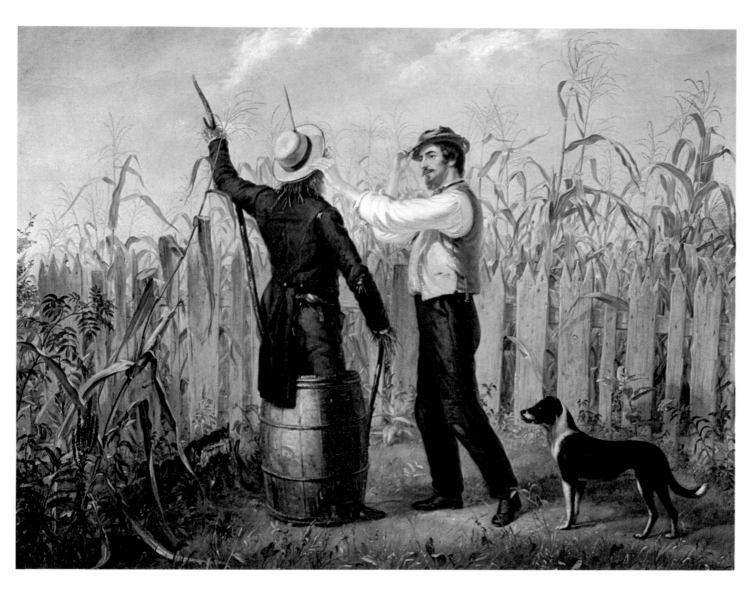

39. *Fair Exchange No Robbery (Even Exchange No Robbery)*. 1865. Oil on panel, 26 × 33 1/2″.
The Museums at Stony Brook, Stony Brook, Long Island

This day 6th Mr. J. R. Davis with his team (after bringing me a load of wood) hauled my boat on a plank to the rear of R. N. Mount's shed for winter quarters. She is to be covered over with thatch, salt hay, [illegible] it rots the wood, or sea weed, and plank or boards (boards are best) laid over to prevent the sun drying her up too much. Also the 6th Sanford Denton sent me a load of wood.

Also, been scraping and painting the seams of the Studio—the 5th inst. Tuesday filed up the cracks on the roof, with white lead driven in with an old white brush. It is better than a new one. Some times I rub the paint in with a rag.

To morrow Thursday Dec 7th, '65, Thanksgiven day—Turkes, Geese, Ducks and chickens in great demand.

Setauket, Dec. 12th, '65

One of my Nephews (last evening) made his third attack upon me—but failed.

137. Paintbrushes. Diary, December 21, 1865. The Museums at Stony Brook, Stony Brook, Long Island

Been coloring Photographs for several days. Poor business—when time is spent in coloring poor impressions.

Suggestions to the Photographer for coloring—in water colors. Make the portrait light, clear and distinct as possible—lay color on dark shadows. To paint on a dark ground is very tedious for the Artist—when water colors are used (as he has to make a body color of Chinese white). Consequently, it takes more than double the time to color a dark photograph and seldom gives perfect satisfaction to the painter.

DOOM OF SLAVERY

The Anti-Slavery Constitutional Amendment. Official Announcement by Secretary Seward of its Ratification by Twenty-seven states. The Amendment Declared Valid as a Part of the National Constitution, etc, etc.

——Washington, Dec. 18, 1865.

Good subject for a painting.

About Photographs, the shadows should be clear and not too dark to color well.

If you have a fine clear photograph to color—mix chinese white with your flesh tints (red and yellow) or with any color you desire, and go over the face or hands quickly—and before it is dry touch in the reds in the cheaks, lips, ears etc. When dry touch on the high lights—at this period paint the eyes, hair, dress and so on. Lastly tone the flesh and background to the color required.

No good painter in oils should ever spend his valuable time in coloring photographs. Unless for some dear friend—

Chinese white can be used with water colors with the same freedom as white lead with oil colors. Chinese white with water colors—is very like Fresco paintings, as you do not exactly know your tint until you have tried it. Practice will make a painter very skilfull in mixing and knowing the effect of *his colors*—before it is laid on.

Scumbling over the flesh (lights and shades) on the second and third paintings (in oil) tends to produce breadth of effect—also, toning with transparent colors and working into them, with a little opaque colors while wet.

Sometimes finish with clear colors—at other times with mixed colors.

Selection of proper brushes is important. The painter should make some of his brushes [pl. 137].

Pine sticks, bristles and brad awl—or gimblet with glue—and brains will make them.

Longest day in summer 15 hours and 17 minutes. In winter, 9h—5m.

[1865?]

I must endeavor to pay strict attention to my own business. The man who attends to his, who does so, will have respect shown him.

Life is too short to be striving to teach those who will not receive instruction, being bound up in their own vanity and self will.

Mr. J. V. Davis, I am conversant with many of the Compositions of Sir Charles Eastlake P.R.A. They are often elegant and classical.

ABOUT SNOW
Snow drifts are fine to study.

The melting of snow on buildings—gives the roof a dark color as far as the water runs down—thus [sketch].

The shine on snow could be well imitated by sifting or throwing some pulverized *mica* or *issinglass*—over the forground.

To have rich colors to look at in your studio—hang up a piece of canvass, or a rag, and spread on your waste colors. *Good effects,* etc.

A large picture exhibits a large mind—when well done.

As regards size, I mean a cabinet painting where the figures are of large size—and effective.

I can paint large figures, and must do it. And from the life—and Landscapes of a larger size. Also—study to be quick in execution—the finest effects of color are often done quickly, repeating and contrasting the colors.

[1865]

An invention for writing in the dark—good for the blind—by Wm. S. Mount.

This entry is illustrated with a drawing of a writing board across which is a movable bar to act as a guide for the writer's hand. In the space above the bar in the drawing Mount writes, "All is dark but the mind; in the stillness of the night the author can write."

correspondence 1864-65

Henry R. Stiles to WSM

Library of the Long Island Historical Society
Brooklyn, N.Y., Jan. 15th, 1864

Dear Sir,

In sending you the enclosed circular, and the accompanying pamphlet, we trust we may not be deemed *presumptuous* if we suggest in what particular way you may render our Society a most signal service.

It is this. We have already, through the generosity of some of our members, a very considerable nucleus of a gallery of historic portraits and paintings—of much artistical value as well as historical interest. In this Gallery, also, we shall be most happy to include specimens of the genius of our *Long Island* artists—for in our collections, of antiquities, relics, books, etc, we give the most prominent place to Long Island. Now, Sir, may we not hope that you will, at no distant day, contribute to our walls one of your most *characteristic* Long Island pictures? For it surely the case that our Rooms are the most appropriate place for such a *souvenir* of one whom Long Islanders have long prided themselves upon, as "their artist." We hope, therefore, that thro' your kind courtesy, we may be able to preserve for posterity some specimen, or specimens of your skill.

Believe Me, Sir,
Yours Sincerely
Henry R. Stiles, M.D.
Librarian

N.B. I send by this mail, also, a copy of Mr Jones' Address before this Society, on "Long Island" in which (p. 21) you will find a notice of yourself and brother, and we shall esteem it an equal favor if he would join you, in adorning our walls with a picture of his. As *portraits* may be more in his line of painting, perhaps he could help us to a portrait of Long Island celebrity, or "old settler."

If either of you visit Brooklyn—we shall be most happy to welcome you to our Rooms.

[NYHS]

WSM to Samuel P. Avery

Setauket, L.I.
Feb. 12th, '64

My dear friend,

I send by L.I. Express to Mr. M. Knoedler 772 Broadway, a sketch in oil to be framed—Child's first Ramble. Painted for Brooklyn and L. Island Fair, in aid of the U.S. Sanitary Commission.

When properly framed the picture will be worth about fifty dollars. If it is worth exhibiting please see that it is favorably hung.

Yours etc.
Wm. S. Mount

[NYHS]

393

WSM to Carrie Strong

Setauket L. Island
Feb. 15th, 1864

My dear Miss Carrie,

Had Mrs. Monson been my own sister I could not have taken more thought to obtain a likeness, it being partly the work of memory. If her numerous relations and friends should recognize the portrait I shall be delighted. It will go far to show that the painter is several steps ahead of the Poet, Historian and the Photographic art—as he brings the loved one into your very presence, with fine form and freshness of color, the eyes looking at you with sweetness of expression peculiar to the individual. Cornelia, was unquestionably one of the most beautiful woman in this County or State.

Yours, very truly
Wm. S. Mount

[NYHS]

WSM to Charles B. Wood

Portable Studio
Setauket L. Island
Feb. 21st, 1864

Dear friend,

The next morning (after seeing you in your new establishment) I was taken with a heavy cold and sore throat. So instead of going to Laight St. and taking breakfast with you and D. A. W. and sisters like a good boy as contemplated, I thought proper to skedaddle down east—consequently I have had a cold ever since.

The object of this letter is to let you know that I am alive and kicking—you would have thought so, had you seen me dancing at a party the other evening. My performance in that way seemed to please the spectators hugely—and they remarked, that no one but a temperance man could have gone through with the rapid movements. Say to your brother Gus—that If he could see the young ladies now growing up around this part of the Island it would do his young heart good and prevent his sleeping so late. My brother Robert N. Mount sends his respects to your brother D. and remarks that he and David were room mates and slept together. If that was the fact, I expect in their dreams, night mares, and snorings, they must have kicked each other quite lively.

We had a carnival on the Setauket Mill Pond Saturday in the way of skating. It was a gay scene, Negros on one pond and whites on the other—that was right and proper.

I have made a highly finished picture of "Boys going Trapping." I forwarded an (oil painting) "Child's first Ramble"—a sketch 6 1/4 × 8 3/4 in—for Brooklyn and Long Island Fair to be sold in aid of the U.S. Sanitary commission. Maria and Miss Perkins were at Church to day (the Episcopal)—of course—

On my next visit to the city I will call and see you.

I remain yours,
Very truly,
Wm. S. Mount

[NYHS]

Charles B. Wood to WSM

590 N B'way N.Y., Mar 2nd, 1864

Dear Mount,

Yours from the Perambulatory Studio of the 22nd ult. was duly recd. I should like to hear from you oftener and *see* you oftener. Bring down your picture "Boys going Trapping" as well as your *Carpet Bag*—your Room is ready for you and Gus and All the Family will be glad to have you occupy it. I like the "Boys going Trapping" and if the price has not gone up much with the *finishing*, I may purchase it. What else are you doing?

I received a few days since a letter from Thomas Seabury with an order for a Carriage for one of his friends Dr. Holliday of New Orleans. His personal affairs are progressing favorably he says—and in a former letter informed me that he designed going into the planting business, with a Colony of about 60 Negros—good luck to him.

Give My love to Perkins, and if she is good looking, kiss her for me.

Yours Sincerely
Chas. B. Wood

[NYHS]

Charles B. Wood to WSM

590 Bway NY, June 6th, '64

Dear Mount,

I purchased at the "Waldo sale" some of those Pannels, viz, 9—26 × 33; 3—28 × 36; 3—24 × 30; 2—22 × 27.

Most of them have the portraits of Somebodies Grandfather or mother on them. They cost but 75¢ each, about what the wood is worth by the foot. If they are of any use to you, you are quite welcome to them. I will send a specimen of each by the sloop to your place, if you will write me where to find her.

In framing your "Boys going Trapping" I thought of making it of carved wood with something appropriate in the design to the subject, similar to the accompanying sketch [pl. 138]. The animals are supposed to be rabbits. What do you think of this idea?

Yours truly
Chas. B. Wood

[NYHS] *This strange letter seems to say that the panels left in the studio of Samuel Lovett Waldo, the distinguished portrait painter, were disposed of like so much raw lumber after that artist's death in 1861. As later documents show, Mount thought nothing of scraping off what Waldo had painted on the panels, in marked distinction to his usual respect for his colleagues.*

WSM to Charles B. Wood

Portable Studio
Setauket L.I.
June 9th, 1864

My dear friend,

I accept with great pleasure your gift of the "Waldo Panels"—seventeen in number. The surface of some of

138. Picture frame with rabbits. Letter Charles B. Wood to WSM, June 6, 1864. The New-York Historical Society

them will require to be put in order before I can use them, and being near to Nunns' Piano Factory—one side can be planed off (a perfect level surface) and colored to the tone required at my studio. Therefore I will thank you to send them wrapped and tied up with paper (The large panels *inside* and the *smaller outside*) so they will not attract attention on board—and directed to Wm S. Mount, Setauket—care of Capt. Hutchinson, Sloop Glide (Packet), Port Jefferson, L.I. and I will pay you when we meet. An act of kindness is appreciated by some individuals. "Bless the lord, O my soul, and forget not all his benefits."

Your design for the frame is a good one and very complimentary. You might substitute in the left hand corner apples and grapes in place of box trap—as it will be repeating the traps in the picture—or you can introduce a quail or partrages, or a wood chuck, skunk, or fox somewhere about the frame—as they have seen and felt a trap. Have the heads without the bodies as you have marked out—or a young rabbit running, as you have marked out.

The "Tease" is improved, I have already work a week upon it.

Yours truly,
Wm. S. Mount

The Packet sails on Friday for Port Jefferson. Place package on board Thursday 18th.

[NYHS]

WSM to Mrs. Andrew Hood

Portable Studio
Setauket, L.I.
June 18, '64

My dear friend,

I should like at some future time to paint the portrait of your dear husband (with your approval) for Mr. Ferd. Hood for one hundred dollars, providing I painted it at his, or your residence—although, it affords me more pleasure to paint from the life than to make a copy. It is the feeling of most artists.

Mr. F. Hood appeared to be such an upright man that I am sorry to hear that there should be any difficulty between you. You are kind hearted and perhaps in after years you may think more kindly of him. However, you know best. I thank you and Andrew most sincerely for desiring me to spend some of my spare time this summer at Scrub Oak. It is a delightful locality, and I will try to make you a visit some time this summer.

Please remember me to the children, Annie in particular. I send you a season ticket. The Academy closes on the 25th of June.

Yours Sincerely
Wm. S. Mount

[Memorandum by Mount at the bottom of his copy:]
Dropt a note to day 28 about the portrait.

[SB]

WSM to Francis Bicknell Carpenter

Portable Studio
Setauket L. Island
Oct. 5th, 1864

My dear friend,

I am pleased to see so favorable a notice in *The Independent* of your historical picture of "President Lincoln's Proclamation of Emancipation before the cabinet."

I have received a notice to view the "Great National Picture" and shall call on my visit to the City. I wish you success.

I take this opportunity to thank you for your kindness in favor of my Nephew Wm. Shepard Mount.

Please give my regards to Mrs. Carpenter.

Yours truly
Wm. S. Mount

[NYHS]

Andrew Hood, Jr., to WSM

Oct. 19th, 1864

My Dear Mr. Mount,

You were kind enough to offer, when at our house, to buy me a tin flute; if you will please let me know the cost, I will send the money by mail, for you to purchase one for me.

If you could leave it with Mr. Alfred Roe 128 Broadway, I should be sure to get it, as my mother is obliged to see him on business frequently.

We are still at Shrub Oaks, and my mother is fearful we shall be obliged to stay here all winter, as it is so difficult to obtain accommodation in the city for so many small children.

As my mother dislikes the country so much, it will be quite a trial for her to remain here all winter.

My grandmother and aunt Kate have been with us all summer, making it pleasant for my mother.

We have often thought of you, and would liked to have had a visit from you, but I suppose you think your studio is far pleasanter than Shrub Oaks. We are all very well, and hope you are enjoying good health also. Mother desires to be kindly remembered, and Annie often asks when Mr. Mount is coming to see her. Hoping I have not encroached to much on your valuable time, allow me to remain,

<div style="text-align:right">Your young friend,
Andrew Hood</div>

[SB]

WSM to Andrew Hood, Jr.

<div style="text-align:right">Portable Studio
Setauket, Oct 24, '64</div>

My dear friend,

About the *tin whistle*—after my return I spoke for four or five whistles but Mr. John S. Lee of Port Jefferson L.I. was so busy that he could not find time to make them so I forgot all about them—I thank you for reminding me. On receiving your note, I called on Mr. Lee at the Port on Saturday—he was absent but his partner Mr. Corwin, said, that Mr. Lee might make some whistles in about three weeks time but they were very busy. When I can obtain one it shall be left according to directions. You have a delightful place. I love the Country—"God made the country man made the town." Your mother acts wisely in spending the winter at Shrub Oak. I have often thought of you, the children, your Mother and your dear Father. Annie is a good girl—

My regards to all

<div style="text-align:right">Yours truly,
Wm. S. Mount</div>

P.S. I hope to see you before many months have passed away.
[SB]

WSM to John R. Reid

<div style="text-align:right">Portable Studio
Setauket, L. Island
Oct. 28th, 1864</div>

My dear friend,

There has been two Republican meetings at this place in the Methodist Church, and the Democrats desire the *listeners to the above meetings* to hear the truth, and are anxious for you to speak at Mr. Carlton Jayne's large room in this village as soon as convenient. The Democrats will foot your bill, and thank you besides. Please

appoint the time and write to John R. Davis Esq. one of the managers.

<div style="text-align:right">Yours truly
Wm. S. Mount</div>

[NYHS]

WSM to Thomas S. Mount

<div style="text-align:right">Setauket, L. Island
October 28, 1864</div>

My dear Nephew,

I have written this day (by request of the Democrats) to John R. Reid Esq of Babylon, to make a speech at this place, as soon as convenient. Also, to ask you to join Mr. Reid in the delivery of the speeches. John R. Davis Esq, one of the managers, will give you notice—or you can write to Mr. Reid on the subject, time, etc.

<div style="text-align:right">Yours truly
Wm. S. Mount</div>

[NYHS]

John R. Reid to WSM

<div style="text-align:right">Babylon L.I.
Oct. 31st, 1864</div>

My dear friend,

I duly appreciate the compliment you bestow in inviting me to address your citizens, but my engagements are such that I am compelled to decline. At no place in our county would I more gladly appear than at Setauket; and to no request would I make a prompter response than your own. Up to the day of election, I am engaged every evening—sunday excepted—to address the people upon the question of the canvass. Had I received your missive a week earlier, I would have foregone some one of my present engagements and done myself the honor of an appearance before the good people of your village.

Again thanking you for your kind invitation and repeating my regrets for my inability to comply. I am,

<div style="text-align:right">Truly Yours,
John R. Reid</div>

[SB]

WSM to Nicholas Ludlum

<div style="text-align:right">Portable Studio
Setauket, L. Island
Jan. 17th, 1865</div>

My dear friend,

Your kind note containing card portraits I have received, but could not find time to color them until this moment. Mrs. Ludlum desired me to paint her portrait handsome. Your photograph (not a strong impression) I have tried to make younger, by darkening the hair and whiskers. Mr. John R. Davis, with whom we drank cider, requested me to say, that he would be pleased to have you and any friend of yours to stop with him; when you are ready to look after more *quail*.

It will afford me pleasure to call and see you when I visit the city.

Yours, very truly,
Wm. S. Mount

P.S. You can have a large photograph taken from this card portrait if you desire. The position is good. If you should sit again, raise your eyes a little higher.
[NYHS]

Andrew Hood, Jr., to WSM

Peekskill, Feb. 20th, 1865
Military Academy

My Dear Mr. Mount,

Mother has just received your letter, and has allowed me to answer it.

I thank you for your present, and shall always think of you when learning to play. I never expect to play as well as you, but will try to play "the girl I left behind me."

Mother thinks you had better send it by express or mail, please direct to Peekskill care of Albert Wells Esq.

I am at the academy, and go home on Friday afternoon; and return on Monday.

Mother finds it very lonely here in the winter; my aunt Kate has stayed with her all winter for company. We are not much acquainted with the people about home, and see very few visitors.

I am studying hard this winter and hope soon to be able to leave school, and help take care of myself.

Mother wishes to be remembered to you, and hopes you are enjoying good health; and now I must close.

Accept my thanks for your kind present,

and believe me
your sincere friend,
Andrew Hood

[SB]

John M. Gardner to WSM

Washington D.C.
Mar. 1, 1865

Dear Sir,

Mr Thompson or Senator Morgan were mistaken yesterday in regard to the action of the Senate. I will get a copy of the *Globe* newspaper containing the official report of their proceedings and send it to you with this. Leutze having painted one staircase, Powell being about to paint the other, there will be two left, one of which you ought to have for young Washington. These paintings will be larger than those in the Rotunda painted by Trumbull, Chapman, Weir, Vanderlyn and Powell; 20 feet by 30 as I before wrote.

I was recently much interested by some remarks on historical composition by Plutarch at the beginning of his life of Pericles; he does not consider that a man may understand a picture without learning Greek.

Yours truly,
John M. Gardner

[SB]

WSM to James Lenox

Portable Studio
Setauket L. Island
March 16, 1865

My dear friend,

Allow me to offer you an apology at this late day and my reasons for not painting for you, a variation of the Power of Music. To tell the truth I did not desire to repeat the subject so soon, although I commenced a picture for you, var. of "Music is Contagious," size 25 × 30. At some future day I will try and see what I can make out of it—or paint some other music subject when my mind feels it. In the mean time, I shall be most happy to show my paintings to you from time to time as they are finished—at your residence or elsewhere.

The National Academy of Design opens the 1st of April in their new building Cor. 23rd st and 4 av. Therefore I expect to be in the city the last of next week to sell my pictures before they are sent to the Academy.

I have been working to improve color and if any one of my pictures should give you a moment's pleasure I shall be gratifyed.

I am yours
very truly
Wm. S. Mount

[NYHS]

Francis Copcutt to WSM

New York, Nov. 17, 1865

Dear Sir,

I have sent you by sloop today a flood of panels and some books. I inquired at Harper's and at Wiley's, but they did not know of a life of Turner. So I have put things in which I hope will interest or amuse you. Now to your Studio, and turn the panels into a couple of thousand dollars this winter, and make us all marvel as we look at the Academy walls next spring.

Yours Truly
Francis Copcutt

[SB]

WSM to Francis Copcutt

East Setauket L.I.
Dec 1865

Dear Sir,

Having been absent in Queens County, I have just been notified of the arrival of your *note books* and *panels*, and kind expressions for my future success in art.

The paintings of the panels will prevent their immediate use. The paint must be thoroughly dry before sketching upon.

Mr. Luther H. Tucker's marriage with Miss Cornelia Strong Vail passed off very brilliantly on the 28 ult.

Yours truly
Wm. S. Mount

P.S. Neptune will be ready in a few days.

[SB]

a mount miscellany: drawings

Vast heaps of drawings by William Sidney Mount are preserved at The Museums at Stony Brook, at the Metropolitan Museum in New York, at the New-York Historical Society, and elsewhere. These drawings will be the subject of a book of their own someday. Here we can do little more than suggest the richness of the subject.

Drawings related to known paintings by Mount were placed throughout this book as close as possible to the paintings in question. A few of his independent landscape drawings are reproduced in a separate grouping. In this section we are concerned with drawings which, so far as is known, are not related to paintings. Some of them may have served as preliminaries to paintings now lost, some as preliminaries to paintings that were never realized; the great majority, however, appear to be notations of the moment, random jottings, and five-finger exercises of the sort made by artists to whom drawing is as natural and necessary as breathing. All but two of them are from the collection at Stony Brook. All are reproduced in their actual size or sufficiently close to it that their dimensions need not be given.

Shown first (pl. 139) is one of Mount's most curious productions, a scene of hog butchering signed and dated "Dec. 13th 18—"; the last two digits are illegible, but Stony Brook dates the drawing 1860. The technique employed—pencil heightened with white chalk in a strangely random and arbitrary way—is unparalleled elsewhere among the Mount drawings known to me.

Next is a group of five drawings about houses: one exterior view and four interiors. No one knows whose houses they were or where they were, but the first one might have been the Mount house of the artist's youth, since there is a tradition to the effect that part of that house was used as a tavern, and one sees the bottles, glasses, and pitcher of a bar through the opening at the right of the drawing (pl. 140).

The second of the five drawings emphasizes a rude construction of wood, repairing a breach in a stone wall, at its center (pl. 141). The house behind this structure is more or less incidental, as is the little girl at the extreme left.

The next two interiors presumably represent two sides of the same living room. In one of them (pl. 142) Mount has taken pains to indicate the subject of the painting on the wall: a bird hanging by its neck and a rabbit hanging by its feet. So far as is known, Mount never painted anything of that sort, nor did his brothers, and this may mean that the house is not the artist's own. The other drawing (pl. 143) contains several verbal notations. At the extreme left, written vertically: "Brown paper / blue figure." On the picture frame: "Gold." In the recess of the fireplace: "Black." On the rug before it: "Lead G." On the wall to the right of the mantel shelf: "Pearl-gray." It will be observed that the patterns of the wallpaper and the rug, and the design of the chairs and the hardware of the doors, are identical in both drawings.

One is tempted to call the old-fashioned room with the fireplace and the cooking equipment in the next drawing

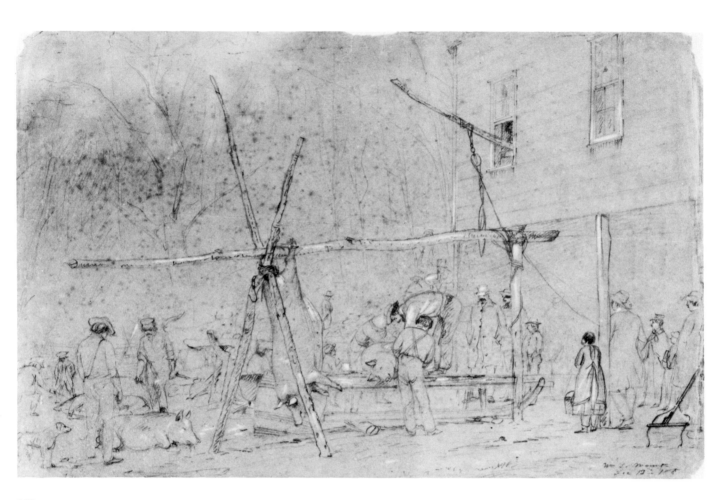

139

140

140

141

142

143

144

145

146

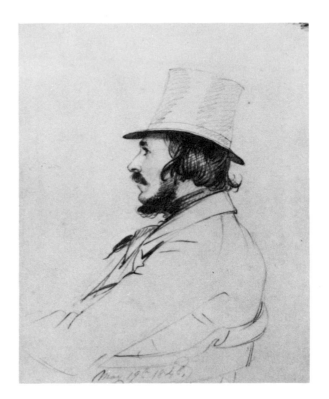

147

148

(pl. 144) a kitchen, but it probably dates from a time when such specialized designations of space in American country houses were unknown; indeed, it is not inconceivable that this drawing is an antiquarian effort on Mount's part and does not represent the conditions under which he lived, at least in the years of his maturity. The huge iron pot hanging on a long crane recalls Mount's watercolor *The Trying Hour* (pl. 39). The lard lamp and candlesticks on the mantel shelf and the L-shaped lamp hanging on a nail below them are precisely such objects as John Frederick Peto was to use around 1890 in his still lifes evoking the past. Mount himself was a magnificent still life painter, but, except for the quickly brushed flower studies of his last years, he produced no independent works of this type; his still life appears always as accessory to story-telling.

The next group of drawings has to do with people. Mount's figure drawing is remarkable for its crispness and clarity. More than one critic has drawn an analogy between Mount's works of this type and those of Ingres and the French neoclassical school in general, but Ingres and the French neoclassicists are perhaps the only major artists of the past and of his own time whom Mount ignores in his endless diary entries concerning his craft and its traditions. At all events, the woman with the shawl over her head and the flowers in her right hand (pl. 145) is an excellent example of Mount's draftsmanship of the figure. The two men in top hats are, of course, formal portraits. One of them is inscribed "A sketch of Revd. F. M. Noll, May 19th 1848"; the other bears the same date but the sitter is unnamed (pls. 146, 147). The tavern scene is an example of the convivial Mount (pl. 148). The man asleep before a fire (pl. 149) with his top hat pulled so far down that it seems to encase his head

entirely suggests the frequent tirades against taverns, liquor, and their effects on susceptible people with which Mount's diaries abound.

The drawing of the black man playing a violin (pl. 150), holding it far down on his upper arm in the time-honored fashion of country fiddlers, sounds a motif central to the world of William Sidney Mount. The association of blacks with music is a cliché which Mount did nothing to dispel in his paintings lithographed and distributed all over the world by William Schaus, but Mount is far more sympathetic about it than any other painter of his time; he is, indeed, more sympathetic in his pictures than either his writings or his political activities would indicate. The black fiddler of this drawing seems to be seated on a rath-er elegant bench. Behind him, on the window ledge, is what appears to be a feather duster. On the table at the right is the unexpected notation "Comb & Brush."

The next two pencil sketches (pls. 151, 152) are from the Louise Ockers Collection, which, as was mentioned in the Foreword, has only recently come to light. The ducks measure 4 × 12 1/2", the child and turkey 6 1/2 × 10". They are unsigned and undated and bear no relationship to any known painting by Mount. The disproportion between the child and the turkey suggests that they are distinct and separate sketches, not intended to be seen together. The general style of the child and turkey is cruder than that of the ducks and therefore suggests an earlier date.

151

152

Last of all is a group of eleven drawings that add up to 131 drawings, and this calls for a little explanation.

Throughout most of his life, Mount would jot down lists of possible subjects in his diaries. He would also jot down aphoristic statements under the repeated heading "Thoughts of the Moment." Late in his career Mount took to expressing the subjects not verbally, as heretofore, but in the form of quick pencil sketches. He would divide one piece of paper into numerous rectangles and draw his ideas within them; at the top of at least one of these sheets appears the familiar "Thoughts of the Moment."

Of the eleven pages reproduced herewith, one is undated and one bears dates of November 25 and 26, 1866. Each individual drawing is dated on the remaining nine sheets; all were done between January 5 and November 25, 1867.

A few of the drawings in this series are unusual in subject matter for Mount, especially those dealing with religious themes and the one and only study of the female nude he is known to have made. Erotic interest is almost totally absent from Mount's work and from his letters and diaries, but in addition to the nude bathers on the sheet for late January, 1867, there are sketches of a man and a woman in close embrace and kissing, a subject which appears nowhere else in Mount's chaste Victorian world.

Many of the drawings contain color notes and explanatory observations of one kind or another. We transcribe only as many of these as seem necessary to the understanding of the sketches.

Plate 153 (undated)

Top center. "My children." A mother rushing into a burning house.

Second rank, left. "Lecture." A woman reading from a book and gesturing for the benefit of another woman.

Second rank, right. "Blackberries."

Third rank, left. "Job's wife." Inscribed above: "Job, white shirt. dark shirt [*sic*]." Below: "Mrs. Job, dark dress."

Bottom rank, right. "sleep on." Three figures asleep at the right while two figures, apparently implying religious revelation, stand in a gloriole at the left. Color notes: "yellow" at left; "Twilight" above; "somber" at lower right.

Plate 154 (November 25 and 26, 1866)

Top left. "before the Election." This drawing is, of course, a reminiscence of Mount's painting *The* Herald *in the Country* of 1853.

Top center. "Listener."

Third rank, right. "comming up."

Plate 155 (January 5 and 6, 1867)

Top left. "The Jews Harp." Another version of the same subject appears directly below.

Plate 156 (January 17 and 18, 1867)

Top left. "Feeding a mamed soldier."

Top right. "Charity to black."

Second rank, left. "Suspense. Reflection."

Second rank, right. "Viewing a drawing."

Third rank, left. "A new water." "Waiter" seems to be meant. The point of the drawing appears to be that an inexperienced waiter has taken it upon himself to read a customer's newspaper over his shoulder; the customer seems to be handing the paper to him with an impatient gesture.

Third rank, center. "Girl & Rabbit."

Plate 157 (January 24–31, 1867)

Top. The above-mentioned drawings of a couple embracing and kissing. At bottom of second drawing: "11 Designs in one day."

Second rank, left. "The Storm." Man and dog waiting under a tree.

Second rank, next right. "The portrait." Two women discussing a miniature.

Second rank, next right. "Fishing."

Third rank, left. "Debate."

Third rank, right. "About to bathe." Mount's unique study of the female nude. Three of the girls are naked. The fourth appears to be undressing.

Plate 158 (February 5–8, 1867)

Top left. "Every business has its time." A man whittling; a beggar taking advantage of this idle moment to put forward his empty hat.

Top center. "Signal to the conductor."

Top right, lower rectangle. "The jealous fiddler." The reason for his jealousy is obscure. He seems to be holding a Mount-style violin.

Second rank, left. "Reading the Almanac."

Third rank, left. "Riding out." Children playing on a log.

Second rank, center. The inscription "Say yes and the thing will [be] settled" appears to apply to the man talking to the woman, probably urging her to marry him. The very lightly sketched head of the woman at the upper right was probably done at a different time and is not intended as part of this drawing.

Plate 159 (February 9–27, 1867)

At the top of the sheet. "Sketches; thoughts of the moment."

Top left. "We have walked far enough."

Top center. "Polly at the window."

Top right. " 'Suffur little children to come unto me.' "

Second rank, left. "Gardening."

Third rank, left. This drawing, a face with small legs walking on the back of a very large hand, should be pointed out as an extreme rarity among the works of Mount, who seldom indulges in such surrealistic fantasy.

Plate 160 (March 11–13, 1867)

Second rank, left. "You dont."

Second rank, right, lower rectangle. "Night train." The yawning man is apparently seated in a waiting room late at night.

Third rank, left. "Horse fly." The woman shrinks in anticipation of a swat on the shoulder as the man is attempting to brush the horsefly away.

Bottom rank, center. "Top of the morning to you."

Bottom rank, right. "Characters. Pretty tight."

Plate 161 (March 23–29, 1867)

Third rank, right. "It is late, my little Dear—Sammy." A woman putting a child to bed.

Bottom rank. "The woman at the Well." Two versions of this New Testament subject.

At the bottom of this page is the inscription "Thos. S. Mount, May 20, 1872." This sheet, and probably others, must have come into the possession of the artist's nephew after Mount's death.

Plate 162 (November 6–13, 1867)

Top left. "Thinking about retaliation." Over the door is the partial inscription "SCH," obviously intended for "SCHOOL." The drawing appears to be of a pair of schoolboys squaring off for a fight.

Plate 163 (November 23–26, 1867)

Second rank, center. "Looking off."

Second rank, right. "alarmed."

Third rank, center. "Great news."

Bottom rank, left. "My birthday." Although the drawing is dated November 26, 1867, which actually was Mount's birthday, the gentleman greeting the morning through the curtains of his bed does not appear to be Mount himself.

Bottom rank, center. "Inticing the Dog."

Bottom rank, right. "Young navigator."

154

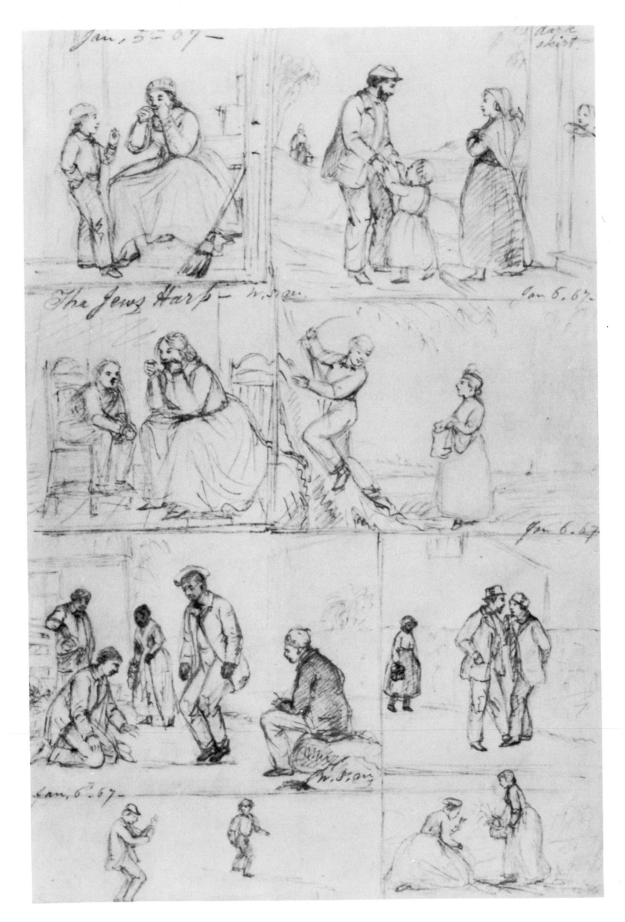

155

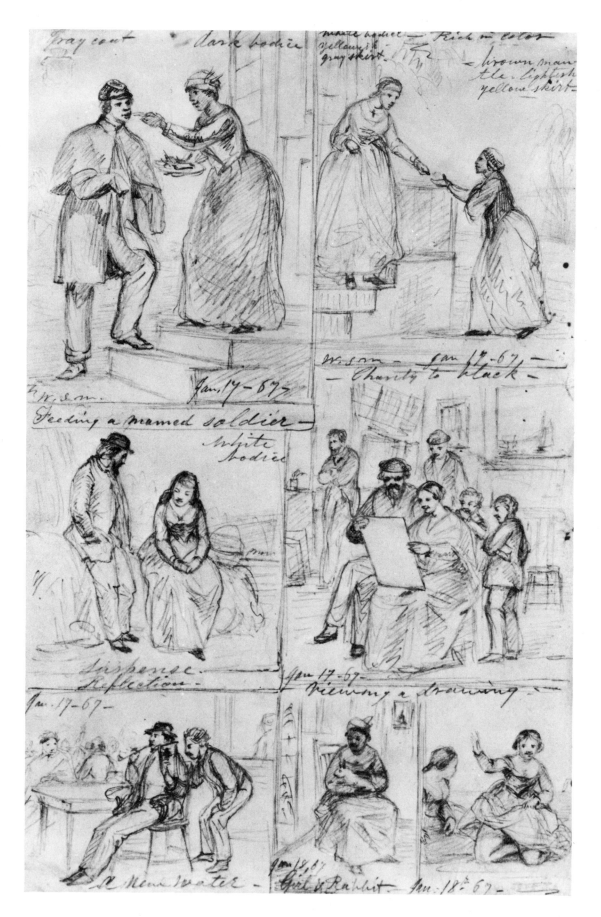

156

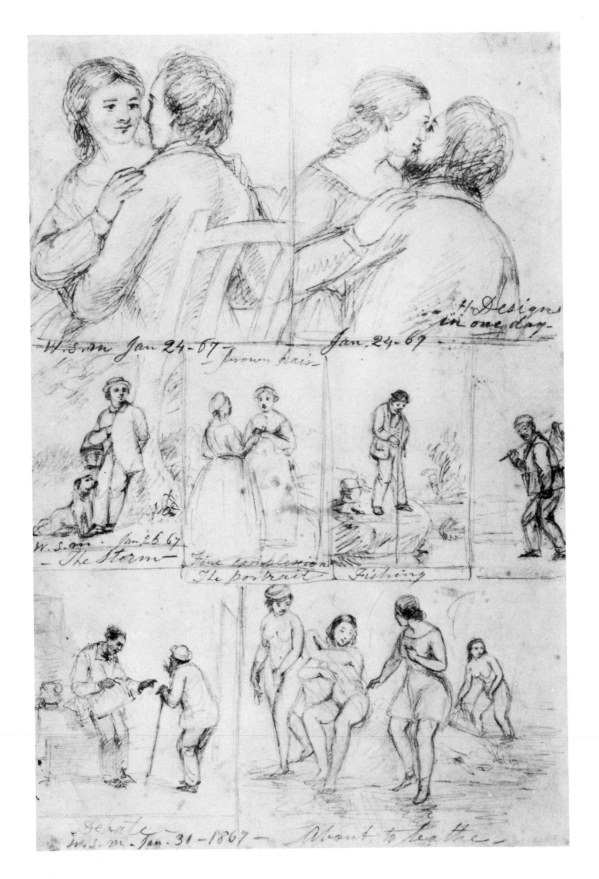

157

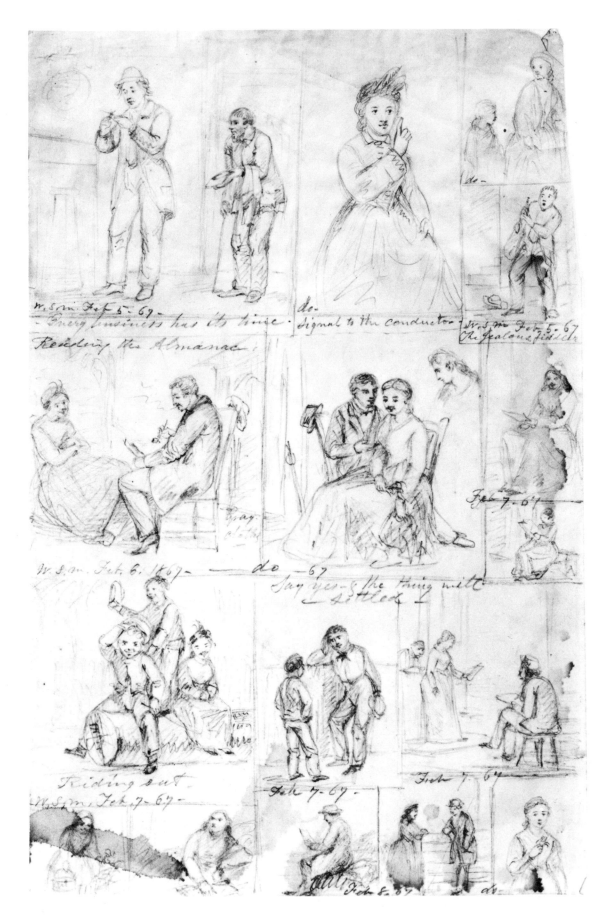

158

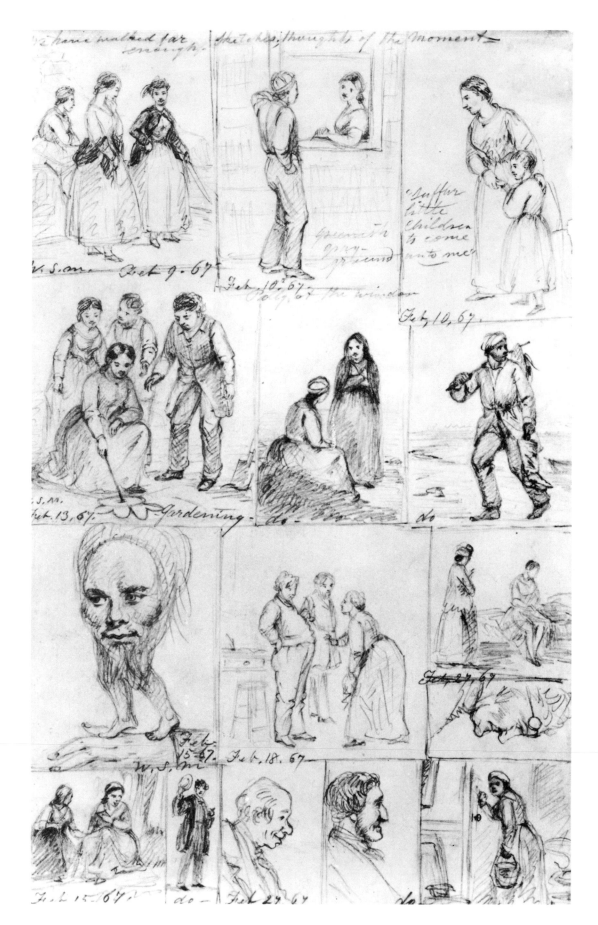

159

W.S.M.
March 14, 69 —

March 12 — 69

you don't — W.S. Mount. March 12th 67.

Horse fly.

night cap
do coat

W.S.M. March 13.67. — do 13th do 13th

Tip of the morning to you —

W.S.m. March 13. 69 —

Characters —
Pretty tight. do 13, 67

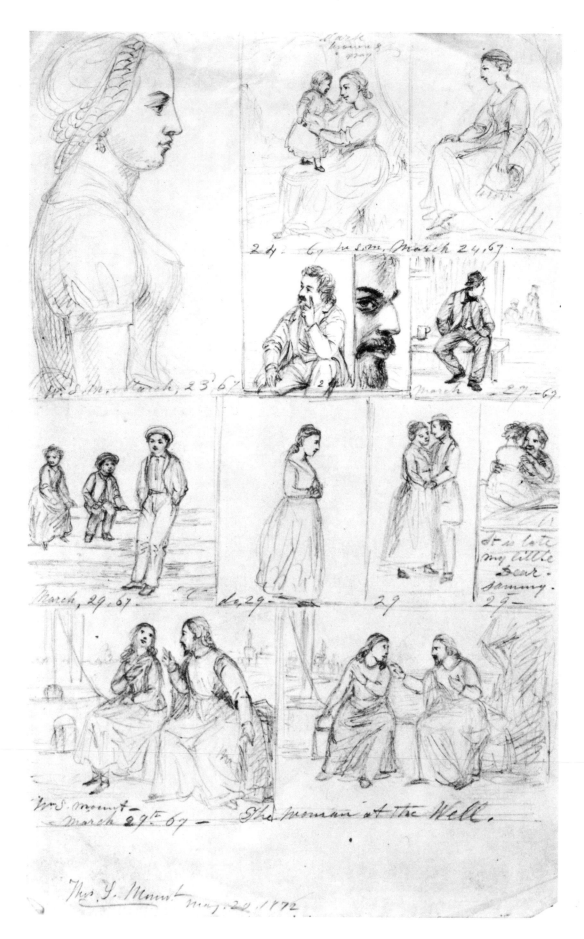

161

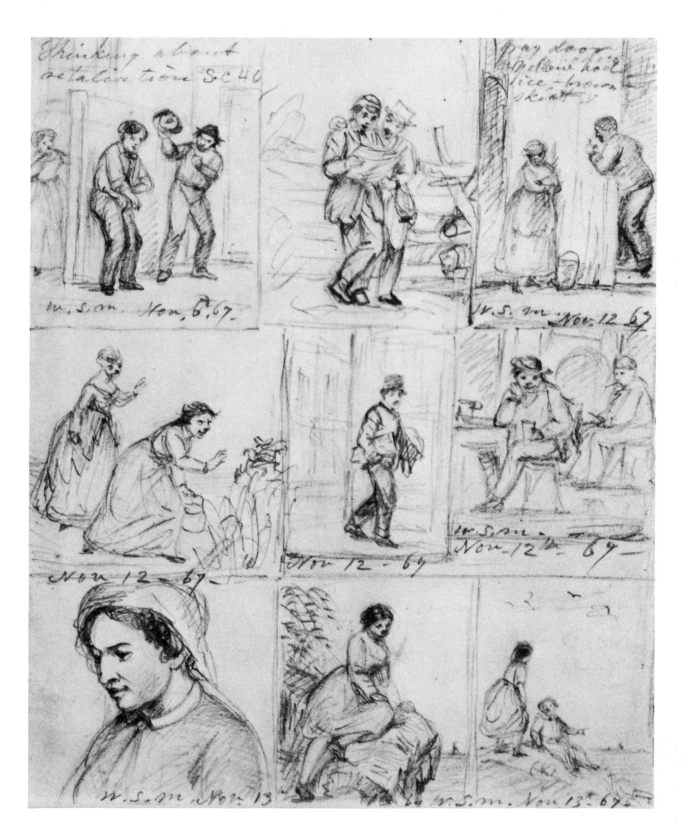

162

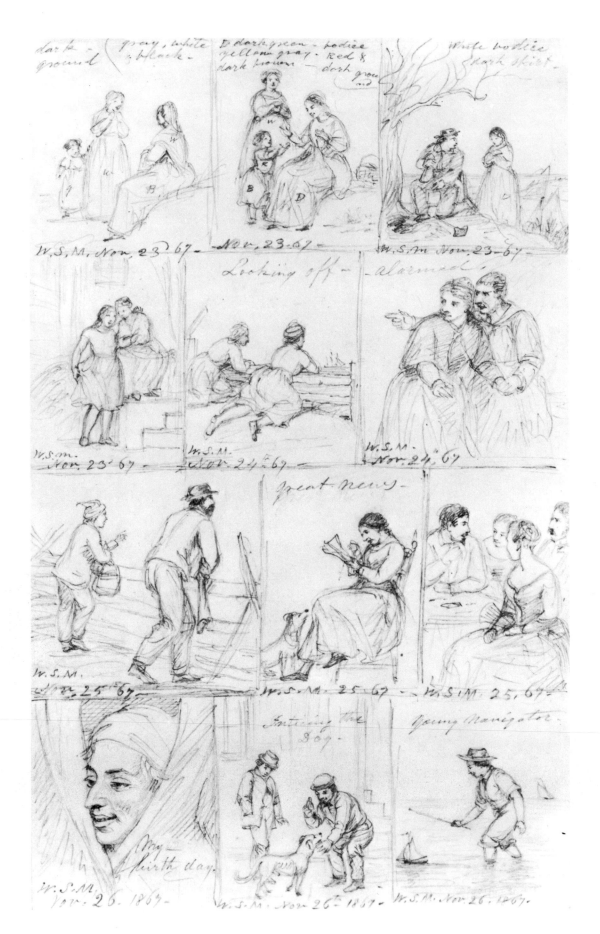

163

diaries 1866-67

William M. Davis (1829–1920), to whom there are several references in Mount's diaries in the 1860s, is one of the most interesting figures in Mount's immediate circle. He lived all of his very long life in Port Jefferson, hard by Stony Brook, and he painted excellent *trompe l'oeil* still lifes in the manner of Harnett and Peto, long before Harnett and Peto had begun their careers or developed any manner of their own. He also painted an extremely skillful paraphrase of Mount's *Cider Making*; it is now in the museum of the New York State Historical Association in Cooperstown.

Davis held an auction of his works at the Union Hall in Port Jefferson on December 29, 1866. Mount wrote an article on the artist and his works which was read on that occasion but which has, lamentably, disappeared; it seems to have been Mount's only exercise in formal art criticism. There exists a letter, however, from Davis to Mount in which Davis expresses his gratitude for the article and adds, "Friend Mount, if during your life instead of painting pictures, playing music, and cracking jokes, you had been spending money to make other people happy, you would have got rid of more of the filthy lucre than did Mr. Gosse who gave away two fortunes. And if instead of generously doing deeds of benevolence, and serving out to others the milk of human kindness, you had been investing money at seven percent, you would now have a greater income than William B. Astor. I shall always be glad to hear that you are prosperous and happy."

A.F.

New Year—Jan 1st rainy. Very mild for the season.

I am very thankful for health, and hope to improve my profession.

My health has improved by the use of salt, hommony and cold water.

1866

Went to the City of N.Y. the 3rd of Jan '66—took with me the portrait of Mr. Floyd, 22 × 27, for Mrs. Wm. H. Wickham, 308 Lexington Avenue.

Painted a new head dress on her old portrait, it was an improvement. Also—touched up her husband's portrait.

Then I moved to Mr. Wood's 36 Laight st. and painted a cabinet portrait of Miss Lizzie Wood, over an old portrait (cabinet size). Also touched up my pictures—

Then went to Mr. Thomas McElrath's No. 8 West Washington Place and painted a new body to an old head —and touched up several old paintings.

Also studied the Flemish, English, and French paintings exhibiting in the city.

And returned with a bad cold to Setauket the 10th of March 1866.

Look at pictures to observe design, drawing, and how color is contrasted and laid on, and the size, and effect of the painting or drawing etc.

I am quite as well pleased to look at pictures, by other artists as I am to paint my own.

What signifies a painter gazing at nature all the time, if he don't draw and paint: constant practice and observation makes the painter—thats so—

I will hint here that models can be obtained much easier in the country in winter than in summer.

From the 4th to the 10th of March, very windy, and dusty.

March 15 & 16th quite mild weather—

Setauket, March 17th, in the afternoon snow squalls, and cold.

Sunday 18th. Thermometer 14 above zero, froze the harbor to Strongs point—

March 20th. Painted on Mr. Floyd Smith's portrait.

22—Painted on Mr. Ludlow's cabinet portrait. Painted on "Ariel's head."

March 25th, '66. Sunday—snow storm—wind N-W-blew heavy.

26th thermometer 15 above zero. Blowing very heavy —3 vessels been on the beach a number of days.

27 painted on Mr. Smith's portrait. Uncle and nephew sat for the dress.

28 a fine day—the birds were singing with cheerful notes.

In the afternoon, dark clouds in the north and west—circle around the sun when about an hour high. In winter look in the South for storms, and spring and summer in the north and west.

29 rainy—

March 29th, '66

If you wish to look back, read over your journal.

I have had some thoughts of sketching from nature with Mr. J. Vollmering, this summer, to be stimulated to greater labor.

March 30

Total eclipse of the moon—it looked as if it was covered over with brown gauze—but, very clear shadow.

March 31st rainy. Frogs peeping in the evening.

1856 [1866?]

National Academy of Design.
Looking Down Yosemite Valley, Cal.—A. Bierstadt N.A., Landscape and Marine painter.
The above view of the valley was an atractive exhibition picture.

March 1866.

If Bierstadt desires to represent a sunny spot of land, rocky mountain, or water he paints the sunny part at once (with a large brush) and while wet touches in the desired effect of nature almost with the shadow tint alone. Only a few lights in the right place to complete the work—so with rocks and mountains in shadow of the right local color, and finishes with true air tints the imitation required.

He often makes up his pictures. If the sun is going down and the foreground is water, he paints a mass of warm yellowish greenish color and touches in while wet the form of the waves and the sun shining through them and the sun light sparkling on the spray, rocks etc.

Bierstadt composes as he paints, and works quick, looks at his picture by gasslight as well as by day light, so as to judge of the form and strength of color, light, shadow and effect.

His memory is good and paints with confidence. He alters the form of objects (rocks etc) as he progresses with his work, until his taste is satisfyed.

Although freely painted, his finished pictures stand the magnifyer, which makes his style the more captivating; and well adapted for exhibition.

Mr. Bierstadt's late large painting, "Storm in the Rocky Mountains," was a very effective painting.

He is building a studio about twenty four miles from the city. It will be about 60 feet in length so that he can see the effect of large works.

He possesses one good quality, minds his own business and works to some purpose. He has made his mark and intends to reach it.

April 1st fine clear day North West wind.

April 5th thermometer 73 degrees quarter to two P.M.

April 6th rain in the afternoon. Frogs very lively.

April 8th sunday—Rain and snow from the North East.

10th

Very heavy frost. Ice in my portable studio—the weather is clear and beautiful. Birds jubilant.

Toned down J. R. Davis's portrait with Madder lake and raw sienna. Lake and brown ochre, would be more durable or Fields Madder brown perhaps—

To make burnt and raw umber durable mix ochres with them—Vandyke with other colors.

[April 14?]

I went to N.Y. City April 13th. Varnishing day came off 14th '66. Good collection, the tone of the pictures better this year. Brother Shepard only had one piece a head of his daughter Tootie.

Not having my picture finished I exhibited five works —two sketches:

Apples in a Champagne glass.
Portrait of an Esquimaux Dog.
Cabinet portrait of Miss Harmer.
Portrait—Frank Ludlow.
Portrait—Mrs. McElrath.

$150.00

Received (New York) April 16th, '66, of Wm H. Wickham Esq.—One hundred and fifty dollars; for making a copy of a portrait of Jessee Floyd; and also, for altering the portrait of Mrs. Wm. H. Wickham. For improvements made in other portraits at the same time, I make no charge.

April 18, 19 & 20th very warm—and Saturday 82 degrees (21st) N.Y.

I forgot to mention that on Tuesday evening April 17th, 1866, that Mr. Henri Appi played on my hollow back violin at the suggestion of Mr. Harvy Dodsworth, the leader, and the latter invited me to take seat in the orchestra, at Niblos Theatre. Mr. Appi observed to me that the violin was powerful and a good orchestra instrument. It is the first made of this style of *f*-holes and narrow at the waist thus (pl. 164). DD left out. Made in 1857.

April 24, 1866

Sec. Seward's Reply to M. Druyn de Lhuys. Maximillian will not be Recognized by the United States. The people of Mexico not accepted the Empire. Nov. 1867 Fixed as the time for the return of the Last French Soldiers.

"The U.S. cannot Remain Silent or neutral spectators." —Good.

Senator Sumner, four days since, said: that the white mechanics had done as much to finish the War as the Negros.

Sumner must have Negro on the brain.

May 1st 66. Afternoon rainy, wind S.E.

Wednesday 9th of May, 1866

Fine rain in the morning—quite warm during the middle of the day. Not feeling very well, did not attend the Annual meeting of the N. Academy.

Having a slight touch of *Colic* and *Cramps*—took Hudnut's Preparation (sold at 195 Court St. opposite Warren, Brooklyn)—composed of *Laudanum, Cayenne Pepper, rhubarb, peppermint* and *Camphor*. It placed me all right in 30 minutes, only took one tea-spoonful in sweetend water.

We had another heavy shower before sun down. Pear trees in full bloom. Also, some apple trees.

Ruskin says: "In landscape, nothing ought to be tolerated but simple bona fide imitation of nature."

A landscape should "suggest more than it represents, not vaguely, but in such a manner as to prove that the conception of each individual *inch* of that distance is absolutely clear and complete in the master's mind."

The effect of nature should be given with poetic feeling and with so much truth, as to captivate the spectator with its honesty.

Sunday 20th

All nature looks fresh and beautiful.

It has been so cold and windy, that if I had launched my boat, she would have been a source of troble to me. About the 25th of May is quite soon enough for boat sailing. To sail on the wind for pleasure warm weather is most desirable.

Apple blossoms look their best, from the 10th to the 17th of May.

21st

Wind west. Took the boards and thatch covering off the bottom of my boat (Pond Lily) this morning; and found where the air reached the paint, it was firm and hard and where the thatch and salt grass touched or laid in masses on the bottom it was damp and the paint peeled off inside. [Sketch] —frame to cover the boat. Simply a frame boarded up clinker style would keep the sun and rain off [sketch] or lay loose boards and poles over the bottom of the boat and thatch on the top—so that it will not touch the boat.

164. Violins. Diary, April 18, 1866. The Museums at Stony Brook, Stony Brook, Long Island

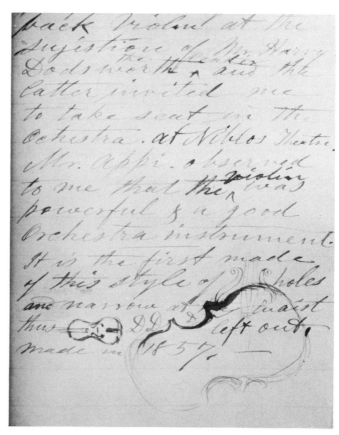

Paint— For the bottom of the boat: Brown Mineral paint and White lead—or White lead and yellow ochre. For a change pure white. Or, verdigris and white, is best—more durable.

Canvas— 6 feet by 10 would be just the thing to draw tight over the boat for winter.

May 22, '66—windy and cold: thermometer 48 at sundown. Painted on my boat.

May 23rd—morning cold and windy—42 degrees. Made fire in my Studio.

May 28th

Forenoon, Mr. James Underhill and Mr. Townsend of Oyster Bay L. I. sailed to me in the yacht Waterfall. Wind blowing West—vessels in the sound reefed.

29th

In the morning painted on my studio, but the rain, quite unexpected stopt that work. It showered till long in the night. Made fire in the Studio.

30th fine morning, but cold after the heavy rain.

June 1st

Wind N.E., quite cool—painted on my boat in the orchard, the bottom with a light dove color—made of Miss. brown and a little chrome and white—zinc.

The best filling for cracks etc is white lead (a paste) patent dryer in prepared oil. Blundell, Spence & Co—Hull and 9 upper Thames st, London.

To [be] mixed together stiff—and fill seams and cracks etc.

June 2, '66—cool wind N.E.—made fire. Wheat and grass looks well.

June 6th—Thermometer 87.

8th—84—rain.

June 9th wind east, quite cool. Joseph W. Underhill returned from the West Indies—in 7 days.

10th 11th 12th—good weather.

13th rainy.

12th rubbed zinc white, thined a little with dryer, in the cracks of the painted roof of my studio.

I have a fine view from my studio window of the vessels on the sound, of sloops, schooners and barks and small boats sailing for blue fish.

The first blue fish taken about the 1st of June. Charley Dykes saw them jumping about the 20th of May—very early in the season for blue fish, and they are of large size. Sold at 10 cts and now at 7 cts per pound.

My friend Miss Lizzie Wood is to be married tomorrow, June 14th '66—I expect to be at the wedding.

June 10th at half past 10 P.M., Mr. Smith store was set on fire—damage $4 or 500.00.

Ariel, a sketch 7 5/8 large by 6 3/4 in. sight measure. Delivered June 14th.

Cabinet portrait of Ludlow, size 10 in. scant by 7 3/8 large.

Attended Miss Lizzie Wood's Wedding 36 Laight St. N.Y. June 14th—good time, everyone happy.

June 15, '66

Called on Mrs. Marsh Staten Island to lighten her portrait. She not being at home, it was not touched.

Setauket, Sunday June 24, '66

Hot, 88 degrees—

Painted more or less (when weather permitted) on my studio and boat during the last for weeks.

The studio and boat thoroughly painted.

Every article requires care.

If I had no portable studio and boat, I might give more time to my pictures. Yet they are useful when moved from place to place. It is some times difficult to find a spare room in a farm house, or a boat when wanted.

June 25th

Thermometer 92 degrees. Walked to Port Jefferson in company with Chas L. Sanford and A. Nesmith.

1/2 past 2 A.M., 87 degrees.

June 26th, '66

93 degrees. Made a visit to Col. Wm H. Ludlow by request. He had left for Washington D.C. on business.

27th

Painted on his portrait. We had some fine strawberris. I left the Cabinet portrait of his brother which I painted who died in Cal.—not paid for, price $85.00. [Added later: I received $50.00 for it From Miss Phebe Ludlow May 1867.]

Wednesday afternoon 27th left Ludlow's for Benj. T. Underhill's, Oyster Bay L.I. Arrived at Tomlins Hotel five minutes before a heavy rain storm. They charge three dollars a day for board—not many boarders at present. Left for Mr. Underhill's.

28th

Cleaned and varnished his 4 portraits. Then altered 4 portraits for James Townsend. Also varnished 4 cabinet portraits for Solomon Townsend of his brothers, painted by John Vanderline and one by [illegible]—pupil of Jarvis,

the portrait painter.

Spent the 4th of July in Oyster Bay, the evening at Mr. Townsend's.

For touching and varnishing $50.00—made no charge to Sol. Townsend—absent, occupied 11 days. It was a pleasant excursion; but the same amount of Labor put upon a characteristic picture would have paid more than double. I left Oyster Bay in the steamer and arrived in N.Y. City about 1/2 after 9 A.M. The City was hot—about 2 P.M. 93 degrees.

Left in the cars for Setauket 1/2 past 3 P.M. 6th of July. Grass, Grain and corn looking fine.

Setauket, July 9th, '66. Launched my skiff Pond Lily.

July 10th

Commenced a picture on canvass, 22 × 27. Catching a tune, "Possum up a gum tree." Three figures [pls. 165, 166].

165. Sketch for *Catching the Tune*. 1866(?). Pencil, 6 1/2 × 4″. The Museums at Stony Brook, Stony Brook, Long Island

166. *Catching the Tune*. 1866. Oil on canvas, 22 × 27″. The Museums at Stony Brook, Stony Brook, Long Island

12th warm day.

13th Friday afternoon very hot—2 and 3, 4 and 5 P.M., 94 degrees. At 11 in the evening 82.

Sunday morning 14th

5 A.M., 64. At 9, 85. 1/2 after 10, 88. 1/2 after 11, 90. 1/2 12, 92—wind south.

I painted 11th, 12th to noon and 13th up to noon. After dinner took a sail and then filled with paint (lead etc) few of the seams in the boat caused by the heat of the sun. Water should be kept in the bottom of the boat in hot weather—when not used.

A boat should be well painted to stand the power of the sun. Yet too much paint is apt to peel off. Thin coats of paint for a boat.

July 18th degrees.

At 5 A.M., 74. 7 A.M., 83. 2 P.M., 94. 3 P.M., 95. In the afternoon, magnificent clouds were gathering for a storm. The rain commenced about 3 P.M. accompanied with terrific thunder and lightning and the dark clouds appeared to crowd the hill tops, and the dry and famished earth seemed to take in the rain as it was really thirsty.

22nd

Cool and pleasant—yet made fire in the afternoon.

To dry my skiff I placed a couple of plank across the ditch thus [sketch] when the tide was falling. In that position the boat can be painted very nicely, if required, as she rests quiet high and dry. After a boat has been painted a week or two (and dry) it should be oild with boild oil. Blue paint should be oild over—oiling improves outside work, oil to be rubbed on with a rag rolled up thus [sketch].

Setauket, July 23, 1866

After having left off drinking molasses for two or three months—I have resumed it again today. When I drink molasses before meals, the worms do not disturb me so much.

I left off eating potatoes two months ago—consequently flatulency has left me. We must know ourselves and know the effect of what we eat and what we drink.

I should write as little as possible—and paint but few photographs. Time was made for our best work.

Paint—Paint—and sail in the Pond Lily—for health.

July 25, '66

This afternoon we are having a magnificent thunder shower accompanied by vivid lightening. The clouds were beautiful to behold. Studies for the painter—such perfect light, shade and reflection.

July 26th, '66—Admission of Tennessee into the Union.

28th

12 noon—thunder and rain storm, accompanied with hail—it has continued about one hour. Clouds splendid.

We ought to be thankful that God suffers us to imitate his works.

To clean and varnish portraits, that have been painted about 20 years— First, wash with hot water, using sponge to remove the fly spects and dirt. And to make more cleanly, go over with turpentine; which will receive the mastic varnish more smoothly. The varnish should be warmed in a hot bath thus [sketch]. Some times the painting should be oild out with sun dryed oil—or raw oil if the varnish should dry too quick. Some fly specks require to be removed with the point of a knife. Some spots, scratches and mildew can be painted over in the varnish. Lastly the painting should be dryed in the sun.

"The Cable in Perfect working order." A message of Peace arrived at Heart's Content at eight A.M. Friday, July 27th, '66.

Despatches to and from the President and secretary Seward.

Heart's Content, July 28th, '66. Rejoicings over the union of the two worlds. "He who rules the winds and the waves has crowned their united efforts with perfect sucess." ——Cyrus W. Field.

From the Mayor of New York to the Lord Mayor of London, July 30th, '66: The energy and genius of man, directed by the providence of God, have united the continents. May this Union be instrumental in securing the happiness of all nations and the rights of all peoples. ——John T. Hoffman, Mayor of N.Y.

Hart's Content, July 28th, '66. Received New York, July 28th. To the Mayor of New York: May Commerce flourish, and Peace and Prosperity unite us.

Aspy[?] Bay, July 30, Monday, '66. The reply of the President of the United States to the message of the Queen of England was received here at 4 o'clock on monday afternoon, and will be delivered to the Queen probably about 2 o'clock on Tuesday afternoon Greenwich time.

Osborne, July 27, 1866. To the President of the United States, Washington: The Queen congratulates the president on the successful completion of an undertaking which she hopes may serve as an additional bond of union between the United States and Great Britain.

Reply. Executive Mansion, Washington, 11:30 A.M., July 30th, 1866. To Her Majesty the Queen of the United Kingdom of Great Britain and Ireland: The President of the United States acknowledges with profound gratification the receipt of Her Majesty's dispatch and cordially reciprocates the hope that the Cable which now unites

the Eastern and Western Hemispheres, may serve to strengthen and perpetuate peace and amity between the Government of England and the Republic of the United States. ——Andrew Johnson.

MARRIED

On Thursday, the 2nd of August, 1866—J. Elliott Mount to Eddie Searing of Glen Cove, Queens Co. L.I. S. A. Mount, Wm. S. Mount and Elizabeth F. Mount were on hand. Had a good time.

I was absent seven days. Fancy Fairs and Festivals; also, Nite receptions, Sunday School Picnics. For benevolent purposes. Family Picnics—all very pleasant but take up a great deal of time.

We have had more thunder and lightening this year than has been known for very many years. And the clouds have been grand—splendid.

August 9th

Rain, quite cool—wind south in the morning and at 11 A.M. East.
Camp Meeting at Northport—John B. Mount and myself thought of going to visit the Camp (in the Pond Lily). Rain prevented

Yesterday, August 8th, '66, Thos. Griffin and Chas. Strong caught off Old Man's harbor about 20 blue fish. The weather being cooler the fish visit the harbor again.

A painter of Mind should not allow his attention to be taken too much away from his profession.

Autograph Hunters. Recd a note from Wm A. Baker, Auburn N.Y.—for my autograph. Curious, how many ways the minds of some individuals are occupied.

It is singular that I have rairly ever practiced immaginative Landscape composition with brushes in oil or in water color. That is, seldom painted landscape in oil colors for practice, which I begin to feel that I should do—and could have done. I can compose a landscape at once with pencil and consequently should paint more from the immagination. Sun sets, clouds etc. Whatever one feels they should do, they should go about it.

When we paint from nature we should be careful to select good models; and if they should turn out poor, we should try to improve upon nature.

A painter should keep at work so that his paints will not dry up in the tubes.

Setauket, August 17, '66

"Harmonious close of the Great National Convention."
"The Union perpetual."
"No state or combination of states, has the right to withdraw from the Union."

Unanimous Endorsement of President Johnson.

August 19, '66

Sunday, had breakfast this morning at quarter past nine A.M.—dull rainy day with occasional sun shine, to enliven—to contrast with the storm cloud. 25 minutes to 7 P.M. thunder storm from the North West.

If to morrow, August 20th '66, should turn out a fine day I expect to commence a portrait 25 × 30, of the late Mrs. Edw. McKeige at Spinola's, near the Flax Pond. To be taken from a Daguerreotype.

August 31st

I painted ten days at Spinola's, Cranes Neck. I have obtained a good likenes of Mrs. McKeige. The head taken from a Daguerreotype, and placed it upon a new body. Mrs. Douglas sat for the figure—Which was of great assistance. A rose bud is to be introduced—price $150.00.

News papers, published at Stony Brook and Setauket, L. Island: I have subscribed for the *Independent Press* 1865 and 1866, 4s, 6s and 10s. H. Markham Editor and proprietor. Also, For the *Long Island Star*, James S. Evans, Jr, Editor. Large sheet price, 20s.

Sept 1st

Warm—82 degrees at one P.M.

I find my health is better for not eating Hash—or potatoes—green corn, pairs and apples—also Ice cream. Ice is better without cream.

Month of August quite cool.

Sept 2nd, '66—warm and muggy. Thermometer 84 degrees at 2 P.M.

Sept 3rd

84 at 10 A.M. Do 4. Wind East—very damp—and heavy.

I have ate some apple and without any injury—when we are not well there is a cause.

Having (to do with) the care of of a (sail) boat at low water in this harbor is dirty business, also at fishing.
We had a good time sailing on sunday afternoon, Sept 2nd, '66, at 5 P.M. Mr. Ansel Jayne, his wife and child, Clarence Jayne, and Miss Raynor, including W.S.M.

Sept 4, '66

I think sailing for blue fish, lost time—that is, for me. Most of the time I spend in my boat should be in sketching and painting.

Friday Sept 14th, '66

Had my sail enlarged on the boom from a point at the gaft to the breadth of the cloth at the boom. It gives a better shape and more sail where it needs it, as the sail was wide on the gaft, or spreet. In reefing with the same spreet, have beckets at both ends, thus [sketch].

For sails that are mildued, soak the sail in salt water. Lime water with salt added is said to preserve sails from mildew; others say that lime will destroy cotton.

Capt Wm. Terril, says, half fill your boat with salt water (clean) then add a quart or two of common salt to the water—and let your sail soak in that for two or three days, which will prevent the sail from mildewing.

My sail got sleightly mildewed by lieing furled up when damp during a wet spell of hot weather, dog days, Sept 1st, in doors—when it should have been spread out. If a sail gets wet while furled on the mast, it should be unfurled when the storm clears off or before the sun shines upon it—or should be unfurled after a storm, if it should remain cloudy. Or, their should be a drying wind. Every thing requires care and attention. Sails should be carefully looked after during damp and hot weather.

Saturday, 15th Sept '66

Saild to Port Jefferson, carried six bushels of apples for Fred Darling. My Nephew John B. Mount was Capt to the port. Wind heavy, North West—sail reefed—time 35 minutes.

I expect to take the portrait of Mrs. McKeige to Brooklyn to morrow 18th, '66.

Brooklyn, 19th

Touched up three portraits for McKeige. Toned his wife's portrait—improved the light background. Rainy day.

21st

Left N.Y. for Setauket.

I must never paint from a small Daguerreotype again. It is hurtful to the eyes.

A lazy man with the habit of drinking rum—there is not much hope of a resurection to life and activity.

There is some charity for an industrious man that drinks a little now and then.

There is not much encouragement for a smart woman who has a lazy drunken husband.

We must avoid habits which are demoralizing.

A stream of water from the valley may be pure but riled at its base; disturbed by foreign material. But stop riling it and it will become clear and pure again. So with a habit, stop it, and we are again purified.

Friday Sept 28th, '66—Painted on ' Catching a tune."

Saturday, 29th

Sailed to Port Jefferson.

The past week Wm. M. Davis has been painting a view of Mr. Van Bront's residence. Mr. Davis told me some weeks since that he was a hard worker.

Sept 24th—saw a bold flower piece, rose-mallow (swamp holly-hock) genus althea, painted by S. A. Mount.

167. Two-hulled boat. Diary, September, 1866. The Museums at Stony Brook, Stony Brook, Long Island

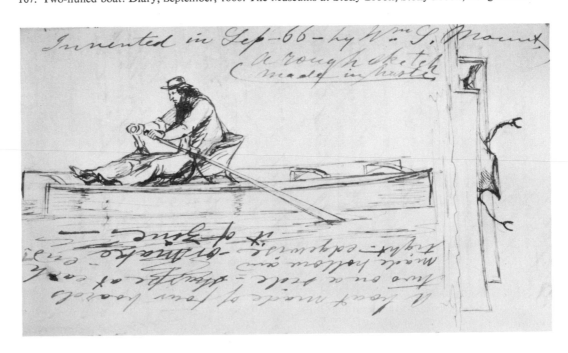

Invented in Sep. '66—by Wm. S. Mount, (a rough sketch made in haste) a boat [pl. 167] made of four boards two on a side—sharpe at each end, made hollow and tight—edgewise—or make it of zinc.

Wednesday Oct 3rd, '66

Half past 10 A.M.—made a study in oil, or composition landscape (in the Pond Lily—the first time since I owned her) of the cove of Setauket harbor. Succeeded, although a squal with some rain made us a visit—it was cold and windy from the N.N.W.

In the afternoon made a sketch (in oil) on Strongs Point. The *subject too tame,* rubbed it out—the panel will do for something else.

My boat is good for sketching or painting in, she is so roomy for her size.

Not much difference in the seasons. Cold winds commenced the 2nd of Oct '65. This year, 3rd of Oct '66. Frost—7th of Oct last year.

Oct 5th, '66

Capt Benjn Jones has invited me to sail with him in his Barque to Rio Janeiro, South America.

Saturday, Oct 6th, '66

In the morning, wrote in the frost—God is good. Last year, the first frost was on the 7th of Oct.

In the afternoon of the 6th commenced a sketch in oil, of Strong's point, taking in R. Woodhull's house—a boat on shore at the point.

8th

A fine day—wind west—painted on two pictures, morning and afternoon. I obtained the effect of the sky and clouds on white ground with blue alone.

At the same time I improved the above sky by adding yellow next to the horison and red above on a white ground, melting them into each other with a large flat brush—but did not disturb the upper part of the sky.

After the Landscape is finished I shall paint the sky—retaining the effect of the sky and clouds as above.

It is a great saving of time not to paint the sky when painting a landscape from nature. Finish the sky at your leisure, from the same locality if you desire. Dispatch is important—no use sleeping over a work, of any kind.

Setauket, Oct 15th, '66

We have had rain for several days; it has been blowing from the east 8 or 9 days very heavy and still continues to day, wind North east. Sun is out, clouds flying. The Moon quarters to morrow at 4 P.M.

Oct 16th—the wind is dying out.

17th and 18th

Fine days.

A woman told me that she had been trying to get rid of her husband, ever since she had been married. At another time she remarked that dealing at a rum store for groceries would be the ruin of her property. I then took the liberty to say, perhaps you had better deal at a store where they sell no liquor at retail.

If individuals will persist in doing evil to themselves, there is not much use of advising. They sometimes will begin to reason when they find their pockets empty.

Oct 19th, '66

The N.Y. Artists are returning—their portfolios full of studies in oil. They deserve credit. It wakes me up to hear such good reports. If I should take a trip next season with some artist it would be a fine thing to stimulate me to work harder.

I must leave Setauket—and perhaps Stony Brook. My Nephew Thos. S. Mount called to day, to see if I would sell my part of the Mount farm at Stony Brook. My brother Shepard and myself have paid taxes without working on any part of the farm on the property, ever since we became part owners to aid Mrs. Henry H. [S.] Mount and family. The more they improve the property while farming, the better it is for them.

Monday, Oct 22, '66

Very windy day. The Pond Lily upset near Strongs Neck about 2 P.M. I had with me Watson R. Jones—he swam ashore with the end of the main sheet tied around him and then hawled the boat ashore. Lost the rudder.

Nov. 1st, 1866—cold day.

Nov 4th, '66—heavy wind and rain. 5th fine day.

Nov 6th Election. The Democrats carried this pole 32 majority.

7th very heavy frost this morning. We only had two light frosts in Oct. 1866—remarkable.

8th and 9th Nov.

Indian summer—

Nov 8 sailed with the Pond Lily into Port Jefferson Bay. Put two cats on shore—there was some fast running up the bank.

My eyes are very much inflamed—been painting some small figures. Large works are better for the sight.

A tea made from Arnica leaves is recomended applyed warm with alcohol. Also a poltice of rotton apples is said to be good. Also, shoe maker's wax, spread upon a piece of muslin, and upon the feet—it is applied on my feet.

168. Eyes. Diary, November 10, 1866. The Museums at
Stony Brook, Stony Brook, Long Island

Nov. 10th

The above is good. Last evening I applyed mustard
plasters to the calves of my legs—and wet white muslin
cloths to my eyes, kept in place with a silk handkerchief.
My eyes are better.

Yesterday finished touching up a small picture for
Evelina; my eyes were too weak.

Good subject—chasing a butter-fly.

The road to success is to never to undertake anything
that you cannot finish--or leave it until you are able to
make a finished work.

To imitate another, is an exhibition of a low mind. The
power to imitate should be spent in the imitation of
nature.

I must make a shade to protect my eyes from too
much light—similar to a stereoscope thus [pl. 168] about
four or five inches in depth.

In painting or in a strong light—I must close my eyes
more, and not read at night.

To Eve—Whenever you have a work on hand and find
yourself loosing an interest in it; then, turn it to the wall
for two, or three, six months, or a year—and you will
resume it (again often no doubt) with great success.

430

Nov 11th, 1866

Sunday morning my eyes pained me very much—the
left one most. Toward the middle of the day they grew
better. Aplied shoe maker's wax (fresh) before going to
bed—besides kept wet muslin on my eyes, most of the
night, and applied hot water to my eyes after breakfast.
Also, sneezing in good style by sniffing powdered kiln-
dried bark from the baberry root—which had good effect
in stimulating to action my wearied eyes. Cause—too
close application to painting and taking cold, in my eyes.
I am thankful that I am getting better. Eyes how precious
how careful we should be of them.

To clear the eyes that are weak, beat up the white of
eggs and spread it (lay it) between too pieces of muslin,
and bind it loosly over the eyes on going to bed. An Eng-
lishman mentioned the above and said it was the best
thing for him. I found alcohol applied gently to the out-
side of the eye with the end of the finger—was also benefi-
cial. It is strengthening—good. Never wear glasses, or
goggles, or shades for weak eyes—keep on using your
eyes if ever so little—they must have air and light to
obtain strength.

R. N. Mount killed hogs—cold day.

Nov 12, in the morning 15 degrees above zero.

Nov 13th—Boys skating on the Mill Pond.

Nov. 14th

Cold windy day— Those should be thankful who have
pleasant homes.

I forgot to mention that on the 12th I placed two iron
bars edgewise by the side of two (carlines) or rafters to
strengthen the roof, screwed fast, thus [sketch].

I have been making some compositions in out line. Get
ready. As a specimen of greys, *nature's coloring,* I must
varnish with (boild oil) a tolerably smooth piece of black
oak bark.

Gum Arabic is best, dampen the wood with water, will
do.

There are pictures to be seen in most every thing we
look at, in the bark of trees, chestnut, in the clouds, in
our foot prints, in the snow on the pavement. Snow is a
good study for the sculptor when it rests thickly upon
bushes and cedars; figures and animals are often well
represented—by the effect. Pictures and sketches are seen
on old dirty and scratchy walls—also, in the dirty spots
on the pavement. Often good effects of portraits to be
seen in knots, in the old weather beaten pine boards also,
in rose wood, mahogany, in varigated marbles, stones
and rocks etc. I have seen streets, buildings, trees, stone
fences, cottages, figures of men, women and children and
animals on the the smooth bark of the black oak tree with
a variety of beautiful gray.

One match will set a city on fire—so will one idea stir
up a nation.

The Artist who will think and work need never be jealous of the works of others—but rather delight in them. As you would listen to sweet music, feel strengthened and strive with renued energy—with invention at the end of your brush or chisel.

The honest searcher after truth will admire the works of others—not to imitate, but to think for himself.

The late Mr. Luman Reed, asked me how he could judge of a painting; I observed, when a painting or any work of art interested him so much that his hand went involuntary to his pocket book—it was an evidence there was some spunk in the production.

Greenwich Observatory, England, Nov. 14th, '66, 6 A.M. Meteoric showers. Brilliant Display. Twelve thousand meteors seen with the naked eye.

The meteors were of great beauty and brilliancy, and radiated from the constellation Leo, near the star Gamma Leonis. Their direction was mostly from the east to the west. Several exoded[?] from the vicinity of Jupiter; one, of immense dimensions, was colored red, blue, green, orange and amber—nearly all had trails of fire—two more, one red and the other of an oriental sapphire color, crossed Alpha Orionia. Some of the meteors burst forth in splendor; one, breaking behind the rising clouds, flashed like sheet lightning, and another of emerald hue burnt near Eta Leonis at fifteen minutes after two o'clock A.M., its trail of flame being visible for a minute and a half, and then faded away in the brilliant nebulae. We counted 5,000 in one hour, nearly 12,000 in all, with the *naked* eye.

Special Cable Telegraph to the *N.Y. Herald*—A cloudy sky prevented any sight of the meteors at New York.

Nov. 16th, '66—A fine day—no frost. Also, a bright Moon light evening.

Nov. 22

A very sleight flurry of Snow.

The same day at New Haven, James Brewster died. He was a carriage maker. Two of my Brothers served their time with him.

Nov. 26th

My birthday. I am thankful that I am permitted to see the wonders of God's creation.

There was a heavy frost and ice this morning. 15 degrees below freezing.

I forgot to mention that I dropt a note to Thomas S. Mount on the 23 inst—stating that a friend of mine would purchase the home or Mount's farm at Stony Brook. Thomas' buying price $600 per eight, which he offered to Shepard and myself. I also forwarded a copy to S. A. Mount.

To day Nov 26 Brother Nelson and myself received a call from Dr. Bowers. We were delighted to see him, he

formily resided in East Setauket. On leaving, he said he was gratifyed with his reception.

Nov 29th, 1866

Showery. Mrs. Underhill and two children arrived from N. York this afternoon—she was much pleased with her visit.

The part I took in thanksgiving was to repair some window lights in the old shed. I am thankful every day— or whenever I can think of it.

Nov 30th

Wind blowed very heavy from the south with rain. Towards noon the wind changed to the North West. In the studio the roof leaked south side of the sky-light—there was water on the stove, it ether reached there by the roof leaking, or through the stove pipe, which appears almost impossible. The roof was painted a day or two before.

I have thought of having the roof tined and painted—at the same time have the roof strengthened inside by three arched wooden beams—*for support.* Flat-irons edge wise would give strength to the roof—I have been told that.

Princes Metallic Paint mixed with boild oil, well stirred up, 72 parts iron—good for a roof, also for a tin roof.

[December] The works of others set men to thinking.

Dec 15th, '66

Clear and cold—15 degrees above zero. Fine skating— December of 1865, very little ice during the above month—mild but wet.

Afternoon of the 15th of Dec. '66, wind east, appearance of snow in the south.

Dec 16th

Wind east—commenced snowing about 1/2 after 11 A.M. I made some drawings instead of going to church; my health is just as good.

Work when the spirit moves as long as it does not disturb thoughts of others—if it does, that is their business to find fault with others; they having nothing else to occupy their minds.

Dec. 20th—15 degrees above zero—blowing strong north wind.

Dec. 21st

6 degrees above zero—wind east.

This evening, Presentation of Veteran's Medal to General Spinola by the City of Brooklyn.

Mrs. General Spinola at home, Friday evening Dec 21st at 8 o'clock—3 Livingstone Place, New York.

Blanche F. Dominique. It speaks meritoriously for the General to be so honored at his own home.

Dec 22nd

Afternoon, Wind south east—rainy.

God loves man; he has printed his image every where—In the marble—in the snow—and on the bark of trees etc. We should in return imitate his works.

Dec 22nd '66—forenoon placed canvas over the Pond Lily in this manner to keep her from the sun and rain—thus [sketch]. Canvas drawn of a pole as above and nailed with galvanized nails (through leather capstans and canvas) into two boards; one on each side of the boat. Boards keep the canvas tight by their weight [illegible]. The boat was hauled out by horse power on a plank, assisted by John R. Davis and others—about Dec. 18.

Canvas 15 × 5 feet—cost $4.50. It was recommended by Mr. Wilson sail maker (we will see the result). The canvas to be tied down to stakes driven into the ground. But I chose to nail the canvas to boards instead. Taking up less room; besides it is hard driving stakes, into the frozen ground.

The result of the canvas is first rate in protecting the boat through the winter months.

Dec 23, '66

Rainy afternoon—wind south. I shall have very little to say about the weather after this week—unless something very extraordinary. There is very little difference in the spring and fall, as regards hot and cold. Write about other matters.

In painting figures in a landscape—paint in the size and effect thinly with one color only, and then work into it thus—to begin— [Sketch]

Dec. 25th, '66—Christmas.

Walked over to Stony Brook to take dinner with my sister Mrs. Chas S. Seabury. It being her birthday, her son Samuel Seabury from U.S. Ship Sabine at New London was at home on leave of absence. Also, her son Thos. S. Seabury—and Lady, children and nurse. Mrs. Ben. T. Onderdonk was there also, had a good time.

On my way over I called on Mrs. Pierce—also, on Mr. Markham Editor.

During the week stopt several days with my Nephew Thos S. Seabury—at his new residence at Raspeag, a delightful locality West side of Stony Brook harbor. There I spent a happy New Year although it was a stormy day—snowing. He is blessed with a cheerful wife and two nice children.

Husband and wife are both musical—

Thos S. Seabury offered me $2,500—two thousand five hundred dollars a year If I would paint pictures for him by the year with board. To work four and five hours per day.

I was about ten days absent from the Portable Studio at Setauket.

T. S. Seabury wishes me to paint the portraits of his Lady and two children—head and busts only—as soon as I can convently.

Dec 28

Very wet but very mild for the season.
I am thankful the photographs are finished.

Dec 29th, '65 ['66]

Attended a Sale (in the evening) of paintings by Wm. M. Davis, at Port Jefferson, L.I. 30 pieces—brought about $320.00. I wrote a short article which was read by Mr. Thos. S. Strong, before the sale commenced.

Dec 30th—snow storm about 10 inches in depth.

31—in the morning beautiful effect of sun light on the snow.

Setauket, L.I. Jan. 3d, '67

Good Sleighing. Clear and cold: two degrees above zero.

Jan 4th

Clear. 20 degrees above zero—wind east. Capt. Tyler sailed out with a load of hay; some ice in the harbor.

I ate some potatoes the other day, but I feel better without them.

For Rheumatism, 1/2 lb of the best sulpher, one Quart of the best Holland Gin; it is important.

Dose—three wine glasses per day, before meals—for four days; then work off with a dose of Epsom salts. ——C. McKeige.

He observed, you never will be troubled with the Rheumatism again if you abstain from hearty living—greasy meats and liquors while taken the medicines. Plain diet. It will have no effect if liquors are used. ——C. M. Keige.

One lb of Perfumer's Glyserine	55 cts.
Lac Sulpher	25 d[itt]o
Sugar lead	25
Tincture Heartshorne	25
	$1.30

Purchase at Aspinwall in Wm. Street near Maidenlane.

You take 2 1/2 oz Glyserine, 1 1/2 tea spoonful lac sulpher, 1 teaspoonful sugar of Lead, 2 tea spoonful tincture of heartshorn.

Mix in a bottle, containing 12 oz of water—shake up well before using. Rub in with spunge or flannel.

How to use it: I would have my hair cut; then use the preparation every day—saturate the head all over (to the roots of the hair) for about a week; twice a day, if you have time, and let it dry well; as soon as your hair changes—three times a week.

Pour the preparation in a cup; use what you want, and if there is any left, put it back in the glass bottle. From C. M. Keige.

Evening of the 5th Jan 1867—rain. Sunday Jan. 6—snow.

To Paint, Draw or Model is to have courage in one's own abilities. To Dare—

Jan 7th, '67

Breakfast half past 9 A.M. Shall set my palette for painting—have not painted in two months, otherwise ingaged. Yet my mind was on art.

Jan 8th

Breakfast about 10. Sitting up late at night makes a late breakfast.

She observed: taking a paper home at night and returning it the morning—has helped to make him a *tippler*.

She observed, her husband got in a bad way by going to the store so often. I replied, "You trained him to it." She said, "I am good mind to tel you; you lie." I then stated to her that she kept him running to the store for different things so often through the day, that it led him into that bad way you speak about. But the above was all said in good humor.

On another occasion I stated to her that she had better make up a list of what she wanted through the day and send him with it to the store at night.

Jan 11, 1867

Composed ten pictures in one day. I have been striving to improve in painting; drawing, color, expression and composition.

It would be well to have small lay figures about 15 or 18 in. in height—dressed in the costume required to imitate. Then the living models would serve only for the hands and countinance.

My niece Lib observed the other day—you have designs enough, go to painting and bring out some large picture. Your friends expect it of you.

Setauket, L.I., Jan. 31, '67

I have somtimes thought of the importance of bringing out more pictures; by taking rooms in the city, or country, and teach or advance a few young men in painting pictures. I should want young men that had considerable practice; to understand my design after I had drawn it out; so as to paint the effect as I describe it. The interior, the figures, or the Landscape, as I thought the effect ought to be. Then I would take the work and finish it—while they were engaged on other designs made out for their practice—and my pleasure of finishing up the compositions. By the above arrangement I could paint two thirds more pictures. I presume the Old Masters must have planned and worked in that way.

[February?]

The individual style of a painter need not be seen if he will represent faithfully what he desires to imitate—let it be still life portraits or landscape.

Still it is sometimes gratifying to recognize the style—

[Sketch] Pulling down a tree while the wood chopper is cutting it— Feb 8, '67.

[March?]

HYDROPATHIC—ON HEALTH

"Schieferdecker's prescription need not be written in latin.

"Rest, regularity, recreation, diet, exercise, pure air, pure water, early hours are nature's physicians.

"Schieferdeckerism says, meat once a day, bread and milk for breakfast and supper, plenty of water inside and out. No alcoholic drinks and no medicine, and sleep with four windows open."

March 30th 1867

I have received great comfort by bathing my eyes with alcohol, and using the sneezing snuff.

Yesterday 19th [29th] made a drawing of Mr. Harmer's residence. Had the pleasure of seeing Mr. and Mrs. Mills of Wading River, L.I.

Received a letter from F. B. Spinola. Also, on the 4th inst. About portraits.

I have most always painted portraits at the residences of those who desired me to paint for them, and have had two prices, one for the country and the other for the City.

I am now using my first spectacles No. 25—my eyes appear to be strengthened by them. My eyes have not been so strong in 5 or 6 years. It is owing to simplicity of living—and the goodness of Almighty God.

April 1st dull day. do—2nd—fine spring day. Fine weather Frogs peeping. 3rd good day. 4th powerful wind from the south.

April 3—letter from my Niece Evelina Mount.

[April 9?]

We should try to paint objects as they appear, at the same time not to forget a few simple rules—of the simplicity in painting, if we would only reason.

The same law of nature to be observed in painting waves, trees, rocks, land, animals and clouds.

We never should loose sight of accidental touches and effects when painting, no matter how quickly a thing is hit off, if the effect is [to be] satisfactory.

I must look at pictures and see if they possess those qualities I have mentioned above.

April 12th, 1867

Left my Portable Studio for New York to paint two portraits—Mrs. Gen. Spinola and husband. He was painted in uniform at my request. Size 27 × 34—sight measure. They occupied about six weeks time. Price $300. They were worth at least $375—singly $200. I worked myself almost down sick— Labored from 7 to 10 hours a day— Did not take exercise enough—should have taken a walk every morning.

It has been quite a cold and rainy spring—good grass etc.

N.Y., May 7th, 1867

FLESH PALLET

1. White—nearest the elbow on the pallet.
2. Yellow ochre,
3. Chinese vermillion,
4. Madder Lake,
5. burnt Roman Ochre,
6. Light red.
7. Ultramarine blue, or ultra. ashes.
8. Caladoman Brown, or Cappah brown,
9. Terre verte.

For toning Ivory, Black can be added. Have but few colors, and use them liberally—Ornamental colors. Add lime[?] Yellow and Cadmium Yellow—also Roman Ochre. Obtain durable colors if possible.

DRY COLORS

Madder lakes, Oxide of Cronium, Cadmium and Zinc colors should be tested by a solution of a few drops of Hydrosulphate of Ammonia. It turns chrome yellow a greenish brown. Cadmium remains pure. Disolve a small lump of Ammonia in water—with it white lead turns dark, zinc remains white. Vermillion Pure will burn up on a red hot shovel. The same treatment will not change Ultramarine, Blue or Cobalt.

Lemon juice will destroy the above two colors.

[June]

Returned from N.Y. Wed, 26 June in the steamer Sun Beam (good sea boat). Wind east, heavy Sea.

29th my eyes very weak and inflamed. Treatment—1st, in the morning warm water. 2, Brimstone ointment around the eyes, eyes closed at the time. After breakfast the left eye being very painful, washed off the ointment with soap and water. 3rd, opened my eyes in warm water, to rince out, to clear them. 4th, went to my studio, applied alcohol with all its strength—kept my eyes closed about 10 minutes; lastly took a pinch or two of sneezing snuff; and my experiments were over—and it has proved so far successful. I ground paint all day.

Sun. June 30th my eyes very much improved. For two or three days my eyeballs were very painful. Never allow anything to enter the eyes—but pure warm water and that very seldom.

July 28th, 1867

I have for years made up my mind not to suffer my thoughts to be interested in a religious worriment. *Time lost—it dont pay*. I believe only in *one great God*; and am thankful; my soul is happy and at rest in that belief.

Such is the nature of the human soul, that it must have a God, an object of supreme affection. ——J. Edwards.

"The Catholic Church in this Country—Rev. Father Hecker at the Paulist church, in 59th street. He is convert to Catholicism; was formerly one of the Redemptorist Missionary Fathers. He is the head of a society composed altogether of converts from Protestantism, and numbers six priests and about eight novices. The object of the society is the conversion of this country from Protestantism to Catholicism. The Roman ritual is fully carried out, processions, masses and the music. He gave a statement of figures, that before the present generation passed away, the Catholics would number more in this country than the Protestants, and that in consequence the governing of the country would be in their hands, and that they must be prepared to assume this important responsibility. Were they ready to do so? The institutions of the United States were founded on great Catholic principles, antagonistic to the Puritan theocracy of New England. The whole country, he said, was now going into rationalism, and the most popular sect were those the least pious, as the Unitarians, the Universalists, and the spiritualists. From preaching the total depravity of man, Protestantism has gone to the other exteme, naturalism, which is mere deism.

"He asserted that if this country were Catholic we would have had no civil war; for the Church that knew how to convert feudal Europe into free and civilized communities would have also known how to convert our slaves into freemen without going to war to do so." ——*N. Y. Herald.*

It is the freedom of this country that has improved the condition of Europe and not the Church. The Pope is trying to make this country Catholic; and Father Hecker is one of his fishermen.

Dec. 7th

Wind north west—finished two small paintings. *Politically dead* and *Mutual respect*.

To make finished paintings they must be kept on hand some time: to be touched here and there, if there is a chance of improvement.

I have spent nearly a month on the small painting, when it took only 4 days to paint the same subject as large as life but not so highly finished.

I will partly repeat again—that I can paint a large picture quicker; than the same subject on a small scale; and

one as highly finished as the other taking the same length of time.

Long Island Star of Dec 6th has an article touching, the Radical Rooster—and Negro. The *Star* calls the old cock the democratic and the negro the republican parties—

Dec 26, 1867

My severe cold was preceded by a violent attact of pin worms—cure, two tea spoonfuls of Pikerq[?] in Rum for several days—in the morning. Salt water injections in the afternoon, to clear out the worms. Took two rum sweats at different times to bring on perspiration. My food for the past seven days—toast bread and warm water with very little salt in it. No butter. Having a very bad cough and sore chest—I put on mustard plasters. A great deal of pain in my head—I took a tea spoonful of Brimstone and molasses—and put a mustard plaster on the back of my neck. For the cough found sweet oil and New Orleans molasses half and half, well shook up, to be a benefit. I doctored myself, Dr. Dering being sick. Observation: If we would abstain from greasy living—and use more dry food—our healths would be better and our intellects brighter.

Cause of my getting sick: painted too closely through the month of Nov. and part of Dec, did not take exercise enough, and too much greasy living—which brings on dyspepsy and colds.

I should board some distance from my studio so I should be compelled to walk more. That added to cutting and sawing of my wood, would be just the thing needed for health.

correspondence 1866-67

Francis Copcutt to WSM

New York, Jany 3, '66

Dear Sir,

I have by accident almost ruined "Ariel," and have sent it by express to Stony Brook to day. I also sent by mail Jarvis' "Art Idea" in which you receive "honorable mention." I also enclose $10 and if without too much trouble you can mount "Ariel" and touch him up so that I can put him in one of the receptions you will oblige me and not injure your own artistic name, as the head is a good one.

Yours truly

[SB] Francis Copcutt

WSM to David A. Wood

East Setauket, L. Island
March 14th, '66

My dear Sir,

I wrote to John Williamson, Secretary of the Brooklyn Art Association yesterday; his residence, 137 Montague Street Brooklyn.

"The Cartman will call for contributions on Monday, March 19th."

The Daguerreotype of your sister Lizzie I thought beautiful in form, showing the figure below the waist—but when I saw the card—only the head and bust exhibited—it was a disapointment.

The whole figure as seen in the daguerreotype should be represented on the Card to give satisfaction. The opportunity I had lately of Studying Foreign Art, affords me some pleasure, that we shall in course of time have painters equal if not superior to any in Europe.

My cold is better. I reached home last Saturday—the 10th.

My regards to all,
Wm. S. Mount

P.S. If you and your brother should have invitations to the Brooklyn Reception, if possible attend.

[NYHS]

WSM to Daniel Huntington

Portable Studio
East Setauket L. Island
May 16th, 1866

My dear Sir,

I have uncorked your good will offering—sent me by the members of the National Academy of Design; a few friends who have a love of art enjoyed its contents with me. The brand is a choice one, bearing your initials and the endorsement of Eastman Johnson Esq. Many thanks to the Academecians for their kind remembrance.

You have my congratulations on your re-Election.

Yours, Very truly,
Wm. S. Mount

P.S. It is gratifying to find so many Academecians and associates, on the side of temperance. My conviction is, that no one but a temperate person should drink liquor and that very seldom.

[NYHS]

WSM to the Editor of the *Long-Island Star*

July 26th, 1866

Mr. Editor,

In your last sheet, you left out, (I presume by an over sight) the record of July 17th, the hotest ever known here.

July 17th 1866: 5 A.M., 82—6 A.M., 82—7 A.M., 85—9 A.M., 89 to 90—10 A.M., 92—11 A.M., 94 to 99—12 noon, 99 to nearly 100—1 P.M., 99—2 P.M., 99—3 P.M., 99—4 P.M., 98—5 P.M., 94—6 P.M., 90.

Yours truly
Wm. S. Mount

[NYHS]

Draft of a Letter to an Editor

Aug 11, 1866

BATHERS LOOK OUT

Mr. Editor, On entering Setauket harbor this afternoon about 5 P.M. August 11th, '66, and approaching Skidmore's Point, by the buoy—wind west—the tide more than two thirds down—Chas. Hawkins at the helm—a large shark about seven or eight feet long arose up out of the water, slid along the side of the sail boat Pond Lily, and going down with the slap of his tail against her; making as much noise as a man would in falling overboard.

Mr. Edward King, a few days since, saw a shark about eight or nine feet in length—opposite Skidmore's Point, Strongs Neck, near the shark rock. Also, lately, near the buoy Skidmore's Point, the skiff "Galloping Tiger," was upset on a squall (main sheet lashed at the time) no hopes for the three men, they went into the watery element; although they had rather not, and to their credit struggled manfully to reach the shore, taking the boat with them. Loss, one clam, and one shoe. A moment before they saw a large shark in proximity.

It would be capital sport, some calm day, near low tide, to try the harpoon at those monsters. Have men stationed on the banks, to give warning to the harpooners. A large hook bated with a fish or a piece of pork might be interesting to the shark.

[SB] W.S.M.

WSM to Evelina Mount

East Setauket, L.I.
Oct. 1866

Evelina,

Your painting after the Butterfly, is a very brilliant work—you have made good use of the wash house; good idea. Painters can move houses and rocks where they please.

After touching up the figures, I thought to assist in perfecting the general arrangement here and there [pl. 169]. You are painting so well now that it will be well for you to pay some attention to perspective. By reflecting your painting in a looking glass—you will find that the *F* end of your cottage should be lowered. The vanishing lines will

169. Perspective drawing. Letter WSM to Evelina Mount, October, 1866. The New-York Historical Society

run to a great distance to reach the *Horison line*. The *O* end—the lines have a short distance to intersect the horison. Please remember that these two lines should always be parallel, thus / / of the roof. The *O* end I took the liberty to correct—you can if you think proper perfect the *F* end.

Reflect the picture again and you will see what I mean.

The flower piece, and the cottage scene are very much admired—the impression is, you will become a great painter. The cottage picture should have mouldings to show the whole surface of the painting.

Yours truly,
[SB] Wm. S. Mount

[NYHS]

Theodore F. Dwight to WSM

Auburn, N.Y.
Oct 20, 1866

Dear Sir,

I very sincerely desire your autograph if it will not trouble you. Will you have the kindness to send it to me.

With respect
Truly Yours
[SB] Theo. F. Dwight

Theodore F. Dwight to WSM

Auburn, N.Y.
Oct. 25, 1866

Dear Sir,

I have but just recd your kind note of the 13 ultimo in response to a request for your autograph. By some mishap at the Post Office it was placed between the *wall* and my drawer box, having become somewhat mutilated by the friction of the drawer. This will explain the second request which I sent to Stony Brook a few days ago—fearing that my first request was wrongly adressed.

With many thanks for your courtesy, I am

Truly yours
[SB] Theo. F. Dwight

WSM to Mr. and Mrs. S. A. Meeker

Portable Studio
East Setauket, L.I.
Nov. 21st, 1866

Mr. and Mrs. S. A. Meeker,

I congratulate you on your "Twenty fifth Anniversary." Your heads deserved to be crowned with laurels: as a bright example of constancy.

The splendor of the scene would be too much for me to witness, just at this time; as my mind is deeply interested in my art.

You have my best thanks for your kind remembrance.

May the Lord preserve you both to your fiftieth golden Anniversary. My best regards to all your family.

Yours, truly
[SB] Wm. S. Mount

WSM to Thomas S. Mount

East Setauket, L.I.
Nov. 23rd, 1866

My dear Nephew,

A friend of mine will buy the Mount farm at Stony Brook (owners consenting) at the same per eight, as you offered me about two weeks since—$600 for each eight—$4000–800, four thousand and eight hundred dollars. (Although he admitted in his note that it was worth double, considering the number of acres, and locality, that sum he would give.) You remain as you are and look about for another place up to the tenth of April 1867. He desires it for a summer residence; and a few congenial friends to visit him; yourself and family included.

He will make some slight repairs and alterations to suit his own convenience. He furthermore, requests me not to mention his name until after the warrantee deed is signed and money paid.

Please answer this note before the first of Dec, 1866, as my friend desires to know if you will agree to the above terms; and an early day fixed for settlement; say, the tenth of Dec, 1866.

I shall send a copy of this note to brother Shepard and thank you to show this letter to Mrs. Henry S. Mount.

I remain your affectionate Uncle,
Wm. S. Mount

[Memorandum by Mount at the bottom of his copy:]

I forgot to mention part of Thomas' talk to me—he said, if you will not sell out, we must have a public sale, or a division; or, if you force me to a sale I shall turn up the carpets and let the buyers see the condition of the house. I was quite surprised at that remark; it shows that he has no friendship where self interest is concerned; and is bound on speculation. My store room *in the will* dont please him—*cant give a clear title*, hence as an ofsett; he speaks about *turning up the carpet* so as to make the place sell cheap. Every one can see that it is an old house without turning up carpets. The purchaser will know what he can do with the place, and it is our duty, if it is brought to the hammer, to ralley our friends and see that it brings a first rate price. Let us keep cool and quiet.

Perhaps, Tom, John and Co. wants to buy us out before the North rail road is finished, to speck on the rise of property. Mother had the will drawn up so as to make it a home for us all. They have had the working of the farm since Mother's death, about 25 years, and we have paid our portion of the taxes with cheerfulness.

If you expect me to stand by you, you will not forget to stand by me.

[NYHS]

WSM to Shepard A. Mount

East Setauket L.I.
Nov. 25th, 1866

Brother Shepard,

I hope by this time you are in good working condition to please the Jones family. They are kind hearted—those I have met with.

I forwarded a note to Thomas, Saturday morning 23rd. If we sell to them at their valuation (they being the *largest owners*), the farm will only cost them $1800.00—a very nice bargain. If we should purchase of them (they should be willing to sell to us at their buying price valuation) we shall only have to pay $3000.00. If they should sell to my friend the price would be $3,600.00. We being part owners, it would be a saving to purchase together. I dont believe they will sell at their buying price. And, the next move Tom will make, will be to cut off all the wood. I only judge from what has past—the future will tell if I am right.

Therefore, it will be well to drop the following to Mrs. Henry S. Mount, and her agent, Thos. S. Mount. After the 1st of Dec, 1866, any wood cut off the Mount farm where we are part owners after this date (Dec 1st 1866) such as cord wood, hoop-poles, locust, ship timber, rails etc without our written consent we shall regard as a trespass.

Everything that is worth cutting is worth asking for. If we are particular about our own interest in the farm they will have more regard for us. They have out side advisers to turn us out of doors if they could—and make a nice lot of money thereby. Your Niece, across the way is affraid that you will marry into some family that will disgrace them—it is laughable. We will see what kind of blood she will get hold of. These inquisitive (getting to be) old maids are funny things, to make the most of them. Yet they have some good qualities.

Brother Nelson went to Stony Brook last evening—has returned this evening. Edward wished to take him to see his brothers new house but he thought the ride would be too cold.

We have very good weather for the season. The School house at East Setauket is nearly finished.

Yours truly,
Wm. S. Mount

P.S. I suppose you know that Mr. James Brewster of New Haven is dead—you will see a short notice in Saturday's *Herald*. He died on the 22nd aged 79. You might find a full notice in the *N- York Observer*.

If Tom will sell at his buying price, the money will be ready for him.

Nov. 26—fine frosty morning. Thermometer 15 degrees below freezing—write when you have time.

[SB]

Francis B. Spinola to WSM

March 29, 1867

My Dear Sir,

Having a moment to spare, it occurred to me that I would like to enquire about what it would cost for a Picture of my Dear Wife and myself. The same size as the one you painted of [illegible] the terms you would have to come to NY and remain at my house. We have one very large room with good light where you could do the work.

I think I can have two or three friends sit for their pictures also at same price as my wife and myself.

Please let me hear from you by return of mail and oblige yourself

Truly
F. B. Spinola

[SB]

Mrs. Mary Laurie to WSM

Copy of letter in WSM's diary

Danbury Conn
March 11th, '67

What would be your terms for painting an allegorical picture to be entitled the Presidential position in 1867. The figures to be a Jackass thrown down upon his haunches his tail lashed to a palmetto tree a copperhead snake coiled about his neck and his head thrown back in defiance gazing at an American eagle swooping down upon him, from the front.

Please name the probable time of completion. If the conception meets your approval and you are willing to undertake it—address your answer to Mrs. Mary Laurie, care of Mrs. Isaac P. Hull, Danbury, Conn.

Received the above note, N.Y. April 16th, '67—W. S. Mount.
[NYHS]

WSM to Mrs. Mary Laurie

New York
No 3 Livingston Place
April 16, '67

Mrs. Mary Laurie,

Your note came to hand yesterday 15th. I do not think it politic or humane, to taunt or trample upon a brave people; after they have acknowledged their submission. I am unwilling to paint a picture such as you have suggested; in your note of March 11th, '67.

Yours etc
[NYHS]
Wm. S. Mount

The *Phrenological Journal* to WSM

389 Broadway, N.Y.
June 21, 1867

Dear Sir,

We are intending to publish in the *Phrenological Journal*, portraits of a group of American Artists, together

with a biographical sketch of each, and would like to include yourself among the number. Would you kindly furnish us with a good photograph of yourself, together with a brief biography—say 500 or 700 words—or refer us to where the same may be procured.

We beg to enclose stamped envelope for reply, and in the mean time beg to remain,

Truly Yours,
Fowler & Wells

[NYHS]

WSM to Thomas S. Seabury

Portable Studio
East Setauket L.I.
Oct 20th, 1867

My dear Nephew,

It is gratifying to state that I have found my drawings. Verily, the imagination is a wild horse.

I thank you and Julia for the interest manifested in the hope of their being discovered. I remain,

Your affectionate Uncle,
Wm. S. Mount

[NYHS]

Addressee Unknown

Portable Studio
Setauket L.I.
Nov 11th, 1867

Wednesday Nov. 6th, '67— We the undersigned thought proper to commemorate the recent Democratic victories by having a drawing, representing *A Rooster standing upon a dead Negro.*

The Break of Day. Accordingly, Capt Joseph Wm Underhill obtained a piece of white muslin of Walter Jones Jun[ior]—for the sketches, and bound it. Size 2 feet 4 in by 4 feet 4 inches. The painter sized it with wheat paste; and on the 7th commenced drawing in the design about 12 (noon) and dead colored the picture in oil colors. At noon the 8th, the work was finished. John Henry Smith has furnished a frame for it.

The committee to see that the Cock shall crow from time to time, protected, and taken to Port Jefferson and Stony Brook, and exhibited in Setauket on his return— are: Messrs

Walter Jones Jun.
Water Smith
Joseph Wm Underhill
John Henry Smith
Wm. S. Mount.

We quite regret that the canvas was not larger and better prepared.

Respectfully,
Wm. S. Mount

[SB]

Radical crowing cannot awake him. The story is well told and comprehensive. It would help make the fortune of any engraver, Photographer or Chromographer to publish it.

It represents a Negro on his back; his eyes closed, "dreaming of the once happy days with his old master" [pl. 170].

The rooster stands on his breast crowing and scratching to awake him; but, is of no use. The painter stated that crowds visited [h]is studio evenings to see it, both Democrats and Republicans.

[NYHS]

Copies by WSM of two newspaper pieces defending his Dawn of Day *against a derogatory article in the* Long-Island Star.

December 9, 1867

It is believed by many that the *Star* Editor wrote that elaborate criticism on Mr. Mount and his painting now hanging in Mr. Jones' Store, "Radical Crowing will not awake him," and not by a correspondent.

Some of the Editor's adherents think it is his greatest effort; while others to the contrary. People will differ and that makes them more active.

The author evidently prepaired himself for the great work by consulting Mrs. Winslow; and she, understanding his physical condition at a glance, advised him to cleanse his stomach by taking a tea spoonful of common table salt well dissolved in a swallow of cold water to give clearness to his capacious brain; for he had wit enough to know, there is a very rapid telegraphic communication between the stomach and Ideality; which is to be felt on both sides of the head and is well known to Phrenologist.

The Critic consented to take the dose. Hence his success in writing his composition and high satisfaction which compelled him by a natural volition, almost equal to Horace Greely, to run down stairs and show his art notice to his intelligent father, how he had touched up the painter and his work. Here the scene. . . .

Monday Dec 9th, '67

Remarks on the above article about the "Rooster and the Negro," (by a correspondent of the *Long-Island Star*) wherein the Editor having the Rooster on the brain, has misrepresented the design of the artist.

From his admiration of the picture, he would like to have the Cock crow on the Republican side (but it is too late for his party); when the fact is, the painting represents the Negro Politically Dead. Radical Crowing will not awake him. It is the Radical Republican—Rooster— trying to make more capital out of the Negro, but, is *about used up for their purpose;* which is glorious news for the whole country. The African needs rest.

Also, The store is the only place to exhibit works of

170. *The Dawn of Day (The Break of Day; Politically Dead)*. c. 1867. Oil on academy board, 7 3/4 × 12″.
The Museums at Stony Brook, Stony Brook, Long Island

public interest (in a country village), pictures, bundles of news papers, etc to be distributed, including the *Independent Press*.

Again as regards the leather medal— The glowing terms in which the Editor of the *Star* has eulogised the work, and the artist, is evidence that he has fairly won the leather medal and that Mr. Bellows be invited to place it properly; where it belongs, and well [illegible], on the Editor of the *Star*'s seat of honor, in presence of the stock holders and a few outsiders.

Lastly: The Editor of the *Star* stating that the "Town Poor house is essentially a democratic institution"; it shows their benevolence in furnishing such an institution and is a very proper place for the Republican party next November 1868, headed by their talented Editor of the *Star*.

We have seen the above painting. The story is well told and comprehensive; and would help make the fortune of a print seller to photograph the work for publication.

If the Negro represents the Republican party (which the Editor of the *Star* states), he will be sure, in his death struggle, to steal the old cock for his last meal.

The rooster is intended to represent such bantams as the editor of the *Star* endevoring to galvanize some life into the defunct nigger. We understand the artist has in contemplation a serio-comic political allegory representing a knight of the Loyal League rescuing the Godess of Liberty from the waves of Democracy. The scene is supposed to occur off a city of New Jersey. He intends to invite the Editor of the *Star* to sit for one of the principal figures.

[NYHS]

WSM to John H. Mount

East Setauket, L.I.
Dec. 26th, 1867

My dear Nephew,

Your note was received yesterday about noon, giving me a cordial invitation from Mr. and Mrs. Searing to spend Christmas with them at Glen Cove, and also, to meet other interesting friends.

Had my health been good and your note had reached me early, we would have had a jolly time with fiddles and tin whistles.

I am now sitting by the fire in the parlor trying to get rid of one of the worst colds and coughs I ever remember to have had. My food for the past seven days—toast bread and water with very little salt in it, no butter. Dr. Dering being sick, I am my own physician; and so far successful. Observation: If we would abstain from greasy living (no nourishment in gravys) we would be more free from dypepsy and colds, our health would be better by using more dry food, and our intellects brighter.

Although I have a wicked cold in my head, I will try and fill up this paper, by relating a little incident. One of our farmer butchers of this village killed a Bull for a neighbor, about the first of last week and skinned him so completely, that he stript the skin off the tail the length of an axe handle, and placed it in his basket (with consent of the bull owner). While on his way home in the evening he stoped at one of the village stores and seated himself on one of the counters. A funny fellow (Walter by name) hawled the Bull's tail from its coil in the basket and began to belabor one of his chums with it (on his back); who in turn grasp the tail from Walter, which pro-

duced great merriment. The butcher at this moment had just discovered the flourish of the Bull's tail, and springs for his property with great anger, and tells Joe to give him the tail, that it was to make soup for his very sick daughter; to give her strength. Joe being a man of mutual [?] sensibility and knowing at once the force and truth of the demand, and the beauty of the young lady, gracefully delivered it up to the anxious father.

Now the sequel. The soup has added greatly to the strength and beauty of the invalid; so much so, that a few evenings since she was married to her lover.

A lady friend of mine who has seen her, says the bride told her in confidence that she was gaining in strength every hour. I suppose upon the virtue and strength of Bulltail soup and a loving husband. [Notation squeezed in by Mount on his copy: The daughter of the Bull owner is to be married in a few days. W.S.M.]

There was a family Christmas dinner party, at Julia Toms'[?] Rassapeuge[?] yesterday. But I was not able to attend—

The Ladies of Setauket think it funny that Jimmie Evans should be freightened at a rooster.

> My regards to all. I remain
> Your affectionate Uncle
> Wm. S. Mount

[NYHS]

diaries 1868

About Jan 7th '68 went to New York to paint the portrait of Master Sinclair Tousey aged three years, on canvass size 17 × 21. Price $150.00. A picture portrait. As the Boy could scarsely talk and did not know what stilness ment, it took much longer time to paint it.

The confinement and anxiety was of no benefit to my health.

About the last of Jan. put a plaster on my right side, it relieved the pain.

An oyster stew to be perfect, should be made without butter or milk. More healthy. Butter and milk dont make oysters. Melted butter is bad.

Stony Brook, Jan 14, '68

WINDOW SHADES

"The cloth being strained on a frame, let it be saturated with a weak solution of white glue, then proceed with a little Vandyke brown, ground in weak glue water, to make out the drawing and the trunks of the trees. When dry, with a little yellow lake ground in oil and mixed with drying oil, proceed to put in the yellow tint of the sky and the landscape and let your work dry. Then proceed with the blue tints of the sky with prussian blue, as with the yellow lake, to which may be added raw sienna for the trees and grassy parts of the picture. When this is done take a piece of thin pine, like the point of a blunt pen-knife, and scrape out all the light parts of the foliage, after which paint your figures and the work is done."

Jan. 23, '68

The work on Mrs. Floyd's portrait—have not received any pay—was worth $50.00. [Added later:] Have received my payment the last of March, 1868. Wm. S. Mount.

First of Feb.

Hired a room at Leggett's Hotel 46 and 48 Chatham St, N.Y.

Feb. 8th

Thermometer on Long Island from 4 to 10 degrees below zero. Plenty of snow make a cold winter. Great deal of suffering in the city.

Advise of the Dr. and druggist—never go to bed hungry; being week and costive I ate at noon chicken soup and dry bread for several days. Two bowls, improved me. For several days, took raw oysters off the shell and a glass of ale, before going to bed; gained strength. To drink coffee in place of tea. Eat eggs boiled or scalled. No hot buckwheat cakes, no hot bread, and no pastry.

Take no bitters, and no medicine but exercise in the open air to obtain pure oxygen. The above advise to me by an old English Doctor. A fine old Gentleman.

WHAT I DONT EAT

No—veal.
No—potatoes.
No—butter.
No—cheese.

Seldom eat cake, pie; or Drink Coffee or tea; take quite *warm water* instead. I find that a warm water drink ten or 15 minutes after eating is good for my health.

Drink no ardent spirits—occasionally take a glass of ale, beer or cider, if I can find it good—but, dont put myself out for it.

"Correct yourself before you correct others."

17th of Feb—crossed on the ice to see Judge Strong and Lady.

20th

Crossed the ice again to see the Judge, staid all night.

I forgot to mention that I returned from the city Feb. 13th. Took board one week with Elderkin, to have a long walk to my studio. *Good house.*

Feb. 22nd

Cold morning 14 above zero. Took board with my brother.

New York City is the best place to spend part of the fall and winter. To hear lectures on all subjects. To see Tragedy or Comedy. To visit Gallerys of paintings, and sculpture. Musical concerts, also a drive to the Central Park, and to steam or sail to all parts of the world—from the *great City of N.Y.*

Recd—from Walter Smith Esq a small can of Delafield white lead, 290 Pearl Street N.Y.—said to be an improvement over other white leads. I shall try it. The inventors claim it to be whiter and more body.

I have tried it—it is a fine working color.

The Manhatten *white lead* is whiter than the Philadelphia white lead.

Saturday Afternoon—stiring news from Washington. The President has removed Stanton and put Major Gen. L. Thomas in his place.

Sunday Feb 23, '68

Cold. Thermometer at zero. [Added later:] Feb 27th snow storm. Do. 29th—clear cold day.

The Presbyterians are trying a New Minister every Sunday in oder to select a good one.

When I was sick she observed I wish you was so sick that you could not stir. No friend of mine—

To clean hands, use the Baking Soda powder with the hard brush, with soap and water. ——Oliver G. Davis.

I have tried the above with warm water, the hands well soaped and the soda put on the hand or brush with a spoon or knife. First rate. It makes the hands clean and soft. ——Wm. S. Mount.

Mr. Buckle, and Sir James Macintosh, insists that morality admits of no discoveries. It is stationary, and must ever remain so.

Macintosh further says that more than three thousand years have elapsed since the composition of the Pentateuch, and then challenges any man to show in what important respect the rule of live has been varied since that period.

I think sometimes that the ambitious men of the age, including the Emporers and the Popes, Priests and scheming politicians, whould rather not have the morals improved by intelligence. Time will tell if the people would only be true to themselves to be intelligent and industrious, happy and contented. If the people were always right, there morals would be good always.

Feb. 24th, '68

The President impeached of high crimes and misdemeanors.

Count—126 yeas against 47 noes.

Died in the village of Stony Brook "on Tuesday morning the 26 inst, Col. Nathaniel Hawkins, aged 76 years, 11 months and 21 days.

The Col. was extensively known and highly esteemed, for his many excellent special qualities and his love for everything calculated to elevate and ennoble mankind." ——H. Markham.

March 1st, '68, Sunday

Snowing moderately, wind N.E.

March 2nd—Snowing fast and strong, N. East wind—cold.

March 3rd

One degree above zero. Clear—wind North West. The sound appears to be completely frozen over. 8 oclock P.M. one degree above zero.

March 4th

About sunrise 3 degrees above zero. Very cold for the season. At 2 A.M. at night 2 degrees below zero. At West Setauket 4 degrees below zero.

March 5th & 6th

Crossed the ice to Strongs Neck, showed the Judge Strong my picture of Radical Crowing will not awake him. Sleds laden with timber were drawn across the harbor with horses.

Politics about this time are interesting the people of the whole country. They begin to think about the constitution.

OF RACES

"Progression is friendly till it meets with opposition, then it is aggressive. As long as there is progression there can be no deterioration; hence the Caucasian race does not go back toward the Indian." ——Du Chaillu's Lecture.

"I believe the Caucasion race to be the most vigorous and the last type of progressive development in the human family." ——Du Chaillu.

Painted on some of my small pictures.

March 7th, 1868

Wind south. The snow is melting. It has been a tight winter from the 30th of Nov. 1867 to the sixth of March 1868.

I find it better for me to drink warm water at my meals than tea or coffee.

A swallow of warm water after eating promotes digestion. ——John Elderkin.

March 19th, 1868

Capt Joseph W. Underhill Lengthened the Pond Lily one foot six and half inches—she is now 15 feet 10 inches, and has room aft to place a sketch after it is painted. It took three days, and the work is well done. Price $9.13 cts. She is a fine boat.

The two past winters I have placed canvass over the boat, thus [sketch], nailed to a board on each side. Bottom side up—for the air to circulate freely.

March 21st, 1868

A violent snow storm. Wind north north East—blowing heavy.

Stony Brook. "Owing to the ice blockade, The Packet Sloop Wonder of Stony Brook, John Smith, Capt, is the first vessel to arrive here from New York March 18th 1868. She left here on her last trip on the 4th of Jan; cannon was fired the joy was so great."

March 23

Mouth of the creek was froze up this morning.
21st played on the Violin not having played before in over three months.

March 24th

Attended Frank Hadaway's funeral at Stony Brook. He was buried at St. James. His friend Mr. Jackson said of Frank: that he was a truthful man.

25 cold morning, the creek skimed over with ice—wind east.

I attended a school meeting to vote for a new school house. Mr. Joseph Rowland, one of the committee, took home my drawings of the old; the remodeled and the New School house contrasted.

Evelina tells me she is about to take a second course of lessons in painting of Mr. James Hart.

March 27, '68

Froze in my studio—

In a note to Geo. P. A. Healy—Chicago Illi—I said: "Your portraits have a spunk and vigor about them that excites my admiration; although not having seen your models, they must have a strong resemblance."

PAINTINGS I EXPECT TO EXHIBIT THIS YEAR

Mutual Respect.
A charming scene in Autumn.
~~The Dawn of Day.~~
Portrait of Gen. F. B. Spinola.
Portrait, Sinclair Tousey.
Head of Ariel.
Five pieces.

Sunday Morning April [5] 1868—snow about five inches deep.

Monday 6th

Ice in my room—cold, wind west.
Wrote this morning to Eastman Johnson N.A.

From the *World,* Tuesday April 7th—Victory!
Waterloo defeat, of *Radicalism in Connecticut.* A Democratic Majority. English elected by 1,781. *Great rejoicings.*

7th a very rainy day—only 184 Dem. and 17 Rep at the Town Meeting in Conn.

 184
 34 twice 17
Dem— 150 maj.

8th—Ice this morning—wind west, clear and sunny.
9th—Cove froze over. 10 de. below zero.

From the *N.Y. Daily News,* April 13th, '68

A CURE

—"for the inebriate who could not get along with less than a pint to a quart of whiskey per day.

It is as follows: sulphate of iron, 5 grains; peppermint water, 11 drachms; spirit of Nutmeg, 1 drachm; twice a day.

This preparation acts as a tonic and stimulant, and so partially supplies the place of the accostomed liquor.

It is to be taken in quantities equal to an ordinary dram, and as often as the desire for a dram returns. Any druggist can prepare the prescription."

It will cure if rigidly carried out.

World, April 17th, 1868

SUBJECTS

Sergeant Bates—The Flag bearer in the South: "A fine looking old Lady (near Richmond Va.) with the tears coursing cheeks said, as she took my hand, 'Tell Andrew Johnson that he has the earnest prayer of the matrons of Virginia for his welfare and happiness.'

"At Whitehall in Alabama Miss White decorated the Flag with wreaths of laurel and flowers—

"They would dismiss schools to meet me, and many of the little girls would want to kiss me and to wave my flag.

"My rooms have been decorated with evergreens, and in North Carolina, girls strewed my way with flowers, and pinned bouquets upon my breast. In passing through North Carolina and Virginia, I had a bouquet in my hand every hour of the day.

"In Georgia—I went with a Confederate soldier to his brother's grave. He stood upon one side of the grave and I upon the other. As I was reading the inscription on a plain wooden head-board, he reached his hand over the grave of his brother. I clasped it. He was willing to stand by the good old flag.

"In North Carolina I met an old man who had served in the rebel forces, he led me over the bridge which had been destroyed by Steedman. It had been rebuilt, was very high, and hard to cross. He feared I might fall and hurt myself."

Sunday morning April 19th, '68

Cold; thermometer 5 below freezing.

Underhill and his wife has been taking a ride this afternoon to try the spirit of the little dark brown mare. He now has a pair of horses for farming purposes.

I hope he will be prosperous, he has an interesting family to take care of.

The past winter the Capt. made a nice little gunning boat—he also, made a sail for it— [Sketch]

Gunning boat—rounding crosswise and lengthwise on the bottom.

Monday morning

(Wind east) rain storm.

Took a seidletz powder in consequence of taking a tea spoonful of pulverized brimstone and molasses.

Dr. Evans says, brimstone should be mixed with cream of tarter; enough to take a teaspoonful for two or three mornings. To break up constipation or costiveness. —To work off.

"Costive: Literally, crow[d]ed, stuffed, as the intestines; hence, bound in [illegible]; retaining fecal matter in the bowels, in a hard and dry state, the bowels too slow."

Monday 27, 1868

John Petty's Mother was buried to day—she was over 90 years old.

I often think that painters sculptors and architects are God's people. Men of God. See the splendid works they have executed from time to time as if by inspiration. What class of men observe the works of God more than the artists—and Poets?

A member of a church in a note—speaks of the Presiding Elder. "Welcome the man of God whenever he may favor us with his visitation."

If there is no inspiration in this period of the wold's history, why call a presiding Elder a God.

We can justly say that every man in every profession who by his genius, enobles, and raises his fellow men from degradation is worthy to be classed as men of God.

May 13th, 1868

A railroad meeting was held in this place last evening, May 12th, 1868. Speeches were made by Evans and Hand. 33 shares were taken—at fifty dollars per share. I took one share. Those who do not subscribe say as an apology that we will have a north side railroad to Port Jefferson and perhaps to Riverhead, L.I. The track should be laid the north side of the hills, so that the traveler can see the Sound and Connecticut. Charlick observed that he had been in the scrub oaks long enough.

May 15, '68

I find that I am inclined to be working at many things besides painting. Well, I take pleasure in it, and sometimes I ask myself for fun what is my profession.

This is a beautiful morning. The country looks fresh and green. The apple blossoms begin to show a little red— and the peach is blooming. The wood pecker is hammering at an old dry limb of a tree—and the sail vessels are moving up and down the sound. The bright sun shine puts on the finishing touch.

The Impeachment Fizzle of Tuesday is put off to Saturday, 16th of May.

Painted several times on my boat when the weather permitted the past three weeks. The boat looks better and my health is better for being in the open air.

Genius is perseverance said Buffon the naturalist. He copyed his work over 18 times, and could repeat the most of it.

May 17th, 1868

I will mention about the Action of the Court on the Charges against the President. Test vote on the Eleventh Article. The President Pronounced not Guilty.

Intense Excitement Throught the Country.

London, May, 18, 1:20 P.M. American securities are active and advancing.

For Conviction—35; not guilty—19. Senators Fessenden, Me.; Fowler; Grimes, Iowa; Ross, of Kansas; Trumble, Ill; and Van Winkle of W. Va—among the Republican Senators, voted not guilty.

Doolittle (rep) of Wis. had come out in favor of President Johnson some weeks since.

The above named Senators will be remembered with honor.

Monday May 18th, '68—one apple tree in bloom.

May 22nd

Finished painting my boat Pond Lily—white sides. French zinc and white lead—mixed with boild oil and liquid dryer.

My 23rd, '68

Heavy rain storm from the N. East. We have had a rain storm about once or twice a week. Mostly from the east. It has been hard weather for the farmers and ship carpenters.

May 24th

The majority of the apple trees are in full bloom. They are about seven days behind time. 17 and 18 of May is the regular time for apple trees to be in full bloom on the North side of Long Island.

It is said that the great quantity of floating ice between here and England is the cause so much east wind. The ice compels ships to sail out of their course.

26 & 27th, 1868

Apple trees in full bloom. 27th a fine day. The wind blowing from every corner.

Herald, May 27, 1868

Impeachment.—The Last Act in the *Great Farce.* The Second and third articles voted upon.

Acquittal of the President [see pl. 171].

Adjournment of Court sine die.

The names of the seven Republican Senators still on the Rool of Honor.

Mr. Johnson congratulated by his friends.

Edwin Stanton gives Up the War Department.

General Thomas Finally Secretary of War Ad Intrem.

Not Guilty—The seven Republican Senators are *bull pups.*

The 35 Republicans who voted guilty are cur pups.

The seven Republican Senators who refused to commit perjury by voting for President Johnson's conviction will be honored for honesty of purpose. They said in their hearts: "my mouth shall not transgress." A photograph of the above 7 would sell.

171. Political poster. 1868. Whereabouts unknown. Photograph courtesy The Museums at Stony Brook, Stony Brook, Long Island

"Who enters the tiger's den gets the whelps." —equivalent to Nothing venture, nothing gain."

"When you talk on the road there are ears in the grass."

"After the pig is killed then speak of the price." —to take advantage. Chinese proverbs.

Will add one more: "To nourish a rat to eat a hole in one's bags."

[May?]

[SUBJECTS; pl. 172]

A girl reading and walking at the same time. [Sketch]
Two men talking privacy behind a wood pile—or a barn. [Sketch]

Painter's liquid dryer—a good siccative; to be added to raw linseed oil, causing it to dry quickly. I have used it a long time to make Black and dark colors dry.

A little turps may be used with boild oil in out door painting—but not in finishing.

June 1st, 1868

It has been a fine sunny day until about 7 P.M. when it commenced raining.

I must change my place of board—Mrs. M. and Mrs. U. have too many cares with out having any thought about my fare. I think so. There are places enough at some distance which will give me exercise while walking to my studio.

Change of place gives change of thought; it stimulates, gives more ambition to both sexes. It is better to board among strangers. Talk less and exercise more. Listen to those who know how to talk.

June 2nd, '68

A fisherman told me, this morning at 2 A.M. was the coldest he ever experienced at this time of year.

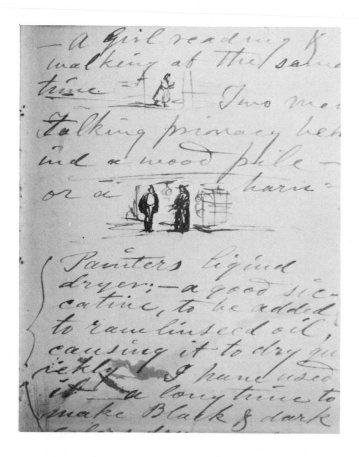

172. "Subjects." Diary, May(?), 1868. The Museums at Stony Brook, Stony Brook, Long Island

Thos S. Seabury, has not called to see me this year. We have had three quite pleasant days—we are thankful.

June 4th, '68, Thursday afternoon

Have concluded to stop a few days with Effingham Tuttle, Port Jefferson—have some work done, visit some friends and walk up to East Setauket every day for exercise. Some carpenters ride and some walk from West Setauket (every good day) to Port Jefferson, and return 6 P.M. (walk) to their homes. After a hard day's work.

Mr. Cozzens, ship carpenter, told me that he walked in the morning from his home (last year) East Setauket to Stony Brook and returned at night—distance about three and 1/2 miles.

For Glazing, use terreverte and Ven. Red.

Sunday June 7th, '68. Thermometer at 80 degrees.—The warmest this season.

June 8th, 1868

Thos. S. Seabury called and paid interest on a $400 (four hundred dollar) note.

June 11th

A cold rain storm—wind east. We have had a storm of rain nearly every week. After walking up from Port Jefferson—made some fire in my studio. I put up with Mr E. Tuttle one week, and well pleased—but the walk is too far in very hot and stormy weather. I shall stop a few days at Elderkin's Hotel, West Setauket, which is about the walk of a mile—and fine scenery on the route.

June 12th

The rain continues—

About criticism— An artist should remember that criticism does not alter the tone of a violin any more than the tone and merit of a painting.

A work (sometimes) can be improved years after it has been painted; therefore just criticism is worthy of attention; and the artist should educate himself to see his own merits as well as the defects in his own work—then he will not be anoyed by opinions of others, but on the road to progress.

June 13th, '68

A bright sunny morning—and we are thankful. Thermometer 80 degrees. Signs of another storm, but I hope we shall be disappointed.

14th

A fine morning.

Although I like my Portable Studio, the only one in the world, I have an idea of parting with it—and also my boat; put my paint room in order at Stony Brook and reside part of every year in New York City.

Paint portraits and pictures in fall and winter—and landscapes in the Country in summer. I painted (years ago) portraits in the city, and figure pieces in the country, in summer. It was not every year, but painted according to circumstances.

Think first before you act.

By making N.Y. my home I would obtain higher prices—could learn the art of speculation, as well as improvement in the art of painting.

Perhaps the studio would be useful to the central park commissioners—for an office—as it could be moved when required to different points of interest. Make an ice cream saloon, or, an oyster saloon, or a movable Taylor's establishment from one County to another. First rate for an architect, having so much light. Or for a bachelor to cook his meals in; live and eat; to suit his own taste and be regular at his meals.

The best plan—to pay so much a week for meals to be put up in a basket at each meal, and sleep in the studio in summer—and have washing sent out. Or breakfast and take dinner in basket.

[July 5]

If Historians were particular in obtaining information direct from the individual artist there would not be so many false storys circulated about them. The cottage scene mentioned in Thos. S. Cummings' work would not have been published. It was written by a lying wag as a sensation article to help his trade.

Mount here refers to the Historic Annals of the National Academy of Design *(Philadelphia, 1865) by Thomas Seir Cummings, who held various offices in the NAD for many years. The story is that when Mount brought the first painting he had ever made to Luman Reed, that gentleman said he could not pay what the picture was worth but asked if Mount would accept a thousand dollars; the artist, whose early canvases were priced at eight and ten dollars, walked off in a daze with Reed's check. The interesting thing about this story as told by Cummings is that Cummings says it isn't true. He calls it an absurdity that had gone the rounds of the newspapers, but he does not say which newspapers or when they ran the story. It is actually one of the old folk tales of art history, like the accounts of animals trying to eat pictures of food; it has been told about many artists over the years and is probably still in circulation.*

Thursday July 16th, 1868, was the warmest day ever known in England—but is coolness compared to July and August in New York. ——*Herald* correspondent.

Since the creation, the number of human beings who have existed (Statistics affirm) to have been 66,627,843, 273,075,221. Dividing this by the superficial capacity of the globe gives each person about one-fifth part of a foot square of terra firma, and in this case the earth is one vast cemitery. By the same calculation the digging of graves for all the dead since the creation would be a work equal to turning over the surface of the earth 281 times. —— *Herald* Foreign Items.

6th period hundreds of Quadrillions.
5 do—hundreds of Trillions.
4 do—hundreds of Billions.

July 30th

At 2 A.M. I awoke sick—having eat wortle berries and a small piece of fresh lamb at supper. It was an experiment and turned out as I expected.
Treatment— Injection—a drink of hot water. At 3 A.M.—Repeated the above. At 9 P.M. invited to go on a sailing excursion. At 10 P.M. concluded to go—took a glass of hot water seasoned with black pepper. Should have been Cayenne red; rubbed myself well—cured.

Met a lively and handsome company on board of Underhill's Yacht Waterfall. Everything fair throughout—God was with us.

Wortle, and Black berries should be well mashed before swallowed. Fruit in the morning—is the best time to be taken in quantity. Also hominy and milk, or custard. *Rice* and *oat meal* is good.

Saturday, August 1st, '68.
Thermometer 90 in the shade.
I left off eating potatoes, in the spring of 1866. I made a meal of them to day August 1st '68, without injury.

August 3, 1868
From 11 to 12 M—92 degrees.
Colored a photograph of Theodore Rowland.

August 4th
A fine shower in the morning and very welcome prospect of a great corn crop. The wheat crop this year, is the greatest ever known in the United States.

August 5th, a fine shower early in the morning, wind East.

August 6th
Grand Union Pic-Nic, every body invited to meet at Cedar Grove, East Setauket. Ice cream, supper and dancing at a late hour in the evening—returned Monday.

[August 7?]
P. S. Harris, of Brooklyn has just completed two portraits of (Judges) Selah B. Strong of the Supreme Court and of John Greenwood on the bench of the Brooklyn City Court.

August 8, '68. Very heavy showers of rain—wind south.

9th
Sunny. Wind South.
In the afternoon walking over to Stony Brook—gave some *colors* to *Eve.*
Rev'd Samuel Seabury and family are stoping with Sister Ruth.
The scenery about the lower part of Stony Brook is best.

August 10th
Colored two photographs (for Mrs. Ivans, a present) Sarah and Christiana. Coloring gave great satisfaction to Capt Davis who morns the Death of his wife Sarah.

August 11th, '68
Appearance of a good day.
If I make a present to the family I am boarding with it

is very acceptable but, if I talk how their place can be improved by a little labor before breakfast (and we have it late) they cant see it, which makes it laughable. I cannot see how a little labor is going to hert any one, so I took the liberty to pick some stone out of the road, before brekfast.

There is a nice discrimination in selecting scenery—Pictorial.

Sunday August 30, '68

1/2 past one P.M. heat 91 degrees. A fine shower commencing about 5 P.M.

Chas. Loring Elliott. On Tuesday evening last (August 25, '68) at his residence in Albany, Elliott breathed his last on earth.

"His death will occasion a vacancy in American art not easily filled."

Mr. Elliott was born in Scipio, in this state, 1812.

How sad I feel that he has been taken away so early; but, he has left works which will be an honor to his name and country.

His funeral at the N.A.D. was proper and effective.

Sept 7th, '68. Made a sketch in oil of Dr. Dering's residence.

8th, worked on the background of Muzzle down.

Sept. 9th. U.S. first so called [in] '76, Wed. Sept 9th.

[September 15]

Thos. and his wife goes to New York to day 15th to invest his wife's property $30,000—one third of her father's property which she has come in possession of.

[September 18?]

Death of another Academician, Shepard Alonzo Mount N.A. at Stony Brook L.I. on Friday Sept. 18th, 15 minutes to 7 P.M. in the 65 year of his age.

He was a good artist and "a most loveable man." Funeral at St James Church, Sun 20th. The members of N.A.D. were invited to attend.

September 28

I spent from Sun'y 20 to 26, with my sister and family. Midn. Samuel Seabury at home; he draws finely with the pencil. He left for Annapolis M.D. to day Sept. 28, a fine day.

I have received letters of condolince from Alden J. Spooner of Brooklyn. From Rear Admiral Bailey of Oyster Bay and from Wm. A. Jones of Norwich town, Conn—speaking in the highest terms of our deceased brother Shepd. Alonzo Mount, N.A.

correspondence 1868

J. M. Wayne to WSM

New York
Jan 26th, '68

Sir,

Enclosed you will find fifteen (15) cents. I would be very much obliged to you if you would buy me another tin whistle and send it up by Fannie Seabury, whom Miss Maria said was coming up to the city the latter part of this week. Those whistles are very much in demand here just now, and some of the little boys have the old kind but there are two or three notes false in each of them. I can play almost any tune on mine now learning them all by ear.

Whenever you come to town we would be very glad to see you and have you examine those pictures that I was telling you about down in the country. You must excuse me for troubling you, but my old whistle is getting rather rusty so I want another one. Hoping that this letter may find you in good health and enjoying yourself

I remain yrs truly
J. M. Wayne

P.S. If it is not done before Fannie comes up Fan will tell you my direction.

[SB]

WSM to George P. A. Healy

Portable Studio
East Setauket, L. Island
March 2nd, 1868

My dear Sir,

Being personally acquainted with you, it affords me great pleasure to state; that I have received an invitation to be present at the artists Reception. The design is a good one, to bring "the friends of Art" and artists together. The scene will be artistically effective when the talent; genius; and beauty of Chicago are brought together. I should judge so, from the description given. As we are in the midst of a snow storm and my health not having been very good the past winter I am sorry to say I cannot be present. However; inclosed is my photograph, you will accept as a token of my esteem. Permit me to suggest; that if your Reception had been put off to the 2nd or 7th of April, it would have accomodated many N.Y. artists to have been present, who are now busily finishing their works to be *sent during the last week in March* to the National Academy of Design for the Spring Exhibition, after which time the weather would be more genial for the artists and friends of art to travel. I hope your reception will be a success. Please give my regards to the members of The Chicago Academy of Design.

Yours, Respectfully,
Wm. S. Mount

[Memorandum by Mount at the bottom of his copy:]
P.S. March 3d—one degree above zero; clear, wind North West. The sound appears to be completely frozen over.

No communication with the City by rail on account of the snow. This place is opposite Bridgeport Conn.

March 4th, 3 degrees above zero, cold for the season. It is thought the cars will go to the city to day.

[NYHS]

WSM to August Belmont

Portable Studio
East Setauket L. Island
March 26th, 1868

Dear Sir,

As you kindly asked me at the Club House if I had set a price upon my picture, Politically dead, Radical crowing will not awake him, I will state the price and conditions, and will be much gratifyed if you should become the owner; you, allowing me the priviledge to have it engraved at the proper time; and perhaps to exhibit it at the Spring Exhibition. 31st of March is the last day the N.A.D. receives works of art. Price for the picture $250.00, the frame will be about $10, including the shadow box.

It was painted to commemorate the Democratic victory last fall, and for all *democratic victories* for the next twenty years.

Before I left town, I showed the painting to a number of democratic Editors; they were very enthusiastic about it; and said, when it is published, and a copy sent to each one of them, they would call the attention of the Public to it. I have been asked to exhibit it by conservative Republicans, as well as by Democrats.

Yours, Respectfully
Wm. S. Mount

P.S. Please answer and leave your note in care of M. Knoedler 772 Broadway, cor 9th st, as I expect to leave here on Monday next, 30th.

[NYHS]

WSM to Michael Knoedler

Portable Studio
East Setauket L. Island
March 26th, 1868

My dear Sir,

I made a great effort to meet you before you left your art rooms, but as I was disappointed, I took the picture to my cousins who reside No. 5, 20th st. I left the City the next day.

To give you some appreciation of my esteem I send you my Carte de visite. It will be gratifying to have yours when it is convenient.

I remain yours,
Very truly,
Wm. S. Mount

P.S. I expect to be in the City next monday 30th.

[NYHS]

WSM to George P. A. Healy

East Setauket L. Island
March 27th, 1868

My dear Sir,

It is gratifying that your reception was satisfactory. I noticed a day or two ago in the *World* that you were painting Gen. Sherman. I hope you will be successful. Your portraits have a spunk and vigor about them that excites my admiration; although not having seen your models, they must have a strong resemblance.

I shall be delighted to have your Carte de visite when it is convenient. I will color it, if you will tell me the color of your eyes.

Long may you live.

Yours truly,
Wm. S. Mount

[SB]

August Belmont to WSM

New York, March 30th, 1868

Dear Sir,

I am in receipt of your letter of 26th inst, offering me your painting.

As I have no longer any room left in my Gallery for new paintings, I am obliged to decline your kind offer.

I remain

Yours very truly,
August Belmont

[SB]

WSM to August Belmont

New York, March 30th, 1868

My dear Sir,

Your note of today is at hand. "On sober second thought," I have concluded not to exhibit the picture at present.

When agreeable to you, it will be gratifying to me (on some future occasion) to see your collection of paintings.

I expect to return to East Setauket L.I. on Wednesday of this week.

I remain yours,
Very truly,
Wm. S. Mount

[SB]

WSM to Eastman Johnson

East Setauket, L. Island
April 6th, 1868

My dear friend,

My list contains five works. Three small pictures: Mutual Respect, A charming scene in Autumn, Head of Ariel (horse head, a sketch). Two portraits, size of life: Gen. F. B. Spinola, Boy holding a flower in his right hand.

Please see that two or three of the five paintings have favorable positions; of course, with the approval of the hanging committee.

My regards to our worthy President.

I remain, yours truly,
Wm. S. Mount, N.A.

P.S. I do not know how many works my brother Shepard will have in the exhibition. I have not seen him since (about) the first of January. The varnishing day and the annual meeting—are great institutions. Yesterday morning (Sunday) we were surprised to find five inches depth of snow on everything where it could stick. The sun rising gave splendor to the scene. Regis Gignoux should have (been round) taking a view.

Cold ice in my studio this morning.

[NYHS]

T. C. Grannis to WSM

41 Fulton St.
N.Y. April 29, '68

Mr. W. S. Mount, N.A.

A personal friend and neighbor of mine, Mr. John A. Parker Jr. a landscape painter by profession, a man of fine talents and worthy in every respect, will be nominated as an "Associate" of the N.A.D. by Mr. Shattuck.

Mr. Parker is not aware of Mr. Shattuck's action in the matter. I take pleasure in calling your attention (and also that of your brother) to this case. Mr. Parker has been a regular contributor to the Academy exhibitions, and this year his picture, a work of merit, hangs well, in the North Room. I don't wish you to favor my friend unless you can do so conscientiously, and I have therefore taken this liberty in writing you, that you may be prepared to act understandingly.

I have mailed to your address my notices thus far of the Academy Exhibition and trust that you will do me the favor to read them and believe that I write for the good of the Academy. With my best wishes I am yours truly,

T. C. Grannis

P.S. Will you kindly call your brother's attention to this case.

[SB]

WSM to T. C. Grannis

East Setauket, L.I.
April 4th, 1868
[May 4 was probably intended.]

T. C. Grannis, Esqr

Your letter and the art notices in the N.Y. Commercial Advertiser are received. You have my thanks and my best bow in country style, for your well written article on portraits and pictures. 239 Morning Mists—from Chicorua, by your friend John A. Parker, Jr. I shall call the attention of several of the academicians, including my brother, to the above work, and believe Mr. Shattuck will do his best for your friend Mr. Parker.

My brother Shepard is at Oyster Bay L.I. painting the portrait of rear admiral Bailey. In his note to me about your writing on the Academy, he observed, He has said much in a few words, that pleases me.

I am yours truly,
Wm. S. Mount

Mount sent a copy of the above letter to Shepard with the following note:

Brother Shepard,

In his note to me—Mr. Grannis says: I take pleasure in calling your attention (and also that of your brother) to this case. Mr. Parker has been a regular contributor to the Academy Exhibitions, etc. I will show you his letter when we meet. You have my answer to his note.

[NYHS]

Thomas Addison Richards to WSM

New York University
June 21st, 1868

Dear Sir,

You may possibly remember that when I last had the pleasure of meeting you, I made some allusion to a review of the Academy Exhibition, which I was then preparing. I have since completed it, in ten parts, eight of which have already appeared in Mr. Bryant's paper—the *Evening Post*. Your own name occurs in the number of to-day; and thinking that it may amuse you, in the quiet of "Stony Brook," I take the liberty to forward a copy. When I see you in the fall I shall be glad to have you look over the other nine "visits," if you have not already read them. I have endeavored to write candidly and kindly and in a vein suited to the importance and interests of the Academy and of Artists and the Arts; though I have, perhaps, fallen greatly short of my aim.

Of course you must not judge of my labor by the single number which I now send you, but must see the whole before you decide upon its worth. I was very much gratified by my election at the last Annual Meeting as an Associate of the Academy, and I beg you to accept my most sincere thanks for the kind share which I feel persuaded you took in procuring me the honor. You know that I occasionally furnish some of our city papers and others with items of "Art-News," and if you would be so kind as to let me know, now and then what you are about in your own studio, I shall esteem it a favor, which I will endeavour to repay as well as I can. I leave directly for my summer rambles, but any communication addressed to me at New York will be duly fowarded to me.

Do not, at this moment, think of any news which it would interest you to hear. As most of the artists are out of town or are preparing to depart, of course there is very little to be said of new pictures at present. I hope you are

preparing some agreeable surprise for us, under the influence of the cool and pleasant ocean breezes in summer. I have, as you will observe, returned to my old quarters in the University, where I shall be glad to see you, when you happen to visit the city, after my own return in October next.

> Very truly yours,
> T. Addison Richards

P.S. The authorship of the Notices in the *Post* is not *public*.

[SB]

Theodorus Bailey to WSM

> The Anchorage at
> Oyster Bay, Sept. 25th, 1868

My dear Mount,

We were much shocked on taking up the *Evening Post* to find that our friend, your gifted brother had passed from among us. During the brief five weeks that he was engaged on my portrait and an inmate of my family, we found so many traits of character to admire that we sincerely join you in sympathy in mourning his loss. Although dead, he still lives in the history of his Noble Art. His name and works are perpetuated on Canvas, and will continue as long as Virtue and genius are admired.

The Portrait he took of me he considered his best effort, and had arranged to call on Varnishing day at the fall opening of the Academy of design, and take it there for exhibition.

The portrait he took of me and the one you painted some years ago, are both considered admirable paintings as well as likenesses—unlike each other, *yours* has spirited action, and *his* calm repose; people differ as to which is the best—they both bear the marks of genius.

We would be well pleased to have you visit us on your way to the fall opening of the Academy.

With condolence from your loss

> I remain Very truly,
> Your friend
> Theodorus Bailey

[SB]

WSM to Alden J. Spooner

> Portable Studio
> East Setauket, L.I.
> Sept. 26, 1868

My dear friend,

It is gratifying to hear from you. I thank you for your sympathy. Brother Shepard always esteemed your friendship.

At your request I send you the particulars of his illness. He was slightly indisposed for a few days and on the 10th inst, was suddenly prostrated by Cholera Morbus; he was relieved of that and became quite hopeful. On Saturday 12th, in the evening, dysentery set in which so reduced

him that there was no chance for recovery. Still, everything that medical skill, together with the most watchful and devoted care of loving hearts and hands, could do for the alleviation of his sufferings was done by day and night, until the last going out of his immortal spirit on Friday 18th, at 15 minutes to 7 P.M. Brother retained his consciousness and interest in everything to the very last moment, and expressed himself to me and his sister Mrs. Seabury as being perfectly happy. He seemed to be gazing with admiration into the spirit world, and exclaimed "how beautiful." He smiled, "I am coming" motioning with his hand. Then, after remaining in quiet thought a few moments, turned on his right side, drew a few short breaths and expired.

Shepard was as your son Frank states "a most loveable man."

"The old double door" shall be opened when ever you feel inclined to come this way; friends young and old will be pleased to give you a hearty welcome. My regards [illegible].

> I remain as ever,
> Yours sincerely
> Wm S. Mount

P.S. As soon as the rainy season is over I am ready to make some sketches from nature. Boarding with farmers gives one an opportunity (owing to early rising) to see the sun rise, which is often more beautiful than the sun setting.

[NYHS]

W. Alfred Jones to WSM

> Norwich Town Conn
> Sept 26, 1868

Dear Sir,

I was grieved and shocked to learn from a letter of Lydia to my wife last week, of the sudden death after a short illness, of your dear brother and most worthy man, Shepard A. Mount. A few days after I was gratified by reading the article in the *Evening Post,* in which justice is done to him as an artist and as a man. I am glad to have put on record on two or three occasions, some years ago, in brief, occasional paragraphs, my imperfect but sincere estimate of your excellent brother's talent and success. And tho' for several years past I have been so unfortunate as to have enjoyed very little of your society; only at rare intervals for short interviews; yet I have enjoyed during the last two or three years of my residence in N. York, his company, at dinner and tea and of an evening, several times, and last winter or this spring, I met him for the last time, on a visit on 23rd St. He was then as genial, as kind, and single-hearted as ever, full of intelligence and humor and vivacity. He was, confessedly, a good, care-free, *honest,* artist, a most attractive and agreeable companion, a *gentleman,* in all his feelings, and judgment, and conduct, a pure minded, humane, upright, liberal, practical christian. I always cherished a sincere regard and

esteem for him, and *he* always evinced a kind feeling for and sympathy with me. With other affectionate relations and admiring friends and pleasant acquaintances, you will still find it impossible to fill his place. He had a true brotherly affection for you, and just as well, sound appreciation of your peculiar genius. He properly regarded you as the *man of genius,* to which he laid no pretensions: tho' his fidelity, and heartfulness, as a man, were leading traits in his character as an artist. He had *talent* and observation and love of nature. As a man, he was the peer of the best, in all the honorable qualities of manhood. I condole with you and your sister and all of his relations, and connections, heartily and in sincerity. Please assure Mrs. Seabury of *our* sympathy with her and yourself and of my good wife's genuine regard for your brother and respect for his memory, no less than my own feeling towards him.

> I am, very truly, your old Friend
> and cordial admirer
> W. A. Jones

[NYHS]

WSM to Theodorus Bailey

> Portable Studio
> East Setauket L.I.
> Sept 29th, 1868

My dear friend,

Your noble letter of condolence, in sympathy at our great loss, is sensitively appreciated.

Shepard Alonzo Mount was a good brother; a "most loveable man" and a fine artist. He was daily improving in his art up to the time he was stricken down upon a sick bed, by Cholera Morbus. Every attention was paid him night and day to the last going out of his immortal spirit on Friday Sept 18th at 15 minutes to 7 P.M.

It will afford me great pleasure to call and see you. I have not been notified about the fall exhibition; but, will endeavor to see that your portrait (among his last works) shall be in the exhibition this fall or next spring.

> I remain very truly
> Your friend,
> Wm S. Mount

P.S. Extract from Mr Spooner's letter, speaking of brother, "Art had not a more modest and spiritual devotee. We are all made better by such a life."

[SB]

WSM to W. Alfred Jones

> Portable Studio
> East Setauket L. Island
> Oct 2nd, 1868

Wm. A. Jones Esqr.

Your noble and heart-felt expressions of condolence is a balm for our great loss. Shepard was to me a sympathiz-

ing brother; he loved his friends and you in particular. As you express in your letter of condolence, he was "a gentleman, in all his feelings—judgment, and conduct." "He was confessedly a good, careful, *honest,* artist, a most attractive and agreeable companion," etc.

Mr. Alden J. Spooner says of him, in his note of the 26 inst. "Shepard Alonzo Mount was a most loveable man" —he also remarked "Art had not a more modest and spiritual devotee—we are made better by such a life."

Shepard was earnest in every thing he undertook, and consequently was daily improving in the art he loved up to the time he was stricken down upon a sick bed, by cholera-Morbus. Every attention was paid him night and day to the last *going out* of his immortal spirit, on Friday 18th at 15 minutes to 7 P.M.

Extract of a letter I sent to Mr. Spooner: Brother retained his consciousness and interest in every thing to the very last. And expressed himself as "perfectly happy." He seemed to be gazing with admiration into the spirit world, and exclaimed "how beautiful!" He smiled and said "I am coming" motioning with his hand; then, after remaining in quiet thought a few moments, turned on his right side, drew a few short breaths and expired.

I send you a publication from the *L. Island Star* Setauket, a letter of condolence from my friend Rear Admiral Bailey.

Your letter which I hold in my hand I shall retain in greatful remembrance. Please give My regards to Mrs. Jones.

> I am very truly
> Your friend
> Wm. S. Mount

P.S. I believe, my sister Mrs Seabury and Maria have gone off traveling. I have laid down the gold and steel pen for a season. This letter I have written with a quill; they have more spring and are moved over the paper with greater freedom.

Brother Shepard always wrote with a quill.

[NYHS]

William Handy Ludlow to WSM

> No. 149 Broadway
> New York, Oct. 28th, '68

Dear Sir,

Every style connected with the candidacy of H. A. Reeve, has been full of mischief to the Democratic party of our district.

So utterly unfit is he for public position, that he could not be elected even if another candidate, beside the Radical, were not in the field. It seems to be criminal folly, for a man thus to force himself on the party, through the medium of a nomination obtained by fraud, in excluding regular [illegible] and admitting bogus ones.

He was nominated by the vote of Robert Chrystie of Richmond who had no more right to a seat in the con-

vention than you or I. Dwight Townsend, the other candidate, has a good record, and is as regularly nominated as Reeve.

Townsend has been endorsed by the county convention of Richmond, Va. and will make a good run. He will be supported by prominent Democrats of Queens and Suffolk. I hope that you will do all you can to give Townsend a good vote at your polls.

<div style="text-align: right">

Yours truly
Wm. H. Ludlow

</div>

[SB]

James Bogle to WSM

<div style="text-align: right">

New York, Oct. 28, '68

</div>

My Dear Wm Mount,

Your favor of the 25th I received this evening. You are coming doubtless to the November Exhibition and have to stay somewhere in this great Bedlam. Cant you bring your little *lute* and take up your abode with us? We can give you a good bed and homely fair, but a great plenty such as it is. By so doing you will gratify my Son and myself and make us happy for a few evenings. You have older friends who have greater and older claims upon you, but I love music and love you, and my son understands music (which I dont) and this place is central and will be convenient to you—come, come!

Answer directly—

<div style="text-align: right">

Yours Affectionately
James Bogle
77 3thd Ave.

</div>

[SB]

WSM to Theodorus Bailey

<div style="text-align: right">

East Setauket, Long Island
Oct. 30th, 1868

</div>

My dear friend,

Your letter of the 29th is at hand. You have spoken so well of my brother Shepard that I was greatly attached to you; and therefore, took the liberty to ask you to assist me in forwarding your portrait to the Academy which you so kindly offered to loan to the Exhibition.

You have done no more than hundreds of Gentlemen have done, there is nothing "egotistical" about it. I have been sorry since I wrote you, that I did not simply ask you to forward the portrait to the City, and you to notify me of its whereabouts—and I would cheerfully have had it sent to the Academy and returned it from N.Y. to your house, at Oyster Bay, with my own hand, free of expense —that I will do now. Send the portrait to your brother's residence in the City, or at any other place, and drop a note to me while I am in the City, concerning it, and I will see that the Academy sends for it. It is my expectation to visit the City on next Tuesday morning Nov. 3rd. I cannot go earlier, in the week. Please see that your letter reaches me by Nov. 3rd, or 4th—direct your note to Wm S. Mount, National Academy of Design, N.Y. care of Mr. Richards.

When you sympathize with artists, *you are among your friends,* and not with enemies.

<div style="text-align: right">

I remain, as ever,
Your sincere friend,
Wm. S. Mount

</div>

[NYHS] *This is the last known document from William's hand. He died of a sudden attack of pneumonia at the home of his brother Robert Nelson Mount on November 18, 1868, two months and a day after the death of his brother Shepard.*

funeral eulogies

Gathered here to pay the last sad tribute of respect to the remains of one, whom living, all loved, whom dead, all lament—I would that some life-long friend of the departed occupied my place this afternoon.

He could pay, as I cannot, a deserved and intelligent tribute, to the many excellent traits in his character of whose existence, even my brief acquaintance convinced me.

To his genial disposition; generous nature; warm sympathy and unselfish efforts to promote the happiness of old and young—you his life-long friends and neighbors bear ample testimony—

"Even his failings leaned to virtue's side."

In his vocation he had few superiors, and his peers were hard to find.

His fame as an artist is not limited to the place of his nativity. To every lover of the humorous and the picturesque acquainted with the history of art in this country; there is no need to speak of the excellence of his productions.

Says a master critic, writing of him some ten years since, "The paintings of Wm. S. Mount, one of the few American Artists that deserve to be called painters, are of a strictly national character; the pride and boast, not only of his native Long Island, nor yet of the State of New York solely, but of the whole country."

To the brotherhood of the Academy of which he was an honored member, his death will be a heavy blow.

The breach occasioned by the death of the Brother artists Shepard A. and William S. Mount will not soon be filled. The Providence which has removed from earthly scenes (in quick succession) the two brothers by more than a natural tie—by that community of feeling which a pursuit of the beautiful in the same branch of art begets— is indeed mysterious. Says the same authority quoted above—"It is delightful to witness the frank and generous pride of the brothers in each other and their family connections, an instance of brotherly sympathy, and disinterestedness as rare as it is grateful. Thus lovely and pleasant in their lives, in their death they were not long divided.

"Death which knocks with equal step at cottage door and palace gate—lays low the head that plans—and palsies the hand that with a cunning skill fixes upon canvass those embodiments of grand ideas—or representations of every-day life—which delight our eyes, instruct our minds and touch our hearts."

Under any circumstances death is solemn: but when it suddenly removes from our midst those *honored* and *beloved,* who a short time since were in the flush of health, we are *startled.* This community mourns its *loss.*

The immediate relatives are called to mourn the death of another of their loved ones, in whose society they found

rare *pleasure* and of whose *sympathy* and *love* they were well assured. Of the extent of their loss we can know but little— "The heart knoweth its own bitterness, even as with its chief joys a stranger intermeddleth not." To *them*, to *us all* this dispensation of God's Providence speaks of the *uncertainty of life*.

"It is even as a vapor which continueth for a little time and then vanisheth away"—"We are like the grass which groweth up in the morning— In the evening it is cut down and withereth."

What an impressive commentary have we in these remains from which the soul has departed—upon the words of the prophet, Isaiah LXIV/6, "We all do fade as a leaf."

The process of growth and decay, is constantly going on. We no sooner begin to live than we begin to die. If this process goes on, uninterrupted by fell disease or direful accident, the growth at first overmasters decay, and our bodies develop and mature—but life's summer past, its autumn sets in. As if it would still triumph over decay, a healthy flush is upon the cheek, a brighter flush in the eye—but ere we suspect it, decay triumphs and the body quickly *withers* and *dies*—or lives on to the winter before its relation to the spirit is severed and the one returns to the earth from which it came, the other to God who givest.

To all *appearance* our friend was in the prime of life—in reality it was but the *flush* of autumn. He was ripening and decaying faster than we suspected—decay gained the victory—and to day its work is before you to preach more instructively and solemnly than human lips can do. Put not your trust in the flesh, for it cannot abide in time of trial. Look not forward with certainty to an old age—ere you are aware in the early autumn a sudden wind may blow upon you—and you will become as a withered leaf, and will be left to mingle with the kindred dust.

How slow we are to learn this profitable lesson. Our desires for life and the things of the world are such that we persuade ourselves—though life is uncertain for others for us it is certain. Yet every where are to be soon evidences that "we all do fade as a leaf." The grave yard with its silent monitors teaches the salutary lesson that we too must lie beneath the clods of the valley. The hushed household—the noiseless performance of necessary duties—the tearful countenances—the mute throng gathered about the couch of the dying—remind us that death has come to sadden our hearts by the removal of those dear to us.

The scenes of earth are constantly changing—the ties which bind man to man in the various pursuits and relations of life are scarcely formed before a stern necessity severs them. The marriage bells scarcely cease their chiming before the funeral knell is heard. The wail of the newborn infant mingles with the groans of the dying. Strong manhood supports feeble old age—while both may be on the brink of the grave. Changes are inevitable and *death is certain.*

Yet on this brittle thread of existence hang the weight of our immortal destinies. Solemn as it is to die, it is fearfully awful and solemn to live—for there is a work to be done while life lasts—or it had been better that we had never been born.

Let a sick man neglect his remedies—let a man bitten by a venomous serpent suffer the poison to spread; (carrying every pulsation to hasten the approach of death) —let a man with his house in flames suffer them to compass him about (and render certain to him a painful death) and we would call him wise compared with one who hazards his chance of securing eternal joys at God's right hand—upon the uncertainty of life. [Phrases in parentheses were marked "Omit" in the manuscript.]

Be admonished then to improve the present moment —now in time of health prepare for sickness, in life prepare for death. What to us are the possessions the honours the enjoyments of earth—they cannot go with us beyond the grave. Whether our share of these be large or small, it matters not, if we have formed in us by God's Holy Spirit, that spiritual character which constitutes the only substantial difference between men. The beggar in the parable was rich in faith, was a member of God's Family wise unto everlasting life, clothed with the righteousness of Christ—these were his passports to the condition of security and repose upon Abraham's bosom. Rich in the same faith—heir of the same inheritance—wise with the same wisdom—clothed with the same righteousness—we will be prepared to live, to properly appreciate all the advantages attendant upon our earthly condition— and death will be to us the gateway to eternal life.

Be then admonished by the uncertainty of life as pictured in the fading and fallen leaves and by these mortal remains, and prepare for the change that awaits us all— prepare to meet God, both in his coming at the hour of death, and at his coming with his holy angels to judge the world.

To all who hope in Christ, death is but a sowing of the natural body that it may be raised a spiritual body. All such can exultingly cry "O death where is thy sting and where thy victory boasting grave." In what has now been said of the uncertainty of life and the consequent necessity for a preparation to come before our maker to be judged of the deeds done in the body—whether they be good or whether they be evil—I have not presumed to sit in judgement upon him whose death is the occasion of these solemn warnings. Of his inner spiritual life I know less than of his outward conduct—my intercourse has been limited to a few casual meetings. Nor is it the province of any human being to pass sentence upon a fellow creature who has been called into the presence of his Maker. At the same time it is our privilege, our duty, so to live—to have such evidence of God's presence with us, to give such evidence to the world around us—that our friend may have a well assured hope of meeting us again in the Mansions of Our Father's house.

The following testimony of one who knew him well I present to you. I neither assent or dissent from anything therin contained. ~~It is my fervent prayer that~~ Rejoice if the hope expressed in the closing sentence is even now realized:

"Always *conscientious,* scrupulously *just* and imbued with the highest principles of *honor* and *integrity*—he was yet a man of so genial and sunny a spirit, that many I have no doubt classed him among the *gay* and *careless,* giving him credit for no depth of thought or feeling. In this they erred: The last time I saw him in health his heart was softened by the heavy stroke of sorrow occasioned by the loss of his dear brother, and he made several remarks which indicated more thought and feeling upon the subject of religion, its *importance,* and *consolations,* than I ever thought to hear him utter. I trust, I believe he has gone home, safe, safe in the bosom of his God."

From a published sketch I glean a few particulars of his life. Familiar, they will yet be of interest to you all. He was born at Setauket L.I. Nov 26th, 1807. At the age of 17 he went to the city—and in 1826 entered as a student the National Academy of Design. The next year he returned to this place—partly on account of health and recreation, but chiefly from a native preference for its quiet and the innocent pleasures it affords. He imagined himself destined to succeed in SS. [sacred?] pieces. The 1st painting he exhibited at the Academy was Christ raising the daughter of Jairus, the original pen and ink sketch of which Prof Morse, then President of the Academy, was slow to believe the production of an artist this side of the Atlantic.

His place as an artist is not easily assignable. He was an original painter, a follower of no school, an imitator of no Master. His subjects were not easily represented, because chosen for common life, the grand and fearful are of much easier representation than the trifling and the little. His best works are in a word humorous pastorals with sweetness and fine tempered satire (where there is any at all); no bitterness, no moral obliquity or personal deformity impair their effect. They present a picture of country life, at once satisfactory for its truth and agreeable in its aspect and general features. His character is reflected in in his works—his sweetness of temper, purity of feeling, truthfulness, gayety of heart, humorous observation and appreciation of homely beauties of nature that were overlooked by the common eye.

Such was he whose place at your firesides, in your social gatherings and in your hearts will not soon be filled.

While we commit his body to earth his spirit is in the keeping of Him who judgeth righteously—whose sentence in regard to our dear departed, whatever it is, will be so explained in the light of Eternity that we can only say—Holy—Holy—is the Lord.

[SB]

The following resolutions adopted by the Council of the National Academy of Design, of which the late lamented William S. Mount was an honored member, will be of interest to our Readers:

"National Academy of Design,
In council, Nov 30th, 1868

The council of the Academy hear with deep sorrow of the death of their fellow member, Wm. Sidney Mount, N.A., so long associated with the Institution as one of its earnest workers and cherished ornaments.

We remember with great interest the many productions of his pencil, in which incidents of domestic and rustic life have been delineated with marked originality, and vivid, truthful character; and we believe they will always be treasured for these invaluable qualities.

As a friend, he was greatly endeared to us by his frank, cheerful and manly character, the wit and humor which brightened his social hours, and by the geniality and warmth of disposition which pervaded his daily life.

We sincerely sympathize with the family in the double affliction they have sustained by the loss of two brothers so admired for their talents, and beloved for their kindly virtues."

By order of the Council,
T. Addison Richards
Corresponding Secy. N.A.

Schedule B of the papers, which includes a list of the paintings left in Mount's studio at the time of his death, is a document of first importance in terms of art history. The other papers are of considerable biographical interest.

A.F.

estate papers

Surrogate's Court, County of Suffolk.

In the matter of the accounting of
Robert N. Mount, Ruth H. Seabury and
Thomas S. Mount, as the administrators
of the estate of Wm. S. Mount, deceased.

We, Robert N. Mount, Ruth H. Seabury, and Thomas S. Mount, of the town of Brookhaven, in the County aforesaid, do render the following account of our proceedings as administrators of Wm. S. Mount, late of the town aforesaid, deceased.

On the eleventh day of January 1869, letters of administration of the goods, chattels and credits of the said deceased were issued to us. On the sixteenth day of August following we made and completed an inventory of the personal estate of the said deceased, and caused the same to be filed in the office of the Surrogate of the County of Suffolk.

On or about the fifth day of August 1869, we caused a notice for claimants to present their claims against the said estate to us within the period fixed by law, and at a certain place therein specified, to be published according to law, for six months pursuant to an order of the Surrogate of the County of Suffolk.

The settlement of the estate has been one of unusual difficulty. The deceased was unmarried. He died after a very sudden illness of a few days duration. The extent of his property, its location and the nature of it (except the articles apparent to every one) were unknown. His effects were much scattered. It was not until after a diligent and protracted search that any evidence of deposit was discovered. Considerable personal property consisted of oil paintings. A few were finished, the most unfinished, a few barely commenced. In July and August 1870, a very considerable portion of the effects, consisting of sketches, engravings and the like, were divided among the next of kin.

In April 1871, about thirty-three pictures and sketches were offered for sale at public auction by Robert Somerville, at his salesrooms in Fifth Avenue in the City of New York— The result of such sale is hereto annexed.

In January 1873, a division of the pictures unsold was made. The money on deposit had been drawn and divided among the next of kin, according to their respective shares, as far as the same could be ascertained before a final accounting.

The only debt due the estate we have been able to find is a note of $400, which at the time of the appraisal was

considered as good as cash and was entered as such in the inventory. Of this note we have been able to collect but ($75) seventy-five dollars. We have delayed our account from time to time in the hope and expectation of collecting the balance.

But a few articles remain as effects of the estate, wholly insufficient in ordinary cases, we believe, to justify a public auction. Yet under the circumstances, we deem it necessary, and propose at once to direct a sale, to divide the proceeds among the next of kin, and immediately to make a supplementary account.

Schedule A, hereto annexed, contains a statement of all moneys received by us in the course of the administration—and the sources whence the same were derived.

Schedule B, hereto annexed, contains a statement of all the property sold by us at public or private sale, with the prices and the manner of sale, which sales were fairly made by us, at the best prices that could then be had, with due diligence as we then believed. It also contains a statement of all the debts due the said estate which have been collected and also all debts due the estate not yet collected.

Schedule C, hereto annexed, contains a statement of all the claims of creditors presented to and allowed by us, together with all moneys paid by us to the creditors of the deceased, their names and the time of such payment, and the expenses of the administration.

Schedule D, hereto annexed, shows the names of all persons entitled, as next of kin of the deceased, to a share of the estate, with their places of residence and degree of relationship.

Vouchers are hereto annexed, which with the schedules aforesaid form a part of our account.

Robert N. Mount
Thomas S. Mount

State of New York
County of Suffolk

Robert N. Mount, and Thomas S. Mount, of the town of Brookhaven in the County aforesaid being severally sworn, does each for himself depose and say that he is one of the administrators of all and singular the goods, chattels and credits of Wm. S. Mount, late of the town of Brookhaven deceased, intestate, and that the annexed account is in all respects just and true; that the same, according to the best of his knowledge, information and belief, contains a full and true account of all his receipts and disbursements in account of the estate of the said deceased and of all sums of money and property belonging to the estate of the said deceased, which have come into his hands as such administrator or which have been received by any other person by his order or authority, for his use; and that he doth not know of any errors or omissions in the said account to the prejudice of any of the parties, mentioned in the estate of the said deceased.

Sworn to before me this
19th day of August 1874.

Edward Oakes Robert N. Mount
Notary Public Thos. S. Mount

County of Suffolk, St.

Thomas S. Mount, one of the administrators within named, being duly sworn says that the sums under twenty dollars, charged in the said account, for which no vouchers or other evidences of payment are hereto annexed, or for which he may not be able to produce vouchers or other evidence of payment, have actually been paid and disbursed by him as charged.

Thos. S. Mount

Sworn to before me this
19th day of August 1874.

Edward Oakes
Notary Public

Schedule A. *Administrators' statement of moneys received and of moneys paid to the heirs of S. A. Mount.*

Cash on hand at decease of intestate...............................	$ 118.47
Money received from Bank for Savings...........................	3578.48
" " " Bowery Savings Bank.......................	2142.79
" " " Sale of pictures	885.00
" " " Sale of other articles	160.25
Money collected on note of Thomas S. Seabury	75.00
Whole amount received	$6959.99
Paid in debts and expenses of administration	1299.32
Leaving ...	$5660.67

One fourth of $5660.67, the portion of
the heirs of Shepard A. Mount........................ $1415.17

Wm Shepard Mount has received........ $450
Joshua E. Mount and heir, recd........ 450
Robert H. Mount has received.......... 450

$1350.00

Amount now due said heirs........................... $ 65.17
Balance now due Mrs. Edna Wilson, as
guardian of the heir of Joshua E. Mount $21.72

Thoms. S. Mount
one of the administrators

Schedule B. *Pictures of the estate of Wm. S. Mount, sold and unsold by Robert Somerville, New York, April 10th & 11th, 1871*

	Unsold	Sold	Name	Unsold	Sold
No 32		1	Cracking Nuts....................		25.00
33	1		The Old Mill.....................	35.00	
35	1		Coming from the Orchard	180.00	
43	1		Bouquet of Beauty	30.00	
45	1		The Mower.......................	50.00	
49	1		Banjo Player	50.00	
59	1		Stony Brook Mill Dam	60.00	
62	1		Dawn of Day.....................	130.00	
75	1		Snow Balling	80.00	
76	1		Laying on his oars	35.00	
77	1		Washington Crossing the Alleghany ..	40.00	
118		1	Waiting for the boat...............		30.00
119	1		The Old Grave Yard	22.00	
127		1	Waiting for the Tide..............		45.00
128		1	Glimpse of the Sound		20.00
134	1		Early Spring	250.00	
135		1	Flowers		17.00
136		1	Landscape		28.00
137		1	Shrine...........................		42.00
146		1	On the Hudson		28.00
147		1	Old Woodhull Homestead		68.00
153a		1	Landscape		35.00
153b		1	Charity Sketch for Cole		20.00
157	1		Exchange is no Robbery............	270.00	
158		1	Daniel Webster		25.00
161	1		Card Players	190.00	
162		1	Waiting for the packet		41.00
163		1	Kitchen Fireplace		105.00
164		1	Primitive Times...................		25.00
166	1		Cherries	12.00	
167	1		Sportsman at the Well..............	220.00	
169		1	Setauket Harbor..................		30.00
181		1	Catching the Tune		300.00
				$1654.00	$885.00

Gross receipts—sum | $885.00

Auctioneer's Comm.—10 p.ct. on sales $88.50

" " 5 " " residue 82.70

In all.................................... $171.20

Bill of Thoms. Wilmont for frames.................. 351.45

$522.65

$522.65

Balance ... | $362.35

Other property sold by general consent of all parties:

Gold watch and chain........................... $65.00

1 Trunk 13.00

1 " 1.00

1 " 1.25

Piano 30.00

Studio 50.00

Debts due the estate:

For a sail boat, money not yet collected—$40.00.

For a Promissory note by Thomas S. Seabury to Wm S. Mount on order dated October 18, 1867, in the sum of $400.00, with interest from date. Two payments have been made on this note and endorsed thereon: One June 8, 1868, of $30. and one 22nd of April, 1874, of $75. No other payments have been made.

Robert N. Mount
Thoms. S. Mount
Executors

Schedule C. *Bills paid and expenses of administration*

1868

Nov	19	Notices sent to daily papers	$ 1.75
"		Bill of Carleton Jayne.................	5.68
"	21	" " E. A. Raynor	58.00
"		" " Robert Dykes	3.00
Dec	28	Notary fees—stamp on bond	2.66
"		Farm Taxes. Paid by R. N. M..........	7.64

1869

Jan	2	Notary fees68
"	12	Surrogates for Stamps and postage	3.12
"	28	School tax for building school house in Setauket, by R. N. M.	2.11
"		Bill of Dr. H. S. Dering..............	7.00
Feb	1, 2 & 3	Expenses to New York 3 days. Fare both ways being 4.10. And hotel	7.50
"	22	Bill of Oran W. Rogers	4.00
March	24 & 25	Expenses to New York 2 days	7.10
"	25	To Sperry (Gave) for boxing pictures—$3. Expense—$1..........	4.00
June	19	School tax.........................	1.45
Sept	25	Expenses to New York 2 days	7.37
"	30	School tax at Stony Brook	1.37
Oct	12	School tax paid by R. N. Mount at Setauket80

Nov	15	Expenses to New York	7.36
"	26	Farm taxes, 2/7 of 7.99	2.28

1870

Jany	11	School tax	2.79
"	"	Postage affidavit and stationery.........	1.56
Feb	15	To H. Markham for printing notice.....	5.00
"	17 & 19	Expenses to New York 3 days.	7.93
"	19	Internal Revenue tax	108.00
"	21	Road tax, $1. Postage 24. c	1.24
Aug	4	School tax.	2.20
Oct	31	Bill of J. N. Gould	9.85
Dec	19	Farm taxes, 2/7 of 9.38	2.68
		Appraisers fee	6.00

1871

Jany	31	To Edward Smith and Store...........	170.00
March 9 & 10		Expenses to New York	9.01
March 15		" " "	3.00
March 10, 11, 12 & 13		" attending sale	16.25
"	10[?]	Bill of J. G. Hawkins, packing	
"	"	pictures...........................	3.00
"	"	Freight on pictures from New York.....	1.00
"	13	Auctioneer's Commissions on Sale of	
		pictures	171.20
"		Thomas A. Wilmont's bill for frames ...	351.45
July	29	School tax for September 1870	1.84
Nov	27	Balance to E. Smith, Sculptor	33.90
		Expenses of R. N. Mount	44.40
		Commission on 1st $1000—or 5 p.ct ...	50.00
		" " balance	149.00

Total to date...................... $1299.32

Dated Aug 19, 1874

<div align="right">

Thomas S. Mount
one of the Administrators

</div>

Schedule D. *Next of Kin of Wm. S. Mount, deceased*

Robert N. Mount	a Brother	residing at Setauket, L.I.
Ruth H. Seabury	a Sister	residing at Stony Brook, L.I.

The only children of Henry S. Mount, deceased brother of Wm. S. Mount, surviving at the decease of the intestate are:

Thomas S. Mount	Nephew	resides at Stony Brook, L.I.
E. Ford Mount	Niece	" " " "
Evelina Mount	"	" " " "
John H. Mount and	Nephew	" " Glen Cove, L.I.
Malcolm Mount	"	" " Gilroy, Cal.

Schedule D
Continued

The only children of Shepard A. Mount, deceased brother of Wm. S. Mount, surviving at the decease of the intestate were:

Wm. Shepard Mount, Nephew, residing at Galveston, Texas
Joshua E. Mount " now deceased
Robert H. Mount " residing at Glen Cove, L.I.

All are adults but Robert H. Mount, who has George Searing of Glen Cove as general guardian.

Joshua E. Mount left one child him surviving whose guardian is Mrs. Edna Wilson, of the city of Brooklyn.

The intestate left him surviving no other Brother or Sister, and no father, mother, widow or child.

> Robert N. Mount
> Thos. S. Mount
> Administrators

mount paintings: four catalogues

This final section falls into four parts. The first, longest, and most important is Mount's own catalogue of his works. It fills forty-five of the fifty-seven pages in a notebook preserved at Stony Brook and covers his output from 1825 to 1866, two years before his death. Mount interlarded the entries with numerous asides, most of them autobiographical. The last twelve pages of the notebook, which I have omitted, are filled entirely with extraneous matter: quotations from unspecified sources regarding the technical procedures of various old masters, autobiographical notes which are repeated elsewhere, and comments on the Long Island weather in 1856 and 1857.

The second part of this section lists the paintings by Mount that are mentioned in his diaries and letters but omitted from his catalogue; the third part lists extant paintings not mentioned in any of the documents; and the fourth lists the more important contemporary engravings and lithographs after Mount.

In parts two and three I have followed Mount's lead in listing only completed paintings; insignificant oil studies, the watercolors, and the drawings are ignored. The oil studies and watercolors are relatively few and relatively unimportant. The drawings are numerous and often superb. There are vast heaps of them at the Metropolitan Museum of Art, at the New York Public Library, and especially at Stony Brook. Organizing, correlating, preserving, and publishing these drawings would be a project in itself, and one that should be undertaken—perhaps by a team of students. Some day, when the art history department of the State University of New York at Stony Brook achieves sufficient maturity to recognize the existence of a major art-historical treasure in its own front yard, this may be done.

A fifth part of this section which I anticipated having to compile has, mercifully, proved to be unnecessary: a list of faked or misattributed paintings. Since three members of the Mount family besides William Sidney were painters, one would expect a great deal of confusion between them, but in actuality there has been very little. Henry died young and painted only a few pictures, and his crude, forceful style is impossible to confuse with William's. Evelina was a hopeless amateur; she had no style at all. Shepard was as thoroughly professional an artist as William Sidney himself, and since they were trained in the same school and practiced among the same class of patrons at the same time, mix-ups between the two would seem to be inevitable. But there have been very few and they are not important. Shepard confined himself more to portraiture than did William Sidney, and he traveled more extensively; he stayed out of his brother's way a good bit of the time, and much of his work, one suspects, is languishing or lost in places far from Stony Brook.

In the eighteen years during which I have specialized in Mount, only one serious attribution problem has arisen. A painting in the Berkshire Museum in Pittsfield, Massachusetts, is catalogued there under the unrevealing title of *Landscape;* it is actually a genre scene wherein a hunter is displaying a freshly killed game bird to a man, wom-

an, child, and dog before a broad river valley. This painting has an excellent Mount signature and was given to the Berkshire Museum in 1915, at a time when the artist's reputation was at its lowest ebb; there would have been no reason whatsoever to fake a Mount during that period. Measuring 41 by 50 1/2 inches, it is the largest known painting attributed to William Sidney Mount, and by virtue of this fact alone one would expect some notice to have been taken of it in the literature. But there was not one word about it anywhere, either in the Mount documents or in any of the printed references to him which I had collected in many years of research. The painting seemed stylistically to belong to Mount's last years. Conceivably it was one of the very last things to leave his easel, too late for documentation in his catalogue. I therefore included the picture in a William Sidney Mount centennial show that made the rounds of the country's museums in 1968.

The exhibition had not been on the road a week when art-historical colleagues, notably Stuart P. Feld, began insisting that the Berkshire picture was not a Mount at all, but was characteristic of the work of Mount's contemporary, Jerome Thompson. One of Thompson's finest pictures, a large picnic scene in a mountain setting, is in the permanent collection of the M. H. de Young Memorial Museum in San Francisco, and when the Mount show reached the de Young, a group of us put the two paintings side by side and made detailed comparisons between them. There could be no question at all that the figures in the Berkshire picture were by Thompson; they were identical in style, and some of the very faces in Thompson's picnic showed up again in the presumed Mount. But the landscape in the Berkshire picture resembles neither Mount nor Thompson, and it is possible that still another hand is involved here.

The presence of a highly characteristic Mount signature on the Berkshire picture remains to be explained. In his diaries Mount often speaks of going to the homes of his patrons and touching up their pictures, his own as well as those painted by other artists. He is known to have gone to the studio of William Ranney after that artist's death and, at the urging of his widow, to have completed the unfinished paintings he found there. At Stony Brook is a picture inscribed on its back, "Landscape by A. D. Shattuck, by particular request figures introduced, March 17, 1859, by W. S. Mount." The painting at the Berkshire Museum must have undergone similar treatment, but it is impossible to determine what Mount's contribution to it may have been.

In editing Mount's own catalogue for publication, I interpolated the names of current owners of the paintings wherever it was possible to do so. Nearly all of Mount's major works are now in the permanent collections of museums and are likely to remain so. The paintings in private hands—mostly portraits, small landscapes, and small still lifes of flowers—are not so settled. Their ownership is constantly changing, and a listing set down today is likely to be incorrect tomorrow. Furthermore, many owners of Mounts prefer not to have their ownership made public, and some have not responded to repeated requests for information about their holdings. As a result, in this book at least, most of the privately owned Mounts show the designation "private collection," plus the name of the city in which that collection may be found. The names of museums and other public institutions owning Mounts are written out in full, except that the phrase The Museums at Stony Brook has been abbreviated to SB. Paintings in the Melville Collection carry the additional abbreviation MC. Where there is no ownership information, those Mounts about which photographs and other data are on file at the Frick Art Reference Library carry the notation FARL. The main purpose of these notations is to indicate that the paintings in question are known to exist. Paintings about which nothing is known are listed here without designation of any kind. Wherever a picture is known by more than one title, the alternate follows immediately in brackets.

A.F.

CATALOGUE OF PORTRAITS AND PICTURES PAINTED BY WILLIAM SIDNEY MOUNT

Throughout his catalogue Mount follows no systematic practice as regards height and width, sometimes listing one first, sometimes the other.

Stony Brook, July 29, 1839

Born in the village of Setauket, Suffolk Co L. Island, Nov 26th, 1807. In the year 1825 I commenced drawing with lead pencil and sometimes with white chalk, on a blackboard—in my brother's paint shop, No. 104 Cherry Street, New York. When I had a leisure moment.

A Scene in *Hamlet* done in umber and white.

A scene in *Pericles,* the same.

A girl at the spring reading a love letter, painted I believe with colors.

Reading ancient history took much of my time.

In the spring of 1828 at Stony Brook I painted ~~my first likeness~~ a portrait of myself. [SB]

Directly after I painted my first design in 1828, "Christ raising the Daughter of Jairus." Painted at Stony Brook. [SB]

Third design, a scene from the *Iliad* of Homer—Death of Hector. From Pope's Homer.

Portrait of my brother Henry painted in New York. [SB-MC]

My second design, Saul and the Witch of Endor. Size

of the picture three by four feet. Painted in New York. Sold to T. Bailey Esqr. for $20.00. [NATIONAL COLLECTION OF FINE ARTS, WASHINGTON, D.C.]

Mother and child—portraits.

Portrait of Mr. Wm Rudyard Williamson, shoe maker. I received a pair of shoes for pay.

Portrait of my brother R. N. Mount.

Portraits of a Lady and Gentleman. $20.00.

The above three portraits painted at Stony Brook.

Whole length of a girl the daughter of Wm. Nunn Esqr, New York. $20.00.

Year 1829

"Crazy Kate," from Cowper. Painted in N.Y. $10.00.

"Celadon and Amelia," from Thomson's *Seasons*. Painted in New York. $19.00. [SB-MC]

Portraits of a Lady and Gentleman. $30.00.

Of a Gentleman. $15.00.

Portrait of Wm. Wickham Mills Esqr. He loaned the painter fifty dollars without security and secured his money again with interest. [FARL]

Portraits of a Lady and Gentleman. Painted on Long Island. $20.00.

Miss Cornelia Strong the daughter of Selah B. Strong, Esqr, Setauket. $10.00.

Girl with a pitcher standing at a well. $8.00. [*Girl and Pitcher*]

Portraits of a Lady and Gentleman and Son. $30.00.

Mrs. Nicoll's three children. Painted at Islip, L.I. $30.00.

Rev. Z. Green, Setauket. $00.00. [SB-MC]

Year 1830

Rustic Dance [*Rustic Dance After a Sleigh Ride*]. Painted at Stony Brook. In the possession of E. Windust Esqr N.Y. $30.00. [MUSEUM OF FINE ARTS, BOSTON]

Portraits of a Lady and Gentleman. $20.00.

Revd Charles Seabury, Setauket. $00.00.

and Mrs. Seabury, his wife. When painting it I used a chair for an easel—while the carpenter was making me one. $00.00.

Portrait of a Gentleman. Painted in N.Y. $15.00.

Portraits of Revd B. T. Onderdonk and Lady. $40.00. [NEW-YORK HISTORICAL SOCIETY]

Lady and Gentleman. Martin E. Thompson (an early friend with large humanity) [METROPOLITAN MUSEUM OF ART] and Lady. $40.00.

Lady and Gentleman. Gidion Tucker and Lady. $40.00. [METROPOLITAN MUSEUM OF ART]

Portrait of John Delafield, Esq. $20.00. [FARL]

Lieutenant Tallmadge U.S. Navy. $20.00.

Ald. Smith and Lady. $40.00.

Portrait of my Mother. Painted at Stony Brook Long Island. [SB]

School Boys quarreling, or Take one of your size. Sold to P. Flanden, Esqr. of N.Y. $50.00.

Landscape with children at play. I gave it to my sister,

Mrs. C. S. Seabury.

Portrait of a Girl, Miss Pearson. Painted in N.Y. $20. [ROCHESTER MEMORIAL ART GALLERY, ROCHESTER, N.Y.]

Half length portrait of Mrs. John Delafield. $40.00.

Mrs. Flanden. $20.00.

Year 1831

Mr. Charles Russell [PRIVATE COLLECTION, NEWPORT, R.I.; FARL] and Lady and a group of two children. $80.00.

Portraits of my Sister and Brother in Law. [Both SB]

A small landscape with figures. Sold to Mr. Dean, N. York. $10.00.

Dr. Delafield. $25.00. [FARL]

Revd George Upfold of St. Thomas Church N.Y. $30.00.

Portraits of Mr. and Mrs. Ludlom. $55.00. [PRIVATE COLLECTION, NEW YORK CITY]

Do——Miss Bordman. $25.00.

Mrs. Delafield, park place. $25.00.

Portrait of Gentleman. $25.00.

Six portraits for John S. Crary Esqr, St. John's park. $150.00.

Boy resting on a fence looking over his left shoulder at the spectator [*Country Lad on a Fence*]. Size of the picture 12 by 14 in. Sold to Mr. R. Gilmor of Baltimore. $25.00. It was engraved for the *N.Y. Mirror* by J. A. Adams Esq.

Interior of a barn with figures dancing [*Dancing on the Barn Floor*]. Part of the fore ground unfinished. Size of the picture 25 by 30 in. Sold in 1835 to James H. Patterson Esq, N.Y. $111.00. [SB]

Portrait of Judge Thomas Strong Esqr, Suffolk Co. $25.00. [PRIVATE COLLECTION, SETAUKET, L.I.; FARL]

Do——Mrs. Selah Strong. $25.00. [PRIVATE COLLECTION, LONG ISLAND; FARL]

Do——Mr. and Mrs. Udall, Islip, L.I. $50.00. [Both FARL]

Do——Lady and two Gentlemen, N.Y. $80.00.

Year 1832

Portraits of Revd B. T. Haight and his brother, N.Y. $60.00.

Lady and Gentleman. $50.00.

Mrs. Russell, N.Y. Head size. $25.00.

Mr. and Mrs. Edward Windust, 27 by 34. $60.00.

Mr. and Mrs. Strong. $60.00.

Lady and Gentleman. $60.00.

Two portraits of a Gentleman at Wallabout L.I. $60.00.

Miss Julia Graham, N.Y. $30.00.

A man in easy circumstances. Painted on L.I. Size of the picture 8 in by 10 inches. Sold to Mr. Clover. $30.00.

A Flower piece. Sold to Mr. Parker. 17 in by 21 in. $15.00.

About this time I painted two or three portraits for practice, one sitting for each.

Portraits of the two Misses Flandens. No. 2 Murray St. $50.00.

Judge Marvin of Wilton Connecticut. $30.00.

Year 1833

Portrait of a Lady. $30.00.

Lady and Gentleman. 27 by 34. $60.00.

Lady and Gentleman. $60.00.

Three portraits for Mr. William Booth, N.Y. $75.00. [*William Booth* alone, FARL]

Portrait of a Lady. Head size. $25.00.

Full-length Portrait of Right Rev. Benjamin T. Onderdonk, Bishop of the Protestant Epis. Church. Not sold. It hangs in Columbia College, N.Y.

A boy sitting on the bannister of a stoop with a book in his hands [*Leisure Hours?*]. Now in possession of J. T. Vanderhoof Esqr. [COLLECTION MR. AND MRS. JOSEPH H. DAVENPORT, JR., CHATTANOOGA, TENN. According to FARL, this picture was signed and dated 1834. There may have been more than one version on the same subject.]

Portrait of a Lady and Gentleman. $60.00.

Do——of a Lady and Gentleman. $75.00.

Four portraits for a Gentleman. $120.00.

Miss Sarah Lott, Bedford L.I. $35.00.

Lady and Gentleman. $60.00.

Portrait of a Gentleman. $30.00.

Farmer Husking corn. Size of the picture 17 in by 21 in. In the possession of Governeur Kemble Esq. It was engraved for an anual. $50.00. [COLLECTION MR. AND MRS. WARD MELVILLE, STONY BROOK, L.I.]

Boy resting on the fence (with a basket in his hand) looking at the spectator. Painted on mahogany. Size 12 in by 14 in. I kept this picture, and finally sold it to Mr. C. Flint Spear in May 1839 for 75 dollars. I ~~sold~~ made a copy of this picture with some alterations (left out the basket, represented a storm rising in the distance) to Mr. James H. Patterson for 25 dollars in 1834.

Year 1834

A group of three figures. A man playing the violin while the others are listening. I believe I called it after dinner. Sold to Mr. James H. Patterson. Size of the picture 11 in by 11 inches and painted on white wood. $30.00. [YALE UNIVERSITY ART GALLERY]

Mother and Child. Size 7 1/2 by nine inches. Sold to Mr. Clover. $12.00. Afterwards fell into the hands of Dr. De Kay. [SB]

Lady and Gentleman of Ohio. $40.00. [Robert Schenck and wife]

Studious Boy. Painted on canvas (12 by 14 in). Sold to George P. Morris. It was engraved on wood by Mr. J. A. Adams.

Portrait of Rev. Wm. M. Carmichael of Hempstead L.I. $20.00.

Mr. and Mrs. Thompson. Benjn. F. Thompson, the Historian—of L.I. $40.00. [SB-MC and FARL]

Three portraits for Alderman Tucker, N.Y. $90.00.

Portrait of Capt. Mathew C. Perry U.S.N. $35.00. Painted in Setauket. [UNITED STATES NAVAL ACADEMY, ANNAPOLIS, MD.]

Year 1835

Bar-room scene, walking the crack [*The Breakdown*]. Size of the picture 22 in by 27. Sold to Governeur Kemble Esqr. $150.00. [ART INSTITUTE OF CHICAGO]

Sportsman's last Visit, on canvas, size 17 in by 21 in [SB] and the Studious Boy sold to George P. Morris Esqr for $100.00.

Farmers bargaining [*Bargaining for a Horse*]. Size of the picture 24 by 30 in. Painted on canvass and painted for Mr. Luman Reed, N.Y. $200.00. [NEW-YORK HISTORICAL SOCIETY]

Undutiful Boys [*The Truant Gamblers*]. Size of the canvass 24 by 30 in. Painted for Mr. Luman Reed. $220.00. [NEW-YORK HISTORICAL SOCIETY]

For an improvement which I made afterwards in the above picture Mr. Reed generously sent me 50 dollars. I mentioned to him that I did not expect extra pay as I had done no more than my duty. "Well," he says, "I am desirous of doing the same"—extra pay. They now belong to the N.Y. Gallery. [Note in margin: Mr. Reed said he would like to hire me by the year.]

About this time I painted a portrait of a Child. Taken after death—for Mrs. Haight, N.Y. $50.00, fifty dollars.

Year 1836

Courtship or winding up. It represents a young Lady winding while her lover is holding a skein of yarn. Painted for John Glover Esqr. Size of the mahogany panel, 15 by 18 1/2 inches. $200.00 [COLLECTION HELEN LE ROY SMITH, NEW YORK CITY]

Portraits of Mr. and Mrs. Smith, Stony Brook. $70.00. [Capt. Jonas Smith and wife]

Farmers Nooning. Size of the canvass 20 by 24 in. Painted for Mr. Jonathan Sturges, N.Y. It has been engraved. [SB]

Frame	$ 30.00
	$270.00
picture and frame	$300.00

Year 1837

The raffle [*Raffling for the Goose*]. Painted for Mr. Henry Brevoort of N. York. Size of the picture 17 1/8 by 23 1/8 in. Painted on mahogany. He gave me three hundred—said I did not charge enough. Price of the raffle $300.00. [Notation at the bottom of the page:] Price of The Raffle $250. Mr. Brevoort kindly gave me 50 dollars extra. [METROPOLITAN MUSEUM OF ART]

I made a sketch of Col. Williamson's Son after he was killed by a loaded waggon passing over his body. A portrait. $15.00. [SB-MC]

Tough Story [*The Long Story*]. Painted for Mr. Robert Gilmor of Baltimore. Size of the picture, I belive, was 17 by 21 inches and painted on mahogany. [CORCORAN GALLERY OF ART, WASHINGTON, D.C.]

Price of picture $200.00
do——frame 22.00
do——packing 2.00
$224.00

Year 1838

Dregs in the cup, or Fortune-telling. Figures half length and size of life. Size of the canvass 4 feet 4 in by 3 feet 6 inches. [Added later:] I gave it to the New York Gallery in 1847. [NEW-YORK HISTORICAL SOCIETY]

Artist showing his own work [*The Painter's Triumph*]. Painted for E. L. Carey Esqr of Philadelphia. Painted on mahogany. It was engraved for *The Gift*. [PENNSYLVANIA ACADEMY OF THE FINE ARTS, PHILADELPHIA]

Price of the picture $250.00
frame and box 24.00
$274.00

Three portraits of Mrs. Meriam Weeks and one portrait of Miss Meriam Underhill [SB] Oyster Bay Long Island. $200.00.

Portrait of Samuel L. Thompson Esqr, Setauket Long Island. $50.00. [SB-MC]

Do——Hon. Selah B. Strong Esqr, St. George's Manor, L.I. $50.00. [PRIVATE COLLECTION, LONG ISLAND]

Portraits of Mr. and Mrs. Weeks. $100.00.

Do——of a Lady and Gentleman. Canvasses 25 by 30. $100.00.

Year 1839

Portrait of Jeremiah Johnson, Mayor. Painted for the Common Council of Brooklyn. Canvass 29 by 36 in. $250.00. [BOROUGH HALL, BROOKLYN, N.Y.]

Boys Trapping, or Catching Rabbits. Painted for Chas. A. Davis, N. York, on mahogany. Size 21 1/2 by 18 1/2 inches. Price of the picture $250.00. [SB]

In the fall of 1839 most of my time was taken up by sketching from nature with a lead pencil.

Year 1840

Disappointed Bachelor. Procrastination, his house is falling, decaying. Painted on canvas. Size of the picture 15 in by 12 1/2 in. Sold to Governeur Kemble Esq. for $200.00.

Blackberry Girls. Size 16 in by 14 inches. Painted on wood. [Added later: Sold to the Art-Union in 1843 for $100.00 including frame.]

Boy hoeing Corn. Size 15 in by 11 5/8 inches. Painted on wood. Sold to Hon. Aaron Ward for $100.00. [SB]

In the month of June 1840 I painted in N.Y. two portraits for Mr. Charles H. Russell of his Daughters. Head size. Price $100.00.

At the same time, and at Mr. Russell's house I painted a portrait, head size, of Miss Phebe Warren of Troy. Price $50.00.

Year 1841

Cider making. Painted for Mr. Chas. A. Davis, N. York. Received two hundred and fifty dollars for the picture. Size of the canvass 27 in by 34 inches. [METROPOLITAN MUSEUM OF ART]

In the Month of June I painted a small cabinet portrait of Mrs. Alford A. Smith. Received fifty dollars for my labours.

Year 1842

Scene in a Long Island Farm-Yard [*Ringing the Pig*]. Painted on canvas 25 by 30 in. For Jona. Sturges Esqr. He liberally paid me thirty dollars more than I asked him for the picture. He gave me $300.00. The picture cost him altogether $337.00. [NEW YORK STATE HISTORICAL ASSOCIATION, COOPERSTOWN]

Stony Brook, August 15th, 1842. This is the first day I have used my paint brush since the middle of April. I am painting the portrait of a Young Lady, from a sketch taken after death. I have no commissions for pictures. For eight or nine years since I have been on the Island, I have frequently been two or three months without painting. The Country for repose and health, but the City to stimulate an Artist to work.

Sept 10th, portrait of Miss Sarah R. Smith, painted from a sketch taken after death. Received sixty dollars.

Portraits of Mr. and Mrs. Underhill, painted at Oyster Bay. Price one hundred dollars.

Two portraits of Mrs. Miriam Weeks, painted at the residence of Mr. Benjamin T. Underhill, Oyster Bay. Received one hundred dollars. I have painted five portraits of Mrs. Weeks. The above portraits painted in the fall of 1842, except three portraits of Mrs. Weeks which I painted in the fall of 1838. [PRIVATE COLLECTIONS OF VARIOUS DESCENDANTS OF MIRIAM WEEKS, OYSTER BAY, L.I.; FARL]

[Year 1843]

In the Spring of 1843 I painted a girl asleep. The size of canvass I believe 22 by 27 in. Present to my niece Maria Seabury. [SB]

The Hustle cop, or disagreeable surprise [*Boys Gambling in a Barn; Hustling Pennies*]. It was engraved for *The Gift*. Size of the white wood panel 8 by 10 in. Painted for E. L. Carey Esqr. Now in possession of A. M. Cozzens Esqr. Price $50.00. [PRIVATE COLLECTION, BOSTON; FARL]

Portrait of a Lady—Miss Elizabeth Mills—painted after death. Received fifty dollars. [SB]

About this time July 27th I visited Hartford Conn. Also Norwich 30th of July. And from there to Albany by the way of N.Y. Took a bad cold and returned to Stony Brook. I felt a desire to study landscape and left N.Y. Sept 2nd 1843 and stopt at different places on the North river. I was so well pleased with the appearance of the Catskill mountains, that I stopt one month in the vil-

lage of Catskill, and made sketches in oil. Visited the Mountain Sept. 17th. I left Catskill Oct 12th for Madison, staid there and painted from Nature about 10 days. My last sketch in oil is dated 20th of Oct. I done more there in ten days—than the whole month at Catskill. I hired a paint room in Catskill at the rate of two dollars a month. Cheap.

I left Madison about the 23d of Oct. (snow ankle deep) for N.Y. I concluded to spend the winter in N.Y. and consequently hired a room of M. Allison 44 Vesey St. Paid him 60 dollars for six months. Altering the window was 13 dollars and one dollar for scrubing the floor. And then I set up my easel and painted a portrait (29 in by 36 in) of Revd. Samuel Seabury D.D. [Added later:] Finished in the year 1844 ($37.00). [GENERAL THEOLOGICAL SEMINARY, NEW YORK CITY]

[Year 1844]

The only copy I ever made from a portrait was of a lady by G. Stuart.

One picture, Trap Sprung [*The Dead Fall*]. Painted for E. L. Carey, Esqr. Received 125 dollars. Size 13 in by 17, on panel. [SB]

A small cabinet portrait of Benjn. Strong, Esqr. 25 dollars.

In the month of May I painted a portrait of George W. Strong at his own residence 108 Greenwich St, N.Y. Price of portrait 60 dollars. He made me a present of 10 dollars. $70.00.

In the summer and fall I made a few sketches in oil from nature.

In Nov. I finished a picture for E. L. Carey Esqr—"Bird egging" [*Children with a Bird's Nest*]. Now in the possession of A. M. Cozzens 47 Broadway. I received 125 dollars. 13 by 17 in on panel. [SB]

In April I made drawings of four children with lead pencils, tinted for D. H. Wickham, N.Y., for which he made me a present of a breast pin and finger ring.

I am now spending the Winter in the quiet Village of Stony Brook, have been here since the Middle of June.

Stony Brook 1845

April 10. One picture, ~~Dance of the Hay Makers~~ Music is contagious. Painted for Charles M. Leupp. Price two hundred—he generously paid me twenty five dollars more than my charge. On canvass 25. by 30 in. [The title *Dance of the Hay Makers,* which Mount here strikes through, is the one by which the work is best known today; SB]

One picture, Fishing along shore [*Eel Spearing at Setauket*]. Painted for George W. Strong Esqr. On canvass 29 × 36. He paid me two hundred and fifty dollars. $250. [Notation at the bottom of the page:] Recollections of early days. Fishing along shore, with a view of the Hon. Selah B. Strong's residence in the distance during a drought at Setauket Long Island. [NEW YORK STATE HISTORICAL ASSOCIATION, COOPERSTOWN]

One portrait of Mr. James Smith from a sketch taken after death. Cabinet size. I received a Cremona violin for pay.

Also, a small portrait of Mrs. James Smith. Received for pay $25.00 and one violin.

In the spring I painted the portrait of Alfred A. Smith from a sketch taken after death. The son of James Smith, and Comptroller of the City of New York. Price I believe was 42 dollars.

Year 1846

Sketch in oil of a little Girl after death. Daughter of Capt. Alexander Smith. I believe I only charged him for the picture $12.00.

Portrait of Anne Elizabeth Smith on canvass. 25 in by 30 in, size of life. Copy in part, from a miniature by Shumway. Price $60.00.

Small cabinet portraits of C. Edward Seabury [SB-MC], Thomas S. Seabury [SB-MC], Julia Ann Seabury [SB], Maria Seabury [SB]. Paid in fire wood.

Portrait of Rev. Charles Seabury—painted after death from memory. For his son Revd Samuel Seabury D.D. I only charged him twenty dollars. And the last I hope I shall paint after death. While death is a patron to some painters, I had rather paint the living. [GENERAL THEOLOGICAL SEMINARY, NEW YORK CITY]

Portrait of the son of Wm Russell aged four years. The last I hope to paint at that age. Price fifty dollars. On canvass 17 in by 21 in. [FARL]

Portraits of Mr. Edward H. Nicoll [COLLECTION MR. AND MRS. DELANCEY NICOLL III, BAYPORT, L.I.] and Lady. Price 75 apiece, but he generously paid me one hundred a piece.

Portrait of Solomon T. Nicoll Esqr. He generously paid me one hundred dollars.

One portrait of Mrs. A. S. Brower, Brooklyn. Price seventy-five dollars.

Year 1847

The power of music [*Music Hath Charms*]. Size 17 in by 21 inches, on canvass. Painted for Mrs. Gideon Lee. Picture and frame two hundred. Mr. Leupp gave me 25 dollars extra. [CENTURY ASSOCIATION, NEW YORK CITY]

The Ramblers. 13 × 17, on canvass. In possession of Thomas McElrath Esqr. Price fifty dollars without frame. Painted May 5th, '47.

Head and bust of Shepard A. Mount, N.A. Size 18 × 24. [SB]

The Novice. Painted expressly for the Art-Union. I received three hundred, the price agreed upon. Canvass 25 × 30. [SB]

One portrait 25 × 30 of Mrs. Eliza Smith. $75.00. Painted for J. Brooks Fenno, 93 Milk Street, Boston Mass.

Year 1848

Caught naping, recollections of early days [*Boys Caught Napping in a Field*]. Painted for Geo. W. Strong, Esqr. On canvass 29 × 36. Price I believe was two hundred and seventy five dollars. $275.00. [THE BROOKLYN MUSEUM]

Loss and Gain. Painted for R. F. Fraser Esq. Price one hundred and seventy five dollars. On canvass. Size I believe 17 × 21. [SB-MC]

~~The Well by the Wayside, on canvass, 25 × 30.~~ [According to Cowdrey and Williams, *The Well by the Wayside* was the title by which *At the Well*, or Mount's *Sportsman at the Well*, was exhibited in 1849. I believe this to be an error and that they are two distinct paintings, both from the year 1848.]

A Farmer Whitting his sythe [*Hay Making*]. On canvass, 20 × 24. I gave it to the N. Academy. It was bought with others for the Art-Union. [SB]

Turning the Leaf [*Surprise with Admiration*]. On panel, size 13 × 17. Sold to James Lenox Esqr. $200.00. [SB]

Year 1849

Made a copy of the portrait of the late Edward H. Nicoll for Soln. T. Nicoll Esqr. On canvass, size 25 × 30. Price $75.00.

I painted a small cabinet portrait of Edward W. Tiess. Price $50.00.

The last of Oct. 1848, Charles Elliott Esq made us a visit at Stony Brook and kindly painted my portrait, 25 × 30 [SB]. In return I painted and presented to him a cabinet portrait of himself—on panel. A man with a beard is nature in her glory. [NATIONAL GALLERY OF ART, WASHINGTON, D.C.].

Last summer 1849 I painted a whole length of an infant boy (drawing made after death), the son of Edmund Thomas Smith of Smithtown, L.I. Price one hundred and fifty dollars.

First of Nov. 1849, I sold a picture—Just in tune—to George J. Price Esqr. Painted on canvass, 25 × 30. Price including frame one hundred and fifty dollars. It is to be engraved in Paris by Emile Lasalle. [Added later:] The above has been engraved. [SB]

A cabinet portrait of Capt. Shalah Hawkins, a present. [*Daniel Shaler Hawkins;* inscribed on the back of the portrait is the date March 12, 1850, which differs from Mount's recollection here. COLLECTION MR. AND MRS., JOHN D. ROCKEFELLER 3RD, NEW YORK CITY]

Stony Brook L.I., Year 1850

California News, or Reading the *Tribune* [*News from the Gold Diggings*]. Painted on canvass. Size 18 in by 20 in, for Thos. McElrath, Esqr. Price $300.00. [SB]

Portrait of Mrs. Ludlow. 20 Amity Place N.Y. On canvass, 25 × 30. Price $100.00.

One picture for the house of Goupil & Co. A Negro, "Right and Left." On canvass, 25 × 30. Price $150.00.

To be engraved in Paris. [SB]

Studio in the attic of Stony Brook, L.I. I have just completed a picture of a Negro—The lucky throw—on canvass, 25 × 30. Painted Dec 1850. Price $150.00.

Year 1851

Jan. 1851. I did not paint—unwell.

One picture, "Who'll Turn Grindstone," painted for Jonathan Sturges Esqr. On canvass, size 29 × 36. Price $300.00. [SB]

May 1851. Painted a portrait of Mrs. Sarah Nicoll of Islip, L.I. for her Son-in-law, Wm H. Ludlow of Sayville. Painted it at Stony Brook in one week. On canvass 25 × 30. Price in the country $75.00.

About May 1st '51 I painted a cabinet portrait of a Boy, Master Mount—Son of Alfred Mount, 48 University Place New York. From a daguerreotype, on white wood. Size 7 in × 9 in. $50.00.

I commenced a portrait of J. T. Vanderhoof, 55 7th Street, New York, June 15th 1851. Size 25 × 30. Price $100.00.

Stony Brook, July and August I painted two portraits, one of myself for my brother S. A. Mount, the second portrait of Mrs. S. A. Mount for herself.

In September I painted a cabinet portrait after death of a Lady for Mr. Raymond [*Julia Parrish Raymond*]. I charged him only twenty-eight dollars. $28.00. [FARL]

I painted eight landscape sketches—from nature. Good practice.

In Nov. I painted a landscape by particular request for Mr. Elisha Brooks, New York. The first Landscape order I ever received. 29 × 36. Price $150.00.

Year 1852

I painted a portrait (from a sketch taken after death) of Miss Mary Strong, daughter of the Hon. Selah B. Strong, for her Aunt Mary B. Strong, Oak Wood, Suffolk County, Long Island. Oval, 25 × 30. Price one hundred and fifty. Such portraits do not pay. I could have painted three portraits at seventy five dollars each in the time, $225.00. But I laboured to obtain a likeness from memory out of respect and esteem for the young Lady.

April, I painted Mary Pickering (at 127 Bleecker St) daughter of Wm. L. Pickering. Price one hundred and five dollars.

May and June, I painted a portrait of Mrs. J. T. Vanderhoof. 25 × 30. Price $100.00. Also, a family Group portrait of Rev. Zachariah Greene and three of his Great Grand Children, for Mr. Vanderhoof 55 seventh St. Oval, 20 × 24. Price $300.00. [COLLECTION MR. AND MRS. HARRY D. YATES, MENANDS, N.Y.]

August 25th 1852. Last winter and spring I painted a portrait of Miss Wells, aged 10 years, from a drawing taken after death. Head and bust. $50.00. [*Matilda Evelina Wells;* COLLECTION MRS. PRISCILLA SMITH, STONY BROOK, L.I.]

At Pentaquit L.I. August 1852, I painted the portrait of Mrs. Hannah Smith. 25 × 30. $75.00.

At the same time a portrait of Frances Amelia Moubray. $50.00, after death. Death incourages the fine arts.

I painted (Oct 1852) a portrait of T. Bailey, Commander U.S.N. 25 × 30. Price $75.00. [COLLECTION MRS. ELIZABETH MORRIS SMITH, NEWPORT, R.I.; FARL]

Year 1853

Cabinet portrait of David Kearney. Painted for his brother M. Kearney.

Cabinet portrait of Mrs. S. Seabury. Painted for Revd Samuel Seabury D.D. He handed me fifty dollars, but I would only take twenty-five dollars.

Politics of 1852, or Who let down the bars [*The* Herald *in the Country*]. Panel 13 × 17 in. Sold to Goupil & Co. $150.00. [SB]

May—Painted a Group of three children (cabinet picture). Size of canvass [left blank]. For John Brooks, 37 Rutgers St. N.Y. $150.00. [MUSEUM OF THE CITY OF NEW YORK]

Portrait of Mrs. Eliza Spinola. Size 25 × 30. Price $75.00, painted for Francis B. Spinola, No. 90 York St. Brooklyn.

Year 1854

Coming to the Point. Just finished. On canvass 25 × 30. Painted by particular request of A. R. Smith Esqr of Troy N.Y. It is a variation of the Farmers Bargaining. He kindly sent me the money for the painting before it was finished. I never before received pay for a picture until it was delivered. Mr. Smith, has given his consent to have it Lithographed in Paris. Wm Schaus, has paid two hundred for the copy right. [NEW-YORK HISTORICAL SOCIETY]

$200	Price of the painting	$300.00
$300	do——frame	25.00
$500		$325.00

Stony Brook Dec. 16, 1854. When I look back I say to myself what have I done. The country is too quiet. Painting of pictures keeps one too secluded. Portraits make the painter more active. And I am sorry to say it is the only branch of art that will pay. My pictures cost me too much time. If I should take up portrait painting as a business a picture might be hit off now and then with more pleasure to myself.

~~One picture of Webster among the people. On canvass 25 × 30—not sold.~~

I painted a portrait of myself, head and bust, for practice.

Portrait of Capt McKeige, 25 × 30. $75.00.

A family Group [*Walking Out*?]—painted for Mr. George Searing. 20 × 24. Price $150.00. [SB]

Year 1855

New York, January 1855, painted a cabinet picture, a group of two children for John Brooks Esqr. 37 Rutgers St. The youngest aged three years having died last Sept, I painted from description. Price of Mr. Brooks' picture $150.00.

One portrait for Mr. Griffin, 18 West 11th, a likeness of his brother after death. Painted at the residence of H. H. Hooper Esqr, 138 E. B.Way. Price $75.00.

One portrait, oval, of Mrs. S. T. Nicoll. 25 × 30. Painted at their residence No 6 21st street. Price $120.00.

I made a sketch of Mr. Nicoll and presented it to Mrs. Nicoll. I made it my home at the time with G. A. Seoncia [?] Esqr, 145 East 25th street.

Portrait, oval, 25 × 30 of Mrs. T. McElrath. Also a second likeness of the above, painted by request over a portrait painted by Mr. Peele. Besides touching up a small picture. Price $150.00.

I made it my home with Mr. McElrath, 42 East 22nd Street, while I was painting his portraits.

In April I stoped with Wm L. Pickering, 106 East 14th St. Varnished his daughter's portrait and painted his portrait (much to his satisfaction) over a small photograph which he did not exactly like. No charge.

In the summer I painted the portrait of Thomas S. Seabury, head and bust—on panel. [SB]

Also the portraits of Thos. S. Mount [SB] and his brother John H. Mount [SB-MC], on panel. The above were presents to my nephews.

Portrait of Mrs. Wickham Mills. The size agreed upon was 25 × 30, for seventy five dollars—but she being such a noble woman I painted her on a larger canvass 27 × 34 for the same price. $75.00. [FARL]

In September I painted a portrait of my Mother, copy from one of my early portraits. [MONTCLAIR ART MUSEUM, MONTCLAIR, N.J.]

Made a few landscape studies.

Year 1856

In January painted the portrait of Wm Wickham Mills Esq. Size 27 × 34. $75.00. [FARL]

Painted a cabinet portrait of My Niece Miss Maria Seabury. *A present.*

Portrait of Henry Wells Esqr. 25 × 30. From a daguerreotype and from memory. Spent nearly four months and a half with Chas. Henry Wells. [SB]

Bone Player—a Negro—painted on canvass 29 × 36, for William Schaus Esqr. for publication. Sold to John D. Jones Esqr. $200.00. Mr. Schaus paid me one hundred—$100.00—for the copyright. Finished April 3. [MUSEUM OF FINE ARTS, BOSTON, M. AND M. KAROLIK COLLECTION]

Banjo Player, a Negro, companion to the above, painted on canvass 29 × 36, for Mr. Schaus for publication. Sold to Charles M. Leupp Esq. for $200.00. Sold the copy right to Mr. Schaus, $100.00. [SB]

The above pictures are now being engraved in Paris.

When the Banjo Player returns, Mr. Leupp will pay me. [Added later: Oct. 1857, have received pay.]

Sometime during the summer I made a variation copy of a small French painting [after W. A. Gay], partly for practice and amusement. Most of my time was taken up during the months of August, Sept and Oct—influencing the people of St. James Place and vicinity to the importance of having a sloop channel cut through the beach at the openings, a general benefit. Men did meet, with teams and drags, at different times removed the top of the beach so as to let in two or three feet of water at high water. All that is now required is for the people to meet next spring and put or place a break water west of the channel and three feet of water in the channel before low water mark. Then a beautiful stream of water is made usefull to vessels and steamers, and property therefore improves.

In 1856, retouched a portrait of My Uncle Micah Hawkins—painted by Louis Child [SB-MC]. Made a small copy for Dr. Ray of Huntington L.I.

About the first of November, I painted a head and bust of a child from memory. For Mr Nathaniel Smith. $75.00.

Also of his daughter, Sarah Cordelia. 25 × 30. Painted in the months of Dec 1856 and January, of 1857. $125.00. [Added later:] Recd. payment in full the 15th of Jan, 1859.

Stony Brook, Year 1857

Commenced a picture on canvass size 17 in × 21 in, a boy selling fish—"Any fish to day." Unfinished. [Added later:] Sold, to David A. Wood for $130—including frame. Price of frame ten dollars. [PRIVATE COLLECTION, IPSWICH, MASS.]

Portrait of a boy, head and bust only, of Master Henry Dering. A sketch, price 35 dollars. For Dr. H. Dering. [Added later: Received July 16th, 1858, on account, $20.00. It was painted I believe in June 1857.]

Portrait of Mrs. Wm G. Spencer. 25 × 30, with hands painted in Sept. $75.00.

I must try and paint more pictures, Large or small, not experiment so much—not have too many irons in the fire.

Painted one picture for J. M. Falconer, Esq, Mischievous drop. Size (on canvass) 9 1/2 in by 12 3/4 inches. Price $150.00. [SB]

Year 1858

A cabinet portrait of a child for C. C. Harrison, N.Y., the likeness picked up from several daguerreotypes. [Added later: Mr. Harrison I believe died in 1864, a good man.]

Portrait of Mrs. Julia A. Wells. Painted from memory from a sketch taken after death. On canvass 25 × 31.

Painted a portrait (cabinet size) with spects for Theo. Searing. It was worth fifty dollars—only charged $30.00.

Painted a portrait for Frederick A. Gould. Life size,

head and bust only. Painted it without spectacles. Size about 17 in × 21 in. Price $25—worth $50. [FARL]

Painted a portrait of Mrs. Breedlove (August 1858). Size of life on canvass 17 by 21 without spects. I must paint no more small portraits. It is sent to New Orleans. Price $30.00, worth $60.00.

Commenced a portrait 25 × 30 of a boy Newton Ludlom, from an Ambrotype the 26 of Nov, finished about the last of Dec. Satisfactory to the parents. I only charged $85.00, worth $150. [Added later: Paid 22nd of June '59.]

For portraits after death I must charge double price, and be careful how I strain my eyes by painting after Daguerreotypes. Say no and you are [illegible].

Stony Brook, Year 1859

The Tease, a young man in conversation with a young lady, at the same time holding a letter in his left [hand]. Size 12 1/2 in by 16 1/2 in, painted on white wood. Sold to Mr. Chas. B. Wood for $200, but he paid me fifty more—$250.00.

The Esquimaux (a dog looking out). On panel as above, size 13 in by 17 in. Sold by Mr. Wood to G. A. Conover Esqr for $250.00. [BERNARD & S. DEAN LEVY, INC./SLOAN & SCHATZBERG, INC., NEW YORK CITY]

For time I spent at Mr. Wood's, touching up some of his paintings (during the months of February and March) I charged nothing, but I was well located. In some respects it was a benefit, but I do not wish to try the experiment again. New York City is the place to make an artist work—he is stimulated by the work of others. Fortunate for me, two exhibitions of French and English paintings were open to the public. I spent two or three weeks studying them. It is well enough to look at the works of others but not to copy—to observe design, drawing, and how color is contrasted.

At South Brooklyn (256) Nov. 1859, I painted a whole length of a boy aged two years. Wm, son of Abel Denison. On canvass size 41 × 32 in. Price $200.00.

Portrait of Noel Joseph Becar Esqr. Painted from memory, 25 × 30. $100.00.

[Year 1860]

Jan. 1860—Portrait of Mrs. Becar, 25 × 30. $100.00.

Do——of Mr. and Mrs. Denison, 27 × 34. $200.00.

About the 17th of Feb I commenced on Staten Island a whole length of a child (girl) aged two years. Daughter of Nathaniel Marsh Esqr. Painted from a drawing I took after death. It was considered a good likeness. On best German canvass, size about 41 × 32. Price $250.00. [*Susan T. Marsh*; SB]

Portrait of Mrs. N. Marsh. 25 × 30. $100.00.

Do——William B. Townsend. 22 × 27. $75.00. [SB]

At the residence of M. C. Morgan, 65 Grand St, Jersey City— I painted the portrait of Mr. Morgan's Daughter, the late Mrs. Porter. From ambrotypes and photographs.

$150.00. Had to use the magnifyer, to the great injury of my eyes. Cured by using hot water—to allay the inflamation.

Glen Cove, Long Island, August 18, '60—at the Residence of G. J. Price, I touched and varnished his paintings. I painted the portraits of himself [FARL] and wife [SB], ovals, 25 × 30. Price $180.00.

[Year 1861]

June 27th, '61—painted the portrait of Lucy Davis (daughter of Wm M. Davis, Painter). Painted from description and considered a good likeness. I made Mrs. and Mr. Davis a present of the Portrait. [PRIVATE COLLECTION, EASTON, CONN.]

Port Jefferson, L.I. June 29th 1861. My portable studio, about finished. At a cost of about one hundred and forty-five dollars. I gave my time in finishing it. I consider it a success.

Port Jefferson, L.I., 1861. The first picture or sketch I painted in my Portable studio, "The Confederate in Tow," size 13 in by 16 1/2 inches—on white wood—was sold (by my friend Mr. Wright of Hoboken) to Samuel B. Caldwell, 20 old slip, N.Y. Residence in Brooklyn. [Added later: Sold 1862, $100.00.]

Port Jefferson, August 28th, '61. Commenced an original picture, "Peace and humor or tranquility" [*The Cannon*].

Painted the portrait, E. T. Darling Esqr, 25 × 30. Price $85.00, but would only receive $65.00, I believe.

Oct. 28th, '61. Made a sketch (in oil) of Port Jefferson harbor (wind blowing fresh) on oild paper. Size 7 1/2 by 10 1/2 in.

[Year 1862]

March 31st, 1862. I have just finished two pictures (they were commenced in my Stony Brook Studio). Returning from the Orchard, size 19 3/4 in × 26 1/4, on wood. [SB]

Going Trapping, on canvass 25 × 30. The above not sold. [Added later: Sold 1863, $325.00.]

"What Have I Forgotten," size about 7 × 9 in. Sold to S. P. Avery, forget the price. [Added later: Sold Feb. 4th 1867 for $135.]

Painted at my Studio Stony Brook, Sept. '62, two portraits—Mrs. Wm. H. Wickham and daughter, one 25 × 30, the other 20 × 24. Finished their sittings in seven days and background in three or four days. $75.00 [and] $50.00 [Both FARL]

The last of October '62—I painted the portrait of Andrew Hood Esqr, 25 × 30, in eight days at his residence five miles from Peekskill landing. $75.00. [NEW-YORK HISTORICAL SOCIETY]

Setauket, Nov 22, 1862. Two horse teams moved my portable Studio up to Setauket in fine style (no damage done). Messers Davis and Denton would not receive any pay for their labor.

Setauket, Nov 24th, 1862. I work on my picture of "Lay-

ing off." My brother R. N. Mount sat [for] one of the hands. Size of the picture about 8 × 10 in, on wood. Mr. W. J. Hays (animal painter) sold it for me to a friend of his for fifty dollars. $50.00. [Added later:] Sold about the 1st of May 1863.

[Year 1863]

Setauket L.I. Chasing the Fiddlers at Low Tide (on wood), about 7 by 8 inches, Sold to Mrs. Francis B. Spinola. $25.00.

Finished two portraits for Andrew Hood Esq. near Peekskill, N.Y. Mrs. Hood, in the clouds, 25 × 30—and her daughter Annie also in the clouds, the latter aged about three years. Mrs. Hood $75.00— July 30th, '63, paid. Annie 50.00. [Both NEW-YORK HISTORICAL SOCIETY]

I must charge more for *Lady Portraits*. They require more time and finish.

Setauket L.I., July 30th 1863. During a heavy rain the 27th inst. the roof of my studio leaked badly. I gave the roof (canvass) a thick coat of white lead, and French Ochre. During the very heavy rain yesterday it did not leak a drop.

About the first of June, '63 I filled up the seams on the outside of the studio with putty (mostly made of white lead). The old putty was driven in with a corking iron and painted—the side is tight.

Perhaps a tin roof would answer for my studio—it would not be so light as the present roof, but stronger—but too noisy during rain.

[Year 1864]

Feb 1864 finished a cabinet portrait of the late Mrs. Monson—partly from memory. For Mrs. Selah B. Strong. Price $100.00. [FARL]

May 1864, sold my picture "Boys going Trapping" to Chas. B. Wood Esqr. Size 25 × 30—canvass. $325.00. It was worth much more.

Year 1865

Early impressions are lasting. Painted on panel 11 1/8 × 9 3/4. Sold to Chas B. Wood Esqr. $150.00.

Catching, or spearing Crabs. Canvass, 18 × 24. Sold to C. B. Wood Esqr. $250.00. [SB]

Loitering by the Way. On panel, 14 × 9 3/4 in. Sold to Chas. B. Wood Esq. $200.00. [SB]

Peace, or Muzzel down. On canvass, 22 × 27. [Added later: Sold to Chas. B. Wood Esqr. $300.00.]

In April I repainted in part, the portrait of Mr. Morgan's daughter, the late Mrs. Porter, which gave more satisfaction. I never worked harder. Mr. Morgan gave me Fifty dollars—he should have given me one hundred dollars, as I had to work from an Ambrotype never having seen Mrs. Porter. Likeness pronounced good.

I forgot to mention that on Sept 10th 1864 I commenced a large cabinet portrait of Miss M. Harmer (on white

wood panel) 13 × 17. Price paid, $100.00. Mr. Harmer was delighted with it. I sold him a fruit piece—Apple on a Champagne glass—$25.00. It was worth more.

In June painted Mr. Jessie Floyd's portrait for Mrs. Wm H. Wickham (a copy) on canvass. 22 × 27—head and bust only. [Added later: It was delivered to Mrs. Wickham Jan 4th, '66.]

Portrait of Mrs. Samuel L. Thompson. Painted partly the day she was buried and from an Ambrotype. For Mrs. Mary L. Berrean for one hundred and eighty five dollars—$185.00. On canvass, 27 × 34. Recd pay Oct 1865. [SB]

Year 1866

I went to the City of N.Y. the 3rd of Jan, '66 and took with me the portrait of Mr. Jessee Floyd. Head and bust only, canvass, 22 × 24. For Mrs. Wm H. Wickham, 308 Lexington Avenue. Painted a new head dress (her hair) on her portrait painted in '62. It was an improvement. Also touched up her husband's portrait.

Then I moved to Mr. Wood's, 36 Laight Street and painted a cabinet portrait of Miss Lizzie Wood, over an old portrait (cabinet size). $75.00. Also touched some of my painting without charge.

Then went to Mr. Thomas McElrath 8 West Washington place and painted a new body to an old head and touched several old paintings. Also $75.00.

Studied the Flemish, English and French paintings, exhibiting in the city, and returned with a bad cold to Setauket the 10th of March, 1866.

I forgot to mention in its proper place, that in July 1865 about the 6th of the Month I went to Glen Cove L.I. to varnish Mr and Mrs Price's portrait[s], but I found that the Portrait of Mr. Price, required repainting in consequence of his poor health and sallow color. I improved both of their portraits and made Mrs. Price a present of my labor. I was well treated, had several drives about that section of country.

Also, year 1859, I made a sketch of a head of Ariel, a horse belonging to Francis Copcutt, and sent it to him as a present [SB]. 1865, Mr. Copcutt sent me a lot of Mahogany panels and five books—for a sketch in oil of his late Esquimaux dog. It was in the last Academy Reception.

In Jan. 30, '66—Mr. Copcutt sent by express, the head of "Ariel" (it being damaged) to be polished up, sanded and retouched. He sent $10.00 and two books and a paper bunch of candy. The Books are interesting: *Art Idea* and *Art Hints*, by J. J. Jarves. Also books for the Esquimaux sketch. *Pre-Raphaelism, The two paths*, by Ruskin, *Across the Continent*, by Bowles, *Parisian sights and French principles* (Illustrated) by J. J. Jarves Esqr. For which I am very well pleased.

I will hint here that models can be obtained much easier in the country in winter than in summer.

What signifyes a painter gazing at nature all this time, if he dont paint and paint; constant practice and observation makes the painter.

I am quite as well pleased to look at pictures by other artists as I am to paint my own.

To see works of art one should be in the City, or live near it, or have a private studio in the City, particular in winter, in a locality where models could be obtained easily.

When I commenced art in 1825, I drew with lead pencil, or with a piece of white chalk, made a few copies from engravings—to give me a start, to feel my strength, to know if I had capacity for art culture; painted some designs in umber and white, to get the use of brushes, as well as light and dark. Then painted my first picture in colors—a Girl at the spring sending a love letter, 1828. Also, a portrait of myself, and then colored in oil a composition I had thought a great deal about: "Christ raising the daughter of Jairus," which I painted. I yearned to be a painter. I asked God in my humble way to strengthen my love for art; and in his goodness he directed me to a closer observation of nature, and I gained strength in art. When I occasionally refer back and remember the progress I made from 1827 to 1838 as one of the first that painted directly from nature (that I had ever heard of), it stimulates me to stick to nature as a short road to perfection. I will add, if I had painted fewer portraits from 1840 to the present time, truer pictures would have been the consequence. Two many portraits is apt to take the painter's attention from pictures, etc. With me poor health has been a great hinderance to my progress. My health is better, and I shall try to be a close *student to nature*.

Strengthen me oh Lord, to paint better and larger works.——W.S.M.

PAINTINGS BY MOUNT
MENTIONED IN THE DOCUMENTS
BUT OMITTED FROM THE
ARTIST'S OWN CATALOGUE

The pictures are listed alphabetically, with alternate titles given in brackets. Portraits are listed by surname. Diary entries are indicated by date, letters by writer, recipient, and date. The word *Inventory* refers to the list of works left in Mount's studio at the time of his death, which appears as Schedule B on page 462. Six paintings by Mount are listed in the exhibition catalogues of the National Academy of Design but cannot otherwise be traced today. These are designated NAD, followed by the date of exhibition. Current documentation is given in brackets; in the absence of such data it may be assumed that no information is available.

At the Well [*Sportsman at the Well; The Huntsman at the Well*]. WSM to G. P. Morris, December 3, 1848; Inventory 167. [NEW BRITAIN MUSEUM OF AMERICAN ART, NEW BRITAIN, CONN.]

Banjo Player in the Barn. Inventory 49. [DETROIT INSTITUTE OF ARTS]

Bouquet of Beauty. Inventory 43.

The Card Players. Inventory 161. [REYNOLDA HOUSE, INC., WINSTON-SALEM, N.C.]

Catching the Tune. Inventory 181. [SB]

A Charming Scene in Autumn. March 27, 1868. [SB-MC]

Cherries. Dated July 6, 1855. Inventory 166. [SB]

Cherry Blossoms. March 18, 1864.

Child of Sanford Denton. April 23, 1864. [At Stony Brook there is a painting of a young man in his twenties entitled *Portrait of Sanford Denton*. It may be that the son had his father's name and that the SB portrait is the one referred to here.]

A Child's First Ramble. February 12, 1864.

Corn. October, 1864.

Cracking Nuts. Inventory 32. [FARL]

The Dance on the Turnpike. November 29, 1864.

John R. Davis. June 11, 1864.

The Dawn of Day [*Politically Dead*]. November–December, 1867; WSM to August Belmont, March 26, 1868. [SB]

Dr. Dering's Residence. September 7, 1868.

Dog (Mr. Davis's) in a Domestic Scene. October, 1864.

Early Spring. Inventory 134.

Ette. NAD, 1861.

Rev. James S. Evans. August 2, 1862.

Fair Exchange No Robbery [*Even Exchange No Robbery*]. November 15 and 16, 1865; Inventory 157. [SB]

Figure in a Large Brimmed Hat. June 22, 1847.

Flowers. Inventory 135.

Fruit Piece: Apples on Tin Cups. December 1, 1863; March 10, 1864. [PRIVATE COLLECTION, CLEVELAND]

Glimpse of the Sound. Inventory 128.

Julia. NAD, 1864.

Kitchen Fireplace. Inventory 163.

Landscape. Inventory 136.

Landscape. Inventory 153a.

Landscape painted in the "Pond Lily." October 3, 1866.

Landscape, Strong's Point, R. Woodhull's house, a boat on shore. October 6, 1866.

Landscape and Boy [*Boy at Waterside?*]. NAD, 1831.

Laying on His Oars. Inventory 76.

Frank Ludlow. April 14, 1866.

William H. Ludlow. March 22, 1866; June 27, 1866.

Mrs. Edward McKeige. August 19, 1866; August 31, 1866.

The Mower. Inventory 45. [SB]

Mutual Respect. December 7, 1867. [SB]

Neptune, a Dog. November 28, 1865.

Northern Sentiment. March 19, 1865. [COLLECTION MR. AND MRS. WARD MELVILLE, STONY BROOK, L.I.]

The Old Grave Yard. Inventory 119.

The Old Mill. Inventory 33.

The Old Woodhull Homestead. Inventory 147. [FARL]

One of the "Tangiers." NAD, 1857. [The "Tangiers" were members of the Smith family descended from Col. William Smith, seventeenth-century governor of Tangier. This nickname stuck to members of his family for many generations to distinguish them from other branches of the same numerous tribe.]

On the Hudson. Inventory 146.

Peach Blossoms. May 5, 1864.

Ida Pfeiffer. October 3, 1859.

W. H. Phare and family. W. H. Phare to WSM, December 3, 1863.

Portable Studio. WSM to S. P. Avery, August, 1862.

Primitive Times. Inventory 164.

Rat Tail Cactus. May 5, 1864.

Scene in a Cottage Yard. NAD, 1831.

Setauket Harbor. Inventory 169.

Shrine. Inventory 137.

Floyd Smith. March 20, 1866. [COLLECTION MR. AND MRS. WARD MELVILLE, STONY BROOK, L.I.]

Snow Balling [*Winter Scene*]. Inventory 75. [SB]

General Francis B. Spinola. Francis B. Spinola to WSM, March 29, 1867.

Mrs. Francis B. Spinola. Francis B. Spinola to WSM, March 29, 1867.

Stony Brook Mill Dam. Inventory 59.

Sinclair Tousey. January 7, 1868. [SB]

Effingham Tuthill. August 1, 1862. [SB]

View from Studio Window. November 26, 1862.

Waiting for the Boat. Inventory 118.

Waiting for the Packet. Inventory 162.

Waiting for the Tide. April 25, 1850; Inventory 127. [FARL]

Washington Crossing the Alleghany. WSM and John Gardner, May–June, 1863; May 29, 1863; Inventory 77. [PRIVATE COLLECTION, LONG ISLAND]

T. T. Woodruff. NAD, 1833.

EXTANT PAINTINGS BY MOUNT
NOT LISTED IN HIS CATALOGUE OR
OTHER CONTEMPORARY
DOCUMENTS

This list includes many small pictures that Mount apparently considered exercises and did not record. However small they may be, they are completely finished paintings, and so must be included here. Also listed are preliminary oil studies for several of the larger works, as well as a few of Mount's major paintings, like the famous *Long Island Farmhouses* at the Metropolitan Museum. Measurements are given in inches, height preceding width.

Apple Blossoms. May 7, 1859; 6 × 5″. [PRIVATE COLLECTION, LOS ANGELES; FARL]

An Artist and His Wife in a Landscape. November 26, 1851; 19 × 28″. [PENNSYLVANIA ACADEMY OF THE FINE ARTS, PHILADELPHIA. The figure of the man resembles Mount himself, but he was never married. It has been suggested that the figures in this work are by Mount, the landscape by Cole. A somewhat improbable theory.]

The Artist Sketching. c. 1855; 9 × 6 1/2″. [FARL]

Autumn: A Girl Walking [*Landscape with Girl and Barn*]. October 10, 1854; 14 1/4 × 11 1/4″. [SB]

Autumn Landscape in a Pasture. "1850 & 3"; 10 × 13 7/8″. [FARL]

The Back Porch. 1862; 9 3/4 × 6″. [SB-MC]

The Barn by the Pool. n.d.; 10 1/8 × 13 3/8″. [FARL]

Barn Door with Horse's Head. n.d.; 10 × 12″. [SB]

Catherine Barnet. 1832; 30 1/8 × 25 1/8″. [THE BROOKLYN MUSEUM]

Joshua Barnet. 1832; 30 1/8 × 25 1/8″. [THE BROOKLYN MUSEUM]

Barn on the Salt Meadow. n.d.; 17 3/8 × 24″. [PRIVATE COLLECTION, SETAUKET, L.I.; FARL]

Barn with Stairway. n.d.; 14 1/4 × 12″. [SB]

Mrs. Ebenezer Beadleston. n.d.; 36 1/2 × 28 1/2″. [COLLECTION MRS. WALTER CORRIGAN, NEW YORK CITY]

Samuel Birdsall. n.d.; 36 × 28″. [FARL]

Boy. n.d.; 21 × 17″. [SB-MC]

Boy at Waterside [*Boy by the Shore*]. 1831; 8 × 10″. [SB-MC]

Study for *Boy Hoeing Corn.* 1840; 14 1/2 × 11 3/8″. [SB]

Boy in a Chair. February 18, 1857; 5 1/4 × 4 1/4″. [SB]

Boy on a Country Path. n.d.; 8 × 9 3/4″. [Listed as #76 in Cowdrey and Williams' *William Sidney Mount*]

Boys Sailing Toy Boats. n.d.; 9 1/2 × 12″. [PRIVATE COLLECTION, NEW YORK CITY; FARL]

Boy with an Ax. c. 1850; 4 5/8 × 2 5/8″. [SB]

Mrs. Henry Sands Brooks. 1853; 29 × 24″. [MUSEUM OF THE CITY OF NEW YORK]

John Brooks. 1853; 33 × 26″. [MUSEUM OF THE CITY OF NEW YORK]

Mrs. John Brooks. 1853; 33 × 26″. [MUSEUM OF THE CITY OF NEW YORK]

By the Shore, Small House in Cove. n.d.; 10 × 14″. [SB-MC]

Cactus with Flaming Red Blossom. May, 1857; 5 3/4 × 6 3/4″. [THE BROOKLYN MUSEUM]

Study for *California News.* 1850(?); 4 7/8 × 4 1/4″. [SB]

Cherries. 1855; 5 1/2 × 9 1/2″. [SB-MC]

Children Playing Before a House. n.d.; 3 5/8 × 4 1/4″. [SB]

Two studies for *Coming to the Point.* n.d.; each about 3 1/2 × 6″. [SB]

Corner of the Mount House. n.d.; 14 1/4 × 12″. [SB-MC]

Corner of the Mount Kitchen. c. 1846; 7 3/4 × 8″. [SB]

The Cove. n.d.; 7 3/8 × 9 5/8″. [Listed as #74 in Cowdrey and Williams' *William Sidney Mount*]

Crane Neck. c. 1843; 6 3/4 × 9 1/2″. [PRIVATE COLLECTION, NEW YORK CITY]

Crane Neck Across the Marsh. n.d.; 12 7/8 × 17″. [SB]

Creek with a Row Boat. n.d.; 7 5/16 × 9 12″. [Listed as #75 in Cowdrey and Williams' *William Sidney Mount*]

Currants. July 22, 1856; 10 3/4 × 14 3/4″. [SB-MC]

Dahlias. n.d.; 12 × 9″. [PRIVATE COLLECTION, NEW YORK CITY]

Study for *Dance of the Haymakers.* 1845(?); 5 3/4 × 7 1/8″. [SB]

Mrs. James Richard Dey. n.d.; 27 × 27″. [PRIVATE COLLECTION, PITTSBURGH; FARL]

Major William Edgar. n.d.; 34 × 27″. [PRIVATE COLLECTION, LAKEVILLE, CONN.; FARL]

Mrs. William Edgar. n.d.; 34 × 27″. [PRIVATE COLLECTION, LAKEVILLE, CONN.; FARL]

The Edmund Thomas Smith Place. June 27, 1849; 10 × 14″. [Listed as #57 in Cowdrey and Williams' *William Sidney Mount*]

Study for *Eel Spearing at Setauket.* 1845; 6 1/2 × 7 1/2″. [SB-MC]

Study for *Fair Exchange No Robbery.* 1865(?); 5 7/8 × 8 1/2″. [SB]

Study for *Farmers Nooning.* 1836(?); 4 1/3 × 5 3/8″. [SB]

The Farm House at St. George's Manor. c. 1845; 6 1/2 × 8 3/8″. [COLLECTION MR. AND MRS. JOHN D. ROCKEFELLER 3RD, NEW YORK CITY; FARL]

Fence on the Hill. n.d.; 8 1/4 × 13 1/8″. [FARL]

Flax Pond, Old Field, Setauket. c. 1846; 9 3/4 × 12″. [SOCIETY FOR THE PRESERVATION OF LONG ISLAND ANTIQUITIES, SETAUKET, L.I.]

Fuchsia. May 31, 1859; 13 1/2 × 10 1/2″. [FARL]

Mrs. Charles F. Goodhue. n.d.; 34 × 27″. [PRIVATE COLLECTION, NEW YORK CITY; FARL]

Haying Scene. c. 1835; 24 3/8 × 11 3/8″. [NEW-YORK HISTORICAL SOCIETY]

Hillside Field. n.d.; 8 3/8 × 15 1/8″. [FARL]

Inlet at Stony Brook. October 14, 1851; 10 × 14″. [SB]

W. Alfred Jones. October 3, 1853; 9 × 7″. [SB-MC]

Kitchen in the Old Seabury House in Setauket. c. 1842; 8 1/2 × 14″. [FARL]

Landscape. c. 1850; 7 5/8 × 7 1/4″. [Listed as #79 in Cowdrey and Williams' *William Sidney Mount*]

Landscape. n.d.; on tin pie plate, 6 1/2″ diameter. [SB]

Landscape, by A. D. Shattuck, inscribed on back: "by particular request figures introduced, March 17, 1859, by W. S. Mount"; 15 3/4 × 9 3/4″. [SB-MC]

Landscape and Water. c. 1851; 8 × 12″. [SB-MC]

Landscape Study, Ducks in Water. 1851; 10 × 13″. [SB-MC]

Landscape with Hills. October, 1856; 6 × 7″. [PRIVATE COLLECTION, GREEN BAY, WIS.]

Landscape with House. n.d.; 10 × 14″. [SB]

Landscape with Sand Pit. n.d.; 9 1/4 × 7 1/4″. [PRIVATE COLLECTION, GREEN BAY, WIS.]

The Letter [*The Farewell*]. May 11, 1862; 3 1/2 × 5″. [SB]

John Leveridge. n.d.; 33 × 26″. [EAST RIVER SAVINGS BANK, NEW YORK CITY]

The Lone Pine Tree. n.d.; 10 1/2 × 13 1/2″. [FARL]

Longbotham's Barn. 1857; 6 3/4 × 10″. [SB-MC]

Long Hill Road, Stony Brook. October 14, 1856; 10 1/4 × 14″. [SB]

Long Island Farmhouse Piazza with Imaginary Landscape Vista [*Corner of the Mount House*]. c. 1846; 12 3/4 × 17″. [SB-MC]

Long Island Farmhouses. c. 1854; 22 × 30″. [METROPOLITAN MUSEUM OF ART]

Long Island Farmhouses. Detail, c. 1854; 5 × 4″. [SB]

Long Island Sound. n.d.; 8 3/4 × 11 1/2″. [SB]

Low Tide in the Cove. n.d.; 9 7/8 × 14″. [FARL]

Mrs. Manice. 1833; 30 × 25″. [PRIVATE COLLECTION, GREENWICH, CONN.; FARL]

Man in a Boat. 1852; 10 × 14″. [SB]

Man with an Ax. October, 1853; 10 1/4 × 14 1/2″. [SB-MC]

Nelson Mathewson. 1840; 7 × 6 1/2″. [SB]

Tompkins H. Matteson. n.d.; 22 × 18″. [FARL]

The Mill at Stony Brook. n.d.; 7 3/4 × 10 1/4″. [SB-MC]

The Mill Dam at Madison. October, 1843; 12 7/8 × 17″. [SB]

Mrs. William Wickham Mills. 1829(?); 26 × 22″. [FARL]

Henry Smith Mount. 1831; 34 1/2 × 27 1/4″. [SB-MC]

William Sidney Mount. 1828; 17 × 14″. [SB]

William Sidney Mount. 1832; 24 1/2 × 20 1/4″. [SB]

William Sidney Mount (copy by Mount of the 1848 portrait by Charles Loring Elliott). c. 1848; 20 × 16″. [NATIONAL ACADEMY OF DESIGN, NEW YORK CITY]

William Sidney Mount (copy by Mount of the 1848 portrait by Charles Loring Elliott). 1851; 21 3/4 × 17 1/2″. [SB]

The Mount Barn. n.d.; 10 × 14″. [SB]

The Mount House. n.d.; 8 1/4 × 10 1/4″. [SB]

The Mount House. 1854; 8 × 9 3/4″. [SB-MC]

Mount House Rooftop. n.d.; 7 1/2 × 9 1/2″. [SB-MC]

Lora Nash. c. 1835; 33 × 27″. [MUSEUM OF THE CITY OF NEW YORK]

Mrs. Lora Nash. c. 1835; 33 × 27″. [MUSEUM OF THE CITY OF NEW YORK]

North Shore of Long Island. n.d.; 9 × 11 1/2″. [FARL]

Mary Lavinia Brooks Owen. 1849; 33 × 26″. [MUSEUM OF THE CITY OF NEW YORK]

Portrait of a Lady. 1832; 30 × 25″. [SB]

Portrait of a Lady. 1832; 34 × 27″. [SB]

Portrait of a Man. 1832; 34 × 27″. [SB]

Portrait of a Man. n.d.; 41 × 32 1/2″. [SB]

Study for *Raffling for the Goose* [*Tavern Scene*]. 1837 (?); 8 1/4 × 12″. [SB]

The Rail Fence. n.d.; 12 × 14″. [SB-MC]

Rear View of the Mount Home, Stony Brook. October 19, 1860; 10 1/8 × 14 1/8″. [FARL]

Reuben. 1832; 21 1/2 × 17″. [SB]

Mary Ford Rice. n.d.; 18 1/2 × 14 1/2″. [SB]

Rock and Trees. n.d.; 12 1/4 × 9 3/4″. [PRIVATE COLLECTION, GREEN BAY, WIS.]

James Rudyard. c. 1840; 21 × 17″. [SB-MC]

St. George's Manor. n.d.; 13 3/4 × 20 1/2″. [SB]

St. George's Manor. 1845; 6 3/4 × 10″. [COLLECTION MR. AND MRS. JOHN D. ROCKEFELLER 3RD, NEW YORK CITY; FARL]

Mrs. Charles S. Seabury and Son Charles Edward. 1828; 30 × 23 5/8″. [SB]

Rev. Charles Seabury. c. 1846; 8 1/4 × 6 5/8″. [SB]

Edward S. Seabury. 1867; 20 1/2 × 17 3/8″. [SB-MC]

Maria Winthrop Seabury. 1867; 20 1/2 × 17 3/8″. [SB-MC]

William Seabury. c. 1844; 21 × 17″. [FARL]

Sisters. 1831; 36 × 29″. [PRIVATE COLLECTION, HOUSTON, TEXAS]

William Wickham Mills Smith. 1850; 4 × 3″. [PRIVATE COLLECTION, STONY BROOK, L.I.; FARL]

Spring Boquet. June 2, 1859; 8 1/2 × 7″. [FARL]

Spring Flowers. c. 1859; 7 × 6 3/8″. [SB-MC]

Mrs. Timothy Starr. 1833; 30 × 25″. [SB]

The Stone Bridge. October 20, 1843; 8 × 12 5/8″. [FARL]

A Suffolk Scene. 1858; 9 3/4 × 13 3/4″. [SB]

The Thomas H. Mills House. November 12, 1847; 10 3/8 × 13 1/2″. [FARL]

The Thomas Strong Farm. October, 1864; 10 3/4 × 17″. [FARL]

Tulips. 1859; 9 × 7 1/8″. [SB]

William Clark Tyler. 1837; 30 × 25″. [SB-MC]

Benjamin Townsend Underhill. n.d.; 33 1/2 × 26 1/2″. [FARL]

Mrs. Benjamin Townsend Underhill. 1835; 33 1/2 × 26 1/2″. [FARL]

Mrs. Harvey Vail. 1834; 20 × 17″. [SB]

View from the Hill. n.d.; 10 3/8 × 13 1/2″.

View of the Sound over Long Island Shore [*Landscape and Water*]. October 17, 1851; 10 × 14″. [SB-MC]

A Woman After Death. n.d.; 8 1/2 × 6 1/2″. [SB-MC]

A Young Girl. 1838; no measurements recorded. [PRIVATE COLLECTION, GARDEN CITY, N.Y.; FARL]

The Young Traveller. 1854; 10 1/4 × 8″. [PRIVATE COLLECTION, PEEKSKILL, N.Y.; FARL]

Thirteen small engravings after paintings by Mount were published in magazines and gift books during his lifetime. He frequently protested their poor quality, and they add nothing to our understanding of him. A complete list of these may be found, by those who are interested in such antiquarianism, in *William Sidney Mount,* by Bartlett Cowdrey and Hermann Warner Williams, Jr. (1944).

The two line engravings after Mount issued by the Apollo Association and its successor, the American Art-Union, are a very different matter; so are the ten color lithographs after Mount which were made in France. These are not poor little things bound in the files of forgotten publications. They are independent works of art peripheral to the paintings from which they came, and they have some importance in their own right. Collections of them can be found at Stony Brook, at the Long Island Historical Society, the New-York Historical Society, and the New York Public Library, and individual copies occasionally appear on the contemporary art market. A list of them is therefore in order here. The wordy letterpress on some has been slightly abbreviated.

American Engravings

1. FARMERS NOONING, 12 3/4 × 16 1/8.
 Signed on Plate: "Wm. S. Mount, 1836."
 Letterpress: PAINTED BY W. S. MOUNT.—ENGRAVED BY ALFRED JONES. / FARMERS NOONING. / From the Original Picture in the Possession of Jona. Sturges Esqre. / Published by the Apollo Association. / Exclusively for the Members of the year 1843. / Printed by Burton.

2. BARGAINING FOR A HORSE, 7 3/4 × 10.
 Letterpress: PAINTED BY W. S. MOUNT.—ENGRAVED BY C. BURT. / BARGAINING FOR A HORSE. / Engraved from the original painting in possession of the New York Gallery of the Fine Arts. / American Art-Union, 1851. . . .

French Lithographs

1. THE POWER OF MUSIC, 14 5/8 × 18 5/8.
 Letterpress: Painted by W. S. MOUNT.—NEW-YORK, Published by GOUPIL, VIBERT & Co. 289, Broadway.—LÉON NOËL fect. / THE POWER OF MUSIC! / This print is Respectfully Dedicated to Mrs. Gideon Lee, / by her most obedient Servants, / Goupil, Vibert, & Co. . . . Entered . . . 1848 by W. S. Mount. . . .

2. MUSIC IS CONTAGIOUS, 14 5/8 × 18 3/4.
 Letterpress: Painted by W. S. MOUNT.—NEW-YORK, Published by GOUPIL, VIBERT & CO. 289, Broadway.—LÉON NOËL fect. / MUSIC IS CONTAGIOUS! / This print is Respectfully Dedicated to Charles M. Leupp, Esqre. / by his most obedient Servants, / Goupil, Vibert & Co. . . . Entered . . . 1849 by W. S. Mount. . . . [The painting from which this lithograph was taken is called *Dance of the Haymakers*.]

3. CATCHING RABBITS, 14 3/4 × 18 3/4.
 Letterpress: Painted by W. S. MOUNT.—NEW-YORK, Published by GOUPIL & CO. 289, Broadway. —LÉON NOËL fect. Landscape by BICHEBOIS. / CATCHING RABBITS! / This print is Respectfully Dedicated to Mrs. Charles Augustus Davis, / by her most obedient Servants, / Goupil & Co. . . . Entered . . . 1850 by W. Schaus. . . . [The painting from which this lithograph was taken was called *Boys Trapping* by Mount.]

4. JUST IN TUNE, 23 1/8 × 18 5/8, rounded corners.
 Printed on plate: Imp. Lemercier, r. de Seine, 57, Paris.
 Letterpress: Peint par W. S. MOUNT.—Entered . . . 1850 by W. Schaus . . . New-York.—Lith. par ÉMILE LASSALLE. / JUST IN TUNE. / Études de Portraits et de Groupes divers. / 3. / This print is Respectfully Dedicated to George J. Price Esqre. / by his most obedient Servants, / Goupil & Co. / New-York. . . .

5. RAFFLING FOR A GOOSE (THE LUCKY THROW), 25 × 19 5/8, rounded corners.
 Signed on plate: "Lafosse."
 Printed on plate: Imp. Lemercier à Paris.
 Letterpress: Painted by W. S. MOUNT.—Entered . . . 1851 by W. Schaus . . . New-York.—Lith. by LAFOSSE. / RAFFLING FOR A GOOSE / (THE LUCKY THROW). / Études de Portraits et de Groupes divers. / 7. / Publié par GOUPIL et CIE. Editeurs. / Paris, Londres, Berlin, New-York.

6. RIGHT AND LEFT, 24 7/8 × 19 1/4, rounded corners.
 Signed on plate: "Lafosse."
 Printed on plate: Imp. Lemercier.
 Letterpress: Painted by W. S. MOUNT.—Entered . . . 1852 by W. Schauss . . . New-York.—Lith. by LAFOSSE. / RIGHT AND LEFT. / EN AVANT-DEUX! / Études de Portraits et de Groupes divers./ 8. / Publié par GOUPIL et CIE. Editeurs. / Paris, London, Berlin, New-York.

7. THE "HERALD" IN THE COUNTRY, 14 7/8 × 12.
Letterpress: Painted by W. S. MOUNT.—Entered
. . . 1854 by M. Knoedler . . . New-York.—
Lithographed by THIELLEY. / THE "HERALD"
IN THE COUNTRY. /BERLIN—Verlag von GOU-
PIL & Cie.—Paris—London. . . . Printed by Le-
mercier, in Paris. [The painting from which this
lithograph was taken was originally called *Politics
of 1852, or Who Let Down the Bars?*]

8. COMING TO THE POINT, 19 3/8 × 23 1/4.
Letterpress: WM. S. MOUNT pinx. 1854.—Entered
. . . 1855 by W. Schaus . . . New York.—SOU-
LANGE TEISSIER lith. / COMING TO THE
POINT.—This print is respectfully dedicated to A. R.
Smith Esqre. / by his most obedient servant W.
Schaus.

9. THE BANJO PLAYER, 25 1/4 × 20 1/8, rounded
corners.
Signed on plate: "Lafosse."
Letterpress: Painted by WM. S. MOUNT.—Entered
. . . 1857 by W. Schaus . . . New-York.—Lith. by
LAFOSSE. / THE BANJO PLAYER. / New-York,
pubd. by W. SCHAUS, 629 Broadway.—Imp. Fois.
Delarue, Paris.

10. THE BONE PLAYER, 25 1/8 × 20, rounded
corners.
Signed on plate: "Lafosse."
Letterpress: Painted by WM. S. MOUNT.—Entered
. . . 1857 by W. Schaus . . . New-York.—Lith. by
LAFOSSE. / THE BONE PLAYER. / New-York,
Pubd. by W. SCHAUS, 629 Broadway.—Imp. Fois.
Delarue, Paris.

national academy of design exhibition record 1828-69

The following listing is reprinted from two sources: The *National Academy of Design Exhibition Record, 1826–1860*, printed in 1943 for the New-York Historical Society; the *National Academy of Design Exhibition Record, 1861–1900,* compiled and edited by Maria Naylor and published by Kennedy Galleries, Inc., New York, in 1973. I am indebted to both publishers for permission to reproduce the Mount excerpts. A proper name in italics designates the owner of the painting as recorded in the exhibition catalogue.

MOUNT, William Sidney (1807–1868)
　　　　Member of the Academy, 1832–1868.
1828　*Address:* Not given.
　　　177. Raising of Jairus' Daughter.
1829　*Address:* 154 Nassau Street.
　　　　2. Crazy Kate. *For sale.*
　　　 92. Celadon and Amelia. *For sale.*
　　　102. Saul, and the Witch of Endor. *For sale.*
1830　*Address:* 71 James Street.
　　　 54. The Rustic Dance after a Sleigh Ride. *For sale.*
　　　108. Girl and Pitcher.
　　　135. Portrait of a Clergyman.
1831　*Address:* 71 James Street.
　　　 16. Portrait of a Lady. *John Delafield.*
　　　 55. Boys Quarrelling after School.
　　　 59. Scene in a Cottage Yard.
　　　104. Landscape and Boy.
　　　115. Dance after a Sleigh-ride.
　　　148. Portrait of a Gentleman. *John Delafield.*
　　　153. Portrait of the Rev. Doctor Upfold.
　　　165. Portrait of a Gentleman.
　　　174. Portrait of a Lady.
　　　181. Portrait of a Gentleman. *M. E. Thompson.*
1832　*Address:* 209 Spring Street.
　　　 41. Portrait. *J. Johnson.*
　　　 59. Portrait of Rev. B. J.[T.] Haight.
　　　 93. Sketch from Nature. *A. B. Durand.*
　　　198. Portrait.
　　　201. Interior of a Barn, with Figures. *For sale.*
　　　203. Portrait. *W. Johnston.*
　　　212. Portrait. *J. S. Crary.*
　　　213. Portrait.
　　　224. Portrait.
1833　*Address:* 24 Howard Street.
　　　 14. Portrait of a Lady. *Mr. Manice.*
　　　 15. Portrait of a Gentleman. *Mr. Booth.*
　　　 19. Man in Easy Circumstances. *Mr. L. P. Clover.*
　　　 74. Portrait of a Gentleman. *Mr. Booth.*
　　　 75. Full Length Portrait of Right Rev. Benjamin T. Onderdonk, Bishop of the Protestant Epis[copal] Church.
　　　 78. Portrait of T. T. Woodruff, Esq.
　　　188. Flower Piece. *J. Parker.*
1834　*Address:* Not given.

17. Portraits of the Misses Russell. *C. M. Russell.*

49. Long-Island Farmer Husking Corn.

50. Boy on the Fence.

77. Mother and Child.

99. After Dinner.

1835 *Address:* Corner William and Wall Streets.

55. The Studious Boy. *For sale.*

141. Bar-room Scene. *For sale.*

187. Sportsman's Last Visit. *For sale.*

1836 *Address:* Not given.

147. Undutiful Boys.

155. Farmer's Bargaining.

1837 *Address:* Stony Brook, L. I.

268. Farmer's Nooning. *J. Sturges.*

285. The Raffle. *Henry Brevoort.*

291. Courtship. *John Glover.*

1838 *Address:* Stony Brook, L. I.

95. Dregs in the Cup, or Fortune Telling. *For sale.*

308. The Tough Story—Scene in a Country Tavern. *Robert Gilmor.*

169. Engraving by R. Hinshelwood, after W. S. Mount. Exhibited by the Engraver.

1839 *Address:* Stony Brook, L. I.

104. Portrait of his Honor the Mayor of Brooklyn [Jeremiah Johnson].

225. Boys Trapping. *Chas. A. Davis.*

1840 *Address:* Stony Brook, L. I.

183. Disappointed Batchelor [*sic*]. *For sale.*

188. Boy Hoeing Corn. *For sale.*

242. The Blackberry Girls.

1841 *Address:* Stony Brook, L. I.

53. Cider Making. *C. A. Davis.*

302. Sketch of the late H. S. Mount.

1842 *Address:* Stony Brook, L. I.

184. Scene in a Long Island Farm-Yard. *Jon. A. Sturges.*

191. Portrait of a Lady. *A. A. Smith.*

1843 *Address:* Stony Brook, L. I.

242. Artist Showing his Work. *E. L. Carey.*

1844 *Address:* Stony Brook, L. I.

94. Portrait of Rev. S[amuel] Seabury, D. D. *Rev. S. Seabury, D. D.*

177. Girl Asleep. *For sale.*

274. Portrait of Benj[amin] Strong, Esq. *A Lady.*

315. Boys Hustling Coppers. *A. M. Cozzens.*

301. Farmers Nooning, Engraved by Alfred Jones for the Apollo Association, from the Original Picture by W. S. Mount. Exhibited by the Engraver.

1845 Member of the Council; Member of the Committee of Arrangements. *Address:* Stony Brook, L. I.

195. Dance of the Haymakers. *C. M. Leupp.*

196. G[eorge] W[ashington] Strong, Esq. *G. W. Strong.*

242. Bird-Egging. *A. M. Cozzens.*

276. Pencil Sketches of Children. *D. H. Wickham.*

1846 *Address:* Stony Brook, L. I.

131. Recollections of Early Days—"Fishing along shore." *Geo. W. Strong.*

328. View of the Catskill Mountains.

342. Portrait of a Lady. *Mrs. James Smith.*

1847 *Address:* Stony Brook, L. I.

115. The Ramblers. *Thos. McElrath.*

149. Portrait of a Gentleman. *S. T. Nicoll.*

158. The Force of Music. *Mrs. Gideon Lee.*

174. S. T. Nicoll.

336. Cabinet Portrait of a Lady. *Chas. S. Seabury.*

1848 *Address:* Stony Brook, L. I.

108. Master Russell. *W. H. Russell.*

127. Maria. *Chas. S. Seabury.*

150. Caught Napping. *G. W. Strong.*

235. Loss and Gain. *R. F. Fraser.*

1849 *Address:* Stony Brook, L. I.

84. "Turning the Leaf." *James Lenox.*

194. The Well by the Way Side. *For sale.*

202. A Farmer Whetting His Scythe. *For sale.*

259. Cabinet Portrait of C. L. Elliott. *C. L. Elliott.*

342. Engraving by Léon Noël, after Wm. S. Mount. Exhibited by the Engraver.

1850 Member of the Council; Member of the Committee of Arrangements. *Address:* Stony Brook, L. I.

166. Portrait of a Gentleman. *Chas. S. Seabury.*

201. News from the Gold Diggins [*sic*]. *Thos. McElrath.*

1851 *Address:* Stony Brook, L. I.

80. Just in Tune. *Geo. J. Price.*

118. Who'll Turn the Grindstone. *Jonathan Sturges.*

1852 *Address:* Stony Brook, L. I.

379. Mrs. S. A. Mount.

420. Portrait of the Artist. *S. A. Mount.*

458. Portrait of a Gentleman. *Mrs. J. T. Vanderhoff.*

1853 *Address:* Stony Brook, L. I.

160. The Politics of 1852: or "Who let down the bars?" *Goupil & Co.*

240. Miss M. E. Pickering. *Wm. L. Pickering.*

362. Great-Grand-Father's Tale of the Revolution—a Portrait of Rev. Zachariah Greene, now in his 94th Year. *J. T. Vanderhoof.*

393. Portrait of a Naval Officer. *N. P. Bailey.*

1854 *Address:* Stony Brook, L. I.

109. Portrait of a Lady.

143. Group of Children. *John Brooks.*

150. Coming to the Point: a Variation of "Bargaining for a Horse." *A. R. Smith.*

292. Portrait in one Sitting. *Wm. A. Jones.*

1855 *Address:* Stony Brook, L. I.

72. Webster among the People. *For sale.*
75. Walking Out. *George Searing.*

1856 *Address:* Stony Brook, L. I.
4. Portrait of a Lady. *Mrs. S. P. Bell.*

1857 *Address:* Stony Brook, L. I.
268. One of the Tangiers. *Thos. S. Mount.*

1858 *Address:* Stony Brook, L. I.
149. Capt. E. E. McKeigle [Mckeige].
493. A Lady. *William G. Spencer.*
521. Mischievous Drop. *J. M. Falconer.*
536. "Any Fish Today?" *D. A. Wood.*
595. Banjo-Player. *C. M. Leupp.*
600. Bone Player. *J. D. Jones.*

1859 *Address:* Stony Brook, L. I.
29. Spring Boquet [*sic*]. *Miss E. Wood.*
371. The Tease. *Charles B. Wood.*
426. Esquimaux [*sic*] Dog. *G. A. Conover.*
442. A Gentleman. *Thos. S. Seabury.*

1860 *Address:* Stony Brook, L. I.
275. Apple Blossoms.
481. A Gentleman. *Abel Denison.*
522. Right and Left. *David A. Wood.*
551. A Lady. *Abel Dennison.*
642. Tulips. *The Artist.*

1861 *Address:* Stony Brook, L. I.
388. Wm. B. Townsend. *Mrs. N. Marsh.*
414. Ette. *G. B. Ripley.*

1862 *Address:* Stony Brook, L. I.
195. Going Trapping. *For sale.*
247. Returning from the Orchard. *For sale.*
365. What have I Forgot? *S. P. Avery.*

1863 *Address:* Stony Brook, L. I.
39. E. T. Darling.

235. Mrs. W. H. W.
359. Chasing the Fiddlers at Low Tide. *Mrs. F. B. Spinola.*
366. Rev. James S. Evans.

1864 *Address:* Stony Brook, L. I.
138. Julia. *Wm. H. Wickham.*
171. Portrait. *W. H. Wickham.*
274. The Late Andrew Hood. *Mrs. M. L. Hood.*

1865 *Address:* Stony Brook, L. I.
97. Catching Crabs. *Chas. B. Wood.*
320. Before the War. *For sale.*
499. Early Impressions are Lasting. *Chas. B. Wood.*
538. Loitering by the Way. *For sale.*

1866 *Address:* Stony Brook, L. I.
115. Portrait of an Esquimaux Dog. *Francis Copcutt.*
194. Portrait.
318. Cabinet Portrait. *C. G. Harmer.*
325. Apples in a Champagne Glass. *Chas. E. Harmer.*
395. Portrait. *William H. Ludlow.*

1867 *Address:* Stony Brook, L. I.
426. Portrait—Mrs. D. C. Becar.

1868 *Address:* Setauket, L. I.
44. Portrait. *Sinclair Tousey.*
256. Mutual Respect. *Rob't Hoe.*
400. Gen. F. B. Spinola.
516. A Charming Scene.
536. A Study. *Francis Copcutt.*

1869 *Deceased.*
157. Peach Blossoms. *J. M. Falconer.*

bibliography

The aim of this bibliography is to be useful, not to be comprehensive. It could easily have included dozens of articles and passing references to Mount which are of little or no value, but that would have been of little or no value to the reader. We include only articles and chapters in books which are substantial in size and instructive to the twentieth-century mind. The instructiveness of the first three titles, however, is of a special sort: they reveal the attitudes of Mount's time toward the artist and are no longer of any value except as evidences of change in taste. The sequence throughout the bibliography is chronological. Page numbers are not given since it may be assumed that literate people know how to use an index.

1. William Dunlap, *A History of the Rise and Progress of the Arts of Design in the United States.* Original edition, New York, 1834. Modern reprint editions issued by Benjamin Blom, 1965, and Dover Publications (paperback), 1969. The first significant notice of Mount, written not long after the start of his career and indicating the impact he had on the art world of his time almost from the very beginning.

2. Charles Lanman, *Letters from a Landscape Painter,* Boston, 1845. The same text, in a slightly revised version, appears in Lanman's *Haphazard Personalities,* Boston, 1866. Lanman's essay on Mount, beginning with the frequently quoted lines "Three cheers for the laughter-loving and incomparable genius of Stony Brook, whom I know to be a first-rate fisherman and a most pathetic player on the violin," has probably done Mount more harm, in its naïve trivialization, than all the unfavorable notices he ever received.

3. W. Alfred Jones, *Characters and Criticisms,* Vol. 1, New York, 1857. Jones was librarian of Columbia College and a literary Pooh-Bah of enormous prolificality and formidable reputation. His essay on Mount is interesting for its indication of the painter's impact on a man of lively intellect who knew little or nothing about painting.

4. Edward P. Buffet, *William Sidney Mount, a Biography. Port Jefferson Times,* December 1, 1923, to June 12, 1924. The modern literature on Mount begins with this remarkable production, which rambled through fifty-six chapters in a Long Island newspaper; scrapbook copies of it may be found in several libraries, notably the New York Public and the library of the Metropolitan Museum. Buffet is cranky, cantankerous, old-fashioned, long-winded, and marvelous. He had access to many Mount documents before they were collected in their present repositories; quite a few of the documents he drew upon have since been lost and can be found in no other source.

5. F. O. Matthiessen, *American Renaissance: Art and Expression in the Age of Emerson and Whitman,* Oxford University Press, 1941. Contains the first

discussion of Mount by a modern literary critic and intellectual historian. Although it is impossible to verify Matthiessen's assertion that Mount was a frequent drinking companion of Herman Melville, his discussion of this artist is, on the whole, one of the finest appreciations of him in the light of his times to appear in the modern literature.

6. [Mary] Bartlett Cowdrey and Hermann Warner Williams, Jr., *William Sidney Mount, 1807–1868,* Metropolitan Museum and Columbia University Press, 1944. The first effort at a comprehensive, scholarly treatment of Mount, as remarkable for the meagerness of its material as for the skill and insight with which it is handled. This book is the first monument of the modern Mount revival, and itself gave enormous impetus to that revival. Although innumerable paintings and documents that were unknown to the authors have since come to light, their work remains indispensable to the student of Mount.

7. Virgil Barker, *American Painting, History and Interpretation,* The Macmillan Company, 1950. Barker's was the first of the general histories of American painting which have appeared in such profusion in recent decades, and his treatment of Mount remains the most extensive, sympathetic, and penetrating of all those to be found in these volumes.

8. James T. Flexner, *That Wilder Image: The Painting of America's Native School from Thomas Cole to Winslow Homer,* Little, Brown and Company, 1962. Extensive and well-documented treatment of Mount, but somewhat too insistent on seeing him as limited and provincial, especially in technique. Flexner's change of attitude toward Mount, as indicated in No. 13 below, is marked and well worth noting.

9. Sidney Kaplan, *The Portrayal of the Negro in American Painting,* Bowdoin College Museum of Art, 1964. One of the earliest evidences of the effect of the racial turmoil of the sixties on art history, with a brief but telling treatment of Mount as painter of black Americans.

10. Stuart P. Feld, "In the Midst of 'High Vintage,' " Metropolitan Museum of Art Bulletin, April, 1967. An article written to signalize the acquisition by the Metropolitan of Mount's *Cider Making.* Superbly documented, this article contains the full text of a piece of fiction woven about the picture by an anonymous author and published originally in the *New York American* in 1841. The story is typical of those that were habitually written about Mount's paintings when they were reproduced in popular journals and gift books. It is the only such story now readily available and is considerably superior to most of its breed.

11. Barbara Novak, *American Painting of the Nineteenth Century,* Praeger Publishers, 1969. The first study to "take the hayseed out of Mount's hair," as the author herself puts it, and to see him in the light of intellectual and aesthetic movements of the highest importance in his time. Miss Novak's juxtaposition of Mount's *Power of Music* with Piero della Francesca's *Flagellation* fairly takes one's breath away. But, as is pointed out in the Foreword, Miss Novak occasionally exaggerates.

12. Donald D. Keyes, "The Sources for William Sidney Mount's Earliest Genre Paintings," *Art Quarterly,* 32, Autumn, 1969. Especially valuable for its indication of the indebtedness of Mount's *Rustic Dance After a Sleigh Ride* (Mount's first success and the work which launched him on his career as a genre painter) to John Lewis Krimmel's *Dance in a Country Tavern.*

13. James T. Flexner, *Nineteenth Century American Painting,* G. P. Putnam's Sons, 1970. "He was a much greater painter than I had previously realized."

14. Russell Lynes, *The Art-Makers of Nineteenth Century America,* Atheneum Publishers, 1970. Although relatively short, the treatment of Mount here is remarkably comprehensive and remarkably astute. It provides perhaps the best total picture of Mount, as artist and as nineteenth-century man, to be found anywhere in the literature.

15. Hermann Warner Williams, Jr. *Mirror to the American Past.* New York Graphic Society, 1973. A very richly illustrated survey of American genre painting in the 18th and 19th centuries, exploring many previously neglected aspects of the subject and placing Mount in perspective against a background of his colleagues and contemporaries.

16. Patricia Hills, *The Painters' America, Rural and Urban Life, 1810–1910,* Praeger Publishers, in association with the Whitney Museum of American Art, 1974. A forthright and penetrating study of 19th-century American genre in terms of its historical and sociological meanings. The first study of American genre to look deeply below the surface of its subject matter to its underlying values.

The following books are in a different category from the preceding because their references to Mount are purely incidental, but they all provide rich and important information with regard to American artist-life in his period.

17. Neil Harris, *The Artist in American Society: The Formative Years, 1790–1860,* George Braziller, 1966. Places the American artist against the full panorama of American life in the period indicated.

18. Lillian B. Miller, *Patrons and Patriotism: The Encouragement of the Fine Arts in the United States, 1790–1860,* University of Chicago Press, 1966. A

thorough study of public and private patronage of the visual arts in America in the same era as that covered by Harris.

19. James T. Callow, *Kindred Spirits: Knickerbocker Writers and American Artists, 1807–1855,* University of North Carolina Press, 1967. A study of interaction between artists, journalists, critics, and novelists in New York City, almost exactly coinciding in its period with Mount's lifetime.

list of illustrations

Colorplates are marked with an asterisk

Plate 1 *William Sidney Mount.* Date unknown
Plate 2 George Lehman, *Dance in a Country Tavern.* 1835–36
Plate 3 *Charles Loring Elliott.* 1848
Plate 4 Sketch for *Christ Raising the Daughter of Jairus.* 1828
Plate 5 *Self-Portrait.* 1828
Plate 6 *Mrs. Charles S. Seabury and Son Charles Edward.* 1828
Plate 7 *Henry Smith Mount.* 1828
Plate 8 *Henry Smith Mount.* 1831
Plate 9 *After Dinner.* 1834
Plate 10 Francis W. Edmonds, *The City and the Country Beaux.* Date unknown
Plate 11 Study for *Raffling for the Goose.* 1837(?)
Plate 12 *Raffling for the Goose.* 1837
Plate 13 Sketch for *Disappointed Bachelor.* 1840(?)
Plate 14 Study for *California News.* 1850(?)
Plate 15 *Rev. Zachariah Greene.* 1852
Plate 16 *Mrs. Zachariah Greene.* 1842

*Plate 1 *Rustic Dance After a Sleigh Ride.* 1830
*Plate 2 *Mrs. Timothy Starr.* 1833
*Plate 3 Charles Loring Elliott, *William Sidney Mount.* 1849
*Plate 4 *Christ Raising the Daughter of Jairus.* 1828
*Plate 5 *Saul and the Witch of Endor.* 1828
*Plate 6 *Celadon and Amelia.* 1829
*Plate 7 *Julia Hawkins Mount.* 1830
*Plate 8 *Dancing on the Barn Floor.* 1831
*Plate 9 *The Sportsman's Last Visit.* 1835
*Plate 10 *Winding Up.* 1836
*Plate 11 *Trap Sprung.* 1844
*Plate 12 *Loss and Gain.* 1848
*Plate 13 *California News.* 1850
*Plate 14 *The* Herald *in the Country.* 1853

Plate 17 *Nelson Mathewson.* 1840
Plate 18 Square-dance notation and music. January 30, 1839
Plate 19 *Jeremiah Johnson.* 1839
Plate 20 "The Braes of Athol." July 6, 1839
Plate 21 "Possum Hunt." January 17, 1841
Plate 22 *Henry Smith Mount on His Deathbed.* 1841
Plate 23 Sketch of Henry Smith Mount. January 31, 1841
Plate 24 "A Sett of Cotillions in the Key of C." February 4, 1841
Plate 25 "Waltz—The Cachucha" and "Visit Sett." August 29, 1841
Plate 26 *Haying Scene.* c. 1835
Plate 27 *The Truant Gamblers.* 1835
Plate 28 *Dregs in the Cup.* 1838
Plate 29 "Cradle of Harmony." March, 1857

*Plate 15 *Jedediah Williamson.* 1837
*Plate 16 *The Long Story.* 1837
*Plate 17 *Catching Rabbits.* 1839

Plate 30 "In the Cars, on the Long Island Rail Road." 1850
Plates 31–33 Patent office model of violin. January, 1852
Plate 34 Diagrams of violin from patent papers. 1851
Plate 35 Sketch of tombstone with violin. November 24, 1853
Plate 36 Study for *Farmers Nooning.* 1836(?)
Plate 37 Sketch for *Ringing the Pig.* 1842(?)
Plate 38 *Who'll Turn the Grindstone?* 1851
Plate 39 *The Trying Hour.* 1844
Plate 40 *Leisure Hours.* 1834
Plate 41 Charles Lanman, *Salmon Fishing in Canda.* Date unknown
Plate 42 Shepard Alonzo Mount, sketch of boy fording river. July 31, 1841
Plate 43 "A Sketch of My Mother." November 14, 1841
Plates 44, 45 Sketches for *Eel Spearing at Setauket.* 1845(?)
Plate 46 Study for *Eel Spearing at Setauket.* 1845
Plate 47 "The Hollow back fiddle." February 29, 1852
Plate 48 Sketch of Washington Monument. May 3, 1853

*Plate 18 *Farmers Nooning.* 1836
*Plate 19 *Ringing the Pig.* 1842
*Plate 20 *Dance of the Haymakers.* 1845
*Plate 21 *Girl Asleep.* 1843
*Plate 22 *The Novice.* 1847
*Plate 23 *Eel Spearing at Setauket.* 1845

Plate 49 Sketch of West Point. August 5, 1846
Plate 50 Sketch of girl ironing. August 29, 1846
Plate 51 Sketch of old woman reading. 1846(?)
Plate 52 Charles Loring Elliott, *William Sidney Mount.* 1848
Plate 53 Charles G. Crehen, *William Sidney Mount.* 1850
Plate 54 Sketches for *Dance of the Haymakers* and *The Power of Music.* 1845(?)
Plate 55 *Dance of the Haymakers.* 1845
Plate 56 *The Power of Music.* 1847
Plate 57 "Fire light." April 18, 1847

*Plate 24 *Self-Portrait.* 1832
*Plate 25 *Shepard Alonzo Mount.* 1847
*Plate 26 *Just in Tune.* 1849

*Plate 27 Jean-Baptiste-Adolfe Lafosse, *The Lucky Throw.* 1851
*Plate 28 *The Bone Player.* 1856
*Plate 29 *The Banjo Player.* 1856
*Plate 30 *Right and Left.* 1850
*Plate 31 *Farmer Whetting His Scythe.* 1848

Plate 58 *Turning the Leaf.* 1848
Plates 59–84 Queens Borough Sketchbook
Plate 85 Study for *Woodman Spare That Tree.* Date unknown
Plate 86 Drawings and plans for studio. July 4, 1850
Plate 87 Sketch for *The Breakdown.* 1835(?)
Plate 88 *The Breakdown.* 1835
Plate 89 Sketch of farmyard with pigs. Date unknown.
Plate 90 Sketch for *Cider Making.* 1841(?)
Plate 91 *Boys Caught Napping in a Field.* 1848
Plate 92 *Admiral Theodorus Bailey.* 1852

*Plate 32 *Boy Hoeing Corn.* 1840
*Plate 33 *Cider Making.* 1841
*Plate 34 *The Painter's Triumph.* 1838

Plate 93 Sketch of portable studio. November 17, 1852
Plate 94 *Bargaining for a Horse.* 1835
Plate 95 *Coming to the Point.* 1854
Plate 96 Plan for studio and exhibition room. March 19, 1854
Plate 97 Elevation for studio. March 19, 1854
Plate 98 Untitled landscape. 1834
Plate 99 Untitled landscape. 1834
Plate 100 *The Row Boat.* October 6, 1839
Plate 101 *The Mill Dam at Madison.* October, 1843
Plate 102 *Long Island Farmhouse Piazza with Imaginary Landscape Vista.* c. 1846
Plate 103 *View of the Sound over Long Island Shore.* October 17, 1851
Plate 104 *Man in a Boat.* 1852
Plate 105 Untitled landscape. October 22, 1859
Plate 106 *By the Shore, Small House in Cove.* Date unknown
Plate 107 *Crane Neck Across the Marsh.* Date unknown
Plate 108 *A Woman After Death.* Date unknown
Plate 109 *W. Alfred Jones.* 1853
Plate 110 *Bishop Benjamin Tredwell Onderdonk.* 1830
Plate 111 *Mrs. Benjamin Tredwell Onderdonk.* 1830
Plate 112 Sketch of sailboat. January 3, 1854
Plate 113 Sketch of fishnets. October 18, 1856
Plate 114 *Ariel.* 1859
Plate 115 *Esquimaux Dog.* 1859

Plate 116	*The Letter.* May 11, 1862
Plate 117	*The Volunteer Fireman.* c. 1840
Plate 118	*Reuben.* 1832
Plate 119	*Mrs. Ebenezer Beadleston.* Date unknown
Plate 120	*Long Island Farmhouses.* c. 1854
Plate 121	*Currants.* July 22, 1856

*Plate 35	"Costumes Drawn at the Bowery Theatre." January 23, 1832
*Plate 36	*The Card Players.* Date unknown
*Plate 37	*Banjo Player in the Barn.* c. 1855

Plate 122	*The Artist Sketching.* c. 1855
Plate 123	Sketch of paddle wheel. May 6, 1857
Plate 124	Unknown artist, "Hercules and the Dragon." March 23, 1858
Plate 125	Unknown artist, sketch of two goddesses. March 23, 1858
Plate 126	Sketch of teeth. September, 1859
Plate 127	Sketch of a sharpy. August 27, 1861
Plate 128	Sketches of subjects. July, 1862
Plates 129, 130	Sketches of subjects. May 29, 1863
Plate 131	*Washington Crossing the Alleghany.* 1863
Plate 132	"Sketch of Huntington's Washington." July 11, 1863

Plate 133	Wash drawing. June 6, 1864
Plate 134	"A Sketch of his Mother." June, 1841
Plate 135	*Loitering by the Way.* 1865
Plate 136	Sketch of fish. October, 1865

| *Plate 38 | *Catching Crabs.* 1865 |
| *Plate 39 | *Fair Exchange No Robbery.* 1865 |

Plate 137	Sketch of paintbrushes. December 21, 1865
Plate 138	Charles B. Wood, sketch of picture frame with rabbits. June 6, 1864
Plates 139–63	A Mount Miscellany: Drawings
Plate 164	Sketch of violins. April 18, 1866
Plate 165	Sketch for *Catching the Tune.* 1866(?)
Plate 166	*Catching the Tune.* 1866
Plate 167	Sketch of two-hulled boat. September, 1866
Plate 168	Sketch of eyes. November 10, 1866
Plate 169	Perspective drawing. October, 1866
Plate 170	*The Dawn of Day.* c. 1867
Plate 171	Political poster. 1868
Plate 172	Sketches of subjects. May(?), 1868

photo credits

Except for those listed below and those in private collections, photographs for all paintings and drawings reproduced in this book were provided by The Museums at Stony Brook, Stony Brook, Long Island. Colorplates are marked with an asterisk.

Addison Gallery of American Art, Phillips Academy, Andover, Mass. (*39*)
The Art Institute of Chicago (*88*)
Borough Hall, Brooklyn, N.Y. (*19*)
The Brooklyn Museum (*125*)
The Century Association, New York City (*56*)
Sterling and Francine Clark Art Institute, Williamstown, Mass. (*10*)
Geoffrey Clements (*57, 59–84, 86, 93, 119, 126, 127, 129, 130, 172*)
Corcoran Gallery of Art, Washington, D.C. (*16**)
The Detroit Institute of Arts (*37**)
Historical Society of Pennsylvania, Philadelphia (*2*)
Kennedy Galleries, New York City (*16, 22, 64*)
Bernard & S. Dean Levy, Inc./Sloan & Schatzberg, Inc.,

New York City (*115*)
The Metropolitan Museum of Art (*12, 33*, 120*)
Museum of Fine Arts, Boston (*1*, 28**)
National Collection of Fine Arts, Smithsonian Institution, Washington, D.C. Gift of International Business Machines (*5**)
National Gallery of Art, Washington, D.C. (*3*, 3*)
The New-York Historical Society (*26, 27, 28, 42, 47, 48, 94, 95, 110–12, 123–25, 138, 169*)
New York State Historical Association, Cooperstown (*19*, 23**)
Pennsylvania Academy of the Fine Arts, Philadelphia (*34**)
Queens Borough Public Library, Jamaica, N.Y. (*59–84*)
Reynolda House, Inc., Winston-Salem, N.C. (*36**)
Smithsonian Institution, Washington, D.C., Division of Musical Instruments (*31–33*)
Joseph Szaszfai, Yale University Art Gallery, New Haven, Conn. (*9*)
United States Patent Office (*34*)
The Rembert Wurlitzer Company, New York City (*29*)

general index

Mount's many misspellings of people's names have not been corrected in text. They are shown here as alternate spellings and appear in brackets immediately following the surname. Family relationships appear in parentheses, as do occasional descriptive designations. Plate numbers of black-and-white illustrations are preceded by pl.; of color plates, by c.pl.

Achenbach, Andreas, 187, 352
Adams, Charles Francis, 203
Adams, Joseph Alexander, 143
 engravings by, 25, 26, 370, 468, 469
Alexander, Francis, 19
Allen, Theodore, 68, 73, 95
Allison, M. (landlord), 471
Allston, Washington, 15, 19, 115, 124, 127
Allston Association, 373
American Academy of Fine Arts, 16, 25
American Art-Union, 104, 480
 administration, 119
 Bullus on, 236
 commissions by, 187–88, 234
 The Novice, c.pl. 22; 30, 117, 119, 174, 471
 engravings for, 104, 153, 480
 exhibitions, 319, 320
 and Goupil & Co., 152, 153, 166–67
 and International Art-Union, 152
 and Lanman, 118, 124
 and S. A. Mount, 118, 188, 234
 Mount's feud with, 104, 187–88, 232, 234
 new headquarters, 13
 paintings owned by
 Blackberry Girls, 29, 470
 Farmer Whetting His Scythe, c.pl. 31; 31, 472
 Loss and Gain, c.pl. 12; 31, 234
 picture lottery, annual, 151
 See also Apollo Association
American Institute of the City of New York, 10, 104
American party, 357
American Review (journal), 334
André, Maj. John, 368
Apollo Association, 104
 engravings for, 99, 480
 Farmers Nooning, 27, 115, 167, 469, 480, 483
 See also American Art-Union
Appi, Henri, 423
Appleton, Mr., 167
Archelaus, King, 184
Archives of American Art, 12, 13, 14, 102
Art history, Mount's interest in, 12
Artists' Fund Society (New York City), 321, 383
Artists' Fund Society (Philadelphia), 59, 77
Art-Union. *See* American Art-Union; International Art-Union
Aspinwall, Mr., 309
Astor, William B., 421

Astor Place riots, 199
Athenaeum, The (London), 120
Audubon, John J., 355
Audubon, J. W., 260
Audubon, Victor G., 259, 260
Austin, George W., 119
 commissions by: (1847) 1 1; (1853?) 266, 267
Authenticity, 13, 466–67
Autobiographical sketches, 12, 14, 15–49, 149
Avery, Samuel Putnam, 348, 368
 commission by, 341, 347, 349
 correspondence, 265, 348–49, 370–71, 393, 477
 on Elliott, 371
 paintings owned by
 Portable Studio, 265, 370, 477
 What Have I Forgot?, 371, 475, 484
 on *The Studious Boy*, 370–71
Awards, 10, 104

Bailey, N. P., 483
Bailey, Theodorus, 149
 correspondence, 251, 257, 454, 455, 456
 on S. A. Mount, death of, 450, 454
 naval career, 251
 portrait of, pl. 92; 32, 251, 257, 454, 473, 483
 portrait of, by S. A. Mount, 453, 454, 455, 456
 Saul and the Witch of Endor owned by, c.pl. 5; 20, 257, 468
Baker, Anson, 199
Baker, Charles, 340
Baker, George Augustus, 124, 185, 242, 247, 318, 354
Baker, William A., 427
Banvard, John, 183
Barker, D. R., commission by, 315
Barker, Virgil, *American Painting, History and Interpretation*, 486
"Barnburners." *See* Free-Soil party
Barnet, Joshua, portrait of, 478
Barnet, Mrs. Joshua (Catherine Barnet), portrait of, 478
Barrett, Joseph H., 94
Barry, J. (neighbor), 380
Barthelemy, Abbé, 375
Beadleston, Mrs. Ebenezer, portrait of, pl. 119; 322, 478
Becar, Mrs. D. C., 484
Becar, Noel Joseph, 67, 351, 474
Becar, Mrs. Noel Joseph, 67, 351, 474
Becar, Noel Joseph, Jr., 353, 379
Becar, Mrs. Noel Joseph, Jr. (niece; "Tootie"; Ruth Hawkins Mount, dau. of Shepard Alonzo), 353, 370, 422
Becar, Mrs. Noel Joseph, Jr. (second wife, Julia B. Thorpe), 379
Beecher, Henry Ward, 358
Bell, Sir Charles, on aesthetics, 143
Bell, Mrs. S. P., 484
Bellows, Mr., 441
Bellows, Albert Fitch, 365
Belly, Felix, 349
Belmont, August, 368, 452, 477
Benedict, Mr., 119, 163
Bennet (critic), 58
Bennet, William W., correspondence, 304
Benson, Eugene, 374
Benton, Thomas Hart, 202
Berkshire Museum (Pittsfield, Mass.), 466–67
Berrian, Mr., 335
Berrian [Berrean], Mrs. Mary L., 388, 476
Betts, F. J., 199

Bible, quotations from, 172–73, 239, 287, 288, 458. *See also* Mount—opinions and observations, on reading
Bichebois, lithograph by, 480
Bierstadt, Albert, 422
Bingham, George Caleb, 10, 128
Birch, Thomas, 19, 49
Birdsall, Samuel, portrait of, 478
Bishop, C. (musician), 258
Black, Edward J. (congressman), 59
Bland, Harry McNeill, 285
Blauvelt, Charles F., 320
Blodge, Oliver, spirit of, 287
Blythe, David Gilmour, 10
Boats, Mount's interest in, pl. 127; 353, 424
 inventions connected with
 boat, two-hulled, pl. 167; 429
 paddle wheel, pl. 123; 335
 yacht, oval-shaped, pl. 112; 302
 "Pond Lily," 344, 386, 387, 429, 445, 448, 463
 care of, 391, 423–24, 428, 432
 sailing, Mount on, 423
Bogle, James, correspondence, 456
Bonfield, George R., 119
Bonheur, Rosa, 127, 309, 318
 The Home Journal on, 343
 paintings by, 309, 319, 320, 343, 344
 painting technique of, 309
Booth, William, 469, 482
Bordman, Miss, portrait of, 468
Boston Notion, 111, 112
Boughton, George Henry, 371
Boutelle [Boudelles], De Witt Clinton, 124, 161, 246, 260, 352
Bowers, Dr. (neighbor), 431
Bowers, J., 204
Bowles, *Across the Continent*, 476
Boydell, Ald. John, 74
Brackett [Bracket], Edward Augustus, 124
Brady, Mr., commission by, 267
Brady, Hugh, 87
Breckenridge, John Cabell, 357
Breedlove, Mrs., portrait of, 474
Bremen, Meyer von, 374, 375
Brent, Henry J., 246, 260
Brevoort [Brevort], Henry, 19, 29, 75, 76, 469, 483
Brewster, Mr. (Robert Nelson Mount's father-in-law), 51, 52, 53, 65, 66
Brewster, Mrs. (Robert Nelson Mount's mother-in-law), 53
Brewster, James, 20, 67, 431, 439
Brewster, Samuel, 94
Bridgman, Mr. (spiritualist), 287
Briggs, Charles F., 106, 118
Brooklyn, Long Island Fair, 378, 393, 394
Brooklyn Art Association, 436
Brooks, Elisha, commission by, 32, 472
Brooks, Erastus, 376
Brooks, Henry Sands, 66
 commission by, 174
Brooks, Mrs. Henry Sands (Lavinia Lion), portrait of, 478
Brooks, James, 375, 376
Brooks, John, 32, 473, 478, 483
Brooks, Mrs. John (Ann Eliza Moseman), 478
Brooks, Van Wyck, *The Times of Melville and Whitman*, 13
Brower, Mrs. A. S., portrait of, 30, 471
Brown, Mrs. (spiritualist), 289
Brown, Charles, 203, 204
Brown, George Loring, 116
Brown, Henry K., 124
Brown, Horace, 203
Brown, James, 199
Brush, Miss. *See* Holland, Mrs. Michael
Brush, Fanny, 65
Bryant, William Cullen, 153, 355

Bryant, William Cullen (cont.)
 correspondence, 335
 Thanatopsis, 124, 240
 "To a Waterfowl," 174, 240, 245, 316
Buchanan, James, and transatlantic cable, 313
Buckle, Mr., on morality, 444
Buffet, Edward P., *William Sidney Mount, a Biography,* 12, 368, 485
Buffon, Georges-Louis-Leclerc de, on genius, 446
Bullard, Isaac, 51
Bullus, Oscar, 232, 236–37, 371
 commission by, 236
Burnet, John(?), 72, 124
Burnham, Thomas Mickell, 108, 109
Burt, Charles, engraving by, 153, 480
Burton (printer), 480
Burton, W. E., correspondence
Butler, William O., 203, 204

Cable, transatlantic, 313, 314, 426–27
Cady, C. M., correspondence, 91, 93, 304
Cain, James, drawing of, 381
Cain, Patrick, drawing of, 381
Caldwell, Samuel B., 475
Callow, James T., *Kindred Spirits: Knickerbocker Writers and American Artists, 1807–1855,* 97, 487
Campton, Maj., 118
Canning, Josiah D., correspondence, 259–60
Caravaggio, 294
Carey [Cary, Clary, Crary, Creary], Edward L.
 commissions by
 Bird Egging, 30, 75, 471
 The Hustle Cop, 29, 74, 470
 The Painter's Triumph, c.pl. 34; 29, 54, 59, 74, 470, 483
 Summer, 116
 Trap Sprung, c.pl. 11; 30, 74, 116, 471
 correspondence, 74–78
 A Man in Easy Circumstances bought by, 25
 See also *The Gift*
Carl, Gilbert, 203
Carleton, Mr. (storekeeper), 367
Carmichael, Rev. William M., portrait of, 26, 469
Carpenter, Francis Bicknell, correspondence, 395
Carter, Luther C., 357
Casilear [Casilaer, Casilier], John W., 76, 354
Cass, Lewis, 187, 201, 202, 203, 204
Catalogues of works, 466–67
 "Catalogue of Portraits and Pictures Painted by William Sidney Mount," 14, 466, 467–76
 "Engravings and Lithographs After Paintings by Mount," 466, 480–81
 "Extant Paintings by Mount Not Listed in His Catalogue or Other Contemporary Documents," 466, 478–79
 "Paintings by Mount Mentioned in the Documents but Omitted from the Artist's Own Catalogue," 466, 477
Century Association, 97
Chalon, Alfred Edward, 104
Chantrey, Sir Francis, 104
Chapin, Mr. (preacher), 66, 67
Chapman, John Gadsby, 116, 397
Charlick, Mr. (neighbor), 446
Chauncey, H., 199
Cheney, John, possible engravings by, 76
Chicago Academy of Design, 451
Child, Lewis, 338, 474
Chilton, R. S., 124–25, 258

Christmas gift books. See *The Gift*
Chrystie, Robert, 455
Church, Frederic E., 342, 345, 346
 commission by, 165, 269
 Mount on, 124, 242
 and NAD presidency, 354
 painting technique of, 316
Cicognara, Count Leopold, 143
Civil War, 10, 201, 251. *See also* Mount—opinions and observations, on Civil War; Politics (1860–65)
Clap, Anthony Hannibal, 91, 93
Clark, Mr., commission by, 174
Clary. *See* Carey
Clay, Clement C., 386
Clement, Clara Erskine, *Artists of the Nineteenth Century,* 127
Clonney, James G., 10, 128
Clover, Lewis P., 25, 468, 482
 Mother and Child painted for, 26, 469
Coit, William, 236
Colden, D. C., 199
Cole, Thomas, 14, 116, 127, 233
 on artists, 268, 311
 biography of, by Noble, 268
 on criticism, 167
 on genius, 267
 on Italian art, 267
 and Lanman, 116, 118
 and Mount, 30, 66
 Mount on, 119, 354
 S. A. Mount on, 110
 on the Old Masters, 267
 paintings by, 117, 199
 The Course of Empire, 68, 70, 72
 painting technique of, 185–86, 199, 236
 and Reed, 68–73 *passim*
Coleman, Charles Caryl, 265
Collins, William Wiehe, 104
Colman, Mr., 114, 124
Colquitt, Walter T. (congressman), 59
Columbia College, 25, 298, 299, 335, 469
Combe, George, 236
Common Council of Brooklyn, 29, 56, 470
Common Council of New York, 123, 258
Conely, William S., 75, 100
Conkling [Conklin], Dr. N. (son of Richard M.), 339, 352, 358
Conkling [Conklin], Richard M., 204, 339
Conover, G. A., 474, 484
Cooper, James Fenimore, 355
Cooper, Mark A. (congressman), 59
Cooper, Peter, and transatlantic cable, 314
Cooper, Thomas Sidney, 111
Copcutt, Francis, 344, 345
 paintings owned by
 Ariel, pl. 114; 436, 476, 484
 Esquimaux Dog (1865), 388, 397, 476, 484
Correggio, 129, 143, 146, 174, 176
Correspondence, 12, 13, 127, 128, 201
 undated, 168
 (1820s) 50–51
 (1830s) 51–57, 68–73, 75–76, 80, 97–99, 101–2
 (1840–44) 57–67, 76–78, 99, 102–3, 104–5, 106–16
 (1845–49) 67, 99–100, 105, 116–23, 149–51, 156–59, 202–4, 232–37
 (1850–54) 19–49, 67, 86–87, 90–93, 100, 123–26, 160–68, 251, 257, 258–61, 299–305
 (1855–59) 93, 168, 292–95, 296, 305, 317–21, 334–38, 348–50
 (1860–64) 67, 262–63, 265, 321, 356–59, 368–77, 393–96
 (1865–68) 396–97, 436–40, 441–42, 451–56
 Allston Association, 373
 American Institute of the City of New

Correspondence (cont.)
 York, *See* Thompson, Martin E., *below*
 anonymous, 19–49, 91, 93, 168, 234, 349, 358, 437, 440
 Audubon, Victor G., 259, 260
 Avery, Samuel P., 265, 348–49, 370–71, 393, 477
 Bailey, Theodorus, 251, 257, 454, 455, 456
 Barrett, Joseph H., 94
 Belmont, August, 452, 477
 Bennet, William W., 304
 Bishop, C., 258
 Bogle, James, 456
 Brent, Henry J., 260
 Brown, Charles, 203, 204
 Bryant, William Cullen, 335
 Bullus, Oscar, 236, 237, 371
 Burton, W. E., 76
 Cady, C. M., 91, 93, 304
 Canning, Josiah D., 259–60
 Carey, Edward L., 74–78
 Carpenter, Francis Bicknell, 395
 Chilton, R. S., 258
 Conkling, Dr. N., 358
 Copcutt, Francis, 397, 436
 Durand, Asher Brown, 73
 Dwight, Theodore F., 438
 Evans, James S., Jr., 437
 Falconer, John M., 317–21
 Ferris, Daniel, 86
 Fuller, S. O., 337–38, 356
 Gardner, John M., 375–77, 397, 477
 Giebner, Hermann, 304–5
 Gilmor, Robert, 74–76
 Goupil, Vibert & Company. See Schaus, William, *below*
 Grannis, T. C., 453
 Hadaway, Thomas H., 296
 Hart, George, 236
 Hawkins, Delia, 151
 Healy, George P. A., 451–52
 Hood, Andrew, 370, 371, 377
 Hood, Mrs. Andrew, 395
 Hood, Andrew, Jr., 395–96, 397
 Huntington, Daniel, 436–37
 Hutchinson, B. T., 202–4
 Jennings, Richard, 357
 Johnson, Eastman, 452–53
 Johnson, W. D., 99–100
 Jones, W. Alfred, 299, 302, 335, 454–55
 Knoedler, Michael, 452
 Lanman, Charles, 13, 106–7, 108–9, 111–26
 with S. A. Mount, 106, 107–8, 109–11
 Laurie, Mrs. Mary, 439
 Layton, J. H., 374–75
 Lenox, James, 397
 Lester, Charles Edwards, 149
 Leupp, Charles M., 105
 Lies, Eugene, 258–59
 Lincoln, Abraham, 373, 377
 Long Island Historical Society. *See* Stiles, Henry R., *below*
 Long-Island Star. See Evans, James S., Jr., *above*
 Ludlow, William Handy, 259, 357, 455–56
 Ludlum, Nicholas, 396–97
 McMaster, William E., 232–33
 Magoon, Rev. E. L., 334
 Matthewson, Nelson, 65
 Meeker, Mr. and Mrs. S. A., 438
 Mitchell, Edward P., 304
 Morgan, M. C., 356–57, 358
 Morris, George Pope, 234
 Moubray, John M., 260
 Mount, Evelina, 437–38
 Mount, Mrs. Henry Smith, 372–73
 Mount, John H., 441–42
 Mount, Robert Nelson, 13, 50–67

Correspondence (cont.)
Mount, Shepard Alonzo, 78, 101–2, 150–51, 202, 372, 439
with Charles Lanman, 106, 107–8, 109–11
Mount, Thomas Shepard (nephew), 335–36, 396, 438
New York Herald, editor of, 358
New York *True Sun:* editor of, 203; proprietors of, 204
Nicoll, Solomon Townsend, 150
Parker, H. W., 334
Phare, W. H., 377
Phrenological Journal, 439–40
Platt, Brad R., 80, 85
Ransom, Caroline L. Ormes, 348, 349–50
Ray, Dr. Joseph H., 338
Reed, Luman, 13, 68–73
Reid, John R., 357, 396
Rembrandt, spirit of, 285, 292–95
Richards, Thomas Addison, 232, 233, 453–54
Ridner, John P., 104
Roberts, Marshall O., 302
Schaus, William: for Goupil, Vibert, 13, 156–63 *passim;* private, 152–53, 162–68 *passim*
Seabury, Thomas Shepard, 87, 440
Searing, George, 305
Smith, Adam R., 165–66, 168
Smith, A. K., 260–61
Smith, Edward Henry, 357, 373–74, 377
Smith, Nathaniel, 335, 348
Spinola, Francis B., 439, 477
Spooner, Alden J., 454
Spooner, Mary A., 104–5
Stiles, Henry R., 393
Strong, Carrie, 394
Sturges, Jonathan, 95–99, 100, 166–67
Thompson, Benjamin Franklin, 102–3, 232, 234–36
Thompson, C. G., 358–59
Thompson, Martin Euclid, 104
Thurber, George W., 302, 304
Tuckerman, Henry T., 149–50
Tuthill, Effingham, 262–63
Upton, Francis H., 86, 87, 90
Wayne, J. M., 451
Whitehorne, James A., 90–91
Williamson, John M., 102
Wood, Charles B., 370, 394–95
Wood, David A., 436
Cousins, Samuel, 104
Cowdrey, Bartlett, and Williams, Hermann Warner, Jr., *William Sidney Mount,* 324, 472, 478, 479, 480, 486
Cowper, William, 20, 468
Cozzens, Mr. (shipwright), 448
Cozzens, A. M., 29, 30, 77, 470, 471, 483
"Cradle of Harmony." *See* Violin, hollowback
Craik, Dr. James, 376
Cranch, C. P., 377
Cranch, John, 375, 377
Crane, Jacob B., commission by, 269
Crary, E. L. *See* Carey
Crary, John S., portraits for, 468, 482
Crawford, Mr., 335
Creary. *See* Carey
Crehen, Charles G., lithograph by, pl. 53; 153, 160
Criticism and reviews, 9–10, 14
19th century
Briggs, Charles F., 106, 118
Dunlap, William, 485
Duyckinck, Evert, 13
Grannis, T. C., 453
Jarves, J. J., 436, 476
Jones, W. Alfred, 298, 334, 485

Criticism and reviews (cont.)
Lanman, Charles, 114–18 *passim,* 122–23, 485
Layton, J. H., 368, 374–75
Lester, Charles Edwards, 106, 120, 148–49
Morris, George P., 232
Mount, William Sidney, 421
Muther, Richard, 152
Reid, John R., 386
Richards, Thomas Addison, 233, 453–54
Tuckerman, Henry, 106, 120
Whitman, Walt, 14
Willis, Nathaniel P., 232, 374, 375
20th century
Barker, Virgil, 486
Buffet, Edward P., 12, 368, 485
Callow, James T., 97, 487
Cowdrey, Bartlett, 324, 480, 486
Feld, Stuart P., 75, 486
Flexner, James T., 486
Harris, Neil, 486
Kaplan, Sidney, 486
Keyes, Donald D., 486
Lewis, R. W. B., 10, 11
Lynes, Russell, 486
Matthiessen, F. O., 13, 485–86
Miles, Josephine, 10, 11
Miller, Lillian B., 63, 68, 104, 348, 368, 486–87
Novak, Barbara, 13, 486
Reich, Sheldon, 10, 12
Williams, Hermann Warner, Jr., 324, 480, 486
Wunder, Richard P., 149
of Mount's works, 13–14, 58, 149, 167, 271
At the Well, 234
Bishop Benjamin Tredwell Onderdonk (1833), pl. 110; 25
The Dawn of Day, pl. 170; 435, 440–41
Dance of the Haymakers, c.pl. 20; 156
Mrs. Shepard Alonzo Mount, 32
The Novice, c.pl. 22; 119
The Power of Music, pl. 56; 118
Rustic Dance After a Sleigh Ride, c.pl. 1; 9–10, 25, 51
Self-portrait (1851), 31–32
The Studious Boy, 26
Winding Up, c.pl. 10; 52
See also Cole, Thomas, on criticism; Mount, Robert Nelson, on critics; individual newspapers and journals
Crocker, Mrs. (NAD employee), 321, 361
Crockett, Davy, 376
Cropsey [Cropsy], Jaspar F., 115, 116, 318, 321, 365, 383
Crystal Palace, Mount exhibits at, 29, 30, 91, 302
Culverwell, Dr., 187
Cummings, Thomas Seir, 449
Curtis, Mr., 183
Cushman, Alexander, on health, 310
Cutting, Mrs. Charlotte, 353

Danforth, M. I., 76
Darley [Darly], Felix O. C., 259
Darling, E. T., 386, 387
portrait of, 360, 475, 484
Darling, Fred, 428
Daughters of the American Revolution, 348
David, Jacques-Louis, 160, 176
Davidson, Richard O., 62
Davis, Capt., 304, 449
Davis, Mr. (spiritualist), 289
Davis [Davies], Mr. (factory owner), 59, 103
Davis, Mr., painting of his dog, 382, 477
Davis, Andrew Jackson, on Moses, 296

Davis, Charles Augustus, 111
paintings owned by
Catching Rabbits, c.pl. 17; 29, 76, 123, 470, 483
Cider Making, c.pl. 33; 29, 202, 470, 483
Dregs in the Cup, pl. 28; 77
Davis, Mrs. Charles Augustus, 480
Davis, Isaac P., 19
Davis, J., 365
Davis, Jefferson, 361, 385
Davis, John R., 363, 388, 391, 396, 432, 475
portrait of, 379, 422, 477
Davis, J. V., 392
Davis, Lucy (dau. of William M.), portrait of, 353, 363, 475
Davis, Mrs. Margaret (Aunt Peggy), 267, 287, 288
Davis, Oliver G., 444
Davis, Richard, 335
Davis, Sarah (wife of Capt. Davis), 449
Davis, William M., 387, 421
article about, by Mount, 421, 432
Lucy Davis painted for, 353, 363, 475
paintings by, 360, 361, 421, 428, 432
Dayton, Joshua, 264
Dean, Mr., painting sold to, 468
Dean, Rev. Samuel, spirit of, 290
Dearing. *See* Dering
Death, 11
Mount on, 11, 30, 32, 114, 317, 471, 473
See also Painting, Mount on, portraits; Portraits, of the dead; Spiritualism
Deborah, Aunt. *See* Shepard, Deborah Hawkins
Debuffe. *See* Dubuffet
Deering, Deery. *See* Dering
de Kay, Dr. James E., 469
Delafield, Dr. Edward, portrait of, 25, 468
Delafield, Mrs. Edward, portrait of, 468
Delafield, John, portrait of, 20, 468, 482
Delafield, Mrs. John, portrait of, 25, 468, 482
Delaroche, Paul, 160, 187
Delarue, François, 481
Democratic party, 10, 201–2. *See also* Politics
Denison, Abel, portrait of, 351–52, 474, 484
Denison, Mrs. Abel, portrait of, 351, 352, 474, 484
Denison, William (son of Abel), portrait of, 351, 474
Denton, John, 475
Denton, Sanford, 379, 388, 391, 477
Derby, H. W., 371
Dering [Dearing, Deering, Deery], Dr. H. S., 53, 59, 122, 344, 435, 441, 463, 474
painting of his residence, 450, 477
Dering, Henry (son of Dr. H. S.), portrait of, 309, 474
Dewey, Rev. Orville, 355
Dey, Mrs. James Richard, portrait of, 478
de Young, M. H., Memorial Museum (San Francisco), 467
Diaries, 12, 127–28
undated entries, 94, 296
(1843–49) 127–30, 141–47, 153–56, 159–60, 170–200
(1850–54) 162, 165, 238–50, 257, 262, 267–73, 287–92
(1855–59) 93–94, 169, 262, 295–96, 306–16, 339–47
(1860–64) 263–64, 351–55, 360–67, 378–83
(1865–68) 67, 94, 383–92, 421–35, 443–50
on spiritualism, 12, 285–92
Whitney Journal, 128
Dignity, Mr., 130, 131–32
Dix, John A., 203

Dodd, Capt., 57, 65
Dodd, Mrs., 65
Dodge, Samuel, commissions by, 174, 266, 267
Dodge, William, 87, 90
Dodge & Upton. *See* Dodge, William; Upton, Francis H.
Dods, John Bovee, 288, 289
Dodsworth [Dodworth], Harvey, 296, 336, 423
Dominique, Blanche F., 431
Doolittle, James R. (congressman), 447
Doughty, Thomas, 116, 187
Douglas, Mrs., 427
Downing, Jack, 111
Draper, Mr. and Mrs., 386
Drawings
 boy fording river (S. A. Mount), pl. 42; 110
 goddesses, two (unknown artist), pl. 125; 337
 "Hercules and the Dragon" (unknown artist), pl. 124; 337
 picture frame with rabbits (C. B. Wood), pl. 138; 394, 395
Drawings (by Mount), 13, 128, 466
 A Mount Miscellany, pls. 139–63; 398, 405, 407–9
 Queens Borough Sketchbook, pls. 59–84; 205
 See also Index of Works: Drawings; Sketches from nature
Drouyn de Lhuys, Édouard, 423
Drummond, Samuel, 104
Dubourjal, Savinien-Edme, 258–59
Dubuffet [Debuffe], Jean, 160
Du Chaillu, Paul Belloni, on Caucasians, 445
Duer, William A., 299
Dunlap, William, 15, 17, 19, 181, 355, 485
Durand, Asher B., 14, 99, 116, 119, 127, 243, 348
 correspondence, 73
 Country Lad on a Fence exhibited by, 482
 Lanman's article on, 118
 on S. A. Mount, 246
 NAD, president of, 246, 354, 355
 paintings by, 19, 68–73 *passim*, 124, 240
 Mount on, 122
 painting technique of, 176, 179, 185, 240, 242, 244, 342
 R. L. Stuart patron of, 318
Dürer, Albrecht, 181
Duyckinck, Evert, 13
Dwight, Theodore F., correspondence, 438
Dykes, Charlie, 424
Dykes, Robert, 463

Eakins, Thomas, 324
Earle, Mr. (of Philadelphia), 49
 commission by, 19
Eastlake, Charles Lock, 104, 111, 392
Eastman, Capt. Seth, 123
Edgar, Maj. William, portrait of, 478
Edgar, Mrs. William (Phebe Baker), portrait of, 478
Edmonds, Judge (spiritualist), 290
Edmonds, Francis W., 10, 15, 19, 116, 128, 259
 The City and the Country Beaux, pl. 10; 27
 Mount on, 122, 142
 and NAD presidency, 354
Edwards, Edward, 13, 205
Edwards, Jonathan, 148
Elderkin, John, 53, 59, 258, 382, 444, 445, 448
Elliott, Charles Loring, 15, 19, 116, 124, 127, 234, 260, 319, 355

Elliott, Charles Loring (cont.)
 Avery on, 371
 death, 450
 influence of, on Mount, 15
 and Lester, 149
 Mount on, 116, 122, 149
 and NAD presidency, 354
 on painting, 187
 painting technique of, 145, 188, 238, 242, 246
 portrait of, pl. 3; 15, 30, 188, 472, 483
 portrait of Henry J. Brent, 246, 260
 portrait of Mount (1848), pl. 52; 15, 30, 161, 186, 472
 copies after, by Mount, 479
 lithograph after, by Crehen, pl. 53; 153, 160
 sittings for, description of, 186
 portrait of Mount (1849), c.pl. 3; 15
 portrait of Mrs. Shumway, 246
 William Wright, commission by, 318
Elliott, Elizabeth. *See* Mount, Mrs. Shepard Alonzo
Elliott, Walter, 304
Embury, Mrs. (writer), 76
Emerson, Ralph Waldo, 74, 240, 485
Emmett, Dan, 152
Engham. *See* Ingham
Engravings, 466, 480–81
 for American Art-Union, 104
 after *Bargaining for a Horse* (Burt), 153, 166–67, 480
 for Apollo Association, 99, 480
 after *Farmers Nooning* (Jones), 27, 115, 167, 469, 480, 483
 after *Farmer Husking Corn*, 25, 469
 for *The Gift*, 76–78
 after *Bargaining for a Horse*, 74, 76, 117, 149
 after *The Hustle Cop* (Pease), 29, 74, 78, 470
 after *The Long Story*, 29, 74, 111, 117
 after *The Painter's Triumph*, 29, 74, 76, 470
 after *Raffling for the Goose*, 29, 74, 76, 111
 after *Trap Sprung*, 30, 74
 by Robert Hinshelwood, 483
 for *Knickerbocker*
 after *Dance of the Haymakers*, 259
 literature written to accompany, 74, 75, 76, 77, 111
 Mount on, 118
 for *New-York Mirror*
 after *Country Lad on a Fence* (Adams), 25, 468
 after *The Studious Boy* (Adams), 26, 370, 469; (Kensett) 368, 370
Essler, Fanny, 64
Eubank, Thomas, 88, 124
Europe
 Mount plans to visit, 54, 103, 186
 Mount's reputation in, 10, 152
 offers for study and travel in, 19, 32, 49, 123, 152, 159–60, 199
 See also Mount—opinions and observations, on Europe
Euterpean Society, 91, 364
Evans, Dr., 446
Evans, Anna, 386
Evans, Rev. James S., 362, 374, 477, 484
Evans, Mrs. James S., 362
Evans, James S., Jr., 427, 437, 442, 446
Evans, T. C., commission by, 267
Everett, William E., 314
Examiner, The (London), 120
Exhibitions
 American Art-Union, 319, 320
 American Institute of the City of New York, 10

Exhibitions (cont.)
 Brooklyn and Long Island Fair, 378, 393, 394
 Crystal Palace (Industry of All Nations), 29, 30, 302
 of hollow-back violin, 91
 Metropolitan Fair, 379
 National Academy of Design, 127, 482–84
 (1830) 9–10
 (1840) 58
 (1841) 110, 111
 (1850) 124, 240
 (1857) 318, 319
 (1858) 319
 (1859) 341, 344, 349
 (1861) 353
 (1862) 361
 (1863) 365, 374
 (1864) 379, 395
 (1865) 386, 387, 397
 (1866) 422
 (1868) 445, 451, 452–53
 Tuileries, 123, 236

Falconer [Falkner], John M., 265, 317, 371
 lends painting to Mount for copying, 308, 317, 318, 474
 The Mischievous Drop painted for, 317, 319, 474, 484
 Peach Blossoms exhibited by, 484
 on *School Boys Quarreling*, 320
Farnsworth, Mr. (spiritualist), 289
Fay, Mr. (newspaper editor), 72
Feld, Stuart P., 75, 467, 486
Fenno, John Brooks, 30, 117, 471
Ferris, Daniel, correspondence, 86
Fessenden, William P. (congressman), 447
Field, Cyrus W., 314, 426
Field, David Dudley, and transatlantic cable, 314
Field, Marriott, on painting, 341, 342
Fillmore, Millard, 203
Firth, Mr. (violin expert), 91
Fish, Hamilton, 203
Fishbourgh, Mr. (spiritualist), 289
Fisher, Alvan, 116
Fishing, Mount's interest in, 116, 120–22
Flagg [Flag], George W., 15, 19, 25, 116
 and Reed, 68, 69, 70, 72
Flanden, the Misses, portraits of, 25, 468
Flanden, Pierre, 25, 468
Flanden, Mrs. Pierre, portrait of, 468
Flexner, James T., 486
Floyd, Mrs., 235
Floyd, Hon. Charles, portrait of, 20
Floyd, Jessie, portrait of, 386, 421, 423, 476
Floyd, Mrs. Jessie, portrait of, 443
Force, Peter, 375
Forrest, Edwin, 320
Forsythe, Mr., 60
Foster, Stephen, 152
Fowler, Joseph Smith (congressman), 447
Fox sisters, 11, 285
Francesca, Piero della, 486
Franklin, Benjamin, 95, 100, 106
Frankly, Col., 109
Fraser, R. F., 117, 119
 Loss and Gain painted for, 31, 234, 472, 483
Frazer, Mr. (musician), 65
Frazer, Eliza, 374
Free-Soil party ("Barnburners"), 201. *See also* Politics (1848)
French, Maj. (Comm. of Public Bldgs.), 375, 376
Frère, Pierre-Édouard, 344, 365, 374
Frick Art Reference Library, 467
Friedländer, Max J., 7
Frithian, Jonathan, 204

Frodsham, Mr., 320
Frothingham, James, 30, 236
Fuller, Mr. (Apollo Assn.), 99
Fuller, S. O., correspondence, 337–38, 356
Fuseli [Fuzeli], Henry, 171

Gainsborough, Thomas, 178, 180, 181
Gale, Dr. (U.S. Patent Office), 124
Gardner, John M., and mural for Capitol Stairway
 plans for, 298, 365, 368, 375–77, 384, 397, 477
 study for. *See* Index of Works: *Washington Crossing the Alleghany*
Gates, Seth M., 203
Gay, Winkworth Alban(?), painting by, copied by Mount, 308, 317, 318, 474
General Theological Seminary, 298, 299, 335
Genre painting, pls. 2*n*, 10*n*; 7, 8, 10, 486.
 See also Painting, Mount on; Painting technique, Mount on
Giebner, Hermann, 304–5
Gifford, Sanford R., 319, 340
Gift, The, 74, 117
 reviewed, 76
 See also Engravings, for *The Gift*
Gignoux, Régis, 318, 342, 453
 on *Caught Napping,* 30
 paintings by, 124, 321, 342, 352
Gilmor [Gilmore], Robert, 25, 468, 483
 commissions by, 29, 74, 75, 469
 correspondence, 74–76
Gist, Christopher, 375, 376
Glover, John, *Winding Up* painted for, c.pl. 10; 27, 76, 77, 99, 159, 469, 483
Gogh, Vincent and Theo van, 152
Goodhue, Mrs. Charles F. (Emma Prentice), portrait of, 478
Gorsuch, Miss, 336
Gorsuch, Robert, portrait of, by S. A. Mount, 343
Gould, Mr., 78
Gould, Frederick A., portrait of, 474
Gould, J. N., 464
Goupil, Léon, 153, 156, 159, 166, 168. *See also* Goupil, Vibert & Company
Goupil, Vibert & Company (later Goupil & Company), 152–53, 236, 259
 and American Art-Union, 152, 153, 166–67
 becomes Goupil & Company (1850), 161
 bought by Knoedler's (1857), 319
 correspondence, 13, 152–53, 156–59, 160–62, 163
 International Art-Union, formation of, 152, 153–56, 160
 offers of patronage by, 49, 123, 152, 159–60
 See also Lithographs, pub. by Goupil & Company; Schaus, William
Graff, Charles, 19, 49
Graham, Gilbert, 356
Graham, Julia, portrait of, 25, 468
Grannis, T. C., correspondence, 453
Grant, Ulysses S., 379, 385
Gray [Grey], Henry Peters, 116, 185, 321, 354
Greeley [Greely], Horace, 123, 358, 440
Greene [Green], Rev. Zachariah, 267
 Mount on, 32
 portraits of: (1829) 20, 468, 482; (1852) pl. 15; 32, 472, 483
Greene, Mrs. Zachariah, drawing of, pl. 16
Greenwood, John, 449
Grey. *See* Gray
Griffin, Mr., portrait of his brother, 473
Griffin [Griffen], Thomas S., 120, 427
Grimes, James W. (congressman), 447
Guérin, Pierre-Narcisse, 160

Hackert (painter), 345
Hadaway, Frank, 445
Hadaway, Thomas H., 287, 296
Haddon, Alexander, 204
Haight, Mrs.
 portrait of her granddaughter, 51, 469
 portrait of her mother, plans for, 257
Haight, Rev. B. T., 335
 portrait of, 25, 468, 482
 portrait of his brother, 468
Hall, Ann(?), 365
Hall, James F., 91
Hall, Gen. William, 91
Halleck, Fitz-Greene, 355
Hallock, Amos, 203
Hallock, Ebenezer, 64, 65
Hallock, Philip, 202
Hallock, Renelahe, 53
Hammon, Squire, 51
Hand, Meyer, 372, 446
Harmer, Charles E. (or G.?), paintings owned by, 381, 433, 475–76, 484
Harmer, Maggie (dau. of Charles E.), portrait of, 381, 423, 475–76, 484
Harnett, William, 421
Harper's Weekly, 320
Harris, Neil, *The Artist in American Society: The Formative Years, 1790–1860,* 486
Harris, Philip Spooner, 449
Harrison, C. C., commission by, 474
Harrison, William Henry, 58, 59, 60, 202
Hart, Abraham, 74
Hart, George, correspondence, 236
Hart, James MacDougal, 318, 445
Hart, Salomon Alexander, 104
Harvey, George, 116
Haseltine, William Stanley, 379
Hatch, John Davis, 285
Hawkins, Charles, 387, 437
Hawkins, Capt. Daniel Shaler, portrait of, 472
Hawkins, Delia (cousin), correspondence, 151
Hawkins, F., 362
Hawkins, J. G., 464
Hawkins, Jimmy, 59
Hawkins, Jonas (grandfather), 16, 267, 287
Hawkins, Mrs. Jonas (grandmother; Ruth Mills), 16, 18, 50, 51, 52, 102, 267
Hawkins, Julia Ann. *See* Mount, Mrs. Thomas Shepard
Hawkins, Micah (uncle, son of Jonas), 17, 50, 51
 birth and death, 91
 and Anthony Clap, epitaph for, 91, 93
 as musician, 79, 80, 91, 364
 portrait of (by Child), copied by Mount, 338, 474
 spirit of, 287
Hawkins, Mrs. Micah (aunt; Letty Lindley), 17, 25, 50, 51
Hawkins, Col. Nathaniel, obituary of, 444
Hawkins, Richard, 347
Hawkins, Ruth Mills. *See* Hawkins, Mrs. Jonas
Hawkins family, 127
Hawkins-Mount family, genealogy, 267
Hawthorne, Nathaniel, 74
Hay, John, 358
Haydon, Benjamin, 129, 171
Hayes, Col. Charles E., 60
Hays, W. J., 475
Hays, Mrs. W. J., commission by, 340
Hazen, Mr. (musical friend), 114, 115, 116, 117
Hazlitt, William, on nature, 310
Health (Mount's interest in), 127

Health, Mount on, 166, 239, 271, 311, 421, 426, 435, 476
 ailments (his own)
 ascarids. *See* worms *below*
 colds, 186, 273, 311, 314, 344, 378, 385, 435, 441
 colic, 423
 costiveness, 443
 eye complaints, 25, 352, 353, 386, 429, 434, 475
 headache, 311, 435
 influenza, 166, 271
 ivy poisoning, 161
 lameness of knee, 177, 267
 piles, 311
 rheumatism, 311
 stomachache, 383
 toothache, pl. 126; 65, 343
 worms, 118, 182, 311, 314, 366, 435
 alcohol and spirits, 240, 270, 349, 352, 353, 363, 367, 428, 429, 433, 444. *See also* temperance *below*
 cheerful dispositions, 269
 coffee and tea, 240, 270, 309, 352, 360, 362
 eating, frequency of, 345, 363. *See also* Mount—opinions and observations, on moderation
 exercise, 142, 183, 185, 271, 273, 443, 447
 fish, 268, 311
 flannel drawers, 352, 353, 363
 foods, healthy, 314, 339, 449
 foods, unhealthy, 268, 345, 427, 432, 441, 444
 hair preparations, 268, 432–33
 hot drinks, 186
 keeping one's neck cool, 184
 meat, 314
 medicine, 362, 443
 melted butter, 268, 443
 remedies for
 alcoholism, 67, 445–46
 biliousness, 66, 269, 312, 344, 345
 bowel complaint, 268
 cancer, 268
 cankers, 268
 cholera morbus, 268
 colds and coughs, 186, 271, 339, 344, 378, 385, 435
 colic, 186, 268, 423
 consumption, 186
 costiveness, 443, 446
 croup, 269
 diarrhea, 352
 dysentery, 66, 269
 dyspepsia, 66, 352
 eyes, inflamed, pl. 168; 353, 386, 429, 430, 433, 434
 eyes, weak, 269, 352, 353, 433
 fever and the ague, 66, 268
 flatulence, 269, 426
 headache, 268, 345, 352, 435
 influenza, 66
 rheumatism, 268, 269, 362, 432
 sleeplessness, 344
 snakebite, 352
 sore throat, 344
 sprained ankle, 381
 stomachache, 383
 toothache, 65
 "water cure," 66
 worms, 182, 268, 273, 314, 339, 366, 426, 435
 Schieferdecker's prescription, 433
 temperance, 188, 238, 313, 437
 tobacco, 240
 washing, 344
 water, cold, 270, 271, 309, 311, 313, 344, 362
 water, warm, 445, 449
Healy, George P. A., 445, 451–52

Hector (neighbor), 120, 122
Hess, Lewis, 316
Hicks, Miss, 199
Hicks, Thomas, 124, 242, 354
Hill, P., 93
Hill, Ureli Corelli, 51, 80, 91, 93
Hilliard, Gray & Company (Boston), 111
Hills, Patricia, *The Painters' America,* 486
Hinshelwood, Robert, engraving by, 483
Historical Society of Pennsylvania, 12
Hoe, Robert, *Mutual Respect* owned by, 484
Hoffman, John T., on transatlantic cable, 426
Hogarth, William, 16, 180, 181
Hokusai, 7
Holland, Mr. (innkeeper), 60
Holland, Michael, 65
Holland, Mrs. Michael (Miss Brush), 65
Holliday, Dr. (of New Orleans), 394
Holloway, D. P., 94
Holloway, Emory (ed., *The Uncollected Poetry and Prose of Walt Whitman*), 14
Holly, Emma M. *See* Lies, Mrs. Eugene
Holmes, J. D., 150, 151
Home Journal, The (journal), 232, 334, 335, 343, 374
Hood, Andrew
 commissions by, 475
 correspondence, 370, 371, 377
 portraits of: (1862) 363, 370, 371, 475, 484; (1864) 395
Hood, Mrs. Andrew (Maria Louise van Tassel), 395, 484
 portrait of, 475
Hood, Andrew, Jr., 377, 395–96, 397
Hood, Anne C. (dau. of Andrew), 377, 395, 396, 475
Hood, Ferdinand, 395
Hood, Mrs. M. L. *See* Hood, Mrs. Andrew
Hooper, H. H., 473
Hoppner [Hopper], John, 147
Hosmer, Harriet Goodhue, 383
Housman, Dr., 271
Houston, Sam, 202
Howard, Henry, 104
Howe, Charles, 353
Hoxie, Joseph, 16
Hubard, William James, 119
Hübner, Karl, 374
Hudson, Mr. (newspaper editor), 358
Hudson, George, sketch of, 387
Hudson, John H., 387
Hudson, Joseph, 201–2
Hudson, Capt. William L., 313
Hudson River School, 10
Hull, Mrs. Isaac P., 439
Hulse, Mrs. (storekeeper), 264
Hulse, Charles, 381
Huntington, Daniel, 77, 116, 240, 318, 348
 Mount on, 118, 122
 and NAD presidency, 101, 321, 354, 436
 Washington Crossing the Allegheny adapted by Mount, pl. 132; 368
Hutchinson, Capt., 395
Hutchinson, B. T., 202–4
Hutton, Lawrence, 127

Independent Press (Stony Brook, L.I.), 427, 441. *See also* Markham, H.
Industry of All Nations, exhibition of. *See* Crystal Palace
Ingham [Engham], Charles Cromwell, 116, 239
Ingres, Mount compared with, 407
Inman, Henry, 15, 20, 101, 116, 143, 181, 388
 Mount's admiration for, 18, 25, 354

Inman, Henry (cont.)
 Mount's early relationship with, 17–18 and NAD, 355
Inness [Innis], George, 249
Inslee, William, 16
International Art-Union, 152, 153–56, 160
Inventions
 boat, two-hulled, pl. 167; 429
 paddle wheel, pl. 123; 335
 writing board, 392
 yacht, oval-shaped, pl. 112; 302
 See also Studio, portable; Violin, hollow-back
Irving, Washington, 19, 142, 371
 Life of Washington, 376
 Mount's paintings admired by, 29, 72
 and NAD, 355
Isherwood, Mr. (spiritualist), 287
Ivans, Mrs., photographs colored for, 449
Ivans, Christiana, 449
Ives, J. J. (sculptor; Chauncey Bradley Ives?), 124

Jackson, Andrew, 376, 377
Jarves, James Jackson, 436, 476
Jarvis, E. (political friend), 204
Jarvis, John Wesley, 424
Jayne, Ansel, 427
Jayne, Carleton, 52, 367, 396, 463
Jayne, Clarence, 427
Jefferson, Thomas, 106
Jennings, Richard, correspondence, 357
Jocelyn, Nathaniel, 250
John, Uncle, 65
Johnson, Mr., 339
Johnson, Andrew, 385, 426–27, 444, 446–47
Johnson, Eastman, 127, 128, 436, 445, 452–53
Johnson, J., portrait exhibited by, 482
Johnson, Jeremiah, portrait of, pl. 19; 29, 56, 470, 483
Johnson, W. D., correspondence, 99–100
Johnston, W., portrait exhibited by, 482
Jones, Alfred, engraving by, 480, 483
Jones, Capt. Benjamin, 429
Jones, Caleb, *School Boys Quarreling* owned by, 320
Jones, Rev. Daniel, 357
Jones, George, 104
Jones, Capt. Havens, 362, 364
Jones, Henry Floyd, 203
Jones, John D., *The Bone Player* owned by, c.pl. 28; 473, 484
Jones, Shepard S., 245, 258
Jones, W. Alfred [William A.], 298, 334, 450
 Characters and Criticisms, 485
 correspondence, 299, 302, 335, 454–55
 portrait of, pl. 109; 479, 483
 portrait of Mount, 335
Jones, Walter, Jr., 440
Jones, Watson R., 429
Jonson, Ben, spirit of, 287, 296
Jouvenet, Jean, 160

Kaplan, Sidney, *The Portrayal of the Negro in American Painting,* 486
Karney. *See* Kearny
Kaulbach, Wilhelm von, 348
Kearney, David, portrait of, 266, 473
Kearney, M. (brother of David), commission by, 473
Kearny [Karney], Philip, 124
Keige, C. M. *See* McKeige, C.
Kellogg, Miner K., 246
Kemble, Gouverneur, paintings owned by, 25, 27, 29, 469, 470
Kensett [Kenset], John Frederick, 124, 242, 318, 371

Kensett, John Frederick (cont.)
 copy and engraving after Mount, 368, 370
 and NAD, 240, 354
Ketcham, James, 203
Keyes, Donald D., on *Rustic Dance After a Sleigh Ride,* pl. 2n; 486
Kidd, Capt., 236
King, Edward, 437
King, John A., 204
Knickerbocker (journal), 32, 106, 109, 259
Knoedler [Nodler], Michael, 166, 319, 393, 452, 481
Krimmel, John Lewis, 15, 19, 49, 128
 Dance in a Country Tavern, 486
 lithograph after, pl. 2
Kyle, Joseph, 247

Lafosse, Jean-Baptiste-Adolphe, lithographs by, 31, 480, 481
Lairesse, Gérard de, 160
Lambinet, Émile, Mount on, 344
Landscape painting, 8, 274, 398. *See also* Painting, Mount on; Paintings (by Mount), misattributions; Painting technique, Mount on
"Landscape parlors," 339–40
Landseer, Charles, 104
Landseer, Edwin, 104
Landseer, John, 104
Lanman, Charles, 106, 153, 240
 on American Art-Union, 117, 124
 articles and stories, 109
 "American Painters," 115
 on artists going to Europe, 116
 on Cole and Durand, 118
 "The Hermit of Aroostook," 119
 on Mount, 123
 "A Nameless Essay by Charles Lanman," 109
 "Our New York Painters," 115
 "The Poet's Pilgrimage," 114
 "Sabbath Evening Thoughts," 108
 books
 Dictionary of the United States Congress, 106
 Essays for Summer Hours, 111, 112, 114
 on fish and fishing, 119
 Haphazard Personalities, 485
 Letters from a Landscape Painter, 114, 485
 on the Mexican campaign, 117
 on Mississippi, 116
 on New York painters, 116, 117–18, 150
 A Summer in the Wilderness, 120
 correspondence
 with Mount, 13, 106–7, 108–9, 111–26
 with S. A. Mount, 106, 107–8, 109–11
 on *Girl Asleep,* 115
 on happiness, 108
 on himself, 113, 114–15
 on Huntington, 122
 marriage, 122
 on Mount, friendship with, 101, 108, 112–13, 114
 on S. A. Mount, friendship with, 108, 111, 123, 124
 moves to Washington, 122
 on *The Novice,* c.pl. 22; 119
 as a painter
 exhibited, 113, 115, 124
 Mount's advice to, 114, 116
 painting technique, 198
 The Power of Music reviewed by, pl. 56; 118
 Salmon Fishing in Canada, pl. 41
 Sketchbook, 111, 114, 124
 on the Whigs, 115

Lassalle [Lasalle, Leselle], Émile, litho-
graph by, 31, 123, 161, 472, 480
Lastman, Pieter, 294
Laurie, Mrs. Mary, correspondence, 439
Lawson, Mr. (engraver), 19, 49
Layton, J. H., 368, 374–75
Lear, Tobias, 376
Lebrun, Charles, 160
Lee, Mrs. Gideon, *The Power of Music*
owned by, pl. 56; 30, 145, 153, 174,
471, 480, 483
Lee, John S., 396
Lee, Robert E., 385
Lefevre, Capt., 59
Lehman, George, *Dance in a Country Tav-
ern* (lith.), pl. 2
Lemercier, lithographs printed by, 480, 481
Lenox, James
commissions by: (1850) 240; (1853?) 266,
267; (1865) 397
Turning the Leaf owned by, pl. 58; 31,
472, 483
Leslie, Charles Robert, 19, 49, 104, 240, 320
Lester, Charles Edwards, 106, 120, 148–49
Le Sueur, Eustache, 160
Leupp, Charles M., 105, 116, 199, 355, 471
commissions by: (1848) 199; (1853) 266
paintings owned by
The Banjo Player, c.pl. 29; 474, 484
Dance of the Haymakers, c.pl. 20; 30,
105, 471, 480, 483
on *The Power of Music*, pl. 56; 30
Leutze, Emanuel, 116, 127, 320, 344
project for Capitol stairway, 368, 375,
376, 397
Leveridge, John, portrait of, 479
Lewis, R. W. B., 10, 11
Lewis, Wilmarth, 13
Liddow, Mr. (lecturer), 67
Lies, Eugene, correspondence, 258–59
Lies, Mrs. Eugene (Emma M. Holly), 358–
59
Lincoln, Abraham, 201, 358, 382, 385
correspondence, 373, 377
"Lincolnpoops," 10, 201, 357
Lithographs, 10, 152–53, 480–81
pub. by Goupil & Company
Catching Rabbits (Noël; Bichebois),
29, 123, 153, 159, 160, 168, 480
The Herald in the Country (Thielley),
32, 153, 167, 168, 473, 481
Just in Tune (Lassalle), 31, 123, 153,
159, 160, 161, 162, 168, 236, 472, 480
Raffling for a Goose (Lafosse: after
The Lucky Throw), c.pl. 27; 10, 31,
153, 164, 168, 480
Right and Left (Lafosse), 31, 153, 162,
168, 472, 480
pub. by Goupil, Vibert & Company
Music Is Contagious (Noël; after
Dance of the Haymakers), 30, 123,
153, 156–60 *passim*, 168, 480
The Power of Music (Noël), 30, 123,
152, 153, 156, 157, 158, 159, 168, 187,
480
pub. by William Schaus, 152, 407
The Banjo Player (Lafosse), 169, 473,
481
The Bone Player (Lafosse), 168, 473,
481
Coming to the Point (Soulange-Teis-
sier), 152, 153, 165–67, 473, 481
See also Crehen, Charles G.; Lehman,
George
Littell, Rev. William H., on Mount's death,
457
Longfellow, William Wadsworth, 74, 348,
349, 350
Long Island Historical Society, 321, 393,
480

Long Islander, 80
Long-Island Star (Setauket), 427, 437, 455
on *The Dawn of Day,* 435, 440–41
Lorrain, Claude, 74, 75, 119, 147, 160, 199
Lott, Sarah, portrait of, 25, 469
Loveland, Mr. (lecturer), 336
Ludlom, Newton, portrait of, 315, 474
Ludlow, Mrs. (mother of William H.), por-
trait of, 31, 240, 259, 472
Ludlow, Frank (brother of William H.), por-
trait of, 423, 424, 477, 484
Ludlow, Phoebe, 424
Ludlow, Hon. William Handy, 67, 343, 357,
484
correspondence, 259, 357, 455–56
portrait of, 388, 422, 424, 477
portraits commissioned
Mrs. Ludlow, 31, 240, 259, 472
Mrs. Sarah Nicoll, 31, 472
Ludlum, Nicholas
commissions by: (1847) 174; (1853?) 266;
(1858) 315
correspondence, 396–97
portrait of, 468
Ludlum, Mrs. Nicholas (Sarah Ann Birds-
all), portrait of, 468
Lumpkin, Wilson (congressman), 60
Lynes, Russell, *The Art-Makers of Nine-
teenth Century America,* 486

McClellan, George Brinton, 379, 381, 382
McDonald, Mr. (spiritualist), 289
McDonald, Gov. Charles J., 60
McElrath, Mrs., on spiritualism, 295
McElrath, Thomas, 117, 421, 473, 476
paintings owned by
California News, c.pl. 13; 472, 483
The Ramblers, 30, 174, 471, 483
McElrath, Mrs. Thomas
portrait of, 421, 423, 473, 476, 484
portrait of, by Peele, 473
Macintosh, Sir James, on morality, 444
McKeige [Keige], C., 432, 433
McKeige, Capt. Edward E., 428, 473, 484
McKeige, Mrs. Edward E., portrait of, 427,
428, 477
Maclise, Daniel, 104
McMarten (painter), 320
McMaster, William E., correspondence,
232–33
McVickers, the Misses, 386
Magoon, Rev. Elias L., 319
commission by, 334
Mainguet, Mr. (colleague of Schaus's), 163
Malbone, Edward Greene, 176
Manice, Mrs., portrait of, 479, 482
Mapes, James J., 355
commission by, 273
Markham, H. (newspaper editor), 427, 432,
444, 464
Marryat, Capt., *Mr. Midshipman Easy,* 51
Marsh, Nathaniel, 67, 351, 474
Marsh, Mrs. Nathaniel, 484
portrait of, 351, 352, 424, 474
Marsh, Susan T. (dau. of Nathaniel), por-
trait of, 67, 351, 474
Marshall, John, *Life of George Washington,*
375
Martin, Josiah, on varnish, 346
Marvin, Judge, portrait of, 25, 468
Mathewson [Mathason], Nelson
correspondence, 65
as dancing master, 51, 52, 53, 54
drinking problem, 53, 57, 62
as musician, pl. 20; 52–53, 58, 62–63, 64,
66, 80
portrait of, pl. 19; 479
Matteson, Tompkins H., 116, 117, 234, 259
portrait of, 479

Matthiessen, F. O., 13, 485–86
Maximilian, 423
Meeker, Mr. and Mrs. S. A., correspon-
dence, 438
Melville, Herman, 13, 486
Metropolitan Fair, 379
Metropolitan Museum of Art, The, 75, 348,
368, 398, 466, 485
Mexican War, 201, 251. *See also* Politics
(1848)
Miles, Josephine, 10, 11
Miller, George, 204
Miller, Lillian B., *Patrons and Patriotism,*
63, 68, 104, 348, 368, 486–87
Mills, Mr. and Mrs., 235
Mills, Mr. and Mrs. A., 335
Mills, Daniel, 51
Mills, Elizabeth, portrait of, 470
Mills, Lester, 387, 433
Mills, Thomas H., painting of his house,
479
Mills, William Wickham, 383
portraits of: (1829) 20, 468; (1856) 473
Mills, Mrs. William Wickham (Eliza Ann
Mills)
portraits of: (1829?) 479; (1855) 473
Miner, Robert, *Essays from the Desk of
Poor Robert the Scribe,* 31, 95
Misattributions. *See* Paintings (by Mount),
misattributions
Mitchell, Edward P., 304
Mize, George E., on Duyckinck, 14
Monson, Cornelia. *See* Monson, Mrs. Mar-
cena
Monson, Mrs. Marcena (Cornelia Shepard
Strong, dau. of Selah B.)
portraits of: (1829) 18, 468; (1864) 367,
378, 379, 394, 475
Moore, Hon. Ely, 202, 203, 204
Morgan, M. C., 352, 356–57, 358, 474, 475
Morland, George, 180, 297
Morris (speaker at political meeting), 204
Morris, George Pope, 232
commission by (after "Woodman Spare
That Tree"), 174, 232, 240, 316
as editor, 232, 234, 334
paintings owned by, 26, 27, 469
Morse, Samuel F. B., 17, 20, 271, 355, 459
and transatlantic cable, 314
Moses, 296
Mosier. *See* Mozier
Moubray, Frances Amelia (dau. of John
M.), portrait of, 248, 260, 285, 473
Moubray, John M., 260
Mount, Alfred, portrait of his son, 472
Mount, Elizabeth. *See* Vail, Mrs. Harvey
Mount, Elizabeth Elliott. *See* Mount, Mrs.
Shepard Alonzo
Mount, Elizabeth Ford (niece, dau. of
Henry Smith), 180, 375, 427, 433, 464
Mount, Evelina (niece, dau. of Henry
Smith), 433, 449, 466
Mount's advice to, 430, 437–38
and Mount's estate, 464
paintings by, 388, 430, 437
pupil of J. McD. Hart, 445
Mount, Henry John. *See* Mount, John
Henry
Mount, Henry Smith (brother), 50, 51, 52,
53, 75, 181, 235, 287, 373
birth, 267
death, pl. 23; 99, 103, 107, 267
Henry Smith Mount on His Deathbed,
pl. 22; 483
S. A. Mount on, 107–8
encourages Mount's painting, 17, 20, 25
health, 59, 61, 103
and Mount, in New York, 16, 20
and Mount's estate, 464
as musician, 57, 59, 364

Mount, Henry Smith (cont.)
 NAD, elected to, 20, 127, 270
 paintings by, 361, 466
 painting technique of, 246
 portraits of: (1828) pl. 7; 20, 467; (1831) pl. 8; 479
 and Reed, 72, 73
Mount, Mrs. Henry Smith (Mary Bates Ford), 181, 336, 372
 correspondence, 372–73
 and the Mount property, 64, 372–73, 429, 439
Mount, John Brewster (nephew, son of Robert Nelson), 67, 427, 428
Mount, John Henry (nephew, born Henry John; son of Henry Smith), 181, 464
 correspondence, 441–42
 portrait of, 473
Mount, John S. (uncle), 65, 267
Mount, Jonas Hawkins (brother), 267
Mount, Joshua Elliott (nephew, son of Shepard Alonzo), 427, 462, 465
Mount, Mrs. Joshua Elliott (Edna Searing, dau. of George), 427
Mount, Julia Ann Hawkins. See Mount, Mrs. Thomas Shepard
Mount, Julia Ann Shepard (sister), 267
Mount, Julia Hawkins (niece, dau. of Henry Smith), 65
Mount, Malcolm (nephew, son of Henry Smith), 250, 464
Mount, Nelson. See Mount, Robert Nelson
Mount, Penelope (aunt), 267, 287, 288
Mount, Robert Henry (nephew, son of Shepard Alonzo), 462, 465
Mount, Robert Nelson (brother), 18, 50, 112, 245, 362, 363, 382, 430, 439, 456, 475
 birth, 267
 on Cider Making, c.pl. 33; 61
 correspondence, 13, 50–67
 on critics, 58
 as dancing master, 51–56 passim, 59, 60, 67, 150, 258
 drinking problem, 367, 433
 on Macon, Ga., 53, 58
 and the Methodists, 372
 and the Mount property, 372, 373
 and Mount's estate, 460–65 passim
 as musician and composer, 52–53, 61, 62, 67, 79, 80, 364
 "Possum Hunt," pl. 21; 61
 painting of his house, 363, 477
 on politics (1840), 58, 59, 60
 portrait of, 20, 468
 on taxes, 382
 on B. F. Thompson, 63
 and D. A. Wood, 394
Mount, Mrs. Robert Nelson (Mary Thompson Brewster), 51, 52, 53, 56, 64, 65, 150, 367
Mount, Ruth Hawkins (niece). See Becar, Mrs. Noel Joseph, Jr.
Mount, Ruth Hawkins (sister). See Seabury, Mrs. Charles Saltonstall
Mount, Sarah Brewster (niece, dau. of Robert Nelson), 51, 53
Mount, Shepard Alonzo (brother), 18, 20, 51, 54, 59, 66, 67, 103, 117, 161, 164, 235, 245, 296, 334, 363
 and American Art-Union, 118, 188, 234
 birth, 267
 in business with Mount, 18
 correspondence
 with Lanman, 106, 107–8, 109–11
 with Mount, 78, 101–2, 150–51, 202, 372, 439
 death, 450, 454–55, 456, 457
 Mount on, 454, 455
 drawing of boy fording river, pl. 42; 110

Mount, Shepard Alonzo (cont.)
 Durand on, 246
 economic difficulties, 202
 exhibited, 108, 111, 124, 246, 361, 422, 453
 health, 62, 64, 110
 on Huntington, 321
 and Lanman
 friendship with, 108, 111, 123, 124
 reviewed by, 117
 and Mount, relationship with, 270
 on H. S. Mount, death of, 107–8
 and the Mount property, 372, 429, 431, 439
 and Mount's estate, 465
 Mount's 1851 self-portrait owned by, 31–32, 472, 483
 and NAD, 20, 110–11, 127, 271
 as a painter, 101, 118, 337, 466
 of landscapes, 118, 270, 349
 of portraits, 20, 53, 64, 118, 334, 353, 393
 paintings by
 flower piece, 428
 portrait of his daughter (Mrs. Noel Joseph Becar, Jr.), 370, 422
 portrait of H. S. Brooks, 66
 portrait of a lady, 67
 portrait of Theodorus Bailey, 453, 454, 455, 456
 portrait of Robert Gorsuch, 343
 painting style of, similarity to William's, 466
 painting technique of, 184, 244
 on politics (1848), 202
 portrait of, c.pl. 25; 471
 Reed on, 73
 travels, 51, 52, 110, 111, 112, 118, 122, 466
Mount, Mrs. Shepard Alonzo (sister-in-law; Elizabeth Elliott), 15, 54, 67, 78, 108, 111, 244
 death of, 313
 and Mount, relationship with, 244, 270
 and S. A. Mount, death of, 108
 portrait of, 32, 472, 483
Mount, Thomas Shepard (father), 16, 17, 267
 death of, S. A. Mount on, 108
Mount, Mrs. Thomas Shepard (mother; Julia Ann Hawkins, dau. of Jonas), 16, 17, 18, 50, 51, 52, 54, 56, 105, 107, 267, 372, 438
 health, 58, 59, 64
 last illness and death, 111, 112, 267, 383
 portraits of: (1830) c.pl. 7; 25, 468; (1855) 473
 sketches of, pls. 43, 134
 and spiritualism, 287
 and George Washington, 347
Mount, Thomas Shepard (nephew, son of Henry Smith)
 correspondence, 335–36, 396, 438
 and the Mount property, 271, 364, 429, 431, 438–39
 and Mount's estate, 460–65
 One of the "Tangiers" exhibited by, 484
 portrait of, 473
Mount, William Shepard (nephew, son of Shepard Alonzo), 67, 108, 109, 367, 395, 462, 465
Mount, William Sidney
 as art critic, 421
 birth and early years, 16–18, 19–20, 102, 267, 459, 467
 career
 apprentice to Inman, 17
 first painting success, 9–10
 NAD: elected to, 25, 270; student at, 17, 25, 102, 459
 self-portraits, pl. 5, c.pl. 24; 17, 20, 31–32, 141–42, 467, 472, 473, 476, 479

Mount, William Sidney (cont.)
 Trumbull, encouraged by, 25
 See also Criticism and reviews; Exhibitions; Painting, Mount on; Painting technique, Mount on; Patronage, offers of
 death, 13, 456, 457–59, 460, 466
 estate settlement, 460–65
 photograph of, pl. 1
 portraits of, by Elliott, 15
 (1848) pls. 52, 53; 30, 153, 160, 161, 186, 472, 479
 (1849) c.pl. 3; 15
 travels, 205
 Athens, Pa. (1834), 19
 Boston (1839), 19
 England, possible trip to, 103
 Fishkill (1850), 243
 Hartford, Norwich, Albany, Catskill (July, 1843), 29–30, 470–71
 Newburgh, Catskill, Madison (Fall, 1843), 66
 Philadelphia (1836), 19, 49
 See also Europe
 See also Boats, Mount's interest in; Health, Mount on; Inventions; Music, Mount's interest in; Politics, Mount on; Spiritualism; Weather, Mount's interest in
Mount, William Sidney—opinions and observations on, 127
 advice giving, 172, 188
 anger, 345
 art unions, 187
 bachelorhood, 172
 bad characters, 244
 bad habits, 428
 bathing, 172
 beards, 30, 31, 472
 being true to oneself, 270
 his birthday, 182, 188, 363, 367, 383, 388, 431
 blushing, 186
 boarding out, 247, 307, 435, 447, 449–50
 building, 186
 city vs. country, 8, 129, 173, 178, 179, 181, 199, 271. See also Stony Brook below; Painting, Mount on
 Civil War, 360, 382
 coal fires, 173
 criticism, 273, 448
 cultivating the fine arts, 114, 240
 dancing masters, 258
 death, 11, 30, 32, 114, 317, 471, 473
 demography, 449
 discussing difficulties with others, 109
 displaying portraits, 181
 encouraging art, 30, 240
 Europe, 49, 123, 160, 181
 exercise. See Health, Mount on, exercise
 fame, 109, 311
 fellow artists, 273, 456
 flattery, 177
 forgiveness, 244
 friends, 270, 444, 456
 vs. hangers-on, 183, 184, 185, 239
 generosity, 30
 genius, 242, 365, 446
 gold rush, 198
 good vs. evil, 305
 happiness, 306
 health. See Health, Mount on
 human nature, 20
 idleness, 184, 188, 200, 239, 246, 307, 428
 ignorance, 180
 improving one's mind, 182
 industriousness, 172, 177, 184, 239, 242, 246, 270, 309, 311, 313. See also Painting, Mount on, perseverance in
 intelligence, 180

Mount, William Sidney—opinions and observations (cont.)
interfering, 306
inventions, 183
jackasses, 270
keeping a journal, 239, 422
kindness, 395
labor, 245, 311
 vs. thinking, 31, 123, 311
the ladies, 106, 122, 151, 270
late suppers, 183
learning, 242
leaving home, 64, 184
Long Island, 173, 180, 197
love, 271
making money, 172, 183, 185, 200, 343,
 365, 385
marriage, 122, 123, 145, 244
meteor shower, 431
minding one's own business, 129, 172,
 176, 184, 239, 270, 344, 391
miserly people, 243, 306
moderation, 185, 270, 271, 344, 386
modesty, 273, 289
Mondays, 179
morality, 444. See also Religion, Mount
 on
mothers with children, 244
music, 86, 271, 364–65, 377. See also
 Music, Mount's interest in
musicians, 258
nature, 109, 181, 271. See also Painting,
 Mount on
neatness, 307
Negroes, 164, 166, 358, 383, 394. See also
 Painting, Mount on
New York City, 234, 347, 444
originality, 49, 123
painters, 273, 308, 446
painting. See Painting, Mount on
parents, 119
paying debts, 109
pens, 59, 67, 455
politeness, 109
politics. See Politics, Mount on
praising the works of others, 188, 233
prices. See Prices (for paintings)
prosperity, 170
punctuality, 30
putty, 365
reading
 the Bible, 142
 by gaslight, 352
 the masters, 142
 too many newspapers, 182
 vs. observing, 363
 vs. talking, 184
 vs. thinking, 186
 the works of others, 382
regret, 239
relatives, 184
 staying with, 306, 344, 345
religion. See Religion, Mount on
respect, 245
rest, 311
 regular hours for, 142, 183
rising early, 308, 311. See also Health,
 Mount on
sailing, 423
self-esteem, 273
shaving, 172
simplicity, 181
snow, 378, 392
societies, belonging to, 240
spiritualism. See Spiritualism, Mount on
Stony Brook, 102–3, 122, 151, 199, 271,
 346
storms, 422
Thanksgiving, 431
time, value of, 346, 347, 365, 426

Mount, William Sidney—opinions and observations (cont.)
traveling, 181, 239. See also Europe
 above; Painting, Mount on, locations
 for
tyranny, 271
war, 379
watchfulness, 176
weather. See Weather, Mount on
wine, 187
wisdom, 172, 200
wives, 239
women, discreet, 186
writing letters, 238
the young, 306
Mount, William Sidney—self-exhortations,
 8, 127, 128, 149
 "Begin now, no time to be lost," 29, 145,
 184, 200, 345, 346, 367
 "I must endeavour to follow the bent of
 my inclinations," 9, 49, 143, 172, 184,
 307
 "I must give my whole mind to painting,"
 145, 170, 172, 180, 184, 310, 427
 "I must not undertake any more than I
 can do easily," 142, 430
 "I must read about painters," 242, 309
 "Keep the mind free, never be a slave to
 any thing," 183
 "Oh man, try to know thyself," 143, 308,
 311, 344, 345, 367
 "Paint, Paint," 129, 141, 200, 308, 309,
 351, 476
 "Perseverance is my motto," 129, 170,
 177
Mount family, 53, 127, 466
 genealogy. See Hawkins-Mount family
 property feud, 271, 364, 368, 372–73, 429,
 431, 438–39
"Mount Mysterious Stranger," 8
Mount papers, 12–13, 102
 autobiographical sketches, 12, 14, 15–49,
 149
 "Catalogue of Portraits and Pictures
 Painted by William Sidney Mount,"
 14, 466, 467–76
 correspondence. See Correspondence
 diaries. See Diaries
 estate papers, 460–65
 funeral eulogies, 457–59
 memorandums to himself, 91, 93, 100,
 103–4, 245–46, 273
 notebooks
 on music, 12, 80
 on perspective, 12, 205
 on spiritualism, 12, 285–92
 Queens Borough Sketchbook, pls. 59–84;
 205
 scrapbook, 14
 "Short History of the villiage School
 Master Mr. Dignity," 131–32
 speech, draft of, 354–55
Mozier [Mosier], Joseph, 124
Murillo, Bartolomé, 119, 181, 247, 309
Museums at Stony Brook, The, 12, 14, 15,
 80, 398, 466, 467, 480
Music, Mount's interest in, 79–80
 Bogle on, 456
 Falconer on, 318
 music notebook, 12, 80
 as performer, 353, 364
 See also Mount—opinions and observa-
 tions, on music; Violin
Muther, Richard, History of Modern Paint-
 ing, 152

NAD. See National Academy of Design
Napoleon, Louis, 349
Napoleon Bonaparte, on enemies, 239

Nash, Lora, portrait of, 479
Nash, Mrs. Lora (Catherine Van Bergen),
 portrait of, 479
National Academy of Design (NAD), 62,
 153, 232, 317, 457
 and International Art-Union, 156
 and Mount, 10, 127, 240
 draft of speech for, 354–55
 elected to, 25, 270
 exhibited at, 482–84
 Farmer Whetting His Scythe given to,
 c.pl. 31; 31, 472
 on Mount's death, 459
 tribute to Sturges, 100
 studies at, 17, 25, 102, 459
 and S. A. Mount, 110–11, 127
 elected to, 20, 271
 exhibited at, 108, 110–11, 124, 246, 361,
 422, 453
 new building, 353, 386, 397
 presidents of, 354–55
 Durand, 246, 355
 Huntington, 101, 321, 436
 Morse, 17, 20, 271, 355, 459
 students, number of, 188
 See also Exhibitions, National Academy
 of Design
National Intelligencer (Washington, D.C.),
 122
Nature, Mount's love of, 17, 118, 167, 175
 descriptions
 springtime, 379, 446
 summertime, 386
 sunrise, 245
 sunset, 147, 381
 See also Mount—opinions and observa-
 tions, on nature; Painting, Mount on
Negro
 in politics, 201–2, 358, 382, 383, 423, 435,
 440–41
 as subject, 10, 152, 201, 407, 486
 See also Mount—opinions and observa-
 tions, on Negro; Painting, Mount on
Nelson, M. (inventor), 352
Nesmith, A. (neighbor), 424
Newberry, Dr. E., on Mount, 344
New Englander (journal), 115
Newsins, Mrs. S. (neighbor), 380
Newton, Stuart, 19
New World (journal), 114, 115
New York American, 75, 486
New York Art-Union. See American Art-
 Union
New York Commercial Advertiser, 453
New York Daily Globe, 202
New York Daily News, 445
New York Daily Tribune, 66
New York Evening Post, 116, 118, 120, 202,
 318, 453, 454
New York Express, 113
New York Gallery of the Fine Arts, 68
 Dregs in the Cup given to, pl. 28; 29, 67,
 78, 99–100, 470
 Reed's collection acquired by, 27, 68, 95
New York Herald, 58, 116, 358, 434, 449
New-York Historical Society, 12, 14, 398,
 480
 Dictionary of Artists in America, 1564–
 1860, 101, 127
 Haying Scene owned by, pl. 26; 68
 New York Gallery collection given to, 68,
 78, 95
New-York Mirror, 52, 54, 56, 72
 engraving for, 25, 468
New York Public Library, 466, 480, 485
New York State Historical Association
 (Cooperstown), 421
New York Sun, 66
New York Sunday Courier, 86
New York Sunday Mercury, 67

New York *True Sun,* correspondence, 203, 204
New York University, 232
New York *Weekly Universe,* 158, 200
New York *World,* 446
Niblo's Theatre, 423
Nicolay, J. G., 358
Nicoll [Nickoll], Mrs., 114
Nicoll, Edward H., portrait of, 30, 471, 472, 483
Nicoll, Mrs. Edward H., portrait of, 30, 471
Nicoll, Henry, commission by, 266, 267
Nicoll, Sarah Greenly (Mrs. William Nicoll)
 portrait of, 31, 247, 472
 portrait of her children, 468
Nicoll, Solomon Townsend, 472
 commission by, 266, 267
 offer of patronage by, 30, 146
 portrait of, 30, 150, 471, 483
 sketch of, 473
Nicoll, Mrs. Solomon T., portrait of, 473
Nicoll, W., 204
Niven, Catharine (cousin), 151
Noble, Louis L., 268
Nodler, *See* Knoedler
Noël, Alphonse-Léon, 159, 483
 lithographs by, 30, 123, 187, 480
Noll, Rev. F. M., 367, 370
 sketch of, pl. 146; 407
Norwich Courier (Conn.), 108, 109
notebooks. *See* Mount papers, notebooks
Novak, Barbara, *American Painting of the Nineteenth Century,* 13, 486
Nunn, William, portrait of his daughter, 468
Nunns, Henry, 387, 395
Nunns, John, 374
Nye, Mr. (gallery owner), 240

Oakes, Edward, 335, 461
Oakes, Nathan, 335
Oaks, Capt. John, 120
Ockers, Louise, 13
O'Connor [O'Conor], Charles, 203, 336
Officer, Thomas, 258
Onderdonk, Bishop Benjamin Tredwell, 298
 portraits of: (1830) pl. 110; 20, 25, 51, 298, 468; (1833) 25, 298–99, 335, 368, 462, 469
Onderdonk, Mrs. Benjamin Tredwell (dau. of Mrs. Charles Seabury), 432
 portrait of, pl. 111; 20, 25, 298, 468
Osgood, Samuel Stillman, painting technique of, 246
Overton, Mr., 53
Owen, Mary Lavinia Brooks, portrait of, 479

Page, Miss (of Schenectady), 381
Page, William, 101, 106, 116, 117, 118
 paintings by, 101, 120, 345
Paine, Thomas, on learning, 179
Painting, Mount on
 amount of: not enough, 433; too much, 242
 animals, 20
 from antique statues, 20, 25
 apprentices, taking, 433
 art historians, 449
 backgrounds, 176
 brushes for, pl. 137; 245, 311, 385, 391
 children, 142
 in the city, 183, 187, 188, 238, 269, 346, 448
 for character, variety of, 147, 173, 344, 347
 figures, 186, 197
 genre, 173, 271
 portraits, 147, 173, 180, 181, 182

Painting, Mount on (cont.)
 for stimulation, 130, 173, 341, 474
 vs. the country, 29, 117, 129, 145, 147, 181, 470
 color, use of, 271
 criticism of, 49, 184
 gradations in, 316
 softness in, 308
 variety in, 244
 colors (paints), 141, 165
 with clear colors, 143
 with few colors, 240, 244, 246
 with pure colors, 244
 repetition of colors, 248, 309, 392
 on commission, 144, 239, 307, 366–67, 388
 complacency in, 172
 copyists, advice to, 247
 in the country, 129, 186, 473. *See also* in the open air *below*
 courage in, 174, 185, 188, 241, 245, 309
 from daguerreotypes. *See* portraits, from daguerreotypes, *below*
 dissatisfaction with his own work, 341
 drawings, preserving, 320
 egg tempera, use of, 177
 engravings from his paintings, 118
 for exhibitions, 172, 273
 experimentation in, 239, 246
 fancy pictures, 240
 flesh, 173
 generalizing, 176, 179
 genre, 199, 248–49, 448, 474
 barnyard scenes, 173
 in the city, 173, 271
 genre painters, 271
 landscape in, 30, 271
 vs. flowers, 365
 vs. landscapes, 246
 vs. portraits. *See* portraits, vs. genre, *below*
 heads, 181, 187, 241
 historical subjects, 18, 20, 314
 improvement in, 143, 172, 433, 434
 independence in, 49, 184
 indifference to, 291
 inspiration for, 383, 430
 interiors, 310
 interruptions in, 173, 250, 366
 judging a painting, 431
 judgment of others, 184, 448
 landscapes, 176, 242, 315, 427
 in genre, 30, 271
 from nature, 178, 267
 landscape painters, 271, 308
 thunderstorms, effect of, 145, 426
 vs. genre, 246
 when to paint, 144–45, 448
 large pictures, 142, 145, 182, 184, 273, 343, 378, 379, 392, 434
 light and shadow, 244, 316, 347
 light for, 179–80, 181, 199
 locations for, 170, 180, 198–99, 271, 307
 changing, necessity of, 130, 184, 185, 197, 245, 262, 267, 346, 429
 in the "Pond Lily," 344, 429
 See also Mount—opinions and observations, on Europe
 meditation, necessity for, 174
 from memory, 309, 345, 361
 models, 171, 172, 188, 345, 347, 433
 in the country, 422, 476
 need to engage, 170, 198
 Negroes as, 365
 relatives as, 129
 vs. statues, 25, 198
 names for pictures, 198
 from nature, 101, 184, 198, 244, 247, 257, 262, 267, 271, 310, 423, 427, 476
 at first hand, 174, 315, 382
 studies, 244, 270, 379

Painting, Mount on (cont.)
 too closely, 180–81
 universality of, 20, 49, 181
 vs. the grand style, 143
 See also in the open air *below*
 Negroes, 164, 166, 365
 the Old Masters, 19, 70, 365, 433
 in the open air (vs. indoors), 175, 185, 198, 233, 270, 271, 367
 best time to color, 316
 portraits, 180
 with an easel, 178, 314
 originality in, 49, 123
 palette for, 347
 panoramas, 183, 199
 perseverance in, 170, 180, 184, 200, 347, 422, 427, 446
 photographs, painting and coloring, 362, 363, 365, 367, 379, 391, 426
 pictures. *See* genre *above*
 to please oneself, 9, 172, 307
 to please the public, 9, 143, 165, 197, 241
 portraits, 18, 20, 102, 187, 188, 433, 448, 474
 in the city, 147, 173, 180, 181, 182
 in the country, 306
 in crayon, 247
 from daguerreotypes, 32, 142, 248, 266, 314, 335, 428, 474
 of the dead, 18, 30, 32, 114, 142, 247, 248, 335, 471, 472, 474
 portrait painters, 266, 271, 308
 out of doors, 180
 touching up and varnishing, 351, 425
 vs. genre, 30, 49, 129, 170, 187, 198, 241, 245, 246, 271, 273, 341, 473, 476
 of women, 18, 352, 475
 prices for. *See* Prices (for paintings)
 repetition in, 309
 at residences of others, 351, 433
 with the right spirit, 109, 172, 181, 250, 269, 307, 431
 screening materials, 170–71, 176, 186, 262
 seascapes, 20
 selectivity in, 382, 450
 self-confidence in, 308, 309, 431, 433
 self-criticism in, 179
 self-doubt in, 145, 174
 self-knowledge in, 308, 345, 367
 simplicity in, 176, 433
 single characters, 247
 sketching, daily, 181, 309
 skylights, pl. 96; 145, 180, 199, 245, 271
 in a standing position, 314
 stimulation for, 130, 173, 309, 341, 474
 studies, preliminary, 141, 144
 studio. *See* Studio
 studying abroad. *See* Mount—opinions and observations, on Europe
 style, broad, 144, 147, 178, 181, 184, 242
 style, individual, 433
 subjects, familiar, 143, 307
 subjects, simple, 309
 subjects, understanding of, 341, 360
 sunsets, 315
 with thought, 242, 361
 in watercolor, 244
 when to paint, 142, 345, 448
 in cloudy weather, 144–45
 in the evenings, 238
 every day, 240, 245, 309
 in hot weather, 310, 311
 at sunset, 315
 works of others
 copying, 146, 184, 188
 observing, 382, 422, 431, 436, 476; vs. imitating, 101, 184, 309, 315–16, 430, 431, 474. *See also* independence in *above*
 touching up, 340, 351, 425

Painting. Mount on (cont.)
 See also Painting technique, Mount on;
 Rembrandt, letters from the spirit of
Paintings
 The City and the Country Beaux
 (Edmonds), pl. 10
 completed by Mount, 339, 467, 478, 479
 copied by Mount
 after W. A. Gay, 308, 317, 318, 474
 after Huntington, pl. 132; 368
 See also Portraits, copied by Mount
 Dance in a Country Tavern (Krimmel),
 pl. 2; 486
 Landscape (artist unknown), 466–67
 Salmon Fishing in Canada (Lanman), pl.
 41
 touched up by Mount, 467
Paintings (by Mount)
 auction of, 460, 462–63
 copied by Mount, 25, 469, 472, 473
 literature written to accompany, 75, 486
 misattributions, 466–67
 A Mount Miscellany, pls. 116–22; 322–24
 ownership of, current, 467
 unfinished, 25, 460
Painting technique (Mount's interest in), 8,
 12, 127, 285
Painting technique, Mount on
 backgrounds, 173
 in portraits, 244
 clothing, 175, 177
 color
 balance in, 310
 breadth of, 178
 force of, 309
 in landscape, 345
 richness of, 179, 240
 simplicity in, 179
 transparency in, 178
 colors (paints)
 dry, 246, 434
 durable, 341, 342
 opaque vs. transparent, 244
 use of, 129, 130, 144, 173, 176, 182, 246,
 247–48, 310, 341
 daguerreotypes, painting from, 314–15
 drapery, 175, 177, 179
 drawings, preliminary, 342, 346
 figures, 247
 in landscape, 341, 432
 light and shadow in, 176, 178, 346
 flesh, 142, 174, 175, 176, 177, 188, 241,
 244–45, 247, 341, 351
 grays in, 176, 179, 246
 light and shadow in, 176, 178, 198, 246,
 270, 340, 341, 342, 346, 391
 of a Negro, 245, 307, 342
 strength of color in, 381
 transparency in, 178
 white in, 176, 183
 foliage, 129, 315
 foregrounds
 in genre, 245
 in landscape, 342
 genre
 foreground in, 245
 light and shadow in, 130, 176, 244
 glazing, 129, 173, 187, 309, 448
 grounds, 244, 315
 heads, 145, 147, 178, 239, 241
 in landscape parlors, 339–40
 landscapes, 129, 145, 176, 244, 315
 clouds in, 270, 342
 color in, 345
 figures in, 341, 432
 foliage in, 129, 315
 foreground in, 342
 grounds for, 244
 light and shadow in, 244
 from memory, 345

Painting technique. Mount on (cont.)
 mountains in, 129, 130
 sky in, 129, 130, 198, 270, 316, 342, 429
 snow scenes, 345
 sunlight in, 129, 242, 340
 sunset in, 129, 244, 270, 312
 at twilight, 311
 water in, 242
 light and shadow, 172, 173, 179, 182, 238,
 346
 in flesh, 176, 178, 198, 246, 270, 340,
 341, 342, 346, 391
 out of doors, 130, 176, 244
 in portraits, 130, 141–42, 145, 178, 239,
 247, 346
 lighting, 171
 mirror image, use of, 144, 270
 night scenes, 311
 paints. *See* colors *above*
 perspective, 270, 308, 310
 photographs, coloring, 291
 portraits, 129, 141–42, 187, 313, 314, 342
 background in, 244
 faces in, 247
 glazing, 187
 light and shadow in, 130, 141–42, 145,
 178, 239, 247, 346
 tints in, 145
 scumbling, 141, 173, 187
 touching up, 267
 window shades, 443
 See also Painting, Mount on; Rembrandt,
 letters from the spirit of; Index of
 Works: individual titles
Painting technique (materials), Mount on
 canvas, preparation of, 177, 183, 199–200,
 315, 383
 colors (paints)
 durability of, 177, 178, 315
 grinding, 165
 mixing, 391
 vehicles for, 177, 248, 308, 312, 315, 361
 glue, to fasten sketches, 249
 glue, for waterproofing, 180
 oil, 308
 drying, 185, 312
 how to purify, 345
 linseed, 178, 185, 308, 312, 361
 nut, 308
 raw: bleached, 360, 361; vs. boiled, 308
 palette, order of, 341
 for flesh, 130, 142, 145, 176, 187, 351,
 434
 panel, preparation of, 315
 pigments, 129, 144, 171, 176, 178–79, 246,
 247, 341
 browns, 342
 durability of, 422
 of Long Island, 235–36
 for shadows, 381
 solvents, 177, 178, 187, 200, 361
 varnish, 185, 250, 270, 308, 360–61
 copal, 187, 200, 308, 361
 demar, 308, 315, 361
 mastic, 367
 wheat paste, uses for, 367
Painting technique of others, Mount on
 Achenbach, Andreas, 187, 352
 Baker, Charles, 340
 Baker, G. A., 247
 Bierstadt, Albert, 422
 Bonheur, Rosa, 309
 Church, F. E., 316
 Cole, Thomas, 185–86, 199, 236
 Durand, A. B., 176, 179, 185, 240, 242,
 244, 342
 Elliott, C. L., 145, 188, 238, 242, 246
 Gignoux, Régis, 352
 Gray, Henry P., 185
 Kensett, J. F., 242

Painting technique of others, Mount on
 (cont.)
 Lanman, Charles, 198
 Morland, George, 297
 Mount, Henry Smith, 246
 Mount, Shepard A., 184, 244
 Osgood, S. S., 246
 Ranney, William, 339
 Rembrandt, 178, 247, 296, 340
 Reynolds, Joshua, 182, 239
 Rubens, 176, 178, 342
 Santerre, Jean-Baptiste, 308
 Stuart, Gilbert, 182
 Titian, 297
 Vernet, Horace, 270
 Williamson, W. R., 249, 250
Palmer, Erastus Dow, 168, 261
Panoramas, 183, 199
Parker, Mr., 54
Parker, H. W., correspondence, 334
Parker, J., *Flower Piece* owned by, 468, 482
Parker, John Adams, 453
Parrish, Miss (of Oyster Bay, L.I.), 65
Parsons, W., possible engraving by, 320
Partridge, Mr. (spiritualist), 287, 296
Patronage, offers of
 Goupil, Vibert & Co., 49, 123, 152, 159–
 60
 Nicoll, Solomon T., 30, 146
 Reed, Luman, 19, 32, 123
 Seabury, Thomas S., 432
 Sturges, Jonathan, 32, 123, 199
 Wood, Charles B., 311, 341
Patterson, George Washington, 203
Patterson, James H., 119, 183
 paintings owned by, 468, 469
Peale, Charles Willson, 106
Pease, Joseph Ives, engraving by, 78
Peele, John Thomas, 240, 473
Pendleton, George Hunt, 381
Penley, Aaron Edwin, 346
Pennsylvania Academy of the Fine Arts, 101
Perkins, Miss (neighbor), 394
Perrin, Jean-Charles-Nicaise, 160
Perry, Matthew Calbraith, portrait of, 26,
 469
Perry, Comm. Oliver H., 306
Perspective, Mount's interest in, 12, 13,
 205. *See also* Painting technique,
 Mount on
Peter Cram, 108
Peto, John Frederick, 405, 421
Petty, John, 446
Pfeiffer, Fred A., 94
Pfeiffer [Pfieffer], Ida, oil sketch of, 344
Phare, W. H., portrait of, with family, 377,
 477
Phrenological Journal, correspondence,
 439–40
Piatti, Anthony, 124
Pickering, Mary E. (dau. of William L.),
 portrait of, 32, 472, 473, 483
Pickering, William L., 32, 472, 483
 portrait of, 473
Pickersgill, William Henry, 104
Pierce, Mrs., 432
Pierce, Franklin, 202
Pierson [Pearson], Antoinette, portrait of,
 468
Pierson, David, 203
Platt, Brad R., correspondence, 80, 85
Plutarch, life of Pericles, 397
Poe, Edgar Allan, 74
Politics, 10, 201–2
 N. Conkling on (1860), 358
 B. T. Hutchinson on (1848), 202, 203–4
 Charles Lanman on (1844), 115
 William H. Ludlow on (1868), 455–56
 R. N. Mount on (1840), 58, 59, 60
 S. A. Mount on (1848), 202

Politics (cont.)
 John R. Reid on (1864), 396
 George W. Thurber on (1853), 302
 See also Index of Works: *Cider Making*,
 The Dawn of Day, *The* Herald *in the
 Country*
Politics, Mount on, 201
 (1840) 60
 (1848) 187, 202, 203, 204
 in Europe, 188
 (1860) 357–58
 (1861) 353, 358
 (1862) 360
 (1863) 367, 373, 377
 (1864) 379, 381, 382, 383, 396
 (1865) 384, 385–86, 391
 (1866) 423, 426, 427, 429
 (1867) 439, 440–41
 (1868) pl. 171; 444, 445, 446–47
Portable studio. *See* Studio, portable
Porter, Mrs. (dau. of M. C. Morgan), por-
 trait of, 352, 357, 358, 474, 475
Port Jefferson Times (L.I.), 12, 368, 485
Portraits
 copied by Mount
 after Child, 338, 474
 after Elliott, 479
 after Shumway, 471
 after Stuart, 30, 130, 471
Portraits (by Mount), 11, 14
 copied by Mount, 472, 473
 of the dead, pl. 108; 11, 285
 See also Painting, Mount on; Paintings
 (by Mount); Painting technique,
 Mount on: Self-portraits; Index of
 Works: Portraits
Portraits (of Mount)
 by Elliott (1848) pl. 52; 15, 30, 161, 186,
 472
 copies after, by Mount, 479
 lithograph after, by Crehen, pl. 53; 153,
 160
 by Elliott (1849) c.pl. 3; 15
 by W. Alfred Jones, 335
Post, Richard B., 203
Poussin, Gaspard, 244
Poussin, Nicolas, 160, 240
Powell, Mr. (William Henry Powell?), 101,
 397
Powers, Hiram, *The Greek Slave*, 119, 120,
 148, 149
Pray, Mr. (spiritualist), 289
Pre-Raphaelites, Falconer on, 319
Press, Barnard, 205
Price, George J., 162
 Just in Tune owned by, c.pl. 26; 31, 123,
 472, 480, 483
 portrait of, 475, 476
Price, Mrs. George J., 386
 portrait of, 475, 476
Price, Harriette, 233
Prices (for paintings)
 genre, 27, 29, 123, 142, 304, 307
 portraits, 20, 25, 27, 29, 30, 51, 53, 142,
 197, 241, 335, 352, 433
 of the dead, 32, 335, 348, 352, 388, 471,
 472, 474
 of women, 352
Pritchard, Col. Benjamin Dudley, 385
Putnam, Gen. (of Riverhead, L.I.), 52

Queens Borough Sketchbook, pls. 59–84;
 205

Randall, John, 202, 203
Ranney, William, 117, 127, 321, 349, 467
 painting technique of, 339
Ransom, Caroline L. Ormes, 348, 349–50

Raphael, 16, 70, 174
 Mount on, 70
 painting style of, 293, 294
Ray, Dr. Joseph H., 203, 338, 474
Raymond, Mr., portrait painted for, 472
Raymond, Julia Parrish, portrait of, 472
Raynor, Miss, 427
Raynor, Mr. (dancing master), 53, 54
Raynor, E. A., 361, 463
Reed, Luman, 13, 68, 74, 431
 on American art, 68, 70
 asks Mount to paint his portrait, 73
 Bargaining for a Horse: painted for, pl.
 94; 27, 68, 177–78, 469; Reed on, 69,
 70
 and Thomas Cole, 68–73 *passim*
 collection acquired by New York Gallery,
 27, 68, 95
 correspondence, 13, 68–73
 death, 73, 100
 and Durand, 19, 68–73 *passim*
 and Flagg, 68, 69, 70, 72
 gallery doors project, 68–73 *passim*
 and Mount, on his friendship with, 72
 on Mount's work, 69
 on S. A. Mount, 73
 offer of patronage by, 19, 32, 123, 469
 The Truant Gamblers painted for, pl. 27;
 27, 68–72 *passim*, 177, 469
Reeve, H. A., 455–56
Regnault, Jean-Baptiste, 160
Reich, Sheldon, 10, 12
Reid, John R., 357, 386, 396
Religion, Mount on, 288–89, 296, 434, 444.
 See also Spiritualism
Rembrandt, 181
 color technique of, 178, 247, 296, 340
 on confidence, 308, 311
 letters from the spirit of, 285, 292–95
 Mount on, 175, 242
Rennell, M. A. (neighbor), 380
Republican party, 10, 201. *See also* Politics
Reuben, portrait of, pl. 118; 322, 479
Reviews. *See* Criticism and reviews
Reynolds, Sir Joshua, 117, 173, 176, 247
 Mount on, 31, 240, 307
 on objective art, 170, 172
 painting technique of, 182, 239
 on pigments, 171
 Gilbert Stuart on, 144
Rice, Daddy, 152
Rice, Mary Ford, portrait of, 479
Richards, Thomas Addison, 126, 232, 453–
 54, 456
 as critic, 233, 453
 on Mount's death, 459
 as painter, 124, 232, 340
Ridner, John P., 104, 112, 118
Rigley, Fordice, 67
Riley, Gen. Bennett(?), on the American
 flag, 382
Ripley, G. B., *Ette* exhibited by, 484
Risley, Mr. (workman), 365
Rizley, Dick, 380
Roberts, Marshall O., 29, 302, 314
Robinson, Mr. (dancing master), 51
Robinson, Richard, 202
Rodgers, Capt., 53
Rodgers, Oran. *See* Rogers
Roe, Alfred, 395
Rogers [Rodgers], Oran W., 59, 203, 463
Rollandson. *See* Rowlandson
Rondell, Abraham T., 204
Rosa, Salvator, 173
Rose, Austin, 203
Ross, Edmund G. (congressman), 447
Rossiter [Rosseter], Thomas Pritchard, 188,
 346
Rowland, Joseph, 445
Rowland, Theodore, 449

Rowlandson [Rollandson], Thomas, 287
Rubens, 122, 147, 247
 painting technique of, 176, 178, 342
 Gilbert Stuart on, 144
Rudyard, James, portrait of, 479
Ruland, Lewis, 311
Ruskin, John, 423, 476
Russell, Mrs., portrait of, 468
Russell, Charles Handy, 25, 468, 470
Russell, Mrs. Charles Handy, 468
Russell, C. M., portraits exhibited by, 483
Russell, William Harry (son of William
 Henry), portrait of, 471, 483
Russell, William Henry, portrait of his son
 exhibited by, 483
Rutgers, Col., 16

Sag-Harbor Watch (L.I.), 102
Saintin. *See* Sartain
Saltmarsh, Mr. (of Macon, Ga.), 51, 53
Sanford, Charles L., 424
Sanitary Commission, U.S., 378, 393, 394
Santerre, Jean-Baptiste, 308
Sargent, Manlius, commissions by, 240,
 266, 267
Sartain [Saintin], John, 371
Satterly [Satterlee], Gen. John R., 53, 249
Schaus, Annie (dau. of William), 164, 168
Schaus, William, 10, 123, 152–53, 168, 241
 American Portrait Gallery, 153, 160
 commissions by, 125, 162, 163, 164, 165,
 169, 245, 267
 correspondence
 for Goupil, Vibert, 13, 156–63 *passim*
 private, 152–53, 162–68 *passim*
 and Lanman, 153, 164
 leaves Goupil & Co.: (1850) 162; (1852)
 152, 163
 lithographs published by. *See* Litho-
 graphs, pub. by William Schaus
 marriage, 163
 Mount's friendship with, 152, 160, 162
 press release by, 153
 wants to buy *Just in Tune*, c.pl. 26; 158–
 59
Schaus, Mrs. William, 163
Scheffer, Ary, 160
Schenck, Peter H., 104
Schenck, Robert, portrait of, 26, 469
Schenck, Mrs. Robert, portrait of, 26, 469
Schoals, F. P., commission by, 174
Scott, Gen. Winfield, 117, 124
Scrapbook. *See* Mount papers, scrapbook
Seabury, Rev. Charles (uncle), 235
 portraits of: (1830) 20, 25, 468; (c.1846)
 479; (1846) 298, 471
Seabury, Mrs. Charles, 20, 25, 468
Seabury, Charles Edward (nephew, son of
 Charles S.), 67, 182, 241, 245, 372,
 439
 portraits of: (with his mother, 1828) pl. 6;
 479; (1846) 471
Seabury, Charles Saltonstall (brother-in-
 law, son of Rev. Charles), 53, 58,
 150, 235, 342
 commission by, 244
 death, 343
 pianoforte factory, 56
 portrait of, 25, 468
 portraits exhibited by, 483
Seabury, Mrs. Charles Saltonstall (sister;
 Ruth Hawkins Mount), 51, 52, 65, 66,
 114, 151, 235, 304, 372, 386, 432, 449,
 450, 454, 455
 birth, 267
 daughter Ruth born, 118
 health, 114, 117, 118, 119
 Landscape with Children at Play given
 to, 25, 468

Seabury, Mrs. Charles Saltonstall (cont.)
 Mount boards with, 200, 314
 S. A. Mount on, 78
 and Mount's estate, 460, 464
 painting lessons, 17, 19
 portraits of: (with son, 1828) pl. 6; 479;
 (1831) 468
 and William Schaus, 163–64, 165
 son Samuel born, 123, 236
Seabury, David (great-uncle of Rev.
 Charles), 235
Seabury, Edward. *See* Seabury, Charles
 Edward
Seabury, Edward S. (greatnephew, son of
 Thomas S.), portrait of, 479
Seabury, John (great-grandfather of Rev.
 Charles), 235
Seabury, John S., 235
Seabury, Julia Ann (niece, dau. of Charles
 S.; m. Charles Henry Wells), 78, 151,
 163, 235, 245, 440
 marriage, 165, 257
 portraits of: (1846) 117, 471, 483; (1858)
 474
Seabury, Lydia, 242
Seabury, Maria (niece, dau. of Charles S.),
 235, 370, 387, 451, 455
 Girl Asleep given to, c.pl. 21; 29, 470
 portraits of: (1846) 471, 483; (1856) 473
Seabury, Maria Winthrop, portrait of, 479
Seabury, Mary, 387
Seabury, Ruth Frances (niece, dau. of
 Charles S.), 118, 451
Seabury, Samuel (nephew, son of Charles
 S.), 123, 236, 432, 450
Seabury, Samuel (grandfather of Rev.
 Charles), 235
Seabury, Bishop Samuel (father of Rev.
 Charles), 235
Seabury, Rev. Samuel (son of Rev.
 Charles), 235, 335, 381, 449, 471, 473
 portrait of, 30, 66, 298, 471, 483
Seabury, Mrs. Samuel, portrait of, 266, 473
Seabury, Thomas Shepard (nephew, son of
 Charles S.), 78, 142, 236, 394, 432,
 448, 484
 copies Mount's violin, pl. 29; 80, 87
 correspondence, 87, 440
 and Mount's estate, 463
 naval service, 232, 236–37
 offer of patronage by, 432
 as a painter, 188, 250
 portraits of: (1846) 471; (1855) 473
Seabury, Mrs. Thomas Shepard, portrait of,
 plans for, 432
Seabury, William (nephew, son of Charles
 S.), portrait of, 479
Seabury family, 235
Searing, Edna. *See* Mount, Mrs. Joshua
 Elliott
Searing, George, 386, 441, 465
 Walking Out owned by, 305, 473, 484
Searing, Mrs. George, 305
Searing, Theo, commission by, 474
Self-portraits
 (1828) 479
 (1828, with flute), pl. 5; 17, 20, 467, 476
 (1832) c.pl. 24; 141–42, 479
 (c.1848, after Elliott) 479
 (1851, after Elliott) 479
 (1851, with hat and cloak) 31–32, 472, 483
 (1854) 473
Seoncia, G. A., 473
Seward, William Henry, 358, 391, 423,
 426
Shakespeare, William, 20, 142, 371, 379
Shattuck, A. D., 453, 467, 479
Shee, Sir Martin Archer, 104
Shepard, Deborah Hawkins (aunt; Mrs.
 John Shepard), 19, 59, 64

Shepard, Joseph (cousin, son of Deborah),
 78
Shepard, Lettie (cousin, dau. of Deborah),
 51, 52, 53, 150
Shepard, Mary (cousin, dau. of Deborah),
 64
Shepard, W. W. (cousin; of Auburn, N.Y.),
 233
Sherman, Gen. William T., 381, 383, 385,
 452
Sherwood (portrait painter), 52
Shields, Jonathan, 98
Shields, Patrick, drawing of, 381
Shooten, G. (Floris van Schooten?), 294
Shumway, Henry C., 471
Shumway, Mrs. Henry C., portrait of, by
 Elliott, 246
Sketch Club, 97, 100, 116
Sketches. *See* Drawings
Slavery, 10, 201. *See also* Politics (1848,
 1860–65)
Smith, Adam R.
 Coming to the Point owned by, pl. 95; 32,
 153, 165–66, 168, 473, 481, 483
 correspondence, 260–61
Smith, Capt. Alexander, 471
Smith, Alford A., 483
Smith, Mrs. Alford A., portrait of, 470, 483
Smith, Alfred A. (son of James), portrait of,
 471
Smith, Anne Elizabeth, portrait of, after
 Shumway, 471
Smith, Ann Marian (sister of Carlton), 53
Smith, Carlton, 51, 53, 54, 57
Smith, Charlotte (dau. of Eliza), 117, 122
Smith, E. (sculptor), 464
Smith, Ald. Edmund Thomas
 painting of his house, 478
 portrait of, 20, 374, 468
 portrait of his son, 157, 472
Smith, Mrs. Edmund Thomas, portrait of,
 468
Smith, Edward, 464
Smith, Edward Henry, 353
 correspondence, 357, 373–74, 377
Smith, Egbert T., 51, 87, 202, 203, 236
Smith, Elias, 64
Smith, Mrs. Eliza, portrait of, 30, 117, 122,
 150, 182, 471
Smith, Floyd, portrait of, 422, 477
Smith, Mrs. Hannah, portrait of, 248, 473
Smith, Capt. Henry, 249
Smith, Isaac, 57
Smith, James, portrait of, 471
Smith, Mrs. James, portrait of, 471, 483
Smith, Capt. John, 445
Smith, John Henry, 440
Smith, Jonas, 150
Smith, Capt. Jonas, 57
 portrait of, 27, 469
Smith, Mrs. Jonas (wife of Capt. Jonas),
 portrait of, 469
Smith, Joshua B., 202, 203
Smith, Marcia (dau. of Eliza), 117
Smith, Nathaniel, portrait of his son, 317,
 335, 348, 474
Smith, Sarah Cordelia (dau. of Nathaniel),
 portrait of, 317, 335, 348, 474
Smith, Sarah R., portrait of, 470
Smith, Seba, 74, 75, 111
Smith, Mrs. Seba, 111
Smith, Walter, 440, 444
Smith, Wessel S., 204
Smith, William Sidney, 203
Smith, William Wickham Mills (son of Ald.
 Edmund Thomas), portrait of, 479
Smithsonian Institution, 79
Smithtown Library (L.I.), 12, 128
Smollett, Tobias, 142
Snodgrass, Dr. J. E., 268

Socrates, 184
Somerville, Robert, and Mount's estate,
 460, 462–63
Soulange-Teissier, Louis-Emanuel, litho-
 graph by, 481
Southern Literary Messenger (journal), 108,
 109
Sparks, Jared, 375
Spear, C. Flint, 469
Spencer, William G., 484
Spencer, Mrs. William G., portrait of, 474,
 484
Spinola, Mrs. Eliza (mother of Gen. Francis
 B.), portrait of, 32, 473
Spinola, Gen. Francis B., 32, 381, 427, 431,
 433, 473
 correspondence, 439, 477
 portrait of, 434, 439, 445, 452, 477, 484
Spinola, Mrs. Francis B., 17, 19, 357, 431
 Chasing the Fiddlers at Low Tide owned
 by, 475, 484
 portrait of, 434, 439, 477
Spiritualism, 10–11, 285
 diary on (notebook), 12, 285–92
 Mount on, 288, 289, 292, 295, 296, 353
 Rembrandt, letters from the spirit of, 285,
 292–95
 "Rochester rappings," 11, 285, 288
Spohr, Louis, 80
Spooner, Alden J., 104
 commissions by: (1847) 174; (1853?) 266,
 267
 on death of S. A. Mount, 450, 454, 455
Spooner, Mrs. Alden J., 66
Spooner, Frank (son of Alden J.), 454
Spooner, Mary A., correspondence, 104–5
Stackweather, Samuel, 66
Stanton, Edwin M., 444, 447
Starr, Mrs. Timothy, portrait of, c.pl. 2; 11,
 479
Stearns, Junius Brutus, 234, 354
Stebbins, Theodore, 102
Stephanoffe, Philip, 75, 76
Stephens, Alexander H., 386
Stevenson, Andrew, 202
Stewart, Mr. (spiritualist), 287, 296
Stiles, Henry R., correspondence, 393
Stony Brook, L.I., 8; *See also* The
 Museums at Stony Brook; Mount—
 opinions and observations, on Stony
 Brook
Strong, the Misses (sisters of Selah B.), 362,
 374
Strong, Mr. and Mrs., portraits of, 468
Strong, Benjamin (uncle of Selah B.), por-
 trait of, 30, 471, 483
Strong, Carrie (Caroline Amelia Strong;
 dau. of Selah B.), 386, 394
Strong, Charles (son of Selah B.), 427
Strong, Cornelia (dau. of Selah B.). *See*
 Monson, Mrs. Marcena
Strong, George Templeton (son of George
 W.), 128
Strong, George Washington (uncle of Selah
 B.)
 paintings owned by
 Boys Caught Napping in a Field, pl. 91,
 30, 150, 174, 182, 472, 483
 Eel Spearing at Setauket, c.pl. 23; 128,
 471, 483
 portrait of, 30, 471, 483
Strong, George W., Jr., commission by,
 266
Strong, Mary Augusta (dau. of Selah B.),
 portrait of, 348, 472
Strong, Mary Brewster (sister of Selah B.),
 commission by, 348, 472
Strong, Selah Brewster, 18, 30, 386, 444,
 468, 472
 nominated for Congress, 65

503

Strong, Selah Brewster (cont.)
 portrait of, 29, 53, 470
 portrait of, by P. S. Harris, 449
Strong, Mrs. Selah Brewster (Cornelia Udall), 346, 379, 475
 portrait of, 468
Strong, Judge Thomas B. See Strong, Judge Thomas Shepard
Strong, Judge Thomas Shepard (father of Selah B.)
 painting of his farm, 479
 portrait of, 25, 468
Strong, Thomas Shepard (son of Selah B.), 432
Stuart, Mr. (spiritualist), 289
Stuart, Alexander H. H., 88
Stuart, Gilbert, 19, 176, 236
 on painters and painting, 144
 painting technique of, 182
 portrait by, copied by Mount, 30, 130, 471
Stuart, Robert L., 318
Studies, oil, 466. See also Index of Works: individual titles
Studio, Mount on
 his own, 52, 171, 242, 244, 334
 ideas for, pls. 86, 96, 97; 144, 198, 242, 271, 308
 color, 198, 245
 size, 170, 180, 184
Studio, portable, 262–65
 care of, 363, 380, 391, 475
 completion of, 264, 475
 construction of, 262–63, 264, 265
 cost of, 264, 475
 disposal of, ideas for, 448
 drawing of, pl. 93; 262
 Mount on, 271, 352, 360, 362, 370, 424
 moved to Setauket, 363, 475
 sketch of, 265, 370, 477
Sturges, Jonathan, 95, 116, 355
 commission by, 199, 240
 correspondence, 95–99, 100, 166–67
 Mount on, 19, 100
 and New York Gallery of the Fine Arts, 68, 95, 99
 offer of patronage by, 32, 123, 199
 paintings owned by
 Farmers Nooning, c.pl. 18; 27, 51, 95, 97, 99, 100, 469, 480, 483
 Ringing the Pig, c.pl. 19; 29, 95, 100, 470, 483
 Who'll Turn the Grindstone?, pl. 38; 31, 95, 100, 472, 483
Stuyvesant, Peter, 371
Stuyvesant, Mrs. P. G., 199
Subjects for painting, 8, 9, 128, 205, 309, 408–9
 chasing a butterfly, 430
 "The Doom of Slavery," 391
 lists of, in diaries, pls. 128, 129, 130, 172 ; 8, 9, 128, 147, 162, 174–75, 200, 241, 245, 266, 269–70, 306–7, 308, 311, 316, 340, 344, 346–47, 362, 365–66, 447
 Mr. Dignity, 130, 131–32
 Old Abraham fishing, 64
 the old oak, 199
 "Sergeant Bates, the Flag Bearer in the South," 446
 suggested by others, 116, 334, 341, 348, 349–50, 374–75, 439
 Water Fowl, 147, 174, 199, 240, 316
 "Woodman Spare That Tree," 147, 174, 198, 232, 240, 245, 267, 316
 study for, pl. 85; 232
 See also Negro, as subject; Painting, Mount on
Suffolk County Historical Society (Riverhead, L.I.), 15

Suffolk Democrat (Huntington, L.I.), Mount reviewed in, 386
Suffolk Museum. See The Museums at Stony Brook
Suffolk Weekly Gazette (Riverhead, L.I.), 70, 302
Sully [Tuly], Thomas, 15, 19, 49, 116, 258
Sumner, Charles, 358, 423
Swedenborg, Emanuel, 292

Talbot, Jesse, 115
Tallmadge, Lt., portrait of, 20, 468
Taylor, Joshua, William Page, the American Titian, 101, 106
Taylor, Moses, and transatlantic cable, 314
Taylor, Zachary, 117, 118, 187, 201, 203, 242
 painted by Vanderlyn, 123, 258
Temperance Society, 25
Teniers, David, the Younger, 156, 172, 176, 240, 271, 294
Terrell [Terril], Capt. William, 102, 428
Terwilliger, George B., 356
Thénot, J. P., Cours de perspective pratique, 12
Thielley, Claude, lithograph by, 481
Thomas, Gen. Lorenzo, 444, 447
Thompson, Benjamin Franklin, 102, 232, 247
 correspondence, 102–3, 232, 234–36
 on death, 235
 Leisure Hours given to, pl. 40; 102
 R. N. Mount on, 63
 portrait of, 26, 469
 portrait of his son, plans for, 235, 236
 visits Mount's studio, 198, 234
 writings
 History of Long Island, 63, 102–3
 Seabury genealogy, 235
Thompson, Mrs. Benjamin Franklin, portrait of, 469
Thompson, C. G., correspondence, 358–59
Thompson, Henrietta, 386
Thompson, Henry (son of Benjamin F.), 235, 236
Thompson, Jerome, 467
Thompson, Martin Euclid, 17, 25, 104, 375
 portrait of, 20, 51, 468, 482
Thompson, Mrs. Martin Euclid, portrait of, 468
Thompson Samuel L., 384
 portrait of, 29, 470
Thompson, Mrs. Samuel L. (Phoebe Satterly), portrait of, 384, 386, 387, 388, 476
Thomson, James, The Seasons, 20, 468
Thorpe, Julia B. See Becar, Mrs. Noel Joseph, Jr.
Thurber, George W., correspondence, 302, 304
Tice, Charles Winfield, 243
Tiess, Edward W., portrait of, 31, 472
Tillotson, Mr., 264
Tim, Uncle, 52
Titian, 145, 146, 174, 176, 183, 235, 247
 Gilbert Stuart on, 144
 palette of, 297
Token, The (annual), 99
Tompkins, Calvin, on S. P. Avery, 368
"Tootie." See Becar, Mrs. Noel Joseph, Jr.
Tousey, Sinclair, M.D., portrait of, as a child, 443, 445, 452, 477, 484
Townsend, Mr. (of Oyster Bay), 424
Townsend, I. Dwight, 456
Townsend, James, 424
Townsend, Solomon, 425
Townsend, William B., portrait of, 351, 370, 474, 484
Tracy, Mr., on perpetual exhibitions, 306
Trinity Church, 298, 299, 335

Troyon, Constant, Mount on, 344
Trumbull [Trumble], Col. John, 25, 75, 397
Trumbull, Lyman (congressman), 447
Tucker, Gideon
 portraits for, 469
 portraits of: (1830) 468; (1834) 26
Tucker, Mrs. Gideon (Jemima Brevoort), portrait of, 468
Tucker, Luther H., 388, 397
Tucker, Mrs. Luther H. (Cornelia Strong Vail), 388, 397
Tuckerman, Henry T., 106, 120, 148, 149
Tuileries, Mount exhibits at, 123, 236
Tuly. See Sully
Turner, J. M. W., 104, 319, 397
Tuthill [Tuttle], Effingham
 Mount boards with, 263, 363, 448
 and Mount's portable studio, 262–64, 265
 portrait of, 362, 477
Twain, Mark, 322
XXI, The, 95, 97, 99. See also Sketch Club
Tyler, Capt., 381, 382, 432
Tyler, John, 59
Tyler, William Clark, portrait of, 479

Udall, Dr. Richard, 54
 portrait of, 468
Udall, Mrs. Richard (Prudence Carll), portrait of, 468
Underhill, Benjamin Townsend, 424
 portraits of: (1835?) 479; (1842) 29, 470
Underhill, Mrs. Benjamin Townsend (Eliza Weeks)
 portraits of: (1835) 479; (1842) 470
Underhill, James, 424
Underhill, Joseph William, 424, 440, 445, 446
Underhill, Miriam Weeks (dau. of Benjamin T.), portrait of, 470
Upfold, Rev. George, portrait of, 25, 468, 482
Upton, Francis H., 86, 87, 90, 124

Vail, Cornelia Strong. See Tucker, Mrs. Luther H.
Vail, Harvey W., 204
Vail, Mrs. Harvey (cousin; Elizabeth Mount, dau. of John S.), portrait of, 479
Van Bront, Mr., 428
Van Buren, John, 202, 204
Van Buren, Martin, 59, 60, 201–4
Vance, Gov. Z. B., 386
Van Corlaer, Arendt, 371
Vanderbilt, William H., 368
Vanderhoof [Vanderhoff], J. T.
 Leisure Hours owned by, pl. 40; 469
 portrait of, 31, 162, 472, 483
 Rev. Zachariah Greene (1852) painted for, pl. 15; 32, 472, 483
Vanderhoof, Mrs. J. T., 483
 portrait of, 32, 472
Vanderlyn [Vanderline], John, 52, 115, 116, 127, 240
 copies of paintings by, 146
 Landing of Columbus, 62, 63, 397
 Mount's admiration for, 123–24
 portrait of Zachary Taylor, 123, 258
 Townsend family portraits, 424
Van Dyck, 174
Van Nest, Abraham, 51
Van Norden, Miss (of New York City), 151
Van Rensselaer, W. P., 199
Van Winkle, P. G. (congressman), 447
Vasari, Giorgio, 142
Vernet, Horace, 270, 321
Vernets, the, 160
Veronese, Paolo, 145, 247

Verplanck, Gulian C., 116
Vibert, Léon, 156, 158, 159, 160, 161. *See also* Goupil, Vibert & Company
Victoria, Queen, 313
Vinci, Leonardo da, 293, 294
Violin (Mount's interest in), 79–94
 as adapter, 80
 as composer
 "Going through the tunnel on the Long Island rail road," 80, 122
 "In the Cars, on the Long Island Rail Road," pl. 30; 80
 as fiddle player, 66, 79, 271, 273, 304, 314, 445
 notations in correspondence
 "The Braes of Athol," pl. 20; 57
 "Possum Hunt," pl. 21; 61
 "A Sett of Cotillions in the Key of C," pl. 24; 62
 square-dance, pl. 18; 54
 "Waltz—The Cachucha" and "Visit Sett," pl. 25; 63–64
 templates for, 13
 varnishes, formulas for, 79, 86, 94
Violin, hollow-back, 91, 125, 302
 "Cradle of Harmony," pl. 29; 79, 80, 86, 87
 criticism of, 124
 early experimentation with, 58, 79, 80–85
 exhibited, 91
 U. C. Hill on, 80, 91, 93
 improvements in, pl. 164; 79, 93–94, 423
 patent and renewal, pl. 34; 86–90, 93, 94, 124, 386
 patent office model, pls. 31–33; 79, 86, 87
 principle of, plans to expand, 93
 remuneration for, 94
Vollmering, Joseph, 341, 342, 422

Wadsworth, James, commission by, 260, 266, 269
Wainwright, Dr., 17–18, 20
Wakeman, T. B., 104
Walcott, J. (spiritualist), 290
Waldo, Samuel Lovett, 380, 394
Walker, Mrs. Robert J., 13
Wallace, Mr. (of New York City), 53
Wallace, William Vincent, on Mount's violin, 79, 91
Walpole, Horace, 13, 143
Walworth, Reuben Hyde, 203
Ward, Hon. Aaron, 29, 62, 470
Ward, James H., 79, 80
Warner, Dr., and spiritualism, 296
Warner, Andrew, 162, 167
Warren, Phebe, portrait of, 29, 470
Washington, George, 347
 as subject of mural, 365, 368, 375–76, 397. *See also* Index of Works: *Washington Crossing the Alleghany*
Watercolors, 466. *See also* Index of Works: individual titles
Waters, Mr. (of Baltimore), commission by, 341

Wayne, Mrs. (neighbor), 380, 386
Wayne, J. M., correspondence, 451
Weather, Mount's interest in, 127
 daily observations, 380, 432, 437
Webster, Daniel, 125–26, 153, 289
 portrait of. *See* Index of Works: *Webster Among the People*
Weeks, Mr., portraits of, 470
Weeks, Mrs., portraits of, 470
Weeks, Mrs. James Huggins (Miriam Doughty)
 three portraits of (1838), 470
 two portraits of (1842), 29, 470
Weir, Robert W., 116, 188, 261, 397
Weitzel, Gen. Godfrey, 385
Wells, Albert, 397
Wells, B. F., 203
Wells, Charles Henry, 473
Wells, Mrs. Charles Henry. *See* Seabury, Julia Ann
Wells, Henry (son of Charles Henry), portrait of, 473
Wells, Julia A. *See* Seabury, Julia Ann
Wells, Matilda Evelina, portrait of, 472
Wells, William, 186
Werner, Charles J., 102, 324
West, Benjamin, 18, 20, 49
Wheeler, Mr. (singing teacher), 52
Whig party, 201, 202. *See also* Politics (1848)
Whig Review. See American Review
White, Chandler, 314
White, Edwin, 318
Whitehorne, James A., 25, 80, 90–91
Whitewash, formula for, 247
Whitman, Walt, 14, 485
Whitney Journal, 128
Wickham, David H., 30, 66, 471, 483
Wickham, Louise Floyd (dau. of Wm. Hull), portrait of, 363, 475
Wickham, Mrs. Ruth, 151
Wickham, William Hull, 423, 484
 portrait of, 365, 421, 476, 484
Wickham, Mrs. William Hull (Louise Floyd), 379
 Jessie Floyd painted for, 421, 476
 portrait of, 363, 421, 423, 475, 476, 484
Wilkie, Sir David, 104, 153, 161, 365
 Blind Fiddler (engraving), 124
 prices for his paintings, 171
Williams, Edwin, 104
Williams, Hermann Warner, Jr.
 and Cowdrey. *See* Cowdrey, Bartlett, and Williams, Hermann Warner, Jr.
 Mirror to the American Past, 486
Williamson, Judge, 372
Williamson, Mr. (father of Col. Wm.), 52
Williamson, Jedediah (son of Col. Wm.), 51, 52
 portrait of, c.pl. 15; 469
Williamson, John, 436
Williamson, John M., 52, 102
Williamson, Col. William, 51, 235, 469
Williamson, William Rudyard, 18, 249, 250
 portrait of, 18, 20, 468
Willis, Nathaniel Parker, 232, 335, 374, 375

Wilmont, Thomas A., 463, 464
Wilmot, David, 201
Wilson, Mrs. Edna, 462, 465
Wilson, Gilbert, 367
Wilson, Henry, 358
Wilson, Richard, 181
Wilson, W., spirit of, 296–97
Windle & Company, 317, 319, 320
Windust, Edward
 portrait of, 25, 468
 Rustic Dance owned by, c.pl. 1; 20, 468
Windust, Mrs. Edward, portrait of, 468
Winslow, Mr., 440
Witherington, William Frederick, 104
Wood, Charles B., 67, 339, 421, 476
 commissions by: (1858) 315; (1859) 347; (1860) 351; (1862) 362
 correspondence, 370, 394–95
 drawing of picture frame, pl. 138; 393, 395
 gift of panels from, 380, 394–95
 invites Mount to paint his portrait, 344
 offers of patronage by, 311, 341
 paintings owned by
 Catching Crabs, c.pl. 38; 386, 387, 475, 484
 Early Impressions Are Lasting, 386, 387, 475, 484
 Esquimaux Dog (1859), pl. 115; 474
 Going Trapping, 370, 379, 394, 475
 Loitering by the Way, pl. 135; 386, 387, 475
 Peace, or Muzzle Down, 386, 387, 475
 The Tease, 382–83, 385, 395, 474, 484
Wood, David A. (brother of Charles B.), 394
 commissions by
 landscape, 341
 scripture piece, 315, 347
 correspondence, 436
 paintings owned by
 Any Fish Today?, 474, 484
 Right and Left, c.pl. 30; 484
Wood, Frederick, 387
Wood, Lizzie (sister of Charles B.), 424, 436, 484
 portrait of, 421, 476
Wood, Richard, 335
Woodbeck, Mr. (house painter), 187
Woodhull, Brewster, 202, 203
Woodhull, Lt. Maxwell, 373
Woodhull, Gen. Nathaniel, 198
Woodhull, Richard, 429, 477
 painting of his house, 462, 477
Woodman, Mr. (spiritualist), 289
Woodruff, T. T., portrait of, 477, 482
Woods, Bartlett, 53
Woodville, Richard C., 128
Woolf, Mr. (spiritualist), 287
Wright, William, 318, 320, 475
 commission by, 341
Wright, W. P., 341
Wright Company, Rawdon, 99
Wunder, Richard P., 149

Yewell, George, H., on Frère, 365
Young, Rev. T. G., 289

index of works

Unless otherwise indicated, works are in oil. If an alternate title is significant, it appears in parentheses after the main title; purely descriptive titles are not italicized.

After Dinner, pl. 9; 25, 469, 483
Any Fish Today?, 474, 484
 possible engraving after, 320
 reviewed, 320
Apple Blossoms, 478, 484
Apples in a Champagne Glass, 381, 423, 476, 484
Ariel, pl. 114; 312, 422, 424, 476
 exhibited as *A Study*, 445, 452, 484
 touched up, 436
Artist and His Wife in a Landscape, An, 478
Artist Showing His Own Work. See *The Painter's Triumph*
Artist Sketching, The, pl. 122; 324, 478
At the Well (Sportsman at the Well; The Huntsman at the Well), 462, 472, 477
 and American Art-Union, 187–88, 234
Autumn: A Girl Walking (Landscape with Girl and Barn), 478
Autumn Landscape in a Pasture, 478

Back Porch, The, 478
Banjo Player. See *Banjo Player in the Barn*
Banjo Player, The, c.pl. 29; 10, 162, 164, 168, 311, 473
 exhibited, 484
 lithograph after, 169, 473, 481
Banjo Player in the Barn, c.pl. 37; 324, 462, 477
Bargaining for a Horse (Farmers Bargaining), pl. 94; 27, 177, 178, 266, 267, 469, 473
 admired, 72, 74, 75
 coloring in, 184–85
 engraving after (1840), 74, 76, 117, 149
 engraving after (1851), 480
 and Goupil & Co., 153, 166–67
 exhibited, 483
 Reed on, 69, 70
 Schaus on, 164, 168
 stories about, 70, 158, 200
 technique used, 177
 variation on *(Coming to the Point)*, pl. 95; 153, 166, 266, 483
 where painted, 249
Barn by the Pool, 478
Barn Door with Horse's Head, 478
Barn on the Salt Meadow, 478
Barn with Stairway, 478
Bar-room Scene, Walking the Crack. See *The Breakdown*
Before the War. See *Peace, or Muzzle Down*
Bird Egging (Children with a Bird's Nest), 30, 75, 471, 483
Blackberry Girls, 29, 470, 483
Bone Player, The, c.pl. 28; 10, 162, 164, 168, 307, 311, 473

 exhibited, 484
 lithograph after, 168, 473, 481
 technique used, 307
Bouquet of Beauty, 462, 477
Boy, 478
Boy at Waterside (Boy by the Shore), 477, 478
Boy by the Shore. See *Boy at Waterside*
Boy Hoeing Corn. c.pl. 32; 29, 62, 470, 483
 study for, 478
 where painted, 249
Boy in a Chair, 478
Boy on a Country Path, 478
Boy on the Fence. See *Leisure Hours*
Boy resting on a fence looking over his left shoulder at the spectator. See *Country Lad on a Fence*
Boy resting on a fence with a basket in his hand, 25, 469
 variation on, without basket, 25, 469
Boy sitting on the bannister of a stoop with a book in his hand. See *Leisure Hours*
Boys Catching Rabbits. See *Catching Rabbits*
Boys Caught Napping in a Field (Caught Napping), pl. 91; 30, 174, 182, 472
 exhibited, 483
 where painted, 249
Boys Gambling in a Barn. See *The Hustle Cop*
Boys Going Trapping. See *Going Trapping*
Boys Hustling Coppers. See *The Hustle Cop*
Boys hustling coppers on the barn floor. See *The Truant Gamblers*
Boys Quarreling After School. See *School Boys Quarreling*
Boys Sailing Toy Boats, 478
Boys Trapping. See *Catching Rabbits*
Boy with an Ax, 478
Breakdown, The (Bar-room Scene, Walking the Crack), pl. 88; 27, 249, 469, 483
 sketch for, pl. 87
 where painted, 249
Break of Day, The. See *The Dawn of Day*
By the Shore, Small House in Cove, pl. 106; 478

Cabinet Portrait. See Portraits, *Harmer, Maggie*
Cabinet Portrait of a Lady. See Portraits, *Seabury, Julia Ann* (1846)
Cactus with Flaming Red Blossom, 478
California News (News from the Gold Diggings; Reading the Tribune*)*, c.pl. 13; 31, 160, 200, 472
 exhibited, 124, 483
 study for, pl. 14; 478
Cannon, The. See *Peace and Humor, or Tranquility*
Card Players, The, c.pl. 36; 322, 462, 477
Catching Crabs (Spearing Crabs) c.pl. 38; 386, 387, 475, 484
 technique used, 384–85
Catching Rabbits (Boys Trapping; Snaring Rabbits), c.pl. 17; 29, 249, 470
 exhibited: Crystal Palace, 29; NAD, 78, 483; Tuileries, 123
 lithograph after (Noël; Bichebois), 29, 123, 153, 159, 160, 168, 480
 possible engraving after, 74, 76, 78
Catching the Tune, pl. 166; 147, 425, 428, 462, 477
 sketch for, pl. 165
Caught Napping. See *Boys Caught Napping in a Field*
Celadon and Amelia, c.pl. 6; 20, 468, 482
Charming Scene in Autumn, A, 477

 exhibited as *A Charming Scene*, 445, 452, 484
Chasing the Fiddlers at Low Tide, 475, 484
Cherries (1855), 478
Cherries (1855; Inv. 166), 462, 477
Cherry Blossoms, 379, 477
Children Playing Before a House, 478
Children with a Bird's Nest. See *Bird Egging*
Child's First Ramble, A, 378, 393, 394, 477
Christ Raising the Daughter of Jairus, c.pl. 4; 17, 102, 467, 476
 exhibited as *Raising of Jairus' Daughter*, 17, 20, 102, 459, 482
 sketch for, pl. 4
Cider Making, c.pl. 33; 29, 102, 421, 470
 exhibited, 29, 111, 483
 R. N. Mount on, 61
 political significance of, 202
 sketch for, pl. 90
 story based on, 75, 486
 where painted, 249
Coming from the Orchard. See *Returning from the Orchard*
Coming to the Point, pl. 95; 32, 266, 473
 criticized, 167
 exhibited, 165, 483
 lithograph after, 152, 153, 165–67, 473, 481
 studies for, 478
 as variation on *Bargaining for a Horse*, pl. 95n; 153, 166, 266, 483
Confederate in Tow, The, 361, 475
Corn, 382, 477
Corner of the Mount House (n.d.), 478
Corner of the Mount House (c. 1846). See *Long Island Farmhouse Piazza with Imaginary Landscape Vista*
Corner of the Mount Kitchen, 478
"Costumes Drawn at the Bowery Theatre" (watercolor), c.pl. 35; 322
Cottage. See *Girl and Pitcher*
Country Dance. See *Rustic Dance After a Sleigh Ride*
Country Lad on a Fence, 249, 468
 engraving after (Adams), 25, 468
 exhibited as *Sketch from Nature*, 482
Courtship. See *Winding Up*
Cove, The, 478
Cracking Nuts, 462, 477
Crane Neck, 478
Crane Neck Across the Marsh, pl. 107; 274, 478
Crazy Kate, 20, 468, 482
Creek with a Row Boat, 478
Currants, pl. 121; 324, 478

Dahlias, 478
Dance of the Haymakers (Music Is Contagious), c.pl. 20, pl. 55; 30, 105, 471
 engraving after, 259
 exhibited, 105, 483
 idea for, pl. 54n
 lithograph after (orig. pub. as *Music Is Contagious*), 30, 123, 153, 156–60 *passim*, 168, 480
 reviewed, 156
 sketch for, pl. 54
 study for, 478
 variation on, begun, 397
Dance on the Turnpike, The, 383, 477
Dancing on the Barn Floor (Interior of a Barn with Figures), c.pl. 8; 25, 468, 482
Dawn of Day, The (Politically Dead; The Break of Day), pl. 170; 445, 452, 462, 477
 political theme of, 201, 435, 440–41

Dead Fall, The. See *Trap Sprung*
Death of Hector, The, 20, 467
Disagreeable Surprise. See *The Hustle Cop*
Disappointed Bachelor (Procrastination), 29, 249, 470, 483
 sketch for, pl. 13
Discovery, The. See *Turning the Leaf*
Dr. Dering's Residence, 450, 477
Dog (Mr. Davis's) in a Domestic Scene, 382, 477
Drawings (untitled; not related to finished paintings)
 big fish (pen), pl. 136; 387
 boat, two-hulled (pen), pl. 167; 429
 Charter Oak, Hartford, Conn., 29–30
 child and turkey (pencil), pl. 152; 407
 for Thomas Cole, 462
 ducks (pencil), pl. 151; 407
 exterior of a house (pencil), pl. 141; 398
 eyes (pen), pl. 168; 430
 farmyard with pigs (pencil), pl. 89
 fiddle player (pencil), pl. 150; 407
 "Fire light" (pen), pl. 57; 174
 fishnets (pencil), pl. 113
 girl ironing (pen), pl. 50; 143
 "Good Subject" (pen), pl. 129; 365
 Harmer residence, 433
 hog butchering (pencil with chalk), pl. 139; 398
 "The Hollow back fiddle" (pen), pl. 47; 124
 interior of a house (pencil), pl. 140; 398
 interiors, three (pencil), pls. 142–44; 398, 405
 Carleton Jayne's house, 367
 man asleep (pencil), pl. 149; 405, 407
 man in a tall hat (pencil), 205
 man in a top hat (pencil), pl. 147; 405
 old woman reading (pen), pl. 51; 147
 paddle wheel (pen), pl. 123; 335
 paintbrushes (pen), pl. 137; 391
 perch, 118
 perspective (pen), pl. 169; 437
 Queens Borough Sketchbook, pls. 59–84; 205
 sailboat (pen), pl. 112; 302
 sharpy (pen), pl. 127; 353
 "Sketch of Huntington's Washington" (pencil), pl. 132; 368
 studio, elevation for (pen), pl. 97; 271
 studio, plans for (pen), pl. 86; 242
 studio, portable (pen), pl. 93; 262
 studio and exhibition room, plan for (pen), pl. 96; 271
 "Subjects" (1862; pen), pl. 128, 362
 "Subjects" (1863; pen), pl. 130; 366
 "Subjects" (1868; pen), pl. 172; 447
 subjects, groups of, for painting (pencil), pls. 153–63; 408–9
 tavern scene (pencil), pl. 148; 405
 teeth (pen), pl. 126; 343
 tombstone with violin (pen), pl. 35; 91, 93
 violins (pen), pl. 164; 423
 wash drawing (pen), pl. 133; 379
 Washington Monument (pen), pl. 48; 125
 West Point (pen), pl. 49; 142
 woman with long hair (pencil), 205
 woman with a shawl (pencil), pl. 145; 405
 See also individual landscapes; Portraits; Sketches from nature
Dregs in the Cup (Fortune Telling; The Fortune Teller), pl. 28; 9, 29, 53, 77–78, 470
 exhibited: Artists' Fund Society, 77; NAD, 483
 New York Gallery, given to, 29, 67, 78, 99–100, 470
 possible engraving after, 77–78

Early Impressions Are Lasting, 386, 387, 475, 484
Early Spring, 462, 477
Edmund Thomas Smith Place, The, 478
Eel Spearing at Setauket (Fishing Along Shore), c.pl. 23; 30, 106, 471
 exhibited as *Recollections of Early Days—"Fishing Along Shore,"* 483
 sketches for, pls. 44, 45
 study for, pl. 46; 478
Esquimaux Dog (1859), pl. 115; 312, 474, 484
Esquimaux Dog (1865), 388, 397, 476
 exhibited, 423, 484
Even Exchange No Robbery. See *Fair Exchange No Robbery*
Exchange Is No Robbery. See *Fair Exchange No Robbery*

Fair Exchange No Robbery (Even Exchange No Robbery; Exchange Is No Robbery), c.pl. 39; 388, 462, 477
 study for, 478
Farewell, The. See *The Letter*
Farmer Husking Corn, 25, 469
 exhibited as *Long-Island Farmer Husking Corn,* 483
 where painted, 249
Farmers Bargaining. See *Bargaining for a Horse*
Farmers Nooning, c.pl. 18; 27, 95, 100, 267, 469
 coloring in, 184–85
 engraving after, 27, 115, 167, 469, 480, 483
 exhibited, 483
 possible engraving after, 99
 Schaus on, 164, 168
 study for, pl. 36; 478
 Sturges on, 97
 variation on, pl. 95*n*
 where painted, 249
Farmer Whetting His Scythe (Hay Making), c.pl. 31; 31, 123, 174, 472
 exhibited, 483
 technique used, 197
 where painted, 249
Farm House at St. George's Manor, The, 478
Fence on the Hill, 478
Figure in a Large Brimmed Hat, 178, 477
Fishing Along Shore. See *Eel Spearing at Setauket*
Flax Pond, Old Field, Setauket, 478
Flower Piece, 25, 468, 482
Flowers, 462, 477
Force of Music, The. See *The Power of Music*
Fortune Teller, The. See *Dregs in the Cup*
Fortune Telling. See *Dregs in the Cup*
French painting (copy after W. A. Gay), 308, 317, 318, 474
Fruit Piece: Apples on Tin Cups, 367, 379, 477
Fuchsia, 478

Girl and Pitcher, 20, 468, 482
 reviewed, 25, 51
Girl Asleep, c.pl. 21; 29, 470, 483
 Lanman on, 115
 technique used, 182
Girl at the spring reading a love letter, 20, 467, 476
Girl with a pitcher standing at a well. See *Girl and Pitcher*
Glimpse of the Sound, 462, 477
Going Trapping (Boys Going Trapping), 370, 379, 394, 475

Going Trapping (cont.)
 exhibited, 361, 484
 Rev. F. Noll on, 370

Hamlet, scene from, 20, 467
Haying Scene, pl. 26; 68, 478
Hay Making. See *Farmers Nooning*
Herald *in the Country, The (Politics of 1852, or Who Let Down the Bars?),* c.pl. 14; 32, 130, 162, 473, 483
 lithograph after, 32, 153, 167, 168, 473, 481
 political significance of, 202
Hillside Field, 478
Huntsman at the Well, The. See *At the Well*
Hustle Cop, The (Boys Gambling in a Barn; Disagreeable Surprise; Hustling Pennies), 29, 470
 engraving after, 74, 78, 470
 exhibited as *Boys Hustling Coppers,* 483
Hustling Pennies. See *The Hustle Cop*

Inlet at Stony Brook, 478
Interior of a Barn with Figures. See *Dancing on the Barn Floor*

Just in Tune, c.pl. 26; 31, 123, 164, 174, 472
 Bullus on, 236
 companion to, commissioned *(Right and Left),* 160, 161, 162
 exhibited: NAD, 483; Tuileries, 123, 236
 lithograph after, 31, 123, 153, 159, 160, 161, 162, 168, 236, 472, 480
 Schaus asks to buy, 158, 159

Kitchen Fireplace, 462, 477
Kitchen in the Old Seabury House in Setauket, 479

Landscape (1834; pencil), pl. 98; 274
Landscape (1834; pencil), pl. 99; 274
Landscape (c. 1850), 479
Landscape (October 22, 1859; pencil), pl. 105; 274
Landscape (for Elisha Brooks), 32, 472
Landscape (Inv. 136), 462, 477
Landscape (Inv. 153a), 462, 477
Landscape (painted in the "Pond Lily"), 429, 477
Landscape (by Shattuck, completed by Mount), 467, 479
Landscape (small, with figures), 25, 468
Landscape ("Strong's Point, R. Woodhull's house, a boat on Shore"), 429, 477
Landscape (on tin pie plate), 479
Landscape (view of West Meadow Creek), 46
Landscape and Boy, 477, 482
Landscape and Water (c. 1851), 479
Landscape and Water (1851). See *View of the Sound over Long Island Shore*
Landscape with Children at Play, 25, 468
Landscape Study, Ducks in Water, 479
Landscape with Girl and Barn. See *Autumn: A Girl Walking*
Landscape with Hills, 479
Landscape with House, 479
Landscape with Sand Pit, 479
Laying Off, 363, 475
Laying on His Oars, 462, 477
Leisure Hours, pl. 40; 102, 469
 exhibited as *Boy on the Fence,* 483
Letter, The (The Farewell), pl. 116; 322, 479
Letting Down the Bars. See *The* Herald *in the Country*

Loitering by the Way, pl. 135; 386, 387, 475, 484
technique used, 385
Lone Pine Tree, The, 479
Longbotham's Barn, 479
Long Hill Road, Stony Brook, 479
Long-Island Farmer Husking Corn. See *Farmer Husking Corn*
Long Island Farmhouse Piazza with Imaginary Landscape Vista (Corner of the Mount House), pl. 102; 479
exhibited as *View of the Catskill Mountains*, 483
Long Island Farmhouses, pl. 120; 324, 479
Long Island Farmhouses (detail), 479
Long Island Sound, 479
Long Story, The (The Tough Story), c.pl. 16; 8, 29, 249, 469, 483
W. E. Burton on, 76
commissioned, 74, 75
engraving after, 29, 74, 111
Mount on, 74, 75–76
story about, by Seba Smith, 74, 117
Loss and Gain, c.pl. 12; 31, 234, 472, 483
Mount on, 30–31
where painted, 249
Low Tide in the Cove, 479
Lucky Throw, The, 31, 156, 160, 162, 164, 472
companion to, commissioned, 162, 169, 175
lithograph after (orig. pub. as *Raffling for a Goose*), c.pl. 27; 10, 31, 153, 168, 480
Mount on, 245

Man in a Boat, pl. 104; 479
Man in Easy Circumstances, A., 25, 468, 482
where painted, 249
Man playing the violin while the others are listening. See *After Dinner*
Man with an Ax, 479
Mill at Stony Brook, The, 479
Mill Dam at Madison, The, pl. 101; 274, 479
Mischievous Drop, The, 317, 319, 474
exhibited, 321, 484
Mother and Child. See Portraits, L. P. Clover, *Mother and Child* for
Mount Barn, The, 479
Mount House, The (n.d.), 479
Mount House, The (1854), 479
Mount House Rooftop, 479
Mower, The, 462, 477
Music Hath Charms. See *The Power of Music*
Music Is Contagious. See *Dance of the Haymakers*
Mutual Respect, 434, 445, 452, 477, 484
Muzzle Down. See *Peace, or Muzzle Down*

Neptune, a Dog, 477
News from the Gold Diggings. See *California News*
Northern Sentiment, 385, 477
North Shore of Long Island, 479
Novice, The, c.pl. 22; 30, 471
American Art-Union, commissioned by, 30, 117, 119, 174, 471
Lanman on, 119
Mount on, 119
J. H. Patterson on, 119

Old Grave Yard, The, 462, 477
Old Mill, The, 462, 477
Old Woodhull Homestead, The, 462, 477
On the Hudson, 462, 477

Painter's Triumph, The (Artist Showing His Own Work), c.pl. 34; 9, 29, 54, 59, 78, 470
engraving after, 29, 74, 76, 470
exhibited, 483
where painted, 249
Peace, or Muzzle Down, 386, 387, 450, 475
exhibited as *Before the War*, 484
technique used, 385
Peace and Humor, or Tranquility (The Cannon), 264, 362, 475
Peach Blossoms, 379, 477, 484
Pericles, scene from, 20, 467
Politically Dead. See *The Dawn of Day*
Politics of 1852, or Who Let Down the Bars?. See *The Herald in the Country*
Portable Studio, 265, 370, 477
Port Jefferson Harbor, 475
Portrait in One Sitting. See Portraits, Jones, W. Alfred
Portrait of a Clergyman. See Portraits, Greene, Rev. Zachariah (1829)
Portrait of the Artist. See Self-portrait (1851)
Portraits
Bailey, Admiral Theodorus, pl. 92; 32, 251, 257, 454, 473, 483
technique used, 257
Barnet, Catherine, 478
Barnet, Joshua, 478
Beadleston, Mrs. Ebenezer, pl. 119; 322, 478
Becar, Noel Joseph, 67, 351, 474
Becar, Mrs. Noel Joseph, 351, 474
Birdsall, Samuel, 478
Booth, *William* (1833), 469
Booth, *William*, two portraits for (1833), 469, 482
Bordman, Miss, 468
Breedlove, Mrs., 474
Brooks, Mrs. Henry Sands, 478
Brooks, John (1853), 478
Brooks, John, children of (1853), 32, 478, 483
Brooks, John, children of (1855), 473
Brooks, Mrs. John, 478
Brower, Mrs. A. S., 30, 471
Cain, James (drawing), 381
Cain, Patrick (drawing), 381
Carmichael, Rev. William M., 26, 469
Clover, L. P., *Mother and Child* for, 26, 469, 483
Crary, John S., six portraits for, 468, 482
Darling, E. T., 475, 484
technique used, 360
Davis, John R., 379, 422, 477
Davis, Lucy, 353, 363, 475
Delafield, Dr. Edward, 25, 468
Delafield, Mrs. Edward, 468
Delafield, John, 20, 468, 482
Delafield, Mrs. John, 25, 468, 482
Denison, Abel, 351, 474, 484
technique used, 351–52
Denison, Mrs. Abel, 351, 352, 474, 484
Denison, William, 351, 474
Denton, Sanford, child of, 379, 477
Dering, Henry, 474
technique used, 309
Dey, Mrs. James Richard, 478
Edgar, Major William, 478
Edgar, Mrs. William, 478
Elliott, Charles Loring, pl. 3; 15, 30, 472, 483
technique used, 188
Ette, 477, 484
Evans, Rev. James S., 362, 477, 484
Flanden, the Misses (two portraits), 25, 468

Portraits (cont.)
Flanden, Mrs. Pierre, 468
Floyd, Hon. Charles, 20
Floyd, Jessie, 386, 421, 423, 476
Floyd, Mrs. Jessie, 443
Goodhue, Mrs. Charles F., 478
Gould, Frederick A., 474
Graham, Julia, 25, 468
Greene, Rev. Zachariah (1829), 20, 468
exhibited as *Portrait of a Clergyman*, 482
Greene, Rev. Zachariah (1852), pl. 15; 32, 472, 483
Greene, Mrs. Zachariah (1842; pencil), pl. 16
Griffin, Mr., brother of, 473
Haight, Mrs., granddaughter of, 51, 469
Haight, Rev. B. T., 25, 468
exhibited as *Portrait of Rev. B. J. Haight*, 482
Haight, Rev. B. T., brother of, 468
Harmer, Maggie, 381, 475–76
exhibited as *Cabinet Portrait*, 423, 484
Harrison, C. C., portrait of a child for, 474
Hawkins, Capt. Daniel Shaler, 472
Hawkins, Micah (copy after Child), 338, 474
Hood, Andrew, 363, 370, 371, 475
exhibited as *The Late Andrew Hood*, 484
Hood, Mrs. Andrew, 475
Hood, Anne C., 377, 475
Hudson, George (pencil), 387
Johnson, Jeremiah, pl. 19; 29, 56, 470, 483
Johnson, Jeremiah, two portraits at residence of (1839), 56
Jones, W. Alfred, pl. 109; 479
exhibited as *Portrait in One Sitting*, 483
Julia, 477, 484
Kearney, David, 266, 473
Leveridge, John, 479
Lott, Sarah, 25, 469
Ludlom, Newton, 315, 474
Ludlow, Mrs., 31, 240, 259, 472
Ludlow, Frank, 424, 477
exhibited as *Portrait*, 423, 484
Ludlow, William H., 388, 422, 424, 477
Ludlum, Nicholas, 473
Ludlum, Mrs. Nicholas, 468
McElrath, Mrs. Thomas (1855), 421, 473, 476
exhibited 1866 as *Portrait*, 423, 484
McKeige, Capt. Edward E., 473
exhibited as *Capt. E. E. McKeigle*, 484
McKeige, Mrs. Edward E., 427, 428, 477
Manice, Mrs., 479, 482
Marsh, Mrs. Nathaniel, 351, 424, 474
technique used, 352
Marsh, Susan T., 67, 351, 474
Marvin, Judge, 25, 468
Mathewson, Nelson, pl. 19; 479
Matteson, Tompkins H., 479
Mills, Elizabeth, 470
Mills, William Wickham (1829), 20, 468
Mills, William Wickham (1856), 473
Mills, Mrs. William Wickham (1829?), 479
Mills, Mrs. William Wickham (1855), 473
Monson, Mrs. Marcena, 367, 378, 379, 394, 475
Moubray, Frances Amelia, 248, 260, 285, 473
Mount, Alfred, son of, 472
Mount, Henry Smith (1828), pl. 7; 20, 467
Mount, Henry Smith (1831), pl. 8; 479
Mount, Henry Smith (1841; pen), pl. 23
Mount, Henry Smith, on His Deathbed (watercolor), pl. 22

508

Portraits (cont.)

exhibited as *Sketch of the late H. S. Mount*, 483

Mount, John Henry, 473

Mount, Julia Hawkins (1830), c.pl. 7; 25, 468

Mount, Julia Hawkins (June, 1841; pencil), pl. 134

Mount, Julia Hawkins (November, 1841; pencil), pl. 43

Mount, Julia Hawkins (1855), 473

Mount, Robert Nelson, 20, 468

Mount, Shepard Alonzo, c.pl. 25; 471

Mount, Mrs. Shepard Alonzo, 32, 472, 483

Mount, Thomas Shepard (nephew), 473

Mount, Mrs. Thomas Shepard. See *Mount, Julia Hawkins*

Mount, William Sidney. *See* Self-portraits

Nash, Lora, 479

Nash, Mrs. Lora, 479

Nicoll, Edward H., 30, 471

copied for S. T. Nicoll, 472

exhibited as *Portrait of a Gentleman*, 483

Frothingham on, 30

Nicoll, Mrs. Edward H., 30, 471

Nicoll, Mrs. Sarah, 31, 472

technique used, 247

Nicoll, Mrs. Sarah, children of, 468

Nicoll, Solomon T. (1846), 30, 150, 471, 483

Nicoll, Solomon T. (1855), 473

Nicoll, Mrs. Solomon T., 473

Noll, Rev. F. M. (pencil), pl. 146; 407

Nunn, William, daughter of, 468

Onderdonk, Bishop Benjamin Tredwell (1830), pl. 110; 20, 25, 51, 298, 468

Onderdonk, Bishop Benjamin Tredwell (1833), 25, 298–99, 368, 462, 469

removed from Columbia, 298, 335

reviewed, 25

Onderdonk, Mrs. Benjamin Tredwell (1830), pl. 111; 20, 25, 298, 468

Owen, Mary Lavinia Brooks, 479

Perry, Comm. Matthew Calbraith, 26, 469

Pfeiffer, Ida, 344

Phare, W. H., and family, 377, 477

Pickering, Mary E., 32, 472, 473, 483

Pickering, William L., 473

Pierson, Antoinette, 468

Porter, Mrs., 352, 357, 358, 474, 475

Price, George J., 475, 476

Price, Mrs. George J., 475, 476

Raymond, Julia Parrish, 472

Reuben, pl. 118; 322, 479

Rice, Mary Ford, 479

Rudyard, James, 479

Russell, the Misses (c. 1833; two portraits), 483

Russell, Mrs., 468

Russell, Charles Handy, 25, 468

Russell, Charles Handy, daughters of (1840; two portraits), 470

Russell, Mrs. Charles Handy, and Children, 468

Russell, William Harry, 471

exhibited as *Master Russell*, 483

Schenck, Robert, 26, 469

Schenck, Mrs. Robert, 26, 469

Seabury, Rev. Charles (1830), 20, 25, 468

Seabury, Rev. Charles (c. 1846), 479

Seabury, Rev. Charles (1846), 298, 471

Seabury, Mrs. Charles, 20, 25, 468

Seabury, Charles Edward, 471

Seabury, Charles S., 25, 468

Seabury, Mrs. Charles S. (1831), 468

Seabury, Mrs. Charles S., and Son Charles Edward (1828), pl. 6; 479

Seabury, Edward S., 479

Seabury, Julia Ann (1846), 117, 471

exhibited as *Cabinet Portrait of a Lady*, 483

Seabury, Julia Ann (1858). See *Wells, Julia A.*

Seabury, Maria (1846), 471, 483

Seabury, Maria (1856), 473

Seabury, Maria Winthrop, 479

Seabury, Rev. Samuel, 30, 66, 298, 471, 483

Seabury, Mrs. Samuel, 473

technique used, 266

Seabury, Thomas Shepard (1846), 471

Seabury, Thomas Shepard (1855), 473

Seabury, William, 479

Searing, Theo, portrait for, 474

Shields, Patrick (drawing), 381

Smith, Capt. Alexander, daughter of, 471

Smith, Mrs. Alford A., 470

exhibited as *Portrait of a Lady*, 483

Smith, Alfred A., 471

Smith, Anne Elizabeth (copy after Shumway), 471

Smith, Edmund Thomas, 20, 374, 468

Smith, Edmund Thomas, infant son of, 157, 472

Smith, Mrs. Edmund Thomas, 468

Smith, Mrs. Eliza, 30, 117, 122, 150, 182, 471

Smith, Floyd, 422, 477

Smith, Mrs. Hannah, 473

technique used, 248

Smith, James, 471

Smith, Mrs. James, 471, 483

Smith, Capt. Jonas, 27, 469

Smith, Mrs. Jonas, 469

Smith, Nathaniel, son of, 317, 335, 348, 474

Smith, Sarah Cordelia, 317, 335, 348, 474

Smith, Sarah R., 470

Smith, One of the "Tangiers," 477, 484

Smith, William Wickham Mills, 479

Spencer, Mrs. William G., 474, 484

Spinola, Mrs. Eliza, 32, 473

Spinola, Gen. Francis B., 434, 439, 477

exhibited, 445, 452, 484

Spinola, Mrs. Francis B., 434, 439, 477

Starr, Mrs. Timothy, c.pl. 2; 11, 479

Strong, Mr. and Mrs., 468

Strong, Benjamin, 30, 471, 483

Strong, Cornelia, 18, 468

Strong, George W., 30, 471, 483

Strong, Mary, 348, 472

Strong, Selah B., 29, 53, 470

Strong, Mrs. Selah B., 468

Strong, Thomas Shepard, 25, 468

Tallmadge, Lt., 20, 468

Thompson, Benjamin Franklin, 26, 469

Thompson, Mrs. Benjamin Franklin, 469

Thompson, Martin Euclid, 20, 51, 468, 482

Thompson, Mrs. Martin Euclid, 468

Thompson, Samuel L., 29, 470

Thompson, Mrs. Samuel L., 384, 386, 387, 388, 476

Tiess, Edward W., 31, 472

Tousey, Sinclair, 443, 445, 452, 477, 484

Townsend, William B., 351, 370, 474, 484

Tucker, Gideon (1830), 468

Tucker, Gideon (1834), 26

Tucker, Gideon, portraits for (1834), 469

Tucker, Mrs. Gideon, 468

Tuthill, Effingham, 362, 477

Tyler, William Clark, 479

Udall, Dr. Richard, 468

Portraits (cont.)

Udall, Mrs. Richard, 468

Underhill, Benjamin Townsend (n.d.), 479

Underhill, Benjamin Townsend (1842), 29, 470

Underhill, Mrs. Benjamin Townsend (1835), 479

Underhill, Mrs. Benjamin Townsend (1842), 470

Underhill, Miriam Weeks, 470

Upfold, Rev. George, 25, 468, 482

Vail, Mrs. Harvey (Elizabeth Mount), 479

Vanderhoof, J. T., 31, 162, 472, 483

Vanderhoof, Mrs. J. T., 32, 472

Warren, Phebe, 29, 470

Webster, Daniel. See *Webster Among the People*

Weeks, Mr. and Mrs. (1838; two portraits), 470

Weeks, Miriam Doughty (1838; three portraits), 470

Weeks, Miriam Doughty (1842; two portraits), 29, 470

Wells, Henry, 473

Wells, Julia A., 474

Wells, Matilda Evelina, 472

Wickham, D. H., four children for (pencil), 30, 471

exhibited as *Pencil Sketches of Children*, 483

Wickham, Louise Floyd, 363, 475

Wickham, William Hull, 365, 421, 476, 484

Wickham, Mrs. William Hull, 363, 421, 423, 475, 476, 484

Williamson, Jedediah, c.pl. 15; 469

Williamson, William Rudyard, 18, 20, 468

Windust, Edward, 25, 468

Windust, Mrs. Edward, 468

Wood, Lizzie, 421, 476

Woodruff, T. T., 477, 482

Portraits (unidentified)

child (1828), 20, 468

"four portraits for a gentleman," 469

gentleman (1828; painted at Stony Brook), 20, 468

gentleman (1829), 468

gentleman (1829), 468

gentleman (1829), 468

gentleman (1829; painted on L.I.), 468

gentleman (1830), 468

gentleman (1830; painted in N.Y.C.), 468

gentleman (1831), 468

gentleman (1831; from N.Y.C.), 468

gentleman (1831; from N.Y.C.), 468

gentleman (1832), 468

gentleman (1832), 468

gentleman (1832; two portraits painted at Wallabout, L.I.), 468

gentleman (1833), 469

gentleman (1833), 469

gentleman (1833), 469

gentleman (1833), 469

gentleman (1833), 469

gentleman (1833; 34 × 27"), 469

gentleman (1838; 30 × 25"), 470

lady (copy after Stuart), 30, 130, 471

lady (1828; painted at Stony Brook), 20, 468

lady (1829), 468

lady (1829), 468

lady (1829; painted on L.I.), 468

lady (1830), 468

lady (1831; from N.Y.C.), 468

lady (1832), 468

lady (1832), 468

lady (1832; 30 × 25"), 479

lady (1832; 34 × 27"), 479

Portraits, unidentified (cont.)
 lady (1833), 469
 lady (1833), 469
 lady (1833), 469
 lady (1833), 469
 lady (1833), 469
 lady (1833; head-size), 469
 lady (1833; 34 × 27″), 469
 lady (1838; 30 × 25″), 470
 man (n.d.; 41 × 34½″), 479
 man (1832), 479
 mother (1828), 20, 468
 son (1829), 468
 "two or three portraits for practice"
 (1832), 468
 young lady (1842; posthumous), 29, 114,
 470
Poster, political, pl. 171
*Power of Music, The (Music Hath Charms;
 Force of Music)*, pl. 56; 153, 160, 236,
 471
 commissioned, 145, 174
 compared with *The Flagellation*, 486
 exhibited: Metropolitan Fair, 379; NAD,
 as *The Force of Music*, 483
 idea for, pl. 54n
 Leupp on, 30
 lithograph after, 30, 123, 152, 153, 156,
 157, 158, 159, 168, 187, 480
 Mount on, 157, 187
 reviewed, 49, 118, 153
 sketch for, pl. 54
 technique used, 173
 variation on, pl. 95n; 266, 397
 where painted, 249
Primitive Times, 462, 477
Procrastination. See *Disappointed Bache-
 lor*

Raffle, The. See *Raffling for the Goose*
Raffling for A Goose (lith.). See *The Lucky
 Throw*
Raffling for the Goose (The Raffle), pl. 12;
 29, 164, 200, 249, 267, 302, 469
 engraving after, 29, 74, 76, 111
 exhibited, 483
 Schaus on, 168
 study for *(Tavern Scene)*, pl. 11; 479
Rail Fence, The, 479
Ramblers, The, 30, 471, 483
 commissioned by McElrath, 174
 technique used, 173
Rat Tail Cactus, 379, 477
Reading the Tribune. See *California News*
*Rear View of the Mount Home, Stony
 Brook*, 479
Recollections of Early Days. See *Eel Spear-
 ing at Setauket*
*Returning from the Orchard (Coming from
 the Orchard)*, 361, 371, 462, 475, 484
Right and Left, c.pl. 30; 10, 31, 162, 164,
 472
 companion to *Just in Tune*, 160, 161, 162
 exhibited, 484
 lithograph after, 31, 153, 162, 168, 472,
 480
*Ringing the Pig (Scene in a Long Island
 Farm Yard)*, c.pl. 19; 29, 95, 100, 470,
 483
 sketch for, pl. 37
Rock and Trees, 479
Row Boat, The (pencil), pl. 100; 274
Rustic Dance After a Sleigh Ride, c.pl. 1;
 18, 20, 102, 468, 486

Rustic Dance After a Sleigh Ride, (cont.)
 adapted from Krimmel, pl. 2n
 exhibited, 104, 482
 reviewed, 9–10, 25, 51
 variation on(?), exhibited (1831), 482

St. George's Manor (n.d.), 479
St. George's Manor (1845), 479
Saul and the Witch of Endor, c.pl. 5; 17, 20,
 102, 257, 467–68, 482
Scarecrow, The. See *Fair Exchange No
 Robbery*
Scene in a Cottage Yard, 477, 482
Scene in a Long Island Farm Yard. See
 Ringing the Pig
*School Boys Quarreling (Take One of Your
 Size)*, 25, 468
 exhibited as *Boys Quarreling After
 School*, 482
 Falconer on, 320
 where painted, 249
Self-portrait (1828), 479
Self-portrait (1828; with flute), pl. 5; 17, 20,
 467, 476
Self-portrait (1832), c.pl. 24; 479
 technique used, 141–42
Self-portrait (c. 1848; copy after Elliott), 479
Self-portrait (1851; copy after Elliott), 479
Self-portrait (1851; with hat and cloak), 31–
 32, 472
 exhibited as *Portrait of the Artist*, 483
Self-portrait (1854), 473
Setauket Harbor, 462, 477
Shrine, 462, 477
Sisters, 479
Sketches. See Drawings
Sketches from nature
 (1839; pencil) 470
 (1843; oil) pl. 101; 66, 471
 (1844; oil) 30, 471
 (1851; oil) 32, 472
 (1864) 382
 (1865) 388
Sketch from Nature. See *Country Lad on a
 Fence*
Snaring Rabbits. See *Catching Rabbits*
Snow Balling (Winter Scene), 462, 477
Spearing Crabs. See *Catching Crabs*
Sportsman at the Well. See *At the Well*
Sportsman's Last Visit, The, c.pl. 9, pl.
 10n; 27, 469, 483
 where painted, 249
Spring Bouquet, 479, 484
Spring Flowers, 479
Stone Bridge, The, 479
Stony Brook Mill Dam, 462, 477
Studious Boy, The, 27, 469, 483
 copy and engraving after (Kensett), 368,
 370
 engraving after (Adams), 26, 370, 469
 reviewed, 26
 where painted, 249
Study, A. See *Ariel*
Suffolk Scene, A., 479
Surprise, The. See *Boys Caught Napping in
 a Field*
Surprise with Admiration. See *Turning the
 Leaf*

Take One of Your Size. See *School Boys
 Quarreling*
Tavern Scene. See *Raffling for the Goose*,
 study for

Tease, The, 380, 382, 385, 395, 474, 484
Thomas H. Mills House, The, 479
Thomas Strong Farm, The, 479
Tough Story, The. See *The Long Story*
Trap Sprung (The Dead Fall), c.pl. 11; 30,
 116, 153, 471
 engraving after, 30, 74
Truant Gamblers, The (Undutiful Boys), pl.
 27; 27, 68–72 passim, 74, 75, 177,
 267, 469
 alteration made in, 72
 exhibited, 483
 possible engravings after, 76, 99
 Reed on, 71, 72
 where painted, 249
Trying Hour, The (watercolor), pl. 39; 97,
 405
Tulips, 479, 484
*Turning the Leaf (Surprise with Admiration;
 The Discovery)*, pl. 58; 31, 123, 197,
 198, 472
 exhibited, 483
 technique used, 197

Undutiful Boys. See *The Truant Gamblers*

View from Studio Window, 363, 477
View from the Hill, 479
View of the Catskill Mountains. See *Long
 Island Farmhouse Piazza with Imag-
 inary Landscape Vista*
*View of the Sound over Long Island Shore
 (Landscape and Water)*, pl. 103; 479
Volunteer Fireman, The (watercolor), pl.
 117; 322

Waiting for the Boat, 462, 477
Waiting for the Packet, 462, 477
Waiting for the Tide, 240, 462, 477
Walking Out, 305, 473, 484
Washington Crossing the Alleghany, pl.
 131; 368, 462, 477
Watercolors. *See* individual titles
Webster Among the People, 153, 168, 304,
 462, 473
 commissioned, 125, 267
 exhibited, 484
 model for, 304
 Mount's dissatisfaction with, 273, 341
 reviewed, 273
 study for, 270
Well by the Wayside, The, 123, 472, 483
What Have I Forgot?, 361, 371, 475, 484
Who Let Down the Bars?. See *The Herald
 in the Country*
Who'll Turn the Grindstone?, pl. 38; 31, 95,
 100, 130, 472, 483
 story behind, 95, 100
 technique used, 245
Winding Up (Courtship), c.pl. 10; 27, 469
 exhibited, 159, 483
 possible engravings after, 76, 77, 99
 reviewed, 52
 where painted, 249
Winter Scene. See *Snow Balling*
Woman After Death, A, pl. 108; 479
"Woodman Spare That Tree," study for
 painting after, pl. 85; 232

Young Girl, A, 479
Young Traveller, The, 479